Handbook of
Medieval Sexuality

GW01057468

GARLAND REFERENCE LIBRARY OF THE HUMANITIES
VOLUME 1696

Handbook of Medieval Sexuality

Edited by
Vern L. Bullough
and James A. Brundage

Garland Publishing, Inc.
New York and London
1996

First paperback edition published in 2000 by
Garland Publishing Inc.
A Member of the Taylor & Francis Group
19 Union Square West
New York, NY 10003

10 9 8 7 6 5 4 3 2 1

Library of Congress Cataloging-in-Publication Data

Handbook of medieval sexuality / edited by Vern L. Bullough and James A.
 Brundage.
 p. cm. — (Garland reference libarary of the humanities ; v. 1696)
 Includes bibliographical references (p.) and index.
 ISBN 0-8153-3662-4 (alk. paper)
 1. Sex customs—History 2. Middle Ages I. Bullough, Vern L. II.
 Brundage, James A. III. Series: Garland reference library of the
 humanities ; vol. 1696.
 HQ14.H35 1996
 306.7'09'02—dc20 95-52021
 CIP

Cover illustration: *Bible moralisée* (Wien, Österreichische Nationalbibliothek
Cod. 2554). Courtesy of the Austrian National Library

Printed on acid-free, 250-year-life paper
Manufactured in the United States of America

CONTENTS

ix INTRODUCTION
James A. Brundage and Vern L. Bullough

SECTION I
1 SEXUAL NORMS

CHAPTER 1
3 CONFESSION AND THE STUDY OF SEX
IN THE MIDDLE AGES
Pierre J. Payer

CHAPTER 2
33 SEX AND CANON LAW
James A. Brundage

CHAPTER 3
51 WESTERN MEDICINE AND NATURAL PHILOSOPHY
Joan Cadden

CHAPTER 4
81 GENDERED SEXUALITY
Joyce E. Salisbury

CHAPTER 5
103 CHASTE MARRIAGE IN THE MIDDLE AGES:
"IT WERE TO HIRE A GREET MERITE"
Margaret McGlynn and Richard J. Moll

CHAPTER 6

1 2 3 HIDING BEHIND THE UNIVERSAL MAN:
MALE SEXUALITY IN THE MIDDLE AGES
Jacqueline Murray

SECTION II

1 5 3 VARIANCE FROM NORMS

CHAPTER 7

1 5 5 HOMOSEXUALITY
Warren Johansson and William A. Percy

CHAPTER 8

1 9 1 TWICE MARGINAL AND TWICE INVISIBLE:
LESBIANS IN THE MIDDLE AGES
Jacqueline Murray

CHAPTER 9

2 2 3 CROSS DRESSING AND GENDER ROLE CHANGE
IN THE MIDDLE AGES
Vern L. Bullough

CHAPTER 10

2 4 3 PROSTITUTION IN MEDIEVAL EUROPE
Ruth Mazo Karras

CHAPTER 11

2 6 1 CONTRACEPTION AND EARLY ABORTION IN THE
MIDDLE AGES
John M. Riddle

CHAPTER 12

2 7 9 CASTRATION AND EUNUCHISM IN THE MIDDLE AGES
Mathew S. Kuefler

SECTION III

307 CULTURAL ISSUES

CHAPTER 13

309 A NOTE ON RESEARCH INTO JEWISH SEXUALITY
IN THE MEDIEVAL PERIOD
Norman Roth

CHAPTER 14

319 A RESEARCH NOTE ON SEXUALITY
AND MUSLIM CIVILIZATION
Norman Roth

CHAPTER 15

329 EASTERN ORTHODOX CHRISTIANITY
Eve Levin

CHAPTER 16

345 SEXUALITY IN MEDIEVAL FRENCH LITERATURE:
"SEPARÉS, ON EST ENSEMBLE"
Laurie A. Finke

CHAPTER 17

369 OLD NORSE SEXUALITY: MEN, WOMEN, AND BEASTS
Jenny Jochens

CHAPTER 18

401 SEX ROLES AND THE ROLE OF SEX IN MEDIEVAL
ENGLISH LITERATURE
David Lampe

427 CONTRIBUTORS

429 INDEX

INTRODUCTION

Medievalists in earlier generations were reluctant to deal with sex. They likewise tended to ignore topics related to sex, such as courtship, concubinage, divorce, marriage, prostitution, and child rearing. They paid little attention to women and even less to gender issues. Gradually, however, like specialists in other fields in the humanities and social sciences, they have begun to investigate and write about these matters that their predecessors studiously ignored. Medievalists who have continued to explore the more traditional subject areas sometimes complain that, in consequence of these new-found interests, those in the current generation engaged in the study of the Middle Ages have abandoned political and economic topics in order to emphasize the "trendy" topics concerned with family and sexual studies. We believe that the broad field of medieval studies has ample room for scholars interested in all types of thought and behavior. We would insist that sexual conduct formed an important element in the lives and thoughts, the hopes and fears, both of individual medieval people and the institutions that they created.

This is not to say that the criticisms that scholars in the more traditional fields of medieval studies have voiced are without merit. Important themes in the political, institutional, and economic life of the Middle Ages certainly remain unexplored, and we hope that studies in these fields will continue to attract younger scholars. However, we also wish to affirm that the broadening of research interests among us during the past thirty years or so has yielded significant results that have considerably enriched the whole field and at the same time have increased its interest and appeal for members of the next generation of scholars.

The decades of the 1970s and 1980s in particular witnessed an outpouring of studies dealing with various aspects of human sexuality during the Middle Ages. One reason for this is quite simply that, once academics began to recognize that it was legitimate and respectable to study sexual

behavior, it also quickly became apparent that medieval records and other sources contained rich lodes of information about sexual behavior. This opened up fresh opportunities for original research and invited new interpretations of earlier conclusions about medieval society and its workings.

Earlier medievalists, to be sure, had not entirely ignored sexual topics. Traditional treatments of sexual matters, however, typically took the form of what may be described as moral discourse. Either such embarrassing matters were abruptly passed over as the instructors or writers hastened with burning blushes to apply themselves to more neutral topics, or else they distanced themselves from the subject with moralistic reflections upon the flawed nature of humankind in this wicked world. An illuminating example of the second type of reaction occurs in the writings of Leopold von Ranke (1795–1886), one of the founders of modern "scientific" history. In his study of the decline of fifteenth-century Italy, Ranke observed:

> Far be it from me to pass judgment upon the temperament of a great nation, which in those days was a source of intellectual stimulus to the whole of Europe. No one can say that it was incurably sick: but it is certain that it suffered from serious diseases. Pederasty, which extended even to the young soldiers in the army, and was regarded as venial because practiced by the Greeks and Romans, whom all delighted to imitate, sapped all vital energy. Native and classical writers ascribed the misfortune of the nation to this evil practice. A terrible rival of pederasty was syphilis which spread through all the classes like the plague.[1]

What Ranke understood by "pederasty" went far beyond the sexual practices that we now associate with the term; rather he used this word as a catch-all term for everything that he disliked. He continued,

> We shall *not* [italics ours] be able to maintain without fear of contradiction that aspiration to fine language rather than to noble deeds, the imitation of antiquity in what it has achieved in the shade, rather than in what it has performed in the sun, as Machiavelli says, is mere luxury, and not healthy for a nation as such: for instance, the training of boys not merely in drawing and in composing prose and verse, but also in "fine hypocrisy," as their teachers expressed it, which consisted in making speeches in public, raising and lowering the voice by turns, now affecting the tone of complaint, now that of triumph, simulating an unreal passion on an unreal theme, a practice which

they continued in a strange manner when grown up—in fact, this whole form of training to which women, whom we find improvising Latin verses to the lyre, also aspired. But no one can doubt that it is a weakness, when those who affect to be masters of life, recommend in place of manliness, chastity, and strict self-control, naught but acuteness and the semblance of such virtues. Besides this, there were youths who preferred to sit upon a mule rather than a horse, men who spoke to their superiors as softly as if they were at their last breath; men who were afraid to move their heads lest they should disarrange their eyebrows; men who carried a looking-glass in their hat and a comb in their sleeve. Many considered it the highest praise to be able to sing well in ladies' society, accompanying themselves on the viol.[2]

Such moralizing continued, although the terms changed, well into the twentieth century. When the author of a medieval history textbook published in 1963 daringly mentioned the word "homosexuality" in his discussion of the transition from late antiquity to the early Middle Ages, he felt necessary to place his reference in a broader moralistic frame:

The civilization of the Roman empire was vitiated by homosexuality from its earliest days. A question, uncomfortable to our contemporary lax moralists, may be raised. Is not the common practice of homosexuality a fundamental debilitating factor in any civilization where it is extensively practiced, as it is a wasting spiritual disease in the individual? It is worth considering that another great and flourishing civilization, the medieval Arabic, where homosexuality was also widespread similarly underwent a sudden malaise and breakdown. Is there some more psychological causation, resulting from the social effects of homosexuality that has been ignored?[3]

Such a statement surely indicates that the author had paid little attention to the knowledge about human sexual behavior that had accumulated since Ranke wrote, more than a century before. Cantor simply repeated the same sort of moralizing that Ranke indulged in, although he placed the flourishing of homosexual activity at the beginning of the Middle Ages, rather than at the end. He also used the newly-minted term "homosexuality," which had not been available to Ranke, to describe the conduct of which he disapproved.

Homosexual behavior obviously occurred in Roman antiquity, in much the same forms and varieties as it does in the late twentieth century. Some of the most gifted writers of the Golden and Silver Ages of Latin lit-

erature produced homoerotic tales, although Roman society as a rule never idealized homosexual practices with the zeal that so many Greek authors displayed. The Stoic and Epicurean writers who flourished in the Roman Empire emphasized instead the importance of self-control and commended sexual abstinence as a virtue. Christian authors embraced these asexual behavioral ideals and carried them over into the world of the Middle Ages.

We would not maintain, of course, that no writers prior to the mid-twentieth century had ever investigated the sexual activities and beliefs of medieval men and women. Numerous monographs and books on medieval sexual customs and practices appeared during the nineteenth and early twentieth centuries. So far as we can discover, however, academic medievalists produced none of those books and monographs. The authors did not present their findings in formal papers at the meetings of academic societies, nor did they publish them in scholarly journals or under the imprint of university presses. Both of the editors of this volume, however, can testify that these studies nevertheless came in for their share of discussion (usually ribald) at informal gatherings of medievalists, usually late at night and after generous alcoholic lubrication had dulled inhibitions.

Among earlier writers on various aspects of medieval sexuality was John Dingwall, whose study of chastity girdles went through several editions.[4] Even more popular than chastity girdles was the "right of the first night" (ius primae noctis),[5] although how reliable most of these publications were is questionable. Several scholars wrote about some aspects of medieval prostitution, notably Iwan Bloch,[6] while historical studies of marriage by scholars such as Edward Westermark, or of women by Robert Briffault and by Hermann Heinrich Ploss, Max Bartels, and Paul Bartels, included considerable information on medieval sexuality.[7] There were others, and while medievalists may well have read them and teachers of undergraduates occasionally mentioned in their classrooms incidents drawn from them (as a way to keep their students attentive), the study of sexuality simply had no place in academic medieval studies. Students, naively unaware of the norms and customs of the profession, who proposed to write theses or dissertations on sexual topics were warned that to do so would endanger their career prospects. After they graduated and secured an academic position, young medievalists were cautioned to refrain from publishing on sexual topics, in order to avoid compromising their chances of receiving tenure. That advice was unquestionably sound and prudent, although the irony that academic tenure is usually justified on the grounds that it guarantees the freedom of scholars to investigate and write on any topics that interest them was apparently lost upon those who gave it.

Arnold Toynbee, writing in 1964, when a younger generation of scholars was beginning to challenge traditional assumptions, felt troubled by some of the trends he saw on the horizon:

> I admire the 19th century West's success in postponing the age of sexual awakening, sexual experience and sexual infatuation far beyond the age of puberty. You may tell me that this was against nature; but to be human consists precisely in transcending nature—in overcoming the biological limitations that we have inherited from our prehuman ancestors.[8]

One of the more popular examples of such reactions to sex in history, although not from a medievalist, occurred in Edith Hamilton's best-selling and wonderfully idealized study of ancient Hellas, in which she never once mentioned the homoerotic practices of Greeks in the classical era.[9] She perhaps ignored such practices because few classicists of her generation admitted any awareness of them. When it finally dawned on one of Miss Hamilton's older contemporaries, John Jay Chapman, that the ancient Greeks whom he so admired had commonly engaged in sexual practices of which he disapproved, he concluded that the "Attic mind" must have been psychologically abnormal. "But why had I not found this out before?" he asked. And he answered: "Because the books and essays on Plato that I had been reading were either accommodated to the Greek psychology or else they accommodated to modern Miss Nancyism—and, by the way, the two agree very sociably."[10]

To challenge the moralistic generalizations of a Ranke or the innocence of an Edith Hamilton required a willingness to examine sexuality in some detail. In the United States during the 1930s and 1940s Freudian psychoanalysts were emphasizing the importance of repressed sexuality, and a few medievalists began to incorporate psychoanalytical perceptions into their work. The real revolution in public discourse about sexuality began in earnest with the publication of the two Kinsey reports on human sexual behavior in the late 1940s and the early 1950s.[11] It took some time, however, before American academics in any discipline felt secure enough to undertake serious research into human sexuality.

Early steps in this direction were cautious. Members of the *Annales* school of historians in France discreetly began to produce occasional studies of the history of marriage, family, and even of sexual behavior during the 1950s. One of the editors of this volume (VLB) published a study of prostitution in 1964, as well as several articles on the history of sexuality, but

none of these appeared in medieval or even historical journals.[12] Surreptitiously, he continued research on sexual topics, taking good care at the same time to publish plentifully on other topics. Finally by the early 1970s he felt secure enough to present a paper entitled, perhaps too cleverly, "Sex in History: A Virgin Field."[13] In it he called for a New History, echoing James Harvey Robinson's war cry of 1912, and challenged historians to include the sexual behavior of humans in particular, and the biological nature of men and women more generally, into their studies. He argued that the study of sexual behavior offered singular opportunities for major breakthroughs in our knowledge base and suggested that these might perhaps lead to radical new interpretations of history.

The other co-editor (JAB) slipped into the study of medieval sexuality even more unobtrusively. In a paper on the Crusades that he presented at the annual meeting of the American Historical Association in the winter of 1968 he referred to a hypothetical legal question posed by a thirteenth-century canonist, Hostiensis (d. 1271), concerning the dilemma presented by a prostitute who made a vow to go on Crusade.[14] The reactions to this reference by the commentator (a jocular protest at the incongruity of the case) and the audience (embarrassed tittering) seemed distinctly puzzling, but at the same time intriguing. He had already published during the previous year two articles on the legal problems that faced the wives of Crusaders, and these had also elicited similar reactions.[15] These experiences led him into a long series of investigations[16] that culminated twenty years later in a large-scale study of the relationship between law, sexual behavior, and religious ideas in medieval Europe.[17]

Incomparably more influential throughout the intellectual world, however, was the pioneering work of Michel Foucault (1926–1984). Foucault argued that the history of sexuality in the modern world had been marked by a continuous increase in the "mechanisms" and "technologies" of power. Beginning in the eighteenth century, as Foucault saw things, the locus of power shifted from the confessional to the research laboratory and the clinic and this made it possible for sexuality to become the subject of serious scientific investigation. He emphasized four mechanisms that employed the "knowledge and power" of sex: (1) "the hysterization of women's bodies"; (2) "the pedagogization of children's sex"; (3) "the socialization of procreative behavior" and (4) "the psychiatrization of perverse pleasure." These mechanisms were directed at four common types of sexual experience: those encountered by hysterical women, masturbating children, couples who used contraceptives to curtail births, and sexually deviant adults.[18]

Foucault's categorizing and theorizing seemed to confer intellectual legitimacy on the study of sexuality and that encouraged scholars from the humanities and history to venture openly into the field, if only to challenge some of Foucault's assumptions. One difficulty with Foucault's approach to the study of sexuality lay in the fact that he began his analysis of the history of sexual behavior with the eighteenth century. Medievalists in particular questioned how valid his assumptions about the earlier past might be. Eventually Foucault himself accepted the wisdom of some of the reservations expressed about his earlier volume, and in the second and third volumes of his *History of Sexuality* he began to explore perceptions of sexuality in classical antiquity.[19] Foucault died, however, before he could carry the enterprise forward into the Middle Ages.

Another breakthrough for historians occurred even before the first volume of Foucault's study appeared. The American Historical Association during its 1970 annual meeting in Boston presented a plenary panel devoted to the theme of "Sex in History."[20] Medievalists, for their part, first accorded professional respectability to studies of sexual matters two years later. The 1972 annual meeting of the Medieval Academy of America, held in Los Angeles, featured an interdisciplinary panel on "Marriage in the Middle Ages," organized by John Leyerle and the newly-created CARA group. This session included papers dealing with marital sexuality.[21] Encouraged by the reception that this panel received, the editors of this volume approached the organizers of the annual medieval congress at Kalamazoo to devote one session of the meeting entirely to sexuality in the Middle Ages. This took place in 1973, was repeated in 1974, and has expanded over the years since then to include numerous annual sessions on many aspects of medieval sexuality.[22]

By the 1990s, as any survey of the literature that appears in medieval journals will show, sex and gender issues have become a staple of scholarly research.[23] Both commercial and university presses eagerly seek out book manuscripts that deal with almost any aspect of the history of sex and gender. Attempts both by feminists and gays to discover more about medieval treatments of issues that concern them have certainly helped to fuel the current explosion of publications that deal with sexual matters.

Where can students interested in these topics look for guidance? Many universities and colleges have established special programs in gay or feminist studies, but those do not necessarily include medievalists. This handbook aims to address the needs of students (and even faculty members) who are interested in the study of medieval sexuality and who would like a guide to the sources and literature bearing on medieval sex. The sources are many and varied, but other than in the fields of canon law and

penitential literature (where effective guides by contributors to the present volume have already appeared), indices to current publications are often not very helpful.

Every experienced scholar can testify that locating the relevant sources for a topic is often a serendipitous process. The authors of this book, many of whom have made path-breaking studies in the field, have contributed overviews and guides, indicating what is known and suggesting opportunities for further research. All know from experience the problems inherent in studying any aspect of medieval sex and gender issues and indicate some of the problems to be avoided and the difficulties to be anticipated.

We have grouped these essays into three categories. The first deals with what may be called sexual norms. These were set in part by the confessional literature, a subject explored by Pierre Payer, and by canon law, on which the co-editor, James A. Brundage, summarizes current findings. Medicine also contributed to the establishment of sexual norms and Joan Cadden, who has written extensively on this subject, summarizes what we already know about sexual norms and indicates some directions for further investigation. Joyce Salisbury, general editor of the Garland Medieval Casebooks, writes about medieval assumptions concerning gender. The medieval church highly prized celibacy from the time of St. Augustine, and even before; Margaret McGlynn and Richard Moll write about celibate marriage and the issues it raised. One of the things that feminist studies have done is to force a re-examination of medieval ideas concerning male sex roles, and Jacqueline Murray surveys this subject.

While medieval society had sex and gender norms, it also included numerous individuals who were at variance with those norms, and this forms the second category of articles. Examining homosexuality are William Percy and the late Warren Johansson, who died shortly after completing the first draft of their joint article. Jacqueline Murray summarizes recent findings about medieval lesbianism, which thus far remains less explored than male homosexuality. Vern Bullough, the other co-editor of this book, looks at cross-dressing and gender norms in the Middle Ages. Ruth Karras, a pioneer in the study of medieval prostitution, summarizes the current state of studies in that field. John Riddle does the same for contraception and abortion, and finds that both were far more common than has been generally supposed. Matthew Kuefler, a recent Ph.D., summarizes current findings about castration and eunuchism, a topic that brings out some of the internal contradictions that marked medieval notions about sexuality.

A third set of papers deals with what may be called cultural issues, the contrasts and conflicts between the treatments of sexual matters within

different cultures and literary traditions in the Middle Ages. Norman Roth contributes two brief articles, one on Islamic attitudes toward sex and the other on Judaism and sex. Eve Levin summarizes, in a slightly longer article, the problems and prospects of studying sexuality in the Eastern Orthodox tradition. Some of the richest sources of information about medieval sexual practices occur in vernacular literature. Laurie Finke summarizes the current state of studies on sexuality in French literature. Jenny Jochens provides an overview of sexual themes in Old Norse literature, and David Lampe does the same for medieval English literature. Although no essays are included on German, Italian, or Spanish literatures, researchers interested in those literary traditions may find helpful suggestions in the treatments on the state of current studies in the other literary traditions.

This handbook, in short, provides an overview of the field. It is by no means exhaustive, nor was it meant to be. The study of sexuality has become an important part of medieval studies during the past thirty years. We welcome additional researchers and we hope that they will find this book helpful in getting started. As any reader will soon discover, there is certainly a lot that we do not yet know. This is precisely what makes the study of human sexuality in the Middle Ages so challenging and interesting.

James A. Brundage
Vern L. Bullough

NOTES

1. Leopold von Ranke, *History of the Latin and Teutonic Nations, 1494–1514*, trans. by G.R. Dennis (London: George Bell, 1909).

2. Ibid., 2.

3. Norman Cantor, *Medieval History: The Life and Death of a Civilization* (New York: Macmillan, 1963).

4. John Dingwall, *Girdles of Chastity* (London, 1931); see also *Encyclopedia Sexualis*, ed. Victor Robinson (New York: Dingwall-Rocks, 1936), 304–12.

5. See Vern L. Bullough, "*Jus Primae Noctis* or *Droit du Seigneur*," *Journal of Sex Research* 26 (February 1991), 163–66.

6. Iwan Bloch, *Die Prostitution*, 2 vols., Handbuch der gesamten Sexualwissenschaft in Einzeldarstellungen (Berlin: Louis Marcus, 1912–1925). Vol. 1 deals with the Middle Ages.

7. Edward Westermarck, *The History of Human Marriage*, 3 vols. (New York: Allerton Books, 1922); Robert Briffault, *The Mothers*, 3 vols. (New York: Macmillan, 1927); Hermann Heinrich Ploss, Max Bartels, and Paul Bartels, *Woman: A Historical, Gynaecological, and Anthropological Compendium*, ed. and trans. Eric John Dingwall, 3 vols. (London: Heinemann, 1935).

8. Arnold Toynbee, "Why I Dislike Western Civilization." *New York Times Magazine*, May 18, 1964.

9. Edith Hamilton, *The Greek Way* (New York: W.W. Norton, 1930 and numerous subsequent printings).

10. John Jay Chapman, *Lucian, Plato, and Greek Morals* (Boston: Houghton Mifflin, 1931).

11. Alfred Kinsey, Wardell Pomeroy, and Clyde V. Martin, *Sexual Behavior in the Human Male* (Philadelphia: W.B. Saunders, 1948), and Kinsey, Pomeroy, Martin, and Paul Gebhard, *Sexual Behavior in the Human Female* (Philadelphia: W.B. Saunders, 1952).

12. Vern L. Bullough, *A History of Prostitution* (New York: Basic Books, 1964). This book was later rewritten in collaboration with Bonnie Bullough and published with illustrations (New York: Crown Books, 1978); it was subsequently reissued without illustrations as *Women and Prostitution* (Buffalo: Prometheus Books, 1987). Among the articles resulting from the research was "Problems and Methods for Research in Prostitution and the Behavioral Sciences," *Journal of Behavioral Sciences* 1 (1965), 244–51.

13. Vern L. Bullough, "Sex in History: A Virgin Field," *Journal of Sex Research* 8 (1972), 101–16.

14. James A. Brundage, "'To Set an Edge on Courage': Crusader Status and Privileges." Although this paper was never published in its original form, the findings presented in it appeared in James A. Brundage, *Medieval Canon Law and the Crusader* (Madison: University of Wisconsin Press, 1969).

15. James A. Brundage, "The Crusader's Wife: A Canonistic Quandary," *Studia Gratiana* 12 (1967), 425–42, and "The Crusader's Wife Revisited," *Studia Gratiana* 14 (1967), 241–52. Both of these studies have been reprinted in *The Crusades, Holy War and Canon Law* (London: Variorum, 1991).

16. Many of these studies have now been collected in James A. Brundage, *Sex, Law, and Marriage in the Middle Ages* (London: Variorum, 1993).

17. James A. Brundage, *Law, Sex, and Christian Society in Medieval Europe* (Chicago: University of Chicago Press, 1987).

18. Michel Foucault, *History of Sexuality, vol. 1: An Introduction,* trans. Robert Hurley (New York: Pantheon Books, 1978). The English version left out the French subtitle, best translated as "the will to power," which is a better key to the theme of the book. On Foucault himself see James Miller, *The Passion of Michel Foucault* (New York: Simon and Schuster, 1993).

19. Michel Foucault, *The Use of Pleasure,* trans. Robert Hurley (New York: Pantheon Books, 1985) is volume 2 of the larger work, while *The Care of the Self,* also trans. Robert Hurley (New York: Pantheon Books, 1986) is volume 3.

20. The panel dealt with both old world and new world history. One of us (VLB) presented a generalized paper about European history entitled "Sex in History."

21. The papers appeared in *Viator* 4 (1973) and were also printed in a separate booklet under the title *Marriage in the Middle Ages,* edited by John Leyerle.

22. Many of the original papers from this first Kalamazoo session were published in Vern L. Bullough and James A. Brundage, *Sexual Practices in the Medieval Church* (Buffalo: Prometheus Books, 1982). The long delay that separated the delivery of the papers (1973) from their appearance in print (1982) resulted from an unforeseeable chain of events which culminated in the original editor, Emily Coleman, leaving the field of medieval history altogether to take up a different career. Bullough and Brundage then stepped in to rescue the project and put the papers into print.

23. For a bibliography as of 1990, see Joyce E. Salisbury, *Medieval Sexuality: A Research Guide* (New York: Garland, 1990).

I
SEXUAL NORMS

1 CONFESSION AND THE STUDY OF SEX IN THE MIDDLE AGES

Pierre J. Payer *

Confession is one of the most intimate of human relationships that was institutionalized in the Christian Church. A repentant sinner (*contrition*) approaches a priest to acknowledge sins committed in the past (*confession*), is placed under an obligation to perform a penance (*satisfaction*), and is forgiven through *absolution*. This relationship is characteristic of private penance, a practice that seems to have been in place by the sixth century in Ireland, whence it spread to Anglo-Saxon England and to continental Europe. The most significant aspect of private penance was its repeatability, marking the Church's coming to terms with the human condition—people frequently sin and ought not to be expected to live under the harsh ancient practice of public penance that allowed only one chance of forgiveness after baptism. Private penance held out the hope to people who sinned that they could be forgiven for their sins as often as they confessed with the right dispositions.[1]

Coincident with the emergence of the practice of private penance, guides were written to instruct priests on how to conduct themselves in the confessional situation. As the practice developed over the centuries the guides followed in step, reflecting the changing conceptions of the institution and the role of the confessor. Generally speaking, the guides for confessors fall into two groups, those that were prevalent from the sixth to the eleventh century, and those that were prevalent from the late twelfth century through the rest of the Middle Ages.

Works comprising the first group are known as penitentials (*libri paenitentiales*), whose characteristic feature is their lists of penanced sins (thus the name 'tariffed penance'). They are guides to the sins that were to be confessed and to the penances that were to be levied for those sins; for

*I would like to express my gratitude to professors Ken Dewar, Joe Goering, and Brook Taylor for their comments.

3

example, "If a layman should kill his neighbour, he shall do penance for five years, three of these on bread and water."[2] Members of the second group have come to be known by the generic name of *summae confessorum* (summas for confessors) but, as we shall see, further refinements among the subspecies of this group must be made. Nonetheless, the twelfth century saw the emergence of new types of guides for confessors and the virtual disappearance of penitentials in the old style. The new works were more discursive and didactic. They placed less emphasis on particularizing sins and on enumerating specific tariffs for specific sins.

The differences in form, content, and state of research between penitentials and *summae confessorum* require that these two types of literature be dealt with separately. Further, this essay will be concerned only with Latin guides for confessors, but from the very beginning of private penance and throughout its long history there were vernacular manuals for priests.[3]

PENITENTIALS

Penitentials are manuals or handbooks designed to guide confessors in the administration of private penance by naming sins and assigning appropriate penances for different types of sin. As a leading researcher in the field puts it, "Penitentials are catalogue-like collections of transgressions (sins) with details of the penances that should be imposed in the ecclesiastical administration of penance (tariffs of penances)."[4] Some penitentials are preceded by general instructions on the role of the confessor, or by a liturgical rite for penance, and some include complex rules on how the often harsh penances could be commuted or compensated for by alternative, less arduous, actions or even by monetary payments.[5] Regardless of the contents, however, most penitentials are relatively short works that a confessor could gain familiarity with rather quickly.

More than fifty years ago Thomas Oakley argued for the use of the penitentials as sources for medieval history and mentioned some areas that could be illumined by their use, such as comparative religion, canon and civil law, liturgy, palaeography and linguistics, and civilization in general.[6] Aside from the mention of 'morals' (p. 210), Oakley does not mention sexual matters nor does he talk about such matters in his article. Given that sexual behavior is one of the most striking types of behavior censured in the penitentials, Oakley's omission is likely attributable to an older hesitation among historians to see the sexual contents of the penitentials as bearing a relationship to actual belief and practice. This hesitation is also apparent in the often sanitized translations of sexually explicit canons.[7] It is symbolic of considerable change that a recent note by Kottje on peni-

tentials as sources of social history leads off with a citation of a penitential canon on adultery.[8]

By any measure the presence of sexual concerns in the penitentials is prominent. The variety of sexual behavior touched on in the more ample handbooks is striking, running the gamut from heterosexual delicts through homosexual infractions, bestiality, to autoerotic acts. The number of canons dealing with sex as a percentage of the total is disproportionately large in comparison to those dealing with other types of offence. Finally, there is a clear continuity of such concern for sexual behavior during the centuries that the penitentials flourished. That much is undeniable.[9]

So penitentials would appear to be excellent sources for the study of sex in early medieval Europe. Indeed, they have been so recognized and used in accounts of contraception, the regulation of marital sexual relations, and the variety of sexual offences. These accounts are usually presented as pieces of serial history in which penitentials are listed in what is thought to be chronological order, accompanied by their sexual contents.[10]

However, penitentials have been exploited for their sexual content with little critical attention given to the texts themselves as documents. Authors who used them have been mesmerized by their contents without paying due attention to them as documents written in time and place, with or without authorial attribution, with sources, spread, and influence. Further, some penitentials have complex manuscript histories with a consequent variety of versions, and few are available in trustworthy critical editions.[11]

Failure to recognize the general lack of trustworthy editions and the relative youth of sophisticated research into the penitentials can only lead to flawed factual bases, uncritical argumentation, and unsound conclusions.[12] In sum, if the penitentials are to be reliable sources, they themselves must be perceived as posing formidable problems for anyone wishing to so use them. As Kottje notes, the value of the penitentials as historical sources is inseparable from their history.[13] A necessary condition for reliable serial history, for example, is the chronologically accurate placement of actual documents of the correct type in the series. Flandrin's study of marital sexual regulations is profoundly flawed because of its failure to respect these basic conditions.[14]

Given as critically solid a documentary base as is possible, how ought one to use the penitentials in the study of sex in the early Middle Ages? A specific answer depends on whether one is interested in a broad overview of sexual behavior or in specific types of such behavior, whether as an historian of ideas, as social or legal historian, or as historical ethnographer. However, two general approaches recommend themselves. The first is a type of serial history providing a chronological overview of of-

fences without particular concern for individual penitentials as such. This has been the usual approach.[15]

One advantage of this approach is that it allows for an overview of the continuity of concerns and of their changing expression over time. It establishes points of reference and provides useful contexts for other studies. Sometimes tracing a particular proscription through the penitentials can bear interesting fruit. For example, in the early penitentials little interest is shown in singling out the specific heterosexual offence of intercourse between two unmarried lay people, with the consequence that there was no term for that sin. In the ninth century, modification was made to a canon of the *Penitential of Bede* making it focus on the heterosexual intercourse of the laity. In the tenth century Regino of Prüm further modified the canon, applying it explicitly to unmarried lay people, and Burchard of Worms in the next century graced the canon with a false inscription (a council of Meaux).[16] Finally, this canon was incorporated into the penitential of Bartholemew of Exeter in the twelfth century under the rubric "De simplici fornicatione" (On simple fornication), one of the earliest uses of this expression for heterosexual intercourse between unmarried persons.[17] Invocation of the authority of this council of Meaux continued. In an early collection of penitential canons attributed to Robert Grosseteste it is noted that "in libro paenitentiali" a penance of three years is assigned for an occasion of simple fornication. In a manuscript containing a fragment of the work there is added after "annorum," "ex meldensi concilio" (from the Council of Meaux).[18]

The disadvantage of this approach is that the penitential canons are torn from their literary context. There is no sense of their relation to other canons dealing with sex in the same work, their relation to canons dealing with other offences is neglected, and they are dissociated from provisions that are made to modify the often harsh penances assigned to particular offences. In short, the chronological listing of canons is somewhat ahistorical.

While the serial approach is initially useful to provide a bird's eye view of the terrain, if you will, it is far more necessary to deal with individual penitentials in their own right. Only in this way will one capture the historical character of the penitential canons regarding sex. One can see the variety of types of offence censured, the proportion of canons dealing with sex, and the penances levied, and the penancing of sexual offences can be compared with the penancing of other offences. Likewise, one can seriously examine the temporal context, the relation between penitentials and contemporary ecclesiastical and secular institutions and writings.[19]

Penitentials, for example, often include canons regulating a bewildering number of types of incest: relations of consanguinity, affinity, and those

arising from particular spiritual contacts between priests and laity, or between laypersons who stood to each other as sponsor and sponsored in baptism and confirmation. What are the sources of these regulations? Are they found in contemporary laws? What do they tell us about kinship relations at the time?[20]

Then there is the question of the relation of the penitentials to the ordinary beliefs and practices of people. Raymund Kottje asks the question in various ways, one of his most recent formulations being, "Did the penitentials in fact have any significance in the practice of ecclesiastical life and thereby for the life of men? Or do we have to do here only with literature authored in the cloister by theologians, but without significance for the ecclesiastical administration of penance and the life of Christians?"[21] Kottje admits that there is no scientifically conclusive way to answer the question. One can point to the total lack of literary merit of the penitentials, suggesting that they would only be copied and recopied for practical purposes. There are the frequent official admonitions to priests to have a penitential and to be familiar with it. There is the interesting fact that even very old penitentials continued to be copied well into the twelfth century.[22] Kottje notes an interesting symbol of the perceived value of penitentials in several palimpsests in which sacred texts were erased to make room for penitential texts.[23] Finally, the use made of penitentials by other types of document such as diocesan statutes and their incorporation into major collections of ecclesiastical law suggest that penitentials were believed to be significant for the life of the Church and its members.[24]

This last point must be borne in mind by any one using the penitentials for the study of moral beliefs. From the second penitential (*Penitential of Columbanus*) onwards there was a continuous tradition of borrowing from earlier works by later works. Initially the original core penitentials borrowed anonymously from their predecessors.[25] Later penitentials soon came to view some of the early works as having a sort of authority and as being worthy of preservation in their own right. This is apparent in the practice of compiling what have come to be called tripartite penitentials. The works are often presented as handing on privileged decisions from three sources: canonical judgments (related to early Frankish penitentials and even earlier councils), judgments of Theodore of Canterbury, and judgments of Cummean. As Frantzen puts it, this work "transferred the handbook into a repository of penitential decisions, a source book rather than a service manual."[26]

This development raises the question of the relevance of penitential prescriptions to the time of the writing of the penitential in which they are

found. The *Rheims Penitential*, for example, has sixteen canons against male homosexual acts covering unspecified persons, boys of different ages, men, and natural brothers engaged in a wide range of behavior. What is to be made of this? It is difficult to say, but it is clear that at least one explanation of the number of canons is the tripartite nature of the penitential with its consequent incorporation of material from Frankish sources (one canon), Cummean (eight canons), and Theodore (five canons).[27] Perhaps these canons indicate more about homosexuality at the time of the writing of the sources than of the later composite work. On the other hand, the *Vallicellian I Penitential* quite self-consciously reorganizes a tripartite penitential (*Merseberg a. Penitential*) along thematic lines. In this case one might argue that the three canons on homosexuality retained by the Vallicellian penitential are more reflective of actual concerns at the time of compilation.[28] These are some of the indicators of the methodological caution that must be used in drawing conclusions about sexual matters from the penitentials.

There is no doubt that the penitentials signal the moral concerns of half a millennium and that directives concerning sexual behavior comprise a prominent part of these concerns. The handbooks offer a virtual cornucopia of material for one studying sexual mores. But after inventorying their sexual contents (which is a relatively easy task), the researcher must ask what is to be made of them. Even the apparently simple task of elaborating a chronological series runs up against the deplorable state of the editions of penitentials. Although perhaps too pessimistic, Frantzen's remarks offer a salutary warning: "But there is little point in further study of the penitential tradition without better editions of the penitentials themselves. It is remarkable that we know so little about their manuscript tradition, their authors, and their relationship to daily life."[29]

Awareness of this cautionary note should forewarn but not dissuade from the study of sex through the confessional instrument of the penitentials. The possibilities are limitless both for advancing the understanding of the penitentials as historical documents and for exploring the relation of their sexual provisions to the life and laws of the times. The historian with an interest in the ethnology of early medieval Europe has much to learn and teach here.[30]

Summas for Confessors

The *Decretum* of Burchard of Worms (ca. 1008) marks the culmination of the penitential tradition. The nineteenth book of that work deals with penance and confession in a treatise that draws on previous penitentials and also contributes substantially to the tradition. This book was often detached from

the whole and circulated separately. For the next 175 years Burchard was the principal source for penitential provisions on sexual matters. In this regard the seventeeth book ('De fornicatione'), which deals with sexual offences generally, was also a prime source for later authors.[31]

Of course, as we have noted, older penitentials continued to be copied well into the twelfth century,[32] and even new works were written that drew heavily on Burchard but that were largely throwbacks to older forms.[33] As a type the older forms of penitential were on the wane, principally under the influence of what can only be called a pastoral revolution that emerged between the Third Lateran Council (1179) and the Fourth Lateran Council (1215). There was a new awareness of the pastoral function whose goal was the conversion of sinners through preaching and confession. Accompanying this consciousness was a felt need for new forms of literature to enable confessors to carry out the pastoral function.[34]

The need was met initially by four works before the Fourth Lateran Council (1215). They mark the transition from the old penitentials to the new forms, often called *summae confessorum*.[35] This expression refers to a narrow range of writings that were aimed at educating the clergy in the theory of confession and in instructing them in its proper administration. Reverend Leonard Boyle has suggested that the whole class of works be called 'pastoralia,' the more academic writings designed to educate to be referred to as *summae confessorum* (summas for confessors), and the practical, instructional manuals to be called *summae confessionis* (summas of confession).[36] While these types are directly relevant to those interested in the study of sex, they are just two of a vast array of pastoral works that followed in the wake of the Fourth Lateran Council.

The academic summas for confessors took their rise mainly from the second edition of the *Summa* of Raymond of Penyafort (1234).[37] They began as systematic treatments of their subject but some of the later works were alphabetically arranged, culminating in the summa of Angelus de Clavasio (*Summa angelica* [1488]).[38] Nothing in the past corresponds to these summas. They are discursive treatises on the whole of the Christian life written by well educated authors who drew on contemporary ecclesiastical law and theology. They are learned, didactic works aimed at providing the knowledge necessary for an effective confessor. They should be seen as mediators between the strictly academic products of the schools of theology and canon law on the one hand and the actual administration of confession on the other. The fact that they could so easily generate alphabetical forms suggests that they had no pretences to systematic originality. A well cross-referenced alphabetical reference book might be more useful to a busy priest who wanted

information about adultery or vows than a systematic treatise on these matters in law or theology.[39]

Every summa for confessors has a section dealing with the actual administration of confession, how confessors are to conduct themselves, the questions they are to ask, and the penances to be levied. Such instruction would be useful and probably adequate for those who actually read these summas. However, it is likely that there was a huge population of simple priests who would have found it difficult if not impossible to read them. These priests needed far more practical instructions than the summas offered. Such instruction was forthcoming in what have been referred to as summas of confession (*summae confessionis*). These works were of a bewildering variety, from schematic formularies of a few manuscript folios to developed practical treatises such as those of Paul of Hungary (ca. 1220), Guido de Monte Rocherii (ca. 1330), and Antoninus of Florence (ca. 1440).[40] Many of the more developed manuals are available at least in serviceable editions and some in excellent critical editions, but few of the shorter, practical *summae confessionis* have been edited. In recent years William de Montibus, Robert Grosseteste, and a Master Serlo have received excellent editorial attention.[41] It is in relation to this type of literature that one ought to associate instructions for confessors that were either included in or annexed to diocesan statutes.[42]

The new confessional works are marked by several distinctive features. First, there is the gradual elimination of lists of sins with their set penances. By the middle of the thirteenth century few works can be found that include lists of tariffed sins. Rather, emphasis is placed on the confessor's discretion (*arbitrium*) in levying penances according to general principles.[43] In spite of this change, however, there was a reluctance entirely to abandon the old penitential-like canons, particularly those found in Gratian's *Decretum* and the later *Decretals*.[44] The most common form of these canons was provided by the canonist Hostiensis in the course of his discussion of the imposition of penances. There are forty-six canons in the version of Hostiensis, several of which (twenty six percent) deal with sexual matters: 1. priests who fornicate; 2. priests who have sexual relations with women to whom they have a spiritual relationship; 3. vice against nature; 5. violation of a vow of virginity; 8. violation of spiritual relations; 9. taking another's fiancée; 10. forms of incest; 18. intercourse with nuns; 23. adultery and marriage; 39. forms of incest; 40. bestiality; 45. penances.[45] The previous mention of 'vice against nature' as well as all subsequent references in this chapter refer to what we would today call male homosexuality. When used in a sexual context the expression itself often has a wider extension embracing all same

sex relations, bestiality, and the use of inanimate objects. As well, the expression is sometimes used in reference to marital sexual relations that were said not to respect the proper vessel (a likely allusion to oral and anal intercourse).[46]

A second, and perhaps most significant, feature of the new confessional literature is that it was written against a sophisticated theological and legal background, with an obvious dependence on ecclesiastical law. Although some authors such as John of Freiburg incorporate into their works much of the theology of Thomas Aquinas, even his summa is substantially dependent on the canon law resources provided by Raymond of Penyafort.[47] But it must be remembered that dependence on Gratian, for example, does not mean that the sources themselves are legal in character. Numerous "legal" texts in Gratian's *Decretum* are nothing more than texts from Jerome, Augustine, and other patristic sources.[48] Paul of Hungary can write an extended discussion of homosexuality (vice against nature), depending exclusively on Gratian for his sources.[49]

Summas for confessors after Raymond of Penyafort represent what of the canon law and theology was deemed relevant for confessors and the parochial clergy generally. Some of these works are massive volumes, rivalling academic theological and canonical writings. They are a far remove from the administration of confession but, nonetheless, were written by men whose interests were in providing what they believed to be the requisite knowledge for confessors. Some exist in good editions and virtually all the others have incunabular or early editions.[50] In one editorial form or another this vast array of writings stands ready to use, and has been used in the study of the social and moral beliefs of medieval society.

Summas of confession, manuals designed to instruct confessors in the actual administration of confession, represent what was considered to be necessary for conducting discreet, intelligent, and humane confessions. It is likely that the run of the mill population of priests, if they read anything, would have read a summa of confession, perhaps in conjunction with relevant local legislation in diocesan statutes. The authors of these works were concerned to provide the basic knowledge that was believed necessary for the practice of confession. They are far removed from the sophistication of the summas for confessors, but perhaps offer the researcher one of the clearest glimpses of actual concerns in actual societies. Unfortunately, manuals of confession have not been well served by editors, and few commanded the attention of printers at the dawn of printing.[51]

The confessional literature of the later Middle Ages has been long recognized as a source for the study of medieval social and moral beliefs and

institutions.[52] In particular, the study of sex has been pursued through the study of the confessional literature.[53] Both *summae confessorum* and *summae confessionis*, to say nothing of the whole range of *pastoralia*, are excellent sources for the study of sex in the later Middle Ages. In most cases the presence of sexual material in the confessional literature at this time is not as striking as it is in the early penitentials. Concern with sex, nonetheless, is omnipresent in all the topical groupings into which the summas are divided. The major rubrics under which discussions of sex are found are substantial: vices and virtues, ten commandments, sacraments, five senses (in the manuals), reserved sins.

The most important areas are the vice of lechery and the sacraments of matrimony and confession. However, the guidance given in the manuals for questioning along the lines of the five senses ought not be overlooked. The concern with the senses seems to be little more than a way to inquire into people's sexual lives.[54] Lists of reserved sins provide an interesting measure of beliefs about the gravity of different types of sin. The more heinous the sin is perceived to be the more absolution for it tends to be reserved to higher authority, the local bishop or even the pope.

The vice of lechery connotes the whole field of proscribed sexual behavior which, from the thirteenth century, was divided into a core of types of behavior. The core itself was relatively stable with modifications made by individual authors. The division in Paul of Hungary represents the traditional core: simple fornication, adultery, incest, vice against nature, violation of virgins (*stuprum*), and rape-abduction (*raptus*).[55] Treatments of sacrilege, prostitution, nocturnal pollution, and touching are frequently added to this subdivision. Adultery and incest usually receive more extensive treatment in the context of discussions of the sacrament of matrimony. Sometimes abuses of marital sex are treated under the rubric of lechery, but are more frequently dealt with in expositions of marriage. The inclusion of these abuses under lechery seems to have originated in a section of the theological summa attributed to Alexander of Hales that was designed to instruct ordinary priests in the ten commandments.[56] The ten commandments gradually replaced the capital sins as an organizing principle for summas for confessors.

Aside from the sacrament of penance itself, the sacrament of matrimony is most relevant to the study of sex. Few topics in the discussion of marriage fail to touch on some sexual topic. Explicit discussion is often found in a subdivision of the treatment of marriage called "On marital intercourse" ("De coitu coniugali"), which deals with the rights and obligations of the marital debt and the casuistry of proposed periods of sexual abstinence.

However, sexual concerns are also found in discussions of the constitutive essence of marriage, the legitimate and illegitimate reasons for marrying and having sexual relations, the different types of impediment to marriage, and a curious concern with vows of chastity in marriage.[57]

The confessional literature of the later Middle Ages offers a marvelous opportunity to study the sexual beliefs of the period. If one imagines the *summae confessorum* as occupying a middle ground, one can readily move up to their legal and theological sources and down to the more practically oriented manuals and *summae confessionis*. Such a holistic approach ought to be de rigeur for those approaching the study of sex through the literature of penance. Sometimes when this is done unexpected results occur. For example, in the late twelfth-century authors were moving toward a strict understanding of simple fornication. The clearest formulation is found in the theological summa attributed to Alexander of Hales (1245). The source seems to have been the confessional summa of Thomas of Chobham (ca. 1216). Although an unlikely source for Thomas of Chobham, a similar definition of fornication is found in a twelfth-century confessional manual in the manuscript, Avranches 136.[58]

This literature can be most revealing of the ordinary beliefs of Christians. One of the persistent beliefs about sex throughout the Christian era was that all sexual behavior outside of marriage was proscribed. Thomas of Chobham says that it is clear to all Christians that simple fornication is a mortal sin.[59] The pastoral and confessional literature from the twelfth century, however, shows that this fundamental belief did not go unchallenged. From the penitential of Bartholomew of Exeter in the twelfth century to the *Summa praedicantium* of John Bromyard in the fourteenth century there are numerous indications that fornication was not taken to be a serious sin. In one of the infrequent original contributions to his penitential, Bartholomew of Exeter, writing for confessors, notes that many, considering the enormity of adultery, incest, and sins against nature, "think every other fornication, which they even call simple, to be no sin or a minor sin."[60] It is not clear whether the complaint is about priests or lay people. A version of Peter the Chanter's *Verbum abbreviatum* leaves no doubt that there were priests claiming that simple fornication was not a mortal sin. As an example of the ignorance of confessors in judging between mortal and venial sins it notes that "there are certain stupid priests, [priests] in name only, who believe that simple fornication is a venial sin, that is, an unattached man sleeping with a woman who has no husband."[61] Members of the Synod of Angers (ca. 1217) complain that they know from experience that confessors give little or no penance for serious sins such as fornication.[62]

Priests were not alone in believing that fornication was not a sin. In a sermon Maurice of Sully mentions single people who are unconcerned about their salvation in this regard because they say that they will not be damned if they have sexual relations when a man does not have a wife and a woman does not have a husband.[63] He goes on to note that if that were the case there would be no point in marriage because men and women would have no reason to bind themselves to each other, a point also made by the pastoral writer, Richard of Wetheringsett.[64] Thomas of Chobham instructs confessors to be diligent in dissuading penitents from believing that fornication is a venial sin, and preachers are to be vigilant in preaching the same since heretics preach the opposite.[65]

This is just a tiny example of how insight into sexual beliefs might be gained through a study of confessional literature. As with the earlier penitentials, there is a wealth of textual material available to those who want to study sex through the literature of penance. Likewise, there is a profound dearth of critically edited texts of the *summae confessorum* and a huge number of unedited works of all types. Fortunately, *summae confessionis* and minor manuals are beginning to receive the editorial attention they deserve.

In the study of sex in the Middle Ages we would like to know what people were actually doing. One source for such information would be the accounts of confessors themselves, and Professor A. Murray has provided a plausible method of ferreting out such information. In his examination of the *exempla* collection of Thomas of Chantimpré (*De apibus*), Murray notes the frequency with which Thomas draws on his own experience of hearing confession for exemplary tales: "A confessor's reminiscences will throw light especially on the field of morals most prone to secrecy: love and sex. Thomas has more than most contemporary narrators to say on these subjects."[66] Murray notes Thomas's particular concern with male homosexuality ('the sin against nature'), which is treated in the second longest chapter of *De apibus*.[67]

There are no medieval treatises entitled 'On sex,' not even any Latin counterparts for our terms 'sex,' 'sexuality,' and 'sexual.' Studies of medieval beliefs about sex must pay attention to medieval contexts and categories if they want faithfully to reflect those beliefs. The confessional literature of the later Middle Ages offers one of the most relevant contexts for the study of sex in the period, and provides virtually all the categories under which sexual matters were discussed from a moral point of view. I have presented this literature as the vehicle and instrument of a pastoral revolution that began in the late twelfth century and was given great impetus by the Fourth Lateran Council (1215). This is an interpretation.

Those who would use summas of confessors for whatever end must address themselves to the question of their purpose, role, and function. This is particularly true for those who would use the material for the study of sex because there is an alternative reading of the texts that sees them not as benign compendia of instruction for confessors and penitents but as instruments of social control.

The terms of the debate were well laid out some years ago in an exchange between Thomas N. Tentler and Rev. Leonard Boyle.[68] With few exceptions these authors differ little about the facts concerning the contents, structure, and history of confessional manuals. They differ profoundly, however, about the role and function of these works in the life of Christians. Tentler sees them as forces for social control that were ultimately incorporated into what he calls "the culture of guilt." In summary he claims that "When we reconstruct the moral, sacramental, and ecclesiastical theology of the summas, we discover immediately that they are intended to bring guilt down on people who deviate."[69] Boyle takes issue with this perception of the summas for confessors, "This is all too negative and sweeping."[70] He is inclined to take them at their face value and to believe the compilers when they say they have produced the works to prepare learned and understanding confessors to bring sinners to God's forgiveness.

This is not the place to enter this debate, which often tends to use references to the treatment of sex to exemplify claims about social control. The debate must be joined, however, by anyone who would seriously study sex through the study of summas for confessors because one's interpretation of the function of the works will color one's understanding of their presentation of sex. There is a pool of writings, from the very early criticisms of Geoffrey May and the musings of Michel Foucault to later analyses, that would see the institution of confession as a sinister instrument of social control, probing the consciences of penitents, requiring conformity to ecclesiastical and political authority and to accepted value systems, and breeding deeply guilt-ridden people.[71] If this is a correct analysis of the summas, then there is surely no better a subject to work with than sex.

The literature of private penance is found in the Middle Ages for a millennium. In all its forms it reflects a marked concern with human sexual behavior, one of the most intimate of human relationships. Whatever its form, it has a distinct practical character aimed at educating and instructing priests in the administration of a central ecclesiastical institution and in their instruction of the Christian people at large. This literature offers a fruitful area of study and if used carefully and critically can provide a rich store of information about sexual beliefs and practices. Curiously, it is the very

mass of material that can hinder a proper use of these texts. This embarrassment of riches often leads to neglecting the state of editions and failing to explore unedited sources, or not making a serious effort to confront the penitential texts with other types of literature, whether literary, political, biological, or legal (i.e., secular law).

Research regarding sex and confessional literature is in a primitive state, largely because of the dearth of critical editions of the relevant texts. With it understood that priority ought to be given to the preparation of an adequate documentary base, there are several areas that would make for fruitful exploration:

1. The sources of sexual canons in the earliest penitentials and the sources of the so-called "canonical judgments" in the early Frankish penitentials are virtually unknown. It would be a valuable undertaking to attempt to identify their sources in early Christian and non-Christian works.

2. Given the debate about medieval tolerance or intolerance of same sex relations, a chronological study of the handling of such behavior from the ealiest penitentials of the sixth century to the late *summae confessorum* of the fifteenth century would be worthwhile—types of offense, descriptions, and penances levied.

3. There is a need for careful analytical studies of the sexual contents of major influential manuals (e.g., works by Raymond of Penyafort, John of Freiburg, Astesanus of Asti, Guido de Monte Rocherii) in their own right. What is striking about these *summae* is the pervasive presence of sexual concerns across the principal divisional categories such as sacraments, vices and virtues, and commandments. Contemporary use of these works has been inclined to focus on more visible topics such as marital sexual relations or homosexuality.

4. In addition to the sad editorial state of standard *summae confessorum* there is a vast amount of manuscript material that is virtually unknown and that would reward exploration. The best place to start would be with the numerous confessional works noted in Morton W. Bloomfield's list of *incipits*.[72]

5. In the first volume of his *History of Sexuality*, and in other places, Michel Foucault offers an intriguing interpretation of the role of confession in the development of the human subject in Western history. Ideas of the problematization of sex, power, and truth are brought to bear on the confession of sexual offences, particularly from the time of the Fourth Lateran Council. (And in unpublished lectures he has explored the phenomenon of confession in early non-Christian and Christian writers). Foucault's thesis

would reward careful examination from one competent in the medieval history of sex and confession.[73]

6. Although not the direct concern of people interested in the study of sex in the Middle Ages, the lack of translations of confessional manuals cries out for a remedy. There are numerous scholars interested in the history of sex who are neither medievalists nor competent in Latin. The translation of a few representative summas for confessors would make a significant contribution to scholarship by giving such scholars access to a type of literature otherwise closed to them.

When all is said and done, what is most important to be borne in mind by the researcher pursuing an interest in the sexual mores of the Middle Ages is that at every stage of history from the sixth to the fourteenth century there existed a body of confessional literature with considerable concern with sexual behavior. This literature both reflected the traditional morality and contributed to its development. It reaches into the deepest recesses of soul and conscience, and offers, perhaps, one of the most reliable contacts with the lives of ordinary people, an important desideratum for anyone engaged in the study of the human past.

NOTES

1. See Pierre J. Payer, "Penance and Penitentials," *Dictionary of the Middle Ages*, vol. 9 (1987), 487–93. For a searching analysis of the Gallic origins of the Irish tradition of private penance see Gianfranco Garancini, "Persona, peccato, penitenza. Studi sulla disciplina penitenziale nell'alto medio evo," in M.G. Muzzarelli, ed., *Una componente della mentalità occidentale: i penitenziali nell'alto medio evo*, Il mondo medievale. Studi di storia e storiografia. Sezione di storia delle istituzioni della spiritualità e delle idee, 9 (Bologna: Patron Editore, 1980), 235–316.

2. "Si quis laicus proximum suum occiderit, V annos peniteat, III ex his in pane et aqua" (*Vallicellian I Penitential*, c. 5, in H.J. Schmitz, *Die Bussbücher und die Bussdisciplin der Kirche nach handschriftlichen Quellen dargestellt* [Mainz: Franz Kircheim, 1883], 257).

3. For the vernacular *Old Irish Penitential* see remarks and translation by D.A. Binchy in *The Irish Penitentials*, ed. Ludwig Bieler with an appendix by D.A. Binchy, Scriptores Latini Hiberniae, 5 (Dublin: Dublin Institute for Advanced Studies, 1975), 258–77. See the following works by Allen J. Frantzen: "Bussbücher, III. Frühe volkssprachliche Ubersetzungen," *Lexikon des Mittelalters*, 2 (1982), 1122–23; *The Literature of Penance in Anglo-Saxon England* (New Brunswick, NJ: Rutgers University Press, 1983); "The Tradition of Penitentials in Anglo-Saxon England," *Anglo-Saxon England* 11 (1983), 23–56. For the thirteenth century see Mario Degli Innocenti, "Una 'Confessione' del XIII secolo. Dal 'De confessione' di Roberto di Sorbona (1201–1274) al volgarizzamento in antico milanese (*ms. Ambr. T 67 sup.* = MA1)," *Cristianesimo nella storia* 5 (1984), 245–302.

4. Raymund Kottje, "Bussbücher," *Lexikon des Mittelalters* 2 (1982), 1118 (my translation). Two classic introductions to the penitentials: G. Le Bras, "Pénitentiels," *Dictionnaire de théologie catholique* 12 (1933), 1160–79; John T. McNeill and Helena M. Gamer, *Medieval Handbooks of Penance. A translation of the princi-

pal 'Libri poenitentiales' and selections from related documents, Records of Civilization. Sources and Studies, 29 (New York: Columbia University Press, 1938). A useful introduction to the history of the penitentials: C. Vogel, Les 'Libri Poenitentiales,' Typologie des sources du moyen âge occidental, 27 (Turnhout, Belgium: Brepols, 1978), to be supplemented by C. Vogel, Les 'Libri Poenitentiales,' Typologie des sources du moyen âge occidental, 27, mise à jour by A.J. Frantzen (Turnhout, Belgium: Brepols, 1985).

5. On commutations see C. Vogel, "Composition légale et commutations dans le système de la pénitence tarifée," Revue de droit canonique 8 (1958), 289–318; 9 (1959), 1–38, 341–59.

6. Thomas P. Oakley, "The Penitentials as Sources for Mediaeval History," Speculum 15 (1940), 210.

7. For examples of these phenomena see A.J. Frantzen, The Literature of Penance, 1–3; Pierre J. Payer, Sex and the Penitentials. The Development of a Sexual Code, 550–1150 (Toronto: University of Toronto Press, 1984), 13, 142.

8. R. Kottje, "Eine wenig beachtete Quelle zur Sozialgeschichte: Die frühmittelalterlichen Bussbücher-Probleme ihrer Erforschung," Vierteljahrschrift für Sozial- und Wirtschaftsgeschichte 73 (1986), 63.

9. See Payer, Sex and the Penitentials, passim.

10. See for example: John T. Noonan, Contraception. A History of Its Treatment by the Catholic Theologians and Canonists (Cambridge, MA: The Belknap Press of Harvard University Press, 1965), 152–70; J.L. Flandrin, Un temps pour embrasser. Aux origines de la morale sexuelle occidentale (VIe–XIe siècles) (Paris: Editions du Seuil, 1983), in particular see the listing of works, 166–68; James A. Brundage, Law, Sex, and Christian Society in Medieval Europe (Chicago: University of Chicago Press, 1987), 152–69, 598–601. Flandrin alone explicitly presents his study as serial history.

11. For an example of a complex manuscript tradition see Allen J. Frantzen, "The Penitentials Attributed to Bede," Speculum 58 (1983), 573–97. The Irish penitentials have been edited in accord with contemporary standards (Ludwig Bieler, ed. and trans., The Irish Penitentials, with an Appendix by D.A. Binchy, Scriptores Latini Hiberniae, 5 [Dublin: Dublin Institute for Advanced Studies, 1975]). But for the Penitential of Vinnian see Rob Meens, "The Penitential of Finnian and the Textual Witness of the Paenitentiale Vindobonense 'B,'" Mediaeval Studies 55 (1993), 243–55. The Rheims Penitential has been edited in a privately reproduced thesis: Franz B. Asbach, Das Poenitentiale Remense und der sogen. Excarpsus Cummeani. Uberlieferung, Quellen und Entwicklung zweier kontinentaler Bussbücher aus der 1. Hälfte des 8. Jahrhunderts (Regensburg, 1975). The first volume of critical editions of continental penitentials has recently been published; see Paenitentialia Franciae, Italiae et Hispaniae, Tomus I: Paenitentialia minor Franciae et Italiae saeculi VIII–IX, edited by Raymund Kottje and Ulrike Spengler-Reffgen (Turnhout, Belgium: Brepols, 1994).

12. For a progress report on penitential research see R. Kottje, "Erfassung und Untersuchungen der frühmittelalterlichen kontinentalen Bussbücher. Probleme, Ergebnisse, Aufgaben eines Forschungprojektes an der Universitäte Bonn," Studi medievali, 3d series 26 (1985), 941–50.

13. Kottje, "Eine wenig beachtete Quelle," 64.

14. See J.L. Flandrin, Un temps pour embrasser, 166–68: few of the penitentials dated to "before 750" can be shown to be so datable; based on the collected editions he says he used, several works that Flandrin claims to have used simply have no corresponding texts in those editions (see his B3, B12, C7, C8, C9, F5)! Finally, Flandrin is scrupulous about distinguishing between penitential texts (the data for Un temps pour embrasser) and what he calls textes canoniques, which he promises to study in a subsequent volume. However, an examination of his list of 'penitentials' reveals the inclusion of several works that are not penitentials but are clearly textes canoniques (see A3, B2, D1, D3, E9, F7). These flaws undermine the reliability of Flandrin's study and the reliability of studies that depend on Flandrin.

15. Some years ago I attempted such an approach in *Sex and the Penitentials*. The preparation of that book brought home to me the hurdles that stand in the way of preparing a critically solid documentary base.

16. See *Penitential of Bede* 3.27 (F.W.H. Wasserschleben, ed., *Die Bussordnungen der abendländischen Kirche* [Halle: Graeger, 1851], 223), modified in the *Bede-Egbert Double Penitential* 1.1 ("Si laicus cum laica") (J. Schmitz, ed., *Die Bussbücher and das kanonische Bussverfahren nach handschriftlichen Quellen dargestellt* [Düsseldorf: L. Schwann, 1898], 685); Regino of Prüm, *De synodalibus causis et disciplinis ecclesiasticis* 2.135, ed. F.W.H. Wasserschleben (Leipzig: Engelmann, 1840), 266; Burchard of Worms, *Decretum* 9.68 (PL 140.826). On the false inscription (*Ex concilio Meldensi*, capite 7) see P. Fournier, "Etudes critiques sur le Décret de Burchard de Worms," *Nouvelle revue historique de droit français et étranger* 34 (1910), 322. Burchard's canon was taken over by Ivo of Chartres, *Decretum* 8.205 (PL 161.626).

17. Bartholomew of Exeter, *Penitential* 70, in Adrian Morey, ed., *Bartholomew of Exeter, Bishop and Canonist. A Study in the Twelfth Century* (Cambridge: Cambridge University Press, 1937), 237. Alan of Lille retained the inscription and rubric of Burchard (*Decretum* 9.68) but reproduced the text from another passage in Burchard (*Decretum* 19.5, q. 43) (see J. Schmitz, ed., *Die Bussbücher and das kanonische Bussverfahren*, 419); see Alan of Lille, *Liber poenitentialis* 2.110 (in J. Longère, *Alain de Lille. Liber Poenitentialis. II. La tradition longue. Texte inédit publié et annoté*, Analecta mediaevalia Namurcensia, 18 [Louvain, Belgium: Editions Nauwelaerts, 1965], 103).

18. See J. Goering and F.A.C. Mantello, eds., "The Early Penitential Writings of Robert Grosseteste," *Recherches de théologie ancienne et médiévale* 54 (1987) variant 115, p. 93. The manuscript in question is Cambridge, Trinity College 1109 (0.2.5) under siglum T, which the editors date to the fourteenth century.

19. See the thesis of Linda M. Spear, "The Treatment of Sexual Sin in the Irish Latin Penitential Literature" (Ph.D., University of Toronto, 1979), *Dissertation Abstracts International* 40.11 (May 1980).

20. See *Penitential of Pseudo-Theodore*, chap. 20 (Wasserschleben, ed., *Die Bussordnungen*, 584–86); C. De Clercq, "La législation religieuse francque depuis les Fausses Décrétales jusqu'à la fin du IXe siècle," *Revue de droit canonique* 7 (1957), 255–59 (regarding the Council of Douzy [A.D. 874]).

21. R. Kottje, "Erfassung und Untersuchung," 948 (my translation). See R. Kottje, "Eine wenig beachtete Quelle," 71–72, and the same author's remarks at the conclusion of his discussion of marriage in the penitentials, "Ehe und Eheverständnis in den vorgratianischen Bussbücher," in W. Van Hoecke and A. Welkenhuysen, eds., *Love and Marriage in the Twelfth Century* (Louvain, Belgium: Leuven University Press, 1981), 38–40.

22. For example: for twelfth-century manuscripts of the *Excarpsus of Cummean* and the *Penitential of Egbert* see Asbach, *Das Paenitentiale Remense*, 26 (no. 11); for Halitgar of Cambrai see R. Kottje, *Die Bussbücher Halitgars von Cambrai und des Hrabanus Maurus. Ihre Uberlieferung und ihre Quellen*, Beiträge zur Geschichte und Quellenskunde des Mittelalters, 8 (Berlin: Walter de Gruyter, 1980), 14 (no. 1), 32 (no. 17), 34 (no. 19), 35 (no. 21), 62 (no. 51); for the *Vallicellian I Penitential* see G. Hägele, *Das Paenitentiale Vallicellianum I. Eine oberitalienischen Zweig der frühmittelalterlichen kontinentalen Bussbücher. Uberlieferung, Verbreitung und Quellen*, Quellen und Forschungen zum Recht in Mittelalter, 3 (Sigmaringen, Germany: Jan Thorbecke Verlag, 1984), 24, 25, 28, 30.

23. R. Kottje, "Erfassung und Untersuchung," 949; "Eine wenig beachtete Quelle," 71–72.

24. See Payer, *Sex and the Penitentials*, 55–59 and chap. 3.

25. Original core penitentials: *Penitential of Vinnian, Penitential of Columbanus, Penitential of Cummean, Iudicia Theodori, Penitential of Bede, Penitential of*

Egbert, and early Frankish penitentials such as the *Burgundian Penitential* and *Bobbio Penitential*. For these works see C. Vogel, *Les 'Libri Paenitentiales.'*

26. Allen J. Frantzen, "The Penitentials Attributed to Bede," 593. The *Rheims Penitential* and the *Capitula iudiciorum* are examples of tripartite penitentials.

27. See *Rheims Penitential* (ed. Asbach): 4.1, 4.12–14, 26–29, 31–33, 35–36, 38, 40, 42, 53.

28. For the *Vallicellian I Penitential* see G. Hägele, *Das Paenitentiale Vallicellianum I.*

29. Frantzen, *The Literature of Penance in Anglo-Saxon England*, 198.

30. The reading list at the end of this article includes several excellent entries that guide one in the use of penitentials that lack adequate editions and that illustrate how penitentials have been used in the study of such topics as abortion, homicide, and children. Note too that there is still virgin territory for the enterprising student who wants to work with penitentials for which no editions exist. Unedited penitential texts may be found in the following manuscripts:

Kynzvart (Königswart b. Marienbad) (20.K.20), ff. 57r–78r (see Kottje, *Die Bussbücher Halitgars*, 33; Letha Mahadevan, "Uberlieferung und Verbreitung des Bussbuchs 'Capitula Iudiciorum'," *Zeitschrift der Savigny-Stitfung für Rechtsgeschichte. KA* 72 (1986), 23).

Munich, Bayerische Staatsbibliothek, Clm 14780, ff. 87r–91r (see Asbach, ed., *Das Paenitentiale Remense*, 131, n. 2).

Oxford, Bodleian Library, Barlow 37, ff. 47r–62r (see H. Sauer, "Zur Uberlieferung und Anlage von Erzbischof Wolfstans 'Handbuch'," *Deutsches Archiv* 36 [1980], 348).

Oxford, Bodleian Library, Bodl. 311, ff. 56r–62r (see Asbach, ed., *Das Paenitentiale Remense*, 28).

Troyes, Bibliothèque municipale, MS 1979, ff. 269r–309r, 309v–13r, 313r–37v (see Kottje, *Die Bussbücher Halitgars*, 64).

Vatican, BAV, Vat. lat. 5751, ff. 49v–52v (see Asbach, ed., *Das Paenitentiale Remense*, 187; Kottje, *Die Bussbücher Halitgars*, 73–74).

Vatican, Arch. s. Pietro H 58, ff. 109v–21v (see Kottje, *Die Bussbücher Halitgars*, 66).

Vienna, Osterreichische Nationalbibliothek, Cod. lat. 2225, ff. 36r–41r (see Asbach, *Das Paenitentiale Remense*, 38).

31. See Paul Fournier, "Etudes critiques sur le Décret de Burchard de Worms," *Nouvelle revue historique de droit français et étranger* 34 (1910), 41–112, 213–21, 289–331, 564–84. For a recent study that provides excellent guidance to Burchard's sources see Hartmut Hoffmann and Rudolf Pokorny, *Das Dekret des Bischofs Burchard von Worms. Textstufen—frühe Verbreitung—Vorlagen*, Monumenta Germaniae historica, Hilfsmittel, 12 (Munich: Monumenta Germania historica, 1991). For Burchard's use of penitential canons dealing with sex see P. Payer, *Sex and the Penitentials*, 81–83, 98–104. Text of Burchard, *Decretum* PL 140; for the nineteenth book see the edition in H.J. Schmitz, *Die Bussbücher und das kanonische Bussverfahren*, 403–67. The edition in Wasserschleben (*Die Bussordnungen*, 624–82) is a later version of the nineteenth book.

32. See above n. 22.

33. See P. Michaud-Quantin, "Un manuel de confession archaïque dans le manuscrit Avranches 136," *Sacris erudiri* 17 (1966), 5–54.

34. See L.E. Boyle, "The Inter-Conciliar Period 1179–1215 and the Beginnings of Pastoral Manuals," *Miscellanea Rolando Bandinelli Papa Alessandro III*, ed. Filippo Liotta (Siena: Accademia Senese degli Intronati, 1986), 45–56.

35. The four works: Alan of Lille, *Liber poenitentialis. 2. La tradition longue*, ed. J. Longère, Analecta mediaevalia Namurcensia, 18 (Louvain, Belgium: Editions Nauwelaerts, 1965); Peter of Poitiers, <*Summa de confessione*> *"Compilatio praesens,"* ed. J. Longère, CCCM 51 (Turnhout, Belgium: Brepols, 1980); Robert of Flamborough,

Liber poenitentialis. A Critical Edition with Introduction and Notes, ed. J.J. Francis Firth, Studies and Texts, 18 (Toronto: Pontifical Institute of Mediaeval Studies 1971); Thomas of Chobham, *Summa confessorum*, ed. F. Broomfield, Analecta mediaevalia Namurcensia, 25 (Louvain, Belgium: Editions Nauwelaerts, 1968).

36. See L.E. Boyle, *"Summae confessorum,"* in *Les genres littéraires dans les sources théologiques et philosophiques médiévales. Définition, critique et exploitation*, Actes du colloque internationale de Louvain-la-Neuve, 25–27 mai 1981 (Louvain-la-Neuve, 1982), 227–37. The article contains a complex schema (p. 231) of types of *pastoralia*. In a subsequent article Boyle provides medieval examples of each type of pastoral literature; see L.E. Boyle, "The Fourth Lateran Council and Manuals of Popular Theology," in *The Popular Literature of Medieval England*, ed. Thomas J. Heffernan (Knoxville: University of Tennessee Press, 1985), 30–43.

37. Raymond of Penyafort, *Summa de poenitentia et matrimonio cum glossis Ioannis de Friburgo* [i.e., the gloss of William of Rennes, not John of Freiburg] (Rome, 1603); see the recent edition, *Summa de paenitentia*, ed. X. Ochoa and A. Diéz, Universa bibliotheca iuris 1B (Rome: Commentarium pro religiosis, 1976).

38. On the principal *summae confessorum* and their editions see: P. Michaud-Quantin, *Sommes de casuistique et manuels de confession au moyen âge (XII–XVI siècles)*, Analecta mediaevalia Namurcensia, 13 (Louvain, Belgium: Ed. Nauwelaerts, 1962); Thomas N. Tentler, *Sin and Confession on the Eve of the Reformation* (Princeton, NJ: Princeton University Press, 1977), 31–39; Thomas N. Tentler, "The Summa for Confessors as an Instrument of Social Control," in Charles Trinkaus and H. Obermann, eds., *The Pursuit of Holiness in Late Medieval and Renaissance Religion*, Studies in Medieval and Reformation Thought, 10 (Leiden: Brill, 1947), 103–09.

39. See the revealing note regarding the use by Albert the Great of alphabetical order: "in his commentary on the *De animalibus*, [Albert] apologizes for using alphabetical order after having said 'hunc modum non proprium philosophie esse'—but he uses it nonetheless, *for the benefit of the unlearned reader"* (my emphasis); Richard H. Rouse and Mary A. Rouse, *"Statim invenire.* Schools, Preachers, and New Attitudes to the Page," in Robert L. Benson, Giles Constable, and Carol D. Lanham, eds., *Renaissance and Renewal in the Twelfth Century* (Cambridge, MA: Harvard University Press, 1982), 211, n. 28.

40. Paul of Hungary, *De confessione*, Bibliotheca Casinensis (Monte Cassino, 1880), vol. 4, 191–215; Guido de Monte Rocherii, *Manipulus curatorum* (London, 1502); Antoninus of Florence, *Summa confessionalis [Confessionale 'Defecerunt']* (Venice, 1584); this edition is in a tiny format, literally a handbook. For a recent study with editions of three manuals of confession, see Conrad of Höxter, *Trois sommes de pénitence de la première moitié du XIIIe siècle. La 'Summula Magistri Conradi.' Les sommes 'Quia non pigris' et 'Decime dande sunt,'* ed. Jean Pierre Renard, 1. *Prolégomènes et Notes complémentaires, 2. Textes inédits*, Lex spiritus vitae, 6, 2 vols. (Louvain-la-Neuve: Centre Cerfaux-Lefort, 1989).

41. See the reading list at the end of this article. For what has some claim to being a very early Dominican handbook see J. Goering and Pierre J. Payer, "The 'Summa penitentie Fratrum Predicatorum': A Thirteenth-Century Confessional Formulary," *Mediaeval Studies* 55 (1993), 1–50. Several short confessional writings of Robert of Sorbonne deserve careful study, but unfortunately they first require extensive editorial consideration; for an introduction to these works see P. Glorieux, "Le Tractatus novus de Poenitentia de Guillaume d'Auvergne," in *Miscellanea moralia in honorem eximii domini Arthur Janssen*, Bibliotheca ephemeridum theologicarum Lovaniensium, series 1, vol. 3 (Louvain, Belgium: 1948), 551–65. For the vernacular use of Robert of Sorbonne see above, n. 3. Note should be made here of a neglected lengthy work of Robert Kilwardby (*De confessione*) that exists in two known manuscripts: British Library, Royal 13.A.VII; Tarragona, Spain: Biblioteca Provincial 100.

42. See Synod of Angers (1217), called by its editor the "Syndodal of the West" because of its subsequent influence throughout western Europe, in Odette Pontal, ed., *Les statuts synodaux français du XIIIe siècle précédés de l'historique du synode diocésain depuis ses origines, 1. Les statuts de Paris et le Synodal de l'oeust (XIIIe siècle),* Collection de documents inédits sur l'histoire de France. Section de philologie et d'histoire jusqu'à 1610. Serie 8, n. 9 (Paris: Editions du Comité des Travaux historiques et scientifiques, 1971); Synod of Nimes (1284) and Synod of Rodez (1289) in Mansi, Sacrorum conciliorum nova et amplissima collectio, vol. 24, 521–66, 965–1056. For an important study of the *Summula* of Bishop Peter Quinel of Exeter (Exeter II, 1287) see J. Goering and Daniel S. Taylor, "The *Summula* of Bishops Walter de Cantilupe (1240) and Peter Quinel (1287)," *Speculum* 67 (1992), 576–94.

43. See Pierre J. Payer, "The Humanism of the Penitentials and the Continuity of the Penitential Tradition," *Mediaeval Studies* 46 (1984), 340–54.

44. See Payer, "The Humanism of the Penitentials," 350–54.

45. See Hostiensis, *Summa, una cum summariis et adnotationibus* 5.38.60 (Lyons, 1537) fols. 283rb–vb. My numbers are those of Hostiensis.

46. For a scholastic treatment see Thomas Aquinas, *Summa of Theology* 2–2.154.11–12. See John Noonan, *Contraception,* 224–27; Pierre J. Payer, *The Bridling of Desire. Views of Sex in the Later Middle Ages* (Toronto: University of Toronto Press, 1993), 76–79.

47. See L.E. Boyle, "The *Summa confessorum* of John of Freiburg and the Popularization of the Moral Teaching of St. Thomas and of some of his Contemporaries," in *St. Thomas Aquinas, 1274–1974. Commemorative Studies,* ed. A. Maurer (Toronto: Pontifical Institute of Mediaeval Studies, 1974), 245–68.

48. See Pierre J. Payer, *The Bridling of Desire. Views of Sex in the Later Middle Ages* (Toronto: University of Toronto Press, 1993), 5–6, 10–11.

49. Paul of Hungary, *De confessione,* 207–10. This discussion is not mentioned by John Boswell, *Christianity, Social Tolerance, and Homosexuality. Gay People in Western Europe from the Beginning of the Christian Era to the Fourteenth Century* (Chicago: University of Chicago Press, 1980). Paul of Hungary's work is a development of a work by Peter the Chanter that Boswell does mention (see Boswell, *op. cit.,* 375–78).

50. Aside from the excellent edition of some works written before Lateran IV (see above, n. 35) and a recent edition of Raymond of Penyafort, none of the major summas for confessors has been edited according to contemporary standards. Michaud-Quantin and Tentler are useful guides to the editions. Some recent editions: John of Erfurt (ca. 1300), *Die Summa confessorum des Johannes von Erfurt,* ed. N. Brieskorn, Europäische Hochschulschriften, Reihe 2, Rechtswissenschaft, 245, 3 vols. (Frankfurt a.M., 1980–81); Rudolf of Liebegg (ca. 1323), *Pastorale novellum,* ed. A.P. Orban, CCCM 55 (Turnhout, Belgium: Brepols, 1982)—in verse.

51. The best source for manuscript information about such works is the extensive survey of Morton W. Bloomfield et al., *Incipits of Latin Works on the Virtues and Vices, 1100–1500 A.D. Including a Section of Incipits of Works on the Pater Noster* (Cambridge, MA: Medieval Academy of America, 1979). For England see the survey in the somewhat misleadingly entitled thesis of L.E. Boyle, "A Study of the Works Attributed to William of Pagula with Special Reference to the *Oculus sacerdotis* and *Summa summarum*" (Ph.D. dissertation, Oxford University, 1956).

52. See for example: Jacques Le Goff, "Métier et profession d'après les manuels de confesseurs au moyen-âge," *Miscellanea mediaevalia 3. Beiträge zum Berufsbewusstsein des mittelalterlichen Menschen* (Berlin: De Gruyter, 1964), 44–60; Pierre Michaud-Quantin, "Aspects de la vie sociale chez les moralistes," *Miscellanea mediaevalia 3. Beiträge zum Berufsbewusstsein des mittelalterlichen Menschen* (Berlin: De Gruyter, 1964), 30–43; Pierre Michaud-Quantin, "La conscience individuelle et ses droits chez les moralistes de la fin du moyen âge," *Miscellanea mediaevalia 5. Universalismus und Particularismus im Mittelalter* (Berlin: De Gruyter, 1968), 42–55; J.C. Payen, "La

pénitence dans le contexte culturel des XIIe et XIIIe siècles. Des doctrines contritionistes au pénitentiels vernaculaires," *Revue des sciences philosophiques et théologiques* 61 (1977), 399–428. Mention will be made later of the literature of social control.

53. See for example: Michel Foucault, *The History of Sexuality. Vol. 1: An Introduction*, trans. Robert Hurley (New York: Vintage Books, a division of Random House, 1978); Jacqueline Murray, "The Perceptions of Sexuality, Marriage, and the Family in Early English Pastoral Manuals" (Ph.D. dissertation, University of Toronto, 1987); Pierre J. Payer, "Sex and Confession in the Thirteenth Century," in Joyce E. Salisbury, ed., *Sex in the Middle Ages. A Book of Essays* (New York: Garland Publishing, 1991), 126–42; A. Teetaert, "'Summa de matrimonio' sancti Raymundi de Penyafort," *Jus pontificium* 9 (1929), 54–61, 228–34, 312–22; Thomas N. Tentler, *Sin and Confession on the Eve of the Reformation* (Princeton, NJ: Princeton University Press, 1977), 162–232 ("Sex and the Married Penitent"); J.G. Ziegler, *Die Ehelehre der Pönitentialsummen von 1200–1350. Eine Untersuchung zur Geschichte der Moral- und Pastoraltheologie* (Regensburg: Verlage Friedrich Pustet, 1956).

54. See J. Goering and P. Payer, "The 'Summa penitentie Fratrum Predicatorum'," *Mediaeval Studies* 55 (1993), 19, notes 69–73.

55. Paul of Hungary, *De confessione*, 207.

56. *Summa theologica, seu sic ab origine dicta "Summa Fratris Alexandri,"* 3, n. 406 (Florence: Quaracchi, 1948), vol. 4.2, p. 595.

57. In alphabetically arranged summas for confessors the subject is found under the entry "Matrimonium," but there is also usually an entry under "Debitum coniugale."

58. "Est autem fornicatio luxuria, qua solutus solutam naturali usu cognoscit; et intelligitur solutus et soluta a vinculo coniugii, et consanguinitatis, et affinitatis, ordinis, religionis, vel voti continentiae." *Summa Fratris Alexandri* 2–2, n. 624 (vol. 3, p. 604). See Thomas of Chobham, *Summa confessorum*, ed. F. Broomfield, 341; P. Michaud-Quantin, "Un manuel de confession archaïque," 40.

59. Thomas of Chobham, *Summa confessorum* (Broomfield, ed., p. 342). For the theological tradition see John F. Dedek, "Premarital Sex: The Theological Argument from Peter Lombard to Durand," *Theological Studies* 41 (1980), 643–67.

60. Bartholomew of Exeter, *Penitential*, chapter 69 in Adrian Morey, ed., *Bartholomew of Exeter, Bishop and Canonist. A Study in the Twelfth Century. With the Text of Bartholomew's Penitential from the Cotton MS. Vitellius A.XII* (Cambridge: Cambridge University Press, 1937), 236–37. The text is reproduced in later authors: see Alan of Lille, *Liber poenitentialis* 2.127 (Jean Longère, ed., 2.111); Robert of Flamborough, *Liber poenitentialis* 5.275 (J.J. Francis Firth, ed., p. 231). The expression "which they even call simple" suggests that those who held such views were perhaps pointing to the use of the qualifier "simple" in support of their position.

61. "Verbi gratia, sunt quidam fatui sacerdotes tantum nomine qui credunt simplicem fornicationem esse veniale peccatum, scilicet solutum hominem dormire cum femina que non habet virum" (Peter the Chanter, *Verbum abbreviatum*, British Library, Additional MS 19767, fol., 154v). Later, under the rubric, "Contra eos qui dicunt fornicationem non esse mortale peccatum," the work offers proofs of the sinfulness of simple fornication (fols., 205v–06r). According to Baldwin this is a reorganization of a version of the *Verbum abbreviatum*, which he dates to 1228 x 1246 (J.W. Baldwin, *Masters, Princes and Merchants. The Social Views of Peter the Chanter and his Circle* [Princeton, NJ: Princeton University Press, 1970], 1.253–54).

62. Synod of Angers, n. 80 (Pontal, ed., 194).

63. "Cil qui sont es fornications ne cuident pas ne ne vuelent otroier qu'il soient perdu por tele maniere de pecie; quar il dient desque le hom n'a feme, ne la feme segnor, n'est pas pecies dampnables se il gisent ensemble" (Maurice of Sully, Sermon on the Twenty-fourth Sunday after Pentecost, in C.A. Robson, *Maurice of Sully and the Medieval Vernacular Homily with the Text of Maurice's French Homilies from a Sens Cathedral Chapter Ms.* [Oxford: Basil Blackwell, 1952], 169).

64. C.A. Robson, *Maurice of Sully and the Medieval Vernacular Homily*, 169. See Richard of Wetheringsett, "Item qualis homo nisi demens uni se coniungeret individualiter si ex pluribus posset quipiam prolem procreare sine peccato et absque matrimonio?" ("Qui bene presunt," British Library, Royal 9.A.XIV, fol. 98va [I am grateful to Professor J. Goering for this transcription]).

65. Thomas of Chobham, *Summa confessorum* (Broomfield, ed., p. 342); Thomas of Chobham, *Summa de arte praedicandi*, ed. Franco Morenzoni (Turnhout, Belgium: Brepols, 1988), CCCM 82.255–56. For the theological concern of Aquinas with this matter see Aquinas, *Summa contra Gentiles* 3.122 (Ex hoc). In a pastorally oriented address (*collatio*) on the sixth commandment St. Thomas leaves no doubt about his belief in this matter: "But it must be realized that although some believe that adultery is a sin, they nonetheless do not believe that simple fornication is a mortal sin." Aquinas, *Collationes in decem preceptis*, 25, in Jean-Pierre Torrell, ed., "Les *Collationes in decem preceptis* de Saint Thomas d'Aquin. Edition critique avec introduction et notes," *Revue des sciences philosophiques et théologiques* 69 (1985), 251–52.

66. A. Murray, "Confession as a historical source in the thirteenth century," in R.H.C. Davis and J.M. Wallace-Hadrill, eds., *The Writing of History in the Middle Ages. Essays Presented to Richard William Southern* (Oxford: Oxford University Press, 1981), 299.

67. Murray, "Confession as a historical source," 300.

68. Thomas N. Tentler, "The Summa for Confessors as an Instrument of Social Control," 103–26; L.E. Boyle, "The Summa for Confessors as a Genre, and Its Religious Intent," 126–30; T.N. Tentler, "Response and Retractatio," 131–37, in C. Trinkaus and H. Oberman, eds., *The Pursuit of Holiness in Late Medieval and Renaissance Religion*, Studies in Medieval and Reformation Thought, 10 (Leiden: Brill, 1974).

69. Tentler, "The Summa for Confessors as an Instrument of Social Control," 124 (p. 123 re the culture of guilt).

70. Boyle, "The Summa for Confessors as a Genre, and Its Religious Intent," 129.

71. See for example: Geoffrey May, *Social Control and Sex Expression* (New York: William Morrow, 1931); John Bossy, "The Social History of Confession in the Age of the Reformation," *Transactions of the Royal Historical Society, fifth series* 25 (1975), 21–38; M. Foucault, *The History of Sexuality. Vol. 1 An Introduction*, trans. Robert Hurley (New York: Vintage Books, a division of Random House, 1990); Bryan S. Turner, "Confession and Social Structure," *The Annual Review of the Social Sciences of Religion* 1 (1977), 29–58 (an interesting study, but marred by its lack of consideration of any original texts); J.C. Payen, "La pénitence dans le contexte culturel des XIIe et XIIIe siècles. Des doctrines contritionistes au pénitentiels vernaculaires," *Revue des sciences philosophiques et théologiques* 61 (1977), 399–428; Hervé Martin, "Confession et contrôle sociale à la fin du moyen âge," *Pratiques de la confession. Des Pères du désert à Vatican II. Quinze études d'histoire*, Groupe de la Boussière (Paris: Cerf, 1983), 117–36.

72. Morton W. Bloomfield, *Incipits of Latin Works on the Virtues and Vices, 1100–1500 A.D. Including a Section of Incipits of Works on the Pater Noster* (Cambridge, MA: Mediaeval Academy of America, 1979). For example, see the work listed in Bloomfield as *Octo sunt species turpitudinis quas quandoque coniugales solent inter se exercere.*

73. See Foucault, *The History of Sexuality. Vol. 1: An Introduction*, trans. Robert Hurley (New York: Vintage Books, 1978); James W. Bernauer, "Michel Foucault's Ecstatic Thinking," in James Bernauer and David Rasmussen, eds., *The Final Foucault* (Cambridge, MA: MIT Press, 1988), 45–82 (see the bibliographical orientation at p. 77, n. 17); Pierre J. Payer, "Foucault on Penance and the Shaping of Sexuality," *Studies in Religion* 14 (1985), 313–20. See the recent edition of unedited lectures by Foucault: Michel Foucault, "About the Beginning of the Hermeneutics of the Self. Two Lectures at Dartmouth," *Political Theory* 21 (1993), 198–227 (edited by Mark Blasius and Thomas Keenan).

BIBLIOGRAPHY

This bibliography is designed as a guide to three areas: 1) the confessional texts; 2) critical discussion of the texts; and 3) studies of sex through the texts. Although it goes without saying that it is not complete, still, if the guides to the texts and sources are used, one will be provided with a fully adequate introduction to the literature. Further, it must be borne in mind that many of the works listed below have, themselves, excellent bibliographies.

The arrangement of the bibliography:
Early Penitentials
 Texts of Penitentials
 Studies
Later Confessional Literature
 Guides to sources
 Texts
 Studies

Early Penitentials

TEXTS OF PENITENTIALS

(Guide to the texts: C. Vogel, *Les 'Libri Poenitentiales,'* Typologie des sources du moyen âge occidental, 27. Turnhout, Belgium: Brepols, 1978. To be supplemented by C. Vogel, *Les 'Libri Poenitentiales,'* Typologie des sources du moyen âge occidental, 27, mise à jour by A.J. Frantzen. Turnhout, Belgium: Brepols, 1985.)

Albers, Bruno. "Wann sind die Beda-Egbert'schen Bussbücher verfasstworden, und wer ist ihr Verfasser?" *Archiv für katholisches Kirchenrecht* 81 (1901), 393–420.
Asbach, Franz B. *Das Poenitentiale Remense und der sogen. Excarpsus Cummeani. Uberlieferung, Quellen und Entwicklung zweier kontinentaler Bussbücher aus der 1. Hälfte des 8. Jahrhunderts.* Regensburg, 1975.
Bieler, Ludwig, ed. and trans. *The Irish Penitentials.* With an appendix by D.A. Binchy. Scriptores Latini Hiberniae, 5. Dublin: Dublin Institute for Advanced Studies, 1975.
Burchard of Worms. *Decretum.* PL 140.
Gonalez Rivas, S. *La Penitencia en la primitiva iglesia española. Estudio historico, dogmatico y canonico de la penitencia en la Iglesia española, desde sus origenes hasta los primeros tiempos de la invasion musulmana.* n.p., 1949.
Kerff, Franz. "Das sogenannte Paenitentiale Fulberti: Uberlieferung, Verfasserfrage, Edition." *Zeitschrift der Savigny-Stiftung für Rechtsgeschichte. KA* 73 (1987), 1–40.
Paenitentialis Franciae, Italiae et Hispaniae, Tomus I: Paenitentialia minora Franciae et Ialiae saeculi VIII–IX. Edited by Raymund Kottje with Ludger Körntgen and Ulrike Spengler-Reffgen. Turnhout, Belgium: Brepols, 1994.
Regino of Prüm. *De synodalibus causis et disciplinis ecclesiasticis.* Edited by F.W.H.

Wasserschleben. Leipzig: Engelmann, 1840.

Schmitz, H.J. *Die Bussbücher und das kanonische Bussverfahren nach handschrift-
lichen Quellen dargestellt.* Düsseldorf: L Schwann, 1898.

———. *Die Bussbücher und die Bussdisciplin der Kirche nach handschriftlichen
Quellen dargestellt.* Mainz: Franz Kirchheim, 1883.

Wasserschleben, F.W.H. *Die Bussordnungen der abendländischen Kirche.* Halle:
Graeger, 1851.

STUDIES

Bezler, Francis. *Les Pénitentiels Espagnols. Contribution à l'étude de la civilisation de
l'Espagne chrétienne du haut Moyen Age.* Spanische Forschungen der Görres-
gesellschaft, II. Reihe, 30 Bd. Münster: Aschendorff, 1994.

Brundage, James A. *Law, Sex, and Christian Society in Medieval Europe.* Chicago:
University of Chicago Press, 1987.

Bullough, Vern L. *Sexual Variance in Society and History.* Wiley-Interscience Publi-
cation. New York: John Wiley & Sons, 1972.

Callewaert, R.S. "Les pénitentiels du moyen âge et les pratiques anticonceptionelles."
La vie spirituelle. Supplément 18 (1965), 339–66.

Flandrin, J.L. *Un temps pour embrasser. Aux origins de la morale sexuelle occidentale
(VIe–XIe siècles).* Paris: Editions du Seuil, 1983.

Fournier, Paul. "Etudes critiques sur le Décret de Burchard de Worms." *Nouvelle re-
vue historique de droit français et étranger* 34 (1910), 41–112, 213–21, 289–
331, 564–84.

Frantzen, Allen J. "Bussbücher, III. Frühe volkssprachliche Ubersetzungen." *Lexikon
des Mittelalters,* 2 (1982), 1122–23.

———. *The Literature of Penance in Anglo-Saxon England.* New Brunswick, NJ:
Rutgers University Press, 1983.

———. "The Penitentials Attributed to Bede." *Speculum* 58 (1983), 573–97.

———. "The Tradition of Penitentials in Anglo-Saxon England." *Anglo-Saxon En-
gland* 11 (1983), 23–56.

Garancini, Gianfranco. "Persona, peccato, penitenza. Studi sulla disciplina penitenziale
nell'alto medio evo." In M.G. Muzzarelli, ed., *Una componente,* 235–316.

Hägele, G. *Das Paenitentiale Vallicellianum I. Eine oberitalienischen Zweig der
frühmittelalterlichen kontinentalen Bussbücher. Uberlieferung, Verbreitung und
Quellen.* Quellen und Forschungen zum Recht im Mittelalter, 3. Sigmaringen,
Germany: Jan Thorbecke Verlag, 1984.

Haggenmüller, Reinhold. *Die Uberlieferung der Beda und Egbert zugeschriebenen
Bussbücher.* Europäische Hochschulschriften III 461. Frankfurt/M.: Peter Lang,
1991.

Hoffmann, Hartmut and Rudolf Pokorny. *Das Dekret des Bischofs Burchard von
Worms. Textstufen—frühe Verbreitung—Vorlagen.* Monumenta Germaniae
historica, Hilfsmittel, 12. Munich: Monumenta Germaniae historica, 1991.

Honings, Bonifacio. "L'arborto nei libri penitenziali irlandesi. Convergenza morale e
divergenze pastorali." In M.G. Muzzarelli, ed., *Una componente,* 155–84.

Kerff, Franz. "Das Paenitentiale Pseudo-Gregorii III. Ein Zeugnis karolingischer
Reformbestrebungen." *Zeitschrift der Savigny-Stiftung für Rechtsgeschichte.
KA* 69 (1983), 46–63.

———. "Libri paenitentiales und kirchliche Strafgerichtsbarkeit bis zum Decretum
Gratiani. Ein Diskussionsvorschlag." *Zeitschrift der Savigny-Stiftung für
Rechtsgeschichte. KA* 75 (1989): 23–57.

Körntgen, Ludger. *Studien zu den Quellen der frühmittalterlichen Bussbücher.* Quellen
und Forschungen zum Recht im Mittelalter, 7. Sigmaringen: Jan Thorbecke
Verlag, 1993.

Kottje, Raymund. "Bussbücher." *Lexikon des Mittelalters* 2 (1982), 1118–22.

———. *Die Bussbücher Halitgars von Cambrai und des Hrabanus Maurus. Ihre Uberlieferung and ihre Quellen.* Beiträge zur Geschichte und Quellenskunde des Mittelalters, 8. Berlin: de Gruyter, 1980.

———. "Ehe und Eheverständnis in den vorgratianischen Bussbücher." In W. Van Hoecke and A. Welkenhuysen, eds., *Love and Marriage in the Twelfth Century. Mediaevalia Lovaniensia,* series 1, Studia VIII, 18–40. Louvain, Belgium: Leuven University Press, 1981.

———. "Eine wenig beachtete Quelle zur Sozialgeschichte: Die frühmittelalterlichen Bussbücher—Probleme ihrer Erforschung." *Vierteljahrschrift für Sozial—und Wirtschaftsgeschichte* 73 (1986), 63–72.

———. "Erfassung und Untersuchungen der frühmittelalterlichen kontinentalen Bussbücher. Probleme, Ergebnisse, Aufgaben eines Forschungprojektes an der Universitäte Bonn." *Studi medievali* 3d series 26 (1985), 941–50.

Krüger, Elke. "Uberlegungen zum Quellenwert der irischen Bussbücher für historische Frauenforschung." In *Frauen in der Geschichte, VII. Interdisziplinäre Studien zur Geschichte der Frauen im Frühmittelalter. Methoden—Probleme—Ergebnisse,* 154–70. Edited by Werner Affeldt and Annette Kahn. Düsseldorf: Schwann, 1986.

Le Bras, G. "Pénitentiels." *Dictionnaire de théologie catholique* 12 (1933), 1160–79.

Mahadevan, Letha. "Uberlieferung und Verbreitung des Bussbuchs 'Capitula Iudiciorum.'" *Zeitschrift der Savigny-Stiftung für Rechtsgeschichte. KA* 72 (1986): 17–75.

Manselli, Raoul. "Il matrimonio nei Penitentiali." In M.G. Muzzarelli, ed., *Una componente,* 185–213.

McNeill, John T. and Helena M. Gamer. *Medieval Handbooks of Penance. A translation of the principal 'Libri poenitentiales' and selections from related documents.* Records of Civilization. Sources and Studies, 29. New York, Columbia University Press, 1938.

Meens, Rob. *Het tripartite boeteboek. Overlevering en betekenis van vroegmiddeleeuwse biechtvoorschriften (met editie en vertaling van vier "tripartita").* Middeleeuwse studies en bronnen XLI. Hilversum, Netherlands: 1994.

Muzzarelli, Maria G. "Il valore della vita nell'alto mediaevo: la testimonianza dei libri penitenziali." *Aevum* 62 (1988): 171–85.

———. "Le donne e i bambini nei libri penitentiali: regole di condotta per una società in formazione." In *Profili di donne—Mito, immagine, realità fra mediaevo ed età contemporanea.* Edited by Benedetto Vetere and Paolo Renzi, pp. 145–92. Galatina, Italy: Congedo, 1986.

———. "Per una ricostruzione ed una interpretazione della penitenza medievale." In A. Ovidio Capitani. Scritti degli allievi bolognesi a cura di M.C. De Matteis. Bologna, 1990, 87–124.

———, ed. *Una componente della mentalità occidentale: i Penitenziali nell'alto medio evo.* Il mondo medievale, studi di storia e storiografia. Sezione di storia delle istituzioni della spiritualità e delle idee, 9. Bologna: Patron Editore, 1980.

Noonan, John T. *Contraception. A History of Its Treatment by the Catholic Theologians and Canonists.* Cambridge, MA: Belknap Press of Harvard University Press, 1965.

Oakley, Thomas P. "The Penitentials as Sources for Mediaeval History." *Speculum* 15 (1940): 210–23.

Payer, Pierre J. "Early Medieval Regulations concerning Marital Sexual Relations." *Journal of Medieval History* 6 (1980): 353–76.

———. "Penance and Penitentials." *Dictionary of the Middle Ages,* vol. 9 (1987): 487–93.

———. *Sex and the Penitentials. The Development of a Sexual Code, 550–1150.* Toronto: University of Toronto Press, 1984.

Spear, Linda M. "The Treatment of Sexual Sin in the Irish Latin Penitential Litera-

ture." Ph.D. dissertation, University of Toronto, 1979.

Vogel, C. "Composition légale et commutations dans le système de la pénitence tarifée." *Revue de droit canonique* 8 (1958), 289–318; 9 (1959): 1–38, 341–59.

———. "Pratiques superstitieuses au début du XIe siècle d'après le *Corrector sive medicus* de Burchard, évêque de Worms (965–1025)." *Etudes de civilisation médiévale (IXe-XIIe siècles). Mélanges offerts à E.R. Labande*, 751–61. Poitiers: Université de Poetiers, 1974.

Later Confessional Literature

GUIDES TO SOURCES

Bloomfield, Morton W. et al. *Incipits of Latin Works on the Virtues and Vices, 1100–1500 A.D. Including a Section of Incipits of Works on the Pater Noster.* Cambridge, MA: Mediaeval Academy, 1979.

Boyle, Leonard E. "A Study of the Works Attributed to William of Pagula with Special Reference to the *Oculus sacerdotis* and *Summa summarum.*" Ph.D. dissertation, Oxford University, 1956.

Michaud-Quantin, Pierre. *Sommes de casuistique et manuels de confession au moyen âge (XII–XVI siècles).* Analecta mediaevalia Namurcensia, 13. Louvain, Belgium: Edit. Nauwelaerts, 1962.

Teetaert, A. "Quelques 'Summae de paenitentia' anonymes dans la Bibliothèque nationale de Paris." *Miscellania Giovanni Mercati,* 2, 311–43. Vatican City, 1946.

TEXTS

Alan of Lille. *Liber poenitentialis. 2. La tradition longue.* Edited by J. Longère. Analecta mediaevalia Namurcensia, 18. Louvain, Belgium: Edit. Nauwelaerts, 1965.

[Augustine of Dacia] Walz, A., ed. "Rotulus pugillaris." *Classica et mediaevalia* 16 (1955), 135–94.

[Avranches 136] Michaud-Quantin, Pierre, ed. "Un manuel de confession archaïque dans le manuscrit Avranches 136." *Sacris erudiri* 17 (1966), 5–54.

Bartholomew of Exeter, *Penitential.* In Adrian Morey, ed., *Bartholomew of Exeter, Bishop and Canonist. A Study in the Twelfth Century. With the Text of Bartholomew's Penitential from the Cotton MS. Vitellius A.XII.* Cambridge: Cambridge University Press, 1937.

Cajetan. *De pollutione ex auditione confessionis proveniente* (Tract 22). Opera omnia Thomae de Vio. Lyons, 1581.

Civitatense. In Wasserschleben, *Die Bussordnungen,* 688–705.

Confessionale. Among the works of Bonaventure, Opera omnia vol. 8, 359–92. Edited by A.C. Peltier. Paris, 1866.

Conrad of Höxter. *Trois sommes de pénitence de la première moitié du XIIIe siècle. La 'Summula Magistri Conradi.' Les sommes 'Quia non pigris' et 'Decime dande sunt.'* Edited by Jean Pierre Renard. 1. *Prolégomènes et Notes complémentaires,* 2. *Textes inédits.* Lex spiritus vitae, 6. 2 vols. Louvain-la-Neuve: Centre Cerfaux-Lefort, 1989.

Gerson, Jean. *De confessione mollitiei.* Oeuvres complètes vol. 8, 71–74. Edited by P. Glorieux. Paris: Desclée, 1971.

———. *De pollutione nocturna et praeparatione ad missam (seu De dignitate celebrationis).* Oeuvres complètes vol. 9, 35–50. Edited by P. Glorieux. Paris: Desclée, 1973.

Grosseteste, Robert. <*De modo confitendi et paenitentias iniungendi>.* In J. Goering

and F.A.C. Mantello, "The Early Penitential Writings of Robert Grosseteste." *Recherches de théologie ancienne et médiévale* 54 (1987): 52–112.

———. *Deus est.* Siegfried Wenzel, ed. "Robert Grosseteste's Treatise on Confession, 'Deus est.'" *Franciscan Studies* 30 (1970): 218–93.

———. *Speculum confessionis.* In J. Goering and F.A.C. Mantello, "The 'Perambulavit Iudas . . .' (*Speculum confessionis*) Attributed to Robert Grosseteste." *Revue Bénédictine* 96 (1986): 125–68.

———. *Templum Dei.* Edited from MS. 27 of Emmanuel College, Cambridge. J. Goering and F.A.C. Mantello, eds. Toronto Medieval Latin Texts, 14. Toronto: Pontifical Institute of Mediaeval Studies, 1984.

Hostiensis. *Summa, una cum summariis et adnotationibus* 5.38. Lyons, 1537.

John of Erfurt. *Die Summa confessorum des Johannes von Erfurt.* Edited by N. Brieskorn. Europäische Hochschulschriften, Reihe 2, Rechtswissenschaft, 245. 3 vols. Frankfurt a. M.: Peter Lang, 1980–81.

Kilwardby, Robert. *De confessione.* In two known manuscripts: British Library, Royal 13.A.VII; Tarragona, Spain: Biblioteca Provincial 100.

[Master Serlo] J. Goering, "The *Summa de penitentia* of Magister Serlo." *Mediaeval Studies* 38 (1976): 1–53.

Peter of Poitiers, *<Summa de confessione> "Compilatio praesens."* Edited by J. Longère. CCCM 51. Turnhout, Belgium: Brepols, 1980.

Raymond of Penyafort. *Summa de poenitentia et matrimonio cum glossis Ioannis de Friburgo* [i.e., the gloss of William of Rennes, not John of Freiburg]. Rome, 1603; see the recent edition, *Summa de paenitentia.* Edited by X. Ochoa and A. Diéz, Universa bibliotheca iuris 1B. Rome, 1976.

Robert of Flamborough, *Liber poenitentialis. A Critical Edition with Introduction and Notes.* Edited by J.J. Francis Firth. Studies and Texts, 18. Toronto: Pontifical Institute of Mediaeval Studies, 1971.

Robert of Sorbonne. *<De confessione secreta sacerdoti facta de peccato luxurie>.* Incipit: "Si dicat peccator, 'Domine vigilans naturam meam pollui'" In William of Auvergne. Opera omnia 2, Supplement, 231–32. Paris, 1674.

[Robert of Sorbonne] Mario Degli Innocenti, "Una 'Confessione' del XIII secolo. Dal 'De confessione' di Roberto di Sorbona (1201–1274) al volgarizzamento in antico milanese (*ms. Ambr. T 67 sup.* = MA1)." *Cristianesimo nella storia* 5 (1984): 245–302.

Rudolf of Liebegg. *Pastorale novellum.* Edited by A.P. Orban. CCCM 55. Turnhout, Belgium: Brepols, 1982.

Summa penitentie Fratrum Predicatorum. J. Goering and Pierre J. Payer. "The 'Summa penitentie Fratrum Predicatorum': A Thirteenth-Century Confessional Formulary." *Mediaeval Studies* 55 (1993): 1–50.

Synod of Angers. In Odette Pontal, ed. *Les statuts synodaux français du XIIIe siècle précédés de l'historique du synode diocésain depuis ses origines, 1. Les statuts de Paris et le Synodal de l'oeust (XIIIe siècle),* Collection de documents inédits sur l'histoire de France. Section de philologie et d'histoire jusqu'à 1610. Serie 8, n. 9. Paris: Editions du Comité des Travaux historiques et scientifiques, 1971.

Synod of Nimes (1284). Mansi, Sacrorum conciliorum nova, et amplissima collectio, vol. 24, 521–66.

Synod of Rodez (1289). Mansi, Sacrorum conciliorum nova, et amplissima collectio, vol. 24, 9651–1056.

Thomas of Chobham, *Summa confessorum.* Edited by F. Broomfield. Analecta mediaevalia Namurcensia, 25. Louvain, Belgium: Edit. Nauwelaerts, 1968.

William de Montibus. J. Goering, *The Schools and the Literature of Pastoral Care.* Studies and Texts, 108. Toronto: Pontifical Institute of Mediaeval Studies, 1992.

STUDIES

Anciaux, P. *La théologie du sacrement de pénitence au XIIe siècle.* Louvain, Belgium: Edit. Nauwelaerts, 1949.

Bossy, John. "The Social History of Confession in the Age of the Reformation." *Transactions of the Royal Historical Society, fifth series* 25 (1975): 21–38.

Boyle, Leonard E. "The Fourth Lateran Council and Manuals of Popular Theology." In *The Popular Literature of Medieval England*, 30–43. Edited by Thomas J. Heffernan. Knoxville: University of Tennessee Press, 1985.

———. "The Inter-Conciliar Period 1179–1215 and the Beginnings of Pastoral Manuals." *Miscellanea Rolando Bandinelli Papa Alessandro III*, 45–56. Edited by Filippo Liotta. Siena: Accademia Senese degli Intronati, 1986.

———. *Pastoral Care, Clerical Education and Canon Law, 1200–1400.* London: Variorum Reprints, 1981.

———. "The *Summa confessorum* of John of Freiburg and the Popularization of the Moral Teaching of St. Thomas and of Some of His Contemporaries." In *St. Thomas Aquinas, 1274–1974. Commemorative Studies.* Edited by A. Maurer. Toronto: Pontifical Institute of Mediaeval Studies, 1974.

———. "*Summae confessorum.*" In *Les genres littéraires dans les sources théologiques et philosophiques médiévales. Définition, critique et exploitation*, Actes du colloque internationale de Louvain-la-Neuve, 25–27 mai 1981, 227–37. Louvain-la-Neuve, 1982.

———. "The Summa for Confessors as a Genre, and Its Religious Intent." In C. Trinkaus and H. Oberman, eds., *The Pursuit of Holiness*, 126–30.

Braswell, Mary Flowers. "Sin, the Lady, and the Law. The English Noblewoman in the Late Middle Ages." *Medievalia et Humanistica* n.s. 14 (1986): 81–101.

Cazenave, Annie. "Aveu et contrition. Manuels de confesseurs et interrogatoires d'inquisition en Languedoc et en Catalogne (XIIIe-XIVe siècles)." In Actes du 99e congrès national des sociétés savantes, Besançon, 1974. Phil. et histoire, 1. La piété populaire au moyen âge, 333–52. Paris: Bibliothèque Nationale, 1977.

Creytens, R. "Les cas de conscience soumis à s. Antonin de Florence par Dominique de Catalogne O.P." *Archivum Fratrum Praedicatorum* 28 (1958): 149–220.

Dedek, John F. "Premarital Sex: The Theological Argument from Peter Lombard to Durand." *Theological Studies* 41 (1980): 643–67.

Faire croire. Modalités de la diffusion et de la réception des messages religieux du XIIe au XVe siècles. Table Ronde organisée par l'Ecole Française de Rome en collaboration avec l'Institut d'histoire médiévale de l'Université de Padoue. Collection de l'Ecole Française de Rome, 51. Rome: Ecole Française de Rome, 1981.

Foucault, Michel. "About the Beginning of the Hermeneutics of the Self. Two Lectures at Dartmouth." *Political Theory* 21 (1993): 198–227 ("Christianity and Confession," 210–27).

———. *The History of Sexuality. Vol. 1: An Introduction.* Translated by Robert Hurley. New York: Vintage Books, a division of Random House, 1978.

Glorieux, P. "Le Tractatus novus de Poenitentia de Guillaume d'Auvergne." In *Miscellanea moralia in honorem eximii domini Arthur Janssen.* Bibliotheca ephemeridum theologicarum Lovaniensium, series 1, vol. 3, 551–65. Louvain, Belgium: Nauwelaerte, 1948.

Goering, J. and Daniel S. Taylor. "The *Summula* of Bishops Walter de Cantilupe (1240) and Peter Quinel (1287)." *Speculum* 67 (1992): 576–94.

Le Goff, Jacques. "Métier et profession d'après les manuels de confesseurs au moyen-âge." *Miscellanea mediaevalia 3. Beiträge zum Berufsbewusstsein des mittelalterlichen Menschen*, 44–60. Berlin: De Gruyter, 1964.

Martin, Hervé. "Confession et contrôle sociale à la fin du moyen âge." *Pratiques de la confession. Des Pères du désert à Vatican II. Quinze études d'histoire*, Groupe de la Boussière, 117–36. Paris: Cerf, 1983.

May, Geoffrey. *Social Control and Sex Expression*. London: Allen & Unwin, 1930.

Michaud-Quantin, Pierre. "Aspects de la vie sociale chez les moralistes." *Miscellanea mediaevalia 3. Beiträge zum Berufsbewusstsein des mittelalterlichen Menschen*, 30–43. Berlin: De Gruyter, 1964.

———. "La conscience individuelle et ses droits chez les moralistes de la fin du moyen âge." *Miscellanea mediaevalia 5. Universalismus und Particularismus im Mittelalter*, 42–55. Berlin: De Gruyter, 1968.

———. "Les méthodes de la pastorale du XIIIe au XVe siècle." *Miscellanea mediaevalia 7. Methoden in Wissenschaft und Kunst des Mittelalters*, 76–91. Berlin: De Gruyter, 1970.

———. "Textes pénitentiels languedociens au XIIIe siècle." *Le crédo, la morale et l'inquisition Cahiers de Fajeaux* 6 (1971): 151–72.

Murray, A. "Confession as a Historical Source in the Thirteenth Century." In R.H.C. Davis and J.M. Wallace-Hadrill, eds., *The Writing of History in the Middle Ages. Essays Presented to Richard William Southern*, 275–322. Oxford: Oxford University Press, 1981.

Murray, Jacqueline. "The Perceptions of Sexuality, Marriage, and the Family in Early English Pastoral Manuals." Ph.D. dissertation, University of Toronto, 1987.

Payen, J.C. "La pénitence dans le contexte culturel des XIIe et XIIIe siècles. Des doctrines contritionistes au pénitentiels vernaculaires." *Revue des sciences philosophiques et théologiques* 61 (1977): 399–428.

Payer, Pierre J. "Foucault on Penance and the Shaping of Sexuality." *Studies in Religion* 14 (1985): 313–20.

———. "Sex and Confession in the Thirteenth Century." In Joyce E. Salisbury, ed., *Sex in the Middle Ages. A Book of Essays*, 126–42. New York: Garland Publishing, 1991.

———. *The Bridling of Desire. Views of Sex in the Later Middle Ages*. Toronto: University of Toronto Press, 1993.

———. "The Humanism of the Penitentials and the Continuity of the Penitential Tradition." *Mediaeval Studies* 46 (1984): 340–54.

Salisbury, Joyce E., ed. *Sex in the Middle Ages. A Book of Essays*. New York: Garland Publishing, 1991.

Santiago Otero, H. "Guido de Monte Roterio. Manuscritos de sus obras en la Staatsbibliothek de Munich." *Revista española de teologia* 30 (1970): 391–405.

Teetaert, A. " 'Summa de matrimonio' sancti Raymundi de Penyafort." *Jus pontificium* 9 (1929): 54–61, 228–34, 312–22.

Tentler, Thomas N. *Sin and Confession on the Eve of the Reformation*. Princeton, NJ: Princeton University Press, 1977.

———. "The Summa for Confessors as an Instrument of Social Control." In Charles Trinkaus and H. Obermann, eds., *The Pursuit of Holiness*, 103–09.

Trinkaus, Charles and H. Obermann, eds. *The Pursuit of Holiness in Late Medieval and Renaissance Religion*. Studies in Medieval and Reformation Thought, 10. Leiden, Netherlands: Brill, 1947.

Turner, Bryan S. "Confession and Social Structure." *Annual Review of the Social Sciences of Religion* 1 (1977): 29–58.

Walz, A. "Si. Raymundi de Penyafort auctoritas in re paenitentiali." *Angelicum* 12 (1935): 346–96.

Ziegler, J.G. *Die Ehelehre der Pönitentialsummen von 1200–1350. Eine Untersuchung zur Geschichte der Moral- und Pastoraltheologie*. Regensburg: Verlag Friedrich Pustet, 1956.

2 SEX AND CANON LAW

James A. Brundage

Christian authorities from the beginning of the church's history have been concerned about the sexual conduct of its members. The letters of St. Paul, which are the earliest Christian documents to survive, deal with sexual behavior in considerable detail. Paul admonished the Christian communities with which he corresponded that heterosexual marital intercourse was the only type of sexual encounter that they were allowed to enjoy. He cautioned them not to focus their attention on transitory sexual pleasures, but rather on the approaching last judgment and the reign of God (thus Romans 1:27; 1 Cor. 6:9–10, 15–19 and 7:9–16; Eph. 5:21–23; 1 Tim. 1:10). Paul also made it clear to his readers that while virginity might not be for everyone, it was inherently preferable for Christians to avoid sex altogether (1 Cor. 7:1, 8–9).

The slightly later Gospel accounts of the career of Jesus refer only infrequently to issues of sexual morality, which was apparently not one of Jesus' central concerns. The Gospels, nonetheless, do supply some further indications about sexual conduct that Jesus and his earliest followers regarded as unacceptable. Jesus, like more conventional rabbis in his period, cautioned his followers against sexual promiscuity and taught that married couples should not divorce, save when one partner had violated the matrimonial covenant through adultery (e.g., Matt. 19:4–12; Mark 10:2–12; Luke 14:20, 25–27, 16:18, 20:34–35). Jesus seemingly accepted most of the marriage and family norms current among contemporary Jewish teachers. In any event, the Gospel narratives give these matters relatively scant attention.[1]

Canon law, which comprises the legal norms that Christian communities attempted to enforce among their members, began to take shape about the beginning of the second century of the common era. Early manuals of church law, beginning with the *Didache* or *Doctrine of the Twelve Apostles*, prescribed rules governing Christian marriage and sexual behavior. So long as Christians were a persecuted minority within the Roman Empire, church

authorities could punish deviations from those rules only by sanctions internal to the Christian community. From the time of the Emperor Constantine I (311–337), however, the Christian church began to receive assistance from public authorities to enforce its internal regulations. Since the fourth century, accordingly, the church, through its canons and the increasingly effective mechanisms devised to implement them, has continued to play a key role in enunciating and defining the norms of sexual behavior among Christians, especially within the Catholic, Orthodox, Anglican, and Lutheran branches of Christianity.[2]

Canonical rules from the outset dealt extensively with the moral and disciplinary problems that arose from sexual attractions and desires. The church required Christians (like pagan Romans, but unlike traditional Jews) to be monogamous. Unlike their pagan contemporaries, however, married Christians were also expected to remain sexually faithful to their spouses, to refrain from divorce (save perhaps on the grounds of the spouse's adultery), and generally to observe restraint in their sexual behavior within marriage, while carefully avoiding any kind of sexual intimacy outside of it.

Christian writers justified their canonical doctrines about sexual conduct against critics by arguing that the church's rules were grounded either in divine revelation or in human reason or (when all else failed) in "nature" or "natural law." They felt compelled to do this in order to respond to criticisms of their way of life put forward not only by pagan and Jewish writers outside of the Christian fold, but also by unorthodox critics within their own ranks, whose teachings mainline Christians rejected as heretical. Some heretical sects (such as the Marcionites, the Abelonians, and the Priscillians) maintained that only persons who abstained from sex altogether could hope to merit salvation. Other sectarians, such as Jovinian and his followers, denied that complete sexual abstinence was the central virtue of Christian life and that only the celibate could anticipate a blessed afterlife.

By far the most influential writer on Christian sexual ethics in the history of the Western church was St. Augustine of Hippo (354–430). Augustine vigorously denounced sexual laxity among his contemporaries. In the process he gradually elaborated a set of basic tenets concerning Christian sexual morality that seemed to him—and to this day continue to seem to many Christians—both reasonable and persuasive.

Human sexuality as we know it, according to one strand of Augustine's theory, departs in many important ways from the original intentions of the divine Creator. In paradise, before Adam and Eve, the progenitors of the entire human race, had committed the first sin, sexual feelings and sexual relations were radically different from anything that we now experience.

Intercourse in paradise brought none of the intense pleasure that we associate with orgasm, while the human sex drive and the sexual organs themselves were entirely subordinate to reason. Our first parents, Augustine thought, knew nothing of the insistent urges and passions that their descendants have experienced ever since the Fall from grace and the consequent expulsion of Adam, Eve, and all their descendants from the bliss of paradise. Sex as we know it, in other words, is (like its sister, death) a consequence of sin, an aspect of humankind's continuing rebellion against God's wishes, a part of the punishment that all humans must suffer as descendants of the first sinners, a depraved craving that we must strive to repress and overcome if we are ever to merit salvation and the friendship of God in the world to come.[3]

Given these premises, Christians have often concluded that sexual behavior presents a key moral issue, a benchmark by which virtue and spiritual strength may be measured. Canonical rules about sexual conduct, therefore, aimed to encourage everyone who could do so to renounce the pursuit of sexual pleasure, and to embrace instead a life of perpetual virginity, unblemished by any sexual experience whatever.

Most Christians, however, have never been willing or able to achieve total abstinence from sex. The minority who did aspire to banish sex from their lives, such as monks, nuns, and sometimes priests and other ministers, accordingly considered themselves a spiritual elite within the church. Members of this elite claimed that their own sexual abstinence qualified them to guide their weaker brethren along the paths of godliness. Celibate clerics ultimately secured a monopoly of leadership positions within the church establishment and, naturally enough, urged their followers to do their best to banish sexual pleasure from their lives and thoughts. Some married Christians responded to such exhortations by renouncing sexual relations entirely, while continuing to live with their spouses in a "spiritual marriage" from which they had banished sex. This type of arrangement, however, remained exceptional even among the devout.[4]

Members of the clerical elite sternly admonished those less heroic Christians who were unable to renounce sex completely that they should confine their obscene gropings to the marriage bed, that they must forswear any sort of sexual pleasure outside of marriage, that even within marriage they should engage in intercourse only rarely, when they explicitly intended to beget a child, and that under no circumstances should they do so simply for the sake of carnal gratification and enjoyment.

Penitentials and other handbooks for confessors, which began to appear around the beginning of the seventh century, reduced such general ex-

hortations to specific guidelines for acceptable sexual behavior. The authors of penitentials agreed, for example, that married couples sinned if they failed to abstain entirely from sexual relations throughout the forty days of the Lenten season each spring, during the season of Pentecost in early summer, and during the four weeks of Advent, just before Christmas. In addition penitential writers commonly taught that it was grievously sinful for married persons to have intercourse on certain days of the week—all Wednesdays, Fridays, and Saturdays, according to some—throughout the year. They also banned marital sex during the wife's menstrual period, during pregnancy, and after pregnancy so long as the child continued to nurse at the mother's breast. Penitentials further warned couples that they sinned if they engaged in sexual relations during the daylight hours, while they were naked, or in positions other than the one that we nowadays describe as the missionary position. Non-marital sex, either social or solitary, heterosexual or homosexual, sleeping or waking, voluntary or involuntary, was likewise sinful according to these authorities, who often advised confessors in considerable detail about possible infractions of these prohibitions that repentant sinners might disclose to them in confession and prescribed penances that they deemed appropriate to deal with each situation.[5]

During the church reform movement that began in the second half of the eleventh century, moreover, high-ranking church authorities commenced a campaign to require all clerics (and especially those in the upper ranks of the church's hierarchy) to renounce marriage and sex altogether as a condition of ordination. While earlier spiritual writers and some church authorities had long praised clerical celibacy and encouraged all clergymen to embrace it, canon law had previously required celibacy only of monks and nuns who lived in religious communities. Now a vow of celibacy suddenly became a requirement for ordination to all of the higher positions in the church's clerical hierarchy.[6]

This new asceticism created innumerable personal crises, not only for priests and other clerics, but also for their wives, children, families, and parishioners. Reformers demanded that married clergymen eject wives and children from their homes and embrace a life of celibacy unencumbered by carnal temptations and the distractions of family life. Canons of the First and Second Lateran Councils (held in 1123 and 1139) ruled that men in holy orders could no longer marry validly and stripped the families of clerics of the legal status and protections that they had previously enjoyed.[7]

Many clerics understandably found this rigorous new discipline unacceptable. Some clergymen fought back against the reformers and resisted attempts to force them into a celibate existence. When the bishop of Paris

ordered his priests to give up their wives and children, his outraged clergy drove him from the cathedral with jeers and blows and forced him to take refuge with the royal family in order to escape a worse fate. Some bishops simply refused to publish the celibacy decrees out of fear for their lives. They had good reason to be afraid: in 1077 Pope Gregory VII (1073–85) reported that the clergy of Cambrai had taken a supporter of clerical celibacy and burned him alive.[8]

Protesters against the reformers' new regime, however, were fighting a losing battle. The new rules took hold slowly, to be sure, and in some regions they never triumphed completely. Still the clergyman who lived openly with a wife or concubine gradually became increasingly rare. By the middle of the thirteenth century, after some two centuries of battling over the issue, clerical celibacy had become a firmly established principle of canon law. The practice of celibacy was another matter. Complaints about clerical concubinage and legal actions against priests and their female companions continued to plague church authorities throughout the later Middle Ages and beyond. Enforcement of the celibacy rules that still prevail among Roman Catholics remains a serious problem for the church to this day.

Although church authorities considered it highly virtuous for married couples to renounce sexual intercourse voluntarily, as we have seen, marriages in which one spouse (usually the man) was sexually impotent and thus physically unable to consummate the marriage posed difficult problems for matrimonial policy. Reproduction was, after all, one of the fundamental considerations that theologians cited when they discussed the reasons why God allowed marital sex and many authorities considered it by far the most important one. It might seem to follow from this that any marriage in which reproduction was impossible or exceedingly unlikely would fail to meet the criteria for legitimate marriage between Christians. Canonists and theologians, however, were unwilling to accept such a sweeping policy position. For one thing, such a rule would mean that elderly persons, and especially women who were past menopause, could not marry at all. This consequence seemed too harsh to be acceptable. Widows and widowers who were beyond their reproductive years, for example, often wanted to marry for companionship and many of them needed to marry for economic reasons as well. A policy that made such marriages impossible would disadvantage large numbers of people and would, in any event, be hopelessly impractical to enforce.[9]

Canonists and theologians likewise thought it improper to permit couples who were able to have intercourse but unable to produce children to annul their marriages and to remarry in the hope of better reproductive

fortune the next time around. On this point the reigning opinion among ecclesiastical authorities conflicted with the needs and desires of numerous laymen, especially monarchs and noblemen, who deemed it essential to produce a legitimate male heir in order to preserve their family's positions, lands, and powers. Kings and feudal noblemen felt that they must be able to free themselves from barren marriages and to remarry in the hope that a new spouse might enable them to father an heir who could succeed them.

This conflict between canonical policy on one side and the political and personal goals of some of the most powerful members of medieval society on the other created a serious impasse, and neither group could readily afford to give way on the issue. Churchmen felt obligated to maintain the principle that valid marriages between Christians were indissoluble, while the heads of families maintained that they must have the freedom to change their own marriage partners or those of their children, should that became necessary to optimize the interests and fortune of the family as a whole.

The upshot was an uneasy and messy compromise. Since the church adamantly refused to give way on the issue of matrimonial indissolubility, laymen who wished to terminate a childless marriage needed to find ways to circumvent the rule. One device that members of the social elite often used to terminate inconvenient marriages centered on issues raised by the church's rules on consanguinity and affinity. Up to 1215 Christians were forbidden to marry anyone related to them within seven degrees of blood kinship. This broad-ranging prohibition rendered marriages even between quite distant cousins invalid, and marital alliances among royalty and the noble classes not infrequently violated the consanguinity rules. Furthermore, marriages could be held invalid by reason of affinity, that is, a relationship contracted through marriage or through baptismal sponsorship. Since well-to-do families frequently intermarried and also tended to call upon persons of their own social class to stand as godparents for their children, families could often "discover" marriage impediments that arose from consanguinity or affinity when it became desirable for one of their members to escape from a marriage that no longer seemed advantageous for family goals. When the Fourth Lateran Council in 1215 reduced the range of the consanguinity prohibition to four degrees of kinship, this method of nullifying marriages became less available, although families continued to employ it from time to time.[10]

Canon law furnished other avenues that individuals and their families could use to evade the indissolubility doctrine. Once Pope Alexander III (1159–81) had ruled that free consent of the parties was essential for valid marriage, defective consent provided one possible escape route, particularly if it could be shown that pressure had been brought on one or the other

spouse to agree to the challenged marriage. Canonical minimum age for marriage was set very young—at twelve for girls, fourteen for boys—but prominent families often arranged their children's marriages at even earlier ages, and this sometimes yielded grounds for securing a declaration of nullity.[11] The very formlessness of the marriage contract itself furnished other possible grounds. Since couples could validly marry, at least after the time of Alexander III, without ceremony, witnesses, public announcement, registration, or ritual, a claim that prior to a solemnized marriage one party had informally consented to marry someone other than the current spouse could, if proved, break up the formal marriage, no matter how long-standing it might have been.[12]

Strategies such as these often provided those with adequate means and incentive with numerous possibilities of escape from fruitless or otherwise inconvenient marriages. At the same time church authorities could continue to maintain that valid Christian marriages were always indissoluble, since termination of any given union was grounded on some defect in the contract that rendered it null and void from the outset. This compromise between the interests of churchmen and those of the laity was more favorable to the institutional church than to its lay members. The nature of the compromise itself virtually guaranteed a steady flow of business into the ecclesiastical courts and that, in turn, greatly increased both the church's income (from the fees and costs assessed by the courts) and its power to intervene in people's lives and to shape their fate. Although canon law furnished numerous possibilities for contesting the validity of marriages, the available grounds by no means guaranteed that even wealthy and determined litigants would invariably succeed in securing their wishes.[13] The matrimonial adventures of the English king, Henry VIII (1510–47), for example, made this amply clear.[14]

Canon law developed into a systematic intellectual discipline during the course of the twelfth century. The appearance about 1140 of the *Decretum* of Gratian provided canonists with a reasoned, analytical textbook that remained the basis for the teaching of canon law in the schools and universities throughout the remainder of the Middle Ages.[15] Indeed Roman Catholic canonists continued to use the *Decretum* as an authoritative collection until the beginning of the twentieth century. Medieval and modern canonistic treatments of sexual behavior were thus grounded largely on positions and ideas that church leaders found in Gratian's work.

Gratian treated sexual pleasure as a disturbing element in human life, a temptation that distracted Christians from the goal of salvation, and an instrument that the devil regularly employed to entice souls into hell. The

clear message of Gratian's *Decretum*, therefore, was that sexual activity of every kind was best avoided altogether. Even married men and women must confine their sexual contacts within stringent limits. Husband and wife, to be sure, could lawfully have sexual intercourse with one another, but they needed to limit and control their lovemaking lest they run afoul of the law. Married persons could properly engage in intercourse only under one of three conditions: either in order to beget a child, or to avert temptations to marital infidelity, or to accommodate the insistent (and probably sinful) demands of their spouses.[16]

All other sexual activity, either within marriage or outside of it, as well as any sexual desire or arousal other than that permitted for lawful purposes between husband and wife was sinful and, if it became publicly known, might be subject to criminal prosecution as well. Thus even within marriage one needed to be careful. The husband who loved his wife too passionately, according to St. Jerome (ca. 331–419/20), was an adulterer, and canon law imposed strict operational limits on legitimate marital intimacy. Among other things, for example, canonists turned their attention to the positions that couples adopted during sexual relations. Medieval church authorities were prepared to condone as "natural" only marital intercourse conducted in what modern writers usually call the "missionary position," with the wife supine and the husband on top of her. Intercourse in any position where the woman lay or sat atop the man seemed to canonists "unnatural," since they believed that such a posture reversed the proper order of relationship between the sexes by making the female superior to the male. Canonists and theologians likewise condemned intercourse "from behind" (*retro*), that is in which the husband entered his wife from the rear, since they considered intercourse in such a posture "beastly" and hence entirely inappropriate for human beings. Church authorities vehemently rejected all anal or oral sexual practices, which Gratian's book described as "extraordinary sensual pleasures" and "whorish embraces," both because such practices were clearly non-procreative and also because they seemed to have sexual pleasure as their sole objective. Writers on theology and canon law frequently branded any departure from heterosexual relations in the missionary position as "sodomy," and maintained that the biblical story of God's destruction of the city of Sodom (Genesis 18–19) definitively demonstrated divine disapproval of any activities, heterosexual or homosexual, that aimed primarily at enhancing sexual pleasure.[17]

Gratian classed adultery as a heinous crime, much more serious than fornication, although it was not quite as grave a lapse as incest or sodomy. Both incest and sodomy (by which he apparently meant any sort of sexual

encounter between persons of the same gender or extra-vaginal intercourse between persons of different genders) deserved in Gratian's eyes to rank with such atrocious crimes as murder, forgery, arson, sacrilege, and heresy. Canonists and theologians regarded simple fornication between two unmarried persons both as a serious sin and as a canonical crime. Gratian and the canonical courts tended to treat fornication as a routine offense, which called for fines and a humiliating penance that might discourage others from such unacceptable behavior. Many among the laity, however, found it difficult to believe that simple fornication could actually imperil their immortal souls. Sexual relations between unmarried men and women seemed to most people so natural and so inevitable that they could not understand how such conduct could be sinful at all. Instructions to confessors frequently advised priests to admonish penitents on this matter and to make sure that they understood that even simple fornication was a serious moral offense.[18]

Most canonists followed Gratian in treating masturbation as a minor peccadillo that ought to be dealt with in confession, rather than in the courts.[19] A few writers in the later Middle Ages, notably Jean Gerson (1363–1429), however, considered solitary sex so serious an offense that only a bishop was empowered to pardon the offender and prescribe suitable punishment.

The canonists thus proscribed in principle every kind of sexual experimentation or deviation from the approved version of marital intercourse, and even more stringently barred all types of non-matrimonial sexual activity. In practice, of course, even the most devout could hardly avoid straying occasionally from the straight and narrow paths that authority prescribed, and sexual offenses, together with marriage problems, accounted for a very large part of the business that came before local ecclesiastical judges almost everywhere.

Numerous sex offenses, however, rarely found their way into the courts at all, but rather were usually dealt with privately in the so-called "internal forum" of confession. This was understandably true of solitary offenses, such as masturbation, as well as private deviations from the prescriptions for marital conduct—engaging in intercourse unclothed, for example, or during the daylight hours, at forbidden times, or in unconventional postures. Pastoral manuals and handbooks for confessors often dealt at such great length and in such detail with sexual sins that it is difficult to escape the conclusion that these behaviors must have flourished rather vigorously among medieval people. Irregular sexual practices certainly fascinated the celibate clergymen who constituted the intended audience for these works.

Confessors' manuals routinely cautioned priests that they must inquire diligently into the sexual habits of the penitents who came to them, but at the same time warned the confessor that he must take care that his questioning not supply penitents with any fresh ideas for disapproved sexual behavior that had not already occurred to them. The dividing line was exceedingly fine and many a confessor must have found it difficult to be sure he had not crossed it.

Punishment of sex offenses by canonical courts could in theory be extremely severe. Although the more common sorts of sex crimes, such as fornication, often brought little more than a casual fine, this was sometimes accompanied by some form of ritual public humiliation designed to impress upon the rest of the community the seriousness of the offense. These exercises might include, for example, a public confession of the offense and a request for the community's forgiveness, topped off by a public whipping and the offering of gifts to the church in reparation for the offense.[20]

The energetic efforts of the clergy to convince ordinary people that sexual pleasure was inherently sinful seem to have made little impression on the great mass of medieval Christians. Ample evidence suggests that a great many medieval people rejected the more rigorous theological prohibitions of common sexual practices and simply refused to believe that fornication and other run-of-the-mill sexual offenses would doom perpetrators to eternal torment in hell.

Since adultery was a far more serious matter than fornication, it was usually punished severely both by canonical tribunals and by secular judges as well, not only because the act itself violated marital vows and threatened the stability of marriage, but also because children conceived in an adulterous relationship could create serious legal problems for the orderly transfer of family identity and property between generations. Although theologians maintained that extramarital sex was as sinful for a man as for a woman, canon law treated adultery primarily as a female offense and only occasionally punished men for violations of their marriage vows. Conviction of adultery might entail the expulsion of a guilty wife from the matrimonial home, separation from her children, and confiscation of her dowry by her husband. This could in many situations effectively reduce the woman to penury and disgrace. In many places adulterous women also had their heads shaved and might be paraded through the streets to the tune of jeers, catcalls, and often physical abuse from bystanders. Canonical authorities, like their Roman predecessors, forbade the betrayed husband to slay his guilty wife, although the courts were notably reluctant to punish the husband who killed his wife's lover.[21]

Incest likewise posed troublesome problems from the beginning of Christian history (see 1 Cor. 5:1–2) and canonical courts in the Middle Ages were prepared to treat convicted offenders very harshly indeed. Marriages between persons who were closely related to each other by blood or marriage were invalid, as we have seen, and consequently the children of such marriages might be considered illegitimate and hence unable to inherit their parents' property. A decretal of Pope Celestine III (1191–98) further held that sexual relations between two persons created a legal impediment to marriage between either party and any close relatives of the other. Thus, for example, a man who had slept with a woman to whom he was not married became ineligible to marry her sisters or any other women in her family. Standing as godparent to a child in baptism also created a spiritual relationship, both between godparent and child and between the godmother and godfather. Canon law accordingly classed subsequent marriages between any of these parties or with their close relatives as incestuous and invalid.[22]

The most serious sexual crime, however, according to most authorities, was sodomy, by which they meant both sexual relations between persons of the same gender and also any type of sexual relations between a man and a woman other than vaginal intercourse. Thus heterosexual fellatio, cunnilingus, or anal intercourse, for example, might be classed as sodomy and, if complained about, could subject participants to severe penalties. Many authorities were inclined to class sexual contacts between humans and other animals as another type of sodomy, although some writers distinguished between these offenses and treated bestiality as a separate class of sex crime, only marginally less serious than homosexual sodomy.[23]

Despite their moral condemnation of all extramarital sex, most canonical writers, oddly enough, were prepared to tolerate prostitution in practice and even in principle. The reigning theory, enunciated by St. Augustine, argued that if prostitutes were not available to slake male lust, men would inevitably solicit sexual favors from respectable matrons and0 other "honest women." That, in turn, Augustine held, would disturb and dislocate the peaceful order of society. It was better, according to this line of reasoning, to allow prostitutes to continue in their sinful and unsavory trade rather than to risk the social disorder that would accompany successful prohibition of commercial sex. Some medieval writers went so far as to argue that, despite the fact that it was morally wrong both for the prostitute and for her client to engage in relations with one another, prostitution was necessary for the public good. One authoritative commentator compounded this paradox by explaining that sex with a prostitute was doubly evil, for it was a wrongful use of an evil thing, as opposed to marital sex, which was a rightful use of

an evil thing. Nonetheless, he argued, just as God tolerated the evil of marital sex because of the good effects that it might produce (such as children and the mutual support and companionship of married couples), so Christian society must tolerate prostitution in order to secure the benefits of social harmony and domestic peace.[24]

Prostitution accordingly not only became a tolerated occupation in many medieval communities, but was even treated in some places as a public utility of sorts. In the fourteenth century many towns carried this principle to its logical conclusion and began to build and operate municipal brothels as a means of regulating the sex trade while realizing a profit from it at the same time. Moral ambiguity concerning the prostitution industry long persisted, and public policy on the matter still remains controversial in Western societies.[25]

Both lawyers and lawgivers typically sought to contain the practice of prostitution by restricting harlots and brothels to specially-designated regions within towns. Municipal statutes, following a decree of the Fourth Lateran Council (1215), often required prostitutes to wear distinctive colors and types of clothing. The rationale that lawmakers usually proposed to explain such regulations was that they would spare respectable women, especially the wives and daughters of established citizens, from the sexual importuning of randy men. This, in turn, was justified as a means to preserve civic peace and harmony. Municipal authorities also attempted in many places to restrict the practice of prostitution to well-defined and usually marginal regions within their towns. Here again they habitually invoked the public good as a reason for these restrictions, although it seems likely that legislation of this sort may also have served the economic and social interests of landlords and property owners in the more salubrious and desirable neighborhoods of the town.[26]

Church leaders and civic authorities alike, moreover, were concerned to provide women who wished to abandon the life of shame with realistic opportunities to do so. Thus, for example, Pope Innocent III (1198–1216) early in the thirteenth century reversed a long-standing policy that had prohibited good Christian men from marrying prostitutes. Innocent not merely permitted these marriages, but positively encouraged them and promised spiritual rewards for men who married loose women, provided of course that the husbands of former prostitutes kept close watch over their wives to make sure that they remained sexually faithful and did not return to their wanton ways. The prospect of marrying a reformed prostitute may well have been especially alluring to financially disadvantaged men, since successful strumpets occasionally managed to accumulate tidy dowries from the profits of their trade.

The thirteenth century likewise witnessed the creation of convents and religious orders of women that provided a haven and a degree of security and chaste companionship for reformed daughters of joy. The most successful of these religious institutes, the Order of St. Mary Magdalene (whose members were informally known as the White Ladies), established houses in many major European cities and in a surprising number of minor ones as well. Such institutions in effect constituted a social security system of sorts for prostitutes who wished to retire from their occupation but required both social and economic support in order to do so.[27]

The moral ambivalence that canonists and other legal experts showed toward prostitution was emblematic of the difficulties that medieval societies experienced in confronting the realities of human sexuality. Committed in principle to restricting sexual activity as narrowly as possible, canonists nonetheless had to take account professionally of the fact that systematic enforcement of the limits they wished to impose was difficult, if not impossible.

Periodic confession of sins provided both some degree of surveillance over private deviations from the sexual norms as well as an opportunity to counsel offenders to avoid future infringement of the rules.[28] For offenses that were public or became publicly known, the lawmakers and administrators of the medieval church had to create a law enforcement system that could detect suspected offenders and courts that could try and punish them, in the hope that this would also deter others from imitating their bad example. The church's enforcement and court systems were neither particularly efficient nor especially effective during the early Middle Ages. Late in the twelfth century, however, church leaders commenced to devise more elaborate and successful mechanisms to repress beliefs and behaviors that they considered undesirable.[29] By the end of the thirteenth century popes and bishops had put in place a complex system of courts, spanning every level of Christian society, all the way from the courts of the archdeacons at the local level through the consistory courts of the bishops and the provincial courts of the archbishops to the central courts of the Roman curia. Sexual misconduct and marital irregularities furnished all of these courts, and particularly those at the lower levels of the hierarchy, with a major part of their business. Offenders against canonistic sexual norms, in effect, not only made this complex judicial structure necessary, but also supported it financially through the fees and fines that the courts generated.[30]

The sexual standards enunciated by medieval canon lawyers have persisted with striking tenacity in modern European and American law. In the United States, for example, fornication, adultery and sodomy remain

crimes in many States and occasionally, under unusual circumstances, offenders may even be prosecuted for them. The so-called "spousal exception," which permits defendants in rape or sexual abuse cases to escape punishment if they can prove that they were married to the victim at the time of the alleged offense, remains to this day the standard rule in many North American jurisdictions and constitutes a striking example of the continuing presence of canonical legal doctrines in twentieth-century civil law.[31]

NOTES

1. James A. Brundage, *Law, Sex, and Christian Society in Medieval Europe*, 57–61; Eric Fuchs, *Sexual Desire and Love*, 64–82; Willy Rordorf, "Marriage in the New Testament and in the Early Church."

2. See esp. Jean Gaudemet, *Les sources du droit de l'église en Occident*.

3. Peter Brown, *The Body and Society*, 399–402; Michael Müller, *Die Lehre des hl. Augustinus von der Paradiesesehe* presents an exhaustive treatment of this topic.

4. Dyan Elliott, *Spiritual Marriage*, treats this matter in detail.

5. On the sexual prescriptions of the early medieval penitentials Pierre J. Payer, *Sex and the Penitentials*, and Jean-Louis Flandrin, *Un temps pour embrasser*, as well as Brundage, *Law, Sex, and Christian Society*, 152–69.

6. James A. Brundage, *Law, Sex, and Christian Society*, 214–23.

7. Ibid., 218–20.

8. John E. Lynch, "Marriage and Celibacy of the Clergy"; Anne Barstow, *Married Priests and the Reforming Papacy*.

9. James A. Brundage, "Impotence, Frigidity and Marital Nullity in the Decretists and the Early Decretalists."

10. Georges Duby outlined these problems and some attempted solutions to them in medieval France in *Medieval Marriage*; he returned to these themes, and somewhat modified his earlier views, in *The Knight, the Lady, and the Priest* and more recently in *Love and Marriage in the Middle Ages*.

11. W. Onclin, "L'âge requis pour le mariage dans la doctrine canonique médiévale."

12. Brundage, *Law, Sex, and Christian Society*, 331–36; John T. Noonan, "Power to Choose"; Charles Donahue, Jr., "The Policy of Alexander the Third's Consent Theory of Marriage" and "The Canon Law on the Formation of Marriage and Social Practice in the Later Middle Ages."

13. Richard H. Helmholz, *Marriage Litigation in Medieval England*, shows how difficult the process could be and the complications that might arise, as does Michael M. Sheehan, "The Formation and Stability of Marriage in Fourteenth-Century England."

14. Henry Ansgar Kelly, *The Matrimonial Trials of Henry VIII*.

15. For a brief introduction to the history of canon law and its sources see Brundage, *Medieval Canon Law*. More extensive treatments may be found in Van Hove, *Prolegomena*; Stickler, *Historia iuris canonici Latini*; and LeBras, Lefebvre, and Rambaud, *L'âge classique*.

16. Brundage, *Law, Sex, and Christian Society*, 278–88, 346–51, 358–60, 364–69; Elizabeth Makowski, "The Conjugal Debt and Medieval Canon Law."

17. James A. Brundage, "Let Me Count the Ways: Canonists and Theologians Contemplate Coital Positions."

18. Brundage, *Law, Sex, and Christian Society*, 245–51.

19. Giovanni Cappelli, *Autoerotismo*, shows how Christian doctrine on solitary sex practices gradually developed in the early church. For later treatments of the subject see Brundage, *Law, Sex, and Christian Society*, 314, 400–01, 535, 571.

20. Brundage, *Law, Sex, and Christian Society*, 319–23, 481–85, 544–46.

21. Ibid., 247–48, 305–08, 385–89, 462–63, 517–21.

22. Joseph H. Lynch, *Godparents and Kinship in Early Medieval Europe*.

23. Brundage, *Law, Sex, and Christian Society*, 212–14, 313–14, 398–400, 472–74, 533–36. John Boswell, *Christianity, Social Tolerance, and Homosexuality* presents a provocative interpretation of the medieval church's policies toward same-sex relationships that remains the subject of lively disagreement both in scholarly journals and in popular discussions.

24. James A. Brundage, "Prostitution in the Medieval Canon Law," 830–31.

25. Brundage, *Law, Sex, and Christian Society*, 210–12, 248–49, 308–11, 389–96, 463–69.

26. Peter Schuster, *Das Frauenhaus*, describes the curious phenomenon of municipally funded and operated brothels in Germany. For similar institutions in France see Leah Lydia Otis, *Prostitution in Medieval Society*, and Jacques Rossiaud, *Medieval Prostitution*.

27. Brundage, *Law, Sex, and Christian Society*, 395–96, 529–30.

28. See Thomas N. Tentler, "The Summa for Confessors as an Instrument of Social Control," but cf. the dissenting comments of Leonard E. Boyle in "The Summa for Confessors as a Genre and its Religious Intent."

29. See the series of articles by Richard M. Fraher, "Conviction According to Conscience," "Preventing Crime in the High Middle Ages," "The Theoretical Justification for the New Criminal Law of the High Middle Ages," and "'Ut nullus describatur reus prius quam convincatur'."

30. A general history of medieval church courts remains to be written. For courts at the local level the best available treatment remains the century-old work of Paul Fournier, *Les officialités au moyen-âge*, which deals exclusively with French church courts. For England see Brian L. Woodcock, *Medieval Ecclesiastical Courts in the Diocese of Canterbury*, and Colin Morris, "A Consistory Court in the Middle Ages." On the central court of the Rota see Charles Lefebvre, "Rote Romain," and for the use of judges-delegate see Jane E. Sayers, *Papal Judges Delegate in the Province of Canterbury*. See also Charles Lefebvre, "Juges et savants en Europe (13e–16e s.)," as well as Brundage, *Medieval Canon Law*, chapter 6.

31. For examples see Brundage, *Law, Sex, and Christian Society*, 608–17.

Bibliography

Ariès, Philippe, and André Béjin, eds. *Western Sexuality: Practice and Precept in Past and Present Times*. Trans. Anthony Foster. Oxford: Basil Blackwell, 1985.

Barstow, Anne Llewellyn. *Married Priests and the Reforming Papacy*. New York, Toronto: Edwin Mellen Press, 1982.

Bonfield, Lloyd. "Church Law and Family Law in Medieval Western Christendom." *Continuity and Change* 6 (1991), 361–74.

Boswell, John. *Christianity, Social Tolerance, and Homosexuality: Gay People in Western Europe from the Beginning of the Christian Era to the Fourteenth Century*. Chicago: University of Chicago Press, 1980.

Boyle, Leonard E. "The Summa for Confessors as a Genre and its Religious Intent." In *The Pursuit of Holiness in Late Medieval and Renaissance Religion*, ed. Charles Trinkaus and Heiko A. Obermann (Leiden: Brill, 1974), 126–37.

Brooke, Christopher N.L. *The Medieval Idea of Marriage*. Oxford: Oxford University Press, 1989.

Brown, Peter. *The Body and Society: Men, Women, and Sexual Renunciation in Early Christianity*. New York: Columbia University Press, 1988.

Brundage, James A. "Coerced Consent and the 'Constant Man' Standard in Medieval Canon Law" (forthcoming).

———. "Impotence, Frigidity and Marital Nullity in the Decretists and the Early Decretalists." In *Proceedings of the Seventh International Congress of Medieval Canon Law*, ed. Peter Linehan (Vatican City: Biblioteca Apostolica Vaticana, 1988), 407–23. Reprinted in *Sex, Law, and Marriage in the Middle Ages.*

———. "Marriage and Sexuality in the Decretals of Pope Alexander III." In *Miscellanea Rolando Bandinelli Papa Alessandro III*, ed. Filippo Liotta (Siena: Accademia Senese degli intronati, 1986), 59–83. Reprinted in *Sex, Law and Marriage in the Middle Ages.*

———. *Law, Sex, and Christian Society in Medieval Europe.* Chicago: University of Chicago Press, 1987.

———. "Let Me Count the Ways: Canonists and Theologians Contemplate Coital Positions." *Journal of Medieval History* 10 (1984), 81–93. Reprinted in *Sex, Law and Marriage in the Middle Ages.*

———. *Medieval Canon Law.* London: Longmans, 1994.

———. "Prostitution in the Medieval Canon Law." *Signs* 1 (1976), 825–45. Reprinted in *Sex, Law and Marriage in the Middle Ages.*

———. *Sex, Law and Marriage in the Middle Ages.* London: Variorum, 1993.

Bullough, Vern L. *Sexual Variance in Society and History.* New York: Wiley Interscience, 1976.

Bullough, Vern L., and James A. Brundage, eds. *Sexual Practices and the Medieval Church.* Buffalo: Prometheus Books, 1982.

Bullough, Vern L., and Bonnie Bullough. *Sin, Sickness, and Sanity: A History of Sexual Attitudes.* New York: New American Library, 1977.

———. *Women and Prostitution.* Buffalo: Prometheus Press, 1987.

Cappelli, Giovanni. *Autoerotismo: Un problema morale nei primi secoli cristiani.* Bologna: Edizioni Dehoniane, 1986.

Donahue, Charles, Jr. "The Canon Law on the Formation of Marriage and Social Practice in the Later Middle Ages." *Journal of Family History* 8 (1983), 144–58.

———. "The Policy of Alexander the Third's Consent Theory of Marriage." In *Proceedings of the Fourth International Congress of Medieval Canon Law*, ed. Stephan Kuttner. Vatican City: Biblioteca Apostolica Vaticana, 1976, 251–81.

———. "The Canon Law on the Formation of Marriage and Social Practice in the Later Middle Ages." *Journal of Family History* 8 (1983), 144–58.

———. "The Policy of Alexander the Third's Consent Theory of Marriage." In *Proceedings of the Fourth International Congress of Medieval Canon Law*, ed. Stephan Kuttner (Vatican City: Biblioteca Apostolica Vaticana, 1976), 251–81.

Duby, Georges. *The Knight, the Lady, and the Priest: The Making of Modern Marriage in Medieval France.* Trans. Barbara Bray. New York: Pantheon, 1983.

———. *Love and Marriage in the Middle Ages.* Trans. Jane Dunnett. Chicago: University of Chicago Press, 1994.

———. *Medieval Marriage: Two Models from Twelfth-Century France.* Trans. Elborg Forster. Baltimore: Johns Hopkins University Press, 1978.

Elliott, Dyan. *Spiritual Marriage: Sexual Abstinence in Medieval Wedlock.* Princeton, NJ: Princeton University Press, 1993.

Flandrin, Jean-Louis. *Un temps pour embrasser: Aux origines de la morale sexuelle occidentale (VIe-XIe siècles).* Paris: Seuil, 1983.

Fournier, Paul. *Les officialités au moyen âge: Étude sur l'organisation, la compétence et la procédure des tribunaux ecclésiastiques en France de 1180 à 1328.* Paris: E. Plon, 1880; repr. Aalen: Scientia Verlag, 1984.

Fraher, Richard M. "Conviction According to Conscience: The Medieval Jurists' Debate Concerning Judicial Discretion and the Law of Proof." *Law and History Review* 7 (1989), 23–88.

————. "Preventing Crime in the High Middle Ages: The Medieval Lawyers' Search for Deterrence." In *Popes, Teachers, and Canon Law in the Middle Ages*, ed. James Ross Sweeney and Stanley Chodorow (Ithaca, NY: Cornell University Press, 1989), 212–33.

————. "The Theoretical Justification for the New Criminal Law of the High Middle Ages: 'Rei publicae interest, ne crimina remaneant impunita'." *University of Illinois Law Review* (1984), 577–95.

————. "'Ut nullus describatur reus prius quam convincatur': Presumption of Innocence in Medieval Canon Law?" In *Proceedings of the Sixth International Congress of Medieval Canon Law*, eds. Stephan Kuttner and Kenneth Pennington (Vatican City: Biblioteca Apostolica Vaticana, 1985), 493–506.

Fuchs, Eric. *Sexual Desire and Love: Origins and History of the Christian Ethic of Sexuality and Marriage*. Trans. Marsha Daigle. Cambridge: James Clarke; New York: Seabury Press, 1983.

Gaudemet, Jean. "Indissolubilité et consommation du mariage: L'apport d'Hincmar de Reims." *Revue de droit canonique* 30 (1980), 28–40.

————. *Le mariage en Occident*. Paris: Cerf, 1987.

————. *Les sources du droit de l'église en Occident du IIe au VIIe siècle*. Paris: Cerf, 1985.

Goody, Jack. *The Development of the Family and Marriage in Europe*. Cambridge: Cambridge University Press, 1983.

Gravdal, Kathryn. *Ravishing Maidens: Writing Rape in Medieval French Literature and Law*. Philadelphia: University of Pennsylvania Press, 1991.

Helmholz, Richard H. *Marriage Litigation in Medieval England*. Cambridge: Cambridge University Press, 1974.

Kelly, Henry Ansgar. *Love and Marriage in the Age of Chaucer*. Ithaca, NY: Cornell University Press, 1975.

————. *The Matrimonial Trials of Henry VIII*. Stanford, CA: Stanford University Press, 1976.

Laiou, Angeliki E., ed. *Consent and Coercion to Sex and Marriage in Ancient and Medieval Societies*. Washington: Dumbarton Oaks, 1993.

LeBras, Gabriel, Charles Lefebvre, and Jacqueline Rambaud. *L'âge classique, 1140–1378: Sources et théorie du droit*. Paris: Sirey, 1965.

Lefebvre, Charles. "Juges et savants en Europe (13e–16e s.): L'apport des juristes savants au développement de l'organisation judiciaire." *Ephemerides iuris canonici* 22 (1966), 76–202; 23 (1967), 9–61.

————. "Rote romain." In *Dictionnaire de droit canonique*, ed. R. Naz, 7 vols. (Paris: Letouzey et Ané, 1935–65), 7:742–71.

Levin, Eve. *Sex and Society in the World of the Orthodox Slavs, 900–1700*. Ithaca, NY: Cornell University Press, 1989.

Love and Marriage in the Twelfth Century, eds. Willy Van Hoecke and Andries Welkenhuysen. Leuven, Belgium: Leuven University Press, 1981.

Lynch, John E. "Marriage and Celibacy of the Clergy: The Discipline of the Western Church." *The Jurist* 32 (1972), 14–38, 189–212.

Lynch, Joseph H. *Godparents and Kinship in Early Medieval Europe*. Princeton, NJ: Princeton University Press, 1986.

Makowski, Elizabeth M. "The Conjugal Debt and Medieval Canon Law." *Journal of Medieval History* 3 (1977), 99–114.

Morris, Colin. "A Consistory Court in the Middle Ages." *Journal of Ecclesiastical History* 14 (1963), 150–59.

Müller, Michael. *Die Lehre des hl. Augustinus von der Paradiesesehe und ihre Auswirkung in der Sexualethik des 12. und 14. Jahrhunderts bis Thomas von Aquin*. Regensburg: Friedrich Pustet, 1954.

Noonan, John T., Jr. *Contraception: A History of its Treatment by the Catholic Theo-*

logians and Canonists. Cambridge, MA: Belknap Press of Harvard University Press, 1965; 2nd ed., 1988.

———. "Power to Choose." *Viator* 4 (1973), 419–34.

Onclin, W. "L'âge requis pour le mariage dans la doctrine canonique médiévale." In *Proceedings of the Second International Congress of Medieval Canon Law*, eds. Stephan Kuttner and J. Joseph Ryan (Vatican City: S. Congregatio de seminariis et studiorum universitatibus, 1965), 237–47.

Otis, Leah Lydia. *Prostitution in Medieval Society: The History of an Urban Institution in Languedoc.* Chicago: University of Chicago Press, 1985.

Payer, Pierre J. *Sex and the Penitentials: The Development of a Sexual Code, 550–1150.* Toronto: University of Toronto Press, 1984.

Rordorf, Willy. "Marriage in the New Testament and in the Early Church." *Journal of Ecclesiastical History* 20 (1969), 193–210.

Rossiaud, Jacques. *Medieval Prostitution.* Trans. Lydia G. Cochrane. Oxford: Basil Blackwell, 1988.

Salisbury, Joyce E. *Medieval Sexuality: A Research Guide.* New York: Garland Publishing, 1990.

———, ed. *Sex in the Middle Ages.* New York: Garland Publishing, 1991.

Sayers, Jane E. *Papal Judges Delegate in the Province of Canterbury, 1198–1254: A Study in Ecclesiastical Jurisdiction and Administration.* Oxford: Oxford University Press, 1971.

Schuster, Peter. *Das Frauenhaus: Städtische Bordelle in Deutschland, 1350 bis 1600.* Paderborn: Ferdinand Schöningh, 1992.

Sheehan, Michael M. "The European Family and Canon Law." *Continuity and Change* 6 (1991), 347–60.

———. "The Formation and Stability of Marriage in Fourteenth-Century England: Evidence of an Ely Register." *Mediaeval Studies* 33 (1971), 228–63.

Sheehan, Michael M., and Jacqueline Murray, comp. *Domestic Society in Medieval Europe: A Select Bibliography.* Toronto: Pontifical Institute of Medieval Studies, 1990.

Stickler, Alfons M. *Historia iuris canonici Latini.* Turin: Pontificium Athenaeum Salesianum, 1950.

Tentler, Thomas N. "The Summa for Confessors as an Instrument of Social Control." In *The Pursuit of Holiness in Late Medieval and Renaissance Religion*, eds. Charles Trinkaus and Heiko Obermann (Leiden, Netherlands: Brill, 1974), 103–26.

A. Van Hove. *Prolegomena ad Codicem iuris canonici.* 2d ed. Malines, Belgium: H. Dessain, 1945.

Weigand, Rudolf. "Zur mittelalterlichen kirchlichen Ehegerichtsbarkeit: Rechtsvergleichende Untersuchung." *Zeitschrift der Savigny-Stiftung für Rechtsgeschichte*, kanonistische Abteilung 67 (1981), 213–47.

Woodcock, Brian Lindsay. *Medieval Ecclesiastical Courts in the Diocese of Canterbury.* Oxford: Oxford University Press, 1952.

Yarborough, O. Larry. *Not Like the Gentiles: Marriage Rules in the Letters of Paul.* Atlanta: Scholars Press, 1985.

3 WESTERN MEDICINE AND NATURAL PHILOSOPHY

*Joan Cadden**

Medieval medical and scientific views of sexuality are elusive for two reasons, one methodological, one substantive. First, neither medical writers nor natural philosophers employed categories congruent with our concept of "sexuality." Unlike their counterparts in the Arabic-speaking world, Western authors expressed limited direct concern with what might be called "sexual hygiene."[1] Although they had plenty to say about some of the topics which we incorporate in that construct—about desire, for example—they usually did so within the framework of other concerns, such as infertility, or in scattered chapters of general works.[2] Modern scholarship has likewise approached the topic obliquely, first within the history of obstetrics and gynecology, then within the history of women and the history of natural philosophy.[3] Only recently have relevant works been written on the history of sexuality.[4] Second, when medieval authors did write about such topics, they often did not adhere to a single theory or model. On subjects such as reproductive roles or sexual pleasure they drew from a rich array of material belonging to many sciences (from gynecology to physiognomy) and to many traditions (from ancient Greek to modern Islamic).[5] For these reasons, any attempt to state "the" medical and scientific perspective on sexuality would not only fall short, as any overview must necessarily do, but would radically misrepresent both the conceptual structures within which elements of what we call "sexuality" inhered and the fluid and contested nature of the opinions that medieval authors stated, revised, compromised, and debated.

MEDICAL AND NATURAL PHILOSOPHICAL SOURCES FOR THE STUDY OF MEDIEVAL SEXUALITY

For these same reasons, the possibilities for developing new interpretive perspectives and particularly for deploying new sets of sources are numerous.

*I am grateful to Monica Green for her criticisms and suggestions.

Only a small proportion of the potential Latin primary sources are available in modern editions (or translations) of any kind, including two tractates on intercourse (from the male perspective); two versions of the widely circulated pseudo-Albertus Magnus's *On the Secrets of Women*; and a number of chapters on lovesickness by different authors.[6] Relevant Hebrew works produced in the West are beginning to appear in modern editions.[7] Large numbers of medieval medical sources were printed during the Renaissance, so that scholars who do not have access to manuscript collections may (with appropriate caution) use these editions of works ranging from the treatises attributed to Trotula to the medical encyclopedias of Constantine the African or Bernard of Gordon.[8] Reliance on them is, however, dangerous, because of fifteenth- and sixteenth-century selectivity, misattributions, interpolations, and emendations.

The greatest opportunities reside in manuscript and archival research. Scholarship to date has tended to rely on Latin texts rather than vernacular, on whole and coherent works rather than the more ad hoc and fragmentary, on works by known authors rather than anonymous works, on works which fall into respectable scientific and medical categories rather than those on chiromancy, physiognomy, astrology, or magic. The neglected texts promise not simply more evidence but, more important, new perspectives on sexuality as represented in medieval medicine and natural philosophy. Lynn Thorndike mapped out much of the richness and diversity of the Latin tradition in his eight-volume *History of Magic and Experimental Science*, which contains the seeds of many potential manuscript-based research projects.[9] Certain genres of medical literature underrepresented among printed editions also await deployment in the history of sexuality. For example, late medieval collections of *consilia*, short accounts of real or fictional consultations with individual patients, cursory though they are, provide representations of physicians' interactions with patients.[10] A number of instruments, again with emphasis on the Latin sources, are available for locating and identifying manuscripts, most notably Thorndike and Kibre's catalogue of opening lines ("incipits") of texts.[11] And, while waiting for travel funds, North American scholars can take advantage of several considerable microfilm collections as well as of a modest number of relevant manuscripts in North American libraries.[12]

If the difficulties of navigating manuscript collections with no subject catalogues (as well as uncertain attributions and changing titles) are grave, those of navigating the archival sources are graver still. Yet it is in local court summaries, records of royal pardons, private acts and other such series of documents that evidence about the actual involvement of medicine

(and, to a lesser extent, natural philosophy) in the sexual lives of medieval people will come to light. The prosecution of a practitioner for charging large sums for various charms, potions, and baths to cure impotence and infertility suggests the rewards that await the patient researcher.[13] Ecclesiastical records may also reveal the involvement of medical experts in cases regarding marriage law, although the significance of "midwives'" testimony has perhaps been exaggerated.[14]

Likewise inadequately charted for the history of sexuality (and indeed for most purposes) are the territories beyond the elite, male, and Latin. The example of Isolde's love philter holds out the promise of discovering women's, vernacular, and popular beliefs and practices, but the enterprise is fraught with difficulties. As Monica Green has persistently pointed out, not all medicine practiced by women was about women's health (much less about sexual subjects), nor do the presumed correlations between men and Latin, women and vernacular withstand scrutiny, nor do the associations of Latin with learnedness and vernacular with popular traditions.[15] The permeability between Latin and vernaculars, folk and academic traditions, and women's and men's beliefs, practices, and articulations all complicate and enrich the enterprise of locating and distinguishing medieval sexual constructs and sensibilities.

The sorts of legal and archival sources just mentioned, along with literary and artistic materials, may provide better evidence about popular beliefs and practices than texts devoted to medicine or natural philosophy.[16] Occasionally folk practices may have found their way into written sources, as may be the case with the introduction of tansy and bishop's wort to the medieval repertoire of antifertility drugs, but the methods and criteria for sorting out what is "folk" medicine and which folk traditions are engaged present a variety of challenges.[17] Among these are the classification and interpretation of beliefs and practices belonging to various types of learned and popular magic.[18] General Latin pharmacological sources, such as Hildegard of Bingen's book of medical simples, and general vernacular recipe collections, such as the Old English leechbooks, probably contain a mixture of various scholarly and various folk traditions.[19]

Identification, editing, and scholarly deployment of Anglo-Saxon and Middle English scientific and medical texts dealing with subjects related to sexuality will be rendered immeasurably easier and more accurate by a forthcoming database that will do for medieval English texts what Thorndike and Kibre did for Latin and more.[20] A few vernacular texts, such as Johann Hartlieb's fifteenth-century German version of the pseudo-Albertus Magnus's *Secrets of Women*; two Middle English texts treating obstetrics and gyne-

53

cology; and a gynecological chapter from the French version of a popular Hippocratic text have been published.[21] The work of editing and placing these in context has begun to illuminate the process and significance of the production of vernacular versions.

The texts known as "Trotula," which derive in part from the work of a woman named "Trota," provide opportunities for exploring vernacular transformations and dissemination (since they were frequently translated from the Latin) and for detecting something about women's perspectives, if the complex history of this cluster of writings is taken into consideration.[22] Although some of the innumerable anonymous texts which touch on generation, fertility, obstetrics, and women's diseases may have been written by women, few medieval works can be definitively associated with women authors. The treatises on medicine and nature by Hildegard of Bingen have not been as thoroughly studied as her mystical writings, but what has been done suggests she had interests in reproduction, sexual appetite, and other relevant topics.[23]

The resources available for the study of medical and scientific perspectives on sexuality are rapidly expanding, as are the strategies for exploiting them. Technical work, such as the dating of manuscripts or the determination of legal jurisdictions, goes hand in hand with interpretive work, such as the tracing of cultural influences or the characterization of medical practices. Thus the discussion below of current thinking on prominent subjects in the field, aside from being stamped with the author's particular perspectives, is necessarily ephemeral. At best, what is offered here is a progress report on a vast scholarly project, the outlines of which are not yet drawn. Not only will the content of our knowledge and the answers to our questions change but the very questions and categories reflected here will be transformed or replaced as well.

SEXUALITY AND TELEOLOGY

The dominant intellectual framework for medieval discussions of sexual and reproductive matters was teleological. The ancient traditions of theoretical medicine and natural philosophy took the category of final cause—the end or purpose for which a thing exists and to which its essence is intimately tied—to be a critical element in the analysis of natural phenomena. Medieval authors, especially the many influenced by Aristotle, Galen, and their Arabic followers, subscribed to the notion that nature did everything for a purpose and nothing in vain. In the area of sexuality, this outlook corresponded to social and religious norms that tied sex to reproduction, to the creation of families and familial bonds. But if physicians and natural phi-

losophers took reproduction seriously as a final cause, they entertained other ends for sexual functions, particularly individual health. Furthermore, although they adhered to this broadly teleological view of sexuality, they did not subscribe strictly to these well-established notions of purpose, as their persistent transmission of methods to control fertility and birth attests.

The Functions of Sexuality: Reproduction

Christians writing about nature and health did not ignore the theological and moral aspects of the sexual subjects which they treated. Underlying the natural order was a divine purpose: a naturalistic teleology and a providential theology were virtually congruent in their general assumptions about the ordinary (non-miraculous) workings of the physical world.[24] Thus it is not surprising to find Constantine the African, a convert from Islam, a monk, and an influential medical writer of the late eleventh century, opening his treatise *On Intercourse* with the words:

> Wishing the race of animals strongly and steadfastly to endure and not to perish, the Creator established that it be renewed by coitus and by generation, so that, renewed, it would not undergo complete annihilation. And for that reason He fashioned for animals natural members which would be suited and proper for that work, and implanted in them such a wonderful power and such a lovable pleasure that there would be no animal which would not experience extreme pleasure in coitus. For if animals despised coitus, the race of animals would surely perish.[25]

Some late medieval authors expressed a more negative and perhaps more moralistic view when they suggested that pleasure helps creatures overcome a natural aversion to a disgusting act,[26] but from this perspective too, the existence of sexual pleasure is providential.

Direct references to God are, however, infrequent in the sorts of texts which concern themselves with reproductive and sexual matters. The theological framework for the institution of sex differences, sexual desires, and sexual pleasures blended in with a more naturalistic teleology and with the specific assertion of Aristotle that sex differences existed so that, even if individual animals necessarily perish, their kinds will be perpetuated indefinitely.[27] Thus when, in the thirteenth century, Albertus Magnus, a theologian and a member of the Dominican order as well as an Aristotelian natural philosopher, speaks of the purpose of pleasure, he leaves the divine out of it: "As Constantine says, pleasure is attached to intercourse so that it will

be more desired, and thus generation will continue."[28] Elsewhere he points out that without some incentive, animals might be reluctant to undertake the burden of pregnancy, the pain of childbirth, and the trouble of caring for young.[29]

In addition to a psychological incentive, sexual pleasure was, according to some medieval authors, a physiological necessity in the process of reproduction. The feelings associated with pulsations and with seminal emissions (there was no regular word for "orgasm") implicated sexual pleasure in the reproductive process. Most medical and scientific authors held that male pleasure was always associated with the emission of generative seed, and was a necessary part of the reproductive process; conversely, the failure of pleasure and the failure of ejaculation were linked with impotence and infertility. There was less agreement about the role of female pleasure in the reproductive process. The twelfth-century author William of Conches was so committed to the necessity of female pleasure for reproduction that he insisted, in a frequently copied passage, that since women who are raped sometimes conceive, they must, in spite of appearances to the contrary, experience pleasure.[30] On the other hand, for a variety of theoretical and empirical reasons, many authors held that female pleasure played no necessary role in conception.[31] Thus, for women, reproduction and pleasure were not inextricably linked at a physiological level.[32] Since, however, it still served as a psychological incentive, female pleasure retained a teleological status.

Sexual distinctions, dispositions, and behaviors were thus an aspect of the natural order with links to the larger scheme by which species were perpetuated and with implications for individual females and males whose bodily parts suited them for and whose appetites guided them toward sexual acts in the service of reproduction. Desire and pleasure while not, from the perspective of the purposes of Nature, ends in themselves, were nevertheless instruments of those purposes. These in turn bore positive values, participating as they did both in the Christian sense that divine creation was good and in the Aristotelian sense that the purposefulness of Nature was for the better.

This perspective on the sexual dimensions of human existence tended to assert or presume a close association of humans and other animals. The goal (reproduction), the differentiated genitalia, and the association of intercourse with pleasure are shared features. Although "animal" was sometimes used in a derogatory sense in connection with specific sexual acts, at this more general level the association of humans with other animals was carefully represented as potentially respectable.[33] Some authors nevertheless noted significant factors that set humans apart. One of these is the posses-

sion of free will or rationality (different authors chose the more religious or the more secular terminology), which permits humans to regulate their sexual behavior and which introduces intention into the evaluation of sexual experience. Thus, according to one anonymous author, "Venerable men do not have intercourse for the sake of pleasure but in order to emit a superfluity [of semen]."[34] Philosophical and medical writers do not devote much discussion to this distinction, but they do see fit to mention it from time to time.

A more frequently cited distinction between humans and animals focuses on the female. Women, the only female animals to menstruate, were also remarkable for their willingness to have intercourse when pregnant—Aristotle had held that only women and mares engaged in such behavior.[35] Indeed, for a variety of reasons, women are "always ready" for intercourse.[36] This perception has a number of implications. Those relating to the distinctions between male and female sexuality are touched on below. In the context of a providential or teleological perspective on pleasure, however, the possibility of sexual activity dissociated from reproduction presents a challenge: pleasure brings humans together sexually not only when conception is possible, but also when it is impossible, that is, when the higher purpose of intercourse and pleasure not only *are* not being served but *cannot* be served. This fissure in the reproductive teleology of sexuality, highlighted by the presence of birth control methods, suggests that medieval culture had room for a broader sense of sexual pleasure and experience.

The Functions of Sexuality: Health

If the acknowledgment of sexual desire and sexual activity among pregnant women represented a breach in the reproductive teleology of sexuality, the widely held medical view that sexual activity was related to health represented a different teleological perspective. Many authors regarded sexual release as a necessary excretory function—to expel certain superfluities from the body—and conversely regarded sexual abstinence as at least potentially unhealthy. This mechanism for the regulation of physiological balance applied to both women and men, and in no way bore the implication that childbearing was healthy for women. In other words, from the point of view of health, the satisfaction of sexual desire served a more individual purpose related to balance in the microcosm, the human body, but not to the larger order of the macrocosm—to the perpetuation of the species.

Medical traditions held that sexual intercourse, like sleeping and waking, like exercise, like eating and drinking, were among the "nonnaturals," those conditions and practices distinct from the body itself upon

whose proper regulation health depended and whose careful management could contribute to the restoration of health in cases of illness. Thus, in Constantine the African's medical encyclopedia, the chapter on coitus is preceded by chapters on clothing and on sleeping and waking, and followed by chapters on the voiding of urine and menstruum and on the emotions.[37] Like baths and exercise, as well as like excretory functions, sexual intercourse had a bearing on the fullness or emptiness of the body, one of the continua within which moderation was to be desired.[38]

Healthy persons of both sexes produced generative material as superfluities resulting from the ordinary processes of nutrition and digestion. These residues were deemed useful because they were necessary elements in the reproductive process, but even useful substances (even, for example, the four basic physiological humors) could be harmful in excess. Thus, just as sneezing keeps the body's level of phlegm in balance, sexual release regulates the level of generative superfluities. Conversely, the retention of such substances causes imbalance and thus ill health. One anonymous thirteenth-century treatise on intercourse cites the authority of several ancient medical greats and remarks, "We have seen some people who, for love of chastity and the admiration of philosophy, did not wish to obey nature, and retained a lot of seed," whose symptoms include headaches, weight loss, and melancholia.[39] Thus the "venerable men" mentioned above—the sort who love chastity and/or admire philosophy—act prudently when they have intercourse if not "for the sake of pleasure" then at least "in order to emit a superfluity."[40] Intercourse was not the only sexual remedy for the problems caused by abstinence or by retention of these fluids for other reasons. The Greek authority Galen and the Arabic authority Avicenna had recommended that celibate men masturbate and that widows or virgins have their genitals rubbed by a midwife until the seed is ejected.[41] (Many medical treatises and compendia contained multiple tests for virginity which indicate that interest in female virginity involved social as well as physiological regulation.)[42]

Although the effects of and remedies for superfluities of this kind were generally discussed in connection with celibate adults (including widows and members of religious orders), medieval authors recognized other circumstances in which the issue arose. In a discussion of puberty unusually detailed for the Middle Ages, Albertus Magnus addressed the relationship between sexual desire, sexual activity, and health in adolescents.[43] This is a period when sexual desire awakens in both girls and boys and during which they masturbate with varying degrees of satisfaction.[44] Intercourse, according to Albertus, plays a role in the process of maturation:

For in this period of puberty women as well as men distill a lot of humidity in their genitals and are greatly moved to seek coitus. And in many, if they practice moderate intercourse at that time, their bodies will grow faster than before. . . . For in those in whose bodies there are many thick humidities, these same [humidities] impede the heat augmenting the body, which is not able to overcome and dissolve [the moisture]. And when it exits in part from the rubbing of intercourse, the body is better able to be nourished by the remaining portion, in males as well as females.[45]

This passage not only illuminates medieval views of adolescent sexuality but also illustrates more generally the sorts of mechanism by which sexual acts were involved in physiological processes. The interest of natural philosophers and physicians in such causal sequences did not blind them to matters of sexual pleasure or of sexual psychology. In the same context, for example, Albertus introduces the role of the imagination when he explains that, for physiological reasons, the sexual desire of adolescents is difficult to satisfy, because both intercourse and masturbation draw to the genitals fluid and heat which are, in turn, difficult to expel:

Certain girls around fourteen years old cannot be satisfied by intercourse. And then, if they do not have a man, they feel in their minds intercourse with a man and often imagine men's private parts, and often rub themselves strongly with their fingers or with other instruments until, the vessels having been relaxed through the heat of rubbing and coitus, the spermatic humor exits, with which the heat exits, and then their groins are rendered temperate and then they become more chaste.[46]

There were also non-sexual, medicinal means to bring the superfluities under control, as well as some ambiguous remedies, such as the one contained in a popular treatise *On the Diseases of Women*, which prescribed treating the pain and sickness associated with sexual abstinence by applying a silk cloth soaked in a mixture of wine and herbs to the vulva.[47] In addition, both women and men might experience nocturnal emissions.[48]

Birth Control and the Limits of Teleology

The functions of sexual activity tied to health or illness do not contradict or exclude those related to reproduction. Indeed, considerable medical energy was expended addressing matters of fertility. Some recipes for aphro-

disiacs and instructions for foreplay given in medical treatises are given as remedies for infertility. It is in that context that John of Gaddesden, in his early fourteenth-century medical encyclopedia, prescribes herbs and ointments for premature ejaculation and, at the same time, recommends accelerating the woman's sexual response: "And he should touch the woman with his hand on her genitals and breasts, and kiss her; and then know her. And this works as a cure."[49]

The medical approach to sexual needs and sexual practices is in no way reducible to reproductive teleology, however. On the contrary, works of both medicine and natural philosophy clearly establish a sexual domain distinct from matters of generation. Sometimes the boundaries between the two functions are difficult to discern. The rubric "On Sterility," which appears with great frequency, may have been the most convenient and decorous repository for general sexual advice and went beyond direct concerns about fertility. Similarly, substances and practices that worked against conception may sometimes have been listed in medical works, not to warn against their use but to communicate contraceptive information discretely. But in spite of occasional rhetorical delicacy, many natural philosophical and medical texts explored a sexual territory not visibly ruled by reproduction. Centering on health and characterized by notions of balance, the medical literature included an acknowledgment of general sexual needs and a place for sexual psychology; it incorporated serious consideration of specific situations and settings which affect diverse individuals, such as adolescence and religious profession; and it provided room for the control of fertility.

Most instructions and recipes for preventing conception or aborting a fetus appear without indications of the context in which they are to be used or comments on the propriety of using them. References to desire and pleasure are almost entirely absent. Occasionally a phrase like "If a woman does not wish to conceive" precedes the directions; rarely does a text offer a justification such as the danger of pregnancy to a woman who has previously been injured by childbirth.[50] Partly because of the lack of expansiveness of texts listing remedies and recipes, medieval medical ideas about birth control have been only barely visible, giving rise to assumptions that they did not form a regular part of licit medical knowledge. These assumptions, along with assumptions about Christian ideology and social imperatives, have led to the suggestion that the medieval mentality did not admit of a separation between sexual intercourse and procreative possibility, that contraceptive techniques were forgotten in the Middle Ages, and that a revival of contraceptive practices would require a more modern outlook on life.[51]

Two approaches to the investigation of medieval birth control under-

mine these assumptions. First, recipes and procedures are widely recorded in medieval medical works, from the anonymous and ad hoc collections of recipes filling blank spaces left in manuscripts of other works, to the Latin texts of the most respected Arabic authorities such as Rhazes and Avicenna, to the works of well placed Latin authors such as Arnald of Villanova and Peter of Spain (who became Pope John XXI). Furthermore, many of the vegetable substances mentioned in these sources have been shown to have relevant pharmacological effects.[52] Like all medieval recipes, these are often difficult to interpret. For example, they often fail to specify what part of a plant (leaf, seed, bark, fruit) is to be used or to specify mode of application (as a drink, as a pessary). Pharmacological and physical elements are occasionally combined with each other and with charms.

The second challenge to the purported absence of birth control in the Middle Ages addresses the conceptual boundaries of birth control. In particular, the modern division between contraception and what we understand as early term abortion may not have existed in the Middle Ages, both because of the ways in which conception was thought of and for practical reasons. In the absence of an evidently established fetus, precoital and postcoital interventions, those that acted as spermicides or as impediments to implantation or as early term abortifacients, would have occupied a continuum. The existence of such a continuum in turn opens up the possibility of regarding the innumerable medieval recipes for the instigation of menstruation as forms of birth control, since they might be employed for amenorrhea due to pregnancy as well as to other causes.[53] Since medieval physicians entertained many other causes for a woman's failure to menstruate, some of them serious threats to health or to fertility, the proliferation of these recipes and instructions, even those which might have had the power to effect early term abortions, is ambiguous. Nevertheless, the reconceptualization of modern concerns about contraception and abortion makes possible new approaches to the sources.

DIVIDED SEXUALITY

In theories of reproduction as well as in ideas about health and illness, medieval medical and scientific authors participated in and contributed to medieval gender constructs. Always clearly distinguished, sometimes fully opposed, the polarities of female and male, feminine and masculine, frequently resonated with social and religious norms concerning both sexual practice and gender. But the binary divisions upon which they rested admitted of mediation and confusion, presenting challenges to authors trying to fit the prodigious natural world into clear categories.

Although the dangers of excess generative superfluities and the need to re-store balance were in many respects parallel for women and men, there were several important differences. Not the least of these was the greater preoc-cupation of those writing on medicine and natural philosophy with the sexual problems of men. Treatises and chapters called "On Coitus," for example, tended to represent the subject from the point of view of men's experiences, problems, and remedies. The authors were almost all male and many were in clerical orders; their audiences were mainly male as well. For these rea-sons as well as for practical ones, most aphrodisiacs seem to have been aimed at promoting a man's erection rather than a woman's arousal.[54] Similarly, in works on sterility that discuss both sexes, impotence figures prominently.[55] Male disorders are often expressed in terms of sexual response, while female disorders are almost always put in reproductive terms—for example, the inability to conceive, the inadequacy of the uterus for gestation.

Various traits distinguished the sexes from each other, such as the cen-trality of the womb to woman's anatomy and function or the relative excellence of man's rationality. Many of the differences which defined the two sexes in re-lation to each other were directly related to warmth and coolness: male strength and hardness, contrasted with female weakness and softness. Differences of degree gave rise to differences of kind, so that, according to medieval Aristotelians, in the cooler bodies of some individuals the useful superfluities were converted into passive nutriment for fetuses, in the warmer bodies of oth-ers they were refined into the formative principle and motive power of genera-tion. Thus parallel processes gave rise to opposites—the active male and the passive female. Even for medieval Galenists, who carried the parallels further, holding that the female produced something that, like the male contribution to generation, might be termed "seed," the cooler, menstruum-producing woman had a different nature from the warmer, seed-refining man.

These distinctions had many sexual implications, several of which bear on the link between intercourse and health. Women, who are weaker because they are cooler, may gain from intercourse in a way that men do not:

> The more women have sexual intercourse, the stronger they become, because they are made hot from the motion that the man makes dur-ing coitus. Further, male sperm is hot because it is of the same na-ture as air and when it is received by the woman it warms her entire body, so women are strengthened by this heat. On the other hand, men who have sex frequently are weakened by this act because they become exceedingly dried out.[56]

Variations on this view, expressed in the work *On the Secrets of Women*, of which dozens of manuscripts survive, suggest a parallel not between the depletions in females and males caused by intercourse, but between the debilitating effects of frequent intercourse for men and frequent childbirth for women, which caused them to age faster and die younger.[57]

Likewise related to the heat differential between the sexes was the fact that women menstruate, while men have no equivalent function. This monthly purgation of useful superfluities maintained a woman's balance by preventing a harmful build-up of generative fluids. Although the relationship between the menses, which served as nutriment for the fetus in a pregnant woman, and the female emission during intercourse, often labeled the "female seed," was an ambiguous one (sometimes one and sometimes the other was credited with being the woman's contribution to reproduction), the regular cleansing function of menstruation rendered the dangers of excess generative superfluities less serious in a woman than in a man. Nevertheless, medieval works concerned with women's health show no lack of concern for widows and nuns, who, without release of their seed, "incur grave illness."[58]

Beyond the Heterosexual Norm

Both the hygienic and the reproductive systems of understanding were closely tied to larger social and cultural gender norms and both linked female-male differences to a heterosexual norm. The very existence and enforcement of this norm contributed to rendering sexual acts and desires between women or between men invisible in the scientific and medical literature. Furthermore, that literature no more entertained a category "homosexuality" than it did "sexuality." Thus any attempt to reconstruct medieval scientific and medical opinion must take an indirect route.

One such approach is through the widely recognized category "hermaphrodite," sometimes construed narrowly to mean a person who possesses organs proper to both sexes, sometimes more broadly to refer to "manly women" and "womanly men." Both the sexual ambiguity of persons of this sort and the possibility they presented of ambiguous sexual pairing led to an association of hermaphroditism with homosexual desires and acts in medieval culture. The connection has not as yet been solidly documented in medical or scientific sources.[59]

Another avenue is through leads provided by Greek and Arabic authoritative sources. For example, a work thought to have been written by Aristotle, *The Problemata*, asks at one point why some men have intercourse with men, and why some of these enjoy both the active and passive roles,

others just the passive.[60] In the early fourteenth century, Pietro d'Abano wrote a commentary on this work and took the opportunity afforded by the text on which he was commenting to discuss the physical and psychological origins of desire for anal sexual stimulation, emphasizing, on the one hand, the malformation of the pores and passageways that normally lead the seminal material and spirit through the penis and, on the other hand, the susceptibility of boys and young men to experiencing pleasure that gives rise to desire, repetition, and habit. In his naturalizing account, Pietro has to confront the standard characterization of such behavior as "sodomy," suggesting why his treatment of the subject is unusual, if not unique, in medieval natural philosophy and medicine.[61]

Indeed, the authoritative work which would have provided medieval authors with the broadest invitation to discuss men's sexual relations with men, Avicenna's *Canon of Medicine*, simultaneously discouraged further discussion. This work, which came to occupy the center of the medical curriculum, devotes a chapter to men called *alubuati* or *aluminati* or *alguagi* (all Latinizations of the Arabic *al-liwât*), an illness of men who become accustomed to having other men fling themselves on them and desire more. But Avicenna declares that "the origin of their sickness is meditative, not natural" and not, therefore, subject to a cure, a pronouncement which Western authors interpreted as placing the subject outside the domain of medicine.[62] Thus, although many Latin authors wrote commentaries on this work, most of those that have been studied are coy about this text or pause only to condemn the sin to which it alludes.[63] Systematic surveys of commentaries and glosses on these and other widely circulated texts may yield further insights.

Scant though it is, the evidence uncovered thus far about men is ample compared to that concerning women enjoying sex with women. Perhaps, at a practical level, medieval society needed no help from science or medicine to enforce women's heterosexual and reproductive roles; perhaps, at a theoretical level, the fate of women's seed was less significant than that of men; perhaps at a conceptual level lesbian sexuality was more distant from medieval Western categories.[64] Indirect approaches too are less promising than for men. Again, Avicenna might provide a pretext: in a chapter on certain fleshy genital growths which are sometimes like a penis and with which a woman may do something similar to intercourse with women. In offering surgical and medical cures for the growth, Avicenna makes no allusion to psychological or moral dimensions of these irregularities, as he had in the case of men, but focuses rather on the physical condition.[65] At least one medieval medical writer, William of Saliceto, takes up this text briefly, and

other commentaries on this passage (and one concerning related growths called *ragadie*) may contain further relevant discussions.[66]

DISORDERED SEXUALITY

As the ambiguities of sexual anatomy and desire suggest, medieval medical writers and natural philosophers confronted the possibilities of danger and disorder in the domains of sexuality. At one level, their concern reflects as much about medicine as it does about sexuality: it is the nature of the enterprise to diagnose and to seek to remedy harmful imbalances and irregularities. At another level, however, medieval discussions of sexual disarray bear broader social and ideological implications, as illustrated by their engagement of love, prostitution, and other culturally and morally charged subjects.

The Pathology of Desire: Lovesickness

In his explanations of men's desire for anal stimulation, Pietro d'Abano invokes the standard Aristotelian physiological and psychological mechanisms associated with appetite in general. These same mechanisms can go awry, giving rise to the condition known variously as *amor eros*, *amor heroes*, or *amor heros*—the slippage of the term itself from "erotic" to "heroic" suggesting the broader cultural associations it acquired with the seigneurial and courtly. Influenced by Ovid as well as by Western and Arabic medical traditions, lovesickness commanded considerable medical attention from the end of the eleventh century.[67]

A man (women are seldom thus afflicted in the medical literature)[68] encounters a beautiful form that he perceives to be a potential source of pleasure. *The greater he judges (with his estimative faculty) the potential pleasure to be, the greater will be his desire to obtain this object.* At the same time, the buildup of seminal superfluities may encourage this impulse. The desire impresses the image of the object on the imagination and the memory and gives rise to a violent appetite to satisfy the desire by obtaining the object. The condition is dangerous, for the violent appetite and the hope and care associated with it can result in a fury or madness. The situation may be exacerbated by the drying of the brain by passing spirits, which in turn makes the imagination more susceptible to the strong imprinting of the image and to melancholy, a dry, cold state, which in turn can lead to a fatal wasting.[69] Medical authors suggested different perspectives on this condition and chose different elements to emphasize or omit. It might be understood as a disease or an accident, its origins might be more psychological or more physical, the source of trouble might reside in the faculty of judgment or in one of several organs.

These differences were amplified when it came to the question of treatment. Physical and psychological approaches addressed both causes and symptoms. A regimen appropriate to melancholics might help but one appropriate to cholerics might be more effective. The use of or abstinence from wine might have some positive effect. A change of scene could take the mind of the afflicted off the object of desire, but it might also encourage longing. Women could be part of the remedy, but was it better to assault the afflicted with misogynistic tales or distract him with an attractive alternative to the object of desire?[70] Authors' choices among these causes and cures affect the extent to which lovesickness is centered on sexual desire. For Peter of Spain, for example, it is the occasion for an extended discussion of men's and women's experiences of sexual pleasure; for Arnald of Villanova and others the link with a melancholy humoral imbalance gives less prominence to sexual appetite per se.[71]

Diseases and Dangers

If unfulfilled desire could be the source of ill health, so could the excessive practice of venery. Frequent intercourse could harm a woman's reproductive capacity, as the widely acknowledged sterility of prostitutes seemed to make clear. Their wombs no longer opened properly to receive seed or had become too smooth to retain the seed once it had entered.[72] Furthermore, women's pursuit of sexual pleasure could harm the resultant child.[73] Excessive coitus did not, however, often figure as a cause of female infertility in the medical literature. Although childbirth might harm a woman, intercourse generally did not. The same could not be said for men, for whom excessive intercourse meant excessive expenditure of heat and moisture. Older men or men in a weakened condition from some other cause were especially susceptible to harm, just as were men and women who experienced *insufficient* release of seed. Indeed, in certain women, sexual appetite was caused by suffocation of the womb, a condition which owes its association with the term "hysteria" more to its nineteenth-century interpreters than to its Hippocratic roots;[74] for them the medically (if not socially) appropriate remedy was intercourse with men.[75] Thus, in general, because of the importance of the expulsion of superfluities for good health, sexual activities per se, whether heterosexual intercourse, homosexual intercourse, or masturbation, did not cause disease.

Yet, in spite of their widely acknowledged role in health, sexual desires and sexual acts were fraught with danger, especially for men. Medieval physicians identified many afflictions of the genitals, some involving discharges (often confused with seed) and others characterized by skin lesions, especially of the genital areas. Several of the latter were apparently

included under the heading of *lepra*, a category that covered some symptoms of leprosy as it is understood today and some symptoms of sexually transmitted diseases. The term *lepra* bore a social and biblical stigma which reinforced and was reinforced by the medical association with sexual intercourse. Although medical authors identified various types of discharges and sores experienced by women, many regarded *lepra* as a condition experienced by men but transmitted by women.[76] This asymmetry may owe something to the fact that some venereal diseases are more likely to be asymptomatic in women and that, even in symptomatic women, the lesions may not be visible, but it must also owe something to the dangers women were understood to present to men. These dangers took many forms. For example, the scholastic treatise *On the Secrets of Women* (attributed to Albertus Magnus in the Middle Ages), incorporated and disseminated medicalized misogyny framed and legitimized by standard discussions of topics such as the generation of the embryo, the causes of infertility, and tests for virginity and chastity. One commentary with which this text frequently circulated introduced and justified the work by rehearsing the dangers menstruating women posed to children, to inanimate objects, and particularly to their male sex partners.[77] Some of the sexual harm caused by women may have been associated with contraceptive practices: *On the Secrets of Women* accuses some, including whores, of inserting iron or a corrosive substance in their vaginas in order to wound men's penises.[78]

That sexuality should be the repository of all sorts of physical danger is not surprising in a culture whose teleological optimism about the good of divine creation coexisted with a profound sense of fallen human nature and the evils of the flesh. Thus, from a modern perspective, medieval sexuality is fragmented not only in the sense that the elements of our construct are dispersed among a wide variety of medical and natural philosophical concerns, but also in the sense that medieval views on any one topic are seldom univocal. If reproduction or health is the purpose of sexual activity, contraceptive practices suggest the possibility of other ends; if the terms of anatomy and physiology contribute to the erasure of sexual variety, the very logic of their systems (not to speak of the diversity of human experience) undermines the coherence of gender dichotomy and heterosexuality.

This diversity in itself makes medical and scientific views of medieval sexuality a rich area for further exploration. What makes it more promising still is the wide range of unexplored questions and the vast quantities of largely unpublished sources to which the scholar may turn with a reasonable expectation of original discoveries.

NOTES

1. Basim F. Musallam, *Sex and Society in Islam: Birth Control before the Nineteenth Century*, Cambridge Studies in Islamic Civilization (Cambridge: Cambridge University Press, 1983) and Jacquart and Thomasset, *Sexuality and Medicine* (see note 4), pp. 122–29. See also Helen Rodnite Lemay, "The Stars and Human Sexuality: Some Medieval Scientific Views," *Isis* 71 (1980): 127–37 and Gerrit Bos, "Ibn al-Jazzar on Women's Diseases and Their Treatment," *Medical History* 37 (1993): 293–312.

2. Among the major Latin genres of medical and philosophical literature likely to include material related to sexuality are (1) obstetrical and gynecological works, such as Monica H. Green, "The *De genecia* Attributed to Constantine the African," *Speculum* 62 (1987): 299–323 and the "Trotula" texts (see n. 6); (2) commentaries on Aristotle's *De generatione animalium* (or the medieval composite *De animalibus*), such as Albertus Magnus, *De animalibus libri XXVI*, ed. Hermann Stadler, Beiträge zur Geschichte der Philosophie des Mittelalters 15 and 16 (Münster: Aschendorff, 1916 and 1920) and *Quaestiones super De animalibus*, ed. Ephrem Filthaut, vol. 12 of *Opera omnia*, ed. Bernhard Geyer (Münster I. W.: Aschendorff, 1955); (3) commentaries on Avicenna's *Canon*, including partial commentaries on the section known as *De generatione embrionis*, such as those of ps.-Dino del Garbo and Jacopo da Forlì, both printed in Bassanius Politus, comp., *De generatione embrionis* (Venice: Bonetus Locatellus, 1502); (4) tracts on sterility and aids to conception, such as one edited by Enrique Montero Cartelle, *Tractatus de sterilitate: Anónimo de Montpellier (s. XIV) atribuido a A. de Vilanova, R. de Moleris y J. de Turre*, Lingüística y Filología 16 (Valladolid, Spain: Universidad de Valladolid and Caja Salamanca y Soria, 1993); (5) general works on natural philosophy and/or medicine, such as Brian Lawn, ed., *The Prose Salernitan Questions Edited from a Bodleian Manuscript (Auct. F.3.10)*, Auctores Britannici Medii Aevi 5 (London: British Academy at Oxford University Press, 1979); Thomas de Cantimpré, *Liber de natura rerum*, pt. I, *Texte*, ed. H. Boese (Berlin: Walter Gruyter, 1973); and Bartholomeus Anglicus, *De genuinis rervm coelestivm, terrestrivm inferarvm* [sic] *proprietatibus libri XVIII*, ed. Georgius Bartholdus Posanus (Frankfurt: Wolfgang Richter, 1601; repr. Frankfurt am Main: Minerva, 1964); (6) tracts on intercourse, of which two have been edited—Constantinus Africanus, *Liber de coitu: El tratado de andrología de Constantino el Africano*, ed. and trans. (Spanish) Enrique Montero Cartelle, Monografías de la Universidad de Santiago de Compostela, 77 (Santiago de Compostela, Spain: Universidad de Santiago, 1983), which has been translated from a Renaissance edition by Paul Delany, "Constantinus Africanus' *De coitu*: A Translation," *Chaucer Review* 4 (1969): 55–65; and *Liber minor de coitu: Tratado menor de andrología anonimo salernitano*, ed. and trans. (Spanish) Enrique Montero Cartelle, Lingüística y Filología 2 (Valladolid, Spain: Universidad de Valladolid, 1987). See also n. 6.

3. For example, Paul Diepgen, *Frau und Frauheilkunde in der Kultur des Mittelalters* (Stuttgart: Georg Thieme, 1963); Vern L. Bullough, "Medieval Medical and Scientific Views of Women," *Viator* 4 (1973): 485–501; Helen Rodnite Lemay, "Anthonius Guainerius and Medical Gynecology," in *Women of the Medieval World: Essays in Honor of John H. Mundy*, ed. Julius Kirshner and Suzanne F. Wemple (Oxford: Basil Blackwell, 1985), pp. 317–36 and "Women and the Literature of Obstetrics and Gynecology," in *Medieval Women and the Sources of Medieval History*, ed. Joel T. Rosenthal (Athens, GA: University of Georgia Press, 1990), pp. 189–209; Joan Cadden, *Meanings of Sex Difference in the Middle Ages: Medicine, Science, and Culture*, Cambridge History of Medicine (Cambridge: Cambridge University Press, 1993). Relevant serial bibliographical resources include *Bibliography of the History of Medicine* (National Institutes of Health, U.S. Department of Health and Human Services, Bethesda, MD); and the *Current Bibliography* of the history of science journal *Isis*.

4. The landmark work in the new history of sexuality is Danielle Jacquart and Claude Thomasset, *Sexuality and Medicine in the Middle Ages*, trans. Matthew

Adamson (Princeton, NJ: Princeton University Press, 1988), originally *Sexualité et savoir médicale au moyen âge*, Les Chemins d'Histoire (Paris: Presses Universitaires de France, 1985). The English edition contains new material as well as an index not included in the French edition. On this work, see Monica Green's essay review, "Sex and the Medieval Physician," *History and Philosophy of the Life Sciences* 13 (1991): 288–93. See also: Helen Rodnite Lemay, "Some Thirteenth and Fourteenth Century Lectures on Female Sexuality," *International Women's Studies Journal* 1 (1978): 391–400; "William of Saliceto on Human Sexuality," *Viator* 12 (1981): 165–81; "Human Sexuality in Twelfth- through Fifteenth-Century Scientific Writings," in *Sexual Practices and the Medieval Church*, ed. Vern L. Bullough and James A. Brundage (Buffalo: Prometheus, 1982), pp. 187–205 and (notes) 278–82; Thomas G. Benedek, "Beliefs about Human Sexual Function in the Middle Ages and Renaissance," in *Human Sexuality in the Middle Ages and Renaissance*, ed. Douglas Radcliff-Umstead, University of Pittsburgh Publications on the Middle Ages and the Renaissance 4 (Pittsburgh: Center for Medieval and Renaissance Studies, University of Pittsburgh, 1978), pp. 97–116; Danielle Jacquart, "Medical Explanations of Sexual Behavior in the Middle Ages," in *Homo Carnalis: The Carnal Aspect of Medieval Human Life*, ed. Helen Rodnite Lemay, Center for Medieval and Early Renaissance Studies, Acta, 14 for 1989 (Binghamton: State University of New York Press, 1990), pp. 1–21; and John W. Baldwin, *The Language of Sex: Five Voices from Northern France around 1200*, Chicago Series on Sexuality, History, and Society (Chicago: University of Chicago Press, 1994), which includes discussion of the prose Salernitan questions. Several recent works offer bibliographical guidance: Monica H. Green, "Female Sexuality in the Medieval West," *Trends in History* 4 (1990): 127–58; Joyce E. Salisbury, *Medieval Sexuality: A Research Guide*, Garland Medieval Bibliographies 5; Garland Reference Library of Social Science 565 (New York: Garland Publishing, 1990); Barbara Duden, *Body History/Körpersgeschichte: A Repertorium/Ein Repertorium*, Kultur- und Sozialgeschichte 1 (Wolfenbüttel: Tandem, 1990), which contains a good number of sources relevant to the Middle Ages.

5. The most important "authorities" for medieval European views concerning sexuality are Aristotle, *Generation of Animals*, ed. and trans. A.L. Peck, Loeb Classical Library (Cambridge: Harvard University Press; London: William Heinemann, 1953) for Greek and English; *De generatione animalium translatio Guillelmi de Moerbeka*. Vol. XVII, 2, of *Aristoteles Latinus*, Union Académique Internationale, Corpus Philosophorum Medii Aevi (Bruges and Paris: Desclée de Brouwer, 1966) for one of the most important medieval Latin translations. Galen, *De semine* in *Opera omnia*, ed. Carl Gottlob Kühn, 20 vols. in 22 (Leipzig: C. Cnobloch, 1821–1833; repr. Hildesheim: Georg Olms, 1964–1965), vol. 4, pp. 512–651 (Greek and modern Latin); pseudo-Galen, *Microtegni seu De spermate*, trans. (Italian) and comm. Vera Tavone Passalacqua (Rome: Instituto di Storia della Medicina dell'Università di Roma, 1959), also known as the *Liber de xii portis*. Soranus, *Gynaeciorum libri iv, De signis fracturarum, De fasciis, Vita Hippocratis secundum Soranum*, ed. Johannes Ilberg, Corpus Medicorum Graecorum 4 (Leipzig and Berlin: B.G. Teubner, 1927) for the Greek text; *Soranus' Gynecology*, trans. Owsei Temkin with Nicholson J. Eastman, Ludwig Edelstein, and Alan F. Guttmacher, Publications of the Institute of the History of Medicine, The Johns Hopkins University, 2d ser., Texts and Documents, vol. 3 (Baltimore: Johns Hopkins University Press, 1956) for an English translation of the Greek text; Caelius Aurelianus, *Gynaecia: Fragments of a Latin Version of Soranus' Gynaecia from a Thirteenth-Century Manuscript*, trans. Miriam F. Drabkin and Israel E. Drabkin, Supplements to the Bulletin of the History of Medicine 13 (Baltimore: Johns Hopkins University Press, 1951) for one medieval Latin version; Muscio, *Sorani Gynaeciorum vetus translatio latina*, ed. Valentine Rose (Leipzig: B.G. Teubner, 1882) for another medieval Latin Version. Avicenna [=ibn Sina], *Liber canonis* (Venice: Pagininis, 1507; repr. Hildesheim, Germany: Georg Olms, 1964) for the twelfth-century Latin translation by Gerard of Cremona. On the fate of some of these tradi-

tions see Monica H. Green, "The Transmission of Ancient Theories of Female Physiology and Disease through the Early Middle Ages," Ph.D. diss., Princeton University, 1985; Helen King, "Once upon a Text: Hysteria from Hippocrates," in Sander L. Gilman, Helen King, Roy Porter, G.S. Rousseau, and Elaine Showalter, *Hysteria Beyond Freud* (Berkeley and Los Angeles: University of California Press, 1993), pp. 3–90; Ann Ellis Hanson and Monica H. Green, "Soranus of Ephesus: *Methodicorum princeps,*" *Aufstieg und Niedergang römishcen Welt,* Teil II, 37.2 (1994) and Joan Cadden, *Meanings of Sex Difference,* ch. 1.

6. Helen Rodnite Lemay, *Women's Secrets: A Translation of Pseudo-Albertus Magnus' De Secretis Mulierum with Commentaries,* SUNY Series in Medieval Studies (Albany: State University of New York Press, 1992). For a German version of this work and other vernacular sources, see n. 21. Mary Frances Wack, *Lovesickness in the Middle Ages: The Viaticum and Its Commentaries,* Middle Ages Series (Philadelphia: University of Pennsylvania Press, 1990), which includes texts by Constantine the African, Gerard of Berry, a certain Giles, Peter of Spain, and Bona Fortuna; Wack, "The *Liber de hereos morbo* of Johannes Afflacius and Its Implications," *Speculum* 62 (1987): 324–44; and Arnaldus de Villanova, *Tractatus de amore heroico,* ed. Michael R McVaugh in *Arnaldi de Villanova opera medica omnia,* vol. 3, Seminarium Historiae Medicae Cantabricense (Barcelona: Publicacions i Edicions de la Universitat de Barcelona, 1985), pp. 11–54. Monica H. Green is completing *"The Diseases of Women According to Trotula": Edition and Translation,* containing a group of texts attributed to the female medical expert "Trota" or "Trotula." See also n. 2.

7. Ron Barkaï, *Les infortunes de Dinah: Le livre de la génération: La gynécologie juive au moyen âge,* intro. trans. Jacqueline Barnavi, treatise and notes trans. Michel Garel, Toledot-Judaïsmes (Paris: Editions du Cerf, 1991), which includes Hebrew text and French translation of *Sefer ha-toledet*; and "A Medieval Hebrew Treatise on Obstetrics," *Medical History* 33 (1989): 96–119.

8. The most important collections of relevant early printed books are in the Vatican Library, the Bibliothèque Nationale de France, and the British Library (the catalogue of which is available in most academic libraries). In North America, major repositories include the United States National Library of Medicine in Bethesda, MD, the New York Academy of Medicine, and the Countway and Houghton Libraries at Harvard. There are several ways to locate copies of rare books in North American Libraries: the *National Union Catalogue* lists all rare books catalogued by the libraries included (although location lists are not complete); locations and compressed bibliographical information are to be found in Frederick R. Goff, *Incunabula in American Libraries: A Third Census of Fifteenth-Century Books Recorded in North American Collections* (New York: Bibliographical Society of America, 1964), with a *Supplement* (1972) that builds on earlier censuses published by Margaret Stillwell; individual collections have public catalogues, some in print—e.g., Dorothy May Schullian and Francis E. Sommer, *A Catalogue of Incunabula and Manuscripts in the Army Medical Library* [=National Library of Medicine] (New York: Henry Schuman, [1948?])—and increasing numbers are available in electronic form via Internet.

9. Lynn Thorndike, *A History of Magic and Experimental Science,* 8 vols. (New York: Macmillan and Columbia University Press, 1923–1958), the subject indexes of which include numerous entries related to sexuality. Some more recent contributions have been made in this area: Lemay, "The Stars and Human Sexuality," and Richard Kieckhefer, "Erotic Magic in Medieval Europe," in *Sex in the Middle Ages: A Book of Essays,* ed. Joyce E. Salisbury, Garland Medieval Casebooks 3, Garland Reference Library in the Humanities 1360 (New York: Garland Publishing, 1991), pp. 30–55.

10. Ide Agrimi and Chiara Crisciani, *Les consilia médicaux,* trans. Caroline Viola, Typologie des Sources du Moyen Age Occidental 69 (Turnhout: Brepols, 1994.) Current research by Peter Jones promises to illuminate this genre of medical writing.

11. Lynn Thorndike and Pearl Kibre, *A Catalogue of Incipits of Scientific*

Writings in Latin, rev. ed., Mediaeval Academy of America, 29 (Cambridge, MA: Mediaeval Academy of America, 1963). For an analogous resource for Old and Middle English manuscripts, see n. 20. Aristotelian sources are well served by Georges Lacombe, Aleksander Birkenmajer, and Lorenzo Minio-Paluello, *Aristoteles Latinus: Codices,* 3 vols., vol. 1, rev. ed., Union Académique Internationale, Corpus Philosophorum Medii Aevi (Bruges and Paris: Desclée de Brouwer, 1957); vol. 2 (Cambridge, England: Academia, 1955); [vol. 3], *Supplementa altera* (Bruges and Paris: Desclée de Brouwer, 1961), which identifies the various Latin translations of Aristotelian works and the manuscripts in which they survive; and Charles Lohr, "Medieval Latin Aristotle Commentaries," *Traditio* 23 (1967): 313–413; 24 (1968): 149–245; 26 (1970): 135–216; 27 (1971): 251–351; 28 (1972): 281–396; 29 (1973): 91–197; 30 (1974): 119–44, which is organized alphabetically by author. Each manuscript collection has its own catalogues, etc., which can be identified by referring to Paul Oskar Kristeller, *Latin Manuscript Books before 1600: A List of the Printed Catalogues and Unpublished Inventories of Extant Collections,* 4th ed., rev. by Sigrid Krämer, Hilfsmittel 13 (Munich: Monumenta Germanicae Historica, 1993).

12. Seymour de Ricci with W.J. Wilson, *Census of Medieval and Renaissance Manuscripts in the United States and Canada,* 3 vols. (New York: Bibliographical Society of America and H.W. Wilson, 1935–40; repr. New York: Kraus Reprint, 1961), and C.U. Faye and W.H. Bond, *Supplement* (New York: Bibliographical Society of America, 1962). The Knights of Columbus Vatican Film Library at the Pius XII Memorial Library of Saint Louis University houses a large collection of microfilms of Vatican manuscripts; the Hill Monastic Manuscript Library at Saint John's University, Collegeville, Minnesota also has a large collection of films, mainly from European monasteries.

13. Joseph Shatzmiller, *Médecine et justice en Provence médiévale: Documents de Manosque, 1262–1348* (Aix-en-Provence: Publications de l'Université de Provence, 1989), no. 56, pp. 176–83.

14. See Michael R. McVaugh, *Medicine before the Plague: Practitioners and Their Patients in the Crown of Aragon, 1285–1345,* Cambridge History of Medicine (Cambridge: Cambridge University Press, 1993), pp. 200–07, and Monica H. Green, "Documenting Medieval Women's Medical Practice," in *Practical Medicine from Salerno to the Black Death,* ed. Luis García-Ballester, Roger French, Jon Arrizabalaga, and Andrew Cunningham (Cambridge: Cambridge University Press, 1994), pp. 322–52 especially pp. 338–40, commenting on Erwin Ackerknecht, "Midwives as Experts in Court," *Bulletin of the New York Academy of Medicine* 52 (1976): 1224–28.

15. See, for example, Monica H. Green, "Women's Medical Practice and Health Care in Medieval Europe," *Signs* 14 (1989): 434–73; Linda Ehrsam Voigts, "Scientific and Medical Books," in *Book Production and Publishing in Britain 1375–1475,* ed. Jeremy Griffiths and Derek Pearsall, Cambridge Studies in Publishing and Printing History (Cambridge: Cambridge University Press, 1989), pp. 345–402.

16. See B.D.H. Miller, "'She Who Hath Drunk Any Potion'" *Medium Aevum* 31 (1962): 188–93.

17. Riddle, *Contraception and Abortion,* p. 123; Lucille B. Pinto, "The Folk Practice of Gynecology and Obstetrics in the Middle Ages," *Bulletin of the History of Medicine* 47 (1973): 513–23.

18. See Thorndike, *History of Magic and Experimental Science,* and Valerie I.J. Flint, *The Rise of Magic in Early Medieval Europe* (Princeton, NJ: Princeton University Press, 1991), esp. pp. 231–39.

19. Thomas Oswald Cockayne, ed. and trans., *Leechdoms, Wortcunning, and Starcraft of Early England,* Rerum Britannicarum Medii Aevi Scriptores 35 (London: Longman, Green, Longman, Roberts, Green, 1864–66; repr. [New York]: Kraus, 1965). For Hildegard, see n. 23.

20. Linda Ehrsam Voigts and Patricia Deery Kurtz are preparing a book and

database, *Catalogue of Incipits of Scientific and Medical Writing in Old and Middle English*. See also Linda Ehrsam Voigts, "Medical Prose," in *Middle English Prose: A Critical Guide to Major Authors and Genres*, ed. A.S.G. Edwards (New Brunswick, NJ: Rutgers University Press, 1984), pp. 315–35, and Monica H. Green, "Obstetrical and Gynecological Texts in Middle English," *Studies in the Age of Chaucer* 14 (1992): 53–88.

21. Margaret Rose Schleissner, "Pseudo-Albertus Magnus: Secreta mulierum cum commento, Deutsch: Critical Text and Commentary," Ph.D. diss., Princeton University, 1987, to be published by H. Wellm in the series Würzburger medizinische Forschungen; and "A Fifteenth-Century Physician's Attitude toward Sexuality: Dr. Johann Hartlieb's *Secreta mulierum* Translation," in *Sex in the Middle Ages: A Book of Essays*, ed., Joyce E. Salisbury, Garland Medieval Casebooks 3, Garland Reference Library of the Humanities 1360 (New York: Garland Publishing, 1991), pp. 110–25; Beryl Rowland, ed. *Medieval Woman's Guide to Health: The First English Gynecological Handbook* (Kent, Ohio: Kent State University Press, 1981), a Middle English text with modern English translation, and M.-R. Hallaert, ed., *The "Sekenesse of Wymmen": A Middle English Treatise on Diseases in Women (Yale Medical Library, Ms. 47 fols. 60r–71v)*, Scripta: Mediaeval and Renaissance Texts and Studies 8 (Brussels: ORIMER [Research Center of Mediaeval and Renaissance Studies], UFSAL, 1982), both of which are versions of chapters from the *Compendium Medicine* of Gilbertus Anglicus (Green, "Obstetrical and Gynecological Texts," pp. 72–82); Chris E. Paschold, *Die Frau und ihr Körper im medizinischen und didactischen Schrifttum des französischen Mittelalters: Wortgeschichtliche Untersuchungen zu Texten des 13. und 14. Jahrhunderts mit kritischer Ausgabe der gynäkologischen Kapitel aus den "Amphorismes Ypocras" des Martin de Saint-Gilles* Würzburger medizinhistorische Forschungen 47 (Pattensen/Han: Horst Wellm, 1989).

22. For edition (in progress) see n. 6; for an analysis of women's relation to the texts and the production of vernacular versions, see Monica H. Green, *Women and Literate Medicine in Medieval Europe: Trota and the "Trotula,"* forthcoming, Cambridge University Press.

23. Hildegard of Bingen, *Causa et Curae [=Liber compositae medicinae]*, ed. Paul Kaiser, Bibliotheca Scriptorum Graecorum et Romanorum Teubneriana (Leipzig: B.G. Teubner, 1903); *Liber divinorum operum simplicis hominis [=De operatione dei]*, ed. Joannes Dominicus Mansi in *Opera omnia*, ed. Friedrich Anton de Reuss, Migne, *Patrologia Latina* 197 (1853), cols. 739–1038; *Liber simplicis medicinae [=Physica]*, ed. C. Daremberg in *Opera omnia*, cols. 1117–353. See Michela Pereira, "Maternità e sessualità femminile in Ildegarda di Bingen: Proposte de lettura," *Quaderni storici* 44 (1980): 564–79; and Joan Cadden, "It Takes All Kinds: Sexuality and Gender Differences in Hildegard of Bingen's *Book of Compound Medicine*," *Traditio* 40 (1984): 149–74.

24. There were, of course, other theological perspectives, but natural philosophers and medical writers tended to emphasize the one centered on procreation. See James A. Brundage, *Law, Sex, and Christian Society in Medieval Europe* (Chicago: University of Chicago Press, 1987), pp. 579–82, summarizing three theological models.

25. Constantinus Africanus, *Liber de coitu*, Prologue, p. 76: "Creator volens animalium genus firmiter ac stabiliter permanere et non perire, per coitum illud ac per generacionem disposuit renovari, ut renovatum interitum ex toto non haberet. Ideoque complasmavit animalibus naturalia membra que ad hoc opus apta forent et propria, eisque tam mirabilem virtutem et amabilem delectacionem inseruit ut nullum sit animalium quod non pernimium delectetur coitu. Nam si animalia coitum odirent, animalium genus pro certo periret."

26. Gilbertus Anglicus, *Compendium medicine* (Lyon: Jacobus Saccon, 1510), bk. VII, ch. [i], fol. 287va; Bernardus de Gordonio, *Practica dicta Lilium* (Venice: Bonetus Locatellus, 1498), pt. VII, ch. 1, fol. 87vb.

27. Aristotle, *Generation of Animals*, bk. II, ch. i, 731b31–32a1.

28. Albertus Magnus, *De animalibus*, bk. IX, tr. ii, ch. 3, §303, p. 716: "sed delectatio, ut dicit Constantinus, apponitur coitui ut plus appetatur et sic continuetur generatio."

29. Albertus Magnus, *De animalibus*, bk. XXII, tr. i, ch. 1, §2, p. 1350; see also Anthony M. Hewson, *Giles of Rome and the Medieval Theory of Conception: A Study of the De formatione corporis humani in utero*, University of London Historical Studies 38 (London: Athalone Press, University of London, 1975), p. 91.

30. William of Conches, *Dialogus de substantiis physicis* [=*Dragmaticon*], ed. Guilielmus Gratarolus (Strasburg: Iosias Rihelius, 1567; repr. Frankfurt-am-Main: Minerva, 1967), bk. VI, pp. 241–42.

31. For example, David of Dinant in Marian Kurdziałek, "Anatomische und embryologische Aeusserungen Davids von Dinant," *Sudhoffs Archiv für Geschichte der Medizin und der Naturwissenschaften*, 45 (1961), pp. 1–22; see especially p. 10. See also, Cadden, *Meanings of Sex Difference in the Middle Ages*, pp. 141–45.

32. Cf. Thomas Laqueur, *Making Sex: Body and Gender from the Greeks to Freud* (Cambridge: Harvard University Press, 1990), p. 161.

33. See Constantine, note 25, or Nemesius of Emesa, *De natura hominis: Traduction de Burgundio de Pise*, ed. G. Verbeke and J.R. Moncho, Corpus Latinum Commentariorum in Aristotelem Graecorum, suppl. 1 (Leiden: E.J. Brill, 1975), ch. 17, p. 101. Sexuality is among the pervasive cultural links between humans and animals—see Joyce E. Salisbury, *The Beast Within: Animals and Bestiality in the Middle Ages* (New York: Routledge, 1994).

34. *De coytu*, MS Munich, Bayerische Staatsbibliothek, CLM 8742, f. 9rb: "Venerabiles viri non coeunt causa delectationis sed ut superfluitatem emittant. . . ." See also Bernardus de Gordonio, *Practica*, pt. VII, ch. i, fol. 87vb.

35. *Propositiones de animalibus*, MS Cambridge University Library, Dd.3.16, fol. 75rb; Aristotle, *Generation of Animals*, bk. IV, ch. v, 773b25–26.

36. Albertus Magnus, *De animalibus*, bk. X, tr. i, ch. 1, §1: "semper parata. . . ."

37. Constantinus Africanus, *Pantegni* in Isaac [Israeli], *Opera omnia* (Lyon: Andreas Turinus, 1515), "Theorica," pt. V, chs. cv-cix, 2nd foliation, fols. 24vb-25rb. See also the influential *Canon* of Avicenna, which mentions sexual intercourse after chapters on waters and wines and on sleeping and waking (bk. I, fen i, doctr. 2, ch. 10, fol. 61vb).

38. Constantinus Africanus, *Pantegni, Theorica*, bk. V, ch. i, 2nd foliation, fol. 28rb.

39. Montero Cartelle, ed., *Liber minor de coitu*, pt. II, ch. 1, pp. 78–80: "Videmus et nos aliquot qui castitatis favore et amore philosophie nature noluerunt obsequi et copiam detinuere seminis. . . ."

40. *De coytu*, MS Munich, Bayerische Staatsbibliothek, CLM 8742, f. 9rb: "Venerabiles viri non coeunt causa delectationis sed ut superfluitatem emittant. . . ."

41. On Galen, Avicenna, and some medieval authors who agree, see Lemay, "William of Saliceto," pp. 177–78. See also Montero Cartelle, ed. *De sterilitate*, p. 104. Monica H. Green traces the basis for and disagreement about sexual activity as therapy in "Transmissions," esp. ch. 1.

42. For one such text see Esther Lastique and Helen Rodnite Lemay, "A Medieval Physician's Guide to Virginity," in *Sex in the Middle Ages: A Book of Essays*, ed. Joyce E. Salisbury, Garland Medieval Casebooks 3, Garland Reference Library for the Humanities 1360 (New York: Garland Publishing, 1991), pp. 56–79.

43. Danielle Jacquart and Claude Thomasset, "Albert le Grand et les problèmes de la sexualité," *History and Philosophy of the Life Sciences*, 3 (1981): 73–93 especially pp. 85–87.

44. Albertus Magnus, *De animalibus*, bk. IX, tr. i, ch. 1, §§6–7, p. 676.

45. Albertus Magnus, *De animalibus*, bk. IX, tr.i, ch.1, §10. p. 677: "In hoc enim tempore pubertatis multa in inguine distillant humiditate tam feminae quam viri,

et moventur multum ad quaerendum coitum: et ut in pluribus si utantur coitu moderato in illo tempore, velocius corpora eorum accipiunt incrementum quam prius. quia illi in quorum corporibus multae sunt et grossae humiditates, ex ipsis eisdem impeditur calor augens corpus non potens eam vincere et dissolvere: et cum exit in parte per confricationem coitus, ex remanente melius augetur et nutritur corpus tam in maribus quam in feminis."

46. Albertus Magnus, *De animalibus*, bk. IX, tr.i, ch. 1, §7, p. 676: "quaedam puellae circa annum quartumdecimum non possunt de coitu satiari: et si tunc non habent virum, tamen mente pertractant coitum virilem et saepe imaginantur veretrum virorum, et forte saepe se confricant digitis vel aliis instrumentis quousque laxatis viis per calorem confricationis et coitus exit humor spermaticus, cum quo exit calor, et tunc temperantur inguina ipsarum, et tunc efficiuntur castiores."

47. *De passionibus mulierum*, Cambridge University Library, MS Dd.11.45, fol. 68v.

48. For example, Albertus Magnus, *De animalibus*, bk. X, tr. 1, ch. 1 §§6–7, pp. 732–33, §12, p. 735, and ch. 2, §21, p. 738.

49. John of Gaddesden, *Rosa anglica practica medicine* (Venice: Bonetus Locatellus, 1516), bk. II, ch. xvii, fol. 75ra-b: "Et debet tangere mulierum cum manu contra muliebria et mamillas, et osculari eam. Deinde cognoscere eam."

50. *De passionibus mulierum*, Cambridge University Library, MS Dd.11.45, fol. 63r.

51. André Burguière, "De Malthus à Max Weber: Le mariage tardif et l'esprit d'entreprise," *Annales: Economies, Sociétés, Civilisations* 27 (1972): 1128–1138, especially p. 1129. See also the work of Philippe Ariès, such as "Sur les origines de la contraception en France," *Population* 3 (1953): 465–72, trans. in Orest Ranum and Patricia Ranum, eds., *Popular Attitudes toward Birth Control in Pre-Industrial France and England* (New York: Harper & Row, 1972); and "Interpretation pour une histoire des mentalités" in Hélène Bergues, ed., *La prévention des naissances dans la famille: Ses origines dans les temps modernes*, Cahiers de l'Institut National d'Etudes Démographiques, Travaux et Documents 35 (Paris: Presses Universitaires de France, 1960), pp. 311–26. Peter B.A. Biller argues against this view in "Birth Control in the West in the Thirteenth and Early Fourteenth Centuries," *Past and Present* 94 (1982): 3–26.

52. John M. Riddle, *Contraception and Abortion from the Ancient World to the Renaissance* (Cambridge: Harvard University Press, 1992).

53. Riddle, *Contraception and Abortion*, p. 27.

54. For example, Constantine, *De coitu*, and Montero Cartelle, ed., *Liber minor de coitu*.

55. For example, Montero Cartelle, ed., *De sterilitate* and the treatises on conception and sterility in MS Bibliothèque Nationale, lat. 7066.

56. Lemay, *Women's Secrets*, ch. IX, comm. B, p. 127; see also p. 70.

57. Albertus Magnus, *De animalibus*, bk. X, tr. ii, ch. 1, §47, p. 749.

58. *De passionibus mulierum*, British Library, MS Sloane 1124, fol. 172va: "gravem incurrunt egritudinem."

59. Cadden, *Meanings of Sex Difference*, pp. 209–14.

60. Aristotle, *Problems*, tr. W.S. Hett, 2 vols., Loeb Classical Library (Cambridge: Harvard University Press; London: William Heinemann, 1936–37), bk. IV, probl. xxvi, 879a35.

61. Pietro d'Abano, *Expositio Problematum Aristotelis* (Mantua: Paulus Johannis Puzpach, 1475), pt. IV, probl. 26.

62. Avicenna, *Canon*, bk. III, fen 20, tr. i, ch. 42, fol. 358: "Nam initium egritudinis eorum meditativum est non naturale."

63. Jacquart and Thomasset, *Sexuality and Medicine*, pp. 156–61; Danielle Jacquart, "Medical Explanations of Sexual Behavior," pp. 7–8; and Lemay, "William of Saliceto," pp. 179–80.

64. Jacquart and Thomasset, *Sexuality and Medicine*, pp. 159–60; Cadden,

Meanings of Sex Difference, pp. 224–25. As on other matters relating to sexuality, Arabic authors are sometimes more forthcoming: Jacquart and Thomasset, p. 124.

65. Avicenna, *Canon*, bk. III, fen 21, tr. i, ch. 22.

66. Helen Rodnite Lemay, "William of Saliceto," pp. 178–79. *Ragadia:* Avicenna, *Canon*, bk. III, fen 21, ch. 12, fol. 172va.

67. Mary Frances Wack, *Lovesickness in the Middle Ages*; Danielle Jacquart and Claude Thomasset, "L'amour 'héroïque' à travers le traité d'Arnaud de Villeneuve," in *La folie et le corps*, ed. Jean Céard with Pierre Naudin and Michel Simonin (Paris: Presse de l'Ecole Normale Supérieur, 1985): 143–58. For editions of primary sources on lovesickness, see n. 6.

68. Wack, *Lovesickness*, 110–13, 174–76, Jacquart and Thomasset, "L'amour 'héroïque,'" p. 158.

69. Jacquart and Thomasset, "L'amour 'héroïque,'" pp. 147–50.

70. Wack, *Lovesickness*, esp. 102–04, 139–44; Jacquart and Thomasset, "L'amour 'héroïque,'" p. 156.

71. Wack, *Lovesickness*, pp. 109–25; Jacquart and Thomasset, "L'amour héroïque'," pp. 156–58.

72. Lawn, *Prose Salernitan Questions*, quest. B 10 and 13.

73. Lemay, *Women's Secrets*, ch. 12, comm. B, p. 138; Cadden, *Meanings of Sex Difference*, pp. 149–50.

74. King, "Once upon a Text: Hysteria from Hippocrates."

75. Lemay, *Women's Secrets*, ch. 11, p. 132.

76. Jacquart and Thomasset, *Sexuality and Medicine*, pp. 177–93; Luke Demaitre, "The Description and Diagnosis of Leprosy by Fourteenth-Century Physicians," *Bulletin of the History of Medicine 59* (1985): 327–44.

77. Lemay, *Women's Secrets*, preface, comm. A, p. 60; ch. 2, comm. A, p. 88; ch. 10, p. 129 and comm. B, p. 130.

78. Ibid., ch. 2 and comms. A and B, pp. 88–90. See Riddle, *Contraception and Abortion*, p. 158.

BIBLIOGRAPHY

Reference Works

Birkenmajer, Aleksander, Georges Lacombe, and Lorenzo Minio-Paluello. *Aristotles Latinus: Codices*, 3 vols.: vol. 1, rev. ed. Union Académique Internationale, Corpus Philosophorum Medii Aevi. Bruges and Paris: Desclée de Brouwer, 1957; vol. 2, Cambridge: Academia, 1955; [vol. 3], *Supplementa altera*, Bruges and Paris: Desclée de Brouwer, 1961.

Duden, Barbara. *Body History/Köpersgeschichte: A Repertorium/Ein Repertorium*. Kultur- und Sozialgeschichte 1. Wolfenbüttel: Tandem, 1990.

Goff, Frederick R. *Incunabula in American Libraries: A Third Census of Fifteenth-Century Books Recorded in North American Collections*. New York: Bibliographical Society of America, 1964. *Supplement*, 1972.

History of Science Society. *Current Bibliography*. In *Isis*. [Formerly *Critical Bibliography*.]

Kibre, Pearl. *Hippocrates Latinus: Repertorium of Hippocratic Writings in the Middle Ages*. Rev. ed. New York: Fordham University Press, 1985.

Kristeller, Paul Oskar. *Latin Manuscript Books before 1600: A List of the Printed Catalogues and Unpublished Inventories of Extant Collections*. 4th ed., rev. Sigrid Krämer. Hilfsmittel 13. Munich: Monumenta Germanicae Historia, 1993.

Lohr, Charles. "Medieval Latin Aristotle Commentaries." *Traditio* 23 (1967): 313–413; 24 (1968): 149–245; 26 (1970): 135–216; 27 (1971): 251–351; 28 (1972): 281–396; 29 (1973): 91–197; 30 (1974): 119–44.

Ricci, Seymour de, with W.J. Wilson. *Census of Medieval and Renaissance Manuscripts in the United States and Canada.* 3 vols. New York: Bibliographical Society of America and H.W. Wilson, 1935–40; reprint New York: Kraus Reprint, 1961; and W.H. Bond, and C.U. Faye. *Supplement.* New York: Bibliographical Society of America, 1962.

Salisbury, Joyce E. *Medieval Sexuality: A Research Guide.* Garland Medieval Bibliographies 5; Garland Reference Library of Social Science 565. New York: Garland Publishing, 1990.

Schullian, Dorothy May, and Francis E. Sommer. *A Catalogue of Incunabula and Manuscripts in the Army Medical Library.* New York: Henry Schuman, [1948?].

Thorndike, Lynn, and Pearl Kibre. *A Catalogue of Incipits of Scientific Writings in Latin.* Rev. ed. Mediaeval Academy of America 29. Cambridge: Mediaeval Academy of America, 1963.

United States Department of Health and Human Services, National Institutes of Health. *Bibliography of the History of Medicine.*

Primary Sources

Albertus Magnus. *De animalibus libri XXVI,* ed. Hermann Stadler. Beiträge zur Geschichte der Philosophie des Mittelalters 15 and 16. Münster: Aschendorff, 1916, 1920.

———. *Quaestiones super De animalibus,* ed. Ephrem Filthaut. Vol. 12 of *Opera omnia,* ed. Bernhard Geyer. Münster I.W.: Aschendorff, 1955.

Aristotle. *De generatione animalium translatio Guillelmi de Moerbeka.* Vol. XVII, 2, of *Aristoteles Latinus.* Union Académique Internationale, Corpus Philosophorum Medii Aevi. Bruges and Paris: Desclée de Brouwer, 1966.

———. *Generation of Animals,* ed. and trans. A.L. Peck. Loeb Classical Library. Cambridge: Harvard University Press; London: William Heinemann, 1953.

———. *Problems.* Trans. W.S. Hett. 2 vols. Loeb Classical Library. Cambridge: Harvard University Press; London: William Heinemann, 1936–37.

Arnaldus de Villanova. *Tractatus de amore heroico,* ed. Michael R. McVaugh. In *Arnaldi de Villanova opera medica omnia,* vol. 3, pp. 11–54. Seminarium Historiae Medicae Cantabricense. Barcelona: Publicacions i Edicions de la Universitat de Barcelona, 1985.

Avicenna. *Liber canonis.* Venice: Pagininis, 1507; repr. Hildesheim: Georg Olms, 1964.

Barkaï, Ron. "A Medieval Hebrew Treatise on Obstetrics." *Medical History* 33 (1989): 96–119.

———. *Les infortunes de Dinah: Le livre de la génération: La gynécologie juive au moyen âge.* Intro. trans. Jacqueline Barnavi; treatise and notes trans. Michel Garel. Toledot-Judaïsmes. Paris: Editions du Cerf, 1991.

Bartholomeus Anglicus. *De genvinis rervm coelestivm, terrestrivm inferarvm* [sic] *proprietatibus libri XVIII,* ed. Georgius Bartholdus Posanus. Frankfurt: Wolfgang Richter, 1601; reprint Frankfurt am Main: Minerva, 1964.

Bernardus de Gordonio. *Practica dicta Lilium.* Venice: Bonetus Locatellus, 1498.

Caelius Aurelianus. *Gynaecia: Fragments of a Latin Version of Soranus' Gynaecia from a Thirteenth-Century Manuscript,* trans. Miriam F. Drabkin and Israel Drabkin. Supplements to the Bulletin of the History of Medicine 13. Baltimore: Johns Hopkins University Press, 1951.

Cockayne, Thomas Oswald. *Leechdoms, Wortcunning, and Starcraft of Early England.* Rerum Britannicarum Medii Aevi Scriptores 35. London: Longman, Green, Longman, Roberts, Green, 1864–66; repr. [New York]: Kraus, 1965.

Constantinus Africanus. *Liber de coitu: El tratado de andrología de Constantino el Africano.* ed. and trans. Enrique Montero Cartelle. Monografias de la Universidad de Santiago Compostela, Santiago de Compostela: Universidad de Santiago, 1983.

————. *Pantegni*. in Isaac [Israeli], *Opera omnia*. Lyon: Andreas Turinus, 1515.

Delany, Paul. "Constantinus Africanus' *De coitu*: A Translation." *Chaucer Review* 4 (1969): 55–65.

Galen. *De semine*. In *Opera omnia*, ed. Carl Gottlob Kühn, 4, pp. 512–651. 20 vols. in 22. Leipzig: C. Cnobloch, 1821–33; repr. Hildesheim: Georg Olms, 1964–65.

Gilbertus Anglicus. *Compendium medicine*. Lyon: Jacobus Saccon, 1510.

Green, Monica H. "The *De genecia* Attributed to Constantine the African." *Speculum* 62 (1987): 299–323.

Hallaert, M.R., ed. *The "Sekenesse of Wymmen": A Middle English Treatise on Diseases in Women (Yale Medical Library, Ms. 47 fols. 60r–71v)*. Scripta: Medieval and Renaissance Texts and Studies 8. Brussels: ORIMER, UFSAL, 1982.

Hildegard of Bingen. *Causa et Curae*, ed. Paul Kaiser. Bibliotheca Scriptorum Graecorum et Romanorum Teubneriana. Leipzig: B.G. Teubner, 1903.

————. *Opera omnia*, ed. Friedrich Anton de Reuss. In *Patrologia Latina* 197 (1853).

Jacopo da Forlì and Dino del Garbo. *De generatione embrionis*. Comp. Bassanius Politus. Venice: Bonetus Locatellus, 1502.

John of Gaddesden. *Rosa anglica practica medicine*. Venice: Bonetus Locatellus, 1516.

Lawn, Brian, ed. *The Prose Salernitan Questions Edited from a Bodleian Manuscript (Auct. F.3.10)*. Auctores Britannici Medii Aevi 5. London: British Academy at Oxford University Press, 1979.

Lemay, Helen Rodnite, ed. and trans. *Women's Secrets: A Translation of Pseudo-Albertus Magnus's De Secretis Mulierum with Commentaries*. SUNY Series in Medieval Studies. Albany: State University of New York Press, 1992.

Montero Cartelle, Enrique, ed. and trans. *Liber minor de coitu: Tratado menor den andrologia anonimo salernitano*. Lingüística y Filología. Valladolid: Universidad de Valladolid and Caja Salamanca y Soria, 1993.

————, ed. *Tractatus de sterilitate: Anónimo de Montpellier (s. XIV) atribuido a A. de Vilanova, R. de Moleris y J. de Turre*. Lingüística y Filología Valladolid: Universida de Valladolid, 1987.

Muscio. *Sorani Gynaeciorum vetus translatio latina*, ed. Valentine Rose. Leipzig: B.G. Teubner, 1882.

Nemesius of Emesa. *De natura hominis: Traduction de Burgundio de Pise*, ed. G. Verbeke and J.R. Moncho. Corpus Latinum Commentariorum in Aristotelem Graecorum, suppl. 1. Leiden: E.J. Brill, 1975.

Pietro d'Abano. *Expositio Problematum Aristotelis*. Mantua: Paulus Johannis Puzpach, 1475.

Rowland, Beryl, ed. *Medieval Woman's Guide to Health: The First English Gynecological Handbook*. Kent, OH: Kent State University Press, 1981.

Schleissner, Margaret Rose. "Pseudo-Albertus Magnus: Secreta mulierum cum commento, Deutsch: Critical Text and Commentary." Ph.D. dissertation. Princeton University, 1987.

Shatzmiller, Joseph. *Médicine et justice en Provence médiévale: Documents de Manosque, 1262–1348*. Aix-en-Provence: Publications de l'Université de Provence, 1989.

Soranus. *Gynaeciorum libri iv, De signis fracturarum, De fasciis, Vita Hippocratis secundum Soranum*, ed. Johannes Ilberg. Corpus Mediocrum Graecorum 4. Leipzig and Berlin: B.G. Teubner, 1927.

————. *Soranus' Gynecology*, trans. Owsei Temkin with Nicholson J. Eastman, Ludwig Edelstein, and Alan F. Guttmacher. Publications of the Institute of the History of Medicine, Johns Hopkins University, 2d series, Texts and Documents, 3. Baltimore: Johns Hopkins University Press, 1956.

Tavone Passalacqua, Vera, trans. and comm. *Microtegni seu De spermate*. Rome: Instituto di Storia della Medicina dell'Università di Roma, 1959.

Thomas de Cantimpré. *Libre de natura rerum*. Part 1, *Texte*, ed. H. Boese. Berlin: Walter de Gruyter, 1973.

Wack, Mary Frances. *Lovesickness in the Middle Ages: The Viaticum and Its Commentaries*. Middle Ages Series. Philadelphia: University of Pennsylvania Press, 1990.

———. "The *Liber de hereos morbo* of Johannes Afflacius and Its Implications." *Speculum* 62 (1987): 324–44.

William of Conches. *Dialogus de substantiis physicis*, ed. Guilielmus Gratarolus. Strasburg: Iosias Rihelius, 1567; repr. Frankfurt-am-Main: Minerva, 1967.

Seconday Sources

Ackerknecht, Erwin. "Midwives as Experts in Court." *Bulletin of the New York Academy of Medicine* 52 (1976): 1224–28.

Agrimi, Jole, and Chiara Crisciani. *Les consilia médicaux*, trans. Caroline Viola. Typologie des Sources du Moyen Age Occidental 69. Turnhout: Brepols, 1994.

Ariès, Philippe. "Sur les origines de la contraception en France." *Population* 3 (1953): 465–72.

Baldwin, John W. *The Language of Sex: Five Voices from Northern France around 1200*. Chicago Series on Sexuality, History, and Society. Chicago: Chicago University Press, 1994.

Benedek, Thomas G. "Beliefs about Sexual Function in the Middle Ages and Renaissance." In *Human Sexuality in the Middle Ages and Renaissance*, ed. Douglas Radcliff-Umstead, pp. 97–116. University of Pittsburgh Publications on the Middle Ages and the Renaissance 4. Pittsburgh: Center for Medieval and Renaissance Studies, University of Pittsburgh, 1978.

Bergues, Hélène, ed. *La prévention des naissances dans la famille: Ses origines dans les temps modernes*. Cahiers de l'Institut National d'Etudes Démographiques, Travaux et Documents 35. Paris: Presses Universitaires de France, 1960.

Biller, Peter B.A. "Birth Control in the West in the Thirteenth and Early Fourteenth Centuries." *Past and Present* 94 (1982): 3–26.

Bos, Gerrit. "Ibn al-Jazzar on Women's Diseases and Their Treatment." *Medical History* 37 (1993): 293–312.

Brundage, James A. *Law, Sex, and Christian Society in Medieval Europe*. Chicago: University of Chicago Press, 1987.

Bullough, Vern L. "Medieval Medical and Scientific Views of Women." *Viator* 4 (1973): 485–501.

Burguière, André. "De Malthus à Max Weber: Le mariage tardif et l'esprit d'enterprise." *Annales: Economies, Sociétés, Civilisations* 27 (1972): 1128–38.

Cadden, Joan. "It Takes All Kinds: Sexuality and Gender Differences in Hildegard of Bingen's *Book of Compound Medicine*." *Traditio* 40 (1984): 149–74.

———. *Meanings of Sex Difference in the Middle Ages: Medicine, Science, and Culture*. Cambridge History of Medicine. Cambridge: Cambridge University Press, 1993.

Demaitre, Luke. "The Description and Diagnosis of Leprosy by Fourteenth-Century Physicians." *Bulletin of the History of Medicine* 59 (1985) 327–44.

Diepgen, Paul. *Frau und Frauheilkunde in der Kultur des Mittelalters*. Stuttgart: Georg Thieme, 1963.

Flint, Valerie I.J. *The Rise of Magic in Early Medieval Europe*. Princeton: Princeton University Press, 1991.

Green, Monica H. "Documenting Medieval Women's Medical Practice." In *Practical Medicine from Salerno to the Black Death*, ed. Luis García-Ballester, Roger French, Jon Arrizabalaga, and Andrew Cunningham. Cambridge: Cambridge University Press, 1994.

———. "Female Sexuality in the Medieval West." *Trends in History* 4 (1990): 127–58.

———. "Obstetrical and Gynecological Texts in Middle English." *Studies in the Age of Chaucer* 14 (1992): 53–88.

———. "Sex and the Medieval Physician." *History and Philosophy of the Life Sciences* 13 (1991): 188–293.

———. "The Transmission of Ancient Theories of Female Physiology and Disease through the Early Middle Ages." Ph.D. dissertation, Princeton University, 1985.

———. *Women and Literate Medicine in Medieval Europe: Trota and the "Trotula."* New York: Cambridge University Press, forthcoming.

———. "Women's Medical Practice and Heath Care in Medieval Europe." *Signs* 14 (1989): 434–73.

Green, Monica H. and Ann Ellis Hanson. "Soranus of Ephesus: *Methodicorum princeps.*" *Aufstieg und Niedergang der römishen Welt,* Teil II, 37.2, 1994.

Hewson, Anthony M. *Giles of Rome and the Medieval Theory of Conception: A Study of the De formatione corporis humani in utero.* University of London Historical Studies 38. London: Athalone Press, University of London, 1975.

Jacquart, Danielle. "Medical Explanations of Sexual Behavior in the Middle Ages." In *Homo Carnalis: The Carnal Aspect of Medieval Human Life,* ed. Helen Rodnite Lemay, pp. 1–21. Center for Medieval and Early Renaissance Studies, Acta 14 for 1989. Binghamton: State University of New York Press, 1990.

Jacquart, Danielle and Claude Thomasset. "Albert le Grand et les problèmes de la sexualité." *History and Philosophy of the Life Sciences* 3 (1981): 73–93.

———. "L'amour 'héroïque' à travers le traité d'Arnaud de Villeneuve." In *La folie et le corps,* ed. Jean Céard with Pierre Naudin and Michael Simonins, pp. 143–58. Paris: Presse de l'Ecole Normale Supérieur, 1985.

———. *Sexuality and Medicine in the Middle Ages,* trans. Matthew Adamson. Princeton: Princeton University Press, 1988.

King, Helen. "Once Upon a Text: Hysteria from Hippocrates." In Sander L. Gilman, Helen King, Roy Porter, G.S. Rousseau, and Elaine Showalter, *Hysteria Beyond Freud,* pp. 3–90. Berkeley and Los Angeles: University of California Press, 1993.

Kurdziałek, Marian. "Anatomische und embryologische Aeusserungen Davids von Dinant." *Sudhoffs Archiv für Geschichte der Medizin und der Naturwissenschaften,* 45 (1961): 1–22.

Laqueur, Thomas. *Making Sex: Body and Gender from the Greeks to Freud.* Cambridge: Harvard University Press, 1990.

Lemay, Helen Rodnite. "Anthonius Guainerius and Medical Gynecology." In *Women of the Medieval World: Essays in Honor of John H. Mundy,* ed. Julius Kirschner and Suzanne F. Wemple, pp. 317–36. Oxford: Blackwell, 1985.

———. "Human Sexuality in Twelfth- through Fifteenth-Century Scientific Writings." In *Sexual Practices & the Medieval Church,* ed. Vern L. Bullough and James A. Brundage, pp. 187–205, 278–82. Buffalo: Prometheus, 1982.

———. "Some Thirteenth and Fourteenth Century Lectures on Female Sexuality." *International Women's Studies Journal* 1 (1978): 391–400.

———. "The Stars and Human Sexuality: Some Medieval Scientific Views." *Isis* 71 (1980): 127–37.

———. "William of Saliceto on Human Sexuality." *Viator* 12 (1981): 165–81.

———. "Women and the Literature of Obstetrics and Gynecology." In *Medieval Women and the Sources of Medieval History,* ed. Joel T. Rosenthal, pp. 189–209. Athens: University of Georgia Press, 1990.

McVaugh, Michael R. *Medicine before the Plague: Practitioners and Their Patients in the Crown of Aragon, 1285–1345.* Cambridge: Cambridge University Press, 1993.

Miller, B.D.H. "'She Who Hath Drunk Any Potion' . . ." *Medium Aevum* 31 (1962): 188–93.

Murray, Jacqueline. "On the Origins and Role of 'Wise Women' in Causes for Annulment on the Grounds of Male Impotence." *Journal of Medieval History* 16 (1990): 235–49.

Musallam, Basim F. *Sex and Society in Islam: Birth Control Before the Nineteenth*

Century. Cambridge Studies in Islamic Civilization. Cambridge: Cambridge University Press, 1983.

Paschold, Chris E. *Die Frau und ihr Körper im medizinischen und didactischen Schrifttum des französischen Mittelalters: Wortgeschictliche Untersuchungen zu Texten des 13. und 14. Jahrhunderts mit kritischer Ausgabe der gynäkologischen Kapitel aus den "Amphorismes Ypocras" des Martin de Saint-Gilles.* Würzburger medizinhistorische Forschungen 47. Pattensen/Han.: Horst Wellm, 1989.

Pereira, Michela. "Maternità e sessualità femminile in Ildegarda di Bingen: Proposte de lettura." *Quaderni storici* 44 (1980): 564–79.

Pinto, Lucille B. "The Folk Practice of Gynecology and Obstetrics in the Middle Ages." *Bulletin of the History of Medicine* 47 (1973): 513–23.

Ranum, Orest, and Patricia Ranum, eds. *Popular Attitudes toward Birth Control in Pre-Industrial France and England.* New York: Harper & Row, 1972.

Riddle, John M. *Contraception and Abortion from the Ancient World to the Renaissance.* Cambridge: Harvard University Press, 1992.

Salisbury, Joyce E. *The Beast Within: Animals and Bestiality in the Middle Ages.* New York: Routledge, 1994.

———, ed. *Sex in the Middle Ages: A Book of Essays.* Garland Medieval Casebooks 3; Garland Reference Library in the Humanities 1360. New York: Garland Publishing, 1991.

Shaw, James R. "Scientific Empiricism in the Middle Ages: Albertus Magnus on Sexual Anatomy." *Clio Medica* 10 (1975): 53–64.

Siraisi, Nancy G. *Medieval & Early Renaissance Medicine: An Introduction to Knowledge and Practice.* Chicago: University of Chicago Press, 1990.

Thorndike, Lynn. *A History of Magic and Experimental Science.* 8 vols. New York: Macmillan and Columbia University Press, 1923–58.

Voigts, Linda Ehrsam. "Medical Prose." In *Middle English Prose: A Critical Guide to Major Authors and Genres,* ed. A.S.G. Edwards, pp. 315–35. New Brunswick: Rutgers University Press, 1984.

———. "Scientific and Medical Books." In *Book Production and Publishing in Britain, 1375–1475,* ed. Jeremy Griffiths and Derek Pearsall, pp. 345–402. Cambridge: Cambridge University Press, 1989.

4 GENDERED SEXUALITY

Joyce E. Salisbury

Scholars in medieval studies have made great strides in illuminating the history of sexual attitudes and sexual practices. Research into the history of sexuality has yielded insights into the past and has helped us understand many of our modern attitudes. Much of the pioneering work in this field has been little interested in the differences in sexual expression and attitudes between men and women.[1] This largely non-gendered approach to the subject particularly suits our modern understandings of gender as culturally determined rather than strictly biologically shaped. Thus we often try to stand beyond gender to look at sexuality as a human phenomenon rather than a male or female one. (In my twentieth century view, this is a perfectly reasonable approach.)

Increasingly, studies of medieval sexuality have begun to address directly medieval attitudes toward male and female sexuality. Feminist scholars have been pathbreaking in this approach, primarily because they have recognized that most texts on sexuality (whether primary or secondary sources) have been about *male* sexuality. As Monica Green succinctly expressed this view: "What we do not hear in all these various discourses is the voice of the populace at large, and most particularly the female half of it." Monica Green's article "Female Sexuality in the Medieval West," written in 1990, summarizes the literature on this subject.[2] I suggest, however, that our understanding of beliefs about masculinity and male sexuality has also been blurred by a non-gendered approach to the texts.

Modern scholars, feminist and otherwise, have been understandably careful about drawing conclusions about what is biological and what is social. Consideration of gendered sexuality can quickly lead to a nature/nurture quagmire. However, it need not. Whatever we may believe about the social construction of gender, medieval thinkers did see biology as destiny. While medieval medicine and philosophy recognized ambivalent expressions

of gendered sexuality—hermaphrodites, homosexuality, and "feminine" men and vice versa[3]—they saw these expressions as exceptions in a world in which the existence of two genders—two sexes—was the natural state. In the *City of God*, Augustine included hermaphrodites in his list of what he called monstrosities: "Others have the characteristic of both sexes, the right breast being male and the left female, and in their intercourse they alternate between begetting and conceiving." He explained that such anomalies, while they may appear, do so to demonstrate, to define, what is normal. By their rarity, they show "what constitutes the persistent norm or nature."[4] If we are to understand medieval views of sexuality in their own terms, we must follow Augustine's vision and look at what they considered the "norm or nature." For them the norm was male and female sexuality, and this norm was determined by the genital organs with which one was born.

In this chapter I shall discuss some of the findings about male and female sexuality in representative works on medieval sexuality. Approaching the texts on sexuality from a gendered perspective offers a fruitful and important method for scholars of the Middle Ages who want to understand sexuality as medieval people did.

Of course, medieval thinkers did not begin their reflections in a vacuum. They inherited a rich body of ideas on sexuality from the Greco-Roman world that preceded them. Romans (like the Greeks before them) surrounded sexual intercourse with prohibitions designed to alleviate some deep fears of sexuality,[5] and these fears were firmly imbedded in notions of gender. Aretaeus the Cappadocian spoke for men of the ancient world when he wrote, "For it is the semen, when possessed of vitality, which makes us men, hot, well-braced in limbs, heavy, well-voiced, spirited, strong to think and act."[6] Notice here the close association with semen and qualities of masculinity that seem not neccessarily attached to biology ("strong to think"). This points to the underlying assumption in medieval thought— gender is linked to sexuality.

Since Roman men (and their medical authorities) identified the source of maleness in semen, their views of male sexuality were joined with fears of losing that masculinity. Peter Brown, Paul Veyne, and Aline Rouselle, among others, have detailed the care with which Roman men expended their sexual energy. Medical authorities warned men against the fatiguing effects of sexual activity, which might deprive the body of vital spirit (*pneuma*). This fear led to medical recommendations (essentially sexual prohibitions) to attempt to ameliorate the adverse effects of coitus. Men should not have intercourse on a full stomach or in the morning on a completely empty stomach. Some exercise before intercourse was recommended and a dry massage

should follow. Men who engaged in sexual relations "without restraint" must "have sufficient sleep and avoid the tiredness that comes from anger, pain, joy, excessively weakening activities, steam baths, sweating, vomiting, drunkenness, heavy work, becoming too hot or too cold."[7]

A man was to expend his sexual *pneuma* sparingly to allow himself to remain strong to contribute to the public good. Of course, his society needed children. Thus, men were also responsible to use their sperm wisely to produce healthy heirs, and women were to be strong to bear hardy children. Aline Rouselle summarized the ideal of responsible Roman sexual expression:

> The *pneuma* which the man went to such lengths to retain, by adopting a strict lifestyle and constantly watching his diet, was to be used for one fertile sexual act, which would take place in the evening, just after the woman's menstrual period. The woman should then cross her legs to keep in this precious semen, and . . . spend several days in bed if she wanted to be certain of conceiving.[8]

Here we have sexual expression controlled and brought into the service of the public good.

It was not only the Greco-Roman medical texts that recommended controlled sexual activity. Philosophers also warned against the moral pollution that could accompany unrestrained sexual expression, and again, such moral repercussions were shaped by ideas of gender. The Romans believed sexual moderation was not only healthy, but it was necessary to preserve gender identity. The ideal Roman man was involved in public service. However, not just men, but men with what they defined as masculine qualities— strength, power, authority—were needed for a public life. Therefore, not only were women excluded from public life, but also traits that were considered "feminine" were thought inappropriate. In the view of the Romans, excessive sexual activity actually had the potential to expend the masculinity of the practitioner. As Areteaus had located masculinity in semen, men could lose their masculinity with ejaculation. Medicine warned that too much ejaculation could cool a man's hot/dry nature, making him more cool and wet, thus more feminine.[9]

Psychologically men could also be "feminized" by stirrings of lust. A man might become emotionally attached, reducing his independence. Lust might drive him physically to reverse the moral order that kept upper-class males in charge of society. An example of such perceived reduction was if a man submitted to a passive role in lovemaking, particularly by allowing pen-

etration in a homosexual encounter. (It was perfectly acceptable to be the active partner in a homosexual relationship, since that preserved the all-important gender definition equating activity with masculinity.) Oral sexuality with a female partner was much condemned since it, too, inverted the social hierarchy.[10] These cultural prohibitions reveal the close tie between sexuality and the public role of the individual in the ancient world. As Peter Brown summarized: "Fear of effeminacy and of emotional dependence, fears based on a need to maintain a public image as an effective upper-class male, rather than any qualms about sexuality itself, determined the moral codes according to which most notables conducted their sexual life."[11]

Medieval thinkers inherited a particular view of male sexuality from the ancient world. This was a view that located the origins of "masculine" behavior in the genitals, and specifically in semen. By defining masculinity in this way, it seemed a state as fragile as the "airlike" *pneuma* that carried it. Male sexuality involved not unbridled lust, but carefully measured behavior. For the ancients, female sexuality was the opposite of male, but equally linked to biology.

The Greco-Roman male authors who wrote about sexuality did not seem to worry about sexual intercourse debilitating women. Women were believed to be profoundly sexual, insatiable in their capacity to experience intercourse and to enjoy it. The famous Greek myth of Tiresias traditionally expressed women's capacity. Tiresias had been turned into a woman and then restored to his original male form. When asked which of the genders enjoyed sex more, he responded:

> If the parts of love pleasure be counted as ten,
> Thrice three go to women, one only to men.[12]

Views of women's sexuality shaped views of their purpose. Women's function was reproductive. If men served the state by bringing their masculine gifts to its service, women served by bringing their reproductive capacities. This preoccupation with women providing the next generation of Romans contributed to such practices as prepubescent consummated marriages.[13] It is perhaps not surprising that one of the most influential contributions of the ancient world to medieval views of female sexuality had to do with the production (or lack) of female seed.

The Middle Ages inherited two views of women's sexuality from the ancient medical world. One, the Galenic view, argued that women, like men, produced seed. In this model, women's sexual pleasure was seen as important for the seed to be released. In the other view, the Aristotelian one, women

did not produce seed. Their pleasure was irrelevant to the goal of reproduction. This medical controversy had profound ramifications for understandings of female sexuality and sexual expression subsequently in the Middle Ages. Historians of science have closely analyzed and discussed in detail the impact of these ideas, and I shall return to this subject below.

Christian thinkers of the late antique world inherited this view of sexuality that saw men's and women's sexual expression as profoundly different. Church fathers did modify classical views of sexuality to some extent, but they kept the strongly gendered emphasis.

As we have seen above, the ancient world associated maleness (through semen) with rational thought and action. Men were "strong to think and act." The early church fathers, too, divided the world by gender, and men were defined as rational (dominated by mental activity) and strong. Early churchmen believed these defining qualities of men gave them authority over women. Isidore of Seville summarized patristic wisdom when he wrote: "Women are under the power of men because they are frequently spiritually fickle. Therefore, they should be governed by the power of men." Elsewhere, Isidore referred to man as the "head of woman."[14] Men's power was visible in his physical qualities and bearing; St. Ambrose explained that men had "different customs, different complexions, different gestures, gait, and strength, different qualities of voice."[15]

A man's power dictated a second characteristic of manliness: that he be active in the world and the active partner in his sexual relationships. This directly continued the Greco-Roman perspective. Patristic understanding of the different *loci* of sexual pleasure in men and women speaks to men's active role in sexual activity. Men's sexuality was located in the loins, while women's was in the navel.[16] The loins represented strength, musculature, power, and activity, while the navel represented passivity, receptiveness, and nurturing. In this view of sexuality, which makes a strong distinction between active and passive partners, the church fathers were drawing from the classical heritage that formed the background for their thought. Paul Veyne has studied the sexual ideas of the Roman Empire and concluded that the church fathers continued the Roman perspective that "to be active was to be male, whatever the sex of the compliant partner. To take one's pleasure was virile, to accept it servile."[17] Church fathers modified the Roman view that accepted homosexual encounters but kept the Roman maxim that to take one's pleasure actively was the manly way.

It is in this context that we might understand Isidore's statement that masturbation was effeminate. Isidore said that in masturbation a man dishonored the vigor of his sex by his languid body.[18] In effect, masturba-

tion was an unmanly, servile acceptance of pleasure rather than an active taking of it. Thus male sexuality was supposed to be a reflection of manliness, expressing power and action. And this sexual expression was caused in turn by the male biology supposedly dominated by power-bestowing sperm.

It is important to recognize that the Christian association of masculinity with power did not mean only physical power. In the same way that in the ancient world power meant moral power that could and should be used for the good of the state, Christian thinkers saw masculine power as including spiritual power. Margaret Miles has demonstrated that male nakedness represented extraordinary spiritual strength as well as physical strength.[19] In this metaphor, we can readily see the way physicality was linked with spirituality. In the minds of most patristic scholars, masculine sexuality was an expression of both.

Women's sexuality was opposite. Isidore, again, succinctly summarizes patristic understanding of the genders: "Man drew his name (*vir*) from his force (*vis*), whereas woman (*mulier*) drew hers from her softness (*mollities*).[20] In contrast to men, who were strong, rational, and spiritual by nature, church fathers believed women to be not only soft, but carnal. They embodied sexuality. Isidore characterized women: "The word *femina* comes from the Greek derived from the force of fire because her concupiscence is very passionate: women are more libidinous than men."[21] It was this essential sexuality that represented a perpetual lure of the flesh for men who got near any women, for all women were temptresses who constantly reproduced Eve's initial temptation of Adam. As Jerome warned:

> It is not the harlot, or the adulteress who is spoken of, but woman's love in general is accused of ever being insatiable; put it out, it bursts into flame; give it plenty, it is again in need; it enervates a man's mind, and engrosses all thought except for the passion which it feeds.[22]

Here Jerome not only reveals the fear of women's sexuality but also identifies the nature of the threat. By "enervating a man's mind" and interfering with his "thought," woman removed him from the rational world of the mind that defined him as spiritual and, indeed, defined his masculinity. Here one can see the Christian application of the Roman stoic fear of a man succumbing to passion and losing his masculine control.

Throughout the Middle Ages women were believed to be more sexually insatiable than men. This accepted "fact" shaped theological tracts and church law. The influential canon lawyer, Gratian, believed that women were

more "susceptible to sexual corruption than men," and by the late Middle Ages legal statutes revealed the continued belief in women as sexually voracious.[23] This concept was linked to women as temptresses to become one of the defining elements of female sexuality in the Middle Ages.

Women's sexuality was also seen as the opposite to man's active power. Her sexuality was perceived to be open and receptive, thus giving a metaphorical logic to a sexual role for women of passivity and submission. The metaphor of sexual women being "open" was pervasive, and this openness was extended to include such things as garrulousness—that is, women with open mouths. Tertullian gives a striking example of the degree to which women with "open mouths," or talkative, were associated with the lust that was defined in women by openness. He says of talkative women that "their god . . . is their belly, and so too what is neighbor to the belly."[24] Being open meant that women were lustful and receptive; it also labeled them as passive recipients of men's power. In this way, even though men had been enticed into falling from their "natural" spiritual state, they could retain their masuline power and express it sexually by dominating their partner. This sexual paradigm would have been familiar to men in the Roman Empire who had grown up considering men's role as active sexually. Woman's sexuality and sexual nature gave her enough power to lure men into lust, but the lure brought with it its own trap: to be subjected to the husband she subjected to her flesh.[25]

In about the early fifth century, the most influential of the western church fathers modified the view of sexuality that had been articulated by the earlier fathers like Ambrose and Jerome. Unlike them, Augustine did not see sexuality as an accident of Adam and Eve's fall but saw it as part of God's plan. However, Augustine did believe that Adam and Eve's disobedience in the Garden introduced physical consequences into the world. These physical consequences shaped his view of gendered sexuality.[26] Elizabeth Clark has shown how Augustine formulated a biological theory to explain his theology of original sin. Augustine argued that original sin was transmitted through semen in sexual acts that were marred by lust, the physical revelation of the original sin embedded in human flesh.[27]

Augustine's understanding of sexuality made him envision a world that was more complicated than that which polarized the world completely by gender. Augustine did not simply see sexuality located in women. When he looked for lust, he found it primarily—and for him most disturbingly—in the male erection. "[T]he genital organs have become . . . the private property of lust."[28] He described passion as that which "rises up against the soul's decision in disorderly and ugly movements."[29]

The degree to which Augustine identified the sin of lust with the male erection led his critic Julian to ask why women covered themselves even though they had no erections to hide. Augustine responded in a way that showed no particular awareness of female sexuality. He argued that women must feel some comparable movement inside, and covered their external genitals in shame for the internal movement that paralleled men's erections. For Augustine, the real cause of Adam and Eve covering themselves was that man had to hide the evidence of his losing struggle with willful flesh.[30] Augustine's view of sexuality has an implied blurring of gender distinctions. Unlike the earlier western fathers, he did not simply regard women as carnal and men as spiritual. Instead, he claimed that sexuality was natural to both genders.[31] Augustine did preserve the ancient world's gender division that equated masculinity with power and femininity with passivity. However, unlike the early church fathers, he did not use sexuality as his reason to establish these gender roles.[32]

The early centuries of the medieval world were dominated by the views of these church fathers superimposed upon the classical heritage. In spite of some implications in Augustine's thought that suggested that men and women shared a common sexual experience, the prevailing view seems to have remained more closely linked to the ancient Greco-Roman tradition. As Margaret Miles has observed, "Christians . . . assumed that there are 'natural' intellectual and psychological as well as biological differences between men and women."[33] For the early Christians, along with the ancients, this difference *was* biological.

Medieval medicine continued and expanded the ancient understandings of sexuality, which became combined with Christian theology. Many excellent works have studied the history of medieval science and medicine to understand their view of sexuality. Within these works one can see the strong gendered quality of perceptions of sexuality in the Middle Ages. Joan Cadden has directly addressed this issue in the late medieval texts in *Meanings of Sex Difference in the Middle Ages* (note 1).

All the studies reaffirm the medieval perception of the centrality of semen and menstrual blood in shaping ideas of gender and of gendered sexuality. Danielle Jacquart and Claude Thomasset in *Sexuality and Medicine in the Middle Ages* (note 16) clearly describe theories of the nature and origin of sperm. Sperm was believed to have come from various places: Ancient Greeks located its origin in the brain, believing that it descended through the spinal cord to the testicles. A second theory was that it came from all parts of the body: "Sperm is thus the seed of the man, composed of the purest substance of all parts of the body." Finally, sperm was thought to be made

from blood that was then turned into semen in the testicles. Avicenna said "It is a better-digested and subtler blood."[34]

These theories coexisted in some degree in the Middle Ages and influenced people's views of masculinity. They further point to the relationship between masculinity and rationality. If semen comes from the brain and is the essence of a man, then masculinity is equated with reason. Semen was also seen as very pure and valuable. As we have seen above, it was made of the best "purest substance" of a man, and the most refined blood. This attitude continued the classical view that saw in semen the essence and the best of a man.

For medieval physicians, menstruation defined the essence of female. As Cadden notes, "Menstruation is a prominent factor in defining both her sex and her social and cultural functions."[35] Jacquart and Thomasset have described medieval views of menstruation and menstrual blood in detail. Medieval thinkers recognized the menstrual function of supplying the fetus with nourishment. Furthermore, the nourishing function of menstruum shaped the belief that milk to nourish infants was formed from menstrual blood heated in the breasts. Scientists also believed menstruation filled a second purpose, that of purification.

Since they believed women to be too cold to burn off residual impurities, menstrual blood served this function. This process explained why women did not have secondary characteristics that marked males: beards, pronounced veins, and according to Aristotle, nosebleeds. In men, superfluous matter was expelled in these ways, but in women it was removed through menstruation.[36] This purifying function of menstruation showed menstrual blood to be derived from imperfection; it marked the inability of the body to become warm enough to refine blood. Furthermore, this meant that the blood itself was toxic, since it was made up of unrefined impurities.

The nature of menstrual blood led people to believe it had a differential impact on the two genders. The toxic qualities of menstrual blood made the process of menstruation seem beneficial to women. Menstruation cleansed women's bodies, "leaving them less polluted by harmful residues or less burdened by excess of useful residues than men."[37] Therefore, menstruation was considered good for women, and medical practice emphasized the importance of menstruation and prescribed cures for amenorrhea.

For men, on the other hand, contact with menstrual blood was dangerous. They could be polluted by the toxins that made up the fluid. For example, the author of *Women's Secrets* warns:

If you knowingly go with a menstruous woman your whole body will be infected and greatly weakened, so that you will not regain your true color and strength for at least a month, and like a liquid adhering to clothes, this stink will corrupt a man's entire insides Do not go near a menstruating woman, because from this foulness the air is corrupted, and the insides of a man are brought to disorder.[38]

The perceived toxic properties of menstrual blood permeated many folk beliefs and were said to pollute many things other than males. The presence of menstrual blood caused crops not to germinate, wine to sour, plants to parch, trees to lose their fruit, iron to be corroded, bronze to turn black, and dogs to become rabid.[39]

Medical views of the nature of male and female secretions led to different recommendations for men and women about what was healthy sexuality. For men, it was for them to save their vital force. For example, Albert the Great continued classical views by recommending against excessive intercourse for men, warning that such activity "was likely to produce numerous undesirable side effects including weakness, trembling, nervousness, ringing in the ears, protruding eyeballs, abdominal pain and hemorrhage."[40] Women, on the other hand, were to expend their toxic female substances and draw strength from the male essence. The late medieval medical tract, *Secrets of Women*, expresses this gendered perspective:

The more women have sexual intercourse, the stronger they become, because they are made hot by the motion that the man makes during coitus. Further, male sperm is hot because it is of the same nature as air and when it is received by the woman it warms her entire body, so women are strengthened by this heat. On the other hand, men who have sex frequently are weakened by this act because they become exceedingly dried out.[41]

Differential opinions on the relative value of fluids also led to different recommendations on masturbation. The belief that female secretions were toxic led to a lack of medical prohibitions of female masturbation, while at the same time the doctors urged men to avoid wasting their precious semen in masturbation. As Jacquart and Thomasset observed, "While medicine attempts to conserve male semen and reduce its production in order to avoid any loss, it encourages the expulsion of female liquid, retention of which can be harmful."[42]

Medieval views of the difference in genders due to biology ranged beyond the precise reproductive processes to include a comprehensive view of what it meant to be male and female. Joan Cadden in *Meanings of Sex Difference in the Middle Ages* has written a clear explanation of the scientific views of the differences between the genders. She quotes the medieval author Jacopo of Forlí: "It must be noted that male differs from female in three [ways], namely, complexion, disposition, and shape. And among these complexion is the most fundamental."[43]

Cadden explains the critical medieval explanation of "complexion" as the balance of qualities, especially hot, cold, moist, and dry, which characterized an individual. Of these various qualities, heat was the most fundamental physical difference between the sexes, and a cause of many other differences. Heat created boys in the womb, and as we have seen, heat allowed men to refine their nutritive superfluities into hair and beards. Women's lack of heat made them softer and less able to exercise vigorously.[44] These are only a few of the many attributes and characteristic behaviors of men and women that people attributed to men's greater heat.

Men's quality of heat was always linked to their sexual and reproductive natures. Remember, semen was the defining element of men and thus the locus of the extra heat. Not only was heat needed to concoct semen from blood but semen itself was hot. Giles of Rome had concisely stated, "Heat is the sperm's essential quality."[45] Thomas Aquinas summarized medieval scientific understanding when he explained that "sperm contains a threefold heat: the elemental heat of the semen, the heat of the father's soul and the heat of the sun."[46] So, through Thomas, we can see the way sexuality and gender were inextricably joined in the medieval mind, and the mechanism for this linkage was primarily the concept of heat. As Cadden has explained, "[Heat] was one of the most fundamental factors in the distinction between females and males. It had a place in pharmacology, astrology, and ideas about the production of semen. It operated as a basis for the conceptualization of the masculine and the feminine both within and beyond reproduction."[47]

Heat also influenced the other two defining gender characteristics, shape and disposition. By shape, medieval authors primarily meant the difference in genitals, but they also referred to such visible qualities as hairiness, which as we have seen were linked to men's heat.[48] Heat influenced the shape of the genitals because medical authorities explained women's genitals as imperfectly heated male genitalia. James Brundage has shown that the medieval legal commentators shared the physicians' views that the "shape" of the genders was determined by differential heat. For example, Nicholas of Lyra explained that women were stout and wide below, but slen-

der and graceful above the waist. This shape resulted from women's cold complexion, which allowed nutriments to settle in the lower parts of their bodies. Men had wider chests, broader shoulders, and larger heads than women because they were hot enough to quickly process their food so it settled in the upper parts of their bodies.[49]

The "shape" of the genders not only distinguished men from women by appearance but also served to dictate more general gendered characteristics. For example, Cadden demonstrates that medieval comparisons of uterus and penis "enhanced two different views of female sexual identity and, in turn, of the feminine gender. . . . [T]he emphasis upon the womb as the central female organ was in harmony with the view of women as essentially passive vessels." In addition, association of the womb with the penis suggested an active sexual organ, which was consistent with the view that women were dominated by insatiable sexual appetites.[50] The "shape" of men and women determined expected behaviors, sexual and otherwise.

The third defining quality of gender, "disposition," included behavioral and temperamental actions. These too were largely determined by the differential heat derived from the genital make-up of the two genders. The mid-thirteenth-century friar, Bartholomew the Englishman, articulated the relationship: "The male passeth the female in perfect complection, in working, in wit, in discretion, in might and in lordship. In perfect complection, for in comparison the male is hotter and dryer, and the female the contrary."[51] Bartholomew was not alone in joining, as Cadden gracefully puts it, "constitution and character."[52] For example, women are moist, thus inconstant. Men are hot, thus given to violence.[53] Medieval science offered a biological explanation for almost any gender stereotype they wanted to promulgate.

The medical texts established a sexually based grounding from which to construct gender expectations. These medical tracts joined theological understandings of gender as articulated by church fathers in a comprehensive system that had practical application as well as theoretical reflection.

One practical result of medical analysis had to do with sexual pleasure. If (and when) medicine advocated a two-seed model, then female pleasure was important, for a woman had to reach orgasm like a man in order to release her seed. Under an Aristotelian model of one seed, female pleasure was irrelevant. She was only a vessel. Once the male had released his seed the reproductive function was fulfilled.[54] The question of sexual pleasure did not end with the purely practical consideration of whether a woman needed to expel seed. Biologically based gender understandings yielded attempts to decide the nature of gender-differentiated sexual pleasure. Most

(male) authors argued that women experienced more pleasure than men, and then proceeded to explain why. Constantine the African in his treatise "On Coitus" is representative of the two-seed theory in his explanation: "Pleasure in intercourse is greater in women than in males, since males derive pleasure only from the expulsion of a superfluity. Women experience twofold pleasure: both by expelling their own sperm and by receiving the male's sperm, from the desire of their fervent *vulva*."[55] Albert the Great, who adhered to the one-seed belief, still argued that women experienced greater pleasure. However, it came from "the touch either of the man's sperm in the womb or of the penis against her sexual part."[56] Adherents to both theories of female seed could bring medical explanation to sustain the theological position of the woman as insatiable sexually.

The question of feminine pleasure also derived from medical understanding of gender-differentiated complexion. For example, Jacquart and Thomasset explain how the traditional question "Why does woman, although she is of a colder and moister nature than man, feel a more burning desire?" received two answers in addition to the two-seed explanation described above: (1) damp wood takes a long time to catch fire, but it burns longer (2) the quality of cold seeks its opposite, so it yearns for hot sperm. Some also suggested that women "experienced a pleasure that was greater in quantity, but lesser in quality and intensity, than men's."[57] The *Secrets of Women*, a late-thirteenth-century treatise falsely attributed to Albert the Great, added a misogynist twist to the question of pleasure: Woman has "a greater desire for coitus than a man, for something foul is drawn to the good."[58] The issue of sexual pleasure, then, was deeply shaped by the biological understandings of gender.

Most of these medical and scientific works were written by men and shaped by men's perceptions of women. Hildegard of Bingen was one exception to this rule, and her understanding of gendered sexuality shows subtle transformations in the prevailing wisdom. Hildegard avoided the misogynist views of sexual secretions outlined by male philosophers. Instead, she offered a description that reversed the traditional vision: "[T]he strength of man in his genital member is turned into poisonous foam, and the blood of woman is turned into a contrary effusion."[59] In Hildegard's analysis, men produce the "poisonous" substance, not women.

In addition, Hildegard departed from traditional medieval views by arguing that women were less lustful than men. She explained that "the storm of sexual lust" in women could "expand within the wide open space of the uterus and the abdomen, thus dissipating and arousing the woman less violently."[60] In this, Hildegard seems to approach modern analyses that

see women's sexual expression as more diffuse than men's. In any case, here is another example of Hildegard's gendered approach to the question of sexuality.

The abbess, however, was a product of her times. Hildegard built on Aristotelian understanding of male and female sexuality, but gave it her own stamp.[61] For Hildegard, men and women were different, and each expressed love and sexuality consistent with his or her gender. She wrote, "The man's love, compared with the woman's, is a heat of ardour like a fire on blazing mountains, which can hardly be put out, whilst hers is a wood-fire that is easily quenched; but the woman's love compared with the man's is like a sweet warmth proceeding from the sun, which brings forth fruits."[62] Hildegard emphasized the fruitful, reproductive function of women's sexuality, and contrasted it with men's sexual activity: "she [is] like a threshing-floor pounded by his many strokes and brought to heat while the grains are threshed inside her."[63] Woman's sexuality is fruitful and passive; man's is active, indeed violent in its expression. This view is consistent with Hildegard's knowledge of medieval "complexion," which endows men with more heat and action, but it seems once again tempered by her awareness of women's experience.

Hildegard was not the only religious thinker shaped by medical and scientific views of gendered sexuality. Pierre A. Payer, in *The Bridling of Desire*, has studied late medieval theologians for their views on sexuality. Within his careful study one can read the theological implications of the view of sexuality that based so much on gendered interpretations. Payer has analyzed the close relationship between marriage and sexual intercourse in medieval thought. At first glance the conjugal debt seemed to weigh equally upon men and women. As Payer noted, "The husband and wife have equal rights to ask or demand and both lie under the duty to respond when asked."[64] Yet theologians' views about male and female sexuality determined differential application of the requirement to pay the debt.

Thomas Aquinas said that the individual need not risk physical well-being in order to pay the marital debt. As Payer noted, "The condition is usually worded in an androcentric manner, envisaging danger to the husband's health should he pay the debt."[65] This is perfectly consistent with the gendered view of sexuality that believed semen to be valuable and to be used sparingly. Albert the Great further recognized that at times men might be unable to pay the debt due to "inability." Women are to be aware in such instances that they cannot expect the marital debt to be paid.[66] Again this was framed in a way that protected men. Women's sexuality was believed to be at least always ready if not insatiable.

Theologians recognized further danger for men in paying the marital debt. We have seen how women and their sexual organs represented some danger or pollution to men. This belief led medical authorities to believe that women could give men disease more easily than the reverse. Jacquart and Thomasset have carefully analyzed this belief, which was perhaps most clearly summarized by William of Conches:

> The hottest woman is colder than the coldest man: such a complexion is hard and extremely resistant to male corruption; nonetheless the putrid matter, coming from coitus with lepers, remains in the womb. And when a man penetrates her the penis, made of sinews, enters the vagina (*vulva*) and, by virtue of its attractive force, attracts this matter to itself (and to the organs to which it is attached) and transmits it to them.[67]

William's summary links the complex beliefs about female constitution and sexuality. She is cold, profoundly different from men, and thus dangerous to them. Therefore scholastics believed that men had more right to refuse the marital debt in such circumstances as the wife having leprosy than women did in the reverse instance.[68]

Differential application of the marital debt also took into consideration men's active role (sexual and otherwise). Men were supposed to be sensitive to their wives' "signals of sexual desire" and pay the marital debt even if the woman did not explicitly request such payment. Aquinas explained: "For the husband, because he has the more noble part in the conjugal act, is naturally more disposed than his wife not to be ashamed to ask for the debt. Consequently, the wife is not bound to pay the debt to her husband who does not seek it in the way the husband [is bound to pay it] to his wife [who does not seek it]."[69] Here the requirements preserve the gender roles that were shaped by perceptions of biology that said men's expressions of sexuality were supposed to be active and women's passive. Thus, men should "ask," an active role, and women should "signal," a passive one. One can see that even with respect to the marital debt, theoretically one of the least gendered medieval notions, ideas of gendered sexuality shaped people's practice.

Helen Rodnite Lemay has done fine work in looking at the consequences of medieval ideas of women's biological inferiority. Lemay has studied thirteenth- and fourteenth-century lectures on female sexuality; she demonstrates that as universities studied medical tracts on women, scholars concluded that because women were biologically inferior they were dangerous

to men.[70] In her edition of the Pseudo-Albert tract, *Women's Secrets*, Lemay argues that by the late Middle Ages theology had combined with medical views of female sexuality to offer a view of women that justified their persecution as witches.[71] This is perhaps the ultimate practical application of beliefs about gendered sexuality.

So far, the texts I have been discussing as revealing a gendered view of sexuality have been medical and religious tracts. These are the ones that have been most studied by medievalists and in which the information is most explicitly addressed. However, they are not the only texts that yield information about ideas of male and female sexuality in the Middle Ages. Another source of information is in hagiographic and mystical writings. These texts, coming from a different point of view than the medical/theological tracts, offer a more nuanced view of gendered sexuality. They assume distinct differences between men and women's expressions of sexuality, but their articulation is not centered so materially in semen, blood, and bodily constitution.

In my study of the sexual ideas implicit in the lives of seven women saints, I demonstrate that, in contrast to the writings of the church fathers, these lives did not reject sexuality and physicality. Women's sexuality was praised by people like Helia, who lauded reproductive imagery: "Happy childbirth for the men, the women, the old who are made fecund." Melania the Younger, speaking of vaginas, said no bodily part that God had created could be filthy, because through it were born the patriarchs, prophets, and other saints. Constantina praised physicality, saying "We need to seek how to please God in our bodily members [as well as spiritually]."[72] This positive view of female sexuality did not extend to men. In these saints' lives male sexuality most often was expressed in a negative light; it was called "diabolical passion."[73] This view most likely grew from the belief that male sexuality restricted women's freedom to pursue their spiritual goals. After all, that was the point of many of such saints' lives that praised women's personal sovereignty that came with a life of chastity.

The portrayal of gendered sexuality in these saints' lives reaffirms a number of the prevailing beliefs about male and female sexuality. The women's fears about being dominated by male sexual expression parallel the classical belief that men were the active partners in sexuality. The validation of female physicality is consistent with medieval views of women as more carnal than men. However, these lives undermine the belief that women's sexuality was insatiable. Unlike the experience described by ascetic men, these women were not plagued by sexual dreams as they renounced sexual intercourse.[74] It seems that women's physicality was not always equated with sexuality, at least not in their own minds.

John Giles Milhaven, in *Hadewijch and Her Sisters*, offers a theoretical model for studying mystic tracts that further illuminates gendered views of sexual experiences. Milhaven analyzes an alternative way of "loving and knowing," that is, alternative to that of traditional male theologians who emphasized the rational as the only legitimate way of knowing. The alternative way of loving and knowing is expressed in mystic writings referring to the love of God, but it also can shed light on women's sexual expression. This way of "knowing" is physical, but not physical that leads to spiritual transcendent knowledge. The physical knowing is sufficient. Milhaven summarizes this awareness: "Complete immersion in a singular place and time, agency and interaffectivity, pervasion by physical touch, surging physical need or desire, and pleasuring typical of family life."[75]

Milhaven includes in his book a discussion of Thomas Aquinas's view of sexuality by way of contrast with that articulated by Hadewijch. Milhaven shows that Aquinas rejected any sensual experiences, including sexual intercourse, unless these experiences led to rational (spiritual, transcendent) knowledge. Since sex was "founded in pure sense knowledge that had no share in reason," Thomas rejected it.[76] This contrast again reaffirms medieval notions that women were more physical and carnal than men, but like in the earlier women saints' lives, Hadewijch makes this a positive rather than a negative quality.

Milhaven also analyzes Hadewijch's portrayal of the mutuality of love and affection. In her description of the mystic union with God, Hadewijch uses terms of mutual pleasuring. Milhaven sees this mutuality as part of this alternative way of knowing and loving.[77] While Hadewijch uses these terms in a mystic sense, they also illuminate a feminine perspective on love (and sex) in the world. Like many mystics, her description of the mystic union was cast in strongly sexual terms:

> . . . with what wondrous sweetness the loved one and the Beloved dwell one in the other, and how they penetrate each other in a way that neither of the two distinguishes himself from the other. But they abide in one another in fruition, mouth in mouth, heart in heart, body in body, and soul in soul, while one sweet divine nature flows through both and they are both one thing through each other, but at the same time remain two different selves—yes, and remain so forever.[78]

When mystics use sexual vocabulary to describe religious feelings and experiences, it yields information about how they perceive sexuality as well as how they perceive the transcendent. Milhaven's analysis of Hadewijch's

words offers an excellent beginning model for others to use in mining mystic tracts for information about gendered sexuality. The writings of mystics such as Angela of Foligno, Catherine of Siena, Mechtild of Magdeburg, and many others could benefit from analysis like Milhaven's.

This look at some of the recent works studying medieval sexuality has been designed to show the intimate relationship between biology and gender in the medieval mind. Furthermore, this complex connection was expressed in people's views of gendered sexuality. They believed that the two genders expressed themselves sexually in dramatically different ways, and these differences were again biologically determined. I have tried to indicate that perceptions of this gendered sexuality appear in many different kinds of medieval texts, from theology to medicine. I know of little on this subject from the point of view of literary sources, although I suspect that those would be rich sources of information.

This chapter and the bibliography attached show that studies of medieval gendered sexuality are really only beginning. As Cadden has demonstrated, "Medieval distinctions of sex and gender [were] . . . one of the important distinctions."[79] Gender was one of the central organizing principles of the Middle Ages. We need to know a good deal more about medieval views on what it meant to be male and female, and how those gender expectations shaped people's sexual lives. The books and articles I have listed in the bibliography point to methods and sources that can be used to develop such studies. In addition to the works I have used directly in this essay I have listed a number of general secondary works exploring women's roles. There is less general material of this sort on men's roles and on definitions of masculinity, but I have found Sørensen's work to be very helpful. The only primary sources I have included in the bibliography are those I have used in this essay, because there are many sources that yield insights into gendered views of sexuality. My book, *Medieval Sexuality: A Research Guide*, listed in the bibliography, offers an extensive listing of primary sources, many of which will be useful in future studies of gendered sexuality. Actually, the key to such studies is not what sources to use, but a different method of looking at the many medieval sources of information on sexuality. This method requires that we suspend for a while our twentieth-century views on gender to look closely at the way people in the Middle Ages understood biology, gender, and the way those elements shaped their identities and their lives.

NOTES

1. Joan Cadden, *Meanings of Sex Difference in the Middle Ages* (Cambridge: Cambridge University Press, 1993), 7, for example notes that Michel Foucault in his influential *History of Sexuality* was uninterested in sex differences and wrote a his-

tory of male sexuality.

2. Monica H. Green, "Female Sexuality in the Medieval West," *Trends in History* 4 (1990), 129.

3. See Cadden, *Meanings of Sex Differences*, 202–18, for a discussion of the medical treatment of ambiguous sexuality.

4. Augustine, *City of God* (Harmondsworth, England: Penguin Books, 1972), 661–62.

5. James A. Brundage, *Law, Sex, and Christian Society* (Chicago: University of Chicago Press, 1987), 15.

6. Aretaeus, *Causes and Symptoms of Chronic Diseases*, quoted in Peter Brown, *The Body and Society* (New York: Columbia University Press, 1988), 10.

7. Aline Rouselle, *Porneia: On Desire and the Body in Antiquity* (Oxford: Basil Blackwell, 1988), 18.

8. Ibid., 20.

9. Paul Veyne, *A History of Private Life* (Cambridge, MA: Harvard University Press, 1987), 243.

10. Ibid.; Paul Veyne, "Homosexuality in Ancient Rome," in *Western Sexuality: Practice and Precept in Past and Present Times* (Oxford: Basil Blackwell, 1985), 29.

11. Veyne, *Private Life*, Basil Blackwell, 243.

12. Vern L. Bullough and Bonnie Bullough, *Cross Dressing, Sex, and Gender* (Philadelphia: University of Pennsylvania Press, 1993), 32–33.

13. Rouselle, *Porneia*, 33–37.

14. Isidore of Seville, *Etimologías*, vol. I (Madrid, 1982), xi, 7, 30, 801. Isidore of Seville, "De Ecclesiasticis Officiis, Lib. II," xx, 6, *PL* 83:811. See J.E. Salisbury, *Church Fathers, Independent Virgins* (London: Verso, 1991), 21.

15. Ambrose, "Letter No. 78," in *Saint Ambrose: Letters* (New York: Fathers of the Church, 1954), 435.

16. Jerome, "To Eustochium," in *A Select Library of Nicene and Post Nicene Fathers, V, VI* (New York: n.p. 1893), 26; Isidore, *Etimologías XI*, 1, 98, 29. See also Danielle Jacquart and Claude Thomasset, *Sexuality and Medicine in the Middle Ages* (Princeton, NJ: Princeton University Press, 1988), 13.

17. Veyne, "Homosexuality," 29.

18. Isidore, *Etimologías* X, 179, 835.

19. Margaret R. Miles, *Carnal Knowing: Female Nakedness and Religious Meaning in the Christian West* (Boston: Beacon Press, 1989), 142.

20. Jacquart and Thomasset, *Sexuality and Medicine*, 14; and Bullough, *Cross Dressing*, 48.

21. Isidore, *Etimologías*, xi, 24, 43.

22. Jerome, "Against Jovinian," 367 in *A Select Library of Nicene and Post Nicene Fathers* (New York: n.p., 1893).

23. Brundage, *Law, Sex, and Christian Society*, 246, 492.

24. Tertullian, "To His Wife," in *A Select Library of the ante-Nicene Fathers* (Grand Rapids, MI: Eardmans Publishing, 1951), 43.

25. Salisbury, *Church Fathers, Independent Virgins*, 24.

26. See Ibid., 39–45, for an explanation of Augustine's views of the Fall and sexuality.

27. Elizabeth Clark, "Vitiated Seed and Holy Vessels: Augustine's Manichean Past," in *Ascetic Piety and Women's Faith* (Lewiston, NY: Edwin Mellen Press, pub. 1986), 291–349.

28. Augustine, *City of God*, XIV, 19, 581.

29. Augustine, *Against Julian* (New York: Fathers of the Church, 1957), 119.

30. Salisbury, *Church Fathers, Independent Virgins*, 45.

31. Augustine, "Adulterous Marriages," in *Saint Augustine: Treatises on Marriage and Other Subjects* (New York: Fathers of the Church, 1955), 62.

32. Salibury, *Church Fathers, Independent Virgins*, 49–50.
33. Miles, *Carnal Knowing*, 45.
34. Jacquart and Thomasset, *Sexuality and Medicine*, 52–60.
35. Cadden, *Meanings of Sex Difference*, 174.
36. Jacquart and Thomasset, *Sexuality and Medicine*, 71–73.
37. Cadden, *Meanings of Sex Difference*, 176.
38. Helen Rodnite Lemay, *Women's Secrets* (Albany: SUNY Press, 1992), 88–89.
39. Salisbury, *Church Fathers, Independent Virgins*, 24.
40. Brundage, *Law, Sex, and Christian Society*, 287.
41. Lemay, *Women's Secrets*, 127.
42. Jacquart and Thomasset, *Sexuality and Medicine*, 153.
43. Cadden, *Meanings of Sex Difference*, 170.
44. Ibid., 171.
45. Jacquart and Thomasset, *Sexuality and Medicine*, 59.
46. Ibid., 57.
47. Cadden, *Meanings of Sex Difference*, 280.
48. Ibid., 177–81.
49. Brundage, *Law, Sex, and Christian Society*, 426.
50. Cadden, *Meanings of Sex Difference*, 178.
51. Ibid., 183.
52. Ibid., 184.
53. Ibid., 185–87.
54. Jacquart and Thomasset, *Sexuality and Medicine*, 61–70.
55. Cadden., *Meanings of Sex Difference*, 65.
56. Ibid., 121. For a full analysis of Albert the Great's position on this subject, see Danielle Jacquart and Claude Thomasset, "Albert le Grand et les problèmes de la sexualité," *History and Philosophy of the Life Sciences, Pubblicazioni della Stazione Zoologica di Napoli* 3 (1981), 73–93.
57. Jacquart and Thomasset, *Sexuality and Medicine*, 81.
58. Lemay, *Women's Secrets*, 51.
59. Cadden, *Meanings of Sex Difference*, 78.
60. M.H. Green, "Female Sexuality," 146. See also Joan Cadden, "It Takes All Kinds: Sexuality and Gender Differences in Hildegard of Bingen's 'Book of Compound Medicine'," *Traditio* 40, 1984, 149–74, 60, for an excellent analysis of Hildegard's views.
61. Cadden, *Meanings of Sex Difference*, 70–88.
62. Barbara Newman, *Sister of Wisdom* (Berkeley: University of California Press, 1987), 111. See also Miles, *Carnal Knowing*, 104.
63. Miles, *Carnal Knowing*, 104.
64. Pierre J. Payer, *The Bridling of Desire: Views of Sex in the Later Middle Ages* (Toronto: University of Toronto Press, 1993), 93. See also Brundage, *Law, Sex, and Christian Society*, 255, for Gratian's expression of the equality of sexual rights between men and women within marriage.
65. Payer, *Bridling*, 95.
66. Ibid., 94.
67. Jacquart and Thomasset, *Sexuality and Medicine*, 189.
68. Payer, *Bridling*, 110.
69. Ibid., 94. See also Brundage, *Law, Sex, and Christian Society*, 427.
70. Helen Rodnite Lemay, "Some Thirteenth and Fourteenth Century Lectures on Female Sexuality," *International Journal of Women's Studies* 1, 4 (1978), 392.
71. Lemay, *Women's Secrets*, 35.
72. Salisbury, *Church Fathers, Independent Virgins*, 112–13.
73. Ibid., 115.
74. Ibid., 116–17. See also Carolyn Walker Bynum, *Holy Feast and Holy Fast*

(Berkeley: University of California Press, 1987), in which she argues that women were more concerned with images of food than images of sexuality.

75. John Giles Milhaven, *Hadewijch and Her Sisters* (Albany: SUNY Press, 1993), 116.

76. Ibid., 137, 140.

77. Ibid., 18.

78. Ibid., 5.

79. Cadden, *Meanings of Sex Difference*, 281.

BIBLIOGRAPHY

Ambrose. "Letter No. 78" in *Saint Ambrose: Letters*. New York: Fathers of the Church, 1954.

Augustine. "Adulterous Marriages." In *Saint Augustine: Treatises on Marriage and Other Subjects*. New York: Fathers of the Church, 1955.

———. *Against Julian*. New York: Fathers of the Church, 1957.

———. *Concerning the City of God Against the Pagans*. Harmondsworth: Penguin, 1972.

Bennett, Judith, et al., eds. *Sisters and Workers in the Middle Ages*. Chicago: University of Chicago Press, 1989.

Brown, Peter. *The Body and Society: Men, Women, and Sexual Renunciation in Early Christianity*. New York: Columbia University Press, 1988.

Brundage, James A. *Law, Sex, and Christian Society in Medieval Europe*. Chicago: University of Chicago Press, 1987.

Bullough, Vern L., and Bonnie Bullough. *Cross Dressing, Sex, and Gender*. Philadelphia: University of Pennsylvania Press, 1993.

Bynum, Carolyn Walker. *Holy Feast and Holy Fast*. Berkeley: University of California Press, 1987.

Cadden, Joan. "It Takes All Kinds: Sexuality and Gender Differences in Hildegard of Bingen's 'Book of Compund Medicine.'" *Traditio* 40 (1984), 149–74.

———. *Meanings of Sex Difference in the Middle Ages*. Cambridge: Cambridge University Press, 1993.

Clark, Elizabeth. "Vitiated Seed and Holy Vessels: Augustine's Manichean Past." In *Ascetic Piety and Women's Faith* (Lewiston, 1986), 291–349.

Duby, Georges. *The Knight, The Lady, and the Priest*. Trans. B. Bray. New York: Pantheon Books, 1983.

Erler, Mary, et al., eds. *Women and Power in the Middle Ages*. Athens: University of Georgia Press, 1988.

Green, Monica H. "Female Sexuality in the Medieval West." *Trends in History* 4 (1990), 127–58.

Holloway, Julia Bolton, et al., eds. *Equally in God's Image: Women in the Middle Ages*. New York: P. Lang, 1990.

Isidore of Seville. *Etimologías*, vol. I. Ed. J. Oroz Reta and M. Marcos Casquero. Madrid: Biblioteca de Autores Cristianos, 1982.

———. "De Ecclesiasticis Officiis, Lib. II." xx, 6, *PL* 83:811.

Jacquart, Danielle, and Claude Thomasset. "Albert le Grand et les Problèmes de la sexualité." *History and Philosophy of the Life Sciences, Publicazioni della Stazione Zoologica di Napoli* 3 (1981), 73–93.

———. *Sexuality and Medicine in the Middle Ages*. Princeton: Princeton University Press, 1988.

Jerome. "To Eustochium," "Against Jovinian." In *A Select Library of Nicene and Post Nicene Fathers*, V, VI. New York, 1893.

Labarge, Margaret W. *A Small Sound of the Trumpet: Women in Medieval Life*. Boston: Beacon Press, 1986.

Lemay, Helen Rodnite. "Some Thirteenth and Fourteenth Century Lectures on Female

Sexuality." *International Journal of Women's Studies* 1, 4 (1978), 391–99.

———. *Women's Secrets*. Albany: State University of New York Press, 1992.

Miles, Margaret R. *Carnal Knowing: Female Nakedness and Religious Meaning in the Christian West*. Boston: Beacon Press, 1989.

Milhaven, John Giles. *Hadewijch and Her Sisters*. Albany: State University of New York Press, 1993.

Newman, Barbara. *Sister of Wisdom: St. Hildegard's Theology of the Feminine*. Berkeley: University of California Press, 1987.

Payer, Pierre J. *The Bridling of Desire: Views of Sex in the Later Middle Ages*. Toronto: University of Toronto Press, 1993.

Petroff, Elizabeth A. *Body and Soul: Essays on Medieval Women and Mysticism*. Oxford: Oxford University Press, 1994.

Rouselle, Aline. *Porneia: On Desire and the Body in Antiquity*. Oxford: Basil Blackwell, 1988.

Salisbury, Joyce E. *Church Fathers, Independent Virgins*. London: Verso, 1991.

———. *Medieval Sexuality: A Research Guide*. New York: Garland Publishing, 1990.

———, ed. *Sex in the Middle Ages: A Book of Essays*. New York: Garland Publishing, 1991.

Sorensen, P.M. *The Unmanly Man: Concepts of Sexual Defamation in Early Northern Society*. Trans. J. Turvill-Petre. Odense: Odense University Press, 1983.

Stuard, Susan Mosher. *Women in Medieval History and Historiography*. Philadelphia: University of Pennsylvania Press, 1987.

Tertullian. "To His Wife." In *A Select Library of the ante-Nicene Fathers*. Grand Rapids: W.B. Eardmans, 1951.

Veyne, Paul. "Homosexuality in Ancient Rome." In *Western Sexuality: Practice and Precept in Past and Present Times*. Oxford: Basil Blackwell, 1985.

———, ed. *A History of Private Life I: From Pagan Rome to Byzantium*. Cambridge, MA: Harvard University Press, 1987.

Wack, Mary Francis. "The Measure of Pleasure: Peter of Spain on Men, Women, and Lovesickness." *Viator* 17 (1986), 173–96.

Chaste Marriage in the Middle Ages

"It were to hire a greet merite"

Margaret McGlynn and Richard J. Moll

A chaste marriage[1] is a relationship that is a normal marriage in every sense except that the participants abstain from sexual activity. Throughout the Middle Ages this practice was undertaken by many people in different parts of the Christian world, at different times and for a variety of reasons. Modern scholars have examined the phenomenon through three different avenues. The earliest form of chaste marriage studied is *syneisaktism*, practiced by desert ascetics. Scriptural interpretation and examinations of the writings of church fathers have contributed to our understanding of this practice. Chaste marriage has also been examined as a by-product of the drive for a celibate clergy, which forced many married priests into vows of chastity within wedlock. Finally, hagiographical sources have been combed in an attempt to observe the practice of chaste marriage within the lay community. Although roughly chronological, these fields of inquiry are by no means mutually exclusive. The debates that surrounded one form of chaste cohabitation inevitably influenced the other forms of the practice, while hagiographical representations, although they dominate scholarship on the phenomenon in the later Middle Ages, are equally numerous and equally important for the period before the twelfth century.

The purpose of this study, therefore, will be to trace the larger patterns of chaste marriage throughout the Middle Ages. Although the field is too vast to allow for an exhaustive discussion, we will examine some of the strengths and weaknesses of current scholarship. The three current avenues of inquiry, for example, each have their own limitations as paths to a realistic picture of chaste marriage. *Syneisaktism* and clerical chaste marriage both resulted from institutional needs, while hagiography presents an idealized picture of chastity and often virginity within marriage. None of these forms of the practice necessarily represents the views or actions of the average layperson, nor do they seem likely to have appealed to them. We

will therefore attempt to propose new avenues of inquiry that may lead to a more complete view of the custom as it was perceived and practiced in the Middle Ages.

Chaste marriage was based on a perception of sex as an activity that held a true Christian from the achievement of sanctity. This bias against sexual pleasure pervaded the early church and led to the exaltation of virginity, often at the expense of marriage. Even for those, such as Augustine, who did not entirely reject marriage, its thirty-fold reward compared unfavorably to the sixty-fold reward of widowhood or the hundred-fold reward of virginity. This aversion to sex does not seem justified on the basis of the words of Christ as related in the Gospels, nor does it come from the Pauline letters. While St. Paul's lukewarm endorsement of marriage hardly swept all opposition before it, neither did it seem to provide any foundation for an outright rejection of the practice. Yet the sexual attitudes of the church fathers, which Brundage argues "sprang in large part from the sexual morality of the late ancient philosophical schools, especially from the vulgarized Stoicism current in the late Roman Empire,"[2] shaped the attitudes of the Western church profoundly. It was impossible, however, for the church fathers to ignore the fact that sex was an integral part of marriage. Although the patristic writers generally agreed that the goods of marriage rectify the sin of sex, chastity remained the preferred state. Augustine's conception of marriage, however, which was based on consent rather than consummation, allowed for both states. He argued that in the later years of a marriage a couple could adopt a chaste lifestyle. According to Augustine, the natural transformation to chastity in the later years of a marriage could even strengthen the marital bond.[3] In a variety of his writings he commented on and corresponded with a large number of couples who had just this sort of chaste relationship, most notably Paulinus of Nola.[4] Assuming that chaste marriages were widely practiced, Augustine's model of a conversion to chastity seems more likely to have been popular than the virginal heroics practiced by ascetics and saints alike.

The maintenance of virginity, while held as an ideal by all the patristic writers, was often not easily attainable, especially for women. The laws penalizing celibacy enacted under the Emperor Augustus made avoidance of marriage difficult, as did familial and societal pressures.[5] Some scholars, most notably Hans Achelis, have argued that early Christians sought relief from these pressures in spiritual marriages, that is, marriages entered into by two ascetics, with the clear understanding that the marriage would never be consummated. The practice of chaste cohabitation in the East is known as *syneisaktism*, while for the West scholars commonly use the term *mulieres*

subintroductae.[6] The argument for the early practice of *syneisaktism* is based on a disputed passage from St. Paul's first letter to the Corinthians.[7] There is, however, no other evidence to support the appearance of the phenomenon before the third century, and it seems unlikely that such a departure from traditional relationships could have gone unnoticed.

More evidence for this practice exists from the third century onward, both among ascetics and within the clerical community. As JoAnn McNamara points out, "It was the common assumption that men could not readily live and function effectively without the services of women, and that women could rarely live at all without the support of men."[8] Despite the apparent convenience of this living arrangement, the practice came under the condemnation of the church fathers, particularly John Chrysostom, whose treatise *Adversus eos* condemns the practice.[9] While Augustine wrote approvingly to Paulinus of Nola, who had gathered around himself a community of couples practicing chaste marriage, it was quickly pointed out that this form of asceticism was beyond most people and would be nothing but a new avenue to temptation for many.[10] De Labriolle argues that "l'Église ait jamais encouragé, réglementé cette forme bizarre d'héroïsme, acceptant que les fidèles s'expossissent à une tentation quotidiennement renouvelée pour la gloire incertaine d'en triompher quotidiennement."[11] The arrangement seems often to have degenerated into a form of clerical concubinage, a cause for scandal and sin, not only because those who ought to have been most holy were falling prey to sexual temptation, but because in so doing they were breaking their vow of chastity. Jerome referred to the *subintroductae* as "one-man whores" (*meretrices univirae*), and the practice was denounced by many church councils. As late as the seventh century "ecclesiastics at the Council of Bordeaux were still forbidding the practice which had been outlawed by at least ten previous councils and synods since the third century."[12]

At the same time that ascetics were renouncing sexual activity while retaining the form of marriage, the first calls for clerical celibacy began to ring through the Western church. This demand had two bases. The first was the demand for cultic purity, which insisted that sexual purity was necessary for worship. As the Christian religion competed with the dualistic religions it felt an increasing need to demonstrate the superiority of its ministers, and to go beyond the Levitical decrees which bound the Jewish priesthood. As Frazee argues, "The Christian enthusiasts had support through appeal to the worship in Judaism and the Hellenistic cults for their demands that their own ministers prepare for the Eucharist through sexual abstinence."[13] As the Christian liturgy became more complex and acts of worship more frequent, the times when sexual activity was permissible became

fewer and complete sexual abstinence came to seem more appropriate for the priest. The second reason for clerical celibacy was more mystical, a belief that virginity allowed one to approach more closely to the divine essence. Crouzel draws on the witness of John the Evangelist, declaring that "dans les traditions greco-romaines, les vierges étaient considérées comme plus aptes à la divination."[14]

While clerical celibacy became increasingly desirable, at least in the eyes of ascetic and reforming bishops, the fact remained that the vast majority of priests were married. Unable to conceive of destroying valid marriages, the synod of Elvira (ca. 305) was the first to take the bold step of forbidding clergy in major orders to have sexual relations with their wives.[15] Though Elvira was merely a provincial Spanish synod, the idea quickly spread, so that by the end of the fourth century the decretals of Popes Damasus and Siricius demonstrate that sexual continence for clerics in major orders had become an ideal of the Latin church.[16] The campaign was extended in the Councils of Ankara (317) and Neocesaria (314–325), which introduced the idea that an ordained man might not marry, a prohibition that appears to have been well established by the fifth century.[17] This ideal was brought into the civil law in the Theodosian code of 438, which adopted the Nicene canon forbidding women, except close relatives, to live in the same house as a cleric, and in the Justinian legislation, which further forbade a married man with children to become a bishop and ordered that any married bishop should abstain from sexual relations with his wife.[18]

Throughout this legislation there was no suggestion that the marriage should be dissolved. Indeed, from one point of view the relationship between husband and wife was being deepened; a letter from Pope Leo the Great to Rusticus, bishop of Narbonne, expressed the idea that from a carnal marriage a new and deeper spiritual marriage would emerge. Despite this exalted idea, there is little evidence that spiritual marriage appealed to the majority of Western priests, or to the wives who were to be so casually put aside. The ideal of a celibate clergy did not in fact become a reality, and though there is little in the way of statistical evidence, it seems likely that the majority of clergymen between the two great reforming periods of the fourth and eleventh centuries were in fact married and sexually active. Despite this disappointment, church legislation continued to exhort its clergy to the celibate ideal throughout these centuries.

The second major push toward clerical celibacy came with the Gregorian reform, and was ultimately successful. This reform had a very different basis from the first attempt to enforce celibacy among the clergy. Cultic purity took a back seat to disciplinary and organizational considerations.

Nepotism and simony had become major problems, particularly in the Germanic church, and the church did not wish to deal with the problems of providing for a clerical wife and family. This, combined with the growth of monastic influence in the church, argued for greater church control over secular society in general and over clerical personnel in particular. The work of the reformers was completed in the first and second Lateran Councils of 1123 and 1139, respectively. A canon was passed at First Lateran declaring that the marriage of anyone in higher orders was forbidden. This was a major step, since as Frazee points out, "church leaders now presumed to say, for the first time, that the clerical order was an impediment to marriage."[19] At the second Lateran Council this legislation was brought to its logical conclusion when the ordination of married men was prohibited. This has remained the position of the Roman church from the twelfth century to the present day, but as with the first attempt at reform, when reforming energies were spent, the clergy relapsed into the married state, and from the fourteenth century to the Counter-Reformation married priests were common.[20]

While the idea of chaste marriage was emphatically rejected by the clergy as a solution to the question of clerical celibacy, it achieved a certain degree of popularity among the pious laity. The negative views of sex held by the church fathers permeated the Western church, affecting the laity as well as the clergy. Payer points out that "this view is reflected in the numerous regulations prohibiting sexual relations during the major liturgical seasons, on feasts and Sundays, and before communion." He further argues that "these regulations were not proposed as a challenge to the Christian to forgo something good but difficult to give up. They were proposed so that the Christian might approach the altar with a pure body and mind. Fundamentally, sex is considered to have a contaminating effect, both physically and spiritually."[21] Thus some devout Christians sought to avoid this contamination by abstaining from sex altogether.

Such a choice was riddled with difficulty. In the early period there was no organized form of monastic life, and so no clear place in society for the virgin. Even after the growth of monasticism, there remained a scarcity of monastic sites to which pious women could retreat. We have already seen that chaste marriage was one solution adopted by ascetic couples wishing to retain their virginity within a situation which was acceptable to the community. Although the church discouraged the practice, for reasons given above, it was unable to forbid chaste wedlock completely since it was advocating chaste marriage as a solution to the problem of the married clergy. The church found that its hands were tied in its attempts to enforce clerical celibacy by its unwillingness to declare the properly celebrated marriages of

priests invalid. This unwillingness was based in the fact that the church at this time was making a concerted effort to define its ideas of marriage, and to bring the whole area of marriage safely within the jurisdiction of the church courts. Part of this campaign was an effort to define exactly what makes a marriage, and thus to make it possible to determine when a marriage had taken place. This required some consideration of the place of sex in marriage.

The *Decretum* of Gratian was intended to reconcile the conflicting views of previous writers and produce a new synthesis. Gratian's definition of marriage is thus an essential starting point for the high Middle Ages. Gratian distinguished two stages in marriage: the exchange of consent, which led to a *matrimonium initiatum*, and consummation, which caused the *matrimonium ratum*, the indissoluble marriage. In his view of consummation as a natural and essential part of an indissoluble marriage, Gratian was part of a long tradition. There was, however, one marriage which the church proclaimed had never been consummated, that of Mary and Joseph, but their marriage could not be anything other than perfect. The theologians and canonists went to work.

Gratian's attempt to reconcile the marriage of Mary and Joseph with rules that might apply to ordinary mortals was clumsy and still seems to imply that coitus was necessary for a valid marriage.[22] Hugh of St. Victor, on the other hand, provided an innovative solution in his two treatises *De beatae Mariae virginitate* and *De Sacramentis*. He distinguished two sacraments in marriage: marriage itself, which represents the union of God and the soul and does not require consummation, and the office of marriage, representing the union of Christ and the church, which does require consummation. This solution provided both for the holy union of Mary and Joseph and the regular marriage of ordinary mortals. Peter Lombard refined Hugh's thought still further in describing marriage as one sacrament, but one which has two aspects, the spiritual and physical. Mary and Joseph's marriage was purely spiritual, but it was no less perfect because of this. This still caused a problem for proponents of chaste marriage: is the higher union of Mary and Joseph placed beyond the reach of ordinary couples, is consummation still required for a valid marriage? Hugh of St. Victor did not think so, and he allowed for a situation in which the husband and wife would mutually vow continence from the beginning of their marriage.

This, however, did not help couples who had already consummated their marriages and wish to assume a chaste relationship. The idea that bound them, that of the conjugal debt, was based on the Pauline letters. In St. Paul's first letter to the Corinthians he had warned, "Do not refuse each

other except by mutual consent, and then only for an agreed time, to leave yourselves free for prayer; then come together again in case Satan should take advantage of your weakness to tempt you."[23] In the same letter he had already pointed out that in marriage the wife's body belonged to the husband, as the husband's body belonged to the wife. Because of the conjugal debt, neither could refuse sex to the other, since this could lead the spurned partner into fornication and thus to sin.[24] The chaste marriage of Mary and Joseph, however, meant that as much as the church wished to draw a clear line between the celibate clergy and the married and procreative laity, it could not make consummation a condition for a valid marriage, or regular intercourse a necessary part of a marriage. The best that it could do was insist that any vow of continence should be mutual and freely given. Once given, the vow could not be rescinded, in fact Innocent IV "went so far as to declare that if a husband and a wife mutually vowed continence and if after the death of the first spouse one of them remarried, the children of the second union would be illegitimate."[25] Thus by the end of the twelfth century, any couple wishing to enter or maintain a chaste marriage had a clear theological exposition of the nature of marriage and could expect to rely on the support, however grudging, of the church courts.

The chaste marriage of Mary and Joseph greatly influenced theologians' and canonists' writings, and we can assume that the ruminations of these scholars affected chaste couples from the twelfth century onward. Their writings, however, generally have very little to say about the actual practice of chaste marriage among the laity of medieval Europe. In an attempt to determine which groups practiced chaste marriage and how that practice was perceived, modern scholars have turned to sources traditionally used in the study of social history. Discussion of chaste marriage has tended to be divided at about the twelfth century. In the early period several histories contain accounts of chaste marriages. Gregory of Tours, in his *Glory of the Confessors* and *History of the Franks*, tells several stories of bishops who were forced into chaste marriages during the initial push for a celibate clergy. Gregory also tells the charming story of the "chaste lovers" in his *History*, in which a young couple are said to have made a pledge of chastity on their wedding night—a pledge that they kept until they were laid in the tomb. Bede also gives the details of chaste marriages; Queen Æthelthryth, for example, remained chaste through both of her royal marriages.

These examples from histories are, however, the minority, and hagiography, particularly the lives of martyrs and celibate clergy, provides us with most of the examples of chaste relationships in the early Middle Ages. This is hardly surprising as the church in this period was largely occupied with

its conversion efforts and, as we have seen, the push for clerical chastity. Schulenburg states that from the fourth through the seventh centuries "the lives of bishop saints frequently describe in miraculous terms the chaste relationships adopted by these men with their former wives."[26]

The chaste martyr is perhaps best epitomized by Saint Cecilia. Throughout the Middle Ages, Cecilia remained the most popular saint to have been involved in a chaste marriage. After she was forced to marry despite her desire to remain a virgin, Cecilia converted her husband Valerian to Christianity and the ideals of chastity on their wedding night. After the conversion of Valerian's brother, the trio achieved sanctity through martyrdom. The marriage was in all senses legitimate even though it remained virginal, contrary to Augustine's notion of chastity as a natural state only in the waning years of married life. Elliott argues that the chaste marriages "of the early Middle Ages were normally more aggressively conceived as virginal unions that were never consummated."[27] A similar pattern is drawn from Saint Alexis. Alexis, however, did not convert his wife to chastity but fled his marriage ceremony to live his life, first as an ascetic, then as a beggar in his parents' own home. Elliott believes that Cecilia and Alexis establish two distinct types of chaste marriages. "The legends of Cecilia and Alexis are representative of the course of action that each sex is depicted as most inclined to take: women stayed, men fled."[28] Elliott's model of male/female patterns breaks down, however, when she later narrates the lives of three male saints who converted their spouses to chaste marriages.[29] Marc Glasser also notes another "group of early male saints, who do not flee before their marriage ceremonies, marry and remain married to their wives . . . only after their spouses consent to lead celibate marriages."[30] Elliott's discussion of the eleventh-century emergence of the "virgin king" also undermines her paradigm. She attempts to dismiss this phenomenon by describing it as the "appropriation of this female pattern of sanctity by males."[31]

The severity of early representations of chaste marriages, epitomized by virginity and martyrdom, appears to have softened in the high and later Middle Ages. Clarissa Atkinson argues that the ideology of virginity became less based on Jerome's sexual phobias and more reliant on Augustine's moderate views. The more spiritual interpretation allowed women in chaste marriages who were not virgins to achieve a type of honorary virginity.[32] The distinction may be due, as Charles Altman argues, to the differences between early *passiones*, which are based on the diametric oppositions of the saint and his/her pagan persecutors, and the later *vitae*, which are based on a gradational opposition between the saint and the lay audience.[33] Under such an opposition, a conversion to chastity within marriage, as originally con-

doned and encouraged by Augustine, is represented as an attainable goal distinct from the virginal relationships of earlier saints. Glasser points to the chaste marriage of Bridget of Sweden (whose daughter Catherine entered a virginal marriage) to "suggest the ability of married-women saints to exist and thrive in marriage and motherhood."[34]

The acceptance of the Augustinian model of chaste marriage corresponds roughly with the increased levels of lay piety which accompanied the reform efforts of the twelfth and thirteenth centuries. As laymen moved to enter religious orders in unprecedented numbers, new orders, such as the Franciscans and the Dominicans, grew to accommodate the demand. For women, however, religious orders were severely restricted. The few sister houses of established orders were insufficient for the demand, and only the Poor Clares received official papal recognition as a women's order. Even this order was dominated primarily by noblewomen. In the place of formalized orders, many quasi-religious communities emerged as an alternative for the pious laity. Women who labored in such communities are grouped together under the general name of Beguines. The Beguines did not adhere to any established rule, but many took personal vows of poverty and chastity. Jacques de Vitry, a supporter of the movement, wrote the *vita* of one of its founders, Mary of Oignies. According to Jacques de Vitry, Mary was the child of rich and respected parents. She had married at the age of fourteen but later persuaded her husband to take a vow of chastity. The two continued to work together after renouncing their wealth. "Many other women like her, in the first half of the thirteenth century, parted from their husbands and became Beguines or nuns, attached to a Franciscan or Dominican house."[35] The Beguine movement is one of the few recorded instances of large-scale participation in chaste marriage, but the sources tell us very little about the backgrounds of these women or their motivations for and experiences of chaste marriage. The evidence provided by Jacques de Vitry concentrates on the life of Mary of Oignies and thus eloquently demonstrates the biases of hagiography.

Despite the popular appeal of the Beguine movement, Weinstein and Bell note that chaste marriage (and especially virginal marriage) in the later Middle Ages seems to be the purview of the nobility.[36] A quick look at Elliott's appendices appears to confirm their suspicion.[37] The sources, however, privilege those who achieved canonization. As Elliott notes, "With the exceptions of Margaret Beaufort and Margery Kempe, the specific evidence concerning spiritual marriage is almost exclusively hagiographical in nature."[38] The saint, by his/her very nature, is different from the average person. The hagiographer chooses to write about a given person precisely be-

cause of those differences; but what is different about the saints who entered chaste marriages? In other words, were they canonized because they participated in chaste marriages, or were they canonized because their social position brought their piety to public attention? In fact, as we have seen with Mary of Oignies, the specific evidence drawn from hagiography has not revealed much about the typical practice of marital celibacy.

Jean Leclercq has astutely observed that "hagiography is a world unto itself. We are all free to choose, in keeping with our tastes, or the particular thesis we wish to illustrate, the texts that best suit our purpose."[39] Many of the scholars who have chosen to work on this topic appear to have followed Leclercq's statement as a guide rather than treating it as a warning. Elliott, for example, notes that early hagiographers chose their subjects "primarily with a didactic intent. Thus the usual criticisms of saints' lives for the purpose of historical inquiry—be they biases, borrowings, or their formulaic nature—present no difficulty for our present aims."[40] With this assurance that hagiography presents no methodological problems, Elliott narrates several saints' lives with little analysis of their style or intent.[41] This pattern continues into the later Middle Ages, where she describes the lives of Catherine of Sweden, Mary of Oignies, and others as typical practitioners of chaste marriage. Part of the problem, obviously, is that the practice of chaste marriage among those who were not canonized is difficult to ascertain, but hagiographical sources could be used more wisely, in regard to both awareness of their restrictions and more imaginative uses of their possibilities.

We have already touched on one major problem in dealing with hagiography, the fact that it does not give us a very broad view of chaste marriage. The number of couples we are given is small, and almost entirely from the nobility and aristocracy. In Elliott's book-length study of the subject, for example, she focuses her entire argument for the late Middle Ages on nine couples.

Another restriction in using hagiography as a source is that it can give us the view of the hagiographer rather than that of the saint. This is not necessarily a problem, as it provides an insight into the orthodox view of chaste marriage. Equally dangerous, however, is the suspicious assumption of many feminist critics that hagiographers are always attempting to manipulate the lives of their subjects. Weinstein and Bell, for example, point out the emphasis hagiographical sources place on the humility and obedience of chaste wives.[42] Scholars who approach chaste marriage intending to see it as a means to female empowerment find this emphasis unacceptable. They argue, generally without any support, that the hagiographers have distorted the attitudes and behavior of the saints whose lives they claim to chronicle

in order to appease the Church establishment. Elliott's assumption, that "submission inevitably overshadows subversion in the hands of a skilled narrator,"[43] is an obvious example of a general problem.

The third problem, though one not inherent in the source, is the fact that many of the scholars who use hagiography are interested only in women's history, and thus only look at the lives of women saints. It is unarguable that a chaste marriage is more likely to be the cause of canonization for a woman than a man, but as Glasser has shown, women were not always the initiators of chaste marriages. Any conclusions on the attitudes of women to chaste marriages, even the women who were in them, are surely premature without some comparative evidence on the views of men. After all, a chaste wife had to have a chaste husband, and under Church law he had to undertake the vow of continence freely.

This is not to say that hagiography cannot provide valuable insights into popular practice. A promising avenue that remains under-explored is the actions of some of the minor characters in saints' *vitae*. One theme that has been mentioned, but not developed, is the tendency for those surrounding the saints also to have chaste marriages. The parents of Alexis, for example, vow chastity in exchange for a child, and Elliott briefly discusses this pattern throughout several saints' lives.[44]

Another promising area of inquiry is the evolution of a saint's *vita* over time. Weinstein and Bell note that, despite the changing attitudes toward celibacy, major early saints, who conform to a different notion of chastity, continue to be venerated throughout the high and later Middle Ages.[45] Since these saints remained in the calendar, it is reasonable to assume that their *vitae* remained in the public consciousness. As their stories were retold they were altered and adapted to changing conceptions of chastity. Stephanie Hollis has produced auspicious results through her study of Saint Æthelthryth. By examining the evolution of the cult of Æthelthryth, Hollis perceives a change in the representation of her chaste marriage to Ecgfrith, arguing that the indissolubility of the marriage bond is more vigorously enforced in the *vitae* written by Alcuin and Ælfrich than in Bede's earlier account.[46]

This style of criticism is not generally practiced by scholars who approach chaste marriage. Elliott never reevaluates her model of chaste marriage, which is based on the early *vita* of Saint Cecilia, even when she is comparing it to hagiography from the fourteenth and fifteenth centuries. Jacobus de Vorgine's *Golden Legend*, while mentioned, is used for statistical analysis rather than close examination. Even Chaucer's *Second Nun's Tale* is totally ignored. In fact, this vernacular retelling of the legend of Cecilia, com-

plete with an invocation to Mary which forms the prologue, receives no recognition from any of the scholars of marital chastity.

The silence that greets vernacular versions of saints' lives is indicative of a larger pattern in scholarship. Popular representations of chaste marriage, whether they are the vernacular lives of Cecilia and Alexis or mere mentions of the practice in other literatures, are simply not examined. In addition to the *Second Nun's Tale* Chaucer alludes to the practice on at least two other occasions. The Parson includes chaste marriage among his remedies for lechery saying: "And certes, if that a wyf koude kepen hire al chaast by licence of hir housbonde, so that she yeve nevere noon occasion that he agilte, it were to hire a greet merite."[47] Even January in *The Merchant's Tale* lists the three goods of marriage as "procreacioun," a cure for "leccherye," and:

> . . . for that ech of hem sholde helpen oother
> In meschief, as a suster shal the brother,
> And lyve in chastitee ful holily."[48]

Although made in passing, these references indicate that a certain amount of knowledge of the practice could be expected from Chaucer's audience. Another interesting example is found in the thirteenth-century *Estoire del Saint Graal*. In this history of the Grail, written during the height of the Beguine movement, all the followers of Joseph of Arimathea have vowed chastity within their marriages. When they arrive at the English Channel, those who have kept their vows miraculously cross the water on Bishop Josephus's tunic. Those who have even lusted after their spouses, however, are chastised and forced to wait on the shore until a ship arrives to take them to Britain.[49]

Elliott does mention some literary examples. She points out that in Ramon Lull's *Blanquerna*, for example, the hero's parents vow chastity after his birth. Both Tristan and the Knight Zifar find themselves in chaste marriages, not for any reasons of piety but because of their devotion to other lovers. Even the Grail knight Perceval enters a chaste marriage in the continuation of Chrétien's unfinished romance. Unfortunately, however, Elliott provides little analysis of the content of these stories, nor does she discuss their influence on popular perceptions.[50]

Secular literature, it seems, may be a valuable source for the scholar of chaste marriage who seeks to determine popular attitudes toward the practice. Devotional literature also provides insights into the practice. Mary and Joseph continued to be the model on which the church built its conception of chaste marriage. Medieval literary representations of the marriage

of the holy family demonstrate popular perceptions of the church's theories. In *The N-Town Plays*, for example, the marriage of Mary and Joseph is contemporized for the fifteenth-century audience. The couple's vows of continence are taken before the bishop, and when Mary's pregnancy is discovered they are brought before an ecclesiastical court to defend themselves. Lynn Squires argues that the case "arises from some gossip about Mary's 'unseemly' pregnancy,"[51] but what is really at stake are the mutual vows of chastity. Not only Mary but Joseph also must prove his innocence, and the Detractors mock him, saying that he was so enamoured of Mary that "of hyre bewte whan he had syght/ He sesyd nat tyll had here a-sayd."[52] Here we have every fear that chaste marriage raised in the medieval Church: scandal, gossip, and the difficulty of policing private vows which could be abandoned, thus leading to mortal sin.

In order to represent the variety of sources available, future scholarship on the subject should obviously look at the phenomenon from a broader perspective. Chaste marriage is not necessarily the property of scholars of women's history. It is time that social historians and literary scholars took an interest in the field. In the introduction to her dissertation Elliott wrote:

> There has been no attempt to trace the development of spiritual marriage over the entire period in order to understand who used it and why, what changes are perceivable in its use, or, perhaps of greater significance, what remains the same.[53]

Elliott does trace the development of chaste marriage from the age of the church fathers to the late fifteenth century with detail and clarity, but there her success ends. As a study of the role of chaste marriage in female sanctity the book is useful, but it does not accomplish the ambitious goal Elliott set for herself. In viewing chaste marriage only within the context of female sanctity, she has followed the trend of current scholarship.

Thus many questions remain unanswered. As mentioned earlier, popular practice has not been adequately explored. Margery Kempe, one of the few well-documented examples of an uncanonized chaste marriage, is conspicuous by her absence from most discussions of the subject. She is occasionally mentioned as an anomaly, but only rarely is she seriously considered.[54] Church court records and sermon literature, both of which have been mentioned but again not seriously studied, may also have some light to throw on the subject.

Furthermore, it is notable that few scholars deal with the question of the spiritual and religious bond between a husband and wife vowed to

chastity. We have seen that in endorsing chaste marriage for the clergy, Pope Leo the Great believed that a deeper spiritual relationship would emerge between husband and wife. Elliott, however, argues that "references to the deepening of the bond between spouses, implicit in the spiritualized definition of marriage, are generally absent."[55] The only exception she admits to is Jacques de Vitry's portrayal of Mary of Oignies's relationship with her husband John, and she qualifies this by pointing out that John was exceptional in other ways. However, in the course of her narrative it becomes clear that other chaste couples also had deeply spiritual marriages.[56] In fact many celibates had close spiritual friends. Leclercq, for example, points to Mary the Egyptian, who had "a trusted and confidential friend with whom she had a deep spiritual friendship."[57] A spouse seems to be a likely candidate for such a relationship.

Chaste marriage is a relatively new field, but much of the basic work of compilation has been done. Scholarship to date, however, in focusing on the political value of chastity, has ignored the spiritual value of marriage. Leclercq's point that representations of chaste marriages "are to be seen as extreme cases, all pointing to the fact that marriage, whether consummated or not, is based on love"[58] deserves further consideration.

Notes

1. We have chosen deliberately to use *chaste marriage* as the blanket term for this phenomenon. Some writers use the term *spiritual marriage,* but we feel that spiritual marriages are a subgroup of chaste marriages, and to use the term indiscriminately is to invite confusion.

2. James A. Brundage, "'Allas! That evere love was synne': Sex and medieval canon law," *Catholic Historical Review* 72 (1986), 5–6.

3. Dyan Elliott, *Spiritual Marriage: Sexual Abstinence in Medieval Wedlock* (Princeton: Princeton University Press, 1993), 47–48. For this conception of marriage, Elliott calls Augustine the "architect of spiritual marriage in the West" (Elliott, *Spiritual Marriage,* 43). Elliott's book is an outgrowth of her University of Toronto thesis: Dyan Elliott, "Spiritual Marriage: A Study of Chaste Wedlock in the Middle Ages" (Ph.D. diss., University of Toronto, 1989). The book is exceptionally useful, since it relieves the scholar who approaches the topic of much of the footwork that usually accompanies a new subject. Except where noted, all references are to Elliott's book.

4. Elliott, *Spiritual Marriage,* 51–63.

5. These laws were finally abrogated when Constantine legalized the Church in the fourth century.

6. It is not clear that those who practiced *syneisaktism* considered themselves involved in legitimate marriages. Nevertheless, the practice has been viewed by scholars as a model for later chaste marriages and is usually treated as an early example of the practice.

7. 1 Cor. 7: 36–38. The traditional interpretation of this passage holds that St. Paul is referring to a father or guardian who is not sure whether he should allow his daughter to be married. Other scholars suggest that the problem concerns a man and his betrothed or a master who has committed his female slave to virginity.

8. JoAnn McNamara, "Chaste Marriage and Clerical Celibacy," in *Sexual Practices and the Medieval Church*, ed. Vern L. Bullough and James A. Brundage (Buffalo: Prometheus Books, 1982), 26.

9. Elizabeth A. Clark, "John Chrysostom and the *Subintroductae*," *Church History* 46 (1977), 171–85. Clark also provides a useful list of references to the practice of *syneisaktism* prior to the Council of Nicea (pp. 172–73).

10. Augustine's approval of Paulinus of Nola and his community may have stemmed from the fact that Paulinus and his wife had a normal marriage before their conversion to Christianity and adopted chastity as a result of that conversion.

11. Pierre de Labriolle, "Le 'Mariage Spirituel' dans l'antiquité chrétienne," *Revue Historique* 137 (1921), 208.

12. Rosemary Rader, *Breaking Boundaries: Male/Female Friendship in Early Christian Communities* (New York: Paulist Press, 1983), 65. Roger Reynolds argues that the practice of *syneisaktism* lasted much later in Ireland and Celtic Wales. His sources, however, depict saints intentionally exposing themselves to temptation by sleeping between 'pointy breasted virgins,' rather than actual chaste cohabitation. See Roger E. Reynolds, "*Virgines Subintroductae* in Celtic Christianity," *Harvard Theological Review* 61 (1968), 547–66.

13. Charles A. Frazee, "The Origins of Clerical Celibacy in the Western Church," *Church History* 41 (1972), 154.

14. Henri Crouzel, "Le Célibat et la Continence Ecclésiastique dans l'Église Primitive: Leurs Motivations," in *Sacerdoce et Célibat*, ed. Joseph Coppens et al. (Louvain, Belgium: Éditions Peeters S.P.R.L., 1971), 339. Joyce Salisbury points to a pagan basis for belief in the mystical power of virginity among women in her study of Galicia, arguing that "by bearing children, . . . women brought fertility to the private sphere of the family, ensuring its survival. Virgins, on the other hand, by renouncing private regeneration brought prosperity to the communal or public sphere of the village as a whole." Joyce E. Salisbury, "Fruitfulness in Singleness," *Journal of Medieval History* 8 (1982), 100.

15. Frazee, "Clerical Celibacy," 154. Although many of the Elvira canons deal with sexual matters, only canon 33 deals with clerical celibacy. For a full discussion of the canons, see Samuel Laeuchli, *Power and Sexuality: The Emergence of Canon Law at the Synod of Elvira* (Philadelphia: Temple University Press, 1972). There is some debate concerning the origins and date of the Elvira canons. See Maurice Meigne, "Concile ou collection d'Elvire?" *Revue d'histoire ecclésiastique* 70 (1975): 361–87.

16. Married clergy in minor orders were allowed to continue a normal married life through the fourth century, but in the fifth century the regulations on continence were extended to subdeacons.

17. Michel Dortel-Claudot, "Le prêtre et le mariage. Évolution de la législation canonique dès origines au XIIe siècle," *L'année canonique* 17 (1973), 322.

18. Frazee, "Clerical celibacy," 157.

19. Ibid., 169.

20. Ibid.

21. Pierre J. Payer, "Early medieval regulations concerning marital sexual relations," *Journal of Medieval History* 6 (1980), 370–71.

22. For a full discussion of what follows see: Penny S. Gold, "Mary and Joseph in the Twelfth-Century Ideology of Marriage," in *Sexual Practices and the Medieval Church*, ed. Vern L. Bullough and James A. Brundage (Buffalo and New York: Prometheus Books, 1982), 102–17.

23. 1 Cor. 7:5.

24. If the rejected partner did in fact fall into fornication, the weight of the sin fell upon the spouse who had refused intercourse.

25. Elizabeth M. Makowski, "The Conjugal Debt and Medieval Canon Law," *Journal of Medieval History* 3 (1977), 109. This applied to vows of continence where

one or both spouses intended to enter a monastery as well as, and probably more often than, to chaste marriages.

26. Jane Tibbets Schulenburg, "Saints and Sex ca. 500–1100: Striding Down the Nettled Path of Life," in *Sex in the Middle Ages: A Book of Essays*, ed. Joyce E. Salisbury (New York and London: Garland Publishing, 1991), 222. Elliott provides a useful list of clerical couples who adopted chaste marriages after ordination (Elliott, *Spiritual Marriage*, 309–10).

27. Elliott, *Spiritual Marriage*, 63–64.

28. Ibid., 65.

29. Ibid., 106–08.

30. Marc Glasser, "Marriage in Medieval Hagiography," *Studies in Medieval and Renaissance History* n.s. 4 (1981), 17.

31. Elliott, *Spiritual Marriage*, 128.

32. Clarissa W. Atkinson, "Precious Balsam in Fragile Glass: The Ideology of Virginity in the Later Middle Ages," *Journal of Family History* 8 (1983), 131–43. Marc Glasser notes the increased acceptance and praise of normal marital relationships in the later Middle Ages. Pierre Payer also provides a good discussion of the nature of virginity according to Aquinas and Albertus Magnus in: Pierre J. Payer, *The Bridling of Desire* (Toronto: University of Toronto Press, 1993), 161–66.

33. Charles F. Altman, "Two Types of Opposition and the Structure of Latin Saints' Lives," *Medievalia et Humanistica* n.s. 6 (1975), 1–11.

34. Glasser, "Medieval Hagiography," 27.

35. Brenda M. Bolton, "*Mulieres Sanctae*," in *Women in Medieval Society*, ed. Susan Mosher Stuard (Philadelphia: University of Pennsylvania Press, 1976), 147.

36. Donald Weinstein and Rudolph M. Bell, *Saints and Society: The Two Worlds of Western Christendom, 1000–1700* (Chicago and London: University of Chicago Press, 1982), 74–80.

37. Elliott provides seven appendices categorizing all the couples that she has found who entered chaste marriages. In every category and period the nobility dominate the ranks (Elliott, *Spiritual Marriage*, 303–20).

38. Elliott, *Spiritual Marriage*, 205.

39. Jean Leclercq, *Monks on Marriage: A Twelfth-Century View* (New York: Seabury Press, 1982), 51.

40. Elliott, *Spiritual Marriage*, 63.

41. This tendency to narrate *vitae* rather than study them is by no means unique to Elliott. Brenda Bolton and Jane Tibbets Schulenburg both tend to gather information rather than process it. Although necessary in the early stages of study, we feel that enough information has been gathered at this point to allow meaningful analysis.

42. Weinstein and Bell, *Saints and Society*, 87–97. Elliott also discusses the emphasis hagiographers placed on the fact that women in chaste marriages were humble, submissive, and obedient to their husbands and/or confessors in all things (Elliott, *Spiritual Marriage*, 256–65). This material does not appear in her dissertation, and her attempt to reconcile it with her general thesis is unconvincing.

43. Elliott, *Spiritual Marriage*, 265.

44. Ibid., 85.

45. Weinstein and Bell, *Saints and Society*, 99.

46. Hollis's discussion is in her second chapter entitled "Some Special Irregularities of Marriage." Stephanie Hollis, *Anglo-Saxon Women and the Church* (Woodbridge, Suffolk: Boydell Press, 1992), 46–74. Virginia Blanton-Whetsell (SUNY Binghamton) is presently working on a dissertation, "The Constructed Lives of Saint Æthelthryth," which will examine the changing representation of the saint and her cult throughout the Middle Ages. Another example of this methodology is Ulrich Mölk's examination of the various versions of the Saint Alexis legend, ending with the Old French verse. Although not specifically concerned with the chaste marriage

of Alexis, his method merits imitation. Ulrich Mölk, "Sainte Alexis et son épouse dans la legende latine et la première chanson française," in *Love and Marriage in the Twelfth Century*, ed. W. Van Hoecke and A. Welkenhuysen (Leuven, Belgium: Leuven University Press, 1981), 162–70.

47. Geoffrey Chaucer, *The Canterbury Tales*, in *The Riverside Chaucer*, ed. Larry Benson (Boston: Houghton Mifflin, 1987), 10.945.

48. Chaucer, 4.1448–55. With regard to chastity in marriage, Kelly incorrectly notes that "this quasi-principal reason for marriage was meant chiefly for the *vir senex non potens. . . .*" Henry Ansgar Kelly, *Love and Marriage in the Age of Chaucer* (Ithaca, NY: Cornell University Press, 1975), 268.

49. *Le saint Graal*, ed. Eugene Hucher, 3 vols. (Le Mans: E. Monnoyer, 1875), III, 126–32.

50. Elliott's book gives brief accounts of these literary representations (Elliott, *Spiritual Marriage*, 174–76). In her dissertation Elliott actually devoted more attention to literature (Elliott, "Spiritual Marriage," 284–87), but unfortunately she chose to cut rather than expand her examination of this material.

51. Lynn Squires, "Law and Disorder in the *Ludus Coventriae*," in *The Drama of the Middle Ages*, ed. Clifford Davidson et al. (New York: AMS Press, 1982), 227.

52. *The N-Town Play*, ed. Stephen Spector, 2 vols. (London: Oxford University Press, 1991), 14.51–52.

53. Elliott, "Spiritual Marriage," 22.

54. Clarissa Atkinson has studied Margery Kempe, but does not place her within the broader context of marital chastity.

55. Elliott, *Spiritual Marriage*, 254.

56. Note the spiritual bond between Dauphine and Elzear (ibid., 290).

57. Leclercq, *Monks on Marriage*, 46.

58. Ibid., 47.

BIBLIOGRAPHY

This bibliography is not exhaustive, but it does represent most of the works that deal with chaste marriage and some important studies touching on related topics. Many of the items have been mentioned in the text, but considerations of space have prevented us from giving each study its due treatment. As we hope we have shown, the primary sources for the study of chaste marriage are so varied that any attempt at a meaningful bibliography would be too large for this format. We would direct any interested researcher to Dyan Elliott's extensive bibliography, particularly her list of saints' lives from the *Acta Sanctorum*. For the sake of convenience, we have divided the bibliography into five sections: General works on marriage, chaste or otherwise, *syneisaktism*, clerical chastity, hagiographical studies, and works on canonists and theologians.

General

Bolton, Brenda M. "*Mulieres Sanctae*." In *Women in Medieval Society*, edited by Susan Mosher Stuard, 141–58. Philadelphia: University of Pennsylvania Press, 1976.

———. "*Vitae Matrum*: A Further Aspect of the *Frauenfrage*." In *Medieval Women*, edited by Derek Baker, 253–73. Studies in Church History, subsidia series, 1. Oxford: Basil Blackwell, 1978.

Cutler, Kenneth E. "Edith, Queen of England, 1045–1066." *Mediaeval Studies* 35 (1973): 222–31.

Elliott, Dyan. *Spiritual Marriage: Sexual Abstinence in Medieval Wedlock*. Princeton, NJ: Princeton University Press, 1993.

Fiorenza, Elisabeth Schüssler. "Word, Spirit and Power in Early Christian Communities." In *Women of Spirit: Female Leadership in the Jewish and Christian Traditions*, edited by Rosemary Radford Ruether and Eleanor McLauglin, 29–70. New York: Simon and Schuster, 1974.

Gaudemet, Jean. *Société et mariage*. Strasbourg: Cerdic Publishing, 1980.

Hollis, Stephanie. *Anglo-Saxon Women and the Church*. Woodbridge, Suffolk: Boydell Press, 1992.

Huyghebaert, Nicolas. "Les femmes laïques dans la vie religieuse des XIe et XIIᵉ siècles dans la province ecclésiastique de Reims." In *I Laici Nella "Societas Christiana" dei Secoli XI et XII*, 346–89. Atti della terza Settimana Internazionale di Studio. Pubblicazioni dell'Università Cattolica del Sacro Cuore. Miscellanea del Centro di Studi Medioevali, 5. Milan: Societa Editrice Vita e Pensiero, 1968.

John, Eric. "Edward the Confessor and the Celibate Life." *Analecta Bollandiana* 97 (1979): 171–78.

Johnson, F.R. "The English Cult of St. Bridget of Sweden." *American Benedictine Review* 103 (1985): 75–93.

Kelly, Henry Ansgar. *Love and Marriage in the Age of Chaucer*. Ithaca, NY: Cornell University Press, 1975.

Leclercq, Jean. *Monks on Marriage: A Twelfth-Century View*. New York: Seabury Press, 1982.

Parmisano, Fabian. "Love and Marriage in the Middle Ages." *New Black Friars* 50 (1969): 599–608, 649–60.

Roché, Déodat. "Les Cathares et l'amour spirituel (1)." *Cahiers d'études Cathares* 2nd ser. 94 (1982): 3–39.

Salisbury, Joyce. "Fruitfulness in Singleness." *Journal of Medieval History* 8 (1982): 97–106.

Wemple, Suzanne Fonay. *Women in Frankish Society: Marriage and the Cloister, 500–900*. Philadelphia: University of Pennsylvania Press, 1985.

Syneisaktism

Achelis, Hans. *Virgines Subintroductae: Ein Beitrag Zum VII Kapitel des I. Korintherbriefs*. Leipzig: J.C. Hinrichs, 1902.

Clark, Elizabeth. "John Chrysostom and the *Sub Introductae*." *Church History* 46 (1977): 171–85.

———. *Ascetic Piety and Women's Faith*. Lewiston, NY: Edwin Mellen Press, 1986.

De Labriolle, Pierre. "Le 'mariage spirituel' dans l'antiquité chrétienne." *Revue Historique* 137 (1921): 204–25.

Hurd, John. *The Origin of 1 Corinthians*. London: S.P.C.K., 1965.

Kugelman, R. "1 Corinthians 7: 36–38." *Catholic Biblical Quarterly* 10 (1948): 63–71.

O'Rourke, J.J. "Hypothesis regarding 1 Corinthians 7, 36–38." *Catholic Biblical Quarterly* 20 (1958): 292–98.

Rader, Rosemary. *Breaking Boundaries: Male/Female Friendship in Early Christian Communities*. New York: Paulist Press, 1983.

Reynolds, Roger E. "*Virgines Subintroductae* in Celtic Christianity." *Harvard Theological Review* 61 (1968): 547–66.

Seboldt, Roland H.A. "Spiritual Marriage in the Early Church: A Suggested Interpretation of 1 Corinthians 7: 36–38." *Concordia Theological Monthly* 30 (1959): 103–19.

Clerical Chastity

Barstow, Anne Llewellyn. *Married Priests and the Reforming Papacy.* Texts and Studies in Religion, vol. 12. Lewiston, NY, and Toronto: Edwin Mellen Press, 1982.

Brennan, Brian. "*Episcopae:* Bishop's Wives Viewed in Sixth Century Gaul." *Church History* 54 (1985): 311–23.

Crouzel, H. "Le célibat et la continence ecclésiastique dans l'église primitive: leurs motivations." In *Sacerdoce et célibat: études historiques et theologiques,* edited by Joseph Coppens et al., 333–71. Bibiliotheca ephemeridum theologicarum Lovaniensium, 28. Louvain, Belgium: Éditions Peeters S.P.R.L., 1971.

Dortel-Claudot, M. "Le prêtre et le mariage. Évolution de la législation canonique dès origines au XIIᵉ siècle." *L'anneé canonique* 17 (1973): 319–44.

Frazee, Charles A. "The Origins of Clerical Celibacy in the Western Church." *Church History* 41 (1972): 149–67.

Gryson, Roger. *Les origines du célibat ecclésiastique.* Gembloux, Belgium: Éditions J. Duculot, 1970.

Laeuchli, Samuel. *Power and Sexuality: The Emergence of Canon Law at the Synod of Elvira.* Philadelphia: Temple University Press, 1972.

Lea, Henry C. *History of Sacerdotal Celibacy.* 2 vols. 3rd rev. ed. London: Williams and Norgate, 1907.

Lynch, John E. "Marriage and celibacy of the clergy." *The Jurist* 32 (1972): 14–38.

McNamara, Jo Ann. "Chaste marriage and clerical celibacy." In *Sexual Practices and the Medieval Church,* edited by Vern L. Bullough and James A. Brundage, 22–33. Buffalo: Prometheus Books, 1982.

Hagiography

Altman, Charles F. "Two Types of Opposition and the Structure of Latin Saints' Lives." *Medievalia et Humanistica* n.s. 6 (1975): 1–11.

De Gaiffier, Baudoin. "*Intactum Sponsum Relinquens.*" *Analecta Bollandiana* 65 (1947): 157–95.

Glasser, Marc. "Marriage in Medieval Hagiography." *Studies in Medieval and Renaissance History* n.s. 4 (1981): 3–34.

Goodich, Michael. *Vita Perfecta: The Ideal of Sainthood in the Thirteenth Century.* Monographien zur Geschichte des Mittelalters, vol. 25. Stuttgart: Anton Hiersemann, 1982.

Heffernan, Thomas J. *Sacred Biography: Saints and Their Biographers.* New York and Oxford: Oxford University Press, 1988.

Mölk, Ulrich. "Sainte Alexis et son épouse dans la legende latine et la première chanson française." In *Love and Marriage in the Twelfth Century,* edited by W. Van Hoecke and A. Welkenhuysen, 162–70. Mediaevalia Lovaniensia. Ser. 1, studia 8. Leuven, Belgium: Leuven University Press, 1981.

Renna, Thomas. "Virginity in the *Life* of Christina of Markyate and Aelred of Rievaulx's *Rule.*" *American Benedictine Review* 36 (1895): 79–92.

Schulenburg, Jane Tibbets. "Female Sanctity: Public and Private Roles, ca 500–1100." In *Women and Power in the Middle Ages,* edited by Mary Erler and Maryanne Kowaleski, 102–25. Athens: University of Georgia Press, 1988.

———. "Saints and Sex ca. 500–1100: Striding Down the Nettled Path of Life." In *Sex in the Middle Ages: A Book of Essays,* edited by Joyce E. Salisbury, 203–31. Garland Medieval Casebooks, vol. 3. New York: Garland Publishing, 1991.

Stargardt, Ute. "The Political and Social Backgrounds of the Canonization of Dorothea of Montau." *Mystics Quarterly* 11 (1985): 107–22.

Tavormina, Teresa H. "Of Maidenhood and Maternity: Liturgical Hagiography and the Medieval Idea of Virginity." *American Benedictine Review* 31 (1980): 384–99.

Vauchez, André. "L'influence des modèles hagiographiques sur les présentations de la sanctité dans les procès de canonisation (xiii-xvᵉ)." In *Hagiographie, cultures*

et sociétés, 585–96. Actes du Colloque organisé à Nanterre et à Paris. Centre de Recherches sur l'Antiquité tardive et le haut Moyen Age, Université de Paris. Paris: Études Augustiniennes, 1981.

Weinstein, Donald and Rudolph Bell. *Saints and Society: The Two Worlds of Western Christianity, 1000–1700.* Chicago: University of Chicago Press, 1982.

Theological and Canon Law Studies

Atkinson, Clarissa. "'Precious Balsam in a Fragile Glass': The Ideology of Virginity in the Later Middle Ages." *Journal of Family History* 8 (1983): 131–43.

Bailey, D.S. *The Man-Woman Relationship in Christian Thought.* London: Longmans, 1959.

Brundage, James A. "'Allas! That Evere Love Was Synne': Sex and Medieval Canon Law." *Catholic Historical Review* 72 (1986): 1–13.

———. "Carnal Delight: Canonistic Theories of Sexuality." In *Proceedings of the Fifth International Congress of Canon Law,* edited by Stephan Kuttner and Kenneth Pennington, 361–85. Monumenta Iuris Canonici. Ser. C: Subsidia, vol. 6. Vatican City: Biblioteca Apostolica, 1980.

Daniélou, Jean. *Theology of Jewish Christianity.* Vol. 1 of *The Development of Christian Doctrine before the Council of Nicaea,* translated by John A. Barker. London: Darton, Long and Todd, 1964.

Delehaye, Philippe. "The Development of the Medieval Church's Teaching on Marriage." *Concilium* 55 (1970): 83–88.

D'Izarny, Raymond. "Mariage et consécration virginale au iv^e siècle." *La vie spirituelle* sup. 6 (1953): 92–118.

Gold, Penny S. "The Marriage of Mary and Joseph in the Twelfth-Century Ideology of Marriage." In *Sexual Practices and the Medieval Church,* edited by Vern L. Bullough and James A. Brundage, 102–17. Buffalo: Prometheus Books, 1982.

Makowski, Elizabeth M. "The Conjugal Debt and Medieval Canon Law." *Journal of Medieval History* 3 (1977): 99–114.

Noonan, John T. "Marital Affection in the Canonists." *Studia Gratiana* 12 (1967): 481–509.

Payer, Pierre J. "Early Medieval Regulations Concerning Marital Sexual Relations." *Journal of Medieval History* 6 (1980): 353–76.

——— *The Bridling of Desire: Views of Sex in the Later Middle Ages.* Toronto: University of Toronto Press, 1993.

Pinckaers, Serdais V. "Ce que le moyen âge pensait du mariage." *La vie spirituelle* sup. 20 (1967): 413–40.

Ruether, Rosemary Radford. "Misogynism and virginal feminism in the Fathers of the Church." In *Religion and Sexism: Images of Woman in the Jewish and Christian Traditions,* edited by Rosemary Radford Ruether, 150–83. New York: Simon and Schuster, 1974.

Schmitt, Émile. *Le mariage chrétien dans l'oeuvre de Saint Augustin: une théologie baptismale de la vie conjugale.* Paris: Études Augustiniennes, 1983.

6 HIDING BEHIND THE UNIVERSAL MAN

MALE SEXUALITY IN THE MIDDLE AGES

Jacqueline Murray

It is ironic that, despite both the dominance of the masculine voice and the phallogocentrism of the medieval world view, we know very little about either masculinity or male sexuality in the Middle Ages.[1] This is due in part to the very primacy of the male perspective among both medieval authors and, until quite recently, modern historians. Just as this asymmetry obscured our understanding of women's experience until feminist historians began a concerted effort to recover women from silence, so too it has blinded us to much of men's experience *qua* men. Inspired by both the successes of feminist scholarship and the anxieties of the nascent men's movement, scholars are beginning to analyze men in their gendered and sexual specificity. By de-universalizing men's voices and analyzing their experience with the methodologies and theoretical perspectives that have done so much to reclaim women's past, new insights are being gained into masculinity[2] and male sexuality.[3] This enterprise is in its nascent stages but promises to be a rewarding field of enquiry.

The very dominance of men in historical and literary sources has been one of the major reasons that their specific experience as men has been obscured. Most medieval texts were written from a male perspective, in a male voice. Until very recently most modern readers and critics were also male. Authors and readers alike, then, brought with them unexamined assumptions and tended to universalize male experience as *human* experience. Woman, as the Other, was subsumed, ignored, or mentioned only as an anomaly. Now it is equally apparent that the notion of a Universal Man obscures men as individual subjects. As James B. Nelson has observed:

> When we have assumed the stance of "generic man," the stance in which male lives are presumed to be the norm for *human* lives, we have not only lost understanding of women's experience, we have also lost knowledge of men's experience insofar as it is specifically *men's*.

Because traditional scholarship and theology made men into pseudo-universal generic human beings, it excluded from consideration whatever was specific to men *as men*.[4]

With a rupture in this masculinist hegemony and the de-naturalizing and de-universalizing of Man, it is now possible not only to begin to analyze men but also to compare male and female experience and to reach a greater understanding of both the construction of gender and sexuality and the relationship between the sexes in the past and the present.

The study of the history of sexuality is still a relatively new field which owes much of its inspiration to the groundbreaking work of French philosopher Michel Foucault.[5] Foucault was the catalyst for a new generation of scholars who began to examine sexuality as a historical construction of specific societies which changes over time.[6] Foucault, however, has been criticized because he relegated sexuality to discourse, while ignoring the importance of both emotion and embodiment.[7] He also virtually ignored the experience of women and failed "to recognize how men and women grow up with a different experience of sexuality."[8] Consequently, while respecting the need to examine sexuality in its specific social and historical contexts, Foucault reinforced the notion of male sexuality as normative.

Other problems also haunt the study of male sexuality. Some scholars, perhaps motivated by the contested relations between men and women in contemporary society, bring an essentializing critique to their examinations of history. For example, given the centrality of the penis to male sexual and psychological identity, there is a temptation to evaluate male sexual violence as inherent and transhistorical.[9] This perspective on the meaning of the phallus to masculine sexuality and identity owes much to Sigmund Freud's ideas about the interplay between body and mind, libido and id in the male psyche, a relationship which would not alter significantly across societies.[10] As Arthur Brittan has observed, for Freud: "Male sexuality becomes valorized in a context in which men are taught that possessing a penis is a sign of their difference and power."[11]

The legitimacy of applying this evaluation of the penis to the construction of male sexual identity in the Middle Ages must be seriously questioned, however, in the light of recent research. For example, Leo Steinberg has examined the theological implications of depictions of Christ's genitalia in late medieval and Renaissance paintings. He concludes that portrayals of Christ's penis were an expression of his humanity, including human sexuality.[12] Caroline Bynum, however, wonders whether penises and erections and sexual activity were even associated in the medieval mind.

She suggests rather that Christ's penis was a sign of embodied suffering, devoid of sexual connotations.[13]

Nancy F. Partner raises similar questions about the instability of sexual meaning in her examination of two unique incidents recorded in Gregory of Tours's *History of the Franks*. In the first case, a genitally whole but sexually impotent man dressed and lived as a woman. In the second case, a genitally incomplete man, one who had been castrated, nevertheless lived as a man despite being sexually incapacitated and, very likely, exhibiting feminine physical characteristics. These two examples raise fundamental questions about sexual and gender identity in Merovingian society.[14] They also alert us to the dangers of imposing modern categories and perspectives onto medieval situations, even when confronting something as physically stable (at least in theory) as the human body.

The body was also central to the most sustained, systematic, and articulate discussions of medieval sexuality, that found in the theological discourse initiated by the patristic fathers and developed throughout the whole of the Middle Ages and even up to today.[15] The early church fathers urged an ascetic mode of life in which the mind ruled the body and controlled and repressed sexual urges.[16]

Ambrose, in particular, viewed sexuality as part of the sinful world and a scar that every body had to bear. He stressed the importance of physical virginity for all believers, whose ultimate goal was to emulate the body of Jesus, unmoved by lust or physical desire.[17] In his treatise *On Virginity* Ambrose not only linked sexuality with original sin but also placed the full responsibility for sin and the Fall onto Eve. He wrote: "If Eve's door had been closed, Adam would not have been deceived and she, under question, would not have responded to the serpent. Death entered through the window, i.e., through the door of Eve."[18] Thus Ambrose linked women to sexual temptation which ultimately led to sin and death.

Similarly, Jerome taught that the body must be strictly controlled at all times and that Christians must avoid any sexual attraction. Like Ambrose, he also believed that original sin was sexual in nature and all of an individual's energies needed to be focused on avoiding lust and taming the flesh.[19] Together, the two writers also identified a sexual tension between men and women, teaching that women were more carnal and sexual than men and were capable of reenacting Eve's initial temptation and arousing male sexual urges.[20] This dualistic understanding of male and female sexuality, which evaluated men as governed by reason and closer to the spiritual realm than women, who were more lustful and mired in the material world, characterized much of later medieval thinking about human sexuality.[21]

The unremittingly negative evaluation of the body and sexuality presented by Ambrose and Jerome was partially mitigated by the great theologian, Augustine of Hippo. While Augustine embraced chastity in his later years, prior to his conversion to Christianity he had enjoyed an active sexual life, experiencing desire and fulfillment, living for many years in a concubinal relationship, and fathering a child. Augustine provided posterity with an unusually candid view of his sexual life in his autobiographical *Confessions*.[22] Perhaps as a result of his own experience in a committed relationship, which encompassed companionship as well as sexuality, Augustine considered marriage and the proper channelling of sexual desire to be a gift from God.[23]

While easing the tension between body and soul, material and spiritual, and woman and man, Augustine still recognized that there were problematic aspects of sexuality. Humanity, he believed, had been sexual before the Fall from Paradise. What distinguished prelapsarian sexuality, however, was its complete subordination to the will and reason. In the *City of God* he wrote: "It was only after the fall, when their nature had lost its power to exact obedience from the sexual organs, that they fell and noticed the loss and, being ashamed of their lust, covered these unruly members."[24] Although sexual activity after the Fall was a source of shame, it was not inherently sinful because, prior to their disobedience, God had ordered Adam and Eve to "go forth and multiply" (Gen. 1: 28). When sin entered the world, however, this gift from God was tainted by lust and man lost control of his sexual organs: "Before man sinned by rebellion and was punished by the rebellion of his passions, his human organs, without the excitement of lust, could have obeyed his human will for all the purposes of parenthood."[25] In Paradise procreation would have occurred through sexual intercourse but the act would have been controlled, free from lust, and consequently without sin. While Augustine presented a more moderate evaluation of human sexuality, he was in agreement with Ambrose and Jerome that in this world chastity was preferable, the sexual organs needed to be tamed and controlled, and men needed to avoid lust, which was excited by women.

These ideas and attitudes dominated theological and canonical evaluations of human nature and sexuality throughout the Middle Ages. Men and women were increasingly perceived in terms of binary oppositions and hierarchies. Women, tied to the material world and nature, were more subject to their bodies and to lust and were considered the source of sexual temptation which men needed to resist. Men's natural sexual appetites were acknowledged and writers urged them to avoid even casual conversation with women. Since women were considered more sensual and open to sexual expression, they could easily lead men into sin.[26] However, because of men's

natural superiority and their inherent right to dominate and control women, sex was evaluated as a masculine activity. Women were viewed as no more than receptacles, which rendered men's emission of semen more or less sinful according to the prevailing moral code.[27]

Medical theory also exercised an important influence on the development of medieval ideas about sexuality and supported the evaluation of men as the dominant and active force. In the discourse of medicine, too, the tension between sexual activity and sexual abstinence is also perceived. For example, one school of ancient medicine, represented by Galen, believed that moderate intercourse promoted men's health, while another, represented by Epicurus, believed sexual abstinence was preferable. Soranus taught that sexual intercourse was far more dangerous for men than for women.[28] All these ideas endured in some form into the Middle Ages. Many served to reinforce the prevailing theological opinions about sexuality, others were in direct contradiction to moral strictures.[29]

One of the most important aspects of ancient medicine, which exercised immense and direct influence on medieval sexual theory and practice, was the so-called "one-sex theory." Based on Galen, this theory proposed that men and women were biologically the same. Sexual difference was accounted for by the fact that women were inverted men and the external genital organs of the man were pushed up inside the woman. This theory suited medieval social values as well. As an inverted man, woman was less perfect and therefore subordinate.[30] Ultimately, male and female sexual processes and desires were perceived to be commensurate but were hierarchically ordered and the body's basic structure was that of the male.[31] Thus, male sexuality was universal, normative, and was transformed into *human* sexuality.

The centrality of the male model is seen clearly in the work of one of the most important medieval medical writers, the eleventh-century monk Constantine the African. Through his editions and translations Constantine was responsible for introducing into Europe, from the Islamic world, the knowledge of ancient Galenic medicine.[32] This corpus of work presented the male as normative and central to any discussion of the body, health, and treatment. This is seen in particular in Constantine's treatise *On Coitus* (*De coitu*), which does not mention women at all despite its focus on such topics as sexual pleasure, dysfunction, and conception.[33] The balance of the treatise is devoted to questions pertaining to the production of semen based on the humours, how the quality of semen influences conception, and how intercourse releases excess fumes and helps maintain a man's health. *De coitu* ends with a series of recipes for aphrodisiacs to enhance a man's sexual prowess and pleasure. The treatise concerns itself solely with male physiology and

the role intercourse should play in a man's regimen and in the maintenance of his health. It also provides an authoritative summary of current theories of conception, despite the complete absence of any discussion of female sexuality or physiology.

From the eleventh century on medical writers continued to elaborate on the basic understanding of sexuality inherited from antiquity. Writers accepted the Galenic theory and its social and biological implications without question. They investigated the relative benefits and disadvantages of intercourse to overall health. How much was needed to expend superfluous humours without dissipating a man's strength? What kind of temperament was needed to produce strong seed and conceive a son? What role did a woman's seed play in conception? These and similar questions occupied medical writers, who addressed them without deviating from the masculinist assumptions that underlay both theology and medicine.[34] Indeed, the theological suspicion of women as the source of lust and sexual temptation began to influence medical writing to such an extent that Danielle Jacquart has concluded: "Medieval physicians were incapable of escaping from a view of sexuality, in which the prevalent idea was that man has to mistrust woman."[35]

There was little deviation from these standard theological and medical views of sexuality in the Middle Ages. Significantly, the one voice of dissent, which challenged the prevailing notions of sex difference and the nature of male and female sexuality, was that of a woman, Hildegard of Bingen. Hildegard drew upon a wide and eclectic body of knowledge as background for her ideas about sexuality and desire.

In *Causae et curae* Hildegard explained that sexual arousal in both men and women was caused by the winds of desire that arose in the marrow. In men, the winds swept through the organs, entered the testicles, ultimately inflating the penis and causing an erection. In women's bodies, however, the winds swept through the relatively open space of the uterus. This explained the difference in male and female sexual natures. In a man the winds are forced through a constricted space and result in more intense and uncontrolled sexual urges. In a woman the winds are diffused and, consequently, she is better able to control herself. This explanation did not challenge the notion that men and women have the same sexual natures, but rather accounted for the difference in the degree of sexual desire between the two sexes.[36] Thus it was a woman who disagreed with the prevailing belief that women were more prone to the temptations of the flesh than men. But, although Hildegard's ideas are an interesting departure, they did not influence or alter the medieval view of either the nature of women or of human sexuality.

The relationship between theological and medical theory and how medieval men perceived themselves as sexual beings, exercised their sexuality, or thought about their sexual partners remains unclear. As learned discourses, the opinions expressed in theological and medical treatises may have had little direct influence on behavior and values. But ideas can exercise an influence, however indirect, on society and individual behavior because they are products of their time and place. While the ideas expressed in works of theology and medicine may have helped to shape the values of medieval society, they in turn were certainly modified by popular culture and beliefs. Consequently, it is not surprising to find that a series of competing and conflicting beliefs and behaviors pertaining to male sexuality could and did coexist in medieval society.

Secular society would appear to have proposed quite different values about male sexuality and sexual conduct in general. For example, the relatively late age of marriage for both men and women in northern Europe resulted in adults remaining unmarried for ten to fifteen years after puberty. Rather than remaining chaste, as the church prescribed, evidence suggests that the laity developed practices such as coitus interruptus and masturbation to cope with this lengthy period without a legitimate sexual outlet.[37]

Moreover, the values inherited from pre-Christian societies were not all as ascetic as those Christianity had adopted from ancient Greek and Roman philosophy and religion. For example, Germanic and especially Scandinavian society was not as laden with sexual taboos as was Christian society and appears to have placed the phallus at the center of its sexual value system. For example, one Norse tale, not recorded until ca. 1390 but reflecting a much earlier period, centers on a *Völsi*, the phallus of a horse. While critics remain puzzled about the exact role of the phallus and whether the story reveals superstition, a religious cult, or bawdy humor, the centrality of the male sex organ is certain.[38] Furthermore, images of some of the Germanic gods, for example, Frey, god of sexuality and fertility, include large phalluses, and in Scandinavia some Romanesque churches integrated various phallic symbols into their fabric.[39] All of this suggests that secular Germanic society valued male sexual prowess in a way quite foreign to Christianized southern Europe.

Some early histories of various European peoples also suggest a secular value system based on male sexual virility. In *The History of the Franks* Gregory of Tours enumerates the polygamy, concubinage, serial monogamy, abduction, and rape that characterized the upper ranks of Merovingian society. For example, the polygamist Chilperic married Galswinth with a promise to dismiss his other wives. The couple quarreled, however, because Chilperic still loved one of his previous wives. Galswinth complained about

this insult and tried to return to her family. Chilperic, tired of Galswinth's complaints, had her garrotted by one of his servants.[40] Similar incidents abound in Gregory's work, remarkable only in how little attention or censure they elicited from the Bishop. If Gregory of Tours presents anything like a representative picture, male sexuality in the early Middle Ages can be characterized as unbounded and uncontrolled, violent, and even vicious. Sex was an act of power and aggression which had little direct connection to love of one's partner or the procreation of children.

Gradually, however, the church successfully promoted its competing view of sexuality, one that prized sexual abstinence and self-control in both men and women.[41] The extension of monasticism encouraged a gulf to develop between men and women as well as between secular and religious. For example, one monastic rule advised: "Let the religious man, then, have such fear of God that he will not want to be an occasion of sinful pleasure to a woman."[42] The values of celibacy began also to influence marriage, and the concomitant reduction in women's role as sexual partners led to a decline in their social status and political influence.[43] By the twelfth century women were viewed with suspicion, rendered subordinate in marriage, and relegated to the private sphere.

At the same time as women were being subordinated and marginalized, Jo Ann McNamara has argued that there developed "ungendered public men who would henceforth be equated with 'people,' screened by such anthropomorphized institutions as 'church' and 'crown.'" A consequence of this was that "it deprived masculine individuals of objects for the sexual demonstrations which proved their right to call themselves men." The development of a celibate class of men "raised inherently frightening questions about masculinity. Can one be a man without deploying the most obvious biological attributes of manhood? If a person does not act like a man, is he a man?"[44] These are profoundly troubling questions that challenge the foundations of male sexual and psychological identity. While the extent to which these changes affected the common man is unclear, the development of a value system that was diametrically opposed to that of secular society must have occasioned at least some anxiety and conflict in the individual who did not embrace monasticism and celibacy.[45]

Examples of how secular and ecclesiastical values were interwoven in medieval perceptions of sexuality abound. The church's theology of conjugal relations, for example, was profoundly influenced by secular notions of men as the active initiators of sex. The theory of the conjugal debt required that each spouse give to the other sexual access whenever it was sought.[46] This teaching has traditionally been interpreted as extending to

women sexual equality in marriage, although it remains unclear how they were to exercise such equality in a relationship in which they were subordinate in every other aspect.[47] The theory, then, recognized that women were sexually passive as well as socially subordinate and so might not be capable of expressing their sexual needs. Consequently, the husband was required to watch his wife and perceive her desires and act upon them without a specific request. As one fourteenth-century moralist advised:

> a man is required to render the debt to his wife not only when she expressly seeks it, but also when she appears to desire it by signs. However, the same is not judged concerning the man's desire, because women are accustomed to greater embarrassment in seeking the debt, than are men.[48]

Advice such as this recognized and reinforced the expectations that men were sexually active and women were sexually passive, dependent, and ultimately, subordinate.[49]

This view of sexually active men and passive women is also reflected in the literature of courtly love and chivalry. This discourse, however, rather than focusing on the marital relationship, took the adulterous love of young bachelors as its basis. One late twelfth-century treatise that epitomizes these values is *The Art of Courtly Love*, written by Andreas Capellanus, a French royal chaplain.[50] While proposing to discuss the nature of love, the treatise provides quite detailed advice to young men on how to seduce women of different ranks and temperaments.

Much of *The Art of Courtly Love* highlights the nature of physical passion and sexual gratification that underlies its ideology. For example, Andreas describes the role of physical attraction in love:

> For when a man sees some woman fit for love and shaped according to his taste, he begins at once to lust after her in his heart; the more he thinks about her the more he burns with love, until he comes to a fuller meditation. Presently he begins to think about the fashioning of the woman and to differentiate her limbs, to think about what she does, and to pry into the secrets of her body, and he desires to put each part of it to the fullest use. (Capellanus, 29).

Men are attracted by a woman's physical aspect and this attraction is gradually transformed, through the process of imagining the woman's body, into a greater sexual desire.

The rules that governed love and sexual conduct varied according to the rank of each partner. In a chapter entitled "The Love of Peasants," Andreas observed that farmers might engage in love, not because they are well schooled in its rules but "naturally, like a horse or a mule, they give themselves up to the work of Venus, as nature's urging teaches them to do." Moreover, peasants should not receive instruction in the art of love, in case they forgo working their farms "while they are devoting themselves to conduct which is not natural to them" (Capellanus, 149). Thus lower class men by nature might know how to woo and make love to a woman; however, the refined behavior and rules of love suitable to the aristocracy are inappropriate to the lower orders.

In *The Art of Courtly Love* it is possible to see a set of values promoted that is at odds with ecclesiastical morality and social propriety. It is clearly a class-based document that condones behavior among young men of a certain rank that was not tolerated in women or men of lower social standing. As with the theory of the conjugal debt, while a man's paramour was theoretically accorded similar access to love's embraces, the punishment for a woman's adultery, especially among the upper ranks of European society, which so treasured legitimate heirs, was sure and swift. While fantasies of adulterous love may have played a role in taming the libidos of young bachelors or fuelling their dreams, it was a threat to a stable social order. Whatever the exact social values reflected in the literature of courtly love and the degree to which they were relevant in daily life,[51] this literature does reveal a perception of male sexuality as lust needing to be constrained by convention. In this it may reflect a means by which the unrestrained sexuality of the early Middle Ages was gradually channeled into behavior that was socially acceptable to the more stable, urban society of the twelfth century.

Similar kinds of tensions between passion and control and secular and ecclesiastical values can be seen in the well-known story of the love between Abelard and Heloise. Abelard, arguably the greatest philosopher of the twelfth century, was hired to tutor the brilliant Heloise. He became infatuated with his student and revealed the course of their love in his *Historia calamitatum*.[52] Abelard reveals a sexually passionate nature, describing himself as: "All on fire with desire for this girl" (Letters, 66). In the course of their tutorials Abelard seduced Heloise. His description of their relationship exhibits tenderness and lust tempered with violence and coercion:

> My hands oftener strayed to her bosom than to the pages; love drew
> our eyes to look on each other more than reading kept them on our

texts. To avert suspicion I sometimes struck her, but these blows were prompted by love and tender feeling rather than anger and irritation, and were sweeter than any balm could be. In short, our desires left no stage of love-making untried, and if love could devise something new, we welcomed it. (Letters, 67–68)

The end of the story is less happy. Heloise bore a child out of wedlock. Her outraged relatives, seeking revenge, subsequently castrated Abelard. Both lovers took the veil and lived as religious for the remainder of their lives.

Despite their separation, the couple continued to correspond, and these letters provide some glimpses into Abelard's later sense of his own sexuality and his understanding of his relationship with Heloise. He wrote to her: "You know the depths of shame to which my unbridled lust had consigned our bodies, . . . Even when you were unwilling, resisted to the utmost of your power and tried to dissuade me, as yours was the weaker nature I often forced you to consent with threats and blows. So intense were the fires of lust which bound me to you that I set those wretched, obscene pleasures, which we blush to even name, above God as above myself" (Letters, 147). Thus, Abelard saw himself as the sexual actor in the relationship, while Heloise became, in his view, the passive recipient of his lust.

In retrospect, then, Abelard adopts an ecclesiastical view of the body as uncontrollable, using language reminiscent of Jerome and Ambrose. His reason was unable to control his body and sexual urges in the face of the temptation of Heloise's very presence.[53] Moreover, although there is evidence suggesting Heloise was a willing participant in the relationship, Abelard also characterizes her as the reticent and weaker partner whom he forced into sexual encounters. This reflects the secular view of female sexual passivity rather than the ecclesiastical view of female sexual agency and temptation. Abelard reveals the emotions of a conflicted man, torn between the secular desire for love and the pleasures of the flesh and the spiritual desire for chastity and self-control. As a cleric and theologian, however, Abelard was particularly aware of the tensions inherent in the contradictory values of the church and the world. Other men, freed from the restraints of celibacy or blissfully unaware of the competing nature of secular and ecclesiastical values, found a way of synthesizing the values of their society into something of a coherent view of male sexuality.

The phallic and assertive nature of secular men's understanding of themselves as sexual beings can be seen in the development of male clothing throughout the high Middle Ages and into the Renaissance. The most obvious example of the eroticization of men's dress is the codpiece, but vari-

ous other articles of clothing were developed to expose and enhance portions of the male anatomy. For example, from the twelfth to fourteenth centuries, colorful, long, pointy shoes called *poulaines* were fashionable in northern Europe.[54] Popular belief linked the size of a man's feet to the size of his penis, and men stuffed the points of their shoes with sawdust to make them stand upright in a clear erotic statement. In the late fifteenth century *poulaines* were replaced by the codpiece as the fashionable focus of male dress.

Innovations in male clothing appear to have been generated by young men, while older men were more conservative in their dress, preferring loose-fitting garments in dark colors.[55] Innovative and sexualized clothing gave young men a means of asserting themselves in the face of economic and social insecurity. Barred from inheritance and marriage, young men, especially younger sons, were in an anomalous position in medieval society. Self-presentation was an important aspect of self-expression and self-definition, especially in the face of personal insecurity. Dress was a means of rebellion against a social structure that sought to control and limit young men. Lois Banner has observed that "by embracing in dress the virility of soldiers or the frivolity of minstrels, they expressed through their bodies the marginality of their transitional state, while providing a warning of their social power."[56]

The social role that sexualized male dress could play in the process of a young man defining himself and asserting his independence can be seen in the way that the codpiece was deployed in some Renaissance paintings. For example, in a portrait commissioned by Guidobaldo II della Rovere, in 1531/32, the codpiece has been described as "erect, protruding, and sizeable, . . . without a doubt, an unabashed statement of virility and masculinity."[57] The portrait was painted while Guidobaldo was locked in a struggle with his father over his choice of marriage partner. By asserting his sexual prowess, the young man was also able to remind his father of his role as heir and ultimate perpetuator of the lineage. Indeed, in much portraiture of the period, the enhanced and prominent phallus seems to suggest tension between fathers and sons and a rivalry which was sexual, generational, or even Oedipal.[58]

The link between male sexuality and masculine gender identity so apparent in prominent, overstuffed codpieces was also manifest in other ways in medieval society. Historians need to reexamine traditional male activities and rites of passage that could have played an important function in defining male identity. For example, hunting and poaching were important male activities in medieval England, which seems to have reinforced masculine

identity. The late fourteenth-century *Parlement of the Three Ages*, which describes poaching, is laden with symbols of both masculinity and male sexuality and portrays the rivalry between poachers and foresters to dominate the forest.[59] It describes an incident in which a poacher took the head of a buck, placed a spindle in its mouth, and faced it toward the sun, "in great contempt of the lord king and his foresters." Barbara Hanawalt has suggested that the act of putting the quintessential female symbol, the spindle, in the mouth of a male deer was a sexual insult suggesting sexual inversion. She concludes: "The combination of hunting and male sexuality was a common literary theme. Even the very terms have parallels: the hunter takes a deer as the man takes a woman."[60]

A similar rite of passage into manhood has been observed in Arthurian literature. Jeffrey Cohen argues that the defeat and decapitation of giants by heroic figures, such as Arthur or Sir Gawain, "is at once an assertion of masculinity and an admission of its constructed nature—of the possibility of other masculinities, of a different gendering of behaviors."[61] Thus, traditionally masculine activities were ways in which men could define, affirm, and assert their dominant and even aggressive sexuality.

Male sexuality may have been particularly aggressive in the Middle Ages because of the many social and religious constraints that were imposed on sexual behavior in general. Political and class boundaries separated potential partners. The rigid moral code prohibited sexual activity outside marriage and controlled and limited it even between husband and wife. Economic necessity resulted in a late age of marriage: the mid-twenties for both women and men, except in the highest reaches of society. As a result, sexual repression, both external and internal, was ubiquitous.[62] It is perhaps, then, not surprising that male sexual violence was a common problem across medieval Europe.

Indeed, the picture of life on the streets of the average medieval town suggests that male sexuality was omnipresent and somewhat threatening. Why else would towns establish red light districts and sumptuary regulations that required prostitutes to dress distinctively, if not to protect honorable women from harassment on the streets?[63] Prostitution was one obvious sexual outlet for unmarried men but, despite the prevalence of brothels, rape, too, was common in medieval cities. These rapes frequently included the abduction of honorable women from their homes and gang rape.[64] Single women and widows in particular were vulnerable to this kind of sexual crime.[65]

Men of the social elite had sexual access to women of the lower classes, willing or not, with impunity.[66] In *The Art of Courtly Love*, Andreas Capellanus virtually condoned the rape of peasant women by knights:

And if you should, by some chance, fall in love with some of their women, be careful to puff them up with lots of praise and then, when you find a convenient place, do not hesitate to take what you seek and to embrace them by force. For you can hardly soften their outward inflexibility so far that they will grant you their embraces quietly or permit you to have the solaces you desire unless first you use a little compulsion as a convenient cure for their shyness.[67]

While in theory the penalties for rape were severe, it was a difficult crime to prove, and in practice the penalties were light. Rape, despite its violence to women's bodies, was also treated very much as a male experience, and both literary and legal sources examined it from the perspective of how this crime might harm or undermine patriarchal society.[68] This patriarchal perspective on sexual crime is seen throughout the records of both ecclesiastical and secular courts that heard the cases of various sexual crimes.[69]

While criminal records and much medieval literature reinforce the notion of male sexuality as active and assertive, if not actually aggressive, there is another side to how medieval men experienced and understood themselves as sexual beings. An examination of various aspects of the history of the body and how men experienced their biological and sexual embodiment brings to light a differing perspective on male sexuality. In fact, when examined from this perspective, medieval men's bodies can be understood as vulnerable and their sexuality as fragile.

An examination of some medieval views of male genitalia suggests that there was something of a concern, if not preoccupation, with the male sexual organs. Theological writers in particular focused on the "weakness of the flesh" and the nature and implications of such phenomena as nocturnal emissions. The classic discussion was contained in Pope Gregory the Great's letter to Augustine of Canterbury.[70] Although Gregory concluded that a man did not sin unless he willed such "illusions," the topic continued to concern writers throughout the Middle Ages.[71] For example, in the mid-twelfth century Guy of Southwick wrote a treatise ostensibly about the nature and efficacy of confession. The longest passage in the work, however, discusses the causes and degree of sinfulness of nocturnal emissions according to whether the man had been drunk or enjoying sexual fantasies before going to sleep.[72] Similarly, spontaneous erections, whether caused by the sight of a woman's face or for no discernible reason, were a constant reminder of the weakness of the flesh. For those medieval men vowed to celibacy the male body with its spontaneous movements and emissions was both a sign of the irrationality and uncontrollable nature of sexuality as well as a weak vessel ready to lead men to sin.

For men in the world, the body's fragility might lead in quite the opposite direction. Castration, a judicial punishment for a variety of crimes, highlighted a man's sexual vulnerability. A man deprived of genitals was unable to marry, could not be ordained a priest, and might face other social and psychological disabilities as well.[73]

Some sources suggest that there was a perceived correlation between the size of the penis and virility. In *Njal's Saga*, Unn reports that her marriage to Hrut is unconsummated because: "Whenever he touches me, he is so enlarged that he cannot have enjoyment of me, although we both passionately desire to reach consummation, but we have never succeeded."[74] The notion of a man's penis being too large to permit intercourse is found in ecclesiastical literature as well. In his *Summa confessorum*, written in the early thirteenth century, Thomas of Chobham advises that if a woman's vagina is too small to accommodate her husband's penis she should try to have it surgically enlarged.[75]

Men also appear to have boasted and told jokes and stories about penis size and how well a man filled his codpiece.[76] While much of this attention to the size of the genitals might derive from little more than ribald, sexual jesting, there is also evidence that men experienced anxiety about penis size, compared with the norm or with some virile ideal. In *Grettir's Saga*, for example, a woman expresses amazement that a man as big as Grettir has such small genitalia. Grettir replies:

It's seldom one can get
so close a look
at a hair-girt sword.
I bet that other men's testicles
won't be bigger than mine,
though their penises may be
larger than this one.[77]

Grettir goes on to say that a penis can grow and he is as yet young, so the woman should not make assumptions. Thus the saga suggests that women had certain expectations about the physical capacity of a large strong man, as well as the fact that a man might be sensitive, if not embarrassed by the size of his genitals and how this might reflect on his virility.

The link between male identity and a sense of self-worth rooted in genital size and sexual prowess, however, was finite and limited. An active sexual life was the province of the virile adult alone. Andreas Capellanus limited the art of love to men under sixty, believing that even if he retained

his sexual capacity, after that age a man lost the requisite emotional and psychological qualities for love.[78] Elderly men were also confronted by notions of social propriety that disparaged their sexuality.[79] Those who indulged in sexual exploits were seen as humorous victims of self-deception.

Geoffrey Chaucer discusses one such unfortunate man in "The Merchant's Tale." January is a sixty-year-old bachelor who suddenly decides to marry. Chaucer presents him as a foolish old man who is a victim of his own self-deception, as one who has convinced himself that he is still so virile that he is in danger of fornication. He admits that: "I am no longer young;/ God knows, I'm near the pit, I'm on the brink:/ I have a soul, of which I ought to think" (285).[80] In order to preserve his chastity, he resolves to marry but tells his friends that: "The woman must on no account be old,/ Certainly under twenty, and demure. . . . I'll have no woman thirty years of age" (285). January convinces himself that he is capable of satisfying a younger woman:

> . . . I dare to make the claim,
> I feel my limbs sufficient, strong and game
> For all that is belonging to a man,
> An am my own best judge in what I can. (286)

Despite all his assurances, on his wedding night, perhaps in order to hedge his bets or to quell any lingering self-doubt, he avails himself of a variety of aphrodisiacs:

> Soon after this the restive January
> Demanded bed; no longer would he tarry
> Except to quaff a cordial for the fire
> That claret laced with spice can lend desire;
> For he had many potions, drugs as fine
> As those that monk, accursed Constantine,
> Has numbered in his book *De Coitu*.
> He drank them all; not one did he eschew. (294)

While with the aid of aphrodisiacs[81] January was indeed capable of sexual activity, the remainder of the story contrasts his increasingly decrepit body with that of his much younger wife, May. Struck blind by age, January is betrayed by May, who prefers the embraces of a younger man. In the end, January is seen to be a foolish and vain cuckold who is responsible for his own misfortunes because he tried to claim for himself the sexuality and virility reserved for younger men.

For younger as well as older men, fear of sexual dysfunction could be a source of anxiety, as a man realized he could not always rely on his body to respond to sexual stimulation. Impotence was an abiding fear, as suggested by the frequent repetition of ancient aphrodisiacs in medieval medical treatises. Medieval men had good cause to worry about impotence because it was a condition that, if permanent, prohibited marriage or could result in an annulment.[82] In the process, it could occasion considerable public embarrassment and ridicule. The procedures by which an ecclesiastical court evaluated a petition for annulment because of alleged impotence could subject a man's sexuality to close public scrutiny. Neighbors and friends might be called to testify about their impressions of the couple's sex life. Doctors or midwives might examine the man's genitals and evaluate their size and suitability for intercourse.[83] In some cases, if the man denied the allegation of impotence, he might be asked to prove his virility and allow midwives to observe his attempts to have intercourse with his wife.[84]

It is difficult to establish how society would have viewed a man required to prove his sexual ability in so public a fashion. Certainly it had the potential to cause shame and embarrassment and to threaten a man's sense of himself. A court record from fifteenth-century York demonstrates the close link between virility and masculinity. The record reports how a group of women observed the husband and wife together in bed. Eventually, one of the women tried to excite sexually the impotent man. She is reported to have "stirred him up in so far as she could to show his virility and potency, admonishing him that for shame he should then and there prove and render himself a man."[85] When the man failed to have an erection, the women "with one voice, cursed him because he presumed to take as a wife some young woman, by defrauding her, unless he had been better able to serve and to please her."[86] Clearly, when she married, a woman was entitled to expect more from her husband. The case also inextricably links sexual ability and male identity and shows that a man who was sexually dysfunctional was considered less than a "real man."

These same values are seen in a contemporary example, from fifteenth-century Venice, in which a man named Nicolò was accused of impotence by his wife. Going to a brothel he showed himself sexually potent in front of witnesses, including a priest. Not content with merely being observed, he "took the hand of this witness saying, 'Look here, I am a man, even though some say I cannot get it up.' And he made this witness feel his member, which was erect just like the member of any other man."[87] Both these examples show that impotence threatened how a man perceived himself and was perceived by others, as well as showing that public proof of

his sexual ability was one way a man could end rumors or questions about his manhood.

Accusations of impotence were taken seriously in medieval society and could result in dishonor and embarrassment. Gary Ferguson has observed that "at the heart of both the courtly romance and of male initiation rites there lies a male fascination with and fear of female sexuality and female power: that is, a fear of impotence."[88] Impotence, moreover, was often thought to be caused by sorcery and love spells cast especially by women.[89] The male genitalia in particular were vulnerable to spells. For example, impotence or magical castration could be caused by an *aiguillette*, that is, by a spell that caused a lace or ligature to tie up the genitals.[90] Similarly, the *Malleus Maleficarum* includes such chapters as "Whether Witches may work some Prestidigitatory Illusion so that the Male Organ appears to be entirely removed and separate from the Body" and "How, as it were, they Deprive Man of his Virile Member."[91]

Men not only had to fear women's ability to harm their genitals by magic; the very act of intercourse could have nasty results. Some medical treatises warned that intercourse with a menstruating woman could cause a man to contract leprosy.[92] Morover, a woman could be malevolent and place iron in the vagina prior to intercourse, to try deliberately to wound a man's penis: "Some women are so wary and cunning that they take iron and place it in the vagina. This iron wounds the penis, but the man does not perceive it at first because of the exceeding pleasure and sweetness of the vulva."[93] Thus, a man was at a certain risk whenever he sought sexual intercourse.

The depth to which men's fear of sexual intercourse with women was psychologically embedded is illustrated in the phenomenon of *penis captivus* or vaginismus. *Penis captivus* was believed to occur during intercourse when a woman's vagina constricted so that the man could not withdraw his penis. Medieval accounts of a man and woman so joined are found in such diverse sources as Robert Mannyng's *Handlyng Synne*, the Book of the Knight of La Tour Landry, and the life of St Clitaucus.[94] Although these stories are the fruit of the medieval imagination, they do provide insight into the psycho-sexual fears that medieval men harbored. As with the *aiguillette*, the *penis captivus* stories are a not-so-veiled manifestation of castration anxiety and a deeply rooted fear of female sexuality.

It is perhaps not surprising that this chapter should end with examples of male sexual anxiety and dysfunction and fear of female sexuality. After all, these ideas underlie much of medieval teaching about sexuality. The notion of female sexuality as an almost irresistible temptation, developed by the early church fathers, led men to feel sexually vulnerable in the face

of women. Fearing women imbued them with sexual power. Thus, women were associated with the negative side of male sexuality. The very sight of a woman could threaten a monk's chastity and cause him to have a nocturnal emission. Women were an ever-present reminder of the irrational and uncontrollable nature of a man's body.

The higher evaluation given to celibacy and the widespread practice of monasticism could have been perceived as an unspoken reproach by laymen, especially those who were married. The need for regular if moderate intercourse to maintain health and balance the humours was complicated by uncertainty about what constituted "moderate" and warnings that sexual release could weaken a man's physical constitution and harm his health. Theological warnings about the need for abstinence during sacred times and those times forbidden by blood taboos were complemented by medical warnings that such activity could result in ill health for the participants or disease and deformity for a fetus thus conceived.

The Church taught that the sexual body needed to be controlled and subdued, yet social values promoted sexual aggressiveness as part of masculine identity. The tension that resulted from these two contradictory sets of values might well have engendered the sexual fears that seem embedded below the surface of so many medieval discussions of sexuality. A woman could render a man impotent, causing him embarrassment and weakening his social position. A woman's ability to use magic to manipulate a man's genitalia and render him impotent overturned the natural hierarchy of the sexes. Thus women were inextricably entwined in a man's failure to control his body's sexual responses.

Research on male sexuality in the Middle Ages is in its nascent stages but, as the foregoing overview suggests, it promises to be a fruitful field of research. Virtually every medieval source has the potential to provide information on how medieval men saw themselves as sexualized and gendered beings. But the sources need to be approached from a critical perspective, and masculine gender identity and male sexuality must be denaturalized. By rejecting the masculine norm and the "universal man," and by consciously moving men to the margins, it will be at last possible to learn about the complex and fascinating history of medieval men as social and sexual subjects.

NOTES

1. I am grateful to James A. Brundage, Jo Ann McNamara, and Clare Lees for sharing with me their unpublished work.

2. For example, there is as yet only one collection of essays devoted exclusively to the exploration of male gender in the Middle Ages. *Medieval Masculinities: Regarding Men in the Middle Ages*, ed. Clare A. Lees, Medieval Cultures, 7 (Minneapolis:

University of Minnesota Press, 1994). In addition, a cluster of four articles analyzing masculinity in medieval literature appeared under the rubric "The Construction of Manhood in Arthurian Literature," in *The Arthurian Yearbook III*, ed. Keith Busby (New York: Garland Publishing, 1993), 173–225.

3. Allen J. Frantzen has suggested a resistance to this trend: "Today, as feminists warily regard the emergence of men's studies alongside women's studies, one might respond that we now see the radical dependency of women's studies on a universalized, if not untheorized, conception of the masculine." "When Women Aren't Enough," in *Studying Medieval Women: Sex, Gender, Feminism*, ed. Nancy F. Partner (Cambridge, MA: Medieval Academy of America, 1993), 153.

4. James B. Nelson, *The Intimate Connection: Male Sexuality, Masculine Spirituality* (Philadelphia: Westminster Press, 1988), 18. Emphasis in the original.

5. Especially important in this regard is Foucault's *The History of Sexuality*, vol. 1, *An Introduction*, trans. Robert Hurley (New York: Pantheon Books, 1978).

6. For example, Jamake Highwater has examined how male sexuality has been expressed in the mythologies of various societies in order to trace its mutability. *Myth and Sexuality* (New York: Meridian Books, 1991). It should be noted, however, that earlier scholars were moving toward this understanding long before Foucault's work appeared. For example, as early as 1959 Keith Thomas identified the social and historical construction of the double standard of sexual behavior. "The Double Standard," *Journal of the History of Ideas* 20 (1959): 195–216.

7. Arthur Brittan, *Masculinity and Power* (Oxford: Basil Blackwell, 1989), 48–51.

8. Victor J. Seidler, "Reason, desire, and male sexuality," in *The Cultural Construction of Sexuality*, ed. Pat Caplan (New York: Tavistock, 1987), 84.

9. For an example of this tendency see Rosalind Miles, *The Rites of Man: Love, Sex and Death in the Making of the Male* (London: Paladin, 1992), 23, 35, 42, 298.

10. A thoughtful summary and critique of Freud's position is found in Brittan, *Masculinity and Power*, 47–49.

11. Ibid., 55.

12. Leo Steinberg, *The Sexuality of Christ in Renaissance Art and in Modern Oblivion* (New York: Pantheon, 1983).

13. Caroline Walker Bynum, "The Body of Christ in the Later Middle Ages: A Reply to Leo Steinberg," in *Fragmentation and Redemption: Essays on Gender and the Human Body in Medieval Religion* (New York: Zone Books, 1991), 79–117.

14. Nancy F. Partner, "No Sex, No Gender," in *Studying Medieval Women: Sex, Gender, Feminism*, ed. Nancy F. Partner (Cambridge, MA: Medieval Academy of America, 1993), 117–41, esp. 117–21. The incidents are found in Gregory of Tours, *The History of the Franks*, trans. Lewis Thorpe (Harmondsworth, England: Penguin, 1974), 10.15. The case of the castrated man who lived as a woman has also been discussed by Vern Bullough, who analyzes it in the context of female cross-dressing saints. Vern L. Bullough, *Sexual Variance in Society and History* (New York: Wiley, 1976), 365–69 and "On Being a Male in the Middle Ages," in *Medieval Masculinities: Regarding Men in the Middle Ages*, ed. Clare A. Lees, Medieval Cultures, 7 (Minneapolis: University of Minnesota Press, 1994), 35–38.

15. Recent pronouncements by Pope John Paul II about the nature and appropriate expression of human sexuality in the contemporary world are but the most recent contribution to this discourse.

16. A brilliant overview and analysis of the teachings of the Patristic Fathers is found in Peter Brown, *The Body and Society: Men, Women, and Sexual Renunciation in Early Christianity* (New York: Columbia University Press, 1988).

17. The views of Ambrose are summarized in Joyce E. Salisbury, "The Latin doctors of the Church on sexuality," *Journal of Medieval History* 12 (1986): 280–82. Ambrose's understanding of sexuality is examined in Brown, *Body and Society*, 341–65.

18. Ambrose, *On Virginity*, trans. Daniel Callam, Peregrina Translation Series, 7 (Toronto: Peregrina Publishing, 1989), XIII. 81.

19. Brown, *Body and Society*, 366–86 and Salisbury, "Latin Doctors," 279–84. See, in particular, Jerome's *Against Jovinianus*, in *St. Jerome: Letters and Select Works*, trans. W.H. Fremantle, Select Library of Nicene and Post-Nicene Fathers of the Christian Church, VI (New York: Christian Literature, 1893), 346–416.

20. Salisbury, "Latin Doctors," 280.

21. For example, Eve Levin has identified the same attitude in a Russian folktale which depicts the Devil himself as being trapped by his desire for a woman and in religious stories in which men were not held responsible for their sexual sins but placed the blame on the women who led them into temptation. *Sex and Society in the World of the Orthodox Slavs, 900–1700* (Ithaca, NY: Cornell University Press, 1989), 53–59. Levin observes that: "Thus a woman's sexuality was perceived as stronger than a man's will and self-control." Ibid. 54.

22. Augustine, *Confessions*, vol. 5, *Writings of Saint Augustine*, trans. Vernon J. Bourke, The Fathers of the Church, 21 (New York: Fathers of the Church, 1953). Peter Brown examines Augustine's ideas in *Body and Society*, 387–427.

23. Salisbury, "Latin Doctors," 286. Augustine developed these ideas in his treatises *On the Good of Marriage* and *Continence*.

24. Augustine, *The City of God*, vols. 6–8, *Writings of Saint Augustine*, trans. Demetrius B. Zema, Gerald G. Walsh et al. (New York: Fathers of the Church, 1952), XIV.21; 7, 396.

25. Ibid., XIV.24; 7, 404.

26. See the many discussions by James A. Brundage, in particular, *Law, Sex, and Christian Society in Medieval Europe* (Chicago: University of Chicago Press, 1987) and "Prostitution in the Medieval Canon Law," *Signs* 1 (1976): 825–45.

27. David N. De Vries, "Fathers and Sons: Patristic Exegesis and the Castration Complex," in *Gender Rhetorics: Postures of Dominance and Submission in History*, ed. Richard C. Trexler, Medieval and Renaissance Studies and Texts, 113 (Binghamton, NY: CMERS/SUNY, 1994), 33–45. The penitentials: for example, evaluated the seriousness of a man's sin according to the class of woman with whom he had sexual relations. Pierre J. Payer, *Sex and the Penitentials: The Development of a Sexual Code 550–1150* (Toronto: University of Toronto Press, 1984), 20–21. An overview of later medieval moral teachings about sexuality is found in Pierre J. Payer, *The Bridling of Desire: Views of Sex in the Later Middle Ages* (Toronto: University of Toronto Press, 1993).

28. An overview of various ancient views of sexuality and the body is found in Aline Rousselle, *Porneia: On Desire and the Body in Antiquity*, trans. Felicia Pheasant (Oxford: Basil Blackwell, 1988).

29. Jacqueline Murray, "Sexuality and Spirituality: The Intersection of Medieval Theology and Medicine," *Fides et Historia* 23 (1991): 20–36.

30. The development of this biological theory has been investigated by Thomas Laqueur in *Making Sex: Body and Gender from the Greeks to Freud* (Cambridge, MA: Harvard University Press, 1990). Laqueur argues that this theory constructed "a world where at least two genders correspond to but one sex, where the boundaries between male and female are of degree and not of kind, and where the reproductive organs are but one sign among many of the body's place in a cosmic and cultural order that transcends biology." Ibid., 25.

31. Danielle Jacquart and Claude Thomasset, *Sexuality and Medicine in the Middle Ages*, trans. Matthew Adamson (Princeton, NJ: Princeton University Press, 1988), 36. A magisterial examination of medieval ideas about the differences between the sexes is found in Joan Cadden, *Meanings of Sex Difference in the Middle Ages: Medicine, Science, and Culture*, Cambridge History of Medicine (Cambridge: Cambridge University Press, 1993).

32. For a discussion of Constantine's importance and his overall contribution see Cadden, *Meanings of Sex Difference*, 55–70.

33. See Paul Delany, "Constantinus Africanus' *De coitu*: a Translation," *Chaucer Review* 4 (1970): 55–65.

34. See the studies by Cadden, Jacquart and Thomasset, and Helen Rodnite Lemay for detailed analyses of the development of medical thought in the Middle Ages.

35. Danielle Jacquart, "Medical Explanations of Sexual Behavior in the Middle Ages," in *Homo Carnalis: The Carnal Aspect of Medieval Human Life*, ed. Helen Rodnite Lemay, Acta, XIV (Binghamton, NY: CMERS/SUNY, 1990), 17.

36. Cadden, *Meanings of Sex Difference*, 72–88 and especially her article "It Takes All Kinds: Sexuality and Gender Differences in Hildegard of Bingen's 'Book of Compound Medicine,'" *Traditio* 40 (1984): 149–74.

37. Jean-Louis Flandrin has examined some of the conflicts between ecclesiastical theory and social practice in "Mariage tardif et vie sexuelle: Discussions et hypothèses de recherche," *Annales d'Histoire economique et sociale* 27 (1972): 1351–78.

38. See Andreas Heusler, "The Story of the *Völsi*, an Old Norse Anecdote of Conversion," trans. Peter Nelson in Joyce E. Salisbury, *Sex in the Middle Ages: A Book of Essays* (New York: Garland Publishing, 1991), 187–200, and Thorkil Vanggaard, *Phallós: A Symbol and its History in the Male World* (New York: International Universities Press, 1972).

39. Vanggaard, *Phallós*, 143–47 and Vern L. Bullough, *Sexual Variance in Society and History*, 350–51.

40. Gregory of Tours, *History of the Franks*, 4.28.

41. Some of Christianity's constraints on male sexual expression in particular originated in the Gospels. See, for example, the discussion by Will Deming, "Mark 9.42–10.12, Matthew 5.27–32, and *B.NID*. 13b: A First Century Discussion of Male Sexuality," *New Testament Studies* 36 (1990): 130–41.

42. The pseudo-Augustinian *Praeceptum*, quoted in Aaron W. Godfrey, "Rules and Regulation: Monasticism and Chastity," in *Homo Carnalis: The Carnal Aspect of Medieval Human Life*, ed. Helen Rodnite Lemay, Acta, XIV (Binghamton, NY: CMERS/SUNY, 1990), 49.

43. The development and dissemination of the practice of chaste marriage is discussed in Dyan Elliott, *Spiritual Marriage: Sexual Abstinence in Medieval Wedlock* (Princeton, NJ: Princeton University Press, 1993). See also the article by Margaret McGlynn and Richard Moll in this book.

44. Jo Ann McNamara, "The *Herrenfrage*: The Restructuring of the Gender System: 1050–1150," in *Medieval Masculinities: Regarding Men in the Middle Ages*, ed. Clare A. Lees, Medieval Cultures, 7 (Minneapolis: University of Minnesota Press, 1994), 5.

45. The dramatic impact that embracing celibacy could have on the life of an individual is seen in the lengths to which some saints went to ensure or prove their chastity. See the discussion in Jane Tibbetts Schulenburg, "Saints and Sex, ca. 500–1100: Striding Down the Nettled Path of Life," in Joyce E. Salisbury, *Sex in the Middle Ages: A Book of Essays* (New York: Garland Publishing, 1991), 203–31.

46. Elizabeth Makowski, "The Conjugal Debt in Medieval Canon Law," *Journal of Medieval History* 3 (1977): 99–114.

47. Jean–Louis Flandrin, *Le sexe et l'Occident: Évolution des attitudes et des comportements* (Paris: Seuil, 1981), 127–28.

48. "non solum quando expresse petit debitum uxori vir tenetur reddere: sed etiam quando per signa apparet eam hoc velle. Non tamen idem iudicium est de petitionem viri: quia mulieres magis solent verecundari petendo debitum quam viri." John of Friburg, *Summa confessorum* (Venice, 1568), Bk. 4, tit. 2, q. 40, 439. Some aspects of the marital relationship have been discussed by Michael M. Sheehan,

"*Maritalis Affectio* Revisited," in *The Olde Daunce: Love, Friendship, Sex, and Marriage in the Medieval World*, ed. Robert R. Edwards and Stephen Spector (Albany, NY: SUNY Press, 1991), 32–43.

49. Flandrin, *Le sexe et l'Occident*, 127–29.

50. Andreas Capellanus, *The Art of Courtly Love*, trans. John Jay Parry, Records of Civilization, 33 (New York: Columbia University Press, 1941). All references are to this edition. John Baldwin provides a useful summary and analysis in *The Language of Sex: Five Voices from Northern France around 1200*, Chicago Series on Sexuality, History, and Society (Chicago: University of Chicago Press, 1994), 16–25.

51. The discussions of courtly love and its literary and historical role are numerous, conflicting, and beyond the scope of this essay.

52. This autobiographical account and a number of letters written by both Abelard and Heloise are easily accessible in *The Letters of Abelard and Heloise*, trans. Betty Radice (Harmondsworth, England: Penguin Books, 1974). All references are from this edition.

53. There is an irony in Abelard's ultimate rejection of the flesh given that he was one of the few twelfth-century theologians to teach that physical pleasure and desire are natural and not intrinsically evil. Brundage, *Law, Sex, and Christian Society*, 203.

54. Lois Banner, "The Fashionable Sex, 1100–1600," *History Today* 42 (April 1992): 40.

55. Ibid., 41.

56. Ibid., 43. A useful analysis of the social and political meaning of male dress in early modern England is found in David Kuchta, "The semiotics of masculinity in Renaissance England," in *Sexuality and Gender in Early Modern Europe: Institutions, Texts, Images*, ed. James Gratham Turner (Cambridge: Cambridge University Press, 1993), 233–46.

57. Konrad Eisenbichler, "Bronzino's Portrait of Guidobaldo II della Rovere," *Renaissance and Reformation* 24 (1988): 22.

58. The social and psychological implications of the codpiece in Renaissance paintings are discussed at length in Patricia Simons, "Alert and Erect: Masculinity in Some Italian Renaissance Portraits of Fathers and Sons," in *Gender Rhetorics: Postures of Dominance and Submission in History*, ed. Richard C. Trexler, Medieval and Renaissance Studies and Texts, 113 (Binghamton, NY: CMERS/SUNY, 1994), 163–86.

59. This discussion is based on Barbara A. Hanawalt, "Men's games, King's deer: poaching in Medieval England," *Journal of Medieval and Renaissance Studies* 18 (1988): 175–93.

60. Ibid., 190–91.

61. Jeffrey Jerome Cohen, "Decapitation and Coming of Age: Constructing Masculinity and the Monstrous," in *The Arthurian Yearbook III*, ed. Keith Busby (New York: Garland Publishing, 1993), 181.

62. Jean-Louis Flandrin, "Repression and Change in the Sexual Life of Young People in Medieval and Early Modern Times," *Journal of Family History* 2 (1977): 196–210.

63. James A. Brundage, "Sumptuary Laws and Prostitution in Late Medieval Italy," *Journal of Medieval History* 13 (1987): 343–55.

64. Jacques Rossiaud provides extracts from records detailing such crimes in *Medieval Prostitution*, trans. Lydia G. Cochrane (Oxford: Basil Blackwell, 1988).

65. Walter Prevenier, "Violence Against Women in a Medieval Metropolis: Paris around 1400," in *Law, Custom, and the Social Fabric in Medieval Europe: Essays in Honor of Bryce Lyon*, ed. Bernard S. Bachrach and David Nicholas, Studies in Medieval Culture, 28 (Kalamazoo: Western Michigan University Press, 1990), 262–84.

66. The rape of noble women by men of lower classes was greeted with horror and outrage. Stephen P. Pistono, "Rape in Medieval Europe," *Atlantis* 14 (1989):

39–40.

67. Andreas Capellanus, *Art of Courtly Love*, 150. The treatment of rape in French vernacular literature has been exhaustively examined by Kathryn Gravdal in "Camouflaging Rape: The Rhetoric of Sexual Violence in the Medieval Pastourelle," *Romanic Review* 76 (1985): 361–73 and *Ravishing Maidens: Writing Rape in Medieval French Literature and Law*, New Cultural Studies Series (Philadelphia: University of Pennsylvania Press, 1991).

68. Kathryn Gravdal, "Chrétien de Troyes, Gratian, and the Medieval Romance of Sexual Violence," *Signs* 17 (1992): 585.

69. In an attempt to soften somewhat modern condemnations of sexual crime in the past, Guido Ruggiero has observed that: "Sexuality that crossed social boundaries, even when it was exploitative and violent, did break through the barriers of a hierarchical society in direct and emotionally significant ways. . . . Thus, we may assert that what has been called the double standard has in hierarchical societies the potential to subvert much more than the family—it threatens the social insularity of the society itself." *The Boundaries of Eros: Sex Crime and Sexuality in Renaissance Venice*, Studies in the History of Sexuality (Oxford: Oxford University Press, 1985), 159.

70. This letter is recorded in Bede, *A History of the English Church and People*, trans. Leo Sherley-Price, revised R.E. Latham (Harmondsworth, England: Penguin, 1955), I.27, 81–83.

71. There are virtually no published secondary sources that discuss this rather sensitive issue at length. James A. Brundage appears to be one of the few scholars to have addressed this topic in a conference paper. "Wet Dreams, Sexual Guilt, and the Right of Privacy: The Views of the Decretists," paper presented at the 26th International Medieval Congress, Kalamazoo, MI, May 1991.

72. The Latin text is found in D. André Wilmart, "Un opuscule sur la confession composé par Guy de Southwick vers la fin du XIIe siècle," *Recherches de Théologie ancienne et médiévale* 7 (1935): 337–52.

73. Brundage, *Law, Sex, and Christian Society*, 456.

74. *Njal's Saga*, trans. Magnus Magnusson and Hermann Pálsson (Harmondsworth, England: Penguin, 1960), 52. This passage is discussed in Cathy Jorgensen Itnyre, "A Smorgasbord of Sexual Practices," in Joyce E. Salisbury, ed. *Sex in the Middle Ages: A Book of Essays* (New York: Garland Publishing, 1991), 148.

75. "Similiter si mulier fuerit ita arcta quod non possit vir coire cum ea, videlicet si vas muliebre fuerit ita parvum quod virile membrum non possit intrare, bene potest vir dimittere talem mulierem et accipere aliam, nisi possit illi mulieri subveniri per artem chirugicam. Vidimus enim in quadam muliere vas muliebre per incisionem ita dilatari postea concepit et peperit." Thomas of Chobham, *Summa confessorum*, ed. F. Broomfield, Analecta mediaevalia Namurcensia, 25 (Louvain, Belgium: Nauwelaerts, 1968), 183–84. This advice was repeated by later writers. Brundage, *Law, Sex, and Christian Society*, 458. It would, however, appear to reflect male fantasy or fear rather than a real problem of genital disparity found in nature.

76. Simons, "Alert and Erect," 171.

77. *Grettir's Saga*, trans. Denton Fox and Hermann Pálsson (Toronto: University of Toronto Press, 1974), 155; discussed in Itnyre, "Smorgasbord of Sexual Practices," 148–49.

78. Andreas Capellanus, *The Art of Courtly Love*, 32.

79. Herbert C. Covey, "Perceptions and Attitudes Toward Sexuality of the Elderly During the Middle Ages," *The Gerontologist* 29 (1989): 93–100.

80. All quotations are taken from Nevill Coghill's modernized version of the "Merchant's Tale" in Geoffrey Chaucer, *The Canterbury Tales*, rev. ed. (Harmondsworth, England: Penguin Books, 1977), 280–313.

81. For a discussion of Chaucer's use of Constantine the African's *De coitu*

see Maurice Bassan, "Chaucer's 'Cursed Monk,' Constantinus Africanus," *Mediaeval Studies* 24 (1962): 127–40 and Paul Delany, "Constantinus Africanus and Chaucer's *Merchant's Tale,*" *Philological Quarterly* 46 (1967): 560–66.

82. For the canon law governing impotence and marital nullity see James A. Brundage, "Impotence, Frigidity and Marital Nullity in the Decretists and the Early Decretalists," in *Proceedings of the 7th International Congress of Medieval Canon Law,* ed. Peter Linehan, Monumenta iuris canonici, subsidia, 8 (Vatican City: Biblioteca Apostolica Vaticana, 1988), 407–23; "The Problem of Impotence," in Vern L. Bullough and James Brundage, *Sexual Practices and the Medieval Church* (Buffalo, NY: Prometheus, 1982), 135–40; and *Law, Sex, and Christian Society.* Some of the implications of impotence are also discussed by Vern Bullough, "On Being Male," 41–43.

83. Jacquart and Thomasset, *Sexuality and Medicine,* 168–73.

84. Jacqueline Murray, "On the origins and role of 'wise women' in causes for annulment on the grounds of male impotence," *Journal of Medieval History* 16 (1990): 235–49. A much harsher evaluation is presented in Pierre Darmon, *Trial by Impotence: Virility and Marriage in pre-Revolutionary France,* trans. Paul Keegan (London: Chatto and Windus, 1985).

85. Translated in Richard H. Helmholz, *Marriage Litigation in Medieval England* (Cambridge: Cambridge University Press, 1974), 89.

86. Translated in Murray, "Origins and Role," 241.

87. Translated in Ruggiero, *Boundaries of Eros,* 147–48.

88. Gary Ferguson, "Symbolic Sexual Inversion and the Construction of Courtly Manhood in Two French Romances," in *The Arthurian Yearbook III,* ed. Keith Busby (New York: Garland Publishing, 1993), 210.

89. Richard Kieckhefer, "Erotic Magic in Medieval Europe," in Joyce E. Salisbury, ed., *Sex in the Middle Ages: A Book of Essays* (New York: Garland Publishing, 1991), 30.

90. Emmanuel LeRoy Ladurie, "The Aiguillette: Castration by Magic," in Ladurie, *The Mind and Method of the Historian,* trans. Siân Reynolds and Ben Reynolds (Chicago: University of Chicago Press, 1981), 84–96.

91. Heinrich Kramer and James Sprenger, *The Malleus Maleficarum,* trans. Montague Summers (London: Redker, 1928; rpt. New York: Dover, 1971).

92. Helen Rodnite Lemay, *Women's Secrets: A Translation of Pseudo-Albertus Magnus's 'De Secretis Mulierum' with 'Commentaries'* (Albany, NY: SUNY Press, 1992), 88–89.

93. Ibid., 88.

94. There is little literature available on this subject. See J.D. Rolleston, "Penis Captivus: A Historical Note," *Janus* 39 (1936): 196–201 and C. Grant Loomis, "Three Cases of Vaginism," *Bulletin of the History of Medicine* 7 (1939): 97–98, both reprinted in Joyce E. Salisbury, ed., *Sex in the Middle Ages: A Book of Essays* (New York: Garland Publishing, 1991), 232–38.

BIBLIOGRAPHY

Primary Sources

Ambrose. *On Virginity.* Trans. Daniel Callam. Peregrina Translation Series, 7. Toronto: Peregrina Publishing, 1989.

Andreas Capellanus. *The Art of Courtly Love.* Trans. John Jay Parry. Records of Civilization, 33. New York: Columbia University Press, 1941.

Augustine. *Against Julian.* Vol. 16, *Writings of Saint Augustine.* Trans. Matthew A. Schumacher. The Fathers of the Church, 35. New York: Fathers of the Church, 1957.

———. *The City of God.* Vols. 6–8, *Writings of Saint Augustine.* Trans. Demetrius B. Zema, Gerald G. Walsh et al. The Fathers of the Church, 8, 14, 24. New York: Fathers of the Church, 1950–54.

———. *Confessions.* Vol. 5, *Writings of Saint Augustine.* Trans. Vernon J. Bourke. The Fathers of the Church, 21. New York: Fathers of the Church, 1953.

———. *Continence.* Trans. Mary Francis McDonald. In *Treatises on Various Subjects,* 183–231. The Fathers of the Church, 16. New York: Fathers of the Church, 1952.

———. *The Good of Marriage.* Trans. Charles T. Wilcox. In *Treatises on Marriage and Other Subjects,* 1–51. Vol. 15, *Writings of Saint Augustine.* Fathers of the Church, 27. New York: Fathers of the Church, 1955.

Bede. *A History of the English Church and People.* Trans. Leo Sherley-Price. Revised R.E. Latham. Harmondsworth, England: Penguin, 1955.

Delany, Paul. "Constantinus Africanus' *De coitu:* a Translation." *Chaucer Review* 4 (1970): 55–65.

Gregory of Tours. *The History of the Franks.* Trans. Lewis Thorpe. Harmondsworth, England: Penguin, 1974.

Grettir's Saga. Trans. Denton Fox and Hermann Pálsson. Toronto: University of Toronto Press, 1974.

Jerome. *Against Jovinianus.* In *St. Jerome: Letters and Select Works,* trans. W.H. Fremantle, 346–416. Select Library of Nicene and Post-Nicene Fathers of the Christian Church, VI. New York: Christian Literature Co., 1893.

John of Friburg. *Summa confessorum.* Venice, 1568.

Kramer, Heinrich, and James Sprenger. *The Malleus Maleficarum.* Trans. Montague Summers. London: Redker, 1928; rpt. New York: Dover, 1971.

The Letters of Abelard and Heloise. Trans. Betty Radice. Harmondsworth, England: Penguin, 1974.

Njal's Saga. Trans. Magnus Magnusson and Hermann Pálsson. Harmondsworth, England: Penguin, 1960.

Thomas of Chobham. *Summa confessorum.* Ed. F. Broomfield. Analecta mediaevalia Namurcensia, 25. Louvain, Belgium: Nauwelaerts, 1968.

Wilmart, D. André. "Un opuscule sur la confession composé par Guy de Southwick vers la fin du XIIe siècle." *Recherches de Théologie ancienne et médiévale* 7 (1935): 337–52.

Secondary Sources

Baldwin, John W. "Five Discourses on Desire: Sexuality and Gender in Northern France around 1200." *Speculum* 66 (1991): 797–819.

———. *The Language of Sex. Five Voices from Northern France around 1200.* Chicago Series on Sexuality, History, and Society. Chicago: University of Chicago Press, 1994.

Banner, Lois. "The Fashionable Sex, 1100–1600." *History Today* 42 (April 1992): 37–44.

Bassan, Maurice. "Chaucer's 'Cursed Monk,' Constantinus Africanus." *Mediaeval Studies* 24 (1962): 127–40.

Brittan, Arthur. *Masculinity and Power.* Oxford: Basil Blackwell, 1989.

Brown, Peter. *The Body and Society. Men, Women, and Sexual Renunciation in Early Christianity.* New York: Columbia University Press, 1988.

Brundage, James A. "Impotence, Frigidity and Marital Nullity in the Decretists and the Early Decretalists." In *Proceedings of the 7th International Congress of Medieval Canon Law,* ed. Peter Linehan, 407–23. Monumenta iuris canonici, subsidia, 8. Vatican City: Biblioteca Apostolica, 1988. Rpt. in *Sex, Law and Marriage in the Middle Ages.* Variorum Collected Studies, 397. Aldershot, Eng.: Variorum, 1993.

———. *Law, Sex, and Christian Society in Medieval Europe*. Chicago: University of Chicago Press, 1987.

———. "The Problem of Impotence." In Vern L. Bullough and James A. Brundage, eds., *Sexual Practices and the Medieval Church*, 135–40. Buffalo, NY: Prometheus, 1982.

———. "Prostitution in the Medieval Canon Law." *Signs* 1 (1976): 825–45. Rpt. in *Sisters and Workers in the Middle Ages*, ed. Judith M. Bennett et al., 79–99. Chicago: University of Chicago Press, 1989. Rpt. in *Sex, Law and Marriage in the Middle Ages*. Variorum Collected Studies, 397. Aldershot, Eng.: Variorum, 1993.

———. *Sex, Law and Marriage in the Middle Ages*. Variorum Collected Studies, 397. Aldershot, Eng.: Variorum, 1993.

———. "Sumptuary Laws and Prostitution in Late Medieval Italy." *Journal of Medieval History* 13 (1987): 343–55. Rpt. in *Sex, Law and Marriage in the Middle Ages*. Variorum Collected Studies, 397. Aldershot, Eng.: Variorum, 1993.

———. "Wet Dreams, Sexual Guilt, and the Right of Privacy: The Views of the Decretists." Paper presented at the 26th International Medieval Congress, Kalamazoo, MI, May 1991.

Bullough, Vern L. "On Being a Male in the Middle Ages." In *Medieval Masculinities. Regarding Men in the Middle Ages*, ed. Clare A. Lees, 31–45. Medieval Cultures, 7. Minneapolis: University of Minnesota Press, 1994.

———. *Sexual Variance in Society and History*. New York: John Wiley, 1976.

Bullough, Vern L., and James A. Brundage. *Sexual Practices and the Medieval Church*. Buffalo, NY: Prometheus, 1982.

Bynum, Caroline Walker. "The Body of Christ in the Later Middle Ages: A Reply to Leo Steinberg." *Renaissance Quarterly* 39 (1986): 399–439. Rpt. in *Fragmentation and Redemption: Essays on Gender and the Human Body in Medieval Religion*, 79–117. New York: Zone Books, 1991.

Cadden, Joan. "It Takes All Kinds: Sexuality and Gender Differences in Hildegard of Bingen's 'Book of Compound Medicine.'" *Traditio* 40 (1984): 149–74.

———. *Meanings of Sex Difference in the Middle Ages: Medicine, Science, and Culture*. Cambridge History of Medicine. Cambridge: Cambridge University Press, 1993.

Chaucer, Geoffrey. *The Canterbury Tales*. Ed. Nevill Coghill. Rev. ed. Harmondsworth, England: Penguin Books, 1977.

Cohen, Jeffrey Jerome. "Decapitation and Coming of Age: Constructing Masculinity and the Monstrous." In *The Arthurian Yearbook III*, ed. Keith Busby, 173–92. New York: Garland Publishing, 1993.

Covey, Herbert C. "Perceptions and Attitudes Toward Sexuality of the Elderly During the Middle Ages." *The Gerontologist* 29 (1989): 93–100.

Crane, Susan. "Brotherhood and the Construction of Courtship in Arthurian Romance." In *The Arthurian Yearbook III*, ed. Keith Busby, 193–201. New York: Garland Publishing, 1993.

Darmon, Pierre. *Trial by Impotence. Virility and Marriage in Pre-Revolutionary France*. Trans. Paul Keegan. London: Chatto & Windus, 1985.

Delany, Paul. "Constantinus Africanus and Chaucer's *Merchant's Tale*." *Philological Quarterly* 46 (1967): 560–66.

Deming, Will. "Mark 9.42–10.12, Matthew 5.27–32, and B.NID. 13b: A First Century Discussion of Male Sexuality." *New Testament Studies* 36 (1990): 130–41.

De Vries, David N. "Fathers and Sons: Patristic Exegesis and the Castration Complex." In *Gender Rhetorics: Postures of Dominance and Submission in History*, ed. Richard C. Trexler, 33–45. Medieval and Renaissance Studies and Texts, 113. Binghamton, NY: CMERS/SUNY, 1994.

Eisenbichler, Konrad. "Bronzino's Portrait of Guidobaldo II della Rovere." *Renaissance and Reformation* 24 (1988): 21–33.

Elliott, Dyan. *Spiritual Marriage: Sexual Abstinence in Medieval Wedlock*. Princeton, NJ: Princeton University Press, 1993.

Ferguson, Gary. "Symbolic Sexual Inversion and the Construction of Courtly Manhood in Two French Romances." In *The Arthurian Yearbook III*, ed. Keith Busby, 203–13. New York: Garland Publishing, 1993.

Flandrin, Jean-Louis. "Mariage tardif et vie sexuelle: Discussions et hypothèses de recherche." *Annales d'Histoire economique et sociale* 27 (1972): 1351–78.

———. "Repression and Change in the Sexual Life of Young People in Medieval and Early Modern Times." *Journal of Family History* 2 (1977): 196–210. Rpt. in *Family and Sexuality in French History*, ed. R. Wheaton and Tamara K. Hareven, 27–48. Philadelphia: University of Pennsylvania Press, 1980.

———. *Le sexe et l'Occident: Évolution des attitudes et des comportements*. Paris: Seuil, 1981.

Foucault, Michel. *The History of Sexuality*. Vol. 1. *An Introduction*. Trans. Robert Hurley. New York: Pantheon Books, 1978.

Frantzen, Allen J. "When Women Aren't Enough." *Speculum* 68 (1993): 445–71. Rpt. in *Studying Medieval Women. Sex, Gender, Feminism*, ed. Nancy F. Partner, 143–69. Cambridge, MA: Medieval Academy of America, 1993.

Godfrey, Aaron W. "Rules and Regulation: Monasticism and Chastity." In *Homo Carnalis: The Carnal Aspect of Medieval Human Life*, ed. Helen Rodnite Lemay, 45–57. Acta, XIV. Binghamton, NY: CMERS/SUNY, 1990.

Gravdal, Kathryn. "Camouflaging Rape: The Rhetoric of Sexual Violence in the Medieval Pastourelle." *Romanic Review* 76 (1985): 361–73.

———. "Chrétien de Troyes, Gratian, and the Medieval Romance of Sexual Violence." *Signs* 17 (1992): 558–85.

———. *Ravishing Maidens: Writing Rape in Medieval French Literature and Law*. New Cultural Studies Series. Philadelphia: University of Pennsylvania Press, 1991.

Hanawalt, Barbara A. "Men's games, King's deer: poaching in Medieval England." *Journal of Medieval and Renaissance Studies* 18 (1988): 175–93.

Helmholz, Richard H. *Marriage Litigation in Medieval England*. Cambridge: Cambridge University Press, 1974.

Heusler, Andreas. "The Story of the *Völsi*, an Old Norse Anecdote of Conversion." Trans. Peter Nelson. In Joyce E. Salisbury, ed., *Sex in the Middle Ages: A Book of Essays*, 187–200. New York: Garland Publishing, 1991.

Highwater, Jamake. *Myth and Sexuality*. New York: Meridian Books, 1991.

Itnyre, Cathy Jorgensen. "A Smorgasbord of Sexual Practices." In Joyce E. Salisbury, *Sex in the Middle Ages: A Book of Essays*, 145–56. New York: Garland Publishing, 1991.

Jacquart, Danielle. "Medical Explanations of Sexual Behavior in the Middle Ages." In *Homo Carnalis: The Carnal Aspect of Medieval Human Life*, ed. Helen Rodnite Lemay, 1–21. Acta, XIV. Binghamton, NY: CMERS/SUNY, 1990.

Jacquart, Danielle, and Claude Thomasset. *Sexuality and Medicine in the Middle Ages*. Trans. Matthew Adamson. Princeton, NJ: Princeton University Press, 1988.

Kieckhefer, Richard. "Erotic Magic in Medieval Europe." In Joyce E. Salisbury, *Sex in the Middle Ages: A Book of Essays*, 30–55. New York: Garland Publishing, 1991.

Kuchta, David. "The semiotics of masculinity in Renaissance England." In *Sexuality and Gender in Early Modern Europe: Institutions, Texts, Images*, ed. James J. Turner. Cambridge: Cambridge University Press, 1993, 233–46.

Laqueur, Thomas. *Making Sex. Body and Gender from the Greeks to Freud*. Cambridge, MA: Harvard University Press, 1990.

Lees, Clare A., ed. *Medieval Masculinities: Regarding Men in the Middle Ages*. Medieval Cultures, 7. Minneapolis: University of Minnesota Press, 1994.

Lemay, Helen Rodnite. "The Stars and Human Sexuality: Some Medieval Scientific Views." *Isis* 71 (1980): 127–37.
———. "William of Saliceto on Human Sexuality." *Viator* 12 (1981): 165–81.
———. *Women's Secrets: A Translation of Pseudo-Albertus Magnus's De Secretis Mulierum with Commentaries.* Albany, NY: SUNY Press, 1992.
LeRoy Ladurie, Emmanuel. "The Aiguillette: Castration by Magic." In Ladurie, *The Mind and Method of the Historian*, 84–96. Trans. Siân Reynolds and Ben Reynolds. Chicago: University of Chicago Press, 1981.
Leupin, Alexandre. *Barbarolexis: Medieval Writing and Sexuality.* Trans. Kate M. Cooper. Cambridge, MA: Harvard University Press, 1989.
Levin, Eve. *Sex and Society in the World of the Orthodox Slavs, 900–1700.* Ithaca, NY: Cornell University Press, 1989.
Loomis, C. Grant. "Three Cases of Vaginism." *Bulletin of the History of Medicine* 7 (1939): 97–98. Rpt. in Joyce E. Salisbury, ed., *Sex in the Middle Ages: A Book of Essays*, 237–38. New York: Garland Publishing, 1991.
Makowski, Elizabeth. "The Conjugal Debt in Medieval Canon Law." *Journal of Medieval History* 3 (1977): 99–114. Rpt. in *Equally in God's Image: Women in the Middle Ages*, ed. Julia Bolton Holloway, Constance S. Wright, and Joan Bechtold, 129–43. New York: Peter Lang, 1990.
McGerr, Rosemarie. "Reversing Gender Roles and Defining True Manhood in *Parzival*." In *The Arthurian Yearbook III*, ed. Keith Busby, 215–25. New York: Garland Publishing, 1993.
McNamara, Jo Ann. "The *Herrenfrage*: The Restructuring of the Gender System: 1050–1150." In *Medieval Masculinities: Regarding Men in the Middle Ages*, ed. Clare A. Lees, 3–29. Medieval Cultures, 7. Minneapolis: University of Minnesota Press, 1994.
Miles, Rosalind. *The Rites of Man: Love, Sex and Death in the Making of the Male.* London: Paladin, 1992.
Murray, Jacqueline. "On the origins and role of 'wise women' in causes for annulment on the grounds of male impotence." *Journal of Medieval History* 16 (1990): 235–49.
———. "Sexuality and Spirituality: The Intersection of Medieval Theology and Medicine." *Fides et Historia* 23 (1991): 20–36.
Nelson, James B. *The Intimate Connection: Male Sexuality, Masculine Spirituality.* Philadelphia: Westminster Press, 1988.
Partner, Nancy F. "No Sex, No Gender." *Speculum* 68 (1993): 419–43. Rpt. in *Studying Medieval Women: Sex, Gender, Feminism*, ed. Nancy F. Partner, 117–41. Cambridge, MA: Medieval Academy of America, 1993.
Payer, Pierre J. *The Bridling of Desire: Views of Sex in the Later Middle Ages.* Toronto: University of Toronto Press, 1993.
———. "Foucault on penance and the shaping of sexuality." *Studies in Religion* 14 (1985): 313–21.
———. *Sex and the Penitentials: The Development of a Sexual Code 550–1150.* Toronto: University of Toronto Press, 1984.
Pistono, Stephen P. "Rape in Medieval Europe." *Atlantis* 14 (1989): 36–43.
Prevenier, Walter. "Violence Against Women in a Medieval Metropolis: Paris around 1400." In *Law, Custom, and the Social Fabric in Medieval Europe: Essays in Honor of Bryce Lyon*, eds. Bernard S. Bachrach and David Nicholas, 262–84. Studies in Medieval Culture, 28. Kalamazoo: Western Michigan University, 1990.
Rolleston, J.D. "Penis Captivus: A Historical Note." *Janus* 39 (1936): 196–201. Rpt. in Joyce E. Salisbury, ed., *Sex in the Middle Ages: A Book of Essays*, 232–36. New York: Garland Publishing, 1991.
Rossiaud, Jacques. *Medieval Prostitution.* Trans. Lydia G. Cochrane. Oxford: Basil Blackwell, 1988.

Rousselle, Aline. *Porneia: On Desire and the Body in Antiquity*. Trans. Felicia Pheasant. Oxford: Basil Blackwell, 1988.

Ruggiero, Guido. *The Boundaries of Eros: Sex Crime and Sexuality in Renaissance Venice*. Studies in the History of Sexuality. Oxford: Oxford University Press, 1985.

Salisbury, Joyce E. "The Latin doctors of the Church on sexuality." *Journal of Medieval History* 12 (1986): 279–89.

————, ed. *Sex in the Middle Ages: A Book of Essays*. New York: Garland Publishing, 1991.

Schleiner, Winfried. "The Nexus of Witchcraft and Male Impotence in Renaissance Thought and its Reflection in Mann's 'Doktor Faustus.'" *Journal of English and Germanic Philology* 84 (1985): 166–87.

Schulenburg, Jane Tibbetts. "Saints and Sex, ca. 500–1100: Striding Down the Nettled Path of Life." In Joyce E. Salisbury, ed., *Sex in the Middle Ages: A Book of Essays*, 203–31. New York: Garland Publishing, 1991.

Seidler, Victor J. "Reason, desire, and male sexuality." In *The Cultural Construction of Sexuality*, ed. Pat Caplan, 82–112. New York: Tavistock, 1987.

Sheehan, Michael M. "*Maritalis Affectio* Revisited." In *The Olde Daunce: Love, Friendship, Sex, and Marriage in the Medieval World*, eds. Robert R. Edwards and Stephen Spector, 32–43. Albany, NY: SUNY Press, 1991.

Simons, Patricia. "Alert and Erect: Masculinity in Some Italian Renaissance Portraits of Fathers and Sons." In *Gender Rhetorics: Postures of Dominance and Submission in History*, ed. Richard C. Trexler, 163–86. Medieval and Renaissance Studies and Texts, 113. Binghamton, NY: CMERS/SUNY, 1994.

Steinberg, Leo. *The Sexuality of Christ in Renaissance Art and in Modern Oblivion*. New York: Pantheon, 1983.

Thomas, Keith. "The Double Standard." *Journal of the History of Ideas* 20 (1959): 195–216.

Vanggaard, Thorkil. *Phallós: A Symbol and its History in the Male World*. New York: International Universities Press, 1972.

II
VARIANCE FROM NORMS

7 HOMOSEXUALITY

*Warren Johansson and William A. Percy**

Homosexuality in the Middle Ages long remained virtually unexplored. All that the pioneer investigators of the pre-Hitler period, Xavier Mayne [pseudonym of Edward Irenaeus Prime-Stevenson], *The Intersexes* (1907), Magnus Hirschfeld, *Die Homosexualität des Mannes und des Weibes* (1914), and Arlindo Camillo Monteiro, *Amor sáfico e socrático* (1922), had to say on the entire period from the death of Justinian the Great in 565 to 1475 could have been contained in two pages. The first to venture into this "blind spot" in history were Canon Derrick Sherwin Bailey, *Homosexuality and the Western Christian Tradition* (1955), who sought to exculpate Bible and Church from blame for homophobia, and J.Z. Eglinton, *Greek Love* (1964), who devoted a section to the continuity of pagan pederastic tradition into the Middle Ages. More recently, Vern L. Bullough, *Sexual Variance in History* (1976), consigned 100 pages to unconventional sexuality in Byzantium and the Latin West. Michael Goodich, *The Unmentionable Vice* (1979) and John Boswell, *Christianity, Social Tolerance, and Homosexuality* (1980), offered the first book-length studies. Taking advantage of the lack of documentation and of organization itself during the Dark Age 500–1000, Boswell expanded Bailey's efforts with the original thesis that Christians were not particularly homophobic before the thirteenth century—in spite of the death penalty imposed by Christian Roman and Byzantine emperors and the anathemas hurled at sodomites by the early Church Fathers. Boswell claimed that the secular governments, far more than Inquisitors, and without direct Christian inspiration, carried out most of the arrests, trials, tortures, and execu-

*This article was nearly completed when Warren Johannson died and it owes much to him. I left his name as first author. My personal thanks are also due to Wayne Dynes for his sage advice, to Ed Boyce for his incomparable editorial and computer skills, and to Tom Sargant for help with typing and editing—William A. Percy.

tions of sodomites during the fourteenth and fifteenth centuries, a period little treated by him, but which Goodich had emphasized in part because documentation is so much more plentiful for it. David F. Greenberg, *The Construction of Homosexuality* (1987), has 60 pages in a slightly Marxist framework while Wayne L. Dynes (ed.), *Encyclopedia of Homosexuality* (1990), with well over 100 pages, is in the liberal mold. The least sound, if longest, monograph is Boswell's *Same-Sex Unions in Pre-modern Europe* (1994), which seeks to identify orthodox liturgical precedents for gay marriages in a society that normally prescribed death for sodomites. The best is Michael J. Rocke's dissertation, "Male Homosexuality and its Regulation in Late Medieval Florence" (1989). Articles are pouring forth, some more significant, like those of Giovanni Dall'Orto on Italian cultural figures in the *Encyclopedia of Homosexuality*, than some burdened by social constructionism.

TERMINOLOGY

One of the problems of studying homosexuality in the Middle Ages is the question of whether homosexuals (or gay people) existed then. "Homosexual" and "gay" are modern words. Károly Mária Kertbeny invented the former and first used it in print in an anonymous pamphlet of 1869; the word gay as applied to homosexuality derives from the slang of the American homosexual underworld (first attestation OED2 1935). Terms keep changing, and currently some radicals prefer "queer." In these contemporary acceptations no one in the Middle Ages was or could have been "homosexual," "gay," or "queer."

Medieval theologians and jurists applied yet another term to those "sinning against nature," namely *sodomite*. Latin Christians classified homosexual behavior under the deadly sin *luxuria*, "lust" or "lechery," and assigned it to the worst form, namely the *peccatum contra naturam*, "sin against nature." It had three subdivisions, *ratione generis*, "by reason of species," that is to say with brute animals; *ratione sexus*, "by reason of sex," with a person having the genitalia of the same sex; and *ratione modi*, "by reason of manner," namely with a member of the opposite sex but in the wrong orifice, any one that excluded procreation, which was thought the sole legitimate motive for sexual activity.

The origin of this medieval notion of sodomy derives from *Genesis* 19 and the destruction of the city of Sodom on account of the wickedness of its inhabitants. Yet this reference by itself cannot explain the semantic development of Jewish Hellenistic Greek *Sodomites*, Christian Latin *Sodomita*, into the medieval notion of the "sodomite"—a far broader concept. The depravity of the Sodomites took the form "to know," that is to have sex with the male strangers (supposedly "angels") who were visiting Lot.

Significantly Lot, following the literary example of the host at Gibeah in *Judges* 19 (perhaps an older version), offers the townsmen his daughters instead of the males that they clamored to know, a fact that implies their bisexuality as well as the low esteem in which females were held. Moreover, the verses add that Lot's daughters had not yet known men. This interpretation of to know (which has ample scriptural precedent) seems more valid than the one that Bailey and Boswell argued, namely, that the Sodomites were punished for inhospitality. Whether it is or not is unimportant, because it is the medieval interpretation that is important here, and this seemed to imply same sex relationships were at issue.

Certainly the reworking in the Hellenistic period of the homosexual aspect of the episode into the legend that the Sodomites were one and all similarly and specifically depraved, making the city's destruction the source of the taboo on homosexuality, did not obliterate other mythopoetic elements. Sodomites were also equated with *satyrs*, beings allegedly endowed with insatiable, and what we should now call "polymorphously perverse" sexual appetites. The prohibitions in *Leviticus* 18:22–23 concern only two categories of offender: males who have intercourse with other males, and males and females who copulate with animals. Both were excluded from the sacral community of Israel, as were subsequently all sodomites in the wider definition from the Christian Church.

The Christian concept of the *sodomita*, and then of *sodomia* (which appears in medieval Latin about 1175, possibly in the Iberian peninsula on the model of Arabic *liwāt* < *lt* "sodomite"), also has as its ideological substratum the mythical archetype of the *satyr*.[1] Satyrs embody male sexual desire by virtue of their enormous virile members and more or less permanent erections, but they are unsuccessful in their pursuit of women. For this reason they prefer to assault sleeping women or boys who are taken unawares, but frustrated in their search for pleasure they often turn to one another or even to animals.[2] This assumption explains the manifest expansion of the biblical tradition and the multiplicity of referents of the term *sodomy*. The legal definition, it is true, may often be a narrower one, restricted to anal intercourse with man or woman or vaginal penetration of an animal. But the psychological understanding, the moral reprobation, rests upon the implicit belief in an uninhibited sexual appetite.

The second aspect of satyrs' behavior that shaped the Christian definition of the sodomite is sacrilege.[3] While, albeit often reluctantly, sacralizing heterosexual activity within marriage, mainstream Christian writers demonized all other forms of sexual expression. They even condemned as sacrilege violation by a religious of the vow of chastity. This part of the mytho-

poetic legacy of the ancients completed the negative image of the sodomite as one who has placed himself outside the pale of Christian belief and practice. In a sense this hypothesis also gives the rationale for classifying as sodomy intercourse with Jews and Saracens,[4] or even, in a case from rural Poland in the eighteenth century, of so labeling a liaison between the daughter of a noble family and a young serf trained as a musician.[5] The sodomite is driven by lusts so bestial, demonic and blasphemous as to make him trample upon every law of God and man in quest of pleasure.

Another term that came into use in the twelfth century but gained ground after 1235, is *Bulgarus*, "Bulgarian," whence French *bougre* and English *bugger* (from which the nouns of action *bougrerie* and *buggery* were subsequently derived). It was the merit of a heresy hunter Robert le Bougre to have confounded all the heretical sects under one name,[6] which became synonymous with "heretic" and then "sodomite" and "usurer." Catholic inquisitors accused adherents of dualist sects of practicing the detestable vice, in part because of their unconventional views on sexual morality.[7] English "buggery" is not, however, unambiguously attested in the sexual sense until the penal law of Henry VIII in 1533; it is nowhere found in Middle English.

PEDERASTY VS ANDROPHILIA

Another question that must be addressed, if only because Boswell has so insistently raised it, is whether medieval (and Roman) homosexuality was predominantly pederastic or androphile. Quite clearly, the homosexuality of the ancient world was predominantly age-asymmetrical. In ancient Greece approved sexual interplay normally took place between an (active) adult male and a (passive) adolescent male between the ages of 12 or 13 and 17 or 18.[8] Theorists praised such erotic relationships (which some maintained should not lead to penetration) as strengthening male bonding and fostering civic virtue and courage on the battlefield. On the other hand, Hellenes and Latins interpreted effeminacy, gender inappropriate behavior in their eyes such as an adult male being penetrated, as evidence of a lack of male strength of character and indicative of cowardice and baseness.

Without social disapprobation, Romans, provided that they were the penetrators, could do as they wished with slaves and freedmen.[9] The opposition heterosexual/homosexual, though not unknown,[10] was, depending as it does exclusively on object choice, usually not emphasized. One reason for this is that the Judeo-Christian taboo on sexual relations with persons having the genitalia of the same sex was unknown to Hellenic culture. The phenomena which the modern mind collects under the rubric of homosexuality fell then into several different distinct and more or less watertight compartments.

A further obstacle to reducing homosexuality to a single category was the pederastic mindset, a psyche aroused not so much by the masculinity as by the androgyny of the male adolescent. Many modern commentators neglect this crucial difference between pederast and androphile. Hellenistic and Roman artists were fond of androgynous youths, and assimilated the eunuch to the adolescent as passive sexual partner. In short, Greeks and Romans did not as a rule think in terms of object choice in determining what might be called "homosexuality," but rather the role played (inserter vs. insertee). The condemnation of all male-male sex was thus more Judaic than Greco-Roman.

"Homosexuality" then is an umbrella concept covering a multitude of constitutional and personality types.[11] The census of those standing under it has varied through the centuries for reasons that have still to be elucidated. Plausibly the same-sex sex of upper-class Greeks was nine-tenths pederastic and one-tenth androphile, while that of modern Americans seems to be nine-tenths androphile and one-tenth pederastic. The type predominating in medieval society need not have been the same during all centuries or in all areas, but fifteenth-century evidence from Florence and Venice, far more detailed than for any previous medieval society, indicates that the classical, age-asymmetrical variant remained normative, though mostly shorn of its pedagogical aspect so touted by the Greeks. Modern androphilia may indeed have first flourished or predominated in areas with Germanic or Celtic populations before 1869 or even 1893 or before 1700, dates debated by social constructionist enthusiasts such as Halperin and Trumbach for the birth of the modern homosexual identity, but they fail to perceive how much the concept of the homosexual derived from that of the sodomite, especially of the habitual sodomite.

ROOTS OF HOMOPHOBIA

Once defined by theologians as "sinful behavior," all homosexual activity, as well as other forms of sodomia, could only be the object of mounting condemnation and repression by clerical and civil authorities. From St. Paul onward, Christians deemed sodomy sinful and, once they gained hegemony over governments, criminal as well. The sources of Christian intolerance were manifold. First, there was the legacy of paganism. Greco-Roman (and primitive Germanic) culture strongly reproved any type of homosexual (and any other) activity that was perceived as gender-discordant. The passive-effeminate male, designated as *cinaedus* in Latin and *argr* in Old Norse, bore the brunt of overpowering contempt and hostility, but only social—not legal—sanctions.[12] However, to call another male the equivalent of an *argr* was an offense under Lombard law.

Judaism bequeathed to Christianity the model of the Levitical clergy, which was heterosexual but not abstinent. Never in all of its 2500-year history has Judaism had celibate priests or virginal priestesses, never any other ideal for its religious elite or for its laity than marriage and fatherhood. From Magna Mater religions of Asia Minor and/or Zoroastrianism, Christianity had adopted a different tradition, one that deferred to the Jewish prohibition of self-castration (in rejection of Origen and other fanatics who made themselves eunuchs "for the sake of Christ"), but still embodied an androgynous norm into which those oriented toward their own sex conveniently fitted.

Leviticus 18:22 and 20:13, alongside *Deuteronomy* 22:5 and 23:18, expressly forbade male homosexuality, cultic cross-dressing and prostitution. Furthermore, the account of the destruction of Sodom in *Genesis* 19 gave quasi-historical example and sanction to the death penalty prescribed in the Priestly Code. All these texts, read in the *Vetus Latina* and then in St. Jerome's translation, gave divine sanction to intolerance. To this day they remain the ineluctable "bottom line" in the arguments of the foes of gay rights, cited by the Supreme Court in *Bowers v. Hardwick*. Even if at the outset the scope and purpose of these provisions of the Mosaic Law were narrower than the blanket condemnation that later became normative, the Judaic tradition was unambiguous. In Hellenistic Judaism, perhaps as an abreaction to Greek *paiderasteia*, male homosex was made tantamount in gravity to murder. Palestinian Judaism did not lag behind; the *Talmud* (b.Sanhedrin 73a) went so far as to ordain that one had the right to kill another male to prevent his committing this crime, a plea still entered as "homosexual panic" in certain gay-bashing cases in the guise of a justly enraged "victim" approached for homosex.

Early Christians adopted and ratified Hellenistic Jewish homophobia. Such passages as *Romans* 1:18–32 and *I Corinthians* 6:9 merely reiterate the Judaic rejection and condemnation of love for one's own sex. In addition, from Gnostic speculation on the role of sexuality in the cosmic process, Christians acquired a profound malaise with sexual dimorphism (as an imperfect human condition) and the ideal of an asexual humanity. From this standpoint heterosexual intercourse even for reproduction within Christian marriage could be little more than a necessary evil; homosexual intercourse of any kind was a wholly unnecessary one.

The Christian emperors, who became the head of the church and remained so in Orthodox lands, instituted the death penalty at first perhaps only for certain, then for all, homosexual acts. The sons of Constantine the Great decreed an anti-sodomy law in 341,[13] and the decree of Theodosius

the Great in 390, followed by Justinian's novellae 77 and 141 in the sixth century, ordained death by burning for the "sin against nature." Moreover, Justinian initiated a long tradition of making tabooed sexuality the scapegoat for society's ills, asserting that God sent plagues, famines, and earthquakes as punishments for sodomy.[14] Hence at the outset of the Middle Ages Imperial law, inspired as it was by theologians, prescribed death.

CHURCH FATHERS

The patristic writings, most of which presume canonical the New Testament if not its Apocrypha, are Christian texts from the second century until the seventh century or even until the thirteenth, when Scholasticism took hold.[15] An exception is a *Secret Gospel of Mark*[16] which may have treated Jesus' implied homoerotic relationship with a catechumen before the theme was expunged from the canonical Mark. As we know them, the gospels are so reticent about the sexuality of Jesus that disputes still rage over whether Jesus recommended the chastity he apparently practiced over the marriage he praised.[17]

More than any other evangelist, Luke portrays Jesus, who criticized those who followed the letter of the law instead of the spirit of love, as contradicting rabbinical conventions on sex, for example by teaching that to follow him a man must reject his wife's love and abandon his parents and that celibacy might be necessary for salvation. In the early church, before tradition or texts became fixed, though a few praised and practiced every variety of sexuality from virginity to promiscuity, most, conscious of standing apart from and above pagans in sexual mores, accepted the Judaic view that homosexuality, like infanticide, was a very grave sin.

Deemed the second founder, St. Paul, whose epistles comprising one third of the New Testament are the earliest of preserved Christian writings, was explicit. He prescribed marriage only for those too weak to remain chaste, but forbade divorce, then available at the whim of Jewish, Greek, and Roman husbands.[18] Influenced by Jewish Scripture, by pharisaic Judaism, and by the melange of ascetic Platonism and theosophical Judaism best exemplified by Philo Judaeus, he categorically forbade all sex outside marriage. He singled out homosex, even between females, for special condemnation, as well as transvestism of either sex, long hair on males and other signs of effeminacy or softness, and masturbation. *Romans* 1:18–27, *Titus* 1:10, *Timothy* 1:10, and *I Corinthians* 6:9 all emphatically condemn male homosex.

All of the Fathers were explicitly or implicitly (in their advocation of virginity, chastity, etc.) homophobic. The earliest postbiblical (non-canoni-

cal) Christian homophobic writing that has been preserved, the anti-Jewish *Epistle of Barnabas*, known in a fourth-century Alexandrine manuscript, explained that the Mosaic Law declared the hare unclean because it symbolized sodomy. The *Acts of Paul and Thecla* claimed that Paul demanded total renunciation of sex. The *Acts of Andrew the Apostle* assured a lady that her renunciation of sex with her husband would overcome her sins resulting from the expulsion of Adam and Eve from the Garden of Eden. In the *Acts of John*, Christ thrice dissuaded the apostle from marrying. By the mid-third century, the *Acts of Thomas* were enthusiastic about the sexless life. The Gnostic *Gospel According to the Egyptians* argued that Adam and Eve by introducing sex brought about death.

On returning to the Near East from Rome in 172, Tatian, a student of Justin Martyr (who had even approved another pious young man's wish to be castrated), enjoined chastity on all Christians. Some Syrian churches baptized only celibate males. Certain second and third-century heretics argued that marriage was Satanic. Marcionites described the body as a nest of guilt. The *Gospel According to the Egyptians* even had Jesus speak of paradise before the sexes had been differentiated. Not all agreed, and among libertine sects the second-century Alexandrian Carpocrates's teen-aged son Epiphanes, who succeeded him as head of the heretical sect, advocated holding of women and goods in common. This tradition, however, was never very strong.

As early as 177 Athenagoras, characterizing adulterers and pederasts as foes of Christianity, subjected them to excommunication, then the harshest penalty that the Church, itself still persecuted by the Roman state, could inflict. The Council of Elvira (305) severely condemned pederasts. Canons 16 and 17 of the Council of Ancyra (314) inflicted lengthy penances and excommunication for male homosex.

Head of the catechetical school in Alexandria until he fled persecution in 202, St. Clement combined Gnostic belief that illumination brought perfection with Platonic doctrine that ignorance rather than sin caused evil. Borrowing from Neoplatonism and Stoicism, Clement, who idealized a sexless marriage as between brother and sister, like Philo, condemned homosexuality as contrary to nature. Pseudo-Clement opined that one had to look far away to the Sinae (to China) for people who lived just and moderate lives (*Recognitions*, 8, 48).

The learned enthusiast Origen, prevented from seeking martyrdom by his mother in 202, reinforced fasts, vigils, and poverty with self-castration, which he understood *Matthew* 19:12 as recommending. In 257 another fanatic, St. Cyprian, bishop of Carthage, opined that the plague had the merit

of letting Christian virgins die intact, but no Christian invoked medical arguments about the benefits of virginity or (as late pagan physicians did) of caution and moderation, which was not at all the same thing. Syriac third-century forgeries ascribed to St. Clement, bishop of Rome, worried about the celibate male virgin traveling from one community to another, because he would be set upon by unmarried females.

The Coptic Father of Christian monasticism, St. Anthony, at 20 gave away his inheritance and devoted himself to asceticism, retiring first into a tomb and then into the desert, in both of which he fought with hordes of demons. Failing to seduce him in the guise of a woman, the Devil reappeared as a black boy. Around 305 Anthony organized the hermits that he had attracted into a community under a loose rule. The end of the persecutions gave such ascetics the glory formerly gained by martyrs. Like St. Anthony, other anchorites found sexual desire the most difficult urge to control and ordained severe fasts to weaken it. The desert fathers increased the sexual negativism of other Christians just as monasticism emerged and heightened the temptations of homosex for the cloistered. Converted after being discharged from the army in 313, another Copt, St. Pachomius, founded a monastery in the Thebaid where he eventually presided over nine such institutions for men and two for women as abbot general. His rule, the first for cenobites, influenced those of St. Basil, John Cassian, Caesarius of Arles, St. Benedict, and that of "the Master." Pachomius said that "no monk may sleep on the mattress of another" (Ch. 40) or come closer to one another "whether sitting or standing" than one cubit (about 18 inches) even when they took meals together.

Most famous of pillar ascetics, St. Simeon Stylites (ca. 390–459) lived on a column for about four decades near Antioch working miracles. Such "athletes for Christ" mortified their bodies more than Olympic athletes had ever improved theirs, but the lack of external discipline and scandals of other hermits encouraged the proliferation of monasteries, where the repression of sodomy became an obsession. Much influenced by the desert fathers, with whom he long sojourned, the Patriarch John Chrysostom, the most eminent of the Greek fathers, raved, "How many hells shall be enough for such [sodomites]?" in *Homily IV* on *Romans* 1:26–27.

The long struggle against the synagogues, begun by St. Paul in Asia Minor, the heartland of Christendom, which continued in Rome and North Africa, stained Christianity with anti-Judaism. Just as Latin Christians borrowed anti-Judaism from Greeks, who had long clashed with them in Alexandria, they also borrowed homophobia from the Jews, which they reinforced with Roman hostility to effeminacy. Catholics may have become even

more homophobic than the Orthodox, who were after all living among the occasionally still somewhat pederastic Greeks.

Becoming bishop of Lyons in 177 after the martyrdom of Pothinus, St. Irenaeus attacked gnosticism. Perhaps the most influential gnostic, Valentinus was said to recommend free love for the "pneumatics," spiritual men freed from the Law by gnosis. Unlike his Alexandrine contemporary St. Clement, who condemned sodomy as "against nature" and brandished other Platonic arguments, Irenaeus emphasized tradition, scriptural canon, and the episcopate in his struggle against the Gnostics.

Educated in liberal arts and in law at Carthage, Tertullian, father of Latin theology, who converted in 197, eventually joined the Montanists. In apologies and controversial and ascetic tracts in Latin and occasionally in Greek, he rebutted pagan accusations that Christians practiced homosex and cannibalism, charges ironically that Christians were soon to hurl against heretics. Tertullian demanded separation to escape from the immorality and idolatry of pagan society. He may have edited the *Passion of Saints Perpetua and Felicitas*, whose virginity he made central.[19] Following Irenaeus in stressing tradition and attacking the Valentinians, he pessimistically dwelt on original sin and the Fall. Eschatological expectations led him to asceticism and perfectionism. In *De Pudicitia*, he condemned the laxity of Pope Callistus and of a bishop of Carthage toward sexual sinners, urging a legalistic system of rewards and punishments. Though influenced by Stoicism, he stressed the literal and historical interpretation of revelation. About 250 another Latin author, probably Novatian, wrote: "Virginity makes itself equal to the angels."

One of the four Latin "Doctors of the Church," St. Ambrose in his treatise on clerical ethics, *De Officiis*, encouraged asceticism and Italian monasticism. After studying at Rome, another of the "Doctors," St. Jerome urged extreme asceticism in *Against Helvidius* and *Against Jovinian*, asserting that "Christ and Mary were both virgins, and this consecrated the pattern of virginity for both sexes." The greatest "Doctor," St. Augustine, who towered over all the other Latin fathers, developed doctrines that held sway throughout the Middle Ages until Thomas Aquinas challenged and modified them in the thirteenth century. The Protestants, however, revived them again. Leaning heavily on the Old Testament and on the doctrine of original sin while rejecting Manichaeism, which he had once accepted, Augustine insisted that all non-procreative modes of sexual gratification were wrong because pleasure was their sole object, and his condemnation prevailed throughout the rest of the Middle Ages.

Withdrawing from the licentiousness at Rome, where he was educated, to a cave at Subiaco, St. Benedict of Nursia organized those monks

attracted to his hermitage into twelve monasteries but in 525 moved to Monte Cassino, where this "Patriarch of Western Monasticism" composed his rule by altering and shortening "The Rule of the Master" and also drawing freely upon the rules of Sts. Basil, John Cassian, and Augustine.[20] His chapter 22 prescribed that monks should sleep in separate beds, clothed and with lights burning in the dormitory; the young men were not to sleep next to one another but separated by the cots of elders. From a noble family that fled Cartagena when it was destroyed by the Arian Goths, St. Isidore, who entered a monastery ca. 589, succeeded his brother as archbishop of Seville. Presiding over several councils in Visigothic Spain, the only Germanic realm whose laws punished homosexual acts, he founded schools and convents and tried to convert Jews. His often fanciful *Etymologies* (such as *miles quia nihil molle faciat*, "miles [soldier] because he does nothing effeminate") became the encyclopedia of the Early Middle Ages. Borrowing from Augustine, Isidore condemned nonprocreative sexuality and approved marriage only hesitantly and solely for the begetting of children. Adopted in toto from such Hellenistic Jewish authors as Philo Judaeus and Flavius Josephus, the homophobia of the early Fathers, reinforced with a sex-negativism peculiar to Christianity, was never contradicted or even questioned by any thinker accepted as an authority by later generations of Christians until the 1950s.

EARLY MIDDLE AGES

The criminalization of homosex by Christian emperors became unenforceable when "barbarians" overwhelmed the Western Empire. Over time Germanic codes replaced Roman law there. Except in Visigothic Spain, where the source of the legal code in Christian doctrine is clearly evident, Germanic codes did not refer to the crime against nature. But at a time when the legal order and society itself were fast disintegrating, gratified (or ungratified) homosexual urges little interested the new, still essentially barbarian rulers.

As Pope Gregory the Great (590–604), the last of the "Doctors of the Church," inaugurated the missions to convert Germans and Celts, the church developed new modes of enforcing its reprobation of the sin against nature. Beginning in Wales and Ireland, newly won for the faith, this role fell to the penitentials, manuals to aid priests in giving spiritual guidance to laity by enumerating the various categories of sin and prescribing appropriate penances.[21] They are striking for their broad, detailed treatment of sexual behavior. All of the several dozen that survive have at least one condemnation of sodomy, and several offer a relatively extended analysis of it with typically a penance of seven to twenty years for sins specifically ascribed to Sodom, three to seven years for oral-genital contacts, three to fifteen years

for anal intercourse, one to three years for intercrural relations, and a mere 30 days to two years for masturbation. Monks were often disciplined more lightly, at least in practice, and allowances made for youth. Lesbian relations are scarcely mentioned. None of the penitentials even implies that the secular arm should prosecute or punish culprits, but most treated homosexual offenses more severely than heterosexual ones, prescribing greater severity for anal than for oral sex—whether with a partner of the opposite or of the same gender. The early canons followed the penitentials, some of which were invested with canonical authority, in prescribing various penances despite *Leviticus*'s death penalty and St. Paul's fulminations.

Arguments that saints' lives showed hatred for homosex are convincing, as well as that monks were tempted by female transvestites, whom they assumed to be beautiful young males.[22] The claim that this attraction undermines the argument of the social constructionists by positing a homosexual to hate is, however, poorly construed because sodomy, as has been emphasized before, was feared and condemned in these episodes, not the "homosexual" personality. Under Charlemagne (768–814), a secular enactment assigned penances for sodomy and a capitulary condemned sodomy among monks, remarking that it had become common.[23]

The ninth-century verses of a Veronese cleric to a youth whom a rival had stolen show true feeling:

O thou eidolon of Venus adorable,
Perfect thy body and nowhere deplorable!
The sun and the stars and the sea and the firmament,
These are like thee, and the Lord made them permanent.
Treacherous death shall not injure one hair of thee,
Clotho, the threadspinner, she shall take care of thee.

Heartily, lad, I implore her and prayerfully
Ask that Lachesis shall treasure thee carefully,
Sister of Atropos—let her love cover thee,
Neptune companion, and Thetis watch over thee,
When on the river thou sailest forgetting me!
How canst thou fly without ever regretting me,
Me that for sight of my lover am fretting me?

Stones from the substance of hard earth maternal, he
Threw o'er his shoulder who made men supernally;
One of these stones is that boy who disdainfully

Scorns the entreaties I utter, ah, painfully!
Joy that was mine is my rival's tomorrow,
While I for my fawn like a stricken deer sorrow! (Curtius, 114)

The dissolution of the Carolingian Empire began in 817, and new waves of invasions ended the brief renascence that it had encouraged. In the mid-ninth century Hincmar of Reims asserted that lesbians are "reputed to use certain instruments of diabolic function to excite desire." Even in later centuries only the use of a dildo (single or double) warranted the intervention of the authorities.[24] Chaos during the ninth and tenth centuries again derailed the Christian attacks on Sodom, which had revived somewhat, as we have seen, when Charlemagne and his immediate successors had restored order and tried to create a Christian commonwealth.

THE CHURCH'S CRACKDOWN

As soon as the Church reorganized itself after the invasions and other disruptions of the early Middle Ages, fervent clerics assailed sodomites. About 1051 Saint Peter Damian, a member of the circle of papal reformers, in the *Liber Gomorrhianus*, bitterly denounced male homosex, particularly among the clergy, where he deemed it rampant and asserted that whoever practiced sodomy was "tearing down the ramparts of the heavenly Jerusalem and rebuilding the walls of ruined Sodom." His denunciations presaged the attitude of later councils and canonists. He charged that such sins were not only common but escaped attention because those guilty of them confessed only to others equally compromised. The response of Pope (later Saint) Leo IX (1049–54) was no more than a polite acknowledgment that Damian had shown himself a foe of carnal pollution. The ardent reformer had not convinced the pontiff that sweeping measures against sodomitic clergy were necessary. Leo was quite willing to let the moral status quo in the Church remain, perhaps sensing that a campaign to identify and oust transgressors would only amount to a self-inflicted wound. That so many individuals with unconventional sexual preferences should have over the centuries served a religion that uncompromisingly forbade their sexual self-indulgence is, in retrospect, a political as well as a psychological problem. The sexual abnormality of the clergy has so far unfortunately been the object of sectarian or anti-clerical polemics rather than dispassionate study.

A new phase in the evolution of attitudes toward sexuality began with Hildebrand (Gregory VII, 1073–1085), the most revolutionary of all popes. He demanded clerical celibacy—that priests put away their wives and concubines. Although not completely successful in enforcement, the relentless

drive against clerical sexuality gave rise to a sort of moral purity crusade which also assailed Orthodox, Muslims, and Jews as well as heretics and sodomites. The intensified emphasis upon asceticism and clerical celibacy was to mark Roman Catholic morality ever after. Priestly sexual abstinence was never again doubted, and condemnation of "unnatural vice" even among the laity inevitably became more strident and imperative.[25]

Canon law, previously rather unarticulated and scattered, developed rapidly and homophobically after 1000. "The canonical compilations demonstrate that the reformers favored moral rigorism: as a group they considered sex and other pleasurable experiences tainted by evil and a potent source of sin."[26] Following Burchard of Worms (d. 1025), Ivo of Chartres (d. 1115) had canons in his *Decretum* that prescribed severe penalties for fellation, bestiality, pederasty, and sodomy. For the Kingdom of Jerusalem, the Council of Nablus decreed in 1120 that those guilty of sodomy should be burned. Gratian's collection, *Concordia discordantium canonum,* in five books, completed shortly before 1150, superceded earlier compilations, becoming the text for scholastics. Updating principles of Roman Law, Gratian introduced "natural law," which became important for sodomy. In 1234 Gregory IX expanded the collection, creating the *Corpus juris canonici*, to which the Liber Sextus was added in 1298 and the Clementines in 1317. These seven books, and the two *extravagantes* added later, were glossed. Increasingly homophobic theologians, including fanatic friars from Thomas Aquinas to Luca da Penne, influenced the glossators. They and Inquisitors inspired feudal, royal, and municipal laws to ordain the fining, castrating, and even burning of sodomites—all penalties that remained foreign to Canon law itself even when revised by the Council of Trent (1545–1563).

Although Gratian devoted little space to "unnatural" sexuality, Peter the Chanter devoted a long chapter of his *Verbum abbreviatum* to it. His circle seems to have originated a fantasy that they ascribed to St. Jerome— the story that at the moment when the Virgin Mary was giving birth to Jesus, all sodomites died a sudden death.[27] Thenceforth canonists regularly cited Justinian's novella 77 that famine, pestilence, and earthquake, to which many added floods and other natural catastrophes, are God's retribution for unpunished "crimes against nature." The Third Lateran Council (1179) ruled that clerics guilty of "that incontinence which is against nature" leave the Church or be perpetually confined in a monastery. Somewhat paradoxically, Bernard of Pavia (d. 1213) held that sodomy did not create affinity and thus constituted no impediment to marriage.

After 1250 savage penalties were ordained. A convenient political invective that the popes hurled against dissidents, sodomy was also repeat-

edly linked with heresy. Many ascribed this vice to clerics—probably justifiably. Like scholastics, canonists treated homosexuality, bestiality, and masturbation as "contrary to nature," because they excluded the possibility of procreation, a touchstone of sexual morality. Such crimes by clerics constituted *sacrilege,* because his or her body was a vessel consecrated to God. These offenses, if notorious, brought infamy *(infamia),* a deprivation of status, unfitness for public office, and loss of the right to be a plaintiff or witness in court. Ironically, the canonist Pierre de La Palud (ca. 1280–1342) explained at length why two males could not marry each other to legitimize their relationship.

Beginning at least as early as Gregory IX's commission to the Dominicans in 1232 to ferret out heretics in southern France, Inquisitors in certain regions extended their jurisdiction to sodomites as well, now viewed as allies of demons, devils, and witches. Those convicted were handed over for punishment to secular authorities, which in time were independently to prescribe and enforce death. Before execution, torture wrung confessions from victims, and often the trial records were burnt together with them.

In the Latin and vernacular literature homosexuality played a role, if only at times perhaps as an afterglow of classical antiquity.[28] It should always be remembered that almost until the end, medieval literature when written at all circulated in manuscript among highly elite audiences who often read and appreciated classical Latin poetry. Neither the Latin nor indeed the vernacular texts, which were often composed for ladies and laymen ignorant of Latin, spoke much about homosex. They were not much subject to the formal and informal censorship that set in once the printing press had made possible a literature aimed at mass readers of the vernacular. The Latin classics, virtually the sole "exotic" literature accessible to medieval readers, were rich enough in homoerotic language and themes to inspire any poet or prose author. The twelfth-century Cistercian Aelred of Rievaulx beautifully praised novices in Latin.[29] Youths in many of these medieval poems, "as in some classical poems, are often not responsive toward their older lovers but haughty and aloof."[30] In addition there were numerous Arabic and, from Muslim Spain, some Hebrew pederastic poems.[31] Stories of the knights and squires living without ladies in castles, where the only woman other than the lord's lady was likely to be a serving wench, who bonded and doubtless had homoerotic feelings towards each other, sometimes reflected these feelings, often obliquely, in vernacular poems and romances.[32] Clerics routinely denounced English royals and courtiers for sodomy, from William II and the son of Henry I to Richard I and Edward II, as well as the German emperors and their courtiers from Henry IV through Frederick II and Conradin.[33]

Four major trends can be discerned in the medieval literature dealing with love for one's own sex: (1) glorification of the physical beauty of the adolescent boy; (2) praise of male bonding and fidelity, often coded as self-sacrificing friendship, since romantic love was restricted to females, whom the romances put on a pedestal as did the new cult of the adoration of the Virgin; (3) treatments in which increasingly ambivalence, aversion, and reprobation come to the fore; and (4) reworkings of biblical or Christian themes that are by their very origin negative and condemnatory, such as the much discussed passages in Dante's *Inferno*.

There was more homosexual verse during the brief renascence of the twelfth century than before or after, which Curtius deemed more of a convention (modeled on classical Latin) than Boswell, who held that such verses were an indication of real life loves whether pederastic or gay.[34] Alan of Lille (c. 1128–1202), known as *doctor universalis*, in the *Complaint of Nature* portrays nature as a figure ignorant of theology, teaching not contrary but different things, but man alone of all beings does not obey her and reverses the law of sexual love. Baudri of Bourgueil (1046–1130), like his contemporary Marbod, wrote love poems to both women and boys:

> This their reproach: that, wantoning in youth,
> I wrote to maids, and wrote to lads no less.
> Some things I wrote, 'tis true, which treat of love;
> And songs of mine have pleased both he's and she's. (Stehling, 151)

Also neither of the two most influential works of the mid-twelfth century, Gratian's *Decretum*, the text for canonists, and Peter Lombard's *Sententiarum*, for theologians, was particularly harsh on sodomites, which Boswell believed, mistakenly we think, to be evidence of church tolerance.

Baldwin (1994), whose "Five Voices" from northern France around 1200 disagreed on a variety of sexual topics, "unequivocally agreed on one common conviction: in accordance with traditional Hebraic-Christian antipathy, they judged all homoerotic relations to be the most reprehensible of sexual behaviors. Because of a universal presumption of heterosexuality the issue of gender was implicit in all five discourses."[35] He drew on three Latin sources written for clerics: Peter the Chanter, who composed in the Augustinian mode; the *Prose Salernitan Questions*, a physician's guide in the mode of Galen; and Andreas Capellanus's exposition of love à la Ovid. He also analyzed Old French sources of two types, one refined for lords and ladies in Jean Renard, who developed the Romantic view of Chrétien de Troyes and Marie de France (the only significant woman writer), and one

bawdy for bourgeois: the fabliaux as exemplified by Jean Bodel. Thus every literate order was represented in his samples, and at a time just before the reception of Aristotle and the logic of the scholastics increased homophobia and "spawned legislation that sought to obliterate homoerotic practices from Western Europe." Even so it was then believed that:

> God instituted holy matrimony to constitute the exclusive domain for sexual relations . . . the procreation of children was one of the two unproblematic goals which the theologians assigned to the institution of marriage. Once again . . . the reproduction of children was the primary justification for intercourse.[36]

Even married women were urged to volunteer to remain chaste henceforth as a *mulier sancta*, not from the current medical theory but from religion, as increasingly priests and deacons were required to be celibate despite protests as early as 1074 in Paris.

Mostly it is true, however, that homosexuality succumbed to the Christian taboo, which was not simply a prohibition of homosexual behavior but also a banishment of the subject from the realm of polite discourse. It was only in the twentieth century that the topic openly and positively returned in world literature. The late Middle Ages, however, saw another phenomenon that was to last down to the twentieth century, namely, the formation of a linguistic code that enabled insiders to communicate their homoerotic feelings and reveal their true sexual orientations to one another without being intercepted by a hostile church and society. This innovation marked a radical break with the explicitly homoerotic literature of antiquity, whose authors and public had no need of such concealment. Much more needs to be done to collect and interpret whatever survives of the clandestine homosexual literature of the late Medieval period. The positive legacy of the Middle Ages included Edward II and Piers Gaveston, the sole unequivocally positive homoerotic model of adult male liaison and commemorated as early as the Elizabethan era in Marlowe's *Edward II*. The survival of a precious body of literature about the pederasty of the ancients, for the most part in late medieval manuscripts, undoubtedly inspired Renaissance pederasts. Among ancient survivals is the *Greek Anthology,* known from a manuscript of the late tenth century, Athenaeus and Hesychius from manuscripts of the early fifteenth, Catullus from three of the fourteenth. Quite clearly the gay-positive heritage of antiquity survived Christian neglect, censorship, and destruction, due to the efforts of a few editors and copyists who merit closer investigation.

We have two "debates" from the thirteenth century, between Helen and Ganymede and between Hebe and Ganymede (Stehling 114, 115) about the relative merits of each type of lover. Although heterosexual love, in accord with nature, wins, the beautiful innocent boy puts up a good argument in each discourse.

DEMONIZATION

Before 1200 sodomy was not normally linked with apostasy; the role which male homosexuality had played in the sacral prostitution of the Ishtar-Tammuz cult or other religions of pagan Asia Minor had long been forgotten and prejudice against *argrs* had mostly become dormant.[37] The Crusades whipped up prejudice against Muslims, believed to be given over to homosexual vices, and against Jews, assumed to be lustful. Westerners also associated sodomy with the dualist heresy of the Bogomils in Bulgaria and the Cathars in Provence.

Toward the mid-thirteenth century the very word *Bulgarus* acquired the meaning of *sodomita*. But most important, the earlier reprobation was now magnified into a full-fledged obsession, which Warren Johansson in 1978 defined and labeled as the *sodomy delusion*. In its fullest formulation it is a complex of paranoid beliefs invented and inculcated by the church, and prevalent in much of Christendom to this day, to the effect that non-procreative sexuality in general, and sexual acts between males in particular, are contrary to the law of Nature, to the exercise of right reason, and to the will of God, and that sodomy is practiced by individuals whose wills have been enslaved by demonic powers. Furthermore, everyone is heterosexually oriented but everyone is susceptible of the demonic temptation to commit sodomy, and potentially guilty of the crime; everyone hates and condemns sodomites but the practice is ubiquitously threatening and infinitely contagious; everyone regards the practice with loathing and disgust, but whoever has experienced sodomitic pleasure retains a lifelong craving for it; it is a crime committed by the merest handful of depraved individuals but, if not checked by the harshest penalties, it would become so rampant as to occasion the suicide of the human race. A source of eternal damnation for the individual sinner, it impairs and undermines the moral character of those who practice it; it is so hateful to God as to provoke his retaliation in the form of catastrophes that can befall an entire community for the unpunished crime of a single individual in its midst. For its own self-preservation every Christian community must be eternally vigilant against its occurrence and spread, and the parties guilty of such abominable practices should be punished with the utmost severity and, if

not put to death in accordance with biblical precept, then totally excluded from Christian society.

This delusion persisted after every other form of medieval intolerance (such as the condemnation of adultery in *Leviticus* and the New Testament) had been abandoned or at least so discredited that it could no longer enter into official policy, even if some vestiges lingered in private attitudes. This tenacious survival of the medieval Christian heritage remains the chief obstacle to gay rights, but it also challenges students of medieval society and power structures. In one respect it is even fortunate that the sodomy delusion survived virtually intact into the Enlightenment, if modified somewhat since then, because it can be examined in vivo with all the tools of the cultural historian and the depth psychologist, not just from yellowing documents of the sixteenth century couched in a language that often obscures what the modern scholar would like to know. Future study of its dynamics and of the social forces that still uphold it can afford precious insight into psychopathology.

In the wake of the adoption of these beliefs, highly questionable if not absurd notions find their way into texts on *sodomia ratione sexus*. Although St. Anselm, Archbishop of Canterbury in 1100, made some excuses for younger clerics who committed the sin of Sodom, the new hard line prevailed. In his *Legenda aurea* (1290), Jacopo da Varagine repeated Peter the Chanter's fantasy that all the world's sodomites had died at Jesus' birth, adding that, according to Saint Augustine, because human nature was defiled with this vice, the Son of Man repeatedly postponed his incarnation and even thought of renouncing the project altogether. Hugh of Saint-Cher, in his commentary on the Vulgate (Paris, 1232), solemnly asserted that grass will not grow on a place where sodomy has so much as been mentioned, and that while an incubus may assume a man's shape, and a succubus a woman's, a succubus would never take on male form because even devils would be ashamed to take the passive role in sodomy. In the emerging law codes, to be sure, the active (normally the older) partner often received harsher penalties.

Christian intolerance enveloped homosexual *behavior* in a nexus of unprovable but credible fantasies. Toward 1360 a South Italian jurist, Luca da Penne, wrote in his *Commentaria in Tres Libros Codicis*, Book XII, 60(61), 3:

> If a sodomite had been executed, and subsequently several times resuscitated, each time he should be punished even more severely if this were possible: hence those who practice this vice are seen to be

enemies of God and nature, because in the sight of God such a sin is deemed graver than murder, for the reason that the murderer is seen as destroying only one human being, but the sodomite as destroying the whole human race. . . .

Guy de Roye [Guido de Monte Rocherii], archbishop of Tours and of Reims, in 1388 in *Manipulus curatorum* (of which a French version from Troyes in 1604 under the title *Le Doctrinal de Sapience* added that the reproach of sodomy is so vile that even the enemies of Jesus did not dare to accuse him of it at the time of his Passion, although they heaped every other kind of abuse on him) opined:

> Of the vice of sodomy Augustine declares how detestable it is, saying that the sin is far greater than carnal knowledge of one's own mother, as shown by the punishment inflicted on the Sodomites who perished in fire and brimstone from heaven. This sin, moreover, cries spiritually unto the Lord, whence in Genesis the Lord says: The cry of Sodom and Gomorrah has come unto me, for as Augustine says, by this sin the society which should be in us with God is violated when the very Nature of which he is himself the prime mover is polluted by the perversity of lust. . . . It is indeed of such accursedness that not the act alone but the mention of it pollutes the mouth of the speaker, the ears of the listeners, and the very elements in general.

Thomas Aquinas played a distinctive role in the onset of the sodomy delusion. In a crucial passage of the *Summa Theologiae* (I–II, q. 31, 7) he "misinterpreted" the material which he borrowed from *Nicomachean Ethics* (VII v 3–4, 1148b). There Aristotle had explicitly stated that sexual attraction to males (*venereorum masculis*) could be motivated either by nature (*natura*) or from habit (*ex consuetudine*). In his commentary on the Latin text of Aristotle, Aquinas dutifully admitted that such unnatural pleasures could be sought and experienced "from the nature of the physical constitution which [certain people] have received from the beginning" (*ex natura corporalis complexionis quam acceperunt a principio*). But in the *Summa Theologiae* he suppressed this concession to assert that what is contrary to human nature (*id quod est contra naturam hominis*) may "become connatural to a particular human being" (*fiat huic homini connaturale*). "Connatural" here does not mean "inborn" but is applied to feelings that have so fused with the personality of the subject as to become "second nature." Later he adds what Aristotle had nowhere said, that "such corruption can

be . . . for psychological causes" (*quae corruptio potest esse . . . ex parte animae*) and exemplifies it with "in intercourse with animals or males" (*in coitu bestiarum aut masculorum*) to paraphrase the Christian notion of *sodomia*.

Like Philo Judaeus, Aquinas paired the Hellenic conception of the "unnatural" with a Zoroastrian-Judaic commandment to produce the scholastic condemnation. Though Aristotle did not condemn homosexual behavior as such, Aquinas in this case imposed the moral sanction on the basis of the biblical tradition.

From the late thirteenth century onward, statutes against sodomy, with penalties ranging from mere fines to castration, exile, and death, enter secular law. The sacral offense moved from canon to civil law. Times and places varied, but the language and motivation are everywhere the same. The first documented execution in Western Europe is from 1277. Illegality became the norm and remained so until the Enlightenment began its work of criticizing and dismantling the Old Regime's criminal law, believing that sodomy, like witchcraft, had been criminalized by superstition and fanaticism.

A further weapon of the Church in its repression of sodomy was the ascription of *infamy of fact*. This was the stigma attached to those who violated specific canons and other clerical ordinances, and in the case of the sodomite it entailed perpetual infamy, which is to say lifelong exclusion from the Christian community. Those found guilty of unnatural vice, or even suspected of it, suffered a civil death: even if not prosecuted, they and their families could be completely ostracized and economically boycotted; they could be assaulted or even murdered with impunity, because civil authorities felt no obligation to prosecute assailants, a mentality that has lasted in police and court practice to this day.

The persistence of medieval infamy into modern times, not some "instinctive aversion" to homosexual activity, underlies the ostracism and persecution which lovers of their own sex currently encounter. Infamy is a subject remarkably neglected by medievalists; recent works have chiefly dwelt upon obscure technical points of canon law rather than upon its social impact, which badly needs to be investigated in connection with the status of sodomites.

PARANOID DELUSIONS

Subsumed under the "crime against nature," sodomy became invisible to the Christian mind, yet the object of a thousand fantasies. It was nowhere, yet everywhere threatened society with destruction. It was blotted out of the annals of the past, unrecorded in the present, forbidden to exist in the fu-

ture. Trial records were burned along with culprits, so that no trace should remain. Yet, enveloped in the impenetrable darkness of ignorance and superstition, it existed silent and unseen, a phantom eluding the clutches of an intolerant world. This shift from the explicit but not obsessive condemnation of earlier centuries to the frantic intolerance of homosexual expression has been a hallmark of Western civilization since the late thirteenth century.[38]

As in the case of prosecution of witches, or leveling charges against Jews, accusations of sodomy brought against a particular individual or sect need not have been grounded in reality. This is the crux of the century-long debate over the alleged guilt of the Knights Templar, who were accused of sodomy and in some cases tortured into confessing it so that their order could be abolished and its property confiscated. The most painstaking investigators have often come to negative conclusions, even pointing out that the charges failed to convince contemporary public opinion that the trials had any other motive than the greed of the French king Philip IV.[39] However, others, perhaps less critical, starting from some such premise as "there are always homosexuals in an all-male organization," or that "male bonding usually involves some form of homosexuality," have freely accepted the charges and even elaborated on them.[40] It is pertinent, however, that the execution of Piers Gaveston—against whom the evidence was far more substantive—occurred a mere two years after the trial of the Templars, and Edward II, his lover, had married Philip IV's daughter, who afterward helped encompass her husband's deposition and brutal murder.

The witchcraft delusion held sway from the end of the fifteenth century to the middle of the eighteenth, by which time it had been discredited in all but remote backwaters. The Judeophobic delusion lasted much longer, certainly down to the middle of the twentieth century, when revulsion at the active or passive complicity of many Christians with the Holocaust inspired profound guilt on the part of theologians because Christians defamed Jews over the centuries. The sodomy delusion remained in full vigor until the 1960s and only now is being challenged.

THE CLOSET AND CLANDESTINE SUBCULTURE

The sodomy delusion forced homosexuals to live in a state of outward assimilation and invisibility. The only social organization which they could devise was that of a criminal subculture that hoped and desired to be invisible to the authorities of an intolerant church and state, and not everyone could discover or gain access to this underworld. Less than a ghetto, they had at most, known solely to initiates, clandestine rendezvous for furtive

sexual encounters, attested from London, Cologne, and many Italian cities, particularly during the fifteenth century.[41]

Lovers of their own sex were forced into dissimulation as the only way of survival. Marginalized by the dominant culture, they could only take refuge in a subculture that hid not just from the authorities but from Christian society as a whole. A proto-homosexual personality type resulted, for which deception and hypocrisy were second nature. The conversion of the religious taboo into an administrative process of repression required the innovation of police procedures, and here the delusional world of the religious mind collided head-on with the real world. The enormity of the offense was matched only by its ubiquitousness.

The impressive dissertation by Michael J. Rocke, "Male Homosexuality and Its Regulation in Late Medieval Florence," a sort of Kinsey Report for the fifteenth century,[42] concluded that as in other Italian cities at least, if not elsewhere, it remained "an integral and apparently ineradicable part of the society of late medieval and early modern Florence." Efforts to suppress homosexual activity were to no avail, even though in fifteenth-century Florence up to a third of males were accused of sodomy, because the belief system could not suppress the cultural traditions (and biological forces) underlying it. The officials charged with policing sodomy quickly became aware that to inflict the death penalty upon every sodomite would wound society. When the penalties were too harsh, magistrates simply refused to convict very often, as in Venice, which imposed the death penalty occasionally but spectacularly. In Florence the death penalties were gradually reduced as the number of those convicted rose. Other north Italian and Tuscan communes had policies somewhere between those of Florence and Venice.[43]

Italian and to a lesser extent northern communes developed a strategy of repression. It hovered between two poles: toleration in the sense of not prosecuting activity that the police kept under surveillance, and sporadically rounding up offenders in droves to punish them with death, mutilation, exile, fines, or other less drastic sentences. With all the vagaries of police administration over the centuries, this remained the pattern to modern times, even in Nazi Germany.[44] Monter (1974) documented a wave-like pattern of several dozen trials for sodomy in Switzerland from the fifteenth to the eighteenth century, and Carrasco (1985) detailed the ubiquitous actions of the Inquisitors in Valencia from the sixteenth to the eighteenth century. Moral crusaders could, of course, make life wretched for sodomites and other denizens of the sexual underworld, but after their usually brief campaigns, life went back to normal or, if you prefer, abnormal. Hypocrisy, corruption, and moral ambivalence became the norm, while homosexual activity became

the invisible one—the screen behind which forbidden urges enacted their dramas of lust and gratification. It was theologians and clerics, often rabid friars like St. Bernardino of Siena, who denounced homosexual desire as a form of madness, and Savanarola, who inspired municipal laws and administered the Inquisition. Clandestine homosexual subcultures such as those in London and Cologne arose, and survived more than six centuries of repression and defamation to become the basis of our modern movement. A homosexual personality type evolved and survived in a hostile milieu by virtue of dissimulation and hypocrisy ("the closet"). All the efforts of church and state failed to eradicate the forbidden tendencies and the outlawed behavior, even if they could drive these underground. Old French literature, which effectively began around 1100 with the *Chanson de Roland*, has almost nothing explicitly homoerotic. Italian literature, which began over a century later at the court of the Hohenstaufen with the Sicilian poets and then the Tuscans, long before the Renaissance encouraged admiration for and imitation of classical pederastic models which reinforced the trend, abounds with homoeroticism or allusions to sodomites from its start to the repression of the Counter-Reformation during the later sixteenth century.

Antonio Beccadelli's jocular *Hermaphroditus* (1425) and Pacifico Massimo of Ascoli's *Hecathalegium* (1489), as well as the invectives that Italian humanists hurled at one another, echo the frequent charges recorded in the police blotters. Donatello, Botticelli, Leonardo, and Michelangelo, homosexuals themselves and admirers of the antique, restored homoeroticism and nudity in art, which had been virtually absent except for St. Sebastian and Jesus and St. John, since the fall of Rome. Beginning with that of the Neoplatonist Marsilio Ficino, numerous treatises on love discussed the permissibility of love between males, including one by Girolamo Benivieni (1453?–1542) and one by Giovanni Pico della Mirandola (1463–1494).

Finally, then Western society adopted the sodomy delusion, a complex of irrational beliefs that made sodomites scapegoats for society's ills—and implicitly for the failure of the Church's own prophylactic and apotropaic rites.

A Note on Boswell

The tenor of this article is contrary to ideas put forth by John Boswell, who in two of his books has attempted to find Church toleration if not sanction for homosexuality. Boswell's *Same-Sex Unions in Pre-Modern Europe* follows the same pattern as his *Christianity, Social Tolerance and Homosexuality*.[45] Both have frequent, complex footnotes in numerous languages. Both exonerate the Christian Church from guilt for persecution of gays, at least up to 1200. He gives a different picture of homosexuality than exists in this

article, or than exists in most of the other writers on the subejct such as Bullough, Compton, Goodich, Dynes, Lauritson, and Johansson. Whether there were gays (persons with a conscious identity and often even pride) in the Middle Ages as Boswell argued and insisted on in his first book and insisted on in an article,[46] or even homosexuals (understood as a type of person), as opposed to merely persons indulging in sodomy, is an ongoing debate. But that established churches condoned such "sins" and created liturgies to bless couples engaged in a love so decadent and unnatural it was not even supposed to be mentioned among Christians is an anchronistic twist not heretofore imagined and should not be taken seriously. We cannot find a single Christian father, Penitentialist, Scholastic or Canonist, Protestant Reformer or Catholic Counter-Reformer or even any Orthodox, Coptic, or Nertorian who ever wrote even a neutral, much less a kind, word about sodomites.

Moreover, as we understand Christian marriage, it was designed to reduce concupiscence and to provide heirs, not to give mutual pleasure or even to provide companionship, although that might well have been one of the results. Boswell imagined that these same-sex unions, as he described them, that he found in Greek and Slavic had parallels in Latin for Catholics but that they have been lost. That may be, but such asexual brotherhoods can serve as precursors for modern (homosexual) gay marriage only by a wide stretch of the imagination and with blatant disregard for both scripture and tradition.

Boswell did find in one of his liturgies for spiritual brotherhood a prohibition against sodomy, but then he argued unconvincingly that sodomy was "not understood by Jews or Christians of the Middle Ages as a reference to homosexual love,"[47] something we find hard to accept. All Boswell's erudition and hair-splitting can't make a gay marriage out of a spiritual bonding. His work, brilliant as it is, can best be understood as a work in the tradition of Christian Apologetics, not dispassionate scholarship, although it is written from a point of view that most other writers of Christian Apologetics could not and would not accept. Readers and scholars who investigate will have to decide for themselves. Certainly the material in this article should furnish a good guide to those beginning their investigations.

NOTES

1. See Lissarague (1987) and Collinge (1989). A.J. van Windekens has proposed a convincing etymology for *sátyros* from Greek for "seizing the female genitalia," van Windekens (1986), pp. 203–04.

2. Collinge (1989), p. 83, "A red-figure cup in Berlin from the wider circle of the Nikosthenes painter . . . shows both of these activities: one satyr is having his anus

penetrated, while another without a partner is attempting to importune a sphinx. The Berlin cup shows anal rather than intercrural copulation, a further indication, possibly, of the satyrs' lack of inhibition and lack of any need to retain respectability. . . . Satyrs also abandon any claim to propriety in their eagerness to penetrate animals. Bestiality is a rare activity for men, from the evidence of the illustrations, but more common for satyrs."

3. Collinge (1989), p. 90. "Satyrs mostly act piously, or mock and tease, but do on occasion commit sacrilege. This last option reveals a hitherto unexpected and apparently serious antipathy towards religion. . . . They occasionally stepped over the accepted limit . . . in the region of religious activities more than any other."

4. Joost de Damhoudere (1646), caput XCVIII, does not, however, regard this departure from the Christian ideal as true sodomy.

5. Baranowski (1955), p. 64, citing Ochocki (1857), pp. 117–18.

6. Robert le Bougre, a member of the Ordo Praedicatorum, as recorded by Matthew Paris in his *Chronica Majora*, ed. Luard, III, 520: "Moreover he called them by the vulgar name of *bougres*, whether they were Patarines, or Jovinians, or Albigensians, or defiled by other heresies." The high point of his activity evidently fell in the years 1236–1238.

7. Greenberg's assertion that the medieval group was founded by a priest Bogomil is but one tradition.

8. See Percy, (1996).

9. Williams (1990), who somewhat laboriously refutes the common opinion that the *mos majorum* condemned homosexuality as such, rightly insisting that it censured all forms of *luxuria* including expensive slave boys and also excesses that might distract from *gravitas* or from certain civic responsibilities, in a chapter entitled "Alternative Models: Spouses, Brothers, Friends and Lovers" (pp. 321–67) follows Boswell into the error of asserting that there were serious Roman gay marriages like ours between adults.

10. See Plato's *Symposium*, *Firmicus Maternus*, the *Problems* of the Pseudo Aristotle, *Dialogues on Love*, and various epigrams in the *Greek Anthology*.

11. Foucault in vols. 2 and 3 (1984), Winkler (1988), and Halperin (1986), unlike Dover (1978), failed to acknowledge the ancients' conception of homosexuality and disdained to use it about ancient or medieval people.

12. At least this is the case if the well known quote in Tacitus's *Germanicus* (xii) did not call for passives or even homosexuals to be drowned in bogs, as many have maintained, but prescribed that death only for cowards and deserters, as we believe, Dynes et al. (1990), II 1275–76.

13. The text which prescribes an "avenging sword" seems ambiguous. Boswell (1980), pp. 123–24, claimed a "lack of any penalty" in this "curiously phrased statute," which he interpreted as outlawing "gay marriages." In Dalla's interpretation, however, it applied to any man acting as the passive partner, Dalla (1987), pp. 167–68. Eva Cantarella, Professor of Roman Law at the University of Pavia, agreeing with Dalla, further observed that until the sixth century the death penalty applied only to *molles* and not to the active sodomite, Cantarella (1988), pp. 265–66.

14. In the long debate over Justinian's novellae 77 and 141 it has been conveniently forgotten that the ancients possessed the rudiments of a science of seismology and that the Emperor's pious indictment of those guilty of the sin of Sodom, so far from being a scientific possibility, was the nadir of superstition. See Darmstaedter (1933).

15. See Brown (1988), Brundage (1987), Fox (1987), and Pagels (1988). Too extensive for any one person to digest, Migne's collections of the Church Fathers, perhaps one hundred times longer than all surviving Greek and Latin pagan texts together, needs to be scanned and searched by computer for key words to further illuminate Patristic attitudes. After 1200, vast official archives as well as unpublished scholastic works and other literature survive, providing about another hundred times as much as Migne. After the development of printing, sources increase exponentially again.

16. As reconstructed by Morton Smith (1973).

17. If Jesus himself ever addressed the topic he may have advocated tolerance: i.e. don't denigrate your brother by calling him "queer" or "racha": Warren Johansson, *Cabirion* (1984).

18. Polygamy was then practiced among Jews, who married at a young age, and it remained so even among those in Christian Europe until the eleventh century, and levirate marriage of a brother's widow had been mandatory.

19. Incredible as it may seem, Boswell (1994), pp. 139–41, deemed that this particular Roman woman and her maid, holy martyrs that they were, as potential models for lesbian marriage.

20. It was only in 500 in Gaul that a common dormitory was instituted in place of the solitary cells (Benedict, Ch. 22) after the old building burned. See Chadwick (1981).

21. The most extensive treatment is by Payer (1984) but see also Bullough (1976). See also Payer's article in this collection.

22. See Gaunt (1994) and Bullough (1974).

23. See Bullough (1976), p. 353, and Boswell (1980), p. 177.

24. See Crompton (1980–81).

25. Flandrin (1969) and (1972) detected a faultline between high medieval practice and theory and suggests that for most, everyday practice fell somewhere between the two extremes of clerical erotophobia and courtly libertinism.

26. Brundage (1987), p. 182. Brundage, now the standard authority, devotes a section in each chronological chapter to homosex and homoeroticism.

27. Baldwin (1994), however, found no mention of this fantasy in the works of either Peter or St. Jerome, pp. 44 and 282.

28. See Stehling (1984) and (1985). In a phone call to the authors, David Greenberg thinks he is on to something heretofore undetected in the Lais of Marie de France and some of the romances.

29. See McGuire (1994) and Hill (1983)—the only positive reference to homosexuality in the whole of J.R. Strayer's multi-volume *Dictionary of the Middle Ages*.

30. Stehling (1984), p. xxi. See also the poem by Marbod of Rennes (ca. 1035–1123), where speaking as a boy he teases his lover with threats of infidelity: "He is even-tempered now but with further delays he'll turn wicked," p. 31.

31. See Roth (1982), and the articles by him in this volume.

32. See Greenberg (1988).

33. Dynes et al. (1990), I 345–6, I 428–9, I 525–6, II 1109–10, and II 1195.

34. Curtius (1953) is the pioneer work on sodomy in medieval literature, a subject which the standard works by Holmes (1937) and Raby (1957) ignore.

35. Baldwin (1994), p. 229.

36. Baldwin (1994), pp. 46, 211, and 225–26.

37. Pagan survivals are attested inter alia by William Hamilton (1883) and Evans (1978), neither, to be sure, unimpeachable sources.

38. Jackson (1921), p. 161, claimed that in the thirteenth century "the high water mark of medieval civilization was attained. Judged by the men who were born or flourished within it, the age is one of the most glorious in history . . . but judged by its fruits it is one of the most disastrous in history." This assertion is certainly true of the Church's relations with women, Jews, heretics, and homosexuals, where the legacy of the thirteenth century lasted intact into the twentieth.

39. The best example of this is Finke (1907). In their defense the Templars had alleged that any Templar found guilty of homosexual behavior—which was one of the principal charges against the order—would be expelled and imprisoned in fetters for the rest of his life; such was their rule. See Burrows (1965) and Parker (1963).

40. Typical of these lines of reasoning are Legman (1966)—his contribution is solidly opposed by Lea (1966)—and Kluncker (1989).

41. Johansson (1984a) and Bloch (1908) proved the existence of such communities in northern cities. By the fifteenth century they certainly existed in the much better documented Florence and Venice.

42. More detailed than anything before or afterward until the Parisian police records of the early eighteenth century and the records of the Portuguese Inquisition exploited by Mott (1988).

43. Recent works (Rocke [1990] on Florence and Ruggiero [1985] on Venice, where sodomy was treated as a major crime on a par with poisoning), using police reports and judicial records so plentiful in the archives of those municipalities, have confirmed Goodich (1979) about the terrible persecutions of sodomites in late medieval and Renaissance communes, and Dall'Orto's brilliant articles on late medieval Italy in Dynes et al. [1990], especially "Italian Renaissance," II 1103–06, have documented nearly a hundred artists and authors in various genres but no one has yet combined the two streams.

44. See Stümke (1988).

45. Paglia (1994) found that Boswell "lacks advanced skills in several major areas, notably intellectual history and textual analysis . . . Speculative reasoning is not his strong suit . . . Boswell's treatment of the Middle Ages, ostensibly his speciality, is strangely unpersuasive." She concluded that Boswell has "not remotely established that [these ceremonies] were originally homosexual in our romantic sense . . . The cause of gay rights is not helped by this kind of slippery, self-interested scholarship, where propaganda and casuistry impede the objective search for truth." Shaw (1994) found texts mistranslated and evidence misconstrued throughout *Same-Sex Unions* and a brotherhood ceremony from the Grottaferrata manuscript mistakenly conflated with an actual marriage ceremony from later pages. Wright (1994) wrote that Boswell's "extraordinary skills and industry are deployed with such tendentiousness, exaggeration, special pleading, and occasional banality that the book deserves, at the very best, the distinctive verdict of the Scottish courts: not proven." Wright disproved Boswell's assertion that he had not received much criticism for his earlier book, citing his own critique of it where Boswell mistranslated two key words, as Johansson et al. (1985) independently pointed out.

46. John Boswell, "Revolutions, Universals and Sexual Categories," *Salmagundi*, 58–59 (1982–83), 89–113.

47. Boswell (1994), p. 293.

BIBLIOGRAPHY

Primary Sources

KEY TO ABBREVIATIONS:

ANF = *The Ante–Nicene Fathers*, eds. Alexander Roberts and James Donaldson. (Grand Rapids, MI: Eerdmans, 1951).

NNF = *Nicene and Post-Nicene Fathers of the Christian Church*, eds. P. Schaff and H. Wace, Series II (New York: Christian Literature Co., 1890–1900).

PG = *Patrologiae Cursus Completus*, ed. Jacques Paul Migne. *Series graeca*. (Paris: Garnier Fratres, 1857–66).

PL = *Patrologiae cursus completus*, ed. Jacques Paul Migne. *Series latina*. (Paris: Garnier Fratres, 1844–64).

Acts of Andrew the Apostle, ANF, v. 8.
Acts of John, ANF, v. 8.
Acts of Paul and Thecla, ANF, v. 8.

Acts of Thomas, ANF, v. 8.

Aelred of Rievaulx. De spirituali amicita, Opera Omnia, ed. A.C. Hoste and C.H. Talbot (Turnhout, Belgium: Brepolis, 1971).

Alain de Lille (Alan of Lille). The Complaint of Nature, trans. Douglas M. Moffat (New York: B. Holt, 1908).

Ambrose. De officiis, PL, v. 16.

Anselm. Letter to the Archdeacon William, PL, v. 159.

Athanasius. Life of St. Anthony, NFF, v. 4.

Athenagoras. A Plea for the Christians, ANF, v. 2.

Baudri of Bourgueil. Les Oeuvres poétiques de Baudri de Bourgueil, ed. Phyllis Abrahams. (Paris: H. Champion 1926).

Beccadelli, Antonio. Hermaphroditus, ed. Donatella Coprini (Rome: Bulzoni, 1990).

Benedict of Nursia. The Rule of St. Benedict, ed. J. McCann (London: B. Oates, 1952).

Bodel, Jean. Les Fabliaux, ed. Pierre Nardin (Dakar: Université de Dakar, 1959).

Clement of Alexandria. The Instructor, ANF, v. 2.

Clement of Rome (ascribed author). Clementines, PG, v. 2.

Cyprian. Liber de habitu virginum, PL, v. 4.

Epiphanes. See Clement of Alexandria, Stromateis, III, 2–6, ANF, v. 2.

Epistle of Barnabas, ANF, v. 1.

Gospel According to the Egyptians, in Montague Rhodes James, The Apocryphal New Testament (Oxford: Clarendon Press, 1924).

Gratian. Concordantia discordantium canonum (Decretum), Corpus Juris Canonici, ed. A. Friedberg, v. 1 (Leipzig: Bernhard Tauschnitz, 1879).

Hugues de Saint-Cher (Hugh of Saint Cher). Concordantia Bibliorum sacrorum vulgatae editionis (Paris: n.p., 1635).

Isidore of Seville. Etymologiarum sive originum libri xx (Oxford: Clarendon Press, 1911).

Ivo of Chartres. Decretum, PL, v. 161.

Jerome. Against Helvidius, tr. John N Hritzu (New York: Fathers of the Church, n.d.).

———. Contre Jovinien, Oeuvres de Saint Jérôme, ed. M.B. Matougus (Paris: Société du Panthéon Littéraire, 1841).

John Chrysostom. Homilies of St. John Chrysostom . . . on the Epistle of St. Paul the apostle to the Romans, trans. J.B. Morris (Oxford: J.H. Parker, 1841).

Josephus. Complete Works (New York: Bigelow, Brown, 1924).

Justinian. The Civil Law, trans. S.P. Scott (Cincinnati: Central Trust Company, 1932).

La Palud, Pierre de. Quartus sententiarum Liber (Paris: n.p., 1514).

Marbode. Poèmes de Marbode évêque de Rennes, ed. Sigismond Ropartz (Rennes: n.p., n.d.).

Origen. Commentary on the Gospel of Matthew, ANF, v. 9.

Pachomus. Chronicles and Rules, trans. A. Veilleux (Kalamazoo, MI: Cistercian Publications, 1982).

Pacifico Massimo. Hecatelegium, ed. Juliette Desjardins (Paris: Diffusion, C.I.D., 1986).

Passions of Saints Perpetua and Felicitas, in Herbert Musurillo, The Acts of the Christian Martyrs (Oxford: Clarendon Press, 1972)

Penna, Lucas de (Luca da Penne). Super tres libros codicis (Paris: n.p., 1509).

Peter the Chanter. Verbum abbreviatum, PL, v. 205.

Peter Damian. Liber Gomorrhianus, PL, v. 145.

Peter Lombard. Sententiarum Libri quatuor, PL, v. 192.

Philo Judaeus. Oeuvres (Paris: Editions du Cerf, 1961).

Pseudo-Clement. Recognitions, ANF, v. 8.

Renard, Jean. Le Roman de la Rose, ed. Félix Lecoy (Paris: H. Champion, 1979).

Roye, Guy de. Le Doctrinal de sapience (Troyes, 1604).

Tatian. Address to the Greeks, ANF, v. 2.

Tertullian. *De pudicitia (On Modesty)*, ANF, v. 4. See also selected works in *ANF, vv. 3 and 4*.

Thomas Aquinas. *In decem libros Ethicorum Aristotelis ad Nicomachum exposito*, ed. A.M. Pirotta (Turin: Marietti, 1933).

Voragine, Jacques de Jacopo da Varagine. *La légende doreé*, trans. J.-B.M. Roze (Paris: Garnier Flammarion, 1967).

Secondary Sources

Ahern, John. "Nudi Grammantes: The Grammar and Rhetoric of Deviation in Inferno XV." *Romanic Review* 82 (1990): 466–86.

Armour, Peter. "The Love of Two Florentines: Brunetto Latini and Bondie Dietaiuti." *Lectura Dantis* 9 (1991): 11–33.

d'Avack, Pietro Agostino. "L'omosessualità nel Diritto Canonico." *Ulisse* 3/18 (1953): 680–97.

Bailey, Derrick Sherwin. *Homosexuality and the Western Christian Tradition*. London: Longmans, Green, 1955.

Baldwin, John W. *The Language of Sex: Five Voices from Northern France around 1200*. Chicago: University of Chicago Press, 1994.

Baranowski, Bohdan. *Sprawy obyczajowe w sdownictwie wiejskim w Plsce wieku XVII i XVIII*. Morals Cases in the Rural Judiciary in Poland of the 17th and 18th Centuries, Prace Wydziau II, No. 16, 1955.

Bein, Thomas. "Orpheus als Sodomit: Beobachtungen zu einer mhd. Sangspruchstrophe mit (literar)historischen Exkursen zur Homosexualität im hohen Mittelalter." *Zeitschrift für deutsche Philologie* 109 (1990): 33–55.

Biener, Friedrich August. *Geschichte der Novellen Justinian's*. Berlin: Ferdinand Dümmler, 1824.

Bloch, Iwan. "Die Homosexualität in Köln am Ende des 15. Jahrhunderts." *Zeitschrift für Sexualwissenschaft* 1 (1908): 528–35.

Boswell, John. *Christianity, Social Tolerance, and Homosexuality: Gay People in Western Europe from the Beginning of the Christian Era to the Fourteenth Century*. Chicago: University of Chicago Press, 1980.

———. "Revolutions, Universals and Sexual Categories." *Salmagundi* 58–59 (1982/3): 89–113.

———. *Same-Sex Unions in Pre-modern Europe*. New York: Villard Books, 1994.

Braeger, Peter C. "The Portrayal of Lot in the Middle English *Cleanness*." *Mediaevalia* 11 (1985): 83–100.

Brall, Helmut. "Geschlechtlichkeit, Homosexualität, Freundesliebe: Über mannmännliche Liebe in mittelalterlicher Literatur." *Forum Homosexualität und Literatur* 13 (1991): 5–27.

Broughton, Lynne C. "Bibliographical Texts and Homosexuality: A Response to John Boswell." *Irish Theological Quarterly* (1993): 141–53.

Brown, Peter. *The Body and Society: Men, Women and Sexual Renunciation in Early Christianity*. New York: Columbia University Press, 1988.

Brundage, James A. *Richard Lion Heart*. New York: Scribner, 1974.

———. *Law, Sex, and Christian Society in Medieval Europe*. Chicago: University of Chicago Press, 1987.

Brusegan, Rosanna. "Le secret de la *Flors enversa*." *Revue des langues romanes* 96 (1992): 119–44.

Bullough, Vern L. "Transvestism in the Middle Ages." *American Journal of Sociology* 79 (1974): 1381–94.

———. *Sexual Variance in Society and History*. New York: John Wiley, 1976. reprinted Chicago: University of Chicago, 1978.

Bullough, Vern L. and James A. Brundage, eds. *Sexual Practices and the Medieval Church*. Buffalo: Prometheus Books, 1982.

Burrows, Toby. "The Templars' Case for their Defence in 1310." *Journal of Religious History* 13 (1965): 248–59.

Canosa, Romano. *Storia di una grande paura: La sodomia a Firenze e a Venezia nel Quattrocento*. Milan: Feltrinelli, 1991.

Cantarella, Eva. *Seconda natura: La bisessualità nel mondo antico*. Roma: Editori Ruiniti, 1988.

Carrasco, Rafael. *Inquisicion y Represion Sexual en Valencia: Historia de los Sodomitas (1565–1785)*. Barcelona: Laertes, 1985.

Chadwick, Owen. *The Making of the Benedictine Ideal*. Washington, DC: St. Anselm's Abbey, 1981.

Collinge, Anna. "The Case of Satyrs," pp. 82–103 in Mary Margaret Mackenzie and Charlotte Roueche, eds., *Images of Authority: Papers Presented to Joyce Reynolds on the Occasion of her Seventieth Birthday*. Cambridge, England: Cambridge Philological Society, 1989.

Crompton, Louis. "The Myth of Lesbian Impunity." *Journal of Homosexuality* 6 (1980–81): 11–26.

Curtius, Ernst Robert. *European Literature and the Latin Middle Ages*. New York: Pantheon, 1953.

Dalla, Danilo. *"Ubi Venus mutatur": Omosessualità e diritto nel mondo romano*. Milano: Dott. A. Giuffrè Editore, 1987.

Dall'Orto, Giovanni. Articles on 14th and 15th century Italy, passim. *Encyclopedia of Homosexuality*, Wayne R. Dynes et al., eds. New York: Garland Publishing, 1990.

Darmstaedter, Ernst. "Anthemios und sein künstliches Erdbeben' in Byzanz." *Philologus* 88 (1933): 477–82.

de Damhoudere, Joost. *Praxis rerum criminalium*. Antwerp: apud Petrum Bellerum, 1646.

Dover, Kenneth J. *Greek Homosexuality*. Cambridge, MA: Harvard University Press, 1978.

Dynes, Wayne R. *Homolexis: A Historical and Cultural Lexicon of Homosexuality*. New York: Scholarship Committee, Gay Academic Union, 1985.

Dynes, Wayne R., Warren Johansson, and William A. Percy (eds.). *Encyclopedia of Homosexuality*. New York: Garland Publishing, 1990.

Eglinton, J.Z. [Pseudonym of Walter Breen] *Greek Love*. New York: Oliver Layton Press, 1964.

Ellis, Havelock. *Sexual Inversion*, third edition. Philadelphia: Davis, 1915.

Evans, Arthur. *Witchcraft and the Gay Counterculture*. Boston: Fag Rag Books, 1978.

Finke, Heinrich. *Papsttum und Untergang des Templerordens*. Münster in Westfalen: Aschendorff, 1907.

Flandrin, J.-L. "Contraception, mariage et relations amoureuses dans l'Occident chrétien." *Annales. Sociétés, économies, civilisations* 24 (1969): 1370–90.

———. "Mariage tardif et vie sexuelle: Discussions et hypothèses de recherche." *Annales. Sociétés, économies, civilisations* 27 (1972): 1351–78.

Foucault, Michel. *Histoire de la sexualité*. vol. 2, *L'usage des plaisirs*. Paris: Gallimard, 1984.

———. *Histoire de la sexualité*. vol. 3, *Le souci de soi*. Paris: Gallimard, 1984.

Fox, Robin Lane. *Pagans and Christians*. New York: Knopf, 1987.

Gaunt, Simon. "Straight minds / "queer" wishes in Old French hagiography." *GLQ* 1 (1994): 3.

Goodich, Michael. "Sodomy in Medieval Secular Law." *Journal of Homosexuality* 1 (1976): 295–302.

———. "Sodomy in Ecclesiastical Law and Theory." *Journal of Homosexuality* 1 (1976): 427–34.

———. *The Unmentionable Vice: Homosexuality in the Later Medieval Period*. Santa Barbara, CA: Ross-Erikson, 1979.

Grayzel, Solomon. *The Church and the Jews in the XIIIth Century: A Study of Their Relations during the Years 1198–1254, Based on the Papal Letters and the Conciliar Decrees of the Period*, revised ed. New York: Hermon Press, 1966.

Greenberg, David F. *The Construction of Homosexuality*. Chicago: University of Chicago Press, 1988.

Halperin, David M. "One Hundred Years of Homosexuality." *Diacritics* 16 (1986): 34–35.

Hamilton, J.S. *Piers Gaveston, Earl of Cornwall, 1307–1312: Politics and Patronage in the Reign of Edward II*. Detroit: Wayne State University Press, 1988.

Hamilton, William. *The Worship of Priapus*. London: George Redway, 1883.

Harley, Marta Powell. "Narcissus, Hermaphroditus, and Attis: Ovidian Lovers at the Fontaine d'Amors in Guillaume de Lorris's *Roman de la rose*." *PMLA* 101 (1986): 324–37.

Harries, Jill and Ian Wood, eds. *The Theodosian Code*. Ithaca, NY: Cornell University Press, 1993.

Hill, Bennet. "Aelred." In Joseph R. Strayer (ed.), *Dictionary of the Middle Ages*. New York: Scribner, 1983.

Holmes, Urban Tigner. *A History of Old French Literature from the Origins to 1300*. New York: F.S. Crofts, 1937.

Hyatte, Reginald. "Recoding Ideal Male Friendship as *fine amor* in the Prose Lancelot." *Neophilologus* 75 (1991): 505–18.

Jackson, F.J. Foakes. *An Introduction to the History of Christianity, A.D. 509–1314*. New York: Macmillan, 1921.

Johansson, Warren. "London's Medieval Sodomites." *Cabirion* 10 (1984): 6–7, 34.

———. "Whosoever Shall Say to His Brother, Racha (Matthew 5:22)." *Cabirion* 10 (1984): 2–4. Reprinted in *Studies in Homosexuality*. Vol. 13, *Homosexuality in Religion and Philosophy*. New York: Garland Publishing, 1992.

Johansson, Warren, Wayne R. Dynes, and John Lauritsen. *Homosexuality, Intolerance, and Christianity: A Critical Examination of John Boswell's Work*. Second, enlarged edition. New York: Scholarship Committee, Gay Academic Union. Gai Saber Monograph No. 1, 1985.

Kamiat, Arnold H. "A Psychology of Asceticism." *Journal of Abnormal and Social Psychology* 23 (1928): 223–31.

Kay, Richard. "The Sin of Brunetto Latini." *Medieval Studies* 31 (1969): 262–86.

Kluncker, Karlhans. "Die Templer: Geschichte und Geheimnis." *Zeitschrift für Religions- und Geistesgeschichte* 41 (1989): 215–47.

Kuster, Harry J. "Gelijkgeschlachtelijke liefde in de middeleeuwen." *Spiegel Historiael* 10 (1975): 232–37.

———. "Homoërotiek in de middeleeuwse poëzie." *Maatstaf* 24/1 (1976): 40–48.

———. "L'Amour physique unisexuel au Moyen Age." *Arcadie* (1976): pp. 665–70.

———. *Over Homoseksualiteit in Middeleeuws West-Europa: Some Observations on Homosexuality in Medieval Western Europe*. Ph.D. diss., University of Utrecht, 1977.

Kuster, Harry J. and Raymond J. Cormier. "Old Views and New Trends: Observations on the Problem of Homosexuality in the Middle Ages." *Studi medievali* 3rd ser., 25 (1983): 587–610.

Lafont, Robert. "*Ar resplan la flors enversa: La Fleur du gay savoir.*" *Revue des Langues Romanes* 96 (1992): 105–17.

Langmuir, Gavin I. *History, Religion, and Antisemitism*. Berkeley: University of California Press, 1992.

———. *Toward a Definition of Antisemitism*. Berkeley: University of California Press, 1991.

Lea, Henry Charles. "The Innocence of the Templars." In Gershon Legman, ed., *The Guilt of the Templars*. New York: Basic Books, 1966.

Legman, Gershon, ed. *The Guilt of the Templars*. New York: Basic Books, 1966.

Leibbrand, Werner and Annemarie Wettley. *Der Wahnsinn: Geschichte der abend-
ländischen Psychopathologie*. Freiburg im Breisgau and Munich: Karl Alber,
1961.

Lenzen, Rolf. "'Altercatio Ganimedis et Helene'—Kritische Edition mit Kommentar."
Mittellateinisches Jahrbuch 7 (1972): 167–86.

Leonhardt, W. "Die Homosexualität in den ältesten deutschen Dichtkunst." *Jahrbuch
für sexuelle Zwischenstufen* 12 (1912): 153–65.

Lissarague, François. "De la sexualité des satyres." *Mêtis* 2 (1987): 61–79.

Maaz, Wolfgang. "Angstbewaltigung in mittelalterlicher Literatur." pp. 51–77 in
Jürgen Kühnel, Hans-Dieter Mück, Ursula Müller, and Ulrich Muller, eds.,
*Psychologie in der Mediävistik. Gesammelte Beiträge des Steinheimer Sym-
posions*. Göppingen: Kümmerle Verlag, 1985.

McGuire, Brian Patrick. *Lover and Brother: Aelred of Rievaulx*. New York: Cross-
word, 1994.

Marchello-Nizia, Christiane and Michèle Perret. "Une Utopie homosexuelle au
quatorzième siècle: *L'Ile sans femmes* d'Agriano." *Stanford French Review* 14
(1990): 231–41.

Mason, H. A. "A Journey through Hell: Dante's Inferno Re-visited." *Cambridge
Quarterly* 21 (1992): 150–69.

Meier, Matthias. *Die Lehre des Thomas von Aquino De passionibus animae in
quellenanalytischer Darstellung*. Münster in Westfalen: Aschendorff, 1912.

Monter, E. William. "La Sodomie a l'époque moderne en Suisse romande." *Annales.
Sociétés, économies, civilisations* 29 (1974): 1023–33.

———. *Frontiers and Heresy: The Spanish Inquisition from the Basque Lands to Sic-
ily*. Cambridge: Cambridge University Press, 1990.

Mott, Luiz. "Pagode português: a subcultura *gay* em Portugal nos tempos inquisi-
tóriais." *Ciência e Cultura* 40 (1988): 2.

Obolensky, Dmitri. *The Bogomils: A Study in Balkan Neo-Manichaeism*. Cambridge:
Cambridge University Press, 1948.

Ochocki, Jan Duklan. *Pamitniki . . . z pozostaych po nim rkopismóv przepisane i
wydane przez J.I. Kraszewskiego*. Memoirs, transcribed from his extant manu-
scripts and published by J.I. Kraszewski. Vilnius, Poland, 1857.

Pagels, Elaine. *Adam, Eve and the Serpent*. New York: Random House, 1988.

Paglia, Camille. Review of John Boswell's *Same-Sex Unions in Pre-modern Europe*.
Washington Post, Washington, DC, July 17, 1994.

Parker, Thomas W. *The Knights Templars in England*. Tucson: University of Arizona,
1963.

Pavan, Elizabeth. "Police des moeurs, société et politique à Venise à la fin du Moyen
Age." *Revue historique* 264 (1960): 241–88.

Payer, Pierre J. *Sex and the Penitentials: The Development of a Sexual Code, 550–
1150*. Toronto: Toronto University Press, 1984.

Pequigney, Joseph. "Sodomy in Dante's Inferno and Purgatorio." *Representations* 36
(1991): 22–42.

Percy, William A. *Pederasty and Pedagogy in Archaic Greece*. Champaign-Urbana:
University of Illinois Press, 1996.

Petkanov, Ivan. "*Bulgar(us) e suknja* nelle parlate italiane e neolatine." *Ricerche
slavistiche* 3 (1954): 43–50.

———. "Slavianski vliianiia v romanskite ezitsi i dialekti (do XVI v.)." Slavic Influ-
ences in the Romance Languages and Dialects (to the 16th century)." *Godish-
nik na Sofiiskiia universitet, Filologicheski fakultet* 55/1 (1960–61): 193–316.

———. "Le nom *Bulgare* dans les langues et les dialectes romans." *Bulgarian His-
torical Review* 12/3 (1984): 97–107.

———. *Slavianski vliianiia v romanskite ezitsi i dialekti*. [Slavic Influences in the Ro-
mance Languages and Dialects] (Sofia: Izdatelstvo na Bulgarskata akademiia
na naukite, 1988), pp. 92–120 (*bulgarin*), pp. 133–34 (*bogomil*).

Praetorius, Numa. [Pseudonym of Eugen Wilhelm]. "Ein homosexueller Ritter des 15. Jahrhunderts." *Jahrbuch für sexuelle Zwischenstufen* 12 (1912): 207–30.

Price, Richard M. "The Distinctiveness of Early Christian Sexual Ethics." *Heythrop Journal* 31 (1990): 257–76.

Primov, Borislav. *Bugrite: Kniga za pop Bogomil i negovite posledovateli.* [The Bougres: A Book about Pop Bogomil and His Followers] Sofia: Izdatelstvo na Otechestveniia Front, 1970.

———. *Les Bougres: Histoire du pope Bogomile et de ses adeptes,* trans. Monette Ribeyrol. Paris: Payot, 1975.

Raby, F.J.E. *A History of Secular Latin Poetry in the Middle Ages.* 2 vols. Oxford: Oxford University Press, 1957.

Richlin, Amy. *The Garden of Priapus: Sexuality and Aggression in Roman Humor.* New Haven, CT: Yale University Press, 1983.

Rocke, Michael J. "Il controllo dell'omosessualità a Firenze nel XV secolo: gli *Ufficiali di Notte*." *Quaderni storici* 44 (1987): 701–23.

———. "Sodomites in Fifteenth-Century Tuscany: The Views of Bernardino of Siena." *Journal of Homosexuality* 16/1–2 (1988): 7–31.

———. "Male Homosexuality and its Regulation in Late Medieval Florence." 2 vols. Ph.D. diss., SUNY at Binghamton, NY, 1990.

Roth, Norman. "Deal Gently with the Young Men: Love of Boys in Medieval Poetry in Spain." *Speculum* 57 (1982): 20–51.

Rouselle, Aline. *Porneia: On Desire and the Body in Antiquity.* Oxford: Oxford University Press, 1988.

Ruggiero, Guido. "Sexual Criminality in the Early Renaissance: Venice 1338–1358." *Journal of Social History* 8 (1975): 18–37.

———. *The Boundaries of Eros: Sex, Crime and Sexuality in Renaissance Venice.* New York: Oxford University Press, 1985.

Russell, Kenneth C. "Aelred, The Gay Abbot of Rievaulx." *Studia Mystica* 5/4 (1982): 51–64.

Schjelderup, Kristian. *Die Askese. Eine religionspsychologische Untersuchung.* Berlin and Leipzig: Walter de Gruyter, 1928.

Shaw, Brent D. "A Groom of One's Own?" *New Republic,* July 28, 1994, p. 25.

Smith, Morton. *Clement of Alexandria and a Secret Gospel of Mark.* Cambridge, MA: Harvard University Press, 1973.

Snell, Otto. *Hexenprozess und Geistesstörung. Psychiatrische Untersuchungen* Munich: Verlag von J.F. Lehmann, 1891.

Spreitzer, Brigitte. *Die stumme Sünde: Homosexualität im Mittelalter. Mit einem Textanhang.* Göppingen: Kümmerle Verlag, 1988.

Stehling, Thomas, ed. *Medieval Latin Poems of Love and Friendship.* New York: Garland Publishing, 1984.

———. "To Love a Medieval Boy," pp. 151–70 in Stuart Kellogg, ed., *Essays on Gay Literature.* New York and Binghamton: Harrington Park Press, 1985.

Storfer, Adolf J. "Askese und Sadomasochismus." *Die psychoanalytische Bewegung* 1 (1929): 163–66.

Stümke, Hans-Georg. *Homosexuelle in Deutschland: Eine politische Geschichte.* Munich: C.H. Beck, 1988.

Symonds, John Addington. *The Renaissance in Italy.* London: John Murray, 1897–1900.

Tilley, Maureen A. "The Ascetic Body and the (Un)Making of the World of the Martyr." *Journal of the American Academy of Religion* 59 (1991): 467–79.

Topentcharov, Vladimir. *Boulgres & Cathares: Deux brasures une, même flamme.* Paris: Seghers, 1971.

Twomey, Michael W. "*Cleanness,* Peter Comestor, and the *Revelationes Sancti Methodii.*" *Mediaevalia* 11 (1985): 203–17.

van Windekens, A.J. *Dictionnaire étymologique complémentaire de la langue greque:*

Nouvelles contributions á l'interprétation historique et comparée du vocabulaire. Louvain, Belgium: Peeters, 1986.

von Verschuer, Undine Freiin. "Die Homosexuellen in Dantes Göttlicher Komödie.'" *Jahrbuch für sexuelle Zwischenstufen* 8 (1906): 353–63.

White, Andrew Dickson. *A History of the Warfare of Science with Theology in Christendom.* New York: Appleton, 1896.

Williams, Craig. "Homosexuality and the Roman Man: A Study in the Cultural Construction of Sexuality." 2 vols. Ph.D. diss., Yale University, New Haven, CT, 1990.

Winkler, John J. "Unnatural Acts." In David Halperin, John J. Winkler, and Froma I. Zeitlin, eds., *Before Sexuality: The Construction of Erotic Experience in the Ancient Greek World.* Princeton, NJ: Princeton University Press, 1988.

Wright, David. "Do You Take This Man . . ." *National Review,* August 29, 1994: 59–60.

8 TWICE MARGINAL AND TWICE INVISIBLE

LESBIANS IN THE MIDDLE AGES

Jacqueline Murray

Any attempt to study lesbians in the Middle Ages is, from the outset, fraught with difficulties, both conceptual and evidential.[1] Of all groups within medieval society lesbians are the most marginalized and least visible. All the difficulties attendant upon the study of female sexuality and male homosexuality are exacerbated in the case of medieval lesbians. These difficulties are theoretical, methodological, and evidential.

Any discussion of medieval sexuality must necessarily take into account the theoretical perspectives that inform this field of study as broadly conceived. This is especially so for the historical study of homosexuality. The two extremes of the theoretical spectrum are the essentialist position, which holds that sexuality or sexual orientation is natural and innate to human beings and constant over time and space.[2] The contrary and more widely held view is that of the social constructionists. This school holds that sexual identity and the individual's understanding of herself as a sexual being is deeply rooted within the structures of a given society or historical period. Consequently, the very notion of sexuality and gay or lesbian identity is a modern construction that requires certain social, economic, and political conditions that did not develop until the seventeenth to eighteenth centuries for men and as late as the twentieth century for women.[3] This particular stance has been adopted both by modern historians and by classicists who now write articles with titles such as "Sex before Sexuality."[4]

For the medievalist neither of these perspectives is entirely satisfactory. While few scholars would minimize the strategic role played by social context in defining possibilities and forming an individual's identity, sexual and otherwise, it nevertheless seems contrary to the evidence to suppose that the Middle Ages were devoid of the erotic expression of sexual desire or, for that matter, individual sexual preference. John Boswell has articulated a theoretical position that takes into account medieval circumstances and allows

for the due recognition of the influence of society in the construction of sexual preference and behavior while avoiding the pitfalls inherent in an immutable essentialist understanding of human sexuality.[5]

Boswell uses the medieval debate over universals as an analogy for the contemporary essentialist/constructionist controversy. He suggests that categories of sexual preference or orientation are the "universals," while the nominalist position is held by social constructionists and the realist position is that of essentialists.[6] For the nominalist, humans designate themselves heterosexual or homosexual because social values tell them that humans are either heterosexual or homosexual. The realist, on the other hand, believes that humans are differentiated sexually and homosexual and heterosexual exist in reality. Boswell argues that if the nominalist/social constructionists are correct, then there is a grave problem for historians.

> If the categories "homosexual/heterosexual" and "gay/straight" are the inventions of particular societies rather than real aspects of the human psyche, there is no gay history. If "homosexuality" exists only when and where people are persuaded to believe in it, "homosexual" persons will have a "history" only in those particular societies and cultures.[7]

Boswell presents an overview of the understandings of human sexuality found in literature from antiquity to the establishment of the modern capitalist state, showing that various understandings of human nature can and did exist at different times in the premodern past.

Related to this theoretical question is a concomitant one concerning language. Can terms like "lesbian" or "gay" be used to describe people and activities in premodern societies, long before the appearance of an identifiable lesbian/gay subculture or lesbian/gay self-awareness? To what extent is the use of terms like homosexual, gay, and lesbian anachronistic? In his ground-breaking study, *Christianity, Social Tolerance and Homosexuality*, John Boswell used the subtitle *Gay People in Western Europe from the Beginning of the Christian Era to the Fourteenth Century*.[8] This led to criticism by theorists, activists, and historians alike, who accused Boswell of essentialism. Boswell defended his use of the term "gay" as applied to the Middle Ages, arguing that it may be usefully used to describe those:

> . . . whose erotic interest is predominantly directed toward their own gender . . . This is the sense in which, I believe, it is used by most American speakers, and although experts in a field may well wish to

employ specialized language, when communicating with the public it seems to me counterproductive to use common words in senses different from or opposed to their ordinary meanings . . .[9]

It is in the same spirit that the term "lesbian" is used in this discussion. It by no means implies consistency over time but rather is used as a convenient term to distinguish those women whose primary relationships, emotional or sexual, appear to be woman-identified.

Most historical and theoretical studies have tended to focus on "homosexuality," which denotes male homosexuality and is no more inclusive than the by now discredited universal "man." While women in general have attracted increasing attention from medievalists, lesbians remain ignored as subjects. Thus medieval lesbians have been twice marginalized. Mainstream women's history has elided them under the rubric "homosexual," while studies of medieval homosexuality focus on men and elide lesbians into the category "women." Medieval lesbians are rendered invisible, relegated to footnotes and tangential references in the works of historians of women and of male homosexuality.[10] Medievalists, however, have begun to look to feminist theorists, for example, Adrienne Rich, and more recently to "queer" theorists, for example, Eve Kosofsky Sedgwick or Judith Butler, for sophisticated and nuanced analytical frameworks to facilitate our approach to the study of lesbians in the Middle Ages.[11]

In her ground-breaking work, "Compulsory Heterosexuality and Lesbian Existence," Adrienne Rich wrote:

> *Lesbian existence* suggests both the fact of the historical presence of lesbians and our continuing creation of the meaning of that existence. . . . *lesbian continuum* [includes] a range—through each woman's life and throughout history—of woman-identified experience, . . . including the sharing of a rich inner life, the bonding against male tyranny, the giving and receiving of practical and political support, . . .[12]

More recently, Eve Kosofsky Sedgwick has proposed that rather than replacing sequentially one model of homosexuality with another, as if these definitions were natural and knowable, historians should recognize "the rationalized coexistence of different models during the times they do coexist." She identifies a series of dismissals or marginalizations of evidence of homosocial or homoerotic relationships found even in the most liberal scholarship.[13]

While some scholars have criticized Rich for proposing a transhistorical notion of lesbian identity, which they identify as perilously close to essentialism,[14] medievalists have found her conceptualization of a "lesbian continuum" similar to Sedgwick's notion of a variety of different models which can coexist in a single culture.[15] Furthermore, the notion of a "lesbian continuum" can help medievalists overcome the problem posed by lack of specific sources on women in general and woman-identified women in particular. The patriarchal nature of medieval society hides and distorts so much information about the lives of women, especially the affective and erotic aspects of their experience. Far fewer sources are available than for male homosexuality; consequently the notion of a lesbian continuum allows for a more nuanced understanding of women's relationships, one that encompasses primary emotional, erotic, and social bonds that stop short of genital sexual expression. As Ann Matter has summarized the state of research:

> . . . we can only find "medieval lesbians" among the landmarks of medieval culture, on that particular continuum, not ours. This portrait in a landscape will have to consider uniquely medieval, and sometimes idiosyncratic, social constructions: constructions of male and female, marriage and the religious life, roles, definitions, and hierarchy. It will also need to come to terms with the fact that there is very little extant evidence . . . We will, indeed, have to learn to read the blanks.[16]

Among the few areas in which there is some consistent evidence for lesbians in the Middle Ages are the ecclesiastical discourses of canon law and theology, which present consistent condemnation of such relationships or practices. The letters of Paul provided the foundation for subsequent writers. In his letter to the Romans Paul wrote:

> For this reason God gave them up to dishonorable passions. Their women exchanged natural relations for unnatural, and the men likewise gave up natural relations with women and were consumed with passion for one another, men committing shameless acts with men and receiving in their own persons the due penalty for their error.[17]

This oblique reference to "unnatural" relations, interpreted to refer to lesbianism in light of the following more explicit reference to male homosexuality, is the sole discussion of lesbian activity found in either Jewish or Christian Scripture.[18] While some scholars have suggested that Paul was not referring to female homosexuality but rather to women who indulged in what might

be termed "heterosexual perversions," nevertheless, this passage is generally interpreted as referring to lesbian sexual activity.[19] Paul wrote in a period during which Roman society condemned female homoeroticism as an attempt by women to usurp the place of men in a strictly delineated gender hierarchy. Exchanging "natural relations for unnatural" can be interpreted as a woman attempting to exchange her passive and subordinate role for the active and autonomous sexual role reserved for men. Thus Paul's condemnation of lesbian sexual activity must be understood in the context of his other observations on gender relations based on hierarchy and female subordination.[20]

John Boswell has proposed an alternate interpretation of Romans 1: 26, which is relevant to the understanding of both homosexuality and lesbianism in the early church. Boswell argues that in this passage Paul was not condemning "gay people" but rather heterosexuals who engaged in homosexual activity. Rather than condemning outright homosexual activity, he suggests that Paul was criticizing people who acted against their true natures or dispositions. Boswell concludes: "It cannot be inferred from this that Paul considered mere homoerotic attraction or practice morally reprehensible."[21] This generous and nonjudgemental interpretation of Paul, however, remains marginal, and most scholars accept the understanding that Romans 1 condemned male homosexuality outright and very likely condemned female homosexuality as well.

While this single scriptural reference may pale to insignificance from the vantage point of two thousand years and a highly secularized society, it nevertheless formed the foundation of an important theological discourse that began with the patristic fathers and continued through Thomas Aquinas and beyond. For example, in his Commentary on Romans 1: 26, John Chrysostom noted that "it is even more shameful that the women should seek this type of intercourse, since they ought to have more modesty than men."[22] Augustine, too, condemned female homoeroticism in a letter to a community of nuns written ca. 423:

> The love between you, however, ought not to be earthly but spiritual, for the things which shameless women do even to other women in low jokes and games are to be avoided not only by widows and chaste handmaids of Christ, living under a holy rule of life, but also entirely by married women and maidens destined for marriage.[23]

This letter, while clearly condemning lesbian sex, may also be one of the earliest sources to distinguish between homoerotic activity and homosocial or homoaffective relationships that could be viewed in a more positive light.

Similar considerations about the quality of the relationships between nuns in the same convent were repeated by later writers, who seemed equally aware of the dangers of proximity in an exclusively female environment. In the seventh century, in his *Regula ad Virginea*, Donatus of Besançon warned nuns against what might now be called "particular friendships."

> 32. That none take the hand of another or call one another "little girl."
>
> It is forbidden lest any take the hand of another for delight or stand or walk around or sit together. She who does so, will be improved with twelve blows. And any who is called "little girl" or who call one another "little girl," forty blows if they so transgress.[24]

This warning focuses on the quality of affection that could arise between two nuns. Donatus, however, moved beyond Augustine, who warned against inappropriate joking and behavior which did not befit the brides of Christ. In Donatus's rule, perhaps as a result of several centuries of experience with women's communities, there is a clear focus on the dangers of homoaffective relationships, characterized by terms of endearment.

Observers of convent life may have had a clear notion that affection could lead to sexual expression. The sleeping arrangements prescribed by Donatus suggest an effort to discourage occasions for sin.

> 65. How they ought to sleep.
>
> Each should sleep in a separate bed and they should accept bedding according to the arrangements of the couches as the mother directs. If possible all should sleep in one place but if the large numbers do not allow this, they should rest by tens and twenties with the elders who have charge of them. Lights should burn in each chamber until daybreak. They should sleep clothed, their girdles bound and always ready for divine service with all gravity and modesty. And when the signal is given, each should hurry to get to the work of God with no delay, before the others. They should not have the younger sisters with them in the bed but be joined by elders or groups. Rising they should exhort each other to the work of God against the excuses of the sleepy.[25]

This rule reinforces the solitary nature of the nun's life, although she lives in community. Nuns were to sleep together, with a complete lack of privacy, while at the same time they should sleep alone, without an occasion to touch a sister, or see a sister naked. Finally, Donatus seemed to have had a par-

ticular suspicion about relationships between young girls and older women. Whether this was the result of personal knowledge or was an extrapolation based on the traditional homosexual relationships between young men and older men remains uncertain.

About the same time that Donatus was setting down his rule for nuns, another kind of literature, the penitentials, began to appear, first in Ireland and England and later on the Continent. These treatises contain lists of all manner of sins, including sexual sins, and their appropriate penances. They were applicable to lay people and religious alike and so they extend our view beyond the convent walls, into the broader community. Consequently, they are an important source for conveying the attitudes and practices of early medieval society.

One of the features that led to official criticism of the penitentials was their lack of cohesiveness and the absence of canonical authority. Not surprisingly the evaluation of lesbian activity differed from one manual to another, although overall it seems to have been considered less serious than male homosexuality.[26] As with most literature generated by clerical writers, lesbian activity was frequently ignored, marginalized, or subsumed under categories of male homosexual sins.

The *Penitential of Theodore* is one of the few penitentials that make specific and separate mention of female homosexual activity. Three canons are of particular relevance:

> 12. If a woman practices vice with a woman, she shall do penance for three years.
> 13. If she practices solitary vice, she shall do penance for the same period.
> 14. The penance of a widow and of a girl is the same. She who has a husband deserves a greater penalty if she commits fornication.[27]

The juxtaposition of lesbian sexual activity and masturbation is significant and highlights the primacy of a phallocentric understanding of human sexuality in contemporary thought. It is the absence of the male partner that unites conceptually masturbation and lesbian sexual activity.

The reference to women who commit "fornication" is more ambiguous and difficult to interpret. Fornication, strictly speaking, refers to sexual relations between an unmarried man and an unmarried woman. The canon's placement in this penitential, however, suggests that it is referring to sexual relations between two women. Certainly, when this passage was adopted in the ninth-century penitential attributed to Rabanus Maurus,

it was with lesbian overtones: "A woman who joins herself to another woman after the manner of fornication shall do penance for three years like a fornicator."[28]

If Canon 14 of *The Penitential of Theodore* does indeed refer to lesbian activity, it does much to increase our understanding of how such relationships were viewed. First, the writer of the penitential did not consider lesbian activity a particularly serious sexual sin, equating it with simple fornication rather than with adultery or another more serious sexual sin.[29] Second, the status of the woman was taken into account when judging the relative seriousness of the sin. Widows and unmarried girls, those women without a permanent male partner, were judged more leniently than were married women. Clearly, a married woman not only committed a sexual sin by having sexual relations with another woman, but she also transgressed the bonds of monogamous marriage. The author also may have been minimizing the sins of the unpartnered woman because she had no legitimate sexual outlet. The married woman, who had ready sexual access to her husband, was more culpable because she rejected him and sought "unnatural" sexual relations with another woman.

The *Penitential of Bede* extends the discussion of lesbian relations from laywomen to nuns: "If nuns with a nun, using an instrument, seven years [penance]."[30] There is nothing in this passage to indicate whether the increased severity of the penance was due to the participants' status as religious women or if it were the use of an "instrument" that occasioned the harsher penance. The use of "instruments" such as dildos was considered far more serious than simple rubbing or mutual masturbation.

The Carolingian writer, Hincmar of Reims, continued the discussion of women who engaged in inappropriate sexual activity with the aid of devices. In his *De divortio Lotharii et Tetbergae* Hincmar wrote:

> They do not put flesh to flesh in the sense of the genital organ of one within the body of the other, since nature precludes this, but they do transform the use of the member in question into an unnatural one, in that they are reported to use certain instruments of diabolical operation to excite desire. Thus they sin nonetheless by committing fornication against their own bodies.[31]

This passage also indicates the terminological difficulties encountered by writers who tried to discuss activities for which no technical vocabulary existed. Hincmar resorted to describing lesbian sexual acts as women fornicating against their own bodies.

All of these passages highlight the phallocentric understanding of human sexuality held by medieval male writers. Sexual activity without a penis was difficult to imagine. In the absence of a penis, male writers assumed that women used instruments such as dildos to replicate heterosexual intercourse and in doing so they challenged the hierarchy natural to sexual relations. In the absence of either penis or a substitute, male writers minimized the seriousness of the sin. Wives, who had a legitimate and natural sexual outlet with their husbands, committed a more serious sin than did women who were deprived of men. Similarly, sexual activity between women that did not attempt to replace the male organ with an artificial penis was regarded as a less serious crime than activity that sought to usurp male prerogative by the use of dildos. Ultimately, female sexuality was not taken seriously except insofar as it threatened male privilege or the natural hierarchy of the genders.

The possibility of women engaging in sexual activity without men did not attract much attention from later reformers, constrained as they were by their phallocentric worldview. Peter Damian, who devoted a whole treatise to condemning male homosexuality, did not mention lesbians in his *Book of Gomorrah*. Other participants in the Gregorian reforms contented themselves with repeating the condemnations of the older penitentials.[32] Similarly, the great twelfth-century theologians did not add insights to the discourse, although condemnations of lesbian activity were repeated. In his commentary on Romans, for example, Peter Abelard observed that nature had created women's genitals for the use of men.[33] Even Hildegard of Bingen, who frequently brought new insights to her understanding of human sexuality, reinforced this traditional understanding of lesbians.

> And a woman who takes up devilish ways and plays a male role in coupling with another woman is most vile in My sight, and so is she who subjects herself to such a one in this evil deed. For they should have been ashamed of their passion, and instead they impudently usurped a right that was not theirs. And, having put themselves into alien ways, they are to Me transformed and contemptible.[34]

This derivative quality permeated both canonical and theological writing throughout the twelfth and thirteenth centuries, so that traditional teachings were reiterated but the discourse was not significantly expanded. Lesbian activity continued to be ignored, although gradually, by the thirteenth century, it was transumed under the broad category of sodomy, which came to include all manner of "unnatural" sexual activity, both heterosexual

and homosexual. Thus, in his *Summa theologiae*, in the discussion of lust, Thomas Aquinas considered four categories of unnatural acts. These included masturbation, bestiality, intercourse in unnatural positions, and both male and female homosexuality.[35] This development rendered lesbian activity even more invisible, while at the same time it acquired the more serious overtones associated with sodomy. In general, however, lesbian activity continued to be minimalized and marginalized by both theologians and canonists.[36]

The medical and scientific discourses inherited from antiquity equally replicated the tendency to render lesbian activity peripheral. Greek writers and their later Arab translators and transmitters discussed sexuality apart from its moral dimension. Secular attitudes did not mean that male writers took lesbians more seriously or discussed them at greater length. This may, however, not be so much the result of marginalization as the nature of the genre. Medical authors focused their attention on illness; therefore lesbianism was discussed only when it was considered a medical disorder.[37]

Some medical writers suggested ways to "cure" lesbian desires. For example, a ninth-century Arabic treatise attributed to Galen provided recipes for "Drugs which make women detest lesbianism even if they madly lust for it." The treatise also included a complementary recipe for "Drugs that make lesbianism so desirable to women that they would keep busy with it and passionately lust for it forgetting all about their work." Furthermore, the reader is assured that if tricked into carrying the potion in her vagina, the woman will continue in a state of passion and excitement for six months.[38]

Later treatises continued to reflect the secular tone of the Greek writers and Arabic commentators. Arab astrological texts, which were eventually incorporated into the curricula of medieval medical faculties, advised that if the stars were all in masculine signs, women would be rendered virile and "act as if their female friends were their wives."[39] Another treatise, written by as-Samau'l ibn Yahyâ in the late twelfth century, suggested that masculine women were more active and intelligent as well as more promiscuous and more dangerous to men:

> There is a certain category of women who surpass others in intelligence and subtlety. There is a great deal of the masculine in their nature, to such an extent that in their movements, and in the tone of their voice, they bear a certain resemblance to men. They also like being the active partners. A woman like this is capable of vanquishing the man who lets her. When her desire is aroused, she does not shrink from seduction. When she has no desire, then she is not ready

for sexual intercourse. This places her in a delicate situation with regard to the desires of men and leads her to Sapphism.[40]

Two medical disorders have relevance to the discussion of lesbian sexuality. Some writers, following Galen, believed that suffocation of the womb was caused by the buildup of seed in a woman who was deprived of sexual intercourse and had no means to emit the seed. Galen recommended that midwives place hot poultices on the woman's genitals and cause the woman to experience orgasm, which would release the retained seed. Later writers could not easily accept Galen's prescription that a midwife masturbate the patient until she experienced orgasm. Such a cure was too obviously in conflict with Christian moral doctrine. Instead, authors such as William of Saliceto, in the thirteenth century, advised marriage as a cure for suffocation of the womb.[41] Gradually the treatment for this ailment was modified to harmonize with the church's moral code, and prescriptions for female masturbation disappeared from medical treatises.

Another female disease, *ragadia* of the womb, was also linked to lesbianism. This, too, was based on the teaching of Greek medical writers. *Ragadiae* were fleshy growths believed to be caused by friction during intercourse or a difficult childbirth. They would sometimes grow outside the vagina, forming a penis-like protuberance. It was thought that women with such growths used them to have sexual intercourse with other women.[42] William of Saliceto did not moralize in his discussion of this disease. The perpetuation of notions that women with "penises" could have intercourse with other women, however, did reinforce the predominant phallocentric worldview. A penis was necessary for sexual activity, and women who, through illness or accident, grew such organs, were thought able to replicate heterosexual intercourse. Thus both the disappearance of masturbation by a midwife as a treatment for suffocation of the womb and the perpetuation of lore about a disorder such as *ragadia* reinforced the prevailing phallocentric world view and helped to render lesbian sexuality invisible.

The relative neglect of lesbians by ecclesiastical and medical writers is paralleled in secular law and literature. Lesbianism, while having the potential to threaten the male social order, nevertheless did not elicit the same fear, revulsion, and attention as did male homosexuality. Indeed, lesbian sexual activity was virtually ignored in medieval secular law codes. The one known exception is the French *Li Livres de jostice et de plet*, compiled around 1260. This law code stipulated that men convicted of sodomy should face mutilation and castration for the first two offenses and be sentenced to burn for the third. The same article stated: "The woman who does this shall

undergo mutilation for [the first and second] offenses and on her third must be burnt. And all of the goods of such offenders shall be the king's."[43] Thus, just as lesbianism was subsumed under the rubric of sodomy by thirteenth-century theologians, so too, on the rare occasions it was mentioned in secular law codes, it was linked to male homosexuality.

Generally, secular courts did not prosecute lesbians despite this theoretical equality. For example, in his survey of sex crimes in fourteenth- and fifteenth-century Venetian courts, Guido Ruggiero concludes:

> Lesbianism, however, was not prosecuted. It is difficult to argue from silence, but presumably the fact that it was a form of sexuality that did not threaten the family with the birth of illegitimate children or with dissolution—as there was virtually no opportunity for women to withdraw from traditional marriage to form female pairs—made it a noncrime.[44]

This may in part explain the relative silence of secular courts across Europe. Prevailing opinion held that women were sexually passive, and the phallocentric orientation of society either did not admit or did not take seriously the possibility of sexual relations without the participation of an active male.

Relative silence, however, should not be taken as absence, nor should the dominance of the patriarchal family suggest that women did not have the opportunity to meet and develop relationships with their own sex. A number of surviving court cases show women could and did develop close emotional and erotic relationships with other women.[45] These cases also indicate that, despite their infrequent appearance in the documentation, when lesbians did come to the attention of the authorities, punishment could be swift and harsh.

For example, a royal register from France records the 1405 appeal for a pardon by a sixteen-year-old married woman named Laurence. She had had a number of sexual encounters with a woman named Jehanne, who worked with her in the nearby fields and vineyards. When their activities were discovered both women were prosecuted. From her prison cell, Laurence applied for a pardon, representing Jehanne as the sexual aggressor: "She climbed on her as a man does on a woman, and the said Jehanne began to move her hips and do as a man does to a woman."[46] Similarly, a lawyer in sixteenth-century Seville reported that there were a number of lesbians in prison who made artificial male genitalia and used the same hard language as men of the underworld. If a woman were discovered with such a device she could have received up to two hundred lashes and been exiled from Seville.[47]

The use of "devices" or the evidence that one of the women pursued an active male sexual role by using dildos or artificial leather penises tied to her body is a recurring theme in the few surviving trial documents. For example, in Spain two nuns were burned for using "material instruments." The records from sixteenth-century France include a case in which a woman passed as a man, married, and was eventually burned when her artificial phallus was discovered.[48] This once again suggests patriarchal society's fear that lesbians threatened the established sexual hierarchy. It also underscores the perceived need for a phallus in sexual activity. One woman was believed of necessity to take on the male role, including fabricating a penis, in order to replicate heterosexual intercourse. Passive partners were sometimes considered to have been duped by the dominant woman and consequently received lighter sentences.[49]

The lesbian relationship itself did not have to be occurring at the time the woman came to the attention of the authorities. In Geneva in 1568, a woman was drowned because of a lesbian relationship in which she had been involved some years prior to her arrest. In this case the court was advised not to read out the full sentence publicly at the execution. Rather, it said only that she had committed "a detestable and unnatural crime, which is so ugly that, from horror, it is not named here."[50] Thus, even the sentencing for lesbian "crimes" could collude in the process of rendering the women invisible to their own society and to subsequent historians.

Sometimes accusations of lesbianism were accompanied by charges of witchcraft or heresy as well.[51] The conceptual link between sexual deviance and spiritual deviance is clear: both were perceived as deliberate and willful challenges to the natural order established by God and nature.[52] The story of Benedetta Carlini serves to illustrate the complex interrelationship between the sexual and spiritual realms. It is also a lesson in the difficulties posed to historians of sexuality when they confront an alien culture and value system such as that of premodern Europe. The case of Benedetta Carlini is perhaps one of the most well-known and problematic examples of alleged premodern lesbian sexual activity. It is a difficult example that foregrounds many of the problems inherent in the study of the history of lesbians and, indeed, of sexuality in general. With Benedetta Carlini the close relationship between religious heterodoxy and sexual deviance is particularly clear.

Benedetta Carlini was a nun living in early seventeenth-century Italy. At the height of the Counter-Reformation she tried to use mystical visions to gain spiritual and temporal authority in her convent and the surrounding community. She also claimed that she was possessed by an angelic spirit, which used her body to have sexual relations with her companion nun. An ecclesiastical tribunal sentenced Benedetta Carlini to life imprisonment, but

the trial transcripts do not make clear whether her crime was her sexual activity or her manipulation of mystical visions to usurp the authority reserved to the male clergy.[53]

Judith Brown, in her book *Immodest Acts: The Life of a Lesbian Nun in Renaissance Italy*, identifies Benedetta Carlini as lesbian. While the transcripts of the investigation indicate that Benedetta did engage in genital sexual relations with another woman, she did not admit to having any memory of such activity, let alone an awareness of making a selfconscious sexual choice. She certainly had no self-identity as a "lesbian" or as a woman we moderns might place comfortably on Adrienne Rich's "lesbian continuum." As Ann Matter has pointed out, Benedetta's sexual relations with her companion nun were "so bizarre as to defy our modern categories of 'sexual identity.'"[54] In particular, she underscores the extent to which Benedetta's sexuality was bound up with her complicated spirituality and that her primary erotic relationship was with Jesus rather than with any human partner.[55]

All these sources, ecclesiastical and secular, medical and legal, point to the relative rarity of any mention of lesbians in medieval society. They also indicate the difficulty encountered by medieval writers who tried to discuss or describe a phenomenon for which there was no language or terminology. Modern critical theory would perhaps suggest that historians are searching for something that simply was not there. The evidence, however, of less formal genres such as poetry and letters leads to quite a different conclusion.

One particularly useful work is *Le Livre de Manières*, written by Etienne de Fougères at the court of the English king, Henry II, between 1173 and 1178.[56] This poem divides society into various estates and discusses the bonds that should exist among the various groups. De Fougères also discussed various abuses such as clerical marriage, usury, and adultery. His overall tone is misogynistic, and he seeks to promote marriage as a means of controlling the sexuality of the laity.[57] It is within this context that de Fougères presented a discussion of sexual relations between women. The uniqueness of the discussion and the literary devices de Fougères employed to describe female sexuality make this one of the most important medieval descriptions of lesbianism. It not only provides additional evidence for female homoeroticism but also suggests something of how society, beyond the rigid and learned discourses of theology, law, and medicine, might have viewed such women.

De Fougères began his discussion by contrasting the "beautiful" heterosexual sin with the "vile" sin against nature, homosexuality.[58] The next five stanzas then treat sexual relations between women, using a series of metaphors that do not describe sexual acts so much as evoke them. Sexual relations be-

tween women are expressed in terms of absence and lack.[59] Robert Clark has observed paradoxically that "what dominates is the ever-present but always absent phallus." De Fougères employed images of women's sexual encounters as two coffins banging together or two shields joining. More frequent, however, are references to what is absent: fire poker, lance, pointer, handle, fishing rod, pestle, and fulcrum. The poem concludes by stating:

> They do their jousting act in couples
> and go at it at full tilt;
> at the game of thigh-fencing
> they lewdly share their expenses.

> They're not all from the same mold:
> one lies still and the other makes busy,
> one plays the cock and the other the hen
> and each one plays her role.[60]

This poem, then, conveys two notions of lesbian sexual acts. First, as in the more formal discourses, human sexuality is expressed in phallocentric terms. The women replicate heterosexual relationships in so far as one woman adopts the "male" role, the other the "female." Second, De Fougères suggested that the women are satisfied in their sexual activities. Although much of his imagery expresses the lack or absence of a phallus, the author did not indicate that the women tried to replace it artificially. His reference to "thigh fencing" suggests that he was also aware that women have sexual alternatives to the imitation of heterosexual intercourse. Thus, while expressing a contemporary understanding of phallocentric sexuality, de Fougères also perceived lesbian sexuality as mutually satisfying. Furthermore, his poem also indicates how lesbianism could be expressed unmistakably despite the absence of a specific vocabulary, either technical or popular.

Thus far almost all the discourses and texts have been male-authored and have presented relationships between women as sinful, illegal, contrary to nature, or pathological. Even the glimpse of a more positive view, suggested by Etienne des Fougères, is set in the context of a defense of marriage, in a work which is overwhelmingly misogynistic in tone.[61] An alternate vision is, however, presented in some of the rare extant examples of writing by medieval women.

The troubadour, Bieiris de Romans, was a woman who used the popular lyrics of courtly love to address another woman. Her poem has been identified as the only surviving example of lesbian poetry in the vernacular.[62]

Nothing, however, is known about either Bieiris or Maria, the woman to whom she wrote. Consequently, many scholars have denied that the author was a woman, in order to avoid the conclusion that the poem is homoerotic. Bieiris has been identified as a pseudonym for a male author; Maria, for her part, is said to be the Virgin Mary.[63] Recent scholarship has also suggested that the poem itself is too conventional a representation of courtly values to be expressing a scandalous relationship between women, concluding that the poem revolves around an absent male and perhaps expresses jealousy and "lightly homoerotic" characters.[64]

Part of the problem posed by literature such as that of Bieiris de Romans lies in the expectations that scholars take with them to medieval society. No medieval women have the characteristics associated with lesbians in the late twentieth century. What little is known about women's relationships does not show self-conscious identity, rebellion against social norms, nor a freely expressed genital sexuality. How, then, can the tender musings of Bieiris de Romans be identified as lesbian? How can we find lesbians in a world of muffled female voices that suppressed and hid all manner of genital sexuality?[65] Recently, however, by expanding our understanding of sexuality beyond the genital sex act alone and by applying new techniques of reading to medieval texts, scholars have come closer to hearing and seeing medieval woman-identified women.

Mary Anne Campbell has argued that the literature of virginity and convent life must be carefully reread and reinterpreted in light of new theoretical perspectives. Building on the work of Caroline Bynum, she contends that the text *Hali Meidenhad*, while encouraging women to follow the virginal life, was also promoting a life "akin to lesbianism. 'Holy maidenhood' provided for medieval women not only a rejection of physical heterosexuality but also a rejection of spiritual heterosexuality—in favor of women-only physical spaces and women-identified spirituality."[66]

Certainly, it is essential to remember that modern categories of love—spiritual, erotic, and affective—have little application in a society in which one's love of Jesus could be erotic and one's love of a friend could similarly have both erotic and spiritual characteristics.[67] We must, then, rethink women's friendships, especially within a convent community.[68] Can the close homoaffective relationships that developed between nuns living in their homosocial environment find a place on the "lesbian continuum"? Given the devaluation of physical relations across medieval society, limiting such an identification to those women who engaged in genital sex acts would seem as anachronistic as the temptation to identify all female relationships as lesbian.

With such caveats in mind, that group of literate medieval women, nuns and beguines, seems to be the most fruitful source for understanding women's relationships be they homosocial, homoaffective, or homoerotic. For example, a twelfth-century manuscript preserves a letter written by one woman lamenting her separation from another. She expressed her passion and pain in powerful images:

> Why do you want your only one to die, who as you know, loves you with soul and body, who sighs for you every hour, at every moment, like a hungry little bird. . . . as the turtle-dove, having lost its mate, perches forever on its little dried up branch, so I lament endlessly . . . you are the only woman I have chosen according to my heart.[69]

Beneath the language and convention and across the chasm of translation the powerful emotions behind these words are still audible. They bespeak a depth of relationship that transcends that prescribed for spiritual sisters.

The letters between medieval women, both famous and less well-known, need to be analyzed for the emotional relationships which underlie the formal and formulaic letter form. In a letter to her sisters, the beguine Hadewijch betrayed a special relationship with one sister, while proffering advice and affection to the others.

> 1. Greet Sara also in my behalf, whether I am anything to her or nothing.
> 2. Could I fully be all that in my love I wish to be for her, I would gladly do so; and I shall do so fully, however she may treat me. She has very largely forgotten my affliction, but I do not wish to blame or reproach her, seeing that Love leaves her at rest and does not reproach her, although Love ought ever anew to urge her to be busy with her noble Beloved. Now that she has other occupations and can look on quietly and tolerate my heart's affliction, she lets me suffer. She is well aware, however, that she should be a comfort to me, both in this life of exile and in the other life of bliss. There she will indeed be my comfort, although she now leaves me in the lurch.[70]

Similarly, the letters of Hildegard of Bingen indicate she used a more frank and emotional tone when writing to women. But, within her vast correspondence, her letters to Richardis von Stade show a depth of relationship and feeling that sets them apart from those of other female recipients.[71] The letters of other medieval women could yet prove a fruitful area of research for

understanding the nature and quality of women's relationships, wherever they might be on the "lesbian continuum."

Hildegard of Bingen also figures prominently in another innovative approach to analyzing female homoeroticism. Bruce Holsinger has argued that, when her music is analyzed in light of her many other writings, it proves to be "Hildegard's elaboration of female homosocial desire . . . [and] represents a simultaneous acknowledgement of the unique powers, pleasures, and fruits of the female body and, indeed, the radical irrelevance of the phallus."[72] Thus the whole corpus of women's writings and their social context need to be reexamined in light of our evolving understanding of human sexuality and emotion.

Medieval art is another field of research that promises new insights into medieval sexuality. Few studies have focused on the interpretation of homosexual images or symbols.[73] Scholars have yet to interpret the images of weasels and hyenas, frequent symbols for homosexuality in medieval iconography. Similarly, pictures of human same-sex couples need to be examined systematically and in greater detail. For example, in the discussion of the serpent's temptation of Eve in the Vienna *Bible moralisée*, two couples are depicted, one female, the other male (Fig. 1).[74] The couples are lying down and embracing, apparently out of doors. They appear to be urged on in their activities by devils. The full meaning and import of this picture, however, needs to be established. Certainly the erotic nature of the couples is unmistakable. Diane Wolfthal has noted that "The chin-chuck gesture of one of the lesbians is a common sign of erotic activity and the couples' loving embracing arms and intertwined legs leave no doubt on the matter."[75] Yet the need for deeper analysis remains.

The study of attitudes and ideas about lesbians in the Middle Ages is neither as anachronistic as some theorists might believe nor as futile as traditional historians might think. The flexible understanding of female sexuality offered by contemporary theory meshes nicely with the complex interweaving of the psychological, spiritual, physical, and emotional that characterized medieval culture. New theoretical and methodological techniques, combined with interdisciplinary approaches, promise a more sophisticated examination of human sexuality in the past, an examination that will extend far beyond a litany of prohibitions and condemnations, that will read from silence and absence, and that, freed from the limitations of genital sexuality, will see medieval women's relationships in their richness, complexity, and diversity. Those women, rendered twice marginal by the collusion of medieval society and medieval historians, are about to move to the center and become an important area for further research.

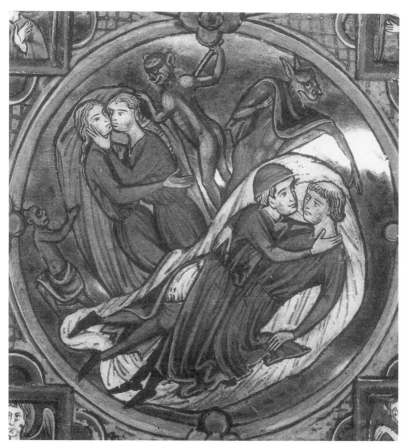

Bible moralisée (Wien, Österreichische Nationalbibliothek, Cod. 2554). Courtesy of the Austrian National Library

Etienne de Fougères. Livre des manières

TRANSLATED BY ROBERT L.A. CLARK

There's nothing surprising about the "beautiful sin"
when nature prompts it,
but whosoever is awakened by the "vile sin"
is striving against nature.

Him [sic] must one pursue with dogs,
throw[ing] stones and sticks;
one should give him blows
and kill him like any cur.

These ladies have made up a game:
With two "*trutennes*" they make an "*eu*,"
they bang coffin against coffin,
without a poker to stir up their fire.

They don't play at jousting
but join shield to shield without a lance.
They don't need a pointer in their scales,
nor a handle in their mold.

Out of water they fish for turbot
and they have no need for a rod.
They don't bother with a pestle in their mortar
nor a fulcrum for their see-saw.

They do their jousting act in couples
and go at it at full tilt;
at the game of thigh-fencing
they lewdly share their expenses.

They're not all from the same mold:
one lies still and the other makes busy,
one plays the cock and the other the hen
and each one plays her role.

The meanings of the words *trutennes* and *eu* are unknown and unattested to elsewhere.

Anonymous letter between two twelfth-century nuns

TRANSLATED BY PETER DRONKE, *Medieval Latin and the Rise of the European Love-Lyric*, II. 479.

To C——, sweeter than honey or honeycomb, B—— sends all the love there is to her love. You who are unique and special, why do you make delay so long, so far away? Why do you want your only one to die, who as you know, loves you with soul and body, who sighs for you at every hour, at every moment, like a hungry little bird. Since I've had to be without your sweetest presence, I have not wished to hear or see any other human being, but as the turtle-dove, having lost its mate, perches forever on its little dried up branch, so I lament endlessly till I shall enjoy your trust again. I look about and do not find my lover—she does not comfort me even with a single word. Indeed when I reflect on the loveliness of your most joyful speech and aspect, I am utterly depressed, for I find nothing now that I could compare with your love, sweet beyond honey and honeycomb, compared with which the brightness of gold and silver is tarnished. What more? In you is all gentleness, all perfection, so my spirit languishes perpetually by your absence. You are devoid of the gall of any faithlessness, you are sweeter than milk and honey, you are peerless among thousands, I love you more than any. You alone are my love and longing, you the sweet cooling of my mind, no joy for me anywhere without you. All that was delightful with you is wearisome and heavy without you. So I truly want to tell you, if I could buy your life for the price of mine, [I'd do it] instantly, for you are the only woman I have chosen according to my heart. Therefore I always beseech God that bitter death may not come to me before I enjoy the dearly desired sight of you again. Farewell. Have of me all the faith and love there is. Accept the writing I send, and with it my constant mind.

NOTES

1. I am indebted to Robert Clark for generously allowing his hitherto unpublished translation of pertinent stanzas of Etienne de Fougères's *Livre des manières* to appear here. I also would like to thank E. Ann Matter and Barry D. Adam, who kindly read and commented on earlier drafts of this chapter.

2. There are virtually no examples of historians of sexuality who embrace a purely essentialist understanding of human sexuality.

3. Michel Foucault, *The History of Sexuality*, vol. 1: *An Introduction*, trans. Robert Hurley (New York: Pantheon Books, 1978) discusses the historical construction of sexuality at length.

4. David M. Halperin, "Sex Before Sexuality: Pederasty, Politics, and Power in Classical Athens," in *Hidden from History: Reclaiming the Gay and Lesbian Past*, eds. Martin Duberman, Martha Vicinus, and George Chauncey, Jr. (New York: Meridian Book, 1989), 36–53.

5. John Boswell, "Revolutions, Universals, and Sexual Categories," *Salmagundi* 58–59 (Fall 1982–Winter 1983): 89–113; rpt. in *Hidden from History: Reclaiming the Gay and Lesbian Past*, eds. Martin Duberman, Martha Vicinus, and George Chauncey, Jr. (New York: Meridian Book, 1989), 17–36.

6. Boswell, "Revolutions, Universals, and Sexual Categories," in *Hidden From History*, 19.

7. Ibid., 20.

8. John Boswell, *Christianity, Social Tolerance, and Homosexuality: Gay People in Western Europe from the Beginning of the Christian Era to the Fourteenth Century* (Chicago: University of Chicago Press, 1980).

9. Boswell, "Revolutions, Universals, and Sexual Categories," in *Hidden From History*, 35.

10. See, for example, the few references to lesbians in Boswell, *Christianity, Social Tolerance and Homosexuality*; Vern L. Bullough, *Homosexuality: A History* (New York: Garland Publishing, 1979), *Sexual Variance in Society and History* (New York: John Wiley, 1976), and "The Sin against Nature and Homosexuality," in *Sexual Practices and the Medieval Church*, ed. Vern L. Bullough and James A. Brundage (Buffalo: Prometheus Books, 1982), 55–71; and Derrick Sherwin Bailey, *Homosexuality and the Western Christian Tradition* (London: Longmans, Green, 1955; rpt. Hamden, CT: Archon Books, 1975). Many studies are even more cursory in their outright dismissal of lesbians or pessimism about the existence of sources to even study medieval lesbians. More recently, John Boswell has presented an apologia in response to mounting criticism about the marginalization of women in studies on medieval homosexuality. *Same-Sex Unions in Premodern Europe* (New York: Villard Books, 1994), xxvii–xxx.

11. Adrienne Rich, "Compulsory Heterosexuality and Lesbian Existence," *Signs* 5:4 (1980): 631–60; Eve Kosofsky Sedgwick, "Introduction: Axiomatic," in *Epistemology of the Closet* (Berkeley: University of California Press, 1990), 1–63; Judith Butler, *Gender Trouble: Feminism and the Subversion of Identity* (New York: Routledge, 1990). A session entitled "'Pastism,' 'Presentism,' Theory: Roundtable on Judith Butler's *Gender Trouble*" explored the application of her theoretical perspective to medieval studies at the 27th International Medieval Congress, Western Michigan University, Kalamazoo, MI, May 1992.

12. Rich, "Compulsory Heterosexuality," 648–49. The emphasis is in the original.

13. Sedgwick, "Introduction: Axiomatic," 44, 52–53.

14. Ann Ferguson, Jacquelyn N. Zita, and Kathryn Pyne Addelson, "On 'Compulsory Heterosexuality and Lesbian Existence': Defining the Issues," *Signs* 7 (1981): 158–99. See, in particular, Ferguson's comments, 160 and her *Sexual Democracy: Women, Oppression, and Revolution* (Boulder, CO: Westview Press, 1991), especially 52–65.

15. See E. Ann Matter's introduction to the Gay and Lesbian issue of the *Medieval Feminist Newsletter* 13 (Spring 1992) and especially the articles by Simon Gaunt and Carolyn Dinshaw.

16. Matter, op. cit., 3. Jo Ann McNamara has written a particularly useful article about writing history from silence. She asks "Can we write a history for which there were no historians, from records that resist the project? . . . This is the history we were all trained not to write: a history in confrontation with our sources rather than in conformity with them." Ultimately, she concludes that, yes, we can write from silence but must do so with judiciousness and caution. Jo Ann McNamara, "*De quibusdam mulieribus.* Reading Women's History from Hostile Sources," in *Medieval Women and the Sources of Medieval History*, ed. Joel T. Rosenthal (Athens, GA: University of Georgia Press, 1990), 239.

17. Romans 1: 26–27.

18. The story of Ruth and Naomi, and especially Ruth's emotional statement of her enduring commitment to Naomi (Ruth 1: 16–17), has recently been interpreted as a positive evaluation of relationships between women. There is no evidence for a lesbian understanding of this passage in medieval Jewish or Christian biblical exegesis. Although lesbian activity is not mentioned in Jewish Scripture, it was condemned in rabbinical writings. James A. Brundage, *Law, Sex, and Christian Society in Medieval Europe* (Chicago: University of Chicago Press, 1987), 57. While lesbianism was not clearly prohibited by law, husbands were advised to keep their wives from associating with women known to engage in such activity. Furthermore, flogging was recommended as a preventive action. Michael Goodich, *The Unmentionable Vice: Homosexuality in the Later Medieval Period* (Santa Barbara, CA: American Bibliographical Center–Clio Press, 1979), 48.

19. Bailey, *Homosexuality and the Western Christian Tradition*, 40–41.

20. See, for example, 1 Cor. 11: 2–16, which enforces strict sex roles and gender distinctions and a hierarchical relationship between men and women. Paul's attitude towards female homoeroticism has been analyzed by Bernadette J. Brooten, "Paul's View on the Nature of Women and Female Homoeroticism," in *Immaculate and Powerful: The Female in Sacred Image and Social Reality*, eds. Clarissa W. Atkinson, Constance H. Buchanan, and Margaret R. Miles, Harvard Women's Studies in Religion Series (Boston: Beacon Press, 1985), 61–87.

21. Boswell provides a thought-provoking argument for his reinterpretation of Paul in *Christianity, Social Tolerance and Homosexuality*, 109–13. This has been challenged by Richard B. Hays, "Relations Natural and Unnatural: A Response to John Boswell's Exegesis of Romans I," *Journal of Religious Ethics* 14 (1986): 184–215.

22. John Chrysostom, Homily IV on the Epistle to the Romans, translated by John Boswell in *Christianity, Social Tolerance, and Homosexuality*, 359–62. In contrast to Chrysostom's condemnation, Boswell cites the attitude of Anastasius as being the more common one. Anastasius simply dismissed the possibility of lesbian sexuality out of hand: "Clearly [the women] do not mount each other but, rather, offer themselves to the men," he wrote in his commentary on Romans 1: 26. Cited in Boswell, *Christianity, Social Tolerance and Homosexuality*, 158.

23. Augustine, Letter 211, trans. Sr. Wilfrid Parsons, *Fathers of the Church*, vol. 32 (New York: Fathers of the Church, 1956), 50.

24. Donatus of Besançon, *The Rule of Donatus of Besançon: A Working Translation*, trans. Jo Ann McNamara and John E. Halborg (Saskatoon, Sask.: Peregrina Publishing, 1985), 21.

25. Ibid., 40. Warnings about the need to keep lights on in the dormitories were reiterated, although over time the underlying rationale became less clear. For example, the Council of Paris (1212) included a canon that reads: "And let lamps burn all night in the dormitory." No context or explanation is supplied, suggesting that the reason was well-known by those charged with the supervision of nuns, but that the Fathers of the Council did not feel comfortable discussing them explicitly. Par. III. Cap

II. Institutiones de Monialibus, Council of Paris (1212) in *Sacrorum Conciliorum nova et amplissima collectio*, ed. by Joannes Dominicus Mansi, Vol. 22 (Venice: apud Antonium Zatta, 1778).

26. Brundage, *Law, Sex, and Christian Society*, 167. Brundage discusses various penitential texts in n. 193. See also Pierre J. Payer, *Sex and the Penitentials: The Development of a Sexual Code, 550–1150* (Toronto: University of Toronto Press, 1984), 40–41, for a discussion of the lack of terminology to describe homosexuals and lesbians and 42–43 for an overview of the treatment of these sins in the penitentials.

27. *Medieval Handbooks of Penance. A translation of the principal libri poenitentiales and selections from related documents*, trans. John T. McNeill and Helena M. Gamer, Records of Civilization, Sources and Studies, 29 (New York: Columbia University, 1938; rpt. 1990), 185–86.

28. "Si mulier more fornicationis ad alteram conjunxerit, tres annos, sicut fornicator, poeniteat." Rabanus Maurus, *Poenitentiale*, PL 110: 490. Pierre J. Payer provides a discussion of the textual difficulties which obscure the meaning of this passage. *Sex and the Penitentials*, 43 and n. 135.

29. Theodore also differentiated the relative seriousness of male homosexual activity according to circumstances. For example, he recommended ten years of penance for "A male who commits fornication with a male" while sodomites should have seven years of penance enjoined. McNeill and Gamer, *Handbooks of Penance*, 185.

30. Ibid., 172, n. 136. Byzantine prohibitions appear to have been directed exclusively to nuns. Boswell, *Same-Sex Unions*, 244.

31. Hincmar of Reims, *De divortio Lotharii et Tetbergae*, PL 125: 692–93. The translation is from Boswell, *Christianity, Social Tolerance and Homosexuality*, 204. Burchard of Worms, in the eleventh century, included a similar discussion of sexual activity between women using "devices in the manner of the virile member." Burchard of Worms, *Decretum, Book 19. Corrector et Medicus* in PL 140: 971–72.

32. Brundage, *Law, Sex, and Christian Society*, 213. Peter Damian's *Liber Gomorrhianus* has been translated by Pierre J. Payer, *The Book of Gommorah: An Eleventh-Century Treatise against Clerical Homosexual Practices* (Waterloo, Ontario: Wilfred Laurier University Press, 1982).

33. "Contra naturam, hoc est contra naturae institutionem, quae genitalia feminarum usui virorum praeparavit, et e converso, non ut feminae feminis cohabitarent." Peter Abelard, *Commentarium super S. Pauli epistolam ad Romanos libri quinque*, PL 178: 806.

34. Hildegard of Bingen, *Scivias*, trans. Columba Hart and Jane Bishop (New York: Paulist Press, 1990), 279.

35. Thomas Aquinas, *Summa theologiae*, trans. Fathers of the English Dominican Province, 3 vols. (New York: Benziger Brothers, 1947–48), 2: 1825.

36. The relatively unimportant evaluation of lesbian activity was not exclusive to Western Christendom. In the orthodox world, as well, lesbian activity was not considered as serious as either heterosexual sins like adultery or male homosexuality. Lesbian activity was deemed similar to masturbation, although it was punished more seriously, by flogging rather than exclusion from communion, if one of the women took the upper, active position reserved for men. See the discussion in Eve Levin, *Sex and Society in the World of the Orthodox Slavs, 900–1700* (Ithaca, NY: Cornell University Press, 1989), 203–04.

37. Helen Rodnite Lemay has observed that "Lesbianism is treated rarely in the medical literature; either doctors considered female homosexuality to be unimportant, or they did not even recognize that it existed." See "William of Saliceto on Human Sexuality," *Viator* 12 (1981), 178. Monica H. Green, however, suggests that the medical discourse's focus on pathologies limited the occasions when lesbian activity could be examined. "Female Sexuality in the Medieval West," *Trends in History* 4 (1990), 155–56.

38. Martin Levey and Safwat S. Souryal, "Galen's On the Secrets of Women and On the Secrets of Men. A Contribution to the History of Arabic Pharmacology," *Janus 55* (1968), 210–11. The authors do not indicate which words they translate as "lesbianism."

39. Helen Rodnite Lemay, "The Stars and Human Sexuality: Some Medieval Scientific Views," *Isis 71* (1980), 131–32.

40. Quoted in Danielle Jacquart and Claude Thomasset, *Sexuality and Medicine in the Middle Ages,* trans. Matthew Adamson (Princeton, NJ: Princeton University Press, 1988), 124. The authors do not identify or discuss the original Latin word which they translate as "Sapphism."

41. Lemay, "William of Saliceto," 177–78.

42. Ibid., 178–79.

43. *Li Livres de jostice et de plet* (Paris: Firmin Didot frères, 1850), 279–80. The translation is from Bailey, *Homosexuality and the Western Christian Tradition,* 142. Louis Crompton suggests that the punishment for women would have been clitorectomy but wonders how it could be performed twice. "The Myth of Lesbian Impunity. Capital Laws from 1270–1791," *Journal of Homosexuality 6* (1980/81), 13. There is no evidence that this is in fact what was intended by the phrase "lose a member" ("perdre menbre"). While castration may be logically conjectured for male homosexuals, clitorectomy did not occupy the same role in medieval judicial or medical theory or in the society's cultural conception of the body.

44. Guido Ruggiero, *The Boundaries of Eros: Sex Crime and Sexuality in Renaissance Venice* (New York: Oxford University Press, 1985), 189, n. 21.

45. John Boswell has found some scant evidence for at least one ceremony of union between women in a church in Dalmatia in 1620. *Same-Sex Unions,* 256–66. An "Office of Same Sex Union," included in the Appendix of Translations, appears to have pertained equally to the unions of two men or two women. Ibid., 317–23. Ultimately, however, there is little evidence that medieval women could formalize their relationships.

46. This case is discussed in Joan Cadden, *Meanings of Sex Difference in the Middle Ages: Medicine, Science, and Culture,* Cambridge History of Medicine (Cambridge: Cambridge University Press, 1993), 224.

47. Mary Elizabeth Perry, *Crime and Society in Early Modern Seville* (Hanover, NH: University Press of New England, 1980), 84.

48. Louis Crompton has assembled a number of premodern cases of prosecution for lesbianism. These cases usually ended in the death penalty. "Myth of Lesbian Impunity," 17–19.

49. For example, in an early-eighteenth-century trial transcript, Catharina Linck's partner, Catharina Mühlhahn, is described as a "simple-minded person who let herself be seduced into depravity." She was sentenced to three years in prison. Brigitte Eriksson, "A Lesbian Execution in Germany, 1721. The Trial Records," *Journal of Homosexuality 6* (1980/81), 40.

50. Louis Crompton discusses this case in "Sodomy and Heresy in Early Modern Switzerland," *Journal of Homosexuality 6* (1980/81), 46–47. The transcript of a trial that occurred in Germany in 1721 survives and provides remarkable detail about the lives and motivations of two women who were prosecuted for lesbianism. One passed herself off as a man and the two lived in a conventional marriage until the truth was discovered. It remains unclear, however, whether it was their relationship or a tendency to switch back and forth from Protestantism to Roman Catholicism that brought them to the attention of the authorities and earned Catharina Linck the death penalty. A translation of the transcript of their trial is found in Eriksson, "A Lesbian Execution," 27–40.

51. Ibid., 48. For example, in his discussion of Cathar heretics, Guibert of Nogent observed: "Clearly although there are few of them in the Latin world, you may see men living with women without the name of husband and wife in such fashion that one man does not stay with one woman, each to each, but men are known to

be with men and women with women, for with them it is impious for men to go with women." *Self and Society in Medieval Franch. The Memoirs of Abbot Guibert of Nogent,* ed. John F. Benton (New York: Harper and Row, 1970), 212.

52. This relationship has been explored by Vern L. Bullough, *Sexual Variance,* 390–97.

53. This case has attracted much scholarly attention. Judith Brown first announced the discovery of the transcripts of Benedetta Carlini's trial in an article "Lesbian Sexuality in Renaissance Italy: The Case of Sister Benedetta Carlini," *Signs* 9 (1984), 751–58. She subsequently published a full length study entitled *Immodest Acts: The Life of a Lesbian Nun in Renaissance Italy* (New York: Oxford University Press, 1986). Brown has been criticized for a tendency to anachronism and essentialism by Rudolph M. Bell, "Renaissance Sexuality and the Florentine Archives: An Exchange. The 'Lesbian' Nun of Judith Brown: A Different Conclusion," *Renaissance Quarterly* 40 (1987), 485–503, and by E. Ann Matter, "Discourses of Desire: Sexuality and Christian Women's Visionary Narratives," *Journal of Homosexuality* 18:3/4 (1989/90), 119–31.

54. Matter, "Discourses of Desire," 119–31, especially 123.

55. Ibid., 128–29. Rudolph Bell has also noted how marginal Benedetta's lesbian activities were in her trials and in her ultimate sentencing. Lesbianism played no role in her coming to the attention of the authorities and was mentioned only in the context of her convent community seeking to discredit her spiritual authority. Benedetta, indeed, even denied the veracity of the sexual acts, explaining that her body was then possessed by an angel. Bell, "Renaissance Sexuality," 497.

56. Etienne de Fougères, *Le Livre des Manières,* ed. R. Anthony Lodge, Textes Littéraires Français (Geneva: Droz, 1979), 12–13. Robert L.A. Clark analyzed the lesbian implications of this work in "Jousting without Lances: The Condemnation of Lesbianism in the *Livre des manières,*" Unpublished paper, 28th International Congress of Medieval Studies, Kalamazoo, MI, May 1993.

57. Lodge, *Le Livre des Manières,* 23–35.

58. The following discussion relies heavily on Clark, "Jousting Without Lances." The pertinent stanzas of the poem are reproduced in full in Appendix I of this chapter. I would like to thank Dr. Clark for allowing his unpublished translation of the poem to appear in this chapter.

59. Susan Schibanoff has described this as "a paradigm of absence and lack," which characterizes so much of medieval literature, suggesting that understanding the blanks and absences may in fact lead to a greater knowledge of medieval lesbians. Susan Schibanoff, "Chaucer's Lesbians: Drawing Blanks?" *Medieval Feminist Newsletter* 13 (Spring 1992), 13.

60. Lodge, *Le Livre des Manières,* 98, ll. 1117–24, trans. by Robert Clark.

61. Clark, "Jousting Without Lances."

62. Boswell, *Christianity, Social Tolerance, and Homosexuality,* 256.

63. Meg Bogin presents some of the arguments used to avoid concluding that the poem is about two women. *The Women Troubadours* (New York: Paddington Press, 1976), 176–77.

64. Angelica Rieger, "Was Bieiris de Romans Lesbian? Women's Relations with Each Other in the World of the Troubadours," in *The Voice of the Trobairitz: Perspectives on the Women Troubadours,* ed. William D. Paden (Philadelphia: University of Pennsylvania Press, 1989), 92. Rieger's argument is carefully developed, complex, and not easily summarized. See, especially, 82–91.

65. We are not particularly better informed on the intimate details of heterosexual relations. For example, did a man and woman speak, kiss, indulge in foreplay? These and similar questions are equally shrouded in medieval secrecy.

66. Mary Anne Campbell, "Redefining Holy Maidenhood: Virginity and Lesbianism in Late Medieval England," *Medieval Feminist Newsletter* 13 (Spring 1992), 15.

67. See, for example, the discussion of the passionate friendships of Aelred of Rievaulx and Christina of Markyate, which bore both spiritual and erotic aspects yet stopped short of physical expression. Ruth Mazo Karras, "Friendship and love in the lives of two twelfth-century English saints," *Journal of Medieval History* 14 (1988), 305–20. John Boswell has also raised questions about the nature of the relationship between Perpetua and Felicitas, the earliest paired female saints. *Same-Sex Unions*, 139–41.

68. An overview of medieval women's friendships and the attention they have received from historians is found in Ulrike Wiethaus, "In Search of Medieval Women's Friendships. Hildegard of Bingen's Letters to Her Female Contemporaries," in *Maps of Flesh and Light. The Religious Experience of Medieval Women Mystics*, ed. Ulrike Wiethaus (Syracuse, NY: Syracuse University Press, 1993), 93–98.

69. Peter Dronke, *Medieval Latin and the Rise of the European Love-Lyric* (Oxford: Clarendon, 1968), II, 479. The letter is reproduced in full in Appendix II of this Chapter.

70. Hadewijch, Letter 25 to Sara, Emma, and Margaret, in *Hadewijch: The Complete Works*, trans. Columba Hart (New York: Paulist Press, 1980), 105–106. E. Ann Matter discusses this letter at length in "My Sister, My Spouse," 84–86.

71. Wiethaus, "Medieval Women's Friendships," 98–109.

72. Bruce Wood Holsinger, "The Flesh of the Voice: Embodiment and the Homoerotics of Devotion in the Music of Hildegard of Bingen (1098–1179)," *Signs* 19:1 (1993), 109, 111.

73. Diane Wolfthal discusses art historians' relative neglect of homosexuality as an area for study. She also indicates the great potential for future research. "An Art Historical Response to 'Gay Studies and Feminism: A Medievalist's Perspective'," *Medieval Feminist Newsletter* 14 (Fall 1992), 16–19.

74. This particular image from the *Bible moralisée* has been analyzed by Michael Camille, *The Gothic Idol. Ideology and Image-making in Medieval Art* (Cambridge: Cambridge University Press, 1989), 90–91.

75. Wolfthal, "Art Historical Response," 18.

BIBLIOGRAPHY

Primary Sources

Augustine. *Letters*. Vol. 5. Trans. Wilfrid Parsons. Fathers of the Church, 32. New York: Fathers of the Church, 1956. Letter 211.

Bede. "Penitential." In *Councils and Ecclesiastical Documents Relating to Great Britain and Ireland*, eds. Arthur West Haddan and William Stubbs. 3 vols. Oxford: Clarendon Press, 1869–78; rpt. 1964.

The Holy Bible. Revised Standard Version. New York: Collins, 1973.

Bieiris de Romans. "Chanson to Maria." In *The Women Troubadours*, ed. Meg Bogin, 132–33. New York: Paddington Press, 1976.

Burchard of Worms. *Decretum*. Book 19. *Corrector et Medicus*. Patrologia Latina, henceforth PL 140: 971–72.

Council of Paris (1212). *Sacrorum Conciliorum nova et amplissima collectio*, ed. Joannes Dominicus Mansi. Vol. 22. Venice: apud Antonium Zatta, 1778.

Donatus of Besançon. *The Rule of Donatus of Besançon: A Working Translation*. Trans. Jo Ann McNamara and John E. Halborg. Saskatoon, Sask.: Peregrina Publishing, 1985.

Etienne de Fougères. *Le Livre des manières*, ed. R. Anthony Lodge. Textes Littéraires Français. Geneva: Droz, 1979.

Guibert of Nogent. *Self and Society in Medieval France. The Memoirs of Abbot Guibert of Nogent*, ed. John F. Benton. New York: Harper and Row, 1970.

Hadewijch. *Hadewijch: The Complete Works*. Trans. Mother Columba Hart. New York: Paulist Press, 1980.

Hildegard of Bingen. *Scivias*. Trans. Columba Hart and Jane Bishop. New York: Paulist Press, 1990.

Hincmar of Reims. "De Divortio Lotharii et Tetbergae." PL 125: 692–93.

John Chrysostom. Homily IV. In *A Select Library of the Nicene and Post-Nicene Fathers of the Christian Church*. Vol. XI. *Saint Chrysostom: Homilies on the Acts of the Apostles and the Epistle to the Romans, 355–59*. Grand Rapids, MI: Eerdmans, rpt. 1975.

Li Livres de jostice et de plet. Paris: Firmin Didot frères, 1850.

McNeill, John T. and Helena M. Gamer. *Medieval Handbooks of Penance. A translation of the principal libri poenitentiales and selections from related documents*. Records of Civilization, Sources and Studies, 29. New York: Columbia University Press, 1938.

Peter Abelard. "Commentariorum super S. Pauli Epistolam ad Romanos libri quinque." PL 178: 806.

Rabanus Maurus. *Poenitentiale*. PL 110: 490.

Theodore. "Penitential." In *Councils and Ecclesiastical Documents Relating to Great Britain and Ireland*, ed. Arthur West Haddan and William Stubbs. 3 vols. Oxford: Clarendon Press, 1869–78; rpt. 1964.

Vogel, Cyrille. *Le Pecheur et la Pénitence au Moyen Age*. Paris: Cerf, 1969.

Secondary Sources

Bailey, Derrick Sherwin. *Homosexuality and the Western Christian Tradition*. London: Longmans, Green, 1955; rpt. Hamden, CT: Archon Books, 1975.

Bell, Rudolph M. "Renaissance Sexuality and the Florentine Archives: An Exchange. The 'Lesbian' Nun of Judith Brown: A Different Conclusion." *Renaissance Quarterly* 40 (1987): 485–503; "Response from Judith Brown." Ibid., 503–11.

Bogin, Meg. *The Women Troubadours*. New York: Paddington Press, 1976.

Bonnet, Marie-Jo. *Un choix sans équivoque. Recherches historiques sur les relations amoureuses entre les femmes xvie–xxe siècle*. Paris: Denoël, 1981.

Boswell, John. *Christianity, Social Tolerance, and Homosexuality: Gay People in Western Europe from the Beginning of the Christian Era to the Fourteenth Century*. Chicago: University of Chicago Press, 1980.

———. "Revolutions, Universals, and Sexual Categories." *Salmagundi* 58–59 (Fall 1982–Winter 1983): 89–113. Rev. and rpt. in *Hidden from History: Reclaiming the Gay and Lesbian Past*, ed. Martin Duberman, Martha Vicinus, and George Chauncey, Jr., 17–36. New York: Meridian Books, 1989.

———. *Same-Sex Unions in Premodern Europe*. New York: Villard Books, 1994.

Brooten, Bernadette J. "Paul's View on the Nature of Women and Female Homoeroticism." In *Immaculate and Powerful: The Female in Sacred Image and Social Reality*, ed. Clarissa W. Atkinson, Constance H. Buchanan, and Margaret R. Miles, 61–87. Harvard Women's Studies in Religion Series. Boston: Beacon Press, 1985.

Brown, Judith C. *Immodest Acts: The Life of a Lesbian Nun in Renaissance Italy*. New York: Oxford University Press, 1986.

———. "Lesbian Sexuality in Medieval and Early Modern Europe." In *Hidden from History: Reclaiming the Gay and Lesbian Past*, ed. Martin Duberman, Martha Vicinus, and George Chauncey, Jr., 67–75. New York: Meridian Books, 1989.

———. "Lesbian Sexuality in Renaissance Italy: The Case of Sister Benedetta Carlini." *Signs* 9 (1984): 751–58. Rpt. in *The Lesbian Issue*, ed. Estelle B. Freedman et al., 271–78. Chicago: University of Chicago Press, 1985.

Brundage, James A. *Law, Sex, and Christian Society in Medieval Europe*. Chicago: University of Chicago Press, 1987.

Bullough, Vern L. *Homosexuality: A History*. New York: Garland Publishing, 1979.

———. *Sexual Variance in Society and History*. New York: John Wiley, 1976.

———. "The Sin against Nature and Homosexuality." In *Sexual Practices and the Medieval Church*, ed. Vern L. Bullough and James Brundage, 55–71. Buffalo: Prometheus Books, 1982.

Bynum, Caroline Walker. "The Body of Christ in the Later Middle Ages: A Reply to Leo Steinberg." *Renaissance Quarterly* 39 (1986): 399–439. Rpt. in Bynum, *Fragmentation and Redemption*, 79–117.

———. "The Female Body and Religious Practice in the Later Middle Ages." In *Zone 3: Fragments for a History of the Human Body*, Part 1, 160–219. New York: Zone Books, 1989. Rpt. in Bynum, *Fragmentation and Redemption*, 181–238.

———. *Fragmentation and Redemption: Essays on Gender and the Human Body in Medieval Religion*. New York: Zone Books, 1991.

———. "Women Mystics and Eucharistic Devotion in the Thirteenth Century." *Women's Studies* 11 (1984): 179–214. Rpt. in Bynum, *Fragmentation and Redemption*, 119–50.

Cadden, Joan. *Meanings of Sex Difference in the Middle Ages: Medicine, Science, and Culture*. Cambridge History of Medicine. Cambridge: Cambridge University Press, 1993.

Camille, Michael. *The Gothic Idol: Ideology and Image-making in Medieval Art*. Cambridge: Cambridge University Press, 1989.

Campbell, Mary Anne. "Redefining Holy Maidenhood: Virginity and Lesbianism in Late Medieval England." *Medieval Feminist Newsletter* 13 (Spring 1992): 14–15.

Clark, Robert L.A. "Jousting without Lances: The Condemnation of Lesbianism in the *Livre des manières*." Unpublished paper, 28th International Congress of Medieval Studies, Kalamazoo, MI, May 1993.

Crompton, Louis. "The Myth of Lesbian Impunity. Capital Laws from 1270–1791." *Journal of Homosexuality* 6 (1980/81): 11–25.

Dinshaw, Carolyn. "The Heterosexual Subject of Chaucerian Narrative." *Medieval Feminist Newsletter* 13 (Spring 1992): 8–9.

Dronke, Peter. *Medieval Latin and the Rise of the European Love-Lyric*. 2 vols. Oxford: Clarendon Press, 1968.

———. *Women Writers of the Middle Ages. A Critical Study of Texts from Perpetua (+203) to Marguerite Porete (+1310)*. Cambridge: Cambridge University Press, 1984.

Eriksson, Brigitte. "A Lesbian Execution in Germany, 1721. The Trial Records." *Journal of Homosexuality* 6 (1980/81): 27–40.

Faderman, Lillian. *Surpassing the Love of Men: Romantic Friendship and Love Between Women from the Renaissance to the Present*. New York: William Morrow, 1981.

Ferguson, Ann. *Sexual Democracy: Women, Oppression, and Revolution*. Boulder, CO: Westview Press, 1991.

Foster, Jeannette. *Sex Variant Women in Literature*. New York: Vantage Press, 1956; rpt. Baltimore: Diana Press, 1975.

Freedman, Estelle B., et al., eds. *The Lesbian Issue: Essays from Signs*. Chicago: University of Chicago Press, 1985.

Gaunt, Simon. "Gay Studies and Feminism: A Medievalist's Perspective." *Medieval Feminist Newsletter* 13 (Spring 1992): 3–8.

Goodich, Michael. *The Unmentionable Vice: Homosexuality in the Later Medieval Period*. Santa Barbara, CA: American Bibliographical Center–Clio Press, 1979.

Green, Monica H. "Female Sexuality in the Medieval West." *Trends in History* 4 (1990): 127–58.

Halperin, David M. "Sex Before Sexuality: Pederasty, Politics and Power in Classical Athens." In *Hidden From History: Reclaiming the Gay and Lesbian Past*, eds. Martin Duberman, Martha Vicinus, and George Chauncey, Jr., 37–53. New York: Meridian Books, 1989.

Halperin, David M., John J. Winkler, and Froma I. Zeitlin, eds. *Before Sexuality. The Construction of Erotic Experience in the Ancient Greek World*. Princeton, NJ: Princeton University Press, 1990.

Hays, Richard B. "Relations Natural and Unnatural: A Response to John Boswell's Exegesis of Romans I." *Journal of Religious Ethics* 14 (1986): 184–215.

Holsinger, Bruce Wood. "The Flesh of the Voice: Embodiment and the Homoerotics of Devotion in the Music of Hildegard of Bingen (1098–1179)." *Signs* 19:1 (1993): 92–125.

Huot, Sylvia. "Addressing the Issue of Lesbianism in a General Course on Women in the Middle Ages." *Medieval Feminist Newsletter* 13 (Spring 1992): 10–11.

Jacquart, Danielle and Claude Thomasset. *Sexuality and Medicine in the Middle Ages*. Trans. Matthew Adamson. Princeton, NJ: Princeton University Press, 1988.

Karras, Ruth Mazo. "Friendship and love in the lives of two twelfth-century English saints." *Journal of Medieval History* 14 (1988): 305–20.

Kicata, Salvatore J. and Robert P. Petersen, eds. *Historical Perspectives on Homosexuality*. [Special issue of] *Journal of Homosexuality* 6 (1980/81).

Kuster, Harry J. and Raymond J. Cormier. "Old Views and New Trends. Observations on the Problem of Homosexuality in the Middle Ages." *Studi Medievali* ser. 3, no. 25 (1984): 587–610.

Lemay, Helen Rodnite. "Human Sexuality in Twelfth- through Fifteenth-Century Scientific Writings." In *Sexual Practices and the Medieval Church*, eds. Vern L. Bullough and James A. Brundage, 187–205. Buffalo: Prometheus Books, 1982.

———. "The Stars and Human Sexuality: Some Medieval Scientific Views." *Isis* 71 (1980): 127–37.

———. "William of Saliceto on Human Sexuality." *Viator* 12 (1981): 165–81.

Levey, Martin and Safwat S. Souryal. "Galen's On the Secrets of Women and On the Secrets of Men. A Contribution to the History of Arabic Pharmacology." *Janus* 55 (1968): 208–19.

Levin, Eve. *Sex and Society in the World of the Orthodox Slavs, 900–1700*. Ithaca, NY: Cornell University Press, 1989.

Matter, E. Ann. "Discourses of Desire: Sexuality and Christian Women's Visionary Narratives." *Journal of Homosexuality* 18:3/4 (1989/90): 119–31.

———. "The 'Lesbian Continuum' and Medieval Sources: Theoretical Issues in the Study of Women's Sexuality." Unpublished paper, Medieval Academy of America Annual Meeting, 1993, Tucson, AZ.

———. "Introduction. MFN Gay and Lesbian Issue." *Medieval Feminist Newsletter* 13 (Spring 1992): 2–3.

———. "My Sister, My Spouse: Woman-Identified Women in Medieval Christianity." *Journal of Feminist Studies in Religion* 2:2 (1986): 81–93. Rpt. in *Weaving the Visions: New Patterns in Feminist Spirituality*, eds. Judith Plaskow and Carol P. Christ, 51–62. San Francisco: Harper Collins, 1989.

McCall, Andrew. *The Medieval Underworld*. London: Hamish Hamilton, 1979.

Monter, E. William. "Sodomy and Heresy in Early Modern Switzerland." *Journal of Homosexuality* 6 (1980/81): 41–53.

Moore, R.I. *The Formation of a Persecuting Society: Power and Deviance in Western Europe, 950–1250*. Oxford: Basil Blackwell, 1987.

Payer, Pierre J. *Sex and the Penitentials: The Development of a Sexual Code, 550–1150*. Toronto: University of Toronto Press, 1984.

Perry, Mary Elizabeth. *Crime and Society in Early Modern Seville*. Hanover, NH: University Press of New England, 1980.

Rich, Adrienne. "Compulsory Heterosexuality and Lesbian Existence." *Signs* 5:4 (1980): 631–60.

Rieger, Angelica. "Was Bieiris de Romans Lesbian? Women's Relations with Each Other in the World of the Troubadours." In *The Voice of the Trobairitz: Perspec-*

tives on the Women Troubadours, ed. William D. Paden, 73–94. Philadelphia: University of Pennsylvania Press, 1989.

Ruggiero, Guido. *The Boundaries of Eros: Sex Crime and Sexuality in Renaissance Venice*. New York: Oxford University Press, 1985.

Schibanoff, Susan. "Chaucer's Lesbians: Drawing Blanks?" *Medieval Feminist Newsletter* 13 (Spring 1992): 11–14.

Sedgwick, Eve Kosofsky. "Introduction: Axiomatic." In *Epistemology of the Closet*, 1–63. Berkeley: University of California Press, 1990.

Wiethaus, Ulrike. "In Search of Medieval Women's Friendships. Hildegard of Bingen's Letters to Her Female Contemporaries." In *Maps of Flesh and Light: The Religious Experience of Medieval Women Mystics*, ed. Ulrike Wiethaus, 93–111. Syracuse, NY: Syracuse University Press, 1993.

Wolfthal, Diane. "An Art Historical Response to 'Gay Studies and Feminism: A Medievalist's Perspective'." *Medieval Feminist Newsletter* 14 (Fall 1992): 16–19.

9 CROSS DRESSING AND GENDER ROLE CHANGE IN THE MIDDLE AGES

Vern L. Bullough

Current concepts of cross dressing and gender role change had their origin in the nineteenth century, and it is from these initial assumptions that current differentiations of sex and gender have evolved. The first description in the professional literature describing a difference between biological sex and gender behavior was by Carl Westphal in 1869, who thought he was describing two cases of what came to be called homosexuality. Both of his cases today would be called cases of gender non-conformity: one, a woman, who was also a lesbian but who wanted to be a man; and the second a man who by current standards was not homosexual but a transvestite or perhaps transsexual.[1] This confusion of gender role and homosexuality was carried over into the writings of Krafft-Ebing, the most influential writer on sex in the last part of the nineteenth century,[2] who included in his discussion of homosexuality a number of cases of men who wanted to dress and act as women as well as of women who wanted to dress and act as men. He considered them examples of sexual paranoia, although he also classified some as fetishists.[3] The influence of Krafft-Ebing led many medically oriented professionals to continue to classify cross dressing as one aspect of homosexuality or fetishism until the middle of the twentieth century, although other investigators had challenged these beliefs.

The term "transvestite" was coined by Magnus Hirschfeld in 1910.[4] Havelock Ellis felt that the term transvestism was much too narrow and overemphasized the importance of clothing and failed to emphasize the challenge to gender stereotypes. He coined the term Eonism based on the historical case of the Chevalier d'Eon de Beaumont (1728–1810), who spent much of his adult life living as a woman and who was only finally determined to be a biological male when he died.[5] In spite of Ellis's legitimate criticism, and some recent attempts to utilize different terms, transvestism was the descriptive term still used to describe such behavior until the 1980s.

John Money and his colleagues further refined the concept of gender, emphasizing that male and female were biological designations but gender behavior, while based on biology, was also a social construct.[6] Feminists increasingly adopted the term gender in the 1980s to distinguish behavioral and other characteristics from anatomical sex, although in some feminist circles there has been an attempt to use the term gender to replace the term sex altogether. This chapter, however, is concerned primarily with cross gender behavior. In recent years a number of terms have been used to describe such behavior, including gender blenders, crossing, and cross genderists, as well as many others coined by individual groups of individuals who do not conform to gender stereotypes. Psychiatrists have not studied the phenomenon very intensely, although the latest *Diagnostic and Statistical Manual of Mental Disorders* lists something called fetishistic transvestism, a diagnosis limited to heterosexual males who cross dress. They also include a category called transsexuals, a group of both males and females who appeared only in the 1950s when sex reassignment through surgical intervention became possible.[7] Perhaps because psychiatric evaluations are often required for surgical transformations, transsexuals have been studied and examined in far greater detail than cross dressers, the term used in this chapter for the more obvious crossing of gender lines.

Prior to the medieval period cross gender behavior had been widespread, although it had been more effectively institutionalized in some societies than others. Greek and Roman mythology and literature is full of cross dressing of both men and women, while male individuals from Aeneas to Hercules are said to have lived part of their life disguised as girls or women. Cross dressing was part of the religious ceremonies of many of the pagan cults including that of Aphrodite. Christianity was, however, hostile to cross dressing, perhaps because of its association with such rival religious groups. A major factor in forming such hostility was Jewish scriptural tradition, especially a passage in *Deuteronomy* (22:5):

> The woman shall not wear that which pertaineth unto a man, neither shall a man put on a woman's garment; for all that do so are an abomination unto the Lord thy God.

Modern biblical scholars have argued that the statement originally was most likely directed against some of the religious rivals of Judaism where, during religious ceremonies, members engaged in cross dressing, and that it was never intended to be a universal prohibition against cross dressing. Still the existence of this particular scriptural prohibition had great influence on

Christian attitudes. Interestingly, however, the prohibition was less likely to be applied to females than it was to males in the medieval period, and this is what makes the study of cross dressing so important in understanding gender roles.

From the data so far explored—and there is much more to investigate—it seems clear that the reason female crossing of the gender barriers was tolerated in the medieval period, even encouraged, was because it was assumed such women were striving to become more male-like and therefore better persons.[8] Male impersonation of females, on the other hand, not only led to a lower status but was suspect because most male writers could find only one possible explanation for a man's adopting woman's guise, namely a desire to have easier access to women for sexual purposes.

This tolerance of female cross dressing and intolerance for male is closely related to the perceived difference between the gender attributes of males and females.[9] These perceived differences date back at least to the Greek times and probably have existed since men have had the power positions in society. A good starting point is Aristotle, who believed he had scientific evidence of female inferiority, and went on to claim that women were not only intellectually but morally inferior to men. This assumption led him to conclude that male domination was the will of nature, and for anyone to try to challenge nature in the name of some imagined principle of equality was quite contrary to the interests both of the individual and of the community.[10] Aristotle went so far as to claim that the female was little more than an incomplete male.[11] This was because of the "fact" that the active force in the seed tended to the production of a perfect likeness in the masculine sex, while the production of the female came from a defect in the active force or from some material indisposition.[12]

Medieval theorists, even those deeply influenced by Aristotle, tended to reject the philosopher on this last point. St. Thomas Aquinas, for example, argued that women could not be misbegotten since the female was part of God's intention. This disagreement, however, did not mean that she was equal to man in power or status:

> For good order would have been wanting in the human family, if some were not governed by others wiser than themselves. So by such a kind of subjection woman is naturally subject to man, because naturally in man the discretion of reason predominates.[13]

Moreover, since the generative power in the female is imperfect compared to the male, and since:

in the arts the inferior art gives a disposition to the matter to which the higher art gives the form . . . so also the generative power of the female prepares the matter, which is then fashioned by the active power of the male.[14]

Such suppositions inevitably had led to the question of whether the nature of the female sex was essentially different from the male, and several medical writers discussed it. Soranus (second century A.D.) in his *Gynecology* briefly listed some of the authorities who had addressed this question. Most of the authorities he cited believed that women were not formed from any different materials than men in spite of the fact that they had different generative organs.[15] His conclusions were adopted by Averroes, the Islamic physician who died in 1198 and who was so influential in the later Middle Ages.[16]

Still, women had different qualities from men. Isidore of Seville believed that he had found the explanation for these differences in the etymologies of the various terms applied to the sexes. A man, he wrote, was called *vir* because there was greater force, *vis*, in him than in women. From *vir* also came *virtu* or strength, because men ruled over women by force. Woman, in contrast, was called *mulier*, a term he said derived from *molites* or softness with one letter taken away and another changed.[17] Though we can make fun of Isidore's etymologies today, his analysis was widely believed in the past and helped justify the status difference between the sexes. According to Isidore, man's strength was greater than woman's so she should be subject to him. One reason a woman could be forced to submit to man was that if she could easily repel a man, his lust might lead him to turn to his own sex for satisfaction, and this Isidore felt was against the will of God.[18]

Adding to this litany of views of women as inferior was Galen, who held that the female was less perfect than the male primarily because she was colder. It was this very lack of heat that kept her reproductive organs inside her rather than outside as in the man, although Galen said this internalizing of her sex organs had proved advantageous for survival.[19] It was Galen who gave his authority to the idea that women were men turned inside out, a long held belief that led individuals like Pliny to argue that if women spread their legs very wide apart when leaping over a fence or similar activity their organs would fall out and they would become men.[20] Tied in with and overlying this view of women as creatures who were physically inferior and subordinate to men was an assumption of the intellectual and perhaps even spiritual inferiority of the females as well. This attitude, which had great effect upon Christianity, was exemplified by the Alexandrian Jewish Neoplatonist,

Philo. He held that the reason the male was superior to the female was because he represented the more rational part of the soul while the female represented the less rational. For Philo, progress meant giving up the female gender, the material, passive, corporeal, and sense-perceptive world, and taking the active rational male world of mind and thought. The easiest way for women to approach the male level of rationality was for women to deny their sexuality, to remain virgins.[21]

Disseminating such ideas among early Christians were several of the Church Fathers. Perhaps because so many of them were celibate, women seemed a danger to them. One of the exceptions was St. Jerome, who argued that there was no cause for shame in associating with women. Still, even he emphasized that as

> long as woman is for birth and children, she is as different from man as body is from soul. But when she wishes to serve Christ more than the world, then she will cease to be a woman and will be called man.[22]

Jerome was repelled by women who seemed to be dominated by their biology. He wrote that he found nothing attractive in motherhood, that he considered a pregnant woman a revolting sight, and that he could not imagine why anyone would want a child, a "brat" to crawl upon a person's breast, soiling their neck with nastiness.[23] A similar concept was expressed by St. Ambrose:

> She who does not believe is a woman and should be designated by the name of her sex, whereas she who believes progresses to perfect manhood, to the measure of the adulthood of Christ. She then dispenses with the name of her sex, the seductiveness of youth, the garrulousness of old age.[24]

The list of similar references could be extended for several more pages, but the net result was not only to assign greater intellectual and social status to the male gender but to imply that it carried greater holiness as well. The female who wore male clothing or who somehow effectively impersonated a man was not only gaining status but making herself more rational and holy. Men who cross dressed were immediately suspected of weakness or effeminacy. Some indication of such hostility appears in the writings of St. Cyprian, who, concerned about effeminacy among Christian men, stated that those who dressed as women or who used feminine gestures or accoutrements should be forced to cease these offensive displays.[25]

Evidence that many women were attempting to pass as men is the action of the Church Council held at Gangra (before 341 B.C.E.), which condemned pious women who disguised themselves as men in order to join ascetic and monastic communities.[26] In spite of the condemnation no action was taken to prevent them from continuing to do so. As a result, throughout the medieval period female cross dressers, with the major exception of Joan of Arc, were never prosecuted or penalized. Both the attempts of women to cross dress and the male toleration of it are strong evidence for the dominance of the male gender role in medieval Christianity.

One of the richest sources for studying the boundaries of gender behavior is the *Acta Sanctorum*, since there were a number of female saints who lived and worshiped as men for most of their lives and whose true sex was only discovered when they died. Unfortunately there is no index to this particular aspect of the saint's lives, or for that matter any other lives. Helpful, however, is a guide to some of the folk literature compiled by Stith Thompson, who used a variety of subject categories to describe transformations to persons of different sex.[27]

The archetype for the female cross dressing saint is Pelagia (Margarito). Her story is rather confused and contradictory because there are so many variant local versions. To try to make sense out of the contradictions in the accounts of her life, early investigators concluded there were two distinct cross dressing saints bearing the same names. This suggestion, however, did not eliminate the confusion, which is undoubtedly indicative of the ubiquity of the legend. In fact, it might well be a Christianized version of a pre-Christian goddess such as Aphrodite, who, at least on Cyprus, was often portrayed in male form. The first Pelagia, who was described as a beautiful dancing girl and prostitute in Antioch, was also called Margarito because of the splendor of her pearls. After being converted to Christianity by the saintly Bishop Nonus, she repented of her past and fled Antioch to start life anew elsewhere. To effect her escape she dressed as a man, although under her outer garments she wore a hair shirt in order to continually remind her both of the sufferings of Jesus and her own human frailty. Eventually she found refuge on Mount Olivet in Jerusalem, where she lived as a man known as Pelagius. As such she became admired throughout the area for her asceticism and holiness and it was not until after her death that her true sex was revealed. When she was found to be a woman the mourners are said to have cried out: "Glory be to thee, Lord Jesus, for thou hast many hidden treasurers on earth, as well female as male."[28]

The other Saint Margarita-Pelagius has a slightly different story. In this second case Margarita was said to have held marriage in such horror that af-

ter her betrothal she fled the nuptial chamber in men's dress, cut her hair, and took refuge in a monastery where she went by the name of Pelagius. Such were her qualities of devotion that she was elected prior (a male position) of a convent. She acted the part of a man so well that when the portress of the convent became pregnant and accused Margarita-Pelagius of being the father, the charge was believed. The result was her expulsion from the convent in disgrace. Margarita-Pelagius then found refuge as a hermit in a nearby cave, and it was only at her death, after her true sex was revealed, that she was proclaimed innocent of the crime of which she had been accused.[29]

Stories with only slightly different variations are told about St. Marina (Marinus),[30] St. Athanasia,[31] St. Perpetua,[32] Saint Euphrosynne, Saint Apollinaris or Dorotheus, Saint Anastasia Patricia, Saint Theodora, and Saint Eugenia.[33] In two other lives, the transvestic experience is only incidental and temporary: Saints Natalia and Thecla.[34] St. Perpetua did not dress as a man but had a vision of herself being carried into an amphitheater stripped of all her clothing but with the sex organs of a man.[35]

Though the stories of the transvestite saints vary slightly, there is enough similarity in most of them that the German scholar Herman Usener more than a hundred years ago argued that they represented survivals of the legend of Aphrodite of Cyprus, where women sacrificed to the goddess in men's clothing and men in women's.[36] Not all scholars accept such identification,[37] and one of the difficulties with this argument is that there are no cross gendered male saints. The issue, however, is not whether the saints' stories were continuation of ancient legends but that they gave sanction to cross dressing for women and not for men. Moreover, the women who did cross dress seemed not only to gain higher status but were much admired for their ability to live among men as a man.

Such stories are not limited to the early church but continue up into the twelfth century with Saint Hildegund. Her story is somewhat different, although the theme is the same, and unlike some of the earlier saints who might or might not be based on pre-Christian sources, she is accepted as a real person. In the conflicting accounts of her life, she is usually portrayed as the daughter of a knight of Neuss on the Rhine who, after the death of his wife, decided to make a pilgrimage to the Holy Land. Unable to find anyone whom he could trust to leave with his twelve-year-old daughter, Hildegund, he solved the problem by dressing her as a boy, calling her Joseph, and taking her with him. The two traveled together to Jerusalem, where the knight died. Before his death he managed to commend his "son" to the protection of a fellow knight. The protector first robbed the "boy," then deserted him at Tyre. Somehow, however, the young Joseph managed to find

"his" way back to Europe. Joseph then became a servant to an old canon of Cologne, and as such accompanied him on a visit to the pope in Rome. Again she/he went through a series of extraordinary adventures that seemingly ended with her being condemned to death as a robber. She proved her innocence by undergoing the ordeal of the red hot iron without disclosing her sex, but she then fell into the clutches of real robbers who actually hanged her. Their technique was so slipshod that Hildegund-Joseph was cut down before she expired. After finally meeting with the pope, she returned to Germany where she entered a monastery at Schonau, remaining there until her death. Only then was it discovered that the famous monk Joseph was actually a woman.[38]

The fact that some of the medieval legends seem to have no basis in fact might lead one to question the others, even of St. Hildegunde, although it matters little whether they were true since they were believed, and they convey the same message about female crossing of the gender barrier. The one that has been investigated the most thoroughly is the case of the legendary Pope Joan, who supposedly ruled under the name of John Anglicus.[39] Several thirteenth-century chroniclers wrote about her in great detail, and during much of the later medieval period her existence was accepted as fact. A statue of her was included among the popes in the Cathedral of Sienna in the fourteenth century, and in the fifteenth century John Hus, the Bohemian heretic, reproached the delegates at the Council of Constance (1415) because their predecessors had allowed a woman to be pope. It was not until the sixteenth century that her existence was seriously disputed, and she soon after became relegated to legend rather than to history. Again, though Hus's comment was negative, the one critical failing about her character was not that she disguised herself as a man, but that she allowed herself to be deceived by another man and become pregnant. In short, she failed to live up to the traditional standards of the transvestite saints of denying her biological femininity, and it was her weakness as a woman that gave her away.

In real life also, some women did run into difficulty in cross dressing, as exemplified by the case of Joan of Arc. Her problem might well have been that people knew she was a woman dressed as a man. She even acted as a man, meeting men on their own terms. One of the original complaints against Joan alleged that she had a male costume made for her, with weapons to match.

> When these garments and these arms were made, fitted and completed, the said Jeanne put off and entirely abandoned woman's clothes; with her hair cropped short and round like a young fop's, she

wore shirt, breeches, doublet, with hose joined together and fastened to the said doublet by 20 points, long leggins laced on the outside, a short mantle reaching to the knees, or thereabouts, a close cut cap, tight fitting boots and buskins, long spurs, sword, dagger, breastplate, lance and other arms in the style of a man-at-arms, with which she performed actions of war and affirmed that she was fulfilling the commands of God as they had been revealed to her.[40]

Later, when the various charges against her were summarized in twelve articles, two of them dealt with her cross gender behavior, as did two of the six admonitions directed against her. It was her resumption of male dress that led to her execution.[41] The singling out of her cross gender behavior, however, was a minor factor in the decision to execute her, which was a political decision, part of the struggle between the English and the French. It does emphasize, however, that when female cross dressers who were known to be female went "too far," whatever that might mean, they also might suffer.

Though so far I have not uncovered any other woman who spent much of her life cross dressed during the late medieval period, there is a sixteenth-century one. This is the Spanish Eleno/Elena de Desopedes (1545–1588). Hers is a long and complicated story of a woman who not only lived as a man but twice passed physical examinations as a man before finally being found to be a female. Eventually, she was convicted of marrying a woman and being in league with the devil. After her trial she disappears from the pages of history.[42] Undoubtedly other examples will turn up as researchers mine the field.

Fiction, however, is a different matter, and one of the more recently discovered accounts is *Le Roman de Silence*, written by Heldris de Cornuälle in the thirteenth century. The romance tells the story of Silence, a girl raised as a boy, in order to guarantee that she could inherit the title and property of her father. One of the most poignant aspects of the story is the struggle Silence has between her natural self and her cross dressing persona. Even though she decides to remain a man, she worries about what might happen when and if her true sex were revealed and she would be entirely unskilled in womanly pursuits. "He" decided to learn at least one feminine art, that of the jongleur, and to do so she joined two traveling jongleurs who promised to teach "him" the art. After a series of adventures, "he" works his way back to his family and undergoes a series of other adventures, even having the queen fall in love with "him," without revealing his true sex. Eventually Silence is dispatched on a mission to find Merlin the magician, and

Merlin, when he is brought back to the court, indicates that the only reason he was captured was because Silence was a woman. Ultimately Silence takes on the woman's role, marries the king, but as she does so she vows never again to speak.[43] Interestingly, when she was exposed to the king as a female, nature herself intervened to make the tanned and hardened Silentius a soft feminine Silentia. Still justice was done, since the king restored the rights of all women to inherit.

The cross dressing female appears increasingly in the secular literature of the later middle ages and early modern period. Generally there is acceptance and understanding of women who try to escape the limitations of their assigned gender role. Ariosto in *Orlando Furioso* has a young princess fall in love with the young Amazon Bradamante, whom she has mistaken for a man. Though Bradamante reveals her true sex to the princess, the princess insists she accompany her, all the while bemoaning her fate that she has been cursed with a love for a woman. Fortunately Bradamante has a twin brother who, after being told by Bradamante of her adventures, goes off to impersonate Bradamante and when the princess finds out that "Bradamante" can perform as a male, the false Bradamante says it is all due to magic.[44] Edmund Spenser in the *Faerie Queen* has Britomart disguise herself as a man while searching for Artegall, with whom she has fallen in love. Artegall is captured by another Amazon, who is disguised as a man and who is slain by Britomart. There are many other examples in literature, too numerous to include in this brief overview.[45] Certainly the crossing of gender boundaries is a prominent theme in Spanish literature of the fifteenth and sixteenth centuries,[46] and it is beginning to be explored in other literary traditions. In real life as well, large numbers of women in the sixteenth and seventeenth centuries sought to escape the limitation of their gender role by adopting masculine attire.[47]

It seems clear that women in some numbers attempted to redress the inequalities of their gender role by cross dressing or otherwise taking on the guise and role of a man. It gave them a new status in society and allowed them to do things not normally allowed to women. Those who were successful in disguising their sex for long periods of time before being discovered came to be admired and respected, by men as well as by women. How many managed to escape detection all of their life is not known and should prove a fruitful field for investigation.

When we come to males cross dressing as females, however, we see a far more hostile society and more limited opportunity, emphasizing how much more significant and important the male was regarded in society. Women could gain freedom and status by adopting a male role, but what

reason could a man have to adopt a female one? For the most part male cross dressing was seen as contrary to the best interests of society, since it was widely believed that the main reason a man might do so was to have access to women. This is even emphasized in the account of Orlando's willingness to impersonate his sister, mentioned above. In the romance of *Silence* the queen has a devoted nun companion who is ultimately exposed as her secret male lover. Just how seriously society feared such impersonation can be illustrated by the story of the male nun as told by Gregory of Tours in the sixth century. He recounts how the abbess at the convent of Radegunde was charged with keeping a man clothed as a woman and pretending he was a woman. Everyone knew, her accusers said, that he "was most plainly of the male sex; and that this person regularly served the abbess." In the investigation that followed it was found that there indeed was a male, but he reported he had donned female garb because as a little boy he "had a disease of the groin" that was regarded as incurable. His mother had then gone to the holy Radegunde (the founder of the convent), who had summoned a local surgeon Reovalis to deal with the case. Reovalis, who was still alive, reported to the investigating committee that he "had cut out the testicles" of the boy and his mother had then raised him as a girl and it was as such that he had later entered the convent. The abbess was then cleared of any misconduct.[48]

The account emphasizes the strong suspicion of sexual overtones in any male cross dressing. If a sexual reason was not readily apparent, the next step was to assume that it must have something to do with witchcraft, perhaps as a carryover of the association of paganism with cross dressing. An early indication of such a fear appears in the penitential of Silos, compiled in the ninth century in the monastery of that same name in Spain. It stipulated that "those who in the dance wear women's clothes" should do penance for one year.[49] Similarly a Frankish penitential of the same period, that of St. Hubert, includes a similar conduct but stipulates a three year penance.[50] The association with witchcraft appears more clearly in the report of an inquisitor in southern France in about 1250. According to his report, a number of men disguised as women entered the house of a rich farmer, dancing and singing: "We take one and give back a hundred." The verse referred to a popular belief in the power of the good people (*bonae*) to confer prosperity upon any house in which they had been given presents. The suspicious wife of the farmer did not accept the claim of the female impersonators to be *bonae* and tried to end the revel, but in spite of her protestations they carried out all the goods from her house. In the ensuing investigation, bishops were requested to look out for throngs of demons transformed into women.[51]

These scattered references seem to imply greater suspicion of the male cross dresser than of the female. Male cross dressing was, however, permitted or at least tolerated under certain conditions: when there was only an illusion of the female (and the person was clearly known to be male) or when the male in drag was performing a function that society wanted or desired but would not, because of other prohibitions, allow women to do. In effect the status loss associated with male cross dressing was only allowed when other more dearly held values of society otherwise would have been threatened.

Illustrating the first condition is the report in the thirteenth century of Cypriot knights fighting in tournaments while dressed as women. Though this was treated as peculiar it was not regarded as criminal.[52] Probably this kind of cross dressing was tolerated for its comedy value and was probably much more widespread than our written sources indicate. Some indication of this is the case of Ulrich von Lichtenstein, a thirteenth-century knight from Styria (now part of Austria). He is best remembered today for his narrative poem *Frauendienst* or *Autobiography in Service of Ladies*.[53] Though originally regarded as a highly reliable autobiography, modern scholars are not so sure. Some look upon it as a fictional comedy work, a kind of predecessor to Cervantes's *Don Quixote*. While this interpretation is debatable, those scholars who have attempted to authenticate some of the events depicted in it have had difficulty in documenting them. One of the most remarkable of Ulrich's adventures took place in 1227 when he, in order to honor his lady and all women, disguised himself as the goddess Venus and as such engaged in a number of jousts on a trip he took between Venice and Styria, Austria. Though he wore women's clothes all the way, and on first impression might have appeared as a woman, underneath his veil he kept his beard. One countess who went up to kiss him remarked when he removed his veil:

> Why you're a man!
> I caught a glimpse of you just now.
> What then? I'll kiss you anyhow.
> From all good women everywhere
> I'll give a kiss. Because you wear
> a woman's dress and honor thus
> us all, I'll kiss for all of us.[54]

Most of the spectators on his tour got into the act, and it seemed to be great fun. There is no question that Ulrich enjoyed his adventure, and as

far as it reflects actual incidents, it would emphasize that impersonation at the comedy level was allowed as long as it was evident—as it was in his jousts, which he won—that he was a real man.

The one area where men were allowed to dress as women, or at least young men were, was on the stage. Since medieval drama began in the church, most of the actors were drawn from the ranks of the clergy. This tradition of men acting as women on stage continued well after the medieval period. Occasionally in the Middle Ages we even get glimpses of some of the actors. This is the case with a young barber's apprentice at Metz, who is said to have performed the role of Saint Barbara:

> so thoughtfully and reverently that several persons wept for pity: for he showed such fluency of elocution and such polite manners, and his countenance and gestures were so expressive when among his maidens, that there was not a nobleman or priest or layman who did not wish to receive this youth into his house to feed and educate him; among whom there was a rich widow . . . who wanted to adopt him as her heir.[55]

The youth's reputation as a female impersonator, however, was short-lived, because the next year when he acted the part of another woman saint his voice changed and the audience was not impressed. He soon abandoned his acting career and went off to Paris to study for the priesthood. Females were not entirely excluded from the mystery or morality plays, and there are occasional references to them, but in general it was not considered proper for a woman to exhibit herself. Moreover, since women played such a minor role in the medieval church, and none at all in the services and offices of the church, they were usually not even considered for such plays.

As the plays became more secularized, and sponsored by various guilds, men continued to play the parts of women. Usually the role of women in the plays was not an active one and so boys could easily stand in for women. The three Marys, for example, are usually passive, silent, or practically silent, and a choirboy could carry off the part appropriately. One or two woman characters, however, had much enlarged roles and demanded much more skill in impersonation. This was particularly true of the fourteenth-century mystery plays, which appeared in England at the major religious centers. One of the major female roles was Noah's wife, who in various plays is always represented as a nagging shrew and gossip. She disapproved of what her husband intended to do and in the plays always refuses to board the ark at the crucial moment, usually for a trivial reason. The re-

sult often was broad farce, a burlesque in a sense of the female role, which remains part of English comedy even today.[56]

One observer has claimed that these plays represent

> the rudimentary beginnings of the pantomime dame tradition, and that continual theme of the tough normal man who enjoys dressing up as a grotesque woman—a phenomenon [still] found in improvised work shows, among rugger teams, and regiments. Anywhere, in fact, where men are together.[57]

Giving further emphasis to this permitted comic cross dressing are some of the unique aspects of the Chester plays themselves. This was because Chester, a city on the Welsh border, was subject to occasional raids by the Welsh, who often entered the walled town dressed as women, mingling with the crowds coming through the gates on market days. Having penetrated to the center, they would tear off their skirts and attack. How a burly and presumably bearded Welsh mountain brigand was able to pass himself off as a farmer's wife is not clear, but a standard feature of the Chester plays was a grotesque female played by a man, dressed up as a Welshwoman complete with steeple hat.

Even when the theater developed into a separate and more permanent structure, it was regarded as a rough place, open to the sky, noisy with smelly, jostling crowds, and a natural breeding ground for all kinds of diseases. In short, the kind of place where no respectable woman would appear. In fact when women did begin to appear on the English stage at the end of the sixteenth century they were equated with prostitutes, and many were.

Female impersonation as well as male impersonation was also permitted under certain carefully controlled conditions during festivals or carnivals in which the usual standards of behavior could be laid aside. Although few of these medieval carnivals have been studied in detail, we know that in some of them women were allowed to act the male role, and men to impersonate women. A remnant of these in England is the so-called Morris dance, supposedly introduced by John of Gaunt from Spain. In medieval times it was usually danced by five men and a boy dressed in a girl's habit, who was called Maid Marian. Animal figures were also common. The dance was not limited to England but appears throughout medieval Europe from Iceland to Spain, from Ireland eastward to Romania. It obviously was a carryover from pre-Christian religions and was denounced as early as 400 A.D. in a homily attributed to Severian:

The new year is consecrated with old blasphemies. Whatever deformities are lacking in nature, which creation does not know, art labours to fashion. Besides people are dressed as cattle, and men turned into women. They laugh at honor, they offend justice, they laugh at public disapproval, they mock at the example of our age, and say they are doing this as a joke.[58]

Remnants of such rituals continued into the twentieth century.[59]

In the Nuremberg festivals of the late medieval period, a number of male dancers wore feminine masks and probably dressed as women. In fact it seems to have been such a common phenomenon that one authority has said that disguising as the opposite sex was a custom that was common to all carnivals. A standard feature of the Nuremberg carnivals, as it was of the Chester plays, was the Wild Woman, a man impersonating a woman, and several fifteenth-century illustrations of such an impersonation have survived.[60] Probably as we recover more data about medieval festivals, both female and male impersonation will turn out to be a standard comedy part. In fact it was the carnivals and festivals that allowed medieval people to temporarily escape from the status and religious inhibitions of society, since there were boy bishops, peasant kings, and many a cross dresser as well. These escape channels have been continued into today's world through the Mardi Gras festivals in New Orleans and elsewhere, the Mummer's Parade in Philadelphia, and various Halloween costumes.

Cross dressing then can give us a major insight into the gender attitudes of the medieval peoples. Quite clearly the male role was desired and admired. Women were simply lower status. Medieval society was understanding of women wanting to be men, living as men, but had less tolerance for the male cross dresser. In fact, except for burlesquing women, they apparently found it difficult to understand why a man would dress as a woman unless there was some ulterior purpose in mind. If this interpretation of medieval society is correct, then the growing existence of male transvestism today indicates that the nature and role of women in our society have changed. Apparently significant numbers of men want to cross dress, to act as women in ways other than burlesquing them, and even to be women. Though the feminists among us might well argue that we have a long way to go to reach equality of genders, it seems fairly clear that men of today find the feminine gender role much more attractive than did their medieval predecessors, and this probably indicates that there has been a radical change in the role of women and in male attitudes toward the female.

1. Karl Westphal, "Die Konträre Sexualempfindung," *Archiv für Psychiatrie und Nervenkrankenheiten*, 2 (1869), 73–108.

2. See Vern L. Bullough, "The Physician and Sex Research in the Nineteenth Century," *Bulletin of the History of Medicine*, 63 (1989), 247–67. See also Vern L. Bullough, *Science in the Bedroom* (New York: Basic Books, 1994).

3. Richard von Krafft-Ebing, *Psychopathia Sexualis*, which, though it went through many editions, continued the confusion. The seventh edition was translated into English by Charles Gilbert Chaddock (New York: F.A. Davis, 1894), while the final edition, the twelfth, was translated by F.J. Rebman (New York: Paperback Library, 1965).

4. Magnus Hirschfeld, *Die Transvestiten: eine Untersuchung über den erotischen Verkleidungstrieb mit unfangreichem casuistischen und historiche Material* (Leipzig: Max Spohr, 1910). An English edition, *The Transvestites: An Investigation of the Erotic Drive to Cross-Dress with Comprehensive Questions of Right and Wrong in Conduct and Historical Material*, trans. Michael A. Lombardi-Nash (Buffalo: Prometheus Books, 1991).

5. Havelock Ellis, *Eonism and Other Supplementary Studies*, vol. 6 in *Studies in the Psychology of Sex* (rev. Philadelphia: F.A. Davis, 1926).

6. John Money and A.A. Ehrhardt, *Man and Woman, Boy and Girl* (Baltimore: Johns Hopkins University Press, 1972); John Money and P. Tucker, *Sexual Signatures* (Boston: Little, Brown and Company, 1975); John Money, *Love and Love Sickness: The Science of Gender, and Pair Bonding* (Baltimore: Johns Hopkins University Press, 1980); see also Robert Stoller, *Presentations of Gender* (New Haven: Yale University Press, 1992).

7. American Psychiatric Association, *Diagnostic and Statistical Manual of Mental Disorders* (3d ed., revised, Washington, DC: American Psychiatric Association, 1987).

8. I argued this in an earlier paper, Vern L. Bullough, "Transvestites in the Middle Ages: A Sociological Analysis," *American Journal of Sociology*, 79 (1974), 1381–94. For other views see John Anson, "The Female Transvestite in Early Monasticism," *Viator*, 5 (1974), 1–32. A more recent study was by Valerie R. Hotchkiss, "Clothes Make the Man: Female Transvestism in the Middle Ages" (Ph. D. diss., Yale University, 1990).

9. An excellent study of the medical attitudes is Joan Cadden, *Meanings of Sex Difference in the Middle Ages: Medicine, Science, and Culture* (Cambridge: Cambridge University Press, 1993). Interested readers are encouraged to look at her explanation which, though similar to the ones in this paper, develops the theme more fully, particularly for the medical concepts.

10. Aristotle, *Historia animalium* 608B., trans. D'Arcy H. Thompson, in *The Works of Aristotle* (Oxford: Clarendon Press, 1910), vol. 4. See also *Politics* 1.2 (1242 B) ed. and trans. H. Rackham (London: Heinemann, 1944); *Generation of Animals*. 729A, 25–34, trans. A.L. Peck (London: Heinemann, 1953).

11. Aristotle, *Generation of Animals*, 720A, 17ff.

12. Ibid., 766A, 19–35.

13. Thomas Aquinas, *Summa Theologica*, translated by the Fathers of the English Dominican Province (New York: Benzinger Brothers, 1947), pt. 1, Q. 92, "The Production of Women," Article 2.

14. Ibid., pt. 3, Q. 32.

15. Soranus, *Gynecology*, edited and translated by Owsei Temkin (Baltimore: Johns Hopkins University Press, 1956), bk. 3, l.2.5.

16. Averroes, *Commentary on Plato's Republic*, translated E.I.J. Rosenthal (Cambridge: Cambridge University Press, 1956), 164–65.

17. Isidore, *Etymologiarum sive originum libri xx*, ed. W.M. Lindsay (Oxford: Clarendon Press, 1911), Bk. XI, ch. ii, 19. He also reports that according to some,

the word *femina* (women) comes from the Greek word for "fiery" because among humans and animals the female is more lustful than the male, ibid., XI, i, 97, 98. Book XI has been translated into English by William D. Sharpe, *Isidore of Seville: The Medical Writings, Transactions of the American Philosophical Society*, n.s. vol. 54, Part 2, 1964.

18. Isidore, *Etymologiarum*, XI, 2, 24. For an analysis of Isidore's concepts of sex and gender see Danielle Jacquart and Claude Thomasset, *Sexuality and Medicine in the Middle Ages*, translated by Matthew Adamson (Princeton, NJ: Princeton Universtiy Press, 1988), 8–16.

19. Galen, *On the Usefulness of the Parts of the Body (De usus partium)*, 14.6., translated by Margaret Tallmade May (2 vols., Ithaca, NY: Cornell University Press, 1968), II, 628–90.

20. Pliny, *Natural History*, translated by H. Rackham (London: Heinemann, 1968), 7.4, 17.37 and 31.23. See also Diodorus Siculus, *Histories*, ed. and trans. C.H. Oldfather (London: Heinemann, 1933), 32.12.

21. Philo, *Questions and Answers on Genesis*, trans. Ralph Marcus (London: Heinemann, 1961); *On the Creation*, trans. F.H. Colson and G.H. Whittaker (London: Heinemann, 1963); and especially Richard A. Baer, *Philo's Use of the Categories Male and Female* (Leiden: E.J. Brill, 1970).

22. Saint Jerome, *Commentarius in Epistolem ad Ephasios*, bk. 16, in *Patrologia Latina*, ed. J.P. Migne, vol. 26 (Paris: Garnier Fratres, 1894), col. 567.

23. Jerome, *Letters*, LIV and CVII, in *Select Letters*, ed. and trans. F.A. Wright (London: Heinemann, 1933).

24. Ambrose, *Expositionis in Evangelius secundum Lucum libri X*, bk. 15, col. 1938, in *Patrologiae Latina*, ed. J.P. Migne, vol. 15 (Paris: Garnier Fratres, 1887).

25. James A. Brundage, *Law, Sex, and Christian Society in Medieval Europe* (Chicago: University of Chicago Press, 1987), 108.

26. G.D. Mansi, ed., *Sacrorum conciliorum et monumentorum historicum, dogmaticorum, moralius amplissima collectio*, 60 vols. (Paris: Hubert Welter, 1901–17), 2:1101; see also Jo Ann McNamara, "Muffled Voices: The Lives of Consecrated Women in the Fourth Century," in *Medieval Religious Women*, vol. 1, *Distant Echoes*, edited by John A. Nichols and Lillian Thomas Shank, Cistercian Studies Series, No. 71 (Kalamazoo, MI: Cistercian Publications, 1984), 23–24.

27. Stith Thompson, *Motif Index of Folk Literature: A Classification of Narrative Elements in Folktales, Ballads, Myths, Fables, Mediaeval Romances, Exempla, Fabliaux, Jest-Books, and Local Legends*, revised and enlarged edition, 6 vols. (Bloomington: Indiana University Press, 1955–56). The most useful categories are D10, D11, D11.1, D12, D624.3, D658.3, D658.3.1, T32, Q551.51.1, K1321, and K521.4.1. Valerie Hotchkiss made good use of these volumes.

28. See A. Butler, *Butler's Lives of the Saints*, ed. and rev. Herbert Thurston and Donald Attwater (4 vols., New York: Kennedy, 1956), IV, 59–61. See also Helen Waddell, *The Desert Fathers* (reprinted Ann Arbor: University of Michigan Press, 1957), 171–88. Wherever possible I have utilized translations, and only when they are not available do I turn to the *Acta Sanctorum*.

29. *Butler's Lives of the Saints*, IV, 59–61.

30. Ibid., I, 313–14.

31. Ibid., IV, 69–70.

32. Marie Delcourt, *Hermaphrodite,* trans. Jennifer Nicholson (London: Studio, 1956), 90–99.

33. Ibid., I, 4–5, 33; II, 546–47; III, 623–25, and IV, 612.

34. Ibid. II, 538, and 623–25.

35. Ibid., 90–99.

36. H. Usener, *Legends der Heiligen Pelagia* (Bonn: A. Marcus, 1879).

37. H. Delehay, *The Legends of the Saints*, trans. V.M. Crawford (South Bend, IN: University of Notre Dame Press, 1961), 204–06.

38. Ibid., II, 135.

39. Johann Dollinger, *Papstfabeln des Mittelalters* (2d ed., Munich: Cotta, 1863); Alexander Cooke, *Pope Joan* (London: Blunt and Barin, 1910); Clement Wood, *The Woman Who was Pope* (New York: Faro, 1931).

40. Quoted from W.P. Barret, *Trial of Jeanne d'Arc* (London: Routledge, 1933), 152.

41. Ibid., p. 158.

42. The story of Eleno/Elena was ferreted out by Richard I. Kagan of Johns Hopkins University and was reported at a seminar in Atlantic History and Culture in April 1986. The full details of the trial giving the necessary background information are in the Archivo Historico Nacional, Madrid; Seccion de de Inquisicion, lejago 234, expeidente 24. It is approximately 150 folios in length. It was also reported by Henry C. Lea, *A History of the Inquisition in Spain* (4 vols., London: Macmillan, 1922), IV, 187–88.

43. The romance exists in only one manuscript, Mi.LM.6, deposited on loan in the Muniments Room of the University of Nottingham. *Le Roman de Silence* comprises folios 181 to 223. It was first brought to light in a series of articles by Lewis Thorpe in *Nottingham Medieval Studies*, V (1961), 33–74; VI (1962); VII (1963), 34–52; VIII (1964), 33–61; X (1966), 25–69; XI (1967), 19–56. These articles were then brought together in book form and amplified, Lewis Thorpe, *Le Roman de Silence: A Thirteenth Century Arthurian Verse-romance by Heldris de Cornuälle* (Cambridge, Eng. W. Heffer, 1972). Thorpe summarized the romance on 17–22. In addition to the edited account by Thorpe, there are other studies. See Kathleen J. Brahney, "When Silence was Golden: Female Personnae in the *Roman de Silence*" in *The Spirit of the Court: Selected Proceedings of the Fourth Congress of the International Courtly Literature Society* (1973), eds. Glyn S. Burgess and Robert A. Taylor (Exeter, Eng.: D.S. Brewer, 1985), 52–61. See also Heather Lloyd, "The Triumph of Pragmatism—Reward and Punishment in *Le Roman de Silence*," in *Rewards and Punishments in the Arthurian Romance and Lyric Poetry of Mediaeval France*, eds. Peter V. Davis and Angus J. Kennedy (Cambridge, Eng.: D.S. Brewer, 1987), 77–88, and R. Howard Bloch, "Silence and Holes: The *Roman de Silence* and the Art of the Trouvere," *Yale French Studies* 70 (1986), 81-99. There is a rapidly expanding literature on the *Roman*.

44. Ludovico Ariosto, *Orlando Furioso*. See also Linda L. Carroll, "Who's On Top? Gender as Social Power Configuration in Italian Renaissance Drama," *Sixteenth Century Journal* 20 (1989), 531–57.

45. Philip Sidney, *The Countess of Pembroke's Arcadia* (Cambridge: Cambridge University Press, 1912), 174–75. A more recent edition is by Victor Skretkowicz (Oxford: Clarendon Press, 1987).

46. See Melveena McKendrick, *Women and Society in Spanish Drama of the Golden Age* (Cambridge: Cambridge University Press, 1974).

47. For reality see Rudolf M. Dekker and Lotte C. van de Pol, *The Tradition of Female Transvestism in Early Modern Europe* (London: Macmillan, 1989).

48. Gregory of Tours, *History of the Franks*, translated by O.M. Dalton (2 vols., Oxford: Clarendon Press, 1927), 2:449.

49. John T. McNeil and Helen Gamer, eds. and trans., *Medieval Handbooks of Penance* (New York: Columbia University Press, 1938), 289, XI.

50. F.H. Wasserschleben, *Die Bussordnungen der abendläischen Kirche* (reprinted, Graz, Austria: Akademische Druck-U. Verlagsanstal [1851], 1958), 383, cap. 42. Interestingly, however, this penitential also prohibited women from cross dressing.

51. Jeffrey Burton Russell, *Witchcraft in the Middle Ages* (Ithaca, NY: Cornell University Press, 1972), 157, 292, 315.

52. James A. Brundage, *Law, Sex, and Christian Society in Medieval Europe* (Chicago: University of Chicago Press, 1987), 473.

53. The narrative first appeared in print in 1812; Ulrich von Lichtenstein, *Frauendienst, oder: Geschichte une Liebe des Ritters un Sängers*, translated by Ludwig

Tieck (Stuttgart, 1812). It was translated in condensed form into English verse by J.W. Thomas, *Ulrich von Lichtenstein's Service of Ladies* (Chapel Hill: University of North Carolina Press, No. 63 of the University of North Carolina *Studies in Germanic Languages and Literature,* 1969).

54. Ibid., Quatrain 538, 110.

55. Karl Mantzius, *A History of Theatrical Art,* vol. 2, *The Middle Ages,* trans. Louise van Cossel (New York: Peter Smith, 1937), 89.

56. See some of the Chester plays, of which there are many editions including several published at different times by the Early English Text Society. See *The Chester Plays,* edited by Hermann Deimling and G.W. Matthew (London: Kegan Paul, Trench, Trubner, 1893, 1916), vols. 62, 115; *The Chester Plays,* eds. R.M. Lumiansky and David Mills (London: Oxford University Press, 1974–1976), vols. 3 and 9.

57. Robert Baker, *Drag: A History of Female Impersonation on Stage* (London: Triton Books, 1968), 56.

58. Quoted by E.K. Chambers, *The Mediaeval Stage* (Oxford: Clarendon Press, 1903), II, 294.

59. See E.W. Cawte, *Ritual Animal Disguise: A Historical and Geographical Study of Animal Disguise in the British Isles* (Cambridge, England: D.S. Brewer, 1978). Though Cawte deals primarily with ritual animal disguise, the book also mentions the she-male, which is an important part of the ceremonies. See also Cecil J. Sharp and George Butterworth, *The Morris Book,* vol. V (London: Novello, 1913). Sharp had published earlier parts of *The Morris Book* with Herbert C. Macilwaine (London: Novello, 1907, 1910, 1912, 1924). An even earlier account was by Francis Douce, *Illustrations of Shakespeare* (London: Longmans, 1807).

60. Samuel L. Sumberg, *The Nuremberg Schembart Carnival* (New York: AMS, 1966).

BIBLIOGRAPHY

Anson, John. "The Female Transvestite in Early Monasticism: The Origin and Development of a Motif." *Viator* 5 (1974): 1–32.

Baldwin, John W. *The Language of Sex: Five Voices from Northern France Around 1200.* Chicago: University of Chicago Press, 1994.

Biddick, Kathleen. "Genders, Bodies, Borders: Technologies of the Visible." *Speculum* 68 (April 1993): 349–418.

Brown, Peter. *The Body and Society: Men, Women, and Sexual Renunciation in Early Christianity.* New York: Columbia University Press, 1988.

Brundage, James A. *Law, Sex, and Christian Society in Medieval Europe.* Chicago: University of Chicago Press, 1987.

———. *Sex, Law, and Marriage in the Middle Ages.* Variorum Collected Studies, 397. Aldershot, Eng.: Variorum, 1993.

Bullough, Vern L. *Sexual Variance in Society and History.* Chicago: University of Chicago Press, 1978.

———. "Transvestism in the Middle Ages: A Sociological Analysis," *American Journal of Sociology* 79 (1974): 1381–94.

Bullough, Vern L. and Brundage, James A., eds. *Sexual Practices and the Medieval Church.* Buffalo, NY: Prometheus Books, 1982.

Bullough, Vern L. and Bullough, Bonnie. *Cross Dressing, Sex, and Gender.* Philadelphia: University of Pennsylvania Press, 1993.

Bullough, Vern L., Brenda Shelton, and Sarah Slavin. *The Subordinated Sex.* Athens: University of Georgia Press, 1988.

Butler's Lives of the Saints, edited and revised by Herbert Thurston and Donald Attwater. 4 vols., New York: Kennedy, 1956.

Cadden, Joan. *Meanings of Sex Difference in the Middle Ages: Medicine, Science, and Culture.* Cambridge: Cambridge University Press, 1993.

Cawte, E.W. *Ritual Animal Disguise: A Historical and Geographical Study of Animal Disguise in the British Isles.* Cambridge, Eng.: D.S. Brewer, 1978.

Chambers, E.K. *The Medieval Stage.* Oxford: Clarendon Press, 1903.

Chester Plays, The. Ed. R.M. Lumiansky and David Mills. London: Oxford University Press, 1974–1976.

Delcourt, Marie. *Hermaphrodite.* Translated by Jennifer Nicholson. London: Studio, 1956.

Edwards, Robert R. and Stephen Spector, eds. *The Olde Daunce: Love, Friendship, Sex, and Marriage in the Medieval World.* New York: SUNY Press, 1991.

Gregory of Tours. *The History of the Franks,* ed. and trans. O.M. Dalton. 2 vols., Oxford: Clarendon Press, 1927.

Hotchkiss, Valerie. "Clothes Make the Man: Female Transvestism in the Middle Ages." Ph.D. diss., Yale University, 1990.

Jacquart, Danielle and Claude Thomasset. *Sexuality and Medicine in the Middle Ages.* Trans. Matthew Adamson. Princeton, NJ: Princeton University Press, 1988.

Laqueur, Thomas. *Making Sex: Body and Gender from the Greeks to Freud.* Cambridge, MA: Harvard University Press, 1990.

Lees, Clare A., ed. *Medieval Masculinities: Regarding Men in the Middle Ages.* Minneapolis: University of Minnesota Press, 1994.

Lemay, Helen Rodnite. *Women's Secrets: A Translation of Pseudo-Albertus Magnus's "De Secretis Mulierum" with "Commentaries."* Albany, NY: SUNY Press, 1992.

LeRoy Ladurie, Emmanuel. "The Aiguillette: Castration by Magic." in *The Mind and Method of the Historian,* trans. Siân Reynolds and Ben Reynolds. Chicago: University of Chicago Press, 1981, 84–96.

McNeil, John T. and Helen Gamer, eds. and trans., *Medieval Handbooks of Penance.* New York: Columbia University Press, 1938.

Nelson, James. *The Intimate Connection: Male Sexuality, Masculine Spirituality.* Philadelphia: Westminster Press, 1988.

Partner, Nancy F. "No Sex, No Gender." *Speculum* 68 (April 1993): 419–45.

Partner, Nancy F., ed. *Studying Medieval Women: Sex, Gender, Feminism.* Cambridge, MA: Medieval Academy of America, 1993. This originated as a special issue of *Speculum* 68 (1993).

Payer, Pierre J. *Sex and the Penitentials: The Development of a Sexual Code.* Toronto: University of Toronto Press, 1984.

Russell, Jeffrey Burton. *Witchcraft in the Middle Ages.* Ithaca, NY: Cornell University Press, 1972.

Salisbury, Joyce, ed. *Sex in the Middle Ages: A Book of Essays.* New York: Garland Publishing, 1991.

Sharp, Cecil J. and George Butterworth. *The Morris Book.* London: Novello, 1913.

Sumberg, Samuel L. *The Nuremberg Schembart Carnival.* New York: AMS, 1966.

Thompson, Stith. *Motif Index of Folk Literature: A Classification of Narrative Elements in Folktales, Ballads, Myths, Fables, Mediaeval Romans, Exempla, Fabliaux, Jest Books, and Local Legends.* 6 vols., revised and enlarged, Bloomington: University of Indiana Press, 1955–56.

Thorpe, Lewis. *Le Roman de Silence: A Thirteenth Century Arthurian Verse-Romance by Heldris de Cornuälle* (Cambridge, Eng.: W. Heffer, 1972).

Trexler, Richard C., ed. *Gender Rhetoric: Postures of Dominance and Submission in History.* Binghamton, NY: Medieval and Renaissance Studies and Texts, 113, 1994.

Ulrich von Lichtenstein. *Frauendienst, oder: Geschichte une Liebe des Ritters un Sängers,* trans. J.W. Thomas as *Ulrich von Lichtenstein's Service of Ladies.* Chapel Hill: University of North Carolina Press, *Studies in Germanic Languages and Literature,* No. 63, 1969.

Wasserschleben, F.W. *Die Bussordnungen der abendläischen Kirche* (reprinted: Graz, Austria: Akademische Druck-U. Verlagsanstal [1851], 1958).

10 PROSTITUTION IN MEDIEVAL EUROPE

Ruth Mazo Karras

What we study when we investigate prostitution in medieval Europe depends on whether we look at prostitution as we now use the term, or at what medieval people meant by it. If we adopt a modern understanding of prostitution—the exchange of sex for money—we are likely to treat it as a problem in economic or legal history. We will see it in the context of the regulation of commerce, or in the context of occupations available to women. If we adopt a medieval understanding, which acknowledged the financial element involved but considered promiscuity rather than monetary exchange the key, we are much more likely to treat it as a problem in social or cultural history. We will see it in the context of marriage patterns and sexual behavior, and of attitudes toward and representations of the female body and feminine sexuality.

Very few medieval writers who discussed prostitution were concerned with defining it. Towns attempting to clear their streets of prostitutes did not find it necessary to specify exactly who fell into that category. Occasionally a source explains the precise meaning of a term, like the fourteenth-century English tract *Fasciculus Morum*, which states that "the term 'prostitute' [*meretrix*] must be applied only to those women who give themselves to anyone and will refuse none, and that for monetary gain."[1] Such specificity, however, is rare. Church courts occasionally took the fact of financial exchange as evidence that a woman was a prostitute,[2] but canon lawyers, who theorized about sexual behavior more systematically than most medieval thinkers, did not consider financial exchange the determining factor.

The leading authority on the canon law of sex, James A. Brundage, explicates in detail the views of various canonists on prostitution.[3] While they included the element of financial gain in their understanding of prostitution, the essential feature of a prostitute was her promiscuity (some canonists also stressed her notoriety and deception). Thus when a canonist used the term

meretrix, he did not necessarily mean someone who engaged in sex for money, although he certainly recognized the existence of such women and probably had them in mind when he was writing.

Although Brundage's work is the indispensable reference tool on the canon law of sex, with regard to prostitution the reader must keep in mind that he uses the terms "prostitute," "whore," and "harlot" interchangeably without noting what Latin terms they translate. This word choice is deliberate: as he writes, "'Prostitute' is a relatively neutral, almost clinical term, while the other terms carry a certain amount of judgmental freight. Since the sources I have used employ terms which are more judgmental than neutral, it seemed appropriate to try to convey some sense of that fact by using English terms of a similar sort."[4] While his terminology succeeds in conveying the flavor of disapprobation, it obscures the fact that the canonists used one term, "meretrix," to mean both "commercial prostitute" and "loose woman." We may choose to use two different terms to express these concepts, but it is important to understand that medieval people generally did not.

There was no single medieval attitude toward prostitution either as a cultural or as a commercial phenomenon. We know the most about it from the fourteenth century on, and most of the following discussion deals with that period. Prostitution assumed a variety of manifestations in medieval towns (in the Middle Ages, as today, it was primarily an urban occupation, although there were also some rural prostitutes and those connected with the army). Towns took one of three general approaches to prostitution: they outlawed it (with more or less success); tolerated and regulated it (either de jure or de facto, by means of fines that were not intended to suppress but rather to tax the trade); or institutionalized it. There was little consistency among towns, and even in successive enactments within the same town. Bronislaw Geremek describes the "fundamental ambiguity" in legislation about prostitution: "On the one hand, a determined struggle against prostitution and, on the other, a tolerance which strives to define a space for it and also to achieve the maximum possible distancing from it."[5]

The strategy of institutionalization merits discussion in some detail because it may seem at first glance somewhat surprising. Many towns in England, France, Germany, and Italy had municipal brothels, founded mainly in the late fourteenth and early fifteenth centuries (the claim of the stews of Southwark in England to have been established in 1162 is false).[6] There has been no recent synthetic treatment of these, but good treatments may be found in books and articles on individual towns and regions.[7] The town or seigneurial authority either hired brothelkeepers or farmed out the brothel to them. In some areas these brothelkeepers were men, in others women.

Where a brothel was merely municipally licensed rather than owned, leading citizens in the town often had a financial interest in it. Although Peter Schuster claims that none of the German towns opened brothels for reasons of profit,[8] the bishops of Winchester, who as lords of the liberty controlled the brothels of the London suburb of Southwark, certainly did. It may be that where powerful men included illicit brothels among their real estate interests, they helped determine that those towns would not open official brothels.

These officially established or licensed brothels had sets of regulations which covered such issues as restrictions on the prostitutes' movement; times and days when the brothels must close; relations between the prostitute and the brothelkeeper, financial and otherwise; relations between the brothelkeeper, who in some cases owned the brothel and in others managed it for the town, and the local authorities; who was allowed to be a prostitute and who a customer; rates of pay; conditions under which women were allowed to leave; and other controls on the women's lives, such as restrictions on their having lovers. Many of the laws attempted to protect the prostitutes from the brothelkeepers in various ways, such as prohibiting beatings or setting fixed prices for victuals. In practice, however, the brothelkeepers exerted a great deal of control over the women and, of course, profited from the enterprise.

The justification for the establishment of the municipal brothels was the "lesser evil" argument. St. Thomas Aquinas had used the metaphor of a sewer in a palace: it might not smell very good but without it the whole palace would reek of excrement.[9] The greater evils that prostitution sought to prevent were several. There was the offense to public decency: if prostitutes walked the streets the scandal would be open, whereas when confined to a house they would be less obtrusive. There was fear of contamination: if prostitutes were allowed to walk about they might associate with respectable women and somehow harm their respectability. There was homosexuality: the city fathers of Florence hoped that by staffing a brothel with attractive women they might convince the young men to discontinue their practice of sodomy (which concerned the authorities not because it was sinful but because they believed it was a major cause of the low birth rate). Finally, there was the corruption of honest women. This potential evil was predicated upon what might be called a hydraulic model of masculine sexuality. The male sex drive, like a dammed-up river, would build up until it burst its bounds, leading the men to seduce or rape the respectable wives and daughters of the city. If prostitutes were available, however, they would serve as a safety valve. The argument rested on a basis of

demographic fact: the large numbers of unmarried men (apprentices and journeymen, foreign traders, clergy) in medieval towns. Despite medieval medical theories that held that the feminine sex drive was as strong as or stronger than the masculine, it was only men for whom brothels were thought necessary; not until the early modern era did those who questioned the "lesser evil" argument carry that argument to its logical conclusion: that women, as the weaker sex, would need to have houses of male prostitutes as a remedy for lust.[10]

Medieval expressions of the "lesser evil" argument were unconcerned with protecting the prostitutes themselves. In the modern period, some jurisdictions that have legalized and regulated prostitution and licensed brothels have argued that this is safer for the prostitutes, because they can be protected from unhealthy working conditions, violent customers, and exploitative pimps. The medieval authorities made no such arguments. The prostitutes themselves were merely necessary sacrifices that had to be made for the greater good, although after they had served their purpose they might repent and save their souls.

Although scholars who have worked on the institutionalized brothels have all recognized that the "lesser evil" argument was the main justification given in the Middle Ages, their analyses of these institutions have varied widely. A look at recent works by Leah Lydia Otis and Jacques Rossiaud, both dealing with prostitution in medieval France and both works of impeccable scholarship, indicates some of the contrasting approaches.[11] Otis's book, dealing with prostitution in the towns of Languedoc as it evolved through phases of toleration, institutionalization, and recriminalization, focuses largely on the efforts of the town authorities. It is a detailed and enlightening study of municipal regulation of private enterprise and of the operation of the brothels themselves, and only incidentally a book about sexuality, although Otis of course does not ignore the nature of the enterprise that was being regulated. Rossiaud's work, on the other hand, is much more about sexuality—to be precise, masculine sexuality. He develops in great detail the "lesser evil" argument. Dijon was afflicted by an epidemic of gang rape, and prostitution was a preventive measure; ironically, some of the prostitutes were women whose marital prospects had been ruined because they had been raped. Rossiaud further relates the notion of the uncontrollable male sex drive to contemporary attitudes about nature and the natural as expressed both in the teachings of the church and in literature. These two works complement rather than conflict with each other, but their differences indicate the wide range of possible approaches to the subject of institutionalized brothels.

Most towns shut down their institutionalized brothels in the mid-sixteenth century. The chronological framework might lead us to believe that either the Reformation or the rise of syphilis was responsible. The latter reason is rejected by most scholars today. Protestant reformers certainly succeeded in closing down brothels in many German towns, but the public brothels of France and Italy were closed down at about the same period. Scholars tend to agree that shifts in morality are primarily responsible, shifts that took place in both Protestant and Catholic countries at this period.[12]

Many towns that did not have official brothels (owned or licensed by the local municipal or seigneurial authority) nevertheless sanctioned prostitution, either restricted to one street or district within their borders, or just outside their walls. Many towns had concentrations of brothels in the immediately adjacent suburbs. While towns with official brothels usually sought to suppress clandestine prostitution on grounds of public order or because it competed with the official brothels, other towns allowed brothelkeepers or prostitutes to operate independently as long as they followed regulations on such issues as opening times and clothing. In Paris, for example, an active prostitution trade was regulated though not administered by both the city and the royal government.[13]

Sumptuary legislation, prohibiting prostitutes from wearing certain types of clothing, requiring them to wear special identifying garments, or occasionally prohibiting all women but prostitutes from wearing particular styles, was one of the most common types of regulation.[14] The ostensible purpose of this legislation varied: to demarcate the prostitutes so respectable women would not be taken for them and harassed in the streets; to cut down on the expense for husbands by preventing their wives from competing with prostitutes' finery; to prevent women from wishing to become prostitutes in order to be able to wear fancy clothing. Clearly, a town that regulated the clothing of prostitutes resigned itself to the continued existence of prostitution, officially tolerating if not institutionalizing it.

In still other towns, though prostitution was illegal, the fines levied on practitioners and facilitators may have been in the nature of de facto licensing fees. These towns recognized the continuing existence of prostitution and attempted to benefit fiscally.[15] Since those practicing other occupations were fined in similar ways, prostitution in these towns can best be studied in the context of other sorts of earning opportunities open to women.

Some recent studies of women's work in England have treated prostitutes in just this context. Maryanne Kowaleski and Jeremy Goldberg both discuss the kinds of work in which women engaged, which tended to be for relatively low wages and require relatively low amounts of capital for en-

try.[16] Neither prostitution nor brothelkeeping was a full-time, long-term occupation; women who engaged in these trades combined or alternated them with petty retailing and victualling. Such women pieced together their income from whatever sources they could, rather than entering one craft or profession for a lifetime. As Goldberg describes the process of change over time in the towns of northern England, women's earning opportunities became more restricted as economic depression set in due to reduced demand following the population decline of the Black Death. Goldberg argues that this led women to marry younger, for a means of support; the decline in opportunities may have constrained more of them to turn to prostitution.[17]

Jacques Rossiaud and Richard Trexler also turn to demographics for part of the explanation for institutionalized prostitution.[18] For Dijon, Rossiaud focuses on the demand for prostitutes rather than the supply: the late age at which men married, combined with large numbers of clergy who did not marry, meant that there were many men in need of a sexual outlet, and if no brothel were provided they would be likely to rape. Trexler sees the development of institutionalized prostitution in Florence as a response to a low birth rate. More work, however, remains to be done in connecting the rise and fall of prostitution (both officially condoned and clandestine) with economic and demographic change.

Some scholars who work on prostitution in other parts of the world have argued eloquently for its treatment as a form of women's work. The approach taken by Goldberg, for example, certainly accords these women a good deal more respect than analyses of prostitution that espouse the medieval view of the prostitute as criminal or sexually deviant. It goes a bit too far, however, to suggest, as does Luise White, that to talk about prostitutes as victims is to accept the categories constructed by reformers.[19] While it may be true that a woman's decision to enter prostitution has little to do with her own sexuality or morals, certainly the way society treats her, and hence the circumstances of her life as a prostitute, have everything to do with cultural notions about sex, gender, and sin. The prostitute as worker does not operate in a value-neutral market. Whatever economic power she may command as the seller of a desirable commodity is undermined by her lack of alternatives and by the way her choice of trade degrades her in her customers' eyes and perhaps in her own. To treat prostitution as nothing more than just another sort of work is to neglect an important part of the story; prostitution is not just a problem in institutional and economic history but also a problem in cultural history and the history of sexuality.

Chastity was perhaps the most prized virtue for women in the Middle Ages. The prostitute, who so directly countered that virtue, could represent

the epitome of feminine sinfulness. At the same time, however, because of the depth of sin she embodied, the prostitute could represent in a very powerful manner the message of repentance. The prostitute could be used as a metaphor for all sinners,[20] or as an example: if she could repent and be saved, then surely so could everyone. The legends of saints who were former prostitutes—including most prominently Mary Magdalen—demonstrate the two different ways in which medieval society used the image of the prostitute. Vern L. Bullough focuses on these saints' lives as messages of repentance, while I have argued that, although they do emphasize repentance, the stories also use the image of the whore to stress the fundamental sexual sinfulness of all women.[21]

The prostitute played a much greater role in medieval culture than simply that of a hagiographical topos. Despite the fact that money was not seen as the defining feature of prostitution, the connection of feminine sexuality and money was prominent in literature, and the prostitute embodied this connection.[22] One reason for the various municipalities' desire to regulate the prostitute's life may have been some distrust of independent women who controlled their own money. Simply bringing into the marketplace what should not be a commodity was threatening enough. Jacques LeGoff finds the treatment of prostitution an extreme case of the medieval taboo on money,[23] although by the high Middle Ages there were attempts made (for example, by Thomas of Chobham) to recognize the legitimacy of the prostitute's earnings, if not of her sexual activity in itself.

A key concept in discussions of prostitution in medieval culture is marginalization. Many authors have treated prostitution in the context of other marginal groups, with titles like "Marginal Groups" and "Marginal People."[24] Schuster critiques the whole concept of "marginal groups" as not particularly useful in the study of prostitution.[25] Clearly it is true that the individual prostitute was in some ways a marginal character, excluded from the community, in the same way anyone not a member of a family or of a religious order was excluded. However, she was also integrated into the community in some ways: as part of local gossip networks, as a witness in court, and so forth.[26] In some places public prostitutes played a formal role in civic rituals and celebrations. Mary Elizabeth Perry labels prostitutes not outsiders but "deviant insiders": "Rather than barring them from the community, legalized prostitution provided a label for these women that functioned not to exclude them, but to integrate them into society under specific regulated conditions."[27] Marie-Thérèse Lorcin finds the prostitute of the French fabliaux an accepted member of society, helping other women (for a fee) to revenge themselves upon would-be seducers.[28]

Marginalization occurs at the level of the group as well as the individual, raising interesting issues involving group identity. Prostitutes were marginalized physically, by restriction to certain streets or areas of a town, as well as conceptually. Yet though prostitutes as a group were identified, circumscribed, and controlled, in some ways they were not marginal but central. Medieval society did have a distinct place for prostitutes; they were seen as important to the social order, and at least in some regions the necessity of public brothels was unquestioned. From a modern perspective we may see prostitutes, as a group, as crucial to medieval mentalities, particularly to the way people understood femininity and sexuality. Several scholars have commented on the decreasing acceptance of prostitution as a sign of changed attitudes in the early modern period,[29] or indeed the limitation to official brothels as a sign of decreased toleration in the fourteenth century.[30]

Both medieval and modern writers have compared prostitutes with, or discussed them in the context of, many other groups. Medieval laws and proclamations, for example, might apply to "whores and scolds," "whores, bawds and pimps," or similar juxtapositions. Bronislaw Geremek treats prostitutes along with criminals, clerks, and beggars; Franz Irsigler and Arnold Lassotta, with beggars and mountebanks. From the point of view of medieval society and these modern authors, what these groups have in common is that they threaten disorder to the society, and therefore need to be regulated. To a certain extent, the connection of clandestine prostitution with a criminal underworld was inevitable: if prostitution is against the law prostitutes have to behave like criminals, hiding from the authorities and perhaps participating in a criminal subculture. Sometimes prostitutes did commit other crimes, like robbing their customers. But on the whole the connection of prostitution with criminality rests on the fact that society lumped prostitutes in with other criminals.

R.I. Moore discusses the formation of a group identity for the prostitute in another context: along with heretics, lepers, Jews, and male homosexuals.[31] The reason behind the definition, marginalization, and oppression of these groups, in his view, is the desire of nascent states (or the church) to demonstrate (or indeed create) their power by persecuting those whom they define as outsiders. Here, indeed, must be the key to understanding the place of the prostitute in medieval society as a cultural phenomenon. That place depends in part, certainly, upon economic and demographic factors. But it also depends upon the reasons a society has at a particular moment for demarcating a specific group and labeling it as unacceptable, or acceptable only under conditions of degradation. Medieval society regarded prostitution as necessary and was not attempting to abolish it, but the efforts to control it

were part of a specifically medieval scheme of regulation of all sexuality that differed from the norm. Much more work remains to be done on the reasons why, at certain times, societies make a different choice of groups to marginalize and cast as "other."

Yet at the same time prostitutes were cast as "other," not belonging *in* the society, they were also considered to belong *to* the society, that is to be in a sense the common property of all men. This, and not only a wish to keep pimps out of the trade, may be behind the prohibition on their having particular lovers. In some towns forced sex with prostitutes was not legally rape, because they did not have the power to withhold consent. The term "common woman" implied not only openness to all but in a sense possession by the community of men.[32]

Another area in need of further work is the study of the experiences of the prostitutes themselves. Some of the scholars who have studied prostitution in its economic and demographic context have begun to approach this question, but the interesting and stimulating work being done on attitudes toward and representations of prostitutes does not really bear on their own experiences. The problem, of course, as with so many topics in the history of medieval sexuality and medieval history more generally, is one of sources. Only extremely rarely do we have the words of prostitutes themselves, and even then generally in court testimony, which was recorded in Latin by someone other than the prostitutes. (Ironically, the only account from a prostitute in medieval England that fully describes her life and mode of operation turns out to come from a male transvestite.)[33] More information is needed on such subjects as relations with customers (how did they find them? was there repeat business?); types of sexual practices; rates of pay (which are sometimes recorded in brothel regulations, but may have varied in practice); relations with other prostitute and non-prostitute women; class variations within the trade; origins of prostitutes; and many similar topics.

Prostitutes were often foreigners or at least strangers to the towns in which they worked, although in some cases they came from immediately surrounding areas.[34] Some of the women may have received foreign names or nicknames not because they really came from abroad but because these names made them sound exotic. However, when a significant fraction not only of prostitutes but of male employees at the Florentine brothel were from the Low Countries,[35] these may have been people who because of their foreignness had a hard time finding other work. In some towns no daughter of a citizen was allowed to work in the official brothel; the towns thus enforcd the prostitutes' outsider status.

Age and life-cycle information, like that on place of origin, is hard to come by because the records only rarely give the ages of prostitutes. It is very difficult to trace them in other sorts of records to find out what happened to them once they left the trade. In some cases prostitutes seem to have been in their early teens or younger, perhaps a reflection of job opportunities (or lack thereof), since quite young girls were expected to leave home and look for positions in domestic service. It may also be, though, that the courts emphasized the youth of prostitutes and called them "young girls" as a means of casting blame on those who led these young innocents into sin—not the men who had sex with them, but procuresses or brothelkeepers, mainly women, who came in for blame as heavy as or heavier than that placed on the prostitutes themselves.[36] The figure of the procuress as a depraved old woman intent upon corrupting the innocent is familiar from literary works in many vernaculars, and this image informed the law as well.[37] In fact many former prostitutes became procuresses and continued their careers in the sex trade.

Modern scholars assume that women entered prostitution for financial reasons and not for the sake of lust. Even canonists writing in the Middle Ages recognized that financial need was a reason for entering into prostitution, even if they did not think that excused it;[38] it was not seen solely as a matter of lust on their part. The evidence, both on the level of larger economic structures and also on the level of individual cases, indicates that some could not get the jobs they were seeking in domestic service. Others were deceived into becoming prostitutes, thinking they were being offered some other kind of work. We know from the early modern period that it was often women who were known to have lost their virginity (by rape or by choice), especially servants who became pregnant (often by their masters), who had to become prostitutes: they had neither job nor marriage prospects. This was probably common in the Middle Ages as well although the evidence is scantier.[39] Some women may have become prostitutes for family reasons, sending money home to their kin; indeed, some were pawned as prostitutes by their parents specifically to pay off debts, although this practice was prohibited in many jurisdictions.[40] Some husbands pimped for their wives and kept the money. Often, however, prostitution provided one means for women to obtain access to cash, albeit a small amount after the brothelkeeper or procurer took a cut. Very few of the prostitutes, however, grew rich from the trade. A very few left wills indicating that they had acquired property, but in the main prostitutes remained among the poorest women in the towns.

Prostitutes entered the trade for a variety of reasons, and they were

no more homogeneous in their mode of operation once in that trade. There were many different types of prostitution. Women in a municipally established house were often at the bottom of the stratification within the profession, then streetwalkers, then women who worked with a procuress and had a steady clientele.[41] Courtesans and mistresses were in one sense at the top of the hierarchy, except that they were not necessarily considered by contemporaries to be in the same trade as common prostitutes (some moralists considered them worse). Some prostitutes worked in their own homes, some in taverns, some in bathhouses, some in houses of assignation that made rooms available. Many were not professionals in the sense of engaging in the trade on a regular basis; rather they used it to supplement meager wages, for example from domestic service. While women in the regulated houses were not supposed to have particular lovers, many clandestine prostitutes did have male friends or husbands whom they supported and who may have pimped for them as well.[42] The notion that prostitutes had their own guild in some towns, which is found in some older scholarship, is not based on reliable evidence,[43] and although they were grouped together in official brothels or Magdalene houses, the degree of solidarity they felt with one another is unknown.

There are few descriptions of the exact sexual practices of the prostitutes,[44] although the fact that male transvestites were able to pass themselves off as women indicates that oral, anal, manual, or interfemoral sex may have been common. Prostitutes may have preferred such acts for contraceptive reasons, although obviously they did not practice them to the exclusion of vaginal intercourse, since they did bear children. The evidence for these children, however, is less than one might expect—there are few records of them in foundling homes, for example—and legal and moral writers do not seem to concern themselves with the birth, abandonment, or infanticide of illegitimate children as one of the harms of prostitution. This may indicate that contraception or non-procreative intercourse was common.[45] Medieval medical theory held that prostitutes were less fertile than other women;[46] it may be that venereal disease left some sterile or that what people were noticing was the result of contraceptive practices.

Brothels were intended to cater for the sexual needs of young unmarried men, and their regulations often prohibited married men, priests, and Jews from patronizing them. Nevertheless court records and literature reveal that priests and other religious were frequent customers. The socioeconomic level of customers is more difficult to determine, and of course varied depending upon the type of prostitute: rich men could have women brought to their homes, poorer men might visit a brothel or pick up a

streetwalker. Scholars have estimated the cost of a visit to a brothel in various regions as 25–125 percent of a day laborer's wages.[47] These figures are rough but do indicate that the services of prostitutes were within the reach of working men.

In many parts of Europe efforts were made to convert prostitutes to a more virtuous way of life. Sometimes these efforts were merely lip service: requiring prostitutes to attend church at certain times, or having special sermons preached to them. In other instances, however, practical action was taken: making dowry money available so that young women could marry instead of entering prostitution, or providing houses of refuge (Magdalene houses), organized like convents, so that women who sought to leave the trade would have somewhere to go. Such homes have been studied in Italy and Germany;[48] the fact that many women not registered as prostitutes claimed to be such in order to get in indicates the tremendous need for a means of support for these women. We do not know how many prostitutes eventually left the profession not for a Magdalene house but for marriage, which would be a good indication of how marginal the individual prostitute actually was in the society: was it a permanent stigma?

We know some of the practical economic reasons why women turned to prostitution. We also know some of the cultural reasons why women came to be regarded as prostitutes. We do not know whether the degradation that law, literature, and other contemporary writing associated with them was internalized by the prostitutes themselves. Did they see what they did as depraved and sinful? Did they see it as just another job? Were there social class differences in attitudes toward promiscuity, so that what the church and the temporal authorities might label as prostitution the participants might see simply as a typical casual liaison? These questions remain open for further research and discussion.

NOTES

1. Siegfried Wenzel, ed. and trans., *Fasciculus Morum: A Fourteenth-Century Preacher's Handbook* (University Park: Pennsylvania State University Press, 1989), 669.

2. Ruth Mazo Karras, "The Latin Vocabulary of Illicit Sex in English Ecclesiastical Court Records," *Journal of Medieval Latin* 2 (1992), 6.

3. James A. Brundage, *Law, Sex, and Christian Society in Medieval Europe* (Chicago: University of Chicago Press, 1987), 248–49, 308–11, 463–69; Brundage, "Prostitution in the Medieval Canon Law," *Signs: Journal of Women in Culture and Society* 1 (1975), 825–45.

4. Brundage, "Prostitution in the Medieval Canon Law," 825, n. 2.

5. Bronislaw Geremek, *The Margins of Society in Late Medieval Paris*, trans. Jean Birrell (Cambridge: Cambridge University Press, 1987), 212.

6. J.B. Post, "A Fifteenth-Century Customary of the Southwark Stews," *Journal of the Society of Archivists* (1977), 420.

7. France has been discussed by Leah Lydia Otis, *Prostitution in Medieval Society: The History of an Urban Institution in Languedoc* (Chicago: University of Chicago Press, 1985), and "Prostitution and Repentance in Late Medieval Perpignan," in *Women of the Medieval World*, ed. Julius Kirshner and Suzanne Wemple (Oxford: Basil Blackwell, 1985), 137–60; and Jacques Rossiaud, *Medieval Prostitution*, trans. Lydia G. Cochrane (Oxford: Basil Blackwell, 1988); "Prostitution, Sex, and Society in French Towns in the Fifteenth Century," in *Western Sexuality: Practice and Precept in Past and Present Times*, ed. Philippe Ariès and André Béjin (Oxford: Basil Blackwell, 1985), 76–94; and "Prostitution, Youth, and Society in Towns of South Eastern France in the Fifteenth Century," in *Deviants and the Abandoned in French Society*, eds. Robert Forster and Orest Ranum, trans. Elborg Forster (Baltimore: Johns Hopkins University Press, 1978), 1–46.

Italy is discussed by Richard Trexler, "La prostitution florentine au XVe siècle: patronages et clientèles," *Annales: economies, sociétés, civilisations* 36 (1981), 983–1015; and Elisabeth Pavan, "Police des moeurs, société et politique à Venise à la fin du Moyen Age," *Revue Historique* 264 (1980), 241–88. Germany is discussed by Peter Schuster, *Das Frauenhaus. Städtische Bordelle in Deutschland (1350–1600)* (Paderborn: Ferdinand Schöningh, 1992); Birgitte Rath, "Prostitution und spätmittelalterliche Gesellschaft im Österreichisch-Süddeutschen Raum," in *Frau und spätmittelalterlicher Alltag*, Österreichische Akademie der Wissenschaften, Philosophisch-historische Klasse, Sitzungsberichte, 473 (Vienna: Verlag der Österreichischen Akademie der Wissenschaften, 1986), 553–71; Lyndal Roper, "Discipline and Respectability: Prostitution and the Reformation in Augsburg," *History Workshop* (1985), 3–28; and Michael Schattenhofer, "Henker, Hexen, und Huren," in *Beiträge zur Geschichte der Stadt München*, Oberbayrisches Archiv, 109:1 (Munich, Verlag der historischen Vereins von Oberbayern, 1984), 113–42.

England has been discussed by Karras, "The Regulation of Brothels in Later Medieval England," *Signs: Journal of Women in Culture and Society* 14 (1989), 399–433, although this article omits Southampton, one of the towns with legal brothels, and Karras, *Common Women: Prostitution and Sexuality in Medieval England* (New York: Oxford University Press, 1996). For a comparable institution in early modern Spain, see Mary Elizabeth Perry, *Gender and Disorder in Early Modern Seville* (Princeton, NJ: Princeton University Press, 1992); "Deviant Insiders: Legalized Prostitutes and a Consciousness of Women in Early Modern Seville," *Comparative Studies in Society and History* 27 (1985), 138–58; and "'Lost Women' in Early Modern Seville: The Politics of Prostitution," *Feminist Studies* 4 (1978), 195–214. An older synthetic work, which must be used with great care but which can provide useful bibliography, is Iwan Bloch, *Die Prostitution*, vol. 1 (Berlin: Louis Marcus Verlagsbuchhandlung, 1912).

8. Schuster, p. 48.

9. Thomas Aquinas, *De regimine principium ad regem Cypri*, in *Opera Omnia* vol. 16 (Parma, Italy: Pietro Fiaccadori, 1864), 281.

10. Perry, *Gender and Disorder*, 144; Roper, 13–14.

11. Otis, *Prostitution in Medieval Society*; Rossiaud, *Medieval Prostitution*.

12. Otis, *Prostitution in Medieval Society*, 41–45; Trexler, 1003–05; Roper; Nicholas Orme, "The Reformation and the Red Light," *History Today* 37 (March 1987), 36–41.

13. Geremek, 211–41; Anne Terroine, "Le roi de ribauds de l'Hôtel du Roi: les prostituées parisiennes," *Revue historique de droit* 56 (1978), 253–67.

14. Brundage, "Sumptuary Laws and Prostitution in Late Medieval Italy," *Journal of Medieval History* 13 (1987), 343–55; Schuster, 147–50.

15. Karras, "Regulation of Brothels," 407.

16. Maryanne Kowaleski, "Women's Work in a Market Town: Exeter in the Late Fourteenth Century," in *Women and Work in Preindustrial Europe*, ed. Barbara Hanawalt (Bloomington: Indiana University Press, 1986), 145–64; P.J.P. Goldberg, "Women in Fifteenth-Century Town Life," in *Towns and Townspeople in the Fifteenth*

Century, ed. J.A.F. Thomson (Gloucester, Eng.: Alan Sutton, 1988), 107–28, and *Women, Work, and Life Cycle in a Medieval Economy: Women in York and Yorkshire c. 1300–1520* (Oxford: Clarendon Press, 1992), 82–157.

17. Goldberg, *Women, Work, and Life Cycle,* 336–40.

18. Rossiaud, "Prostitution, Youth, and Society," and *Medieval Prostitution;* Trexler.

19. Luise White, "Prostitutes, Reformers, and Historians," *Criminal Justice History* 6 (1985), 201–27.

20. H.U. von Balthasar, "Casta Meretrix," in *Sponsa Verbi: Skizzen zur Theologie* (Einsiedeln: Johannes Verlag, 1961), 2:203–305.

21. Vern L. Bullough, "The Prostitute in the Middle Ages," *Studies in Medieval Culture* 19 (1977), 9–17; Karras, "Holy Harlots: Prostitute Saints in Medieval Legend," *Journal of the History of Sexuality* 1 (1990), 3–32.

22. See Marie-Thérèse Lorcin, *Façons de sentir et de penser: les fabliaux français* (Paris: Honoré Champion, 1979), 65; Karras, "Prostitution in Medieval English Culture," in *Desire and Discipline: Essays on Sex and Sexuality in Premodern Europe,* ed. Jacqueline Murray and Konrad Eisenbichler (University of Toronto Press).

23. Jacques LeGoff, "Licit and Illicit Trades in the Medieval West," in *Time, Work, and Culture in the Middle Ages,* trans. Arthur Goldhammer (Chicago: University of Chicago Press, 1980), 58–70.

24. František Graus, "Randgruppen der städtischen Gesellschaft im Spätmittelalter," *Zeitschrift für historische Forschung* 8 (1981), 385–437; Franz Irsigler and Arnold Lassotta, *Bettler und Gaukler, Dirnen und Henker: Randgruppen und Außenseiter in Köln 1300–1600* (Cologne: Greven Verlag, 1984); Geremek (his original Polish title translates as "Marginal People in Medieval Paris"); Annette Lömker-Schlögel, "Prostituierte—'umb vermeydung willen merers übels in der cristenhait,'" in *Randgruppen der spätmittelalterlichen Gesellschaft: Ein Hand- und Studienbuch,* ed. Bernd-Ulrich Hergemöller (Warendorf, Germany: Fahlbusch, 1990), 52–85; Atsushi Kawahara, "The Marginal Groups in Late Medieval Urban Society: A Case Study of Lepers and Prostitutes," *Jimbun Gakuho: The Journal of Social Sciences and Humanities* 229 (1992), 1–26.

25. Schuster, 1992.

26. See Lorcin, "La prostituée des fabliaux, est-elle integrée ou exclue?" in *Exclus et systèmes d'exclusion dans la littérature et la civilisation médiévales,* Senefiance, 5 (Aix-en-Provence: Centre universitaire d'études et de recherches médiévales, 1978), 105–18.

27. Perry, *Gender and Disorder,* 137; "Deviant Insiders."

28. Lorcin, *Façons,* 51–67.

29. Schuster; Merry E. Wiesner, "Paternalism in Practice: The Control of Servants and Prostitutes in Early Modern German Cities," in *The Process of Change in Early Modern Europe,* eds. Phillip N. Bebb and Sherrin Marshall (Athens: Ohio University Press, 1988); Larissa Taylor, *Strange Bedfellows: Preachers and Prostitutes in Late Medieval and Early Modern Europe* (forthcoming).

30. Graus, 409.

31. R.I. Moore, *The Creation of a Persecuting Society: Power and Deviance in Western Europe, 950–1250* (Oxford: Basil Blackwell, 1987).

32. Roper, "'The common man,' 'the common good,' 'common women': Gender and Meaning in the German Reformation Commune," *Social History* 12 (1987), 1–21.

33. David Lorenzo Boyd and Ruth Mazo Karras, "The Interrogation of a Male Transvestite Prostitute in Fourteenth-Century London," *GLQ: A Journal of Lesbian and Gay Studies* 1 (1994), 459–65.

34. E.g. Rossiaud, *Medieval Prostitution,* 32.

35. Trexler, 986.

36. See Karras, *Common Women,* 57–64, for discussion procuring, and Roper, "Mothers of Debauchery: Procuresses in Reformation Augsburg," *German History* 6

(1988), 1–19, on the procuress in the early modern period.
 37. For an allegorical interpretation of this figure see Robert Haller, "The Old Whore and Medieval Thought: Variations on a Convention" (Ph.D. Diss., Princeton University, 1960), 180–238.
 38. Brundage, "Prostitution in the Medieval Canon Law," 835–36.
 39. Rossiaud, *Medieval Prostitution*, does present some evidence for Dijon.
 40. Beate Schuster, "Frauenhandel und Frauenhäuser im 15. und 16. Jahrhundert," *Vierteljahrschrift für Sozial- und Wirtschaftsgeschichte* 2 (1991), 172–89.
 41. Irsigler and Lassotta, 214–15.
 42. Geremek, 228–33.
 43. Vern L. Bullough, "The Prostitute in the Later Middle Ages," in *Sexual Practices and the Medieval Church*, eds. Vern L. Bullough and James A. Brundage (Buffalo: Prometheus, 1982), 176–86.
 44. Rossiaud, *Medieval Prostitution*, 109, and Schuster, *Das Frauenhaus*, 65, cite some evidence on positions.
 45. See John M. Riddle, *Contraception and Abortion from the Ancient World to the Renaissance* (Cambridge, MA: Harvard University Press, 1992), and "Oral Contraceptives and Early Abortifacients during Classical Antiquity and the Middle Ages," *Past and Present* 132 (1991), 3–32, on available methods.
 46. Danielle Jacquart and Claude Thomasset, *Sexuality and Medicine in the Middle Ages*, trans. Matthew Adamson (Princeton, NJ: Princeton University Press, 1988), 25, 63–64, 80–81.
 47. Schuster, *Das Frauenhaus*, 113; Chr. Vandenbroeke, "De prijs van betaalde liefde," *Spiegel Historiael* 18:2 (1983), 92.
 48. Sherrill Cohen, *The Evolution of Women's Asylums Since 1500: From Refuges for Ex-Prostitutes to Shelters for Battered Women* (New York: Oxford University Press, 1992); A. Simon, *L'ordre des pénitentes de Sainte Marie-Madeleine en Allemagne* (Fribourg, Switzerland: Imprimerie et Librairie de l'Oeuvre de Saint-Paul, 1918).

BIBLIOGRAPHY

Aquinas, Thomas. *De regimine principium ad regem Cypri*. In *Opera Omnia* vol. 16. Parma, Italy: Pietro Fiaccadori, 1864.
von Balthasar, H.U. "Casta Meretrix." In *Sponsa Verbi: Skizzen zur Theologie*. Einsiedeln: Johannes Verlag, 1961, 2:203–305.
Bloch, Iwan. *Die Prostitution*, vol. 1. Berlin: Louis Marcus Verlagsbuchhandlung, 1912.
Boyd, David Lorenzo and Ruth Mazo Karras. "The Interrogation of a Male Transvestite Prostitute in Fourteenth-Century London." *GLQ: A Journal of Lesbian and Gay Studies* 1 (1994), 459–65.
Brundage, James A. *Law, Sex, and Christian Society in Medieval Europe*. Chicago: University of Chicago Press, 1987.
———. "Sumptuary Laws and Prostitution in Late Medieval Italy." *Journal of Medieval History* 13 (1987): 343–55.
———. "Prostitution in the Medieval Canon Law," *Signs: Journal of Women in Culture and Society* 1 (1975): 825–45. Reprinted in *Sexual Practices and the Medieval Church*, eds. Vern L. Bullough and James A. Brundage. Buffalo: Prometheus, 1982, 149–60. Also reprinted in *Sisters and Workers in the Middle Ages*, ed. Judith M. Bennett, Elizabeth A. Clark, Jean F. O'Barr, B. Anne Vilen, and Sarah Westphal-Wihl. Chicago: University of Chicago Press, 1989, 79–99.
Bullough, Vern L. "The Prostitute in the Later Middle Ages." In *Sexual Practices and the Medieval Church*, eds. Vern L. Bullough and James A. Brundage. Buffalo: Prometheus, 1982, 176–86.

———. "The Prostitute in the Middle Ages." *Studies in Medieval Culture* 19 (1977): 9–17. Reprinted, slightly revised, in *Sexual Practices and the Medieval Church*, eds. Vern L. Bullough and James A. Brundage. Buffalo: Prometheus, 1982, 34–42.

Cohen, Sherrill. *The Evolution of Women's Asylums Since 1500: From Refuges for Ex-Prostitutes to Shelters for Battered Women.* New York: Oxford University Press, 1992.

Geremek, Bronislaw. *The Margins of Society in Late Medieval Paris.* Trans. Jean Birrell. Cambridge: Cambridge University Press, 1987.

Goldberg, P.J.P. *Women, Work, and Life Cycle in a Medieval Economy: Women in York and Yorkshire c. 1300–1520.* Oxford: Clarendon Press, 1992.

———. "Women in Fifteenth-Century Town Life." In *Towns and Townspeople in the Fifteenth Century.* Ed. J.A.F. Thompson. Gloucester, Eng.: Alan Sutton, 1988, 107–28.

Graus, František. "Randgruppen der städtischen Gesellschaft im Spätmittelalter." *Zeitschrift für historische Forschung* 8 (1981), 385–437.

Haller, Robert. "The Old Whore and Medieval Thought: Variations on a Convention." Ph.D. Diss., Princeton University, 1960.

Irsigler, Franz and Arnold Lassotta. *Bettler und Gaukler, Dirnen und Henker: Randgruppen und Außenseiter in Köln 1300–1600.* Cologne: Greven Verlag, 1984.

Jacquart, Danielle and Claude Thomasset. *Sexuality and Medicine in the Middle Ages.* Trans. Matthew Adamson. Princeton, NJ: Princeton University Press, 1988.

Karras, Ruth Mazo. "Prostitution in Medieval English Culture." In *Desire and Discipline: Essays on Sex and Sexuality in Premodern Europe*, ed. Jacqueline Murray and Konrad Eisenbichler. University of Toronto Press.

———. *Common Women: Prostitution and Sexuality in Medieval England.* New York: Oxford University Press, 1996.

———. "The Latin Vocabulary of Illicit Sex in English Ecclesiastical Court Records." *Journal of Medieval Latin* 2 (1992), 1–17.

———. "Holy Harlots: Prostitute Saints in Medieval Legend." *Journal of the History of Sexuality* 1 (1990): 3–32.

———. "The Regulation of Brothels in Later Medieval England." *Signs: Journal of Women in Culture and Society* 14 (1989): 399–433. Reprinted in *Sisters and Workers in the Middle Ages*, ed. Judith M. Bennett, Elizabeth A. Clark, Jean F. O'Barr, B. Anne Vilen, and Sarah Westphal-Wihl. Chicago: University of Chicago Press, 1989, 100–34.

Kawahara, Atsushi. "The Marginal Groups in Late Medieval Urban Society: A Case Study of Lepers and Prostitutes." *Jimbun Gakuho: The Journal of Social Sciences and Humanities*, 229 (1992): 1–26.

Kowaleski, Maryanne. "Women's Work in a Market Town: Exeter in the Late Fourteenth Century." In *Women and Work in Preindustrial Europe*, ed. Barbara Hanawalt. Bloomington: Indiana University Press, 1986, 145–164.

LeGoff, Jacques. "Licit and Illicit Trades in the Medieval West." In *Time, Work, and Culture in the Middle Ages.* Trans. Arthur Goldhammer. Chicago: University of Chicago Press, 1980, 58–70.

Lömker-Schlögel, Annette. "Prostituierte—'umb vermeydung willen merers übels in der cristenhait.'" In *Randgruppen der spätmittelalterlichen Gesellschaft: Ein Hand- und Studienbuch*, ed. Bernd-Ulrich Hergemöller. Warendorf, Germany: Fahlbusch, 1990, 52–85.

Lorcin, Marie-Thérèse. *Façons de sentir et de penser: Les fabliaux français.* Paris: Honoré Champion, 1979.

———. "La prostituée des fabliaux, est-elle integrée ou exclue?" *Exclus et systèmes d'exclusion dans la littérature et la civilisation médiévales.* Senefiance, 5. Aix-en-Provence: Centre universitaire d'études et de recherches médiévales, 1978, 105–18.

Moore, R.I. *The Formation of a Persecuting Society: Power and Deviance in Western Europe, 950–1250.* Oxford: Basil Blackwell, 1987.

Orme, Nicholas. "The Reformation and the Red Light." *History Today* 37 (March 1987), 36–41.

Otis, Leah Lydia. *Prostitution in Medieval Society: The History of an Urban Institution in Languedoc.* Chicago: University of Chicago Press, 1985.

——. "Prostitution and Repentance in Late Medieval Perpignan." In *Women of the Medieval World,* eds. Julius Kirshner and Suzanne Wemple. Oxford: Basil Blackwell, 1985, 137–60.

Pavan, Elisabeth. "Police des moeurs, société et politique à Venise à la fin du Moyen Age." *Revue Historique* 264 (1980), 241–88.

Perry, Mary Elizabeth. *Gender and Disorder in Early Modern Seville.* Princeton, NJ: Princeton University Press, 1992.

——. "Deviant Insiders: Legalized Prostitutes and a Consciousness of Women in Early Modern Seville." *Comparative Studies in Society and History* 27 (1985): 138–58.

——. "'Lost Women' in Early Modern Seville: The Politics of Prostitution." *Feminist Studies* 4 (1978): 195–214.

Post, J.B. "A Fifteenth-Century Customary of the Southwark Stews." *Journal of the Society of Archivists* (1978): 418–28.

Rath, Brigitte. "Prostitution und spätmittelalterliche Gesellschaft im Österreichisch-Süddeutschen Raum." In *Frau und spätmittelalterlicher Alltag.* Österreichische Akademie der Wissenschaften, Philosophisch-historische Klasse, Sitzungsberichte, 473. Vienna: Verlag der Österreichischen Akademie der Wissenschaften, 1986, 553–71.

Riddle, John M. *Contraception and Abortion from the Ancient World to the Renaissance.* Cambridge, MA: Harvard University Press, 1992.

——. "Oral Contraceptives and Early Abortifacients during Classical Antiquity and the Middle Ages." *Past and Present* 132 (1991): 3–32.

Roper, Lyndal. "Mothers of Debauchery: Procuresses in Reformation Augsburg." *German History* 6 (1988): 1–19.

——. "'The common man,' 'the common good,' 'common women': Gender and meaning in the German Reformation commune." *Social History* 12 (1987): 1–21.

——. "Discipline and Respectability: Prostitution and the Reformation in Augsburg." *History Workshop* (1987): 3–28.

Rossiaud, Jacques. *Medieval Prostitution.* Trans. Lydia G. Cochrane. Oxford: Basil Blackwell, 1988.

——. "Prostitution, Sex, and Society in French Towns in the Fifteenth Century." In *Western Sexuality: Practice and Precept in Past and Present Times,* ed. Philippe Ariès and André Béjin. Oxford: Basil Blackwell, 1985, 76–94.

——. "Prostitution, Youth, and Society in Towns of South Eastern France in the Fifteenth Century." In *Deviants and the Abandoned in French Society,* ed. Robert Forster and Orest Ranum. Trans. Elborg Forster. Baltimore: Johns Hopkins University Press, 1978, 1–46.

Schattenhofer, Michael. "Henker, Hexen, und Huren." In *Beiträge zur Geschichte der Stadt München.* Oberbayrisches Archiv, 109:1. Munich: Verlag der historischen Vereins von Oberbayern, 1984, 113–42.

Schuster, Beate. "Frauenhandel und Frauenhäuser im 15. und 16. Jahrhundert." *Vierteljahrschrift für Sozial- und Wirtschaftsgeschichte* 2 (1991), 172–89.

Schuster, Peter. *Das Frauenhaus. Städtische Bordelle in Deutschland (1350–1600).* Paderborn, Germany: Ferdinand Schöningh, 1992.

Simon, A. *L'ordre des pénitentes de Sainte Marie-Madeleine en Allemagne.* Fribourg, Switzerland: Imprimerie et Librairie de l'Oeuvre de Saint-Paul, 1918.

Taylor, Larissa. *Strange Bedfellows: Preachers and Prostitutes in Late Medieval and Early Modern Europe.* Forthcoming.

Terroine, Anne. "Le roi de ribauds de l'Hôtel du Roi: les prostituées parisiennes." *Revue historique de droit* 56 (1978): 253–67.

Trexler, Richard. "La prostitution florentine au XVe siècle: patronages et clientèles." *Annales: Economies, Sociétés, Civilisations* 36 (1981): 983–1015.

Vandenbroeke, Chr. "De prijs van betaalde liefde." *Spiegel Historiael* 18:2 (1983): 90–94.

Wenzel, Siegfried, ed. and trans. *Fasciculus Morum: A Fourteenth-Century Preacher's Handbook*. University Park: Pennsylvania State University Press, 1989.

White, Luise. "Prostitutes, Reformers, and Historians." *Criminal Justice History* 6 (1985): 201–27.

Wiesner, Merry E. "Paternalism in Practice: The Control of Servants and Prostitutes in Early Modern German Cities." In *The Process of Change in Early Modern Europe*, ed. Phillip N. Bebb and Sherrin Marshall. Athens: Ohio University Press, 1988, 179–200.

11 CONTRACEPTION AND EARLY ABORTION IN THE MIDDLE AGES

John M. Riddle

Medieval peoples knew about and used contraceptives and birth control, and they employed them sufficiently well to limit births. Modern scholars have been unwilling to believe that medieval peoples could have been so well informed. After all, this was the Middle Ages, and birth control is something we discovered in our modern age. Previous histories of contraception assert that effective techniques became available in the late eighteenth century as the concept of coitus interruptus spread from the elite to the masses. In the 1950s the researches of Gregory Pincus and John Rock resulted in the contraceptive pill, a combination of estrogen and progesterone hormones that, when taken correctly, was a safe contraceptive. Finally, the subject of a safe abortion pill is still a matter of controversy and uncertainty. Could people in the Middle Ages know what we do not?

THE LORSCH MANUSCRIPT

Medieval women were the possessors of much knowledge about birth control. One reason the use of effective pre-modern birth control escaped detection is that, by and large, it was a woman's secret. A glimpse of a manuscript from a male religious community informs us about what medieval men knew and how they knew it. About the year 800 in the Benedictine abbey at Lorsch in what is now Germany, medieval monks composed a treatise on medicine that contained cures for common illnesses and afflictions. Much of the information in this medical manuscript that has survived to this day dates back in many instances to classical antiquity. Some of its medical information, however, derived from medieval discoveries. A male, monastic setting would not be a likely place to find information about birth control.

Folio 19 verso of the Lorsch manuscript has a medical prescription with the title "A Cure for All Kinds of Stomach Aches."[1] The prescription calls for the following ingredients:

8 oz. white pepper

8 oz. ginger (*Zingiber officinale* L.)

6 oz. parsley (*Petroselinum sativum* Nym.)

2 oz. celery seeds (*Apium graveolens* L.)

6 oz. caraway? (*caregium*=? *Carum carvi* L.)

6 oz. spignel seeds (*libesticium*= ?*Peucedanum cervaria* L.)

2 oz. fennel (*Foeniclum vulgare* Mill.)

2 oz. geranium/ or, giant fennel (*amonum*=? *Geranium sp./* or, *Ferula tingitana* L.)[2]

8 oz. cumin

6 oz. anise (*Pimpinella anisum*)

6 oz. opium poppy (*miconum*= *papaver somniferum* L.)

1 oz. = approx. 30 gr.

At first, this prescription does not appear totally unpleasant, composed as it is of a number of food and spice plants. The manuscript text, however, says its purpose is medicinal: "For women who cannot purge themselves, it moves the menses." In today's words, the prescription allegedly provokes or stimulates menstruation. In order to understand what happened to birth control during the Middle Ages, we need to look deep into this beautiful eighth-century Carolingian script.

Pepper contains a substance called piperine that is known to cause abortions in animals and in humans.[3] In the Roman period, pepper was given as a post-coitus contraceptive.[4] Ginger is reported in modern scientific studies as having strong antifertility qualities.[5] Parsley is listed in a French medical guide, as late as the year 1939, as a drug for stimulating menstruation.[6] Celery seeds were found in animal testing conducted in 1983 to terminate early pregnancy in rats.[7] Caraway seeds are drunk by women in modern India to stimulate menstruation, but one scientific animal test revealed that they had no antifertility effect.[8] Also in modern India, but in contrast with caraway seeds, spignel is used as a contraceptive.[9] Judgment is reserved on *amonum* because its identification is uncertain, but three of the remaining four ingredients in the prescription are also antifertility plants, namely, fennel, cumin, and anise. The last plant, opium poppy, may have been included in this amount for a soothing, mild narcotic effect.

Of those ingredients that are known antifertility agents, most were known in classical medicine and may have been in texts available to the authors of the Lorsch work. No classical text contains the Lorsch prescription, thereby making the Lorsch prescription unique. Two substances in the Lorsch prescription are not even found in classical writings on female problems:

fennel and celery seeds. Macer (Marbode of Rennes, d. 1123) wrote an herbal in which he named fennel as being a "menstrual purgative."[10] Thus the Lorsch manuscript marks the earliest record for fennel's use. Celery seeds are even more interesting. Celery is one of two plants employed in the earliest known contraceptive prescription. In the Berlin Papyrus, dating from the Nineteenth Dynasty (ca. 1300 B.C.E.) but based on an earlier prototype, celery seeds are listed as a contraceptive.[11] No surviving classical texts, however, employ celery as an antifertility agent. With no classical sources to provide a bridge, it is impossible for there to be a direct connection between the Berlin Papyrus and the Lorsch manuscript. Assuming (as is almost certainly the case) that the Lorsch writers did not have classical texts about which we do not know, it is fair to conclude that the author of the Lorsch prescription was simply employing folk or common usage. In other instances within the Lorsch account, this is verified. In summary, the Lorsch manuscript of 800 A.C.E. not only contains antifertility information but also incorporates new information unknown to classical writers.

The Lorsch prescription would have terminated an early pregnancy, a conclusion reasonably inferred from what we know from modern science. Three large questions remain: Was it a contraceptive or an abortion "pill"?; Was the prescription known and widely employed?; Did they know that a menstrual regulator was for contraception or birth control? Based on the evidence that is presented in the rest of this article, the answers are: both contraceptive and abortifacient; yes, or similar prescriptions; and yes, they did know.

MENSTRUAL REGULATORS

An issue of most newspapers published in North America and Western Europe during the nineteenth century would typically contain small, discreet advertisements to "ladies" for pills or draughts that were called variously, "restorers," "female monthly pills," "French renovating pills," or "menstrual regulators." They contained some of the same ingredients as those listed in the Lorsch manuscript. Maybe more often they contained other herbal and a few mineral substances that were stronger in action than the Lorsch ingredients. These other ingredients included rue, myrrh, tansy, and pennyroyal. Of these, rue, tansy and pennyroyal are still sold in "health stores" as teas for women to regulate their menstrual cycles. If only one cup of tea is taken in a day, then probably there would be no harm. If, however, greater amounts are taken, the result is a miscarriage should pregnancy be indicated. The difference between now and the Middle Ages is that during the Middle Ages most women knew the antifertility purposes for which these plants could be used.

A thirteenth-century treatise called *Women's Secrets* revealed what we suppose was the common understanding among women.[12] They believed that there was an interval between the deposit of a man's semen and the uncertain point at which a woman's body turned the man's seed into an embryo. Latin terms for what we call an embryo were *conceptus, embryo,* and *fetus*. In modern speech we distinguish between an embryo, which we define as the first three months of a fertilized egg, and a fetus, a child *in utero* after three months of development. Neither the Middle Ages nor the classical antiquity of the Romans and Greeks made such distinctions. Thus there was an indefinite, intuited, and sensed time, a window as it were, when a medieval woman could end what we call a pregnancy, and neither she nor her contemporaries regarded it as an abortion. Taking a drug for delayed menstruation was just that and little more.

CONTRACEPTION AND ABORTION

The Latin and Greek languages distinguished between contraception (e.g., *atokios, atocium, sterilitas, asyll ptos*) and abortion (e.g., *abortum, phthorion*). In common usage the distinctions blurred. One example is a plant that is variously said to be a contraceptive or an abortifacient, as labeled by ancient and medieval medical authorities. In the classical and medieval sources the seeds of Queen Anne's lace (*Daucus carrota* L.) are said to prevent conception and to abort if taken soon after coitus. Recent pharmaceutical research mostly conducted in China reports that the seeds block or interfere with progesterone.[13] The action could be to prevent implantation (in which case it would fit the modern definition of contraceptive), or it could dislodge a recent implantation (in which case we would call it an abortifacient).

Prior to the Middle Ages, neither the Greeks nor the Romans nor, as best we can tell, Germanic and Celtic peoples regarded contraception or abortion as immoral. Ancient law, dating back at least to the Assyrians, protected a male's right to have a child (presumably in wedlock) when a woman wished to abort. The law codes of the early medieval states continued this provision.

Christianity modified the non-restrictive attitude toward birth control, but not significantly during the first thousand years of church history. St. Jerome railed against women who drink potions to prevent conception or to abort birth.[14] Mincius Felix condemned those "women who, by drinking medicaments and drinks, extinguish the source of the future man in their very bowels, and thus commit a parricide before they bring forth."[15] The distinction between "medicaments and drinks" is curious. Probably Mincius

was drawing a contrast between the strong drugs, such as rue and penny-royal, and the less harsh ones such as were in the Lorsch manuscript. In any case some early Christian writers were influenced by Stoic teachings on the nature of the soul. Whereas most Stoics asserted that the soul (*psychē*) entered the new person when the child took its first breath of cold air at birth, a few Stoics observed that from conception there was present the potential for ensoulment.

Early Greek and Latin Church Fathers were divided about the ethics of abortion. In a sermon around A.D. 390, John Chrysostom, the bishop of Constantinople, decried those who used contraceptives, likening the practice to sowing a field in order to destroy fruit, and raising the question of whether it was not the same as murder.[16] The association with murder was in excess of St. Jerome's statement that merely condemned the practices of contraception and abortion. John's position was not particularly influential or representative until around the thirteenth century when the church position hardened on the issue of birth control. The position that the church most consistently held was expressed by St. Augustine (354–430), bishop of Hippo, who derived his answer based on Aristotle's proposition that *psychē* did not enter the embryo until the fetus had "formed" recognizable human features.[17] Like most intelligent observers in ancient and medieval societies, Aristotle and Augustine were aware that accidents or Caesarean procedures can cause women to give birth prior to full term and still the child can survive.[18] Thus Aristotle said that the *psychē* or "animation" occurs at some point prior to birth. The Greek church father, Gregory of Nyssa (330–395), took Aristotle's and Augustine's position when he wrote that the unformed embryo could not be considered a human being.[19] By and large, Christianity for twelve hundred years did not differ radically from the position taken by the pagans on birth control. What the church fathers wrote is a matter of record. What is not known is what the silent church mothers' attitudes were.

From the time of Augustus Caesar (d. 19 A.C.E.), the Romans were aware of the deleterious results of a declining population. Accordingly from the first through the third centuries the Romans periodically financed child-rearing support. People, presumably women, were given a monthly allowance for food with monetary differentials based on gender and wedlock. The highest payments went to males born in wedlock and the least amount to females out of wedlock. It is difficult to draw conclusions about the degree to which early Christian thought was influenced by the problem of low birth rates. In any case, the writings of some of the church fathers spoke against abortion and, to a much lesser extent, contraception. The connection be-

tween the early church fathers and governmental officials is that both groups shared a pro-birth policy.

Borrowing from Stoic writings, Christian theology transformed Aristotle's concept of *psychē*, meaning animation, into the meaning of soul, *animus* or *spiritus* in Latin. Medieval people did not believe that the soul originated at conception. The event was too ill-defined in the experience of those lacking microscopes and an understanding of cells and mitosis and DNA combinations. Instead, they thought that at some moment after coitus conception takes place, and then there exists an embryo. First, it becomes alive, and then for months it develops. The theologian Albert the Great (d. 1280) noted that in a fresh abortion or miscarriage the embryo (or fetus) is "seen to have a movement of dilation and contraction when it is pricked with a needle: and thus that creature is known for certain to be animated."[20] The embryo had animal character at this point, not human, because it was prior to its receiving a soul.

Aristotle's question about the timing of animation became, to the Middle Ages, a question about when ensoulment took place. Aristotle was trying to determine when a fetus was capable of surviving outside the womb, and his answer, like the question, was biological. "When is a fetus capable of being a person?" was Aristotle's question. Medieval thinking transformed the question into when does the soul enter the fetus (or child) to become a human with body and soul? Another question was: do any parts of the soul develop before the whole body? No, this cannot be, because parts cannot pre-exist the body.[21] "Some of our colleagues," Albert said, believe that each plant and animal has a soul that is transferred, split off (*ex traducde*), from its parents. These misguided colleagues argued from the observation of nature that a "spirit" of the parents is embedded in the offspring. Thus, they argued, the "spirit" (*spiritus*) must have been present from the beginning. They may have looked at nature, but God, through nature, supplies the soul, and it does not come from the body's parents, Albert believed.

Albert believed as did Aristotle that the embryo/fetus developed like other animals until a time came when it connected with the Divine Intellect or, in another way of saying it, God. This connection is the soul as it enters the body. Thus the soul derives from God, not from the about-to-be-born child's parents. Albert expresses what Aristotle conveyed, "What is alive is not at the same moment sentient, and what is sentient is not at the same moment man."[22] What he understood this to mean is that the embryo develops life first, and afterwards it is endowed with rationality. Humans are rational animals, Seneca asserted. Albert agreed when he wrote:

"The rational [i.e. the human] soul is one substance, from which are derived the vegetative and sensible and intellectual powers, and some of these are affixed to the body, and some not. Those that are not cannot come from the body. Therefore entirely from outside the matter of the seed (*sperma*) the rational and intellectual soul is brought into the fetus (*conceptum*) by the light of the agent intellect."[23]

St. Thomas of Aquinas maintained that the soul is created by God and not by humans.[24] Giles of Rome (1243–1316) restated the Aristotelian-Albertian-Thomistic position in even stronger terms: the early stage of the human embryo is not human but a kind of animal. The logical nail was driven in by Robert Kilwardby, archbishop of Canterbury (1272–9), who said that were the embryo to perish before the soul entered the body there would be no soul to have perished because a soul cannot exist without a body. Otherwise, the soul would be denied the opportunity of resurrection since it would never have had a body from which to resurrect.[25]

Medieval theologians provided the interval between intercourse or conception and human formation of the fetus as a period when a woman could terminate what we, not medieval people, call pregnancy. This was the period when women took drugs to abort by our definition. There was never consistency on this position, however, as the writings of John Noonan describe.[26] No one can read Albert and believe that he thought either contraception or abortion to be sinless. In his works on theology, Albert agreed with the Church's position that humans should not intervene to prevent conception or birth. In his works on natural philosophy, Albert gives practical advice on what to take for birth control. Was this hypocrisy or a change of mind in a different period of life? The answer to both questions is no. Most medieval people had no strict, hard-and-fast rule for birth control, as indicated by what they wrote and how they acted. Abortion could not be said to be approved, but to a degree it was tolerated. And there are varying degrees of sin. One penitential that was later repeated in canon law expressed the intention as being an important factor; "It makes a big difference whether she is a poor woman and acted on account of the difficulty of feeding, or whether she acted to conceal a crime of fornication."[27]

In the period of the Early Middle Ages, when the Lorsch account was composed, libraries contained classical medical writings by Hippocrates, Dioscorides, and Galen, all of which had a number of both contraceptive and early abortifacient prescriptions. The question remains whether medieval people were aware that when a woman took a drug before or after in-

tercourse, she was interfering with her fertility. The answer is that most women probably knew that the drug could prevent a pregnancy as they defined the term. Whether medieval men knew women's secrets is more conjectural. Certainly it would vary according to circumstances and, to a large degree, what women cared to tell.

In some penitentials of the Early Middle Ages, this question was asked by the priest, "Have you drunk any *maleficium*, that is herbs or other agents so that you could not have children?"[28] If the answer was affirmative, a forty-day penance was prescribed. Some of the same penitentials make a distinction between the time period when a drug was taken. Forty days was not only the penance but also the period during which the division was made between a large and a small sin. If a drug or, presumably though not stated, another procedure was successfully employed, the penance was much longer. One sacramentarium around the year 1000 employed the word "homicide" to a woman who aborted after the fetus's appendages had formed.[29] This was in keeping with the division made by Aristotle and accepted by theologians such as Augustine of Hippo. It is meaningful that whenever the means of producing birth control were mentioned in Church sources, drugs were the stated procedure. Also it is important that the term often used for such drugs was *maleficium*, a term associated with black magic.

When women took menstrual regulators to stimulate the menses, they probably knew what it would do to a pregnancy. As we noted, the concept of pregnancy differs from our own. In the terms of the Middle Ages, a male seed was still in the body; in our term, conception had taken place and was the reason for menstrual interruption. Only occasionally during the Middle Ages is this awareness made explicit. For instance, in *On Degrees*, a treatise translated by Constantine the African (d. ca. 1085), celery (presumably celery seed) "provokes urine and menstruation to the greatest extent. Physicians (*medicii*) prohibit pregnant women and those nursing to have celery."[30]

St. Hildegard of Bingen (1098–1117) knew that a menstrual stimulator would prevent birth if a seed or embryo was growing in the uterus. She was abbess of her convent and a keen observer of nature's herbal remedies. In her medical works she explains about seven menstrual regulators. The plant she called *haselwurtz*, our *Asarum europaeum* L., is given to pregnant women who "languish" or to those whose fetus is a danger to her body. She said the plant is given to women who suffer from the pains of delayed menstruation.[31] Clearly she was familiar with the notion that the same plant that stimulated menstruation also aborted a fetus. *Asarum* is employed in modern North American folk medicine for the same purpose.[32] Long before Hildegard's time the plant was employed as a menstrual regulator during

classical antiquity as it was recorded in classical texts.[33] Hildegard, however, did not receive her information from a classical source. Whereas she may have used some texts as references, it is not certain which ones. When she did not know the Latin term for a plant, she was unable to relate what the text said about plants that she knew only in her native German. Not knowing the Latin term *asarum*, she was forced to employ the German word, *haselwurtz*. The source for her information was from her culture. What she knew she learned from others, almost certainly women, women who knew that if you did not want a baby, you took this plant.

St. Hildegard is a good indication of popular culture during the Middle Ages. In her text is recorded the first use of tansy *(Tanacetum vulgare* L.) as a menstrual regulator or, as the case may be, an abortifacient.[34] Tansy is a well-known abortifacient in modern medicine.[35] What is remarkable is that tansy tea is still sold in health food stores whose labels recommend its use as a tonic for women. Women who had a cup of tea infrequently would have no ill effect. One who is pregnant, however, and takes tansy tea frequently over a few days time will most likely have a miscarriage. The difference between a miscarriage and an abortion in the terminology used here is one of intention. A miscarriage was unintentional; an abortion was a desired result. There is no recorded use of tansy in classical Latin or Greek. Indeed, there is no recorded use of a word for the plant, although it certainly existed in Roman and Greek times. Thus the text of Hildegard, one of the most venerated holy women during the Middle Ages, was not only the source of information about abortifacients but it also brought about the delivery of information newly researched in the popular culture.

The numerous references in legal, theological, and medical documents establish that contraceptives and early-term abortifacients were used throughout the Middle Ages. The case with tansy demonstrates that even new drugs were found during the period. For detail, let us look at two of about thirty herbs and, to a lesser degree, minerals that medieval women used to interfere with fertility.

ARTEMISIA

The plant is named after Artemis, goddess of women and the woodland. Artemisia is an aromatic, scrubby perennial that grows from about one to six feet in height and is found throughout Europe and North America (imported from Europe) along roadsides, in vacant fields and margins of woodlands and river banks. Indeed, this common plant is called a weed. It was more than a weed in the Middle Ages; it had fame. The author of one of the most popular herbals produced in the Middle Ages, Macer or Marbode,

chose artemisia as the first and most honored herb to discuss among the seventy-one herbs in his easily remembered poem about medicinal plants. Writing in the late eleventh century, Macer explains why the name comes from the goddess who was called Diana by the Romans. It was Artemis who discovered its uses. And what were they? The poem says, "Mainly it cures female ailments. It stimulates the menses and, whether drunk or applied, it produces an abortion."[36]

Explicitly Macer recognized that menstrual regulators also acted as abortifacients. As a rule, medieval writings were more reluctant to specify abortifacients than were classical works; instead they relied more on circumlocutions, such as menstrual stimulators. The Greek text of Oribasius (fl. 360) said that artemisia caused an abortion, whereas the Latin translation that circulated in Western Europe translated the words to mean an emmenagogue, that is, menstrual stimulator.[37] Artemisia was prescribed explicitly for an abortion to be taken orally by Theodorus Priscianus (late 4th century).[38] Aspasia (f. 2nd century) wrote a treatise on gynecology in which artemisia was given in a prescription for a sitzbath that produced an abortion. If the sitzbath did not work, one was advised to take a drachma of artemisia seeds in a drink.[39]

Another popular work during the Middle Ages was the *Regimen of Health* (*Regimen sanitatis Salernitanum*) that circulated in verse, we suppose, both orally and in written form. One of the early versions that is recorded has only one birth control agent, artemisia, that is said to be for "an abortion" and taken either orally or by application, meaning as a suppository.[40] In contrast and more in keeping with the historical trend, the works of the first female gynecologist recommend artemisia but not specifically for an abortion. The work attributed to Trotula (late twelfth or early thirteenth century) said only that artemisia was a menstrual stimulator.[41] Arnald of Villanova (c. 1240–1311), who taught and practiced medicine at Montpellier, gave only one recipe for delayed menstruation in his work *On compound medicines*. The recipe consisted of caper and artemisia.[42]

Knowledge about the use of artemisia for birth control continued throughout the Middle Ages but the plant was referred to as a menstrual regulator. Animal research in modern laboratories over the last twenty years indicates that plants of the artemisia genus cause a delay in the production of the female hormone estrus. This can either interfere with ovulation or with implantation, thereby confirming what was known during the Middle Ages; namely, artemisia could act as both a contraceptive and an abortifacient. That part of the knowledge was lost in modern times until recent scientific studies. In 1939 a French medical guide listed artemisia as an emmenagogue (menstrual stimulator), and in 1986 the popular *Reader's Digest* guide called

Magic and Medicine of Plants repeated the same line.[43] What many moderns do not know and what we suppose most medieval women did know is that it was an antifertility agent.

JUNIPER

Juniper is an evergreen shrub or small tree from the Cypress family. Its berries were used in various medicines and were thought to prevent diseases. It may have been for that reason that juniper berries were placed in alcoholic drinks, thus making what we now call gin. The Roman writer, Pliny the Elder (d. 79), gave another use for juniper berries and one that probably was their most important and popular use. Pliny reported, "Gossip records a miracle: that to rub it [crushed juniper berries] all over the penis before coitus prevents conception."[44] The action of juniper was not on the male but the female. The male member was merely the deliverer. Throughout the Middle Ages, juniper was often prescribed variously as a contraceptive, abortifacient, and menstrual stimulator. Salernitan works of the twelfth and thirteenth centuries referred to it as a regulator, while a number of Arabic medical writers said that it was an abortifacient. They include Al-Razi (Rhazes, 865–925), ibn Sarafyun (Serapion the Elder, 9th c.), and ibn Sīnā (d. 1037). When Gerard of Cremona (d. 1187) translated each of their works into Latin, he did not hesitate to say that juniper provokes the menses but, if the woman was pregnant, it would cause an abortion.[45]

In another way, Gerard's translation of ibn Sīnā's use of juniper is revealing: "Juniper provokes the menses, destroys the fetus/embryo inside the womb, and extracts a dead one."[46] Many of the classical texts and some medieval ones said only that the drugs expelled a dead fetus. A woman who declared her fetus dead, as best we can tell, would have her word accepted. Thus a physician who assisted her would not knowingly deliver an abortion. He would believe that he was engaging in a therapeutic act. Neither the physician nor others in the household or community would know that what killed the fetus was the drug that was taken to expel a dead fetus. Medieval society was similar to ancient Greek society in the way it regarded a woman's word as being the determinant of pregnancy. According to Greek law, a woman was the sole determiner unless the pregnancy was so advanced as to be obvious. But that same society did not accept the testimony of women in court as reliable witnesses.[47] Even though our knowledge of the actual antifertility drugs is derived mostly from medical documents that were written chiefly by men, most women who took them did so not because of the advice or even with the knowledge of physicians. What to take, in what amount, at what time, preparation, and frequency they learned from their

mothers or from community herbalists, midwives, and rustic practitioners. Indeed, from them comes much of the data that appears in the documents.

MEDICINE, ABORTION AND THE LAW DURING THE MIDDLE AGES

Seldom do the medical documents discuss either contraception or abortion. Some physicians thought that they were bound ethically to the precepts of the Hippocratic Oath, even though it was not formally administered during the Middle Ages. Just the same, the Hippocratic ethic survived. Latin texts of the Oath contain a line that said, "Neither will I give to a woman an abortative." The line was a mistranslation of the Greek. The Hippocratic Oath in its original text, as best modern scholars can determine, said, "Neither will I give to a woman an abortative pessary."[48] In other words, the physician was not promising to withhold his services in the performance of an abortion. He merely denied himself the use of one procedure. Pessaries for abortion were considered dangerous and the cause of harmful side-effects, such as ulcers.

A few medieval physicians did comment on what they must have thought was a Hippocratic prohibition for abortion. Strangely, there is little recognition in the medieval documents of where a medieval physician expressed doubt or confusion. In the gynecological treatises attributed to Hippocrates, there are numerous contraceptive and abortifacient recipes, as we observed earlier. These treatises were unavailable in Latin, but the Arabic writers whose works were known in Latin did recognize what we would say was a contradiction. Theodore Priscianus (4th century) and Ibn Sīnā justified abortions in some circumstances and, in the case of Theodore, he was aware of the version of the Oath that prohibited any abortion.[49] Whereas Theodore noted that the Hippocratic Oath prohibited abortions, he added that Hippocrates was also a compassionate physician who swore to help those in need. There are times, he said, when a continuation of pregnancy will result in death to the mother and child. Two specific examples he gave was extreme youth or an opening too small for delivery. In cases where suffering would be great, the physician should assist in a termination of pregnancy. In other words, there were times when the physician's concern for women patients overrode a reluctance to administer an abortion. When action is required, a physician should know what to do. Accordingly, Theodore gave a number of recipes for contraception and abortion.[50] The recipes included artemisia and some of the same ingredients found in the Lorsch manuscript.

The physician William of Saliceto (d. ca. 1280) took the same position as Theodore and Ibn Sīnā except, rather than citing the Hippocratic

Oath, he said, "according to the strict rules of law."[51] There were no medieval laws that made abortion criminal. A late medieval principle allegedly promulgated by Edward I (1271–1307) of England came close to making abortion criminal. One who assisted a woman whose pregnancy was advanced ("formed and animated") was guilty of a homicide.[52] The rule could be interpreted, however, to be an extension of the ancient and early medieval principle that held a person guilty of malpractice who denied to a man a child whom he had conceived. To be noted, the woman who had the abortion was not liable to a legal infraction. English medieval common law did not make abortion per se criminal.

To what then was William of Saliceto referring? Within the context of his time and society, he meant "law" in the sense of "customary practice" or, in our terms, according to the ethics of his profession. Since the Roman Empire, abortionists were associated with "black magic." The term would have included those who performed surgical or manipulative procedures as well as drugs. William justified positive action by the physician: "Nevertheless [despite the "laws"] [it is necessary] for the ordinary course of medical science on account of the danger that comes to a woman because of a dangerous risk of conceiving on account of her health, debilities, or the extremity of youth" for him to give information to his readers about contraception and abortion.[53] The first recipe that he gave was a drink composed of juniper and a fern that prevented conception. Next he gave a recipe if the period after sexual union had been more than ten days. It consisted of three drachmas of juniper and rue.[54] If the interval was much longer (a time period he did not define), there were a number of other recipes that would relieve the woman from bearing a child. Was it abortion? To him, it was a discerning judgment of the type that a compassionate physician was compelled to make.

The recipes given by William were not exactly the same as those that appeared in the Lorsch manuscript of around 800 A.D. There was a connection. The link was a continuation of knowledge about birth control agents that were effective and safe, if taken in amounts within a safe range and prepared in the proper way. The knowledge was mostly possessed by women. They learned primarily from orally transmitted knowledge. In modern times, there are few women who now know what was once known by many.

Epilogue

In 1803 Parliament passed the Ellenborough Act, the first law in the English-speaking world that made abortion a criminal act. The only type of abortion specified was the taking of "noxious and destructive substances."

In 1852 Dr. Pascoe in Cornwall was found guilty of administering juniper to a woman who was pregnant even though she had not informed him of her condition.

In 1869 Pope Pius IX dropped the distinction between formed/unformed fetus and, therefore, the point where ensoulment occurs. The practical and perceived result was that the Catholic Church recognized that life (hence, ensoulment) began at conception.

In 1924 the State of Iowa had an anti-abortion law that included this provision: "No person shall sell, offer or expose for sale, deliver, give away, or have in his possession with intent to sell, except upon the original written prescription of a licensed physician, dentist, or veterinarian any cotton root, ergot, oil of tansy, oil of savin [juniper], or derivatives of any said drug."

Cotton root is an abortifacient, the knowledge of which was brought by African slaves. Ergot is a drug from a toxic fungus whose antifertility properties were employed in eighteenth-century medicine for late-term abortions and for stimulating birth contractions. By listing the abortion drugs, unwittingly the Iowa lawmakers acknowledged that these drugs were a combination of medieval and modern discovered medical lore through empirically derived experiences. Cotton root and ergot were modern; tansy was a medieval discovery and juniper went back to remote antiquity. Thus in the twentieth century we have a reflective continuation of medieval practices, however faint, that was combined with new discoveries. These discoveries resulted from experiences by ordinary people within a common, popular culture. Modern science is just now recognizing that medieval people knew more about the world than we thought possible. They also had more control of their lives than we thought conceivable.

NOTES

1. Bamberg Ms med. 1, as published by Ulrich Stoll, Das 'Lorscher Arzeibuch' (Stuttgart: Franz Steiner, 1992), 116.

2. Amonum was sometimes a synonym for the geranium plant. See William F. Daems, Nomina simplicium medicinarum ex synonymariis medii aevi collecta (Leiden: Brill, 1993), no. 378, 231. It may also be a form for ammoniacum, in which case it would be from the giant fennel family.

3. C.K. Atal, Usha Zutshi, and P.G. Rao, "Scientific Evidence on the Role of Ayurvedic Herbals on Bioavailability of Drugs," Journal of Ethnopharmacology 4 (1981): 231; Merck Index, 1976, 1129; James A. Duke and E.S. Ayensu, Medicinal Plants of China, 2 vols. (Algonac, MI: Reference Publications, 1985), 1, 484.

4. Dioscorides, De materia medica 2, 159. Ed. Max Wellmann, 3 vols. (Berlin: Weidman, 1958: in Greek). For an English edition see The Greek Herbal of Dioscorides, Englished by John Goodyer (1655) and edited by Robert T. Gunther (New York: Hasner, 1959).

5. Norman Farnsworth et al., "Potential Value of Plants as Sources of New Antifertility Agents," Journal of the Pharmaceutical Sciences 64 (1975): 577.

6. A. Goris and A. Liot, *Pharmacie Galénique*, 2 vols. (Paris: Masson, 1939), 1833.

7. B.B. Sharma et al., "Antifertility Screening of Plants. Part I: Effect of Ten Indigenous Plants on Early Pregnancy in Albino Rats," *International Journal of Crude Drug Research* 21 (1983): 185.

8. R.C.D. Casey, "Alleged Anti-fertility Plants of India," *Indian Journal of Medical Sciences* 14 (1960), 590–600; Farnsworth et al., "Potential Value of Plants," 554.

9. Farnsworth et al., "Potential Value of Plants," 576.

10. Macer, in *Aemilius Macer De herbarum virtutibus;* Commentaries by Joannis Atrociani (Freidburgh, 1530), fol. 45v.

11. Berlin Papyrus 192 (Rs. 1,2–2).

12. See Helen Rodnite Lemay, *Woman's Secrets: A Translation of Pseudo Albertus Magnus's De Secretis Mulierum with Commentaries* (Albany: SUNY Press, 1992).

13. See references in John M. Riddle and J. Worth Estes, "Oral Contraceptives in Ancient and Medieval Times," *American Scientist* 80 (1992): 226–33.

14. Jerome, *Letter 22, to Eustochium* 13, *Patrologia Latina*, ed. J.P. Migne (Paris: Garnier Fratres, 1844–64), 22:401. Henceforth *PL*.

15. Mincius Felix, *Octavius* 30 (Wallis trans., Ante-Nicene Fathers, ed. A. Roberts and J. Donaldson (repr. Grand Rapids: Eerdmans, 1951–56. 4:192).

16. John Chrysostom, *Homily 24 on the Epistle to the Romans, Patrologia Graeca*, ed. J.P. Migne (Paris: Garnier Fratres, 1857–86), 60:626–7.

17. Augustine, *Quaestiones Exodi* 80, 1439–45, *Corpus Christianorum Series Latina* (Turnhout, Belgium: Brepols, 1953–7), *33*, pt. 5.

18. Aristotle, *History of Animals* 7.3.588b; cf. *Generation of Animals*, 736a–b, where he is less definite about the timing.

19. Gregory, *Adversus Macedonianos*, as cited by G.R. Dunstan, "The Human Embryo in the Western Moral Tradition," in *The Status of the Human Embryo: Perspectives from Moral Tradition* (London: King Edward's Hospital Fund for London, 1988), 44.

20. Albertus Magnus, *De animalibus* 9. tr. 1, c 3, as cited in Luke Demaitre and Anthony A. Travill, "Human Embryology and Development in the Works of Albertus Magnus," in *Albertus Magnus and the Sciences. Commemorative Essays 1980.* James A. Weisheipl, ed. (Toronto: Pontifical Institute of Mediaeval Studies, 1980), 405–440, esp. p. 427.

21. Aristotle, *On the Generation of Animals*, 2.3.736b27–8.

22. Albert, *De Animalibus* 16.1.11 in *Opera Omnia* (Paris: 18); for a discussion, see Pamela M. Huby, "Soul, Life, Sense, Intellect: Some Thirteenth-Century Problems," in *The Human Embryo: Aristotle and the Arabic and European Traditions* (Exeter, Eng.: Exeter University Press, 1990), 116 [113–2].

23. Albert, *De Animalibus* (Stadler ed., p. 1093).

24. Thomas, *Summa Theologiae*, trans. English Dominicans (Burns, Oates, and Washburne, 1972). Ia. 118, art. 1–2.

25. Huby, pp. 120–21.

26. John T. Noonan, *Contraception: A History of Its Treatment by the Catholic Theologians and Canonists*, rev. ed. (Cambridge, MA: Harvard University Press, 1988).

27. Pseudo-Bede, *Penitential* 2.11; Burchard. *Decretum.* 19 (*PL*, 140:972).

28. Pseudo-Bede, *Order for Given Penance* 30 (cf. James Noonan, *Contraception*, 156).

29. Text published by L. Lewin, *Die Fruchtabtreibung durch Gifte und andere Mittel: ein Handbuch für Ärtze und Juristen* (Berlin: Julius Springer, 1922), 84.

30. Constantine, *On Degrees*, p. 379, in *Opera* (Basel, 1536).

31. Hildegard, *Physica* 42 (*PL*, 198: 1148).

32. V. Brondegaard, "Contraceptive Plant Drugs," *Planta Medica* 23 (1973): 168.

33. E.g., Dioscorides. *De materia medica*, 1.10.

34. *Physica* 111 (*PL* 197:1174).

35. James A. Duke, *CRC Handbook of Medicinal Herbs* (Boca Raton, FL: CRC Press, 1985), 474.

36. Macer. *De herbarum virtutibus* (1530 ed.), no. 1, fol. 1.

37. Oribasius. *Ecologae medicamentorum*, 632 in ed. Johannes Raeder, *Oribasi Collectionum medicarum* (Leipzig: Talner, 1928–33) 6, pt. 2, fasc. 2, p. 302); cf. with Latin translation, *Synopsis* 2 in *Oribasius Latinus*, ed. Hennig Morland (Oslo: Brogger, 1940), p. 148.

38. Theodore. *Euporiston* 3.6 (Wellmann ed., 241–44).

39. Cited through Aëtius, *Biblia iatrika* 16.17 in Peri ton en metrai pathon, ed. Skévos Zervòs (Leipzig: Anton. Mangkos, 1901) (Zervòs ed.); the same prescription is in Soranus, *Gynaecology* 64, *Sorani gynaecorum libri IV*, ed. Johannes Ilberg (Berlin: Teubner, 1927). There is an English translation, *Gynaecology* by Owsei Temkin (Baltimore: Johns Hopkins University Press, 1956).

40. *Regimen Sanitatis*, 14 (De Renzi edition edited Salvatore De Renzi, *Collection Salernitana* (repr. Milan: Ferro Edizioni, 1967), 1:462.

41. Trotula, *Gynecology* (in Gynaeciorum hoc est De Mulierum tam aliis, ed. Conrad Gesner and Caspar Wolf (Basel: Thomas Guarinus, 1566), cols. 222–3).

42. Arnald, *Antidotarium* chapter 56 (1495 in facsimile ed.) (Burriana, Spain: Castellon, 1985).

43. A. Goris and A. Liot, *Pharmacie Galénique*, 2 vols. (Paris: Masson, 1939), 2: 1833; *Magic and Medicine of Plants* (Pleasantville, NY: Reader's Digest Association, 1986), 258, 348.

44. Pliny, *Natural History*, 24.11.18, ed. and trans. W.H.S. Jones (Cambridge, MA: Harvard University Press, 1929–71).

45. See references in John M. Riddle, *Contraception and Abortion from the Ancient World to the Renaissance* (Cambridge, MA: Harvard University Press, 1992), 130–34.

46. Ibn Sīnā, *Canon* 2. tract. 2. chap. 5, trans. Gerard of Cremona [1557]. For further discussion see Riddle, *Contraception and Abortion*, pp. 127–35.

47. Helen King, "Making a Man: Becoming Human in Early Greek Medicine," in: *The Status of the Human Embryo*, 11.

48. Riddle, *Contraception and Abortion*, 7.

49. Theodore Priscianus, *Euporiston* 3.6 ed. Valentino Rose (Leipzig: Teubner, 1894), 240–4; Ibn Sīnā, *Canon* 3. fen. 21, chaps. 12–14.

50. Theodore Priscianus, *Euporiston* 3.6 (240–44).

51. William of Saliceto, *Summa Consruationis et curationis* (Venice, 1502), 175.

52. *Juris anglicani* 1.23.10, as cited by Lewin, p. 89.

53. William, *Summa* chapter 175.

54. Ibid., 163.

BIBLIOGRAPHY

Brundage, James A. *Law, Sex, and Christian Society in Medieval Europe.* Chicago: University of Chicago Press, 1987.

Bullough, Vern L. *Sexual Practices and the Medieval Church.* Buffalo: Prometheus Books, 1982.

Dunstan, G.R. *The Human Embryo: Aristotle and the Arabic and European Traditions.* Exeter, Eng.: University of Exeter Press, 1990.

Green, Monica H. "Women's Medical Practice and Health Care in Medieval Europe." *Signs: Journal of Women in Culture and Society,* 14 (1989): 434–73.

Hopkins, Keith. "Contraception in the Roman Empire." *Comparative Studies in Society and History,* 8 (1965–6):124–51.

McLaren, Angus. *A History of Contraception from Antiquity to the Present Day.* Oxford: Basil Blackwell, 1990.

Mohr, James C. *Abortion in America: The Origins and Evolution of National Policy, 1800–1900.* Oxford: Oxford University Press, 1978.

Noonan, John Thomas, Jr. *Contraception: A History of Its Treatment by the Catholic Theologians and Canonists.* Rev. ed. Cambridge, MA: Harvard University Press, 1986.

Riddle, John M. *Contraception and Abortion from the Ancient World to the Renaissance.* Cambridge, MA: Harvard University Press, 1992.

For further references and sources, see Riddle, *Contraception and Abortion from the Ancient World to the Renaissance.*

12 CASTRATION AND EUNUCHISM IN THE MIDDLE AGES[1]

Mathew S. Kuefler

The modern bibliography of medieval castration truly begins with the 1936 publication by the German Jesuit scholar Peter Browe of a work entitled *Zur Geschichte der Entmannung: Eine Religions- und Rechtsgeschichtliche Studie*.[2] The several general histories of castration that antedate Browe's study must be considered as having been largely superseded by it. This earlier list is mostly comprised of turn-of-the-century works in French,[3] which tend to be less scholarly than Browe and lack, for instance, his extremely detailed footnotes. Browe also occasionally corrects the errors of earlier scholars.[4]

In addition to improving upon the work of earlier scholars, Browe is also relatively unusual among his contemporaries and authors of later works in having avoided the perspective of psychoanalysis as his point of departure. Since both Sigmund Freud[5] and Carl Jung[6] incorporated castration into their analysis of sexuality and human development, and both also championed the historical and mythological application of their ideas, it was not surprising that some scholars took up the task of integrating psychological and historical understandings of castration.[7] This interpretation has been brought to bear on the medieval record, in debates over castration anxiety in the memoirs of Guibert of Nogent,[8] or in appreciating Peter Abelard.[9] It remains seriously controversial, however.

Browe's work, while intending to be an overview of the eunuch's place in world civilization, barely scratches the surface of non-Western (if such a term has meaning) experiences and expressions of castration. This is perhaps not too surprising for a scholar of medieval Europe whose previous works had dealt with eucharistic theology and Jewish-Christian relations. While fortunate for us who work in this field, Browe is not to be preferred in cross-cultural analysis to his predecessors or successors. Much work could still be done by future scholars in comparative cultural studies of institutionalized castration.[10]

Still, Browe has not been supplanted by any modern, that is, late twentieth-century history of medieval castration.[11] Only brief if interesting discussions exist, for example, by Vern L. Bullough on eunuchs in the Byzantine imperial court in his survey of the history of sexuality,[12] or by Aline Rousselle on the links between religious castration and infant sacrifice in her work on religion and sexuality in later Roman antiquity.[13] Other works that help to fill this gap will be mentioned in the course of this article. Still other works are in process, which it can be hoped will supplement the literature on the subject.[14] At present, therefore, there is no modern synthesis of castration in Europe in the Middle Ages.[15]

The trans-historical focus of most works on castration reminds us that eunuchs in medieval European society had a history stretching back much further than the beginning of the Middle Ages. Any study of castration must take into consideration the continuities of medieval society with the ancient world. These continuities, especially in the production and uses of eunuchs, were much more pronounced in Byzantine Europe than in Germanic Europe, since generally more of the institutions of classical Greece and Rome survived in the east. Continuities with the ancient world in the use of eunuchs are also very much apparent in the Muslim world, and they influenced Christian Europeans whenever and wherever interactions between these two cultures took place. For example, the ninth-century bishop Eulogius of Toledo in Muslim Spain mentioned a eunuch administrator,[16] and Holy Roman emperor Frederick II brought Muslim eunuchs from Sicily to Germany in 1235 as part of his wedding gift to his English bride, Isabella, sister of King Henry III.[17] There were also brief contacts with eunuchs of more distant cultures contemporary to medieval Europe, for instance, those made by Marco Polo in his travels.[18]

A different but equally important link with castration in the ancient world was literary continuity: first, religious, through the many examples of eunuchs in the Christian Bible; second, legal, through the persistence of Roman law on the practice of castration in medieval Europe; and third, in belles lettres, through the transmission of the many classical Latin authors who included mentions of eunuchs in their works. On this last point one need only think of Hroswith of Gandersheim, the tenth-century Christian playwright, who presented her plays expressly to counter the immoral influence of the popular plays of Terence, which surely included his famous *Eunuchus*.[19]

The Bible abounds with depictions of eunuchs in positions of power. Potiphar, the official of the Pharoah in Egypt whose wife tried to seduce Joseph, was a eunuch;[20] as was Bagoas, the chargé d'affaires to the Assyrian

commander Holofernes in the story of Judith;[21] as too were the nameless functionaries in King David's court;[22] Ebedmelech, the courtier of King Zedekiah, perhaps the same man as the unnamed commander of the defenders of Jerusalem at the time of the prophet Jeremiah;[23] and Ashpenaz, who trained the prophet Daniel to serve at Nebuchadnezzar's court.[24] Even Daniel himself was a eunuch, according to Jewish tradition,[25] a tradition which Jerome transmitted to medieval Christians.[26]

Other ancient governments in addition to that of Israel depended on eunuchs in their bureaucracies, and literate persons in the Middle Ages could read of them in ancient Greek and Roman histories.[27] The Christian Roman government continued the practice of using eunuchs in several of its imperial ministries, and they are mentioned in virtually all emperors' biographies as important court officials. An article by Keith Hopkins discusses the use of eunuchs in the later Roman government,[28] and a more recent work by Peter Guyot on eunuchs in ancient bureaucracies includes a chapter on the fourth century C.E.[29] This reliance upon the administrative functions of eunuchs continued throughout the history of the eastern Roman or Byzantine Empire. The variety of offices performed by eunuchs in later Roman and Byzantine governments has been exhaustively studied by Rodolphe Guilland in *Recherches sur les institutions byzantines*,[30] again demonstrating the continuity between the ancient and medieval uses of eunuchs.

Guilland also discusses the assignment of military commands to eunuchs by the Byzantine government, if much more briefly. Nevertheless, he lists forty-five examples of eunuchs charged with military commands, beginning with Narses, the sixth-century general under Justinian.[31] Future scholarship is sure to expand on this curiously masculine role for a group of men so frequently denigrated as unmanly.[32] To Guilland's references might be added that of the fourth-century writer Ammianus Marcellinus, who hinted at the military importance of Eusebius, a eunuch adviser of Constantius II,[33] or the fifth-century poet Claudian's complaint that a military victory of the eastern Romans against the Huns in 398, under the leadership of the eunuch Eutropius, had resulted in his being rewarded with the consulship for the following year.[34]

Religious castration is another important institutionalized aspect of castration in the ancient world with continuities in the medieval world. It is also the starting point of most histories of castration.[35] Castration was often associated with pagan religious mythology, and this was reflected in medieval texts. Saturn's castration, for example, found a place both in the theology of John Scotus Erigena and the epic adventure of the *Roman de la Rose*.[36] Castration was especially important in the religious cult of the great

goddess, worshiped with her son and consort under various titles and names in the syncretic atmosphere of the later Roman Empire.[37] The primary myth of the cult centered on the love of the great goddess for her consort, either her lover or son or both, who had been castrated and whose death she overcame by restoring him to life.[38] The fourth-century Roman emperor Julian the Apostate was a fervent devotee of the cult of the great goddess and author of an apologetic work on the religion.[39]

In addition to the presence of castration as a strong mythic element in the cult, priests of the great goddess were known to castrate themselves at the annual commemoration of the castration of their goddess's consort on March 24. These eunuch-priests, called *galli*,[40] were also known to dress in women's clothing, to engage in riotous music-playing and frenzied dancing, and to practice ritual or sacred prostitution with men who attended the festival.[41] The reasons for the association of castration with the worship of the great goddess have never been satisfactorily explained.[42]

Christian writers strongly condemned the religion, as they did all pagan rites, but especially because of the sexual practices and blurring of gender distinctions particular to this religion. The condemnation of religious castration was an important part of patristic polemics against pagan religion, and thus found its way into the canon of medieval religious writings. Strongest in their condemnations were Lactantius,[43] Firmicus Maternus,[44] and Augustine of Hippo.[45] Interestingly, all of these writers came from Africa, as did Tertullian, who was most anxious to distinguish Christianity from worship of the great goddess.[46] The two religious movements had much in common: a holy mother, a divine son, a sacrificial death, a miraculous resurrection, an annual spring commemoration, and an unmarried clergy.[47] Nonetheless, the possible continuities between the two groups have not been adequately treated despite the overwhelming evidence; for example, the church of Sta. Maria Maggiore in Rome was known even in the twelfth century to have been built over the site of an ancient temple to the great goddess.[48]

Part of the problem which Tertullian and later medieval writers were obliged to address in distinguishing the Christian religion from the religion of the great goddess is the biblical tradition that Jesus had asked his followers to become eunuchs for the sake of the kingdom of heaven.[49] There was much patristic and medieval commentary on this saying, virtually all of which interpreted it as a call to sexual renunciation.[50] A search such as can now be done on the computer disk programs for some medieval sources produces some fascinating results on the details of this exegetical tradition.[51] According to my searches of some significant writers of later Roman antiquity and the early Middle Ages, Augustine repeated the idea in thirteen of his trea-

tises,[52] and Jerome used it in fourteen of his treatises and letters.[53] In contrast, Bede only used the biblical phrase once in the eighth century,[54] and Thomas Aquinas only referred to it once in the *Summa Theologiae*.[55] What had changed between late antique and medieval exegesis on spiritual castration? Perhaps the greater presence of self-castrating eunuchs in society demanded explanation of the biblical text more than in later periods, but such a conclusion must remain tentative until further study is done. Computer searches might well be done on any of the other biblical references to eunuchs, with interesting results.

In the use of castration as a positive metaphor, Christianity set itself against Jewish tradition. The *Torah* is clear on the ostracism of eunuchs specifically from the priesthood,[56] although the prophet Jeremiah escaped death because of a eunuch's assistance,[57] and the prophet Isaiah did look to a future in which eunuchs would be fully integrated into the community.[58] It is probably in claiming that this future had arrived that the story of the apostle Philip's baptism of a eunuch, identified as a government official of Ethiopia, was included in the New Testament.[59] There was considerable medieval commentary on this passage too, although most of it dealt with defining the nature of baptism rather than exploring the inclusion of eunuchs in the Christian community.[60] Thomas Aquinas, however, in commenting on the passage in *Isaiah*, reasoned that God's grace is given in no way less to eunuchs than to others.[61] On that score, as much as Firmicus Maternus maligned the eunuch-priests of the great goddess, he still invited them to repent and believe in the true religion.[62]

The possibility that eunuchs might live pious Christian lives was continually reinforced by the numbers of eunuchs revered as saints or holy men. The earliest example is a young Alexandrian praised by Justin Martyr.[63] Browe includes a list of over a dozen names, mostly Greek, from various sources.[64] Other, less honorable eunuchs are also named.[65] In addition, Browe cites references to dozens of other, nameless monks and hermits who were eunuchs.[66] One might also list the numerous tales of holy men castrated by saints or angels sent by God: Pachon of Scetis,[67] Serenus the Gardener,[68] Equitius of Valeria,[69] Hildefonsus of Toledo,[70] and an anonymous thirteenth-century German Cistercian monk.[71] Even Thomas Aquinas was said by one of his biographers to have had his loins tied by two angels, in an obvious parallel to the earlier stories.[72] The wide geographical distribution of such legends, here from Egypt to the Rhineland, is in itself noteworthy.

Although medieval Jewish tradition had its own legends of men castrated by angels,[73] for the most part the ancient regulations against castration were upheld. The *Mishnah*, for example, in commenting upon *Leviticus*,

prohibited eunuchs from entering into Jewish congregations.[74] The *Talmud*, while it included an amusing tale of a rabbi and a eunuch insulting each other,[75] and often returned to the stereotyped hairlessness of eunuchs,[76] seemed much more concerned with the varieties of genital abnormalities and the significance of these abnormalities for the status of the men involved, especially in marriage and participation in the community as adult males. Three different types of eunuchs were delineated: castrated men,[77] men who were wounded in the genitals,[78] and men with disorders preventing their genitals from developing at puberty.[79] A rewarding study of the medieval Jewish biblical and Talmudic exegetical tradition could be made.[80]

All Jewish men were circumcised, though. It is possible that part of the medieval Christian opposition to the practice of circumcision stemmed from its perceived relationship to castration, since Roman and medieval texts tend to regard it as a sort of half-castration. Roman law in the *Digest* excused Jews from suffering any penalty for castration because of the circumcision of their sons, which implies that there was some confusion in the minds of judges; all non-Jews were forbidden to circumcise, however, or risk those very penalties.[81] Early Germanic law does not take a stand on this point, but from the twelfth century onward German law also forbade circumcision to non-Jews, perhaps under the influence of the spread of the *Digest*.[82] Especially vulnerable to circumcision, it was believed, were Christians employed by Jews as servants or bought as slaves; their circumcision was both required by Jewish law[83] and forbidden by Christian law.[84] The relationship between the stigma of castration and that of circumcision in the medieval Christian mind might be profitably examined by future scholars.

Notwithstanding the medieval opposition to circumcision, part of the Christian tradition of "making oneself a eunuch for the sake of the kingdom of heaven" is that some followers of Jesus took him at his word. We have numerous examples of self-castration by Christians. Browe deals with this, and notes both the typical condemnation by Christian writers[85] and yet its perennial recurrence. Enough clerics were doing it that the practice had to be outlawed by the Council of Nicaea in 325,[86] and this provided the legal precedent for the opposition to the ordination of eunuchs in later western canon law,[87] although it was permitted in the eastern churches.[88] The devil, however, could appear in the guise of a saint and counsel a man to castrate himself, as Guibert of Nogent explained in the late eleventh century,[89] but this could only be successful because an uneducated Christian might think self-castration something a saint would recommend.

Many groups in early Christianity advocated complete celibacy by condemning sex and marriage, like the Encratites of Syria or the Marcionites of

Asia Minor, and Tertullian, for example, dismissed these groups as no better than eunuchs, because they prohibited what should be permitted.[90] But at least one group in the region of Philadelphia in Syria at the turn of the fifth century, called the Valesians after their founder, either Valens or Valesius, went one step further and advocated physical castration for all its male adherents.[91]

The most famous case of Christian self-castration was without doubt Origen of Alexandria, who although a second-century figure, enjoyed a certain immortality through the description of his life and self-castration in Eusebius's *Ecclesiastical History*, translated in the fourth century into Latin by Rufinus and widely circulated in the Middle Ages. Eusebius says that Origen's action was done out of a youthful and misguided exuberance to avoid the scandal that his religious instruction of women was provoking.[92] This is often the motive given for self-castration by later Roman and medieval Christians.

Notwithstanding this prophylactic self-castration, it is unclear just how effective such a procedure would have been in removing sexual desire from men. Modern studies are inconclusive, but show a continued sexual interest in a significant minority of castrated men.[93] Ancient and medieval writers were aware of the ambiguous effects of castration on sexual interest.[94] The Bible, for instance, represented castration not as removing desire for sex, but merely the means of effecting the desire.[95] Tertullian[96] and Claudian[97] in late antiquity repeated this idea. In the same vein, Eusebius declared that Origen had castrated himself in order to avoid the potential for sex, and Peter Abelard in the twelfth century also believed that his castration removed all possibility of sexual scandal from his conduct.[98] In reality, however, castration at least permitted the individual eunuch to engage in non-penetrative sexual activity. Basil the Great implied this, saying in the context of a discussion of castration that a de-horned bull will attempt to butt with its head.[99] There are usually only vague references to the types of sexual activity possible to eunuchs, but they include oral, anal, and manual stimulation of another's genitals. Often, therefore, a conflation between castration and passive homosexuality was made in the sources.[100]

The variety of medical methods of castration played a part in the possibility of a eunuch's involvement in sexual activity. Unfortunately, reticence has prevented historians of medicine from adequately documenting methods of castration. Even a recent historical discussion of sexuality and medicine in the Middle Ages barely mentions castration.[101] Frankly put, there were three possibilities: first, removal or disabling of the penis; second, removal or disabling of the testicles; and third, removal or disabling of the entire genitals. The different surgical procedures are described by the sev-

enth-century Byzantine writer Paulus Aegineta.[102] It is not unreasonable that at least some eunuchs who still retained their penises could continue to achieve erections, and this can be confirmed from contemporary sources.[103] The operation was a dangerous one, however: Justinian mentioned in a law that he had heard of one episode in which ninety men were castrated, but only three survived the procedure.[104]

The opinion of ancient science that castration, despite its risks, could cure or at least alieviate certain ailments also made its way into medieval medicine.[105] In the thirteenth century Thomas Aquinas justified what had long been medical practice, that castration was a permissible mutilation if used to save the whole person.[106] The variety of diseases that castration was believed to cure, as documented by Browe, is a striking assessment of medieval notions of medicine. While castration as a cure for satyriasis and elephantiasis was perhaps understandable because these diseases involve abnormalities of the genitals, hernias seem also to have been indirectly treated through castration. Eunuchs were also thought not to suffer from baldness, and so castration might be a draconian measure for the prevention of hair loss.[107] Castration as a treatment for leprosy might have also been connected to this belief in the unique properties of eunuchs' skin. Gout and varicose veins seem completely unconnected to the genitals or to any possible benefits from castration (although they were treated in this manner) except perhaps through medieval notions of the circulatory system, in which semen was thought to be purified blood; gout was also widely believed to be caused by the sort of riotous living to which castration might help put an end. In the case of epilepsy, which might also be treated through castration, ancient medical writers considered it to be brought on or at least aggravated by sexual passion, and so castration might be used to lessen epileptic fits.[108]

Also of medical note is the fact that ancient and medieval writers often included groups different from castrated men in the category of eunuch. Roman law spoke of eunuchs by nature,[109] probably referring to men with undeveloped sex organs, which is usually how Jesus' statement about eunuchs born that way from their mother's womb is interpreted.[110] The *Talmud*, after listing congenital eunuchs and eunuchs made so by men together, adds the category of hermaphrodites, or at least those persons of indeterminate sex.[111] Impotent men were sometimes also classified with eunuchs.[112] These are important conceptual points for the history of medieval sexuality that need greater clarification.

Another important aspect of institutionalized castration, although one which Browe refuses to discuss, is that eunuchs might also be the object of sexual desire for men.[113] In this regard, one might speculate that the castra-

tion of a pre-pubescent boy would prolong his appeal to a man attracted to ephebic qualities. The sexual use of eunuchs is well documented for the ancient world.[114] That such uses continued into the Christian Roman Empire can be determined from the critiques by Christian writers of the eunuch-priests of the great goddess, which reproach them for their sexual libertinism,[115] as well as the several mentions in later Roman law.[116] Despite equal polemic, Jerome still described in one letter the youthful beauty associated with eunuchs.[117] For that matter, women might also be attracted to eunuchs, and here their ready availability within the home may have been a factor.[118]

Browe speculates that this cultural history of sexual use of eunuchs is the reason why they were not accepted in the western Christian churches until the sixteenth century, when *castrati* were first introduced into Spanish and Italian church choirs.[119] This seems doubtful, since eunuchs can be found in eastern church choirs from at least the fifth century. Nonetheless, they always appear in the sources as choir directors, which might simply indicate that they were chosen for their administrative abilities from already castrated men rather than castrated specifically to ensure the preservation of youthful voices, as they would be in Renaissance and Enlightenment choirs.[120]

The Latin repugnance toward eunuchs long antedates Christian condemnation, however. Roman law, as preserved in the *Digest* of Justinian, is clearly against the practice of castration, however common it was in later Roman society.[121] Even masters were prohibited from castrating their slaves,[122] and doctors performing castration could also be liable for prosecution.[123] This became part of later Roman and Byzantine legal tradition, and later eastern emperors added to the laws prohibiting castration.[124] Justinian felt likewise moved in the sixth century, he wrote, out of humanitarian concern because of the low survival rate of eunuchs, to free any castrated slave.[125] Eastern emperor Leo VI in the early tenth century renewed the prohibition, declaring a man's procreative ability a God-given right.[126] Still, throughout the Middle Ages, eunuchs were imported to Byzantium, through such loopholes as that opened by the emperor Leo I, who in the fifth century granted permission for Romans to buy and sell eunuchs as long as they were foreign-born.[127]

The Byzantine penalties against castration of its citizens would seem to preclude the use of castration as the punishment for any crime. Leo VI specifically rejected castration as a suitable punishment for those who castrate others;[128] but this might mean it had been done before his time. No extant Byzantine law threatens felons of any sort with castration, although according to some sources Justinian had punished homosexuals or pederasts in this way.[129]

Germanic legal tradition, insofar as it is represented in the law codes of the early kingdoms of medieval Europe, also threatened those who castrated others with civil penalties. In northern Europe, however, the context of castration was very different from that in southern Europe. Rather than institutionalized use of eunuchs as the main motivation for castration, early medieval legal tradition opposed castration when inflicted as a punitive measure on one's enemies. Or so it has been interpreted, for example by Browe.[130] It should be noted, however, that the laws are distinctly vague, and might be nothing more than regulated compensations for accidental castration; alternately, they might be attempts by the Christian clerics involved in the establishment of these codes to prevent institutionalized castration from spreading from more Romanized regions.

The early medieval legal practice of translating most offenses into financial equivalents permits the inclusion of castration into the social setting of birth and rank; as might be expected, the fine for castrating a freeman was much greater than that for castrating a slave.[131] A comparison might also be made between the penalties for castration and those for other illicit actions. For example, in the Frankish decree of Childebert, forced castration is given the same punishment as cutting off a hand or tongue, but also for plundering a sleeping man or a corpse, killing a fetus, or attempted murder.[132] Other laws provide interesting details.[133] In the early medieval western legal tradition, castration was the penalty for certain offenses. According to Frankish law, slaves faced castration for theft[134] or fornication.[135] Visigothic law punished homosexual sex with castration.[136] These might have been attempts to let the punishment fit the crime, although Browe suggests that castration as a penalty for sexual offenses was a way of avoiding recidivism.[137]

Castration continued in western European legal tradition as the penalty for certain crimes, curiously despite the gradual adoption of Roman law in the twelfth century, with its prohibitions of the practice. In the Crusader kingdom of Jerusalem in the twelfth century, castration was the penalty for a Christian man who married a Muslim woman.[138] Rape might also incur castration in the twelfth century in western Europe; this has been investigated by James Brundage, who says that "by the end of the thirteenth century it had begun to fade out of [legal] fashion."[139] Castration also remained the penalty for homosexual activity in several secular lawcodes of later medieval Iberia,[140] and became part of the law, too, in thirteenth-century France.[141] Finally, castration was introduced as the penalty for bigamy in one later medieval Italian town, if the offender was unable to pay the required fine.[142]

Punitive castration in western Europe might just as easily take place as the unofficial, extralegal penalty for certain acts considered particularly heinous. The first assaults involving castration were said to have taken place during various episodes of violence in the eleventh century.[143] It is in this light that the capture and castration of a man accused of impregnating a nun of Watton by the other nuns, as described by Ælred of Rievaulx in the twelfth century, is usually seen.[144]

Partway between the penal and the impromptu castration were the fates of Piers Gaveston and Hugh le Despenser, favorites of the early fourteenth-century King Edward II of England, told in various later medieval chronicles. The exact reason for the castration of these two men after their fall from influence, whether because of general unpopularity or because of their alleged sexual relationships with Edward, is disputed by historians.[145] For example, the chronicler Froissart also referred to the castration and execution of their contemporary Roger Mortimer,[146] who according to rumour had been engaged in a sexual relationship with Edward's wife, Queen Isabella, and this may well have played a part in his punishment. Alternately, it could have been an inevitable part of such hostile executions but unrelated to perceived sexual offenses.

Probably the most famous case of ad hoc punitive castration for a sexual offense in the Middle Ages was that of Peter Abelard, as described in his early twelfth-century autobiography. As a young teacher in Paris, Abelard became the tutor of Heloise, niece of a canon named Fulbert, and the two fell in love. When Heloise subsequently became pregnant and bore a son, Abelard married her, but since this would have ruined his career in the church, they kept it a secret, and enrolled Heloise in a convent. When Fulbert and his kinsmen discovered the plan, however, they broke into Abelard's home and castrated him. In shame and remorse, Abelard entered the monastic life.[147]

Abelard plainly stated that his story was written so that the reader might consider his troubles trivial in comparison.[148] In mentioning this, Abelard touched on the great stigma attached to castration in the Middle Ages. He described in detail his shame and embarrassment,[149] although he drew consolation by seeing himself as a latter-day Origen.[150] Eunuchs were almost universally despised figures, from late Roman antiquity[151] to the end of the Middle Ages and beyond. This problem has been only superficially addressed by historians.[152] In imperial bureaucracies the low opinion of eunuchs might well have been related to the belief that they wielded authority inappropriately, since they were neither noble-born nor true men capable of fathering children, but this was of course what had made them

so desirable in the emperors' eyes in the first place for these positions. The castration of men thrown down from places of power as part of their punishment may be the reverse of these ideological links between masculinity, nobility, and power,[153] and this conjunction was equally disastrous for women rulers in the Middle Ages, especially those of lower-class birth. Finally, the castration of prisoners of war is also recorded during medieval wars,[154] and this can be seen as motivated by a desire on the part of the victors to embody the debasement of their enemies. More scholarship needs to be done in this area.

The eunuch as an emblem of ridicule runs through medieval literature as another heritage of classical antiquity. The character of Gnatho in Terence's *Eunuchus* was itself modelled after a Greek comedy of Menander. In late Roman antiquity a letter of Sidonius Apollinaris described a man, also named Gnatho, in comic terms, obviously relying on his audience's recognition of the stock characteristics of the eunuch: obesity, a high-pitched voice, and an unpleasant, overbearing demeanor.[155] A similar description can be found in parodic poems of Ausonius.[156]

At the other end of the Middle Ages, Heinrich Kaufringer of Landsberg in fourteenth-century Germany included in his comic tales the story of a wife who tricks her hen-pecked husband into cutting off his testicles.[157] The figure of the Pardoner in Geoffrey Chaucer's *Canterbury Tales,* likewise, has the stereotypical high voice and beardless chin of the eunuch.[158] As with all other aspects of Chaucer, this has an extensive secondary literature, which is divided in interpreting him as a eunuch,[159] a hermaphrodite,[160] or a homosexual.[161]

Castration as a theme in medieval French literature has been recently if briefly examined by Maurizio Virdis,[162] who discusses several *lais* of Marie de France,[163] the story of the Fisher King in Chrétien de Troyes,[164] and the troubadour poetry of Raimbaut d'Orange,[165] as well as Peter Abelard's autobiography.[166] The episode of the wounded loins in Chrétien de Troyes continued to find a place in the Arthurian literature of the Middle Ages. In thirteenth-century poet Wolfram von Eschenbach's *Parzival,* the King Anfortas, guardian of the Holy Grail, is described as having been wounded in the scrotum through a battle injury, after being encouraged in a foolhardy display of courage, ironically, by his love for a woman.[167] Also in this same version of the tale a magician named Clinschor is found to be a eunuch, castrated by an irate royal husband as punishment for adultery. After the incident, Clinschor learned powerful magic in order to wreak vengeance on all.[168] Gawan is said to laugh loud and long when told about Clinschor's castration.[169]

The shame of castration was equally an important theme in the Scandinavian sagas. In northern literature it is obviously part of the humiliation of unmanliness, and this has been described more generally.[170] In Sturla Þórðarson's *Islendingasaga*, two priests named Snorri and Knút are castrated by a man named Sturla in a vengeful raid on the local church.[171] There is some relation here to the perceived unmanliness of Christians by the pagans as depicted in the sagas.[172] Snorri Sturluson describes in the *Heimskringla* the castration and blinding of King Magnus IV of Norway when he was deposed, in order that he might never again be considered as a candidate for the throne.[173] Again, the relationship between manliness and the exercise of power is the unquestioned assumption in this action.

This final point brings us to a significant omission in all of the work on eunuchs in medieval Europe. While castration has been analysed as a political or religious or legal problem, castration and the presence of eunuchs in medieval Europe as a case study in medieval definitions of gender has been virtually ignored. A recent article by Kathryn Ringrose on Byzantine eunuchs is the sole investigation into this area with which I am familiar.[174] Some preliminary remarks on this theme can nonetheless be made. Eunuchs, despite their maleness, were often portrayed as the equivalent of women in early medieval writings, and the stereotypes of their character are virtually the same as those of women: carnal, voluptuous, wanton, irrational, fickle, manipulative, deceitful.[175]

As early as the *Historia Augusta*, written at the end of the fourth century C.E., however, the Roman emperor Severus is said to have described eunuchs as a third type of humanity.[176] It is possible that much of the Roman problematization of eunuchs, which continued in Byzantine and medieval culture, is this intermediary status they were felt to have, neither male nor female but somewhere in between. For example, much of the discussion of eunuchs in Roman law focuses on the question of whether eunuchs deserved the privileges accorded other adult males.[177] Along this line of thinking, Byzantine emperor Leo VI felt that castration transformed a man into a different type of being,[178] and prosecuted any who tried to marry women.[179] Justinian forbid eunuchs from adopting.[180]

It was perhaps this intermediary status that contributed to the role that Byzantine eunuchs played as go-betweens in marriage preparations, child-rearing, and other aspects of male-female relations. Eunuchs of late Roman antiquity acted as bedside attendants to women,[181] as investigators of potential brides,[182] and as tutors to children.[183] Their gender status was even less threatening than their sexual performance; they could associate with women and participate in feminine activities even in intimate surroundings,

but also traveled freely among men and in public and held offices and wielded authority reserved to men. Ostracized from true membership in both masculine and feminine genders, they were nonetheless tolerated in both male and female environments.

This uncertainty regarding the appropriate gender of eunuchs in the Byzantine east is also hinted at in the fewer examples of eunuchs in the medieval west. A famous episode recounted by Gregory of Tours presented an impotent, perhaps castrated man who chose to act as a woman, dressing in female garb and entering the female monastery at Poitiers.[184] Albert the Great, who discussed the castration of animals, casually mentioned that human eunuchs typically serve in women's private chambers; perhaps he meant in the west as well as the east.[185] The Western legal tradition repeated the Roman ambiguity about permitting eunuchs the status and privileges of adult manhood; there was considerable debate about the validity of marriage for a castrated or otherwise impotent man in canon law.[186]

Another difficult question concerns women and eunuchism. Ancient sources refer to female eunuchs, without much clarity, although it is possible that they describe female genital mutilation. This is not taken up by the medieval literature, however. Nonetheless, some thought needs to be given to the idea that the removal of women's noses, common enough as a theme in medieval history and literature, functioned in many of the same ways as the castration of men. There are examples both of women's self-mutilation as a restraint against sexual activity, although for women it is mainly the threat of unwanted sexual relations, especially rape, instead of men's fears of their own uncontrollable sexual desires; and of women punished by mutilation of the nose for the illicit use of sex, just as men suffered castration for such offenses. An article by Jane Tibbits Schulenberg analyzes these problems.[187]

Ultimately, a comprehensive history of medieval castration still remains to be written. This tentative study has real omissions and gaps; my greater knowledge of the early Middle Ages as opposed to the later Middle Ages and of western as opposed to eastern Europe are perhaps the most obvious. The study of castration, however, even if apparently peripheral to the main corpus of medieval sexuality, may prove to be an illuminating margin to future research.[188]

EDITIONS ABBREVIATED IN THE NOTES

AASS *Acta Sanctorum*. Societas Bollandiana. Antwerp: Jan Meursius, 1643–1925.

CCSL *Corpus Christianorum. Series Latina*. Turnhout: Brepols, 1954 sqq.

CSEL *Corpus Scriptorum Ecclesiasticorum Latinorum.* Academia Litterarum Caesareae. Vienna: C. Gerold Sons, 1867 sqq.

DJ Watson, Alan, ed. *The Digest of Justinian.* 4 vols. Philadelphia: University of Pennsylvania Press, 1985.

MGH LL *Monumenta Germaniae Historica.* Societas aperiendis fontibus rerum Germanicarum mediiaevi. Leges nationum Germanicarum. Hannover and Leipzig: Hahn, 1886 sqq.

MGH SS *Monumenta Germaniae Historica.* Societas aperiendis fontibus rerum Germanicarum mediiaevi. Scriptores nationum Germanicarum. Hannover and Leipzig: Hahn, 1826 sqq.

PG *Patrologiae cursus completus. Series Graeca.* Paris: J.-P. Migne, 1844–64.

PL *Patrologiae cursus completae. Series Latina.* Paris: J.-P. Migne, 1844–64.

ST *St. Thomas Aquinas. Summa Theologiae.* 61 vols. Blackfriars, general eds. London: Eyre and Spottiswoode/New York: McGraw-Hill, 1964.

NOTES

1. I am grateful to Professor John Boswell of the history department at Yale University for first suggesting a study of medieval eunuchs, and to Rebecca Krawiec of the Religious Studies department at Yale University for permitting me to read her unpublished paper, "'Eunuchs who have made themselves eunuchs for the sake of the kingdom of heaven': Mt. 19:12 and the Role of Eunuchs in Second to Third Century Asceticism," which provided a unique perspective for thinking about eunuchs as a problem in male privilege. I am also grateful to the Social Sciences and Humanities Research Council of Canada for financial support during the research and writing of this article.

2. Peter Browe, *Zur Geschichte der Entmannung: eine Religions- und Rechtsgeschichtliche Studie* (Breslau: Müller und Seiffert, 1936).

3. Including Frédéric Bergmann, *Origine, signification et histoire de la castration, de l'eunuchisme et de la circoncision* (Palermo: L.P. Lauriel, 1883); Paul Adam, *Irène et les eunuques* (Vienne: Larousse, 1906); Richard Millant, *Les eunuques à travers les ages* (Paris: Vigot frères, 1908); Mohamed Guindy, *Les eunuques. Étude anatomophysiologique et sociale* (Lyon: Université de Lyon [Doctoral dissertation], 1910); and Démétrius Zambaco, *Les eunuques d'aujourd'hui et ceux de jadis* (Paris: Masson, 1911).

4. See, for example, his questioning of the assertion of Millant, given without reference (Millant, p. 37), that Pope Leo I had issued a bull in 395 formally forbidding castration in all of its forms; Browe found no evidence for such a bull of Leo, who, as he notes, was not even pope in 395, but ruled from 440 to 461 (Browe, p. 28, n. 98). Nonetheless, Browe is not without his problems, mainly of reference, for which reason I have revised, e.g., his listing of eunuch saints (Browe, p. 20; here, n. 64).

5. Sigmund Freud, "Anal Erotism and the Castration Complex," first published 1918, in Alix Strachey and James Strachey, eds., *Sigmund Freud: Collected Papers* (New York: Basic Books, 1959), 3.548–67; see also in the some collection "The Passing of the Oedipus-Complex," first published 1924, 2.269–76; "Some Psychological Consequences of the Anatomical Distinction between the Sexes," first published 1925, 5.186–97.

6. Carl Jung, "The Sacrifice," ch. 8 of *Symbols of Transformation*, first published 1912, in Herbert Read et al., eds., *The Collected Works of C.G. Jung* (Princeton, NJ: Princeton University Press, 1956), 5.394–440.

7. See, e.g., C. Blondel, *Les automutilateurs: étude psychopathologique et médico-légale* (Paris: Rousset, 1906); Ionel Rapaport, *Les faits de castration rituelle: essai sur les formes pathologiques de la conscience collective* (Paris: Université de Paris [Doctoral dissertation], 1945).

8. First introduced as part of a more general psycho-analytic discussion in John F. Benton, *Self and Society in Medieval France: The Memoirs of Abbot Guibert of Nogent* (New York: Harper, 1970; reprinted Toronto: University of Toronto Press, 1984), 26–7; repeated by J. Kantor, "A Psycho-Historical Source: The Memoirs of Abbot Guibert of Nogent," *Journal of Medieval History* 2 (1976): 281–303; and criticized by M.D. Coupe, "The Personality of Guibert de Nogent Reconsidered," *Journal of Medieval History* 9 (1983): 317–29.

9. See Jean Leclerq, "Modern Psychology and the Interpretation of Medieval Texts," *Speculum* 48 (1973): 476–90. For more on Abelard, see pp. 19–20.

10. I make brief mention here of studies of several of these groups in other periods and other cultures which might be of comparative interest: (1) the *skoptzy*, a religious sect in eighteenth- and nineteenth-century Russia and Roumania that required castration of its male adherents; most of the secondary literature is in Russian; see, however, Ionel Rapaport, *La castration rituelle: l'état mental des Skoptzy* (Paris: Lipschutz, 1937); (2) the *hijras* of India, both historical and present-day castrated male devotees of a Hindu goddess; see Serenda Nanda, "The Hijras of India: Cultural and Individual Dimensions of an Institutionalized Third Gender Role," *Journal of Homosexuality* 11 (1985): 35–54; expanded as *Neither Man Nor Woman: The Hijras of India* (Belmont, CA: Wadsworth, 1989); and revised as "Hijras: An Alternative Sex and Gender Role in India," in G. Herdt, ed., *Third Sex, Third Gender: Beyond Sexual Dimorphism in Culture and History* (New York: Zone, 1994), 373–417; (3) the court-eunuchs of dynastic China; for recent studies in English, neither very probing, see Mary Anderson, *Hidden Power: The Palace Eunuchs of Imperial China* (Buffalo: Prometheus Books, 1990), or T. Mitamura, *Chinese Eunuchs: The Structure of Intimate Politics* (Rutland, VT: Charles Tuttle, 1970); (4) the bureaucratic eunuchs of the Ottoman Turkish empire; as far as I know, only discussed in general works on Ottoman bureaucracy; and (5) the eunuchs of ancient Persian, Hellenistic, and Roman societies; see Peter Guyot, *Eunuchen als Sklaven und Freigelassene in der griechisch-römischen Antike* (Stuttgart: Klett-Cotta, 1980); for religious castration in the ancient period, not part of Guyot's study, see n. 37.

11. Virtually not worth mentioning is the salacious work of Charles Humana, *The Keeper of the Bed: The Story of the Eunuch* (London: Arlington Books, 1973).

12. Vern L. Bullough, *Sexual Variance in Society and History* (Chicago: University of Chicago Press, 1976), 326–30; see also Bullough, "Formation of Medieval Ideals: Christian Theory and Christian Practice," in V. Bullough and J. Brundage, eds., *Sexual Practices and the Medieval Church* (Buffalo, NY: Prometheus Books, 1982), 16–17.

13. Aline Rousselle, *Porneia. De la maîtrise du corps à la privation sensorielle, IIe–IVe siècles de l'ère chrétienne* (Paris: Presses universitaires de France, 1983), 156–65, trans. by F. Pheasant as *Porneia: On Desire and the Body in Antiquity* (Oxford: Basil Blackwell, 1988), 121–28. Her first chapter, while only making superficial reference to castration, is worthwhile for its discussion of men's bodies, especially the effects which the production of semen were supposed to have had, from which one might assume opposite effects for eunuchs.

14. I mention here my dissertation in the History department at Yale University, entitled "Eunuchs and Other Men: The Crisis and Transformation of Masculinity in the Later Roman West," which I expect to complete in 1995. It includes a discussion of eunuchs as a problem in masculinity. Gary Brower, a doctoral student at Duke University, is currently also writing a dissertation on eunuchs in early eastern Christianity. Preliminary results of his research were presented at the meeting of the American Academy of Religion in 1992.

15. Even Browe's book, as his title suggests, only attempts to be a discussion of the religious and legal history of castration. Nonetheless, I have relied on his work for a full third of the references I have collected. Another full third of the following research came from the recent annotated bibliographical research guide compiled by Joyce Salisbury (*Medieval Sexuality: A Research Guide* [New York: Garland Publishing, 1990]), which was extremely useful. I wish to give credit to both of these scholars here rather than in dozens of footnotes. To supplement Browe and Salisbury, I have also relied on isolated references in works on peripherally related topics. Nonetheless, there will be many gaps in this compilation, for which I apologize in advance.

16. Eulogius of Toledo, *Memorialis sanctorum* 2.1.3 (PL 115.793).

17. Matthew of Paris, *Historia maiora, anno 1235* (anon. ed. [London: A. Mearne et al., 1684], 351). I am unable because of linguistic barriers to provide any truly useful discussion of eunuchs in medieval Muslim society; a brief introduction to the subject may be found in Bullough, *Sexual Variance*, pp. 231–32.

18. At two places in his account of his travels, Marco Polo mentions eunuchs: at the court of the Great Khan of the Mongols (*Le divisement dou monde* 82 (anon. ed., *Recueil de voyages et de mémoires, publié par la société de géographie* [Paris: d'Éverat, 1824], 1.88), possibly Chinese-type servants, called *esculiés*, as well as eunuchs in Bengal (126 [*Recueil*, 1.144]), possibly *hijras* (see n. 10), but again referred to as *escuiles*.

19. Hroswith of Gandersheim, *praefatio in sex comoedias suas* 1 (PL 137.971–74).

20. *Genesis* 39:1. It is curious that no modern discussions of the "Potiphar's wife" legend in medieval Jewish or Christian societies seem to mention this seemingly important detail to the story. Jewish tradition offered the opinion that Potiphar had purchased Joseph to satisfy him sexually. *Babylonian Talmud, Seder Nashim, Sotah* 13b. See p. 285 on the conflation of castration and passive homosexuality.

21. *Judith* 12:10–15.

22. 1 *Chronicles* 28:1.

23. *Jeremiah* 38:7–13, 39:15–18, and 52:25.

24. *Daniel* 1:3–21.

25. *Babylonian Talmud, Seder Nezikin, Sanhedrin* 93b.

26. Jerome, *Adversus Jovinianum* 1.25 (PL 23, 244–45) and *Commentarius in Danielem* 1.1.3 (CCSL 75A.779).

27. The numerous ancient references to eunuchs are too many to warrant listing here, but are amply discussed in Guyot, *passim*.

28. Keith Hopkins, "Eunuchs in Politics in the Later Roman Empire," *Proceedings of the Cambridge Philological Society* 189 (1963): 62–80.

29. Guyot, ch. 7: "Die Hofeunuchen im Römischen Reich im 4. Jahrhundert," 130–76.

30. Rodolphe Guilland, *Recherches sur les institutions byzantines* (Berlin: Akademie-Verlag, 1967), 1.165–380. Guilland conveniently incorporates a wide range of legal and historical sources in lengthy footnotes. This is only the last of numerous studies on Byzantine administration by Guilland, including several on eunuchs: "Les eunuques dans l'Empire byzantin. Étude de titulature et de prosopographie byzantines," *Études Byzantines* 1 (1943): 196–238; "Fonctions et dignités des Eunuques," *Études Byzantines* 2 (1944), 185–225 and 3 (1945): 179–210; "Études de titulature byzantine: les titres auliques réservés aux eunuques," *Revue des Études Byzantines* 13 (1955): 50–84 and 14 (1956): 122–57; "Études sur l'histoire administrative de l'Empire byzantin: les titres auliques des eunuques. Le protospathaire," *Byzantion* 25/27 (1955/57): 649–95. To Guilland may be added these earlier studies: J.B. Bury, *The Imperial Administrative System in the Ninth Century* (reprinted New York: Burt Franklin, 1958), 120–29; also, Baudouin de Gaiffier, "Palatins et eunuques dans quelques documents hagiographiques," *Analecta Bollandiana* 75 (1957): 17–46.

31. Guilland, 170–76.

32. See discussion, pp. 291–92, on gender and eunuchs.

33. Ammianus Marcellinus, *Res gestae* 14.10–15.3, 15.5 *passim*, ed. and trans. J. Rolfe (Cambridge, MA: Harvard University Press, 1956), 1.78–157, also briefly discussed in Guyot, p. 162.

34. Claudius Claudianus, *In Eutropium* 1, vv. 242–62 (LCL [M. Platnauer, ed., 1976], 1.156–59).

35. Browe, 13–18; Millant, 7–30; Rapaport, 9–33.

36. See the discussion in Thomas Hill, "Narcissus, Pygmalion, and the castration of Saturn: Two Mythographical Themes in the Roman de la Rose," *Studies in Philology* 71 (1974): 404–26. Hill compares the *Roman de la Rose* (vv. 5183–88) to the use of Saturn's castration as a symbol for original sin in John Scotus Erigena's *Adnotationes in Marcianum* 8.8 (Cora Lutz, ed. [Cambridge, MA: Medieval Academy of America, 1939], 13).

37. Including most popularly as Egyptian Isis, Phrygian Cybele, Ephesian Artemis, Greek Aphrodite or Rhea or Demeter, and Carthaginian Tannit. Her Latin titles included *Bona Dea*, *Magna Mater*, and *Caelestis*. The classic work on the subject is Henri Graillot, *Le culte de Cybèle, mère des dieux* (Paris: Fontemoing, 1912); see also Maarten J. Vermaseren, *The Legend of Attis in Greek and Roman Art* (Leiden: E.J. Brill, 1966); also Graillot, *Cybele and Attis: The Myth and the Cult* (London: Thames and Hudson, 1977); Giulia Sfameni Gasparro, *Soteriology and Mystic Aspects in the Cult of Cybele and Attis* (Leiden: E.J. Brill, 1985). A multi-volume corpus of inscriptions related to the cult has been published by M.J. Vermaseren, *Corpus Cultus Cybelae Attidisque* (Leiden: E.J. Brill, 1977–1989). All these works nevertheless mention only briefly the element of castration in the myth and the eunuch priests often associated with the religion.

38. The consort/son was variously worshipped as Egyptian Osiris, Phrygian Attis, or Greek Adonis. Later Roman and Greek authors who describe the cult include: *Scriptores Historiae Augustae, Commodus Antoninus* 9 (LCL [D. Magie, ed., 1967], 1.286–9); Arnobius Iunior, *Adversus gentes* 5.5–7 (PL 5.1088–99); Ammianus Marcellinus, *Res gestae* 22.9.15 (LCL [J. Rolfe, ed., 1972] 2.250–51); Lactantius, *Epitome institutionum divinarum* 23 (PL 6.1030–31); Herodian, *Basileia Historia* 1.10–11 (LCL [C. Whittaker, ed., 1969], 1.64–73). Classical authors are too numerous to mention; but see Guyot or Graillot, *passim*. By the later Roman Empire, the cult became conflated with some of the death-and-resurrection myths of Rome and Greece, including worship of the Olympians Apollo-Helios and Liber-Bacchus-Dionysios, the Persian Mithra, and the mysteries of Eleusinian Demeter and Orpheus. For examples of this syncretism in later Roman writers, see Julian, *Oratio* 4 (LCL [W. Wright, ed., 1962], 1.352–435); Ausonius, *Epigrammata* 48–49, (ed. and trans. H. White, [Cambridge, MA: Harvard University Press, 1967], 2.186–87); *Scriptores Historiae Augustae, Antoninus Heliogabalus, passim* (LCL [D. Magie, ed., 1967], 2.104–77).

39. Julian, *Oratio* 5 (LCL [W. Wright, ed., 1962], 1.442–503).

40. The origin of this title is unknown. It seems most likely that the name is derogatory, and that calling these men "roosters" referred not to the absence of "cocks" but to their high-pitched "crowing." Chinese eunuchs were insulted in remarkably similar terms (see Anderson, p. 311). A less plausible later explanation is that this title derived from a Mount Gallus in Bithynia, where Attis is supposed to have lived; see Herodian, *Basileia Historia* 1.11.2 (LCL [C. Whittaker, ed., 1969], 1.68–69).

41. At least, according to their detractors; see below, nn. 43, 44, and 45, who also mention female sacred prostitutes at the shrines.

42. An important article, however, is Arthur Nock, "Eunuchs in ancient religion," *Archiv für Religionswissenschaft* 23 (1925): 25–33.

43. Lactantius, *Divinae institutiones* 1.17 and 1.21 (PL 6.206–08, 234–38).

44. Firmicus Maternus, *De errore profanarum religionum* 4 (PL 12.989–91).

45. Augustine, *De civitate Dei* 2 *passim* (CCSL 47.34–65).

46. See George Sanders, "Les galles et le gallat devant l'opinion chrétienne," in M. de Boer, ed., *Hommages à Maarten Vermaseren* (Leiden: E.J. Brill, 1978), 3.1062–91.

47. Few scholars have compared the numerous similarities between the two; see, however: Geoffrey Ashe, *The Virgin: Mary's Cult and the Re-emergence of the Goddess* (London: Arkana, 1976); Arthur Evans, *The God of Ecstasy: Sex Roles and the Madness of Dionysos* (New York: St. Martin's Press, 1988), ch. 7, "Dionysos and Christ," 145–73. More reputable, if more limited in its scope, is the Sanders article noted above, n. 46.

48. According to the anonymous work, *Mirabilia urbis Romae* 3.14 (Francis Morgan Nichols, ed. [New York: Italica, 1986], 44).

49. *Gospel according to Matthew* 19:12.

50. See Walter Bauer, "Matthäus 19,12 und die alten Christen," in *Neutestamentliche Studien: Georg Heinrici zu seinem 70. Geburtstag (14 Marz 1914) dargebracht von Fachgenossen, Freunden und Schulern* (Leipzig: J.C. Hinrichs, 1914).

51. There is the CETEDOC CD-ROM Library of Christian Latin Texts (Turnhout, Belgium: Brepols/Catholic University of Louvain, 1991; hereafter CETEDOC CD-ROM), which includes early Christian and medieval texts from several editions, including the PL and CCSL. There exists on CD-ROM also about one hundred volumes of the PL, mostly the early volumes, with plans to transfer the entire series to computer disk (PL Database [Alexandria, VA: Chadwyck-Healey, 1991]).

52. *Confessiones* 8.1; *Contra Adimantum* 3; *Contra aduersarium legis et prophetarum* 1; *Contra Faustum* 16.22; *Contra philosophos* 3; *De adulterinis coniugiis* 2.18; *De ciuitate Dei* 6.10; *De doctrina christiana* 3.17; *De opere monachorum* 32; *De sancta uirginitate* 23; *Epistulae nuper in lucem prolatae* 3; *Expositio epistulae ad Galatas* 42; *Speculum* 25 (CETEDOC CD-ROM).

53. *Apologia adversus libros Rufini* 2; *Adversus Jovinianum* 1.12; *Commentarii in evangelium Matthaei* 3; *Commentarii in Ezechielem* 1.4; *Commentarii in Isaiam* 15.56; *Commentarii in prophetas minores, In Sophroniam* 1, *In Zachariam* 3; *Commentarii in epistulam Paulinam ad Galatas* 3; *Contra Joannem Hierosolymitanum* 34; *De viris inlustribus* 45; *Epistulae* 14, 22, 66, 123 (CETEDOC CD-ROM).

54. Bede, *In Lucae evangelium expositio* 6.23 (PL 92.615).

55. Thomas Aquinas, *Summa Theologiae* 2a.2ae.65.1.3 (ST [M. Lefébure, ed., 1975], 38.50–53).

56. *Deuteronomy* 23:1–2.

57. *Jeremiah* 38:7–13 and 39:15–18.

58. *Isaiah* 56:3–5.

59. *Acts of the Apostles* 8:26–39.

60. For the Latin patristic period alone there is Ambrose, *Expositio evangelii secundum Lucam* 9; Apponius, *In Canticum Canticorum expositio* 1, 9; Augustine, *Ad catholicos de secta Donatistarum* 11, 21; idem, *Contra litteras Petiliani* 3; idem, *De fide et operibus* 12; *Sermones* 99, 266; Bede, *Expositio actuum apostolorum* 8; idem, *In Cantica Canticorum libri* vi 2; idem, *Retractatio in actus apostolorum* 1; Cassiodorus, *Expositio Psalmorum, praefatio*; Chromatius Aquileiensis, *Sermones* 2; idem, *Tractatus in Matthaeum* 9; Fulgentius Ruspensis, *De veritate praedestinationis et gratiae Dei* 1.19; idem, *Epistula* 12; Gregorius Magnus, Moralia in Job 28; Jerome, *Altercatio Luciferiani et Orthodoxi* 9; idem, *Commentarii in Isaiam* 14, 17; idem, *Epistulae* 3, 46, 53, 69; Petrus Chrysologus, *Collectio sermonum* 60, 61, 160; Tertullian, *De baptismo* 4, 18 (CETEDOC CD-ROM). See also William Lawrence, "The History of the Interpretation of Acts 8:26–40 by the Church Fathers Prior to the Fall of Rome" (New York: Union Theological Seminary [Ph.D. diss.], 1984).

61. Thomas Aquinas, *Summa theologiae* 1a.2ae.105.3.2 (ST [D. Bourke and A. Littledale, eds., 1969], 29.294–95). Children born to prostitutes are Thomas's other example.

62. Firmicus Maternus, *De errore profanarum religionum* 4.3 (PL 12.991).

63. Justin Martyr, *Apologia prima pro Christianis* 29.2–3 (PG 6.373–34).

64. Browe, p. 20. Fourteen were verifiable: Nereus and Achilleus (AASS 12 Maii, 4–16), Calocerus and Parthenius (AASS 19 Maii, 301–04), Prothus and Hyacinthus (AASS 11 Septembris, 746–62), Indes (Nicephorus Callistus, *Ecclesiastica Historia* 7.6 [PG 145.1215–16]), Tigrius (AASS 12 Januarii, 725–27; Sozomen, *Historia ecclesiastica* 8.24 [PG 67.1579–80]), Boethazat and Azat (*Menologium Basilianum Graecorum*, 20 Novembris and 14 Aprilis [PG 117.172 and 401), Melito of Sardes (Eusebius, *Historia ecclesiastica* 5.24 [PG 20.495–96]), Hesychius of Antioch (Flodoard of Rheims, *De triumphis Christi Antiochiae gestis* 1.15 [PL.135.565–66]), and two patriarchs of Constantinople: Macedonius in the early sixth century (Nicephorus Callistus, *Ecclesiastica Historia* 16.26 [PG 147.167–68]), and Methodius in the ninth century (Joseph Genesius, *Historia de rebus Constantinopolitanis* 4 [PG 109.1097; Zonaras, *Annales* 16.1 [PG 135.11–12]).

65. Browe, pp. 21–23. Browe notes the third-century Roman priest, Hyacinthus (Origen of Alexandria, *Philosophumena, sive omnium haeresium refutatio* 9.12 [PG 16.3381–82]) and the fourth-century patriarch Leontius of Antioch (Athanasius, *Apologia de fuga sua* 26 [PG 25.677–78]; Athanasius, *Historia Arianorum ad monachos* 28 [PG 25.723–26]; Socrates, *Historia ecclesiastica* 2.26 [PG 67.269–70]).

66. Browe, pp. 21–22.

67. Palladius of Helenopolis, *Historia Lausica* 29 (PG 34.1084–89), who adds that this was "... ou kata alētheian alla kata phantasian..." ("not in truth but in fantasy").

68. John Cassian, *Conlationes* 7.2 (PL 49.669–70).

69. Gregory the Great, *Dialgi* 1.4.1 (PL 77.165; AASS 7 Martii, 649–51).

70. Axillas (or Zixila or Cixila) of Toledo, *Vita sancti Ildefonsi*. See Sister Athanasius Braegelmann (*The Life and Writings of Saint Ildefonsus of Toledo* [Washington, DC: Catholic University of America, 1942]) who calls this biography "unreliable" (p. 2).

71. Caesarius of Heisterbach, *Dialogus miraculorum* 4.97 (H. von E. Scott and C.C. Swinton Bland, eds. [London: Routledge, 1929], 1.302–03).

72. William of Tocco, *Vita sancti Thomae Aquinatis* (AASS 7 Martii, 655–747 at 661).

73. According to the *Babylonian Talmud, Seder Nashim, Sotah* 13b, the Egyptian eunuch Potiphar had been castrated by the angel Gabriel. See also n. 20.

74. *Mishnah, Seder Nashim, Jebamot* 8:1 and 8:2.

75. *Babylonian Talmud, Seder Mo'ed, Shabbath* 152a.

76. *Babylonian Talmud, Seder Mo'ed, Shabbath* 50b; *Seder Nashim, Yehamoth* 79b–81a; *Seder Nashim, Kiddushin* 35b.

77. *Babylonian Talmud, Seder Nezikin, Sanhedrin* 93b; *Seder Tohoroth, Zabim.*

78. *Babylonian Talmud, Seder Nashim, Yebamoth* 75a–76b.

79. *Babylonian Talmud, Seder Nashim, Yebamoth* 61b, 62b, 79b–81a, 97a, 119a; *Seder Nazikim, Baba Bathra* 155b; *Seder Tohoroth, Niddah* 32a and 47b.

80. A recent study of sexual issues in the *Talmud* failed even to mention castration or eunuchism: Daniel Boyarin, *Carnal Israel: Reading Sex in Talmudic Culture* (Berkeley: University of California Press, 1993).

81. Justinian, *Digesta* 48.8.11 (DJ 4.821).

82. E.g., *Sachsenspiegel* 3.7.1 (Julius Weiske, ed. [Leipzig: Fues, 1877], 79).

83. E.g., Moses ben Maimon [Maimonides/Rambam], *Mishnah Torah, Sefer Ahavah, Hilchot Milah* 1.1–6 (Eliyahu Touger, ed. [Jerusalem: Moznaim, 1991], 1.6.196–204).

84. E.g., Regino of Prüm, *De synodalibus causis et disciplinis ecclesiae* 2.89–90 (Trever Ratbod, ed. [Leipzig: Wilhelm Engelmann, 1840], 248).

85. Browe's list (pp. 23–25) includes Isidor of Pelusium (*Epistula* 1.463 [PG

78.437]), John Chrysostom (*Homiliae in Matthaeum* 62.3 [PG 58.599–600]), Epiphanius of Salamis/Cyprus (*Expositio fidei catholicae et apostolicae ecclesiae* 13 [PG 42.805–08]), Cyril of Alexandria (*Commentarium in Evangelium Joannis* 6.9.11 [PG 73.967–68]), Ambrose of Milan (*De viduis* 13 [PL 16.257–60]), and Hincmar of Rheims (Flodoard of Rheims, *Historia ecclesiae Remensis* 3.23 [PL 135.226]).

86. Canon 1. The analysis of the text in H.J. Schroeder (*The Disciplinary Decrees of the General Councils* [St. Louis, MO: B. Herder, 1937], 18–19) lists numerous precedents and examples of ordinations of eunuchs. Browe (p. 25) also lists some papal dispensations permitting the ordination of eunuchs.

87. See Regino of Prüm, *De synodalibus causis et disciplinis ecclesiae* 2.87–88 (Ratbod, p. 247).

88. Sigebert of Gembloux called the ordination of eunuchs a Greek heresy: ". . . castratos etiam in episcopatum promovebant . . ." (*Chronographia, anno* 1054 [MGH SS 6.359]).

89. Guibert of Nogent, *De vita sua* 3.19 (E.-R. Labande, ed. [Paris: Belles Lettres, 1981], 442–49).

90. Tertullian, *Adversus Marcionem* 1.1 and 1.29 (CCSL 1.442 and 473); *Adversus Valentinianos* 30.3 (CCSL 2.774); *De monogamia* 1 (CCSL 2.1229).

91. Discussed in Epiphanius of Salamis/Cyprus, *Adversus octaginta haereses* 58 (PG 41.1009–18); repeated in Augustine, *De haeresibus* 37 (CCSL 46.306); and Michael Akominatos, also called Nicetas Choniates, *Thesaurus orthodoxae fidei* 4.30 (PG 139.1300–01). Browe (p. 18) and Rapaport (pp. 34–38) both doubt the existence of this sect, without giving their reasons.

92. Eusebius, *Historia ecclesiastica* 6.8 (PG 20.535–38). The veracity of Eusebius's account has been widely disputed by modern historians, especially because of Origen's championing of an allegorical interpretation of Matthew 19:12, in his *Commentarium in Matthaeum* 15.1–3 (PG 13.1253–68); for a bibliographical list of the limitless secondary works on Origen, see *Bibliographie critique d'Origène* (The Hague: M. Nijhoff, 1971, supplemented in 1982).

93. E.g., Benjamin Sachs and Robert Meisel ("The Physiology of Male Sexual Behavior," in E. Knobil et al., eds., *The Physiology of Reproduction* [New York: Raven, 1988]) 1422) write that "half to two-thirds of the men reported a rapid loss of sexual desire and interest, whereas in the remaining men sexual activity waned gradually, with as many as 10% reporting sexual intercourse for up to 20 years after castration." Other modern studies of the effects of castration, an understandably difficult area for which to find subjects, include J. Bremer, *Asexualization: A Follow-Up Study of 224 Cases* (New York: Macmillan, 1959); and C.C. Hawke, "Castration and Sex Crimes," *American Journal of Mental Deficiency* 55 (1950): 220–26.

94. An example of the ramifications of the perceived relationship between castration and sexual desire may be represented by the theological debate between Julian of Eclanum and Augustine of Hippo in the fifth century. Julian, who attacked Augustine for his theory that *concupiscentia* ("sexual desire") was the origin of sin, apparently suggested that Augustine must have believed Jesus to have been a eunuch. It seems that Julian argued that according to Augustine's definition, since Jesus had been sinless, he must not have had any sexual desire; but since all men have sexual desire, then Jesus must have equally had no *virilitas* ("maleness"), therefore, he must have been a eunuch. Augustine rejected this conclusion. Augustine, *Opus imperfectum contra Julianum* 4.49 and 4.52 (PL 44.762–64).

95. *Ecclesiasticus* 20:2–4 and 30:20–21.

96. Tertullian, *Adversus Marcionem* 1.29 (CCSL 1.474).

97. Claudian, *In Eutropium* 1, vv. 190–91 (LCL [M. Platnauer, ed., 1976], 1.152–53).

98. Peter Abelard, *Historia calamitarum* 14 (PL 178.177). See also the further discussion of Abelard, pp. 289–90.

99. Basil, *De virginitate* 63 (PG 30.797–800).

100. In one carefully euphemistic passage, the poet Claudian implies that the eunuch Eutropius was involved in anal, oral, and manual sex acts (*In Eutropium* 1, vv. 360–70; LCL [M. Platnauer, ed., 1976], 1.164–67). The whole of Claudian's long invective against the eunuch Eutropius, consul of the eastern empire, is a detailed if hostile source of information about the sexual practices of eunuchs, hinting among innumerable other libels at a career involving the sexual gratification of several masters (*In Eutropium* 1, vv. 58–71 and vv. 165–67; LCL [M. Platnauer, ed., 1976], 1.142–43). This same Eutropius was toppled from political influence by John Chrysostom (Socrates Ecclesiasticus, *Historia ecclesiastica* 6.5 [PG 67.671–74]).

101. Danielle Jacquart and Claude Thomasset, *Sexualité et savoir médical au Moyen Age* (Paris: Presses universitaires de France, 1985), trans. by M. Adamson as *Sexuality and Medicine in the Middle Ages* (Princeton: Princeton University Press, 1982). There are only two references: Galen's belief that eunuchs live longer because they abstain from sexual activity (p. 118) and the observation of ninth-century Arabic writer Qusta ibn Luqa that eunuchs have high voices and large breasts (p. 123).

102. Paulus Aegineta, *Compendium medici* 6.65 (I.L. Heiberg, ed. [Leipzig and Berlin: B.G. Teubner, 1921; *Corpus medicorum graecorum* 9] 2.111–12; transl. in Bullough, *Sexual Variance*, p. 329). The very terms for eunuch in Latin, mostly borrowed words from Greek, describe the various procedures: *thlibia*, from the Greek *thlibein*, "to twist or confine"; *thlasia*, from the Greek *thlan*, "to crush," *spado*, from the Greek *spēn*, "to tear or rend." Millant (pp. 142–44) tries to match terms with types of castrations. The Latin verb *castrare*, "to castrate," from which came the adjectival noun *castratus* ("eunuch"), might have been derived from an archaic Latin *castrum* ("knife"). This is suggested in Millant (p. 4), but I was unable to confirm this etymology. In the ancient world, the verb *castrare* was widely believed to be related to *castor* ("beaver"), which led to a widespread medieval legend that if a beaver were pursued, it would gnaw off its testicles and fling them at the hunter to facilitate its escape. Apuleius (*Metamorphoses* 1.9; LCL [J. Hanson, ed., 1989], 1.20–21) mentions this legend. Medieval references include a thirteenth-century Castilian translation of the bestiary of Brunetto Latini, *Libro del tesoro* 181 (S. Baldwin, ed. [Madison, WI: Hispanic Seminary of Medieval Studies, 1989], 86), and the thirteenth-century French work of Pierre de Beauvais, *Bestiare* 16 (G. Mermier, ed. [Paris: A.G. Nizet, 1977], 72–73). In the last, the tale is seen as a moral of the importance of avoidance of sin. It has been suggested that this legend is behind the use of the beaver as the emblem of the Benedictine order, but I was unable to confirm either this usage or its origin.

103. E.g., John Cassian, *Conlationes* 12.9–10 (PL 49.887–89).

104. Justinian, *Novellae Justiniani* 9.25.2/142 (Theodor Mommsen and Paul Krueger, eds., *Corpus Iuris Civilis* [Berlin: Weidmann, 1954], 3.705).

105. Browe, ch. 5: "Entmannung aus medizinischen Gründen," pp. 53–62.

106. Thomas Aquinas, *Summa Theologiae* 2a.2ae.65.1.3 (ST [M. Lefébure, ed., 1975], 38.50–53).

107. See Pliny (*Historia naturalis* 11.47, ed. and trans. H. Rackham (Cambridge, MA: Harvard University Press, 1967, 3.514–15) for this belief, implied perhaps also in the *Babylonian Talmud* (*Seder Mo'ed, Shabbath* 152a).

108. Browe, from whom I took these examples, refers (pp. 57–58) to the various medieval authors who mention curative castrations.

109. Justinian, *Digesta* 50.16.128: ". . . natura spadones . . ." (DJ 4.944).

110. *Gospel according to Matthew* 19:12. For parallel references to this in the *Babylonian Talmud*, see n. 79.

111. *Babylonian Talmud, Seder Tohoroth, Zabim*; see also *Seder Nashim, Yebamoth* 83b–84a; *Seder Kodashim, Bekoroth* 42b–43a.

112. See n. 186.

113. Browe calls it *ekelerregender* ("nauseating," p. 45).

114. See especially Guyot, pp. 59–66; see also David Greenberg, *The Construction of Homosexuality* (Chicago: University of Chicago Press, 1988), 120–23; and

Millant, pp. 130–36.

115. See above, nn. 43, 44, and 45.

116. E.g., Justinian, *Digesta* 48.8.3 (DJ 4.820).

117. Jerome, *Epistula* 130.13 (PL 22.1117–18).

118. E.g., Claudian, *In Eutropium* 1, vv. 79–89 (LCL [M. Platnauer, ed., 1976], 1.145). See also the discussion of the free association of eunuchs with women, pp. 23–24.

119. Browe, p. 46.

120. See Sozomen, *Historia ecclesiastica* 8.8 (PG 67.1537–38), or Socrates Ecclesiasticus, *Historia ecclesiastica* 6.8 (PG 67.689–90). On the institution of the *castrati* singers, see Browe, ch. 6: "Entmannung als künstlerischen Gründen," pp. 83–117; or more recently Patrick Barbier, *Histoire des castrats* (Paris: B. Grasset, 1989), and Angus Heriot, *The Castrati in Opera* (New York: Da Capo, 1975). Neither Barbier nor Heriot mention eunuchs in medieval eastern choirs.

121. Justinian, *Digesta* 48.8.3 and 48.8.5 (DJ 4.820).

122. Ibid., 48.8.6 (DJ 4.820). The penalty was the loss of half the master's property.

123. Ibid., 48.8.4 (DJ 4.820).

124. Constantine I, *Codex Justinianus* 4.42.1 (Mommsen and Krueger 2.179).

125. Justinian, *Novellae Justiniani* 9.25.2/142 (Mommsen and Krueger 3.705–06).

126. Leo VI, *Novellae Leonis* 60 (Kriegel, *fratres*, eds., *Corpus Iuris Civilis* [Leipzig: Baumgärtner, 1887], 3.802).

127. Leo I, *Codex Justinianus* 4.42.2 (Mommsen and Krueger, 2.179). For an example of such a practice, see Ammianus Marcellinus, *Res gestae* 16.7.5 (LCL [J. Rolfe, ed., 1971], 1.226–29). A medieval Greek term for eunuchs, *kartzamadantes* was said to have been derived from Kharizm, a Turkish Muslim kingdom, presumably the source of many eunuchs, although I was unable to confirm the use of this term (see Browe, p. 4, n. 14).

128. Leo, *Novellae Leonis* 60 (Kriegel, 3.802).

129. Procopius, *Anecdota* 11.36 (LCL [H. Dewing, ed., 1969], 6.140–41); *paiderastia* is what is forbidden. See the discussions in John Boswell (*Christianity, Social Tolerance, and Homosexuality: Gay People in Western Europe from the Beginning of the Christian Era to the Fourteenth Century* [Chicago: University of Chicago Press, 1980], pp. 171–74) and Bullough (*Sexual Variance*, pp. 333–36). Boswell lists John Malalas (*Chronographia* 18.168 [PG 97.643–44]) and Georgius Hamartolus (*Chronicon* 4.222 [PG 110.797–806]) as evidence for this penalty; Justinian's own law on the subject of "sins against nature" (*Novellae Justiniani* 6.6.1 [Mommsen and Krieger 3.381–83]) does not mention castration, but does not specify any punishment.

130. Browe, ch. 5, "Entmannung aus Rache und als Strafe," 63–82. I find Browe's interpretations of early medieval laws on castration generally unsatisfactory.

131. A fine of one hundred *solidi* was exacted against anyone who castrated a freeman or wounded him so as to make him sterile, according to Frankish law (*Pactus Legis Salicae* 29.17 [MGH LL 4.1.117]). The law of the Ripuarian Franks distinguished between those who castrate a freeman, who were fined two hundred *solidi* (*Lex ribuaria* 6 [MGH LL 3.2.76]), and those who castrate a slave, who were fined only thirty-six *solidi* (*Lex ribuaria* 28 (27) [MGH LL 3.2.84]). Later Frankish law further differentiated a fine of two hundred *solidi* if the victim of castration was an *antrustio*, that is, a soldier in another man's service, and added an additional penalty for all types of castration of nine *solidi* for medical treatment (*Capitula legi Salicae addita* 71.1–2 [MGH LL 1.241]).

132. *Decretus Childeberti* 5.5 (MGH LL 4.1.271).

133. *Leges Alamannorum* 57.58, where a penalty of 40 *solidi* is exacted against someone who cut off the entire genitalia of another, but see also 57.59, where the penalty is only 20 *solidi* for depriving a man of his *virilia* (MGH LL 1.5.1.127), and 57.69,

where a penalty of 3 *solidi* is exacted for causing a hernia in another (MGH LL 1.5.1.128); see also *Lex Thuringorum* 16, 17, and 18 (MGH LL 5.122); *Lex Frisonum* 22.58–59, and 22.86 (Karl von Richthofen, ed. [Leeuwarden: G.T.N. Suringar, 1866], 24, 26).

134. *Pactus legis Salicae* 40.11 (MGH LL 4.1.153).

135. *Pactus legis Salicae* 25.5 (MGH LL 4.1.94–95).

136. *Leges visigothorum* 3.5.4 and 3.5.7, called *masculi cum masculos inlicita stupri actio* (MGH LL 1.163, 1.165). See the discussions in Boswell, pp. 174–76, and in Bullough, *Sexual Variance*, pp. 351–53.

137. Browe, p. 74.

138. Council of Nablus of 1120, canon 12, as mentioned by James A. Brundage (*Law, Sex, and Christian Society in Medieval Europe* [Chicago: University of Chicago Press, 1987], 207, n. 158), who also lists several examples of just such marriages apparently with no legal penalties.

139. Brundage, p. 471, who lists numerous primary references in his n. 278.

140. Boswell (p. 288) quotes and translates the relevant passage from the *Fuero real* (4.9.2) of Alfonso X of Castile and Leon; Brundage (p. 473) mentions its influence on the thirteenth-century Portuguese *Costums de Tortosa* 9.24.3.

141. *Li livres di jostice et de plet* 22, promulgated under Louis IX in 1270, which demands loss of the testicles for the first offense, loss of the penis for the second, and loss of life for the third. Women were similarly punished for sexual acts with other women (cap. 23: "Feme qui le fet doit a chescune foiz perdre membre et la tierce doit estre arsse"), although the precise meaning of the law as regards women is disputed. See the discussion in Louis Crompton, "The Myth of Lesbian Impunity: Capital Laws from 1270 to 1791," *Journal of Homosexuality* 6 (1980): 11–25 at 13.

142. From Belluno, *Ius municipale* 3.20; see the discussion in Brundage, p. 540, n. 230.

143. E.g., an Alsacian war (*Bertholdi Annales, anno 1078* [MGH SS 5.312]).

144. Ælred of Rievaulx, *De sanctimoniali de Wattun* (PL 195.789–96). Since the episode parallels remarkably the climax of the ancient Greek tragedy *Bacchae* by Euripides, however, we must not be too quick to interpret it literally (vv. 1050–150; LCL [A. Way, ed., 1971], 3.90–97]).

145. See Boswell's discussion pp. 298–300, where he lists a number of primary sources. Neither of two modern histories of the reign of Edward II and the careers of his favorites, by Natalie Fryde (*The Tyranny and Fall of Edward II, 1321–1326* [Cambridge: Cambridge University Press, 1979]) and J.S. Hamilton (*Piers Gaveston, Earl of Cornwall, 1307–1312: Politics and Patronage in the Reign of Edward II* [Detroit: Wayne State University Press, 1988]) mention the castrations.

146. Jean de Froissart, *Chroniques* 43 (George Diller, ed. [Geneva: Droz, 1972], 186).

147. Peter Abelard, *Historia calamitarum* (PL 178.126–35); also discussed in Fulk of Deuil, *Epistula ad Abaelardum* (PL 178.371–76). There is an extensive secondary literature on the relationship between Abelard and Heloise, most of it unscholarly; a notable exception is Étienne Gilson, *Héloise et Abélard* (Paris: Librairie philosophique J. Vrin, 1964, 3rd edn.); or Peter Dronke, *Abelard and Heloise in Medieval Testimonies* (Glasgow Press: University of Glasgow, 1976). For other references, see Salisbury, *passim*.

148. Peter Abelard, *Historia calamitarum, prologus* (PL 178.113).

149. Ibid., 8 (PL 178.135–40).

150. Ibid., 8 and 14 (PL 178.139 and 176–7).

151. Claudian, *In Eutropium, passim* (LCL [M. Platnauer, ed., 1976], 1.138–229); Ammianus Marcellinus, *Res gestae* 16.7.4–8 (LCL [J. Rolfe, ed., 1971], 1.226–31).

152. Guyot, pp. 37–51 and 157–9; Rapaport, pp. 30–33.

153. Especially in Byzantium: the anonymous ninth-century continuator of the

Chronographia of Theophanes describes two incidents in Byzantium when castration was a consequence of dethronement: when Michael I Rangabe was deposed by Leo V the Armenian in 813, his two sons were castrated (1.10 [PG 109.33–34]); and when Leo himself was deposed in 820 by Michael II the Stammerer, his four sons were also castrated (2.7 [PG 109.59–62]). See also J.B. Bury, *A History of the Eastern Roman Empire from the Fall of Irene to the Accession of Basil I (A.D. 802–867)* (London: Macmillan, 1912). Millant (pp. 96–97) also mentions the incident in Sicily in the twelfth century when Henry VI had his defeated rival Tancred's son castrated and blinded, but does not provide references to primary sources for this episode.

154. Liutprand of Cremona (*Antapodosis* 6.6 [PL 136.895–96]) tells of the castration of Beneventan warriors captured by the Byzantine emperor. Other examples for which I was not able to find the primary sources include the castration of French troops captured during the Sicilian vespers of 1282, and the sentence of castration leveled by the English Duke of Worcester against his prisoners in 1410. See also n. 143.

155. Sidonius Apollinaris, *Epistula* 3.13 (LCL [W. Anderson, ed., 1965], 2.46–57). The very name Gnatho comes from the Greek *gnathos* ("jaw"), and might have the connotations of something like the modern slang, "mouthy."

156. Ausonius, *Epigramma* 106, ed. and trans. H. White (Cambridge, MA: Harvard University Press, 1967], 2.214–15).

157. Heinrich Kaufringer of Landsberg, *Drei listige Frauen* (Paul Sappler, ed. [Tübingen: Max Niemeyer, 1972], 1.116–30).

158. Geoffrey Chaucer, *Canterbury Tales, General Prologue*, v. 691: "I trowe he were a geldyng or a mare." (John Manly and Edith Rickert, eds. [Chicago: University of Chicago Press, 1940], 3.1.30).

159. Walter Curry, "The Pardoner's Secret," ch. 3 in idem, *Chaucer and the Medieval Sciences* (New York: Barnes and Noble, 1926), 54–70; Robert Miller, "Chaucer's Pardoner, the Scriptural Eunuch, and the Pardoner's Tale," *Speculum* 30 (1955): 180–99.

160. Beryl Rowland, "Animal Imagery and the Pardoner's Abnormality," *Neophilologus* 48 (1964), 56–60; idem, "Chaucer's Idea of the Pardoner," *Chaucer Review* 14 (1979): 140–54.

161. Monica McAlpine, "The Pardoner's Homosexuality and How it Matters," *Publications of the Modern Language Association* 95 (1980): 8–22.

162. Maurizio Virdis, *L'immagine della castrazione: un tema ricorrente nella letteratura francese del medioevo* (Cagliari: CUEC, 1983).

163. Virdis compares Marie de France's *Lai de Guigemar* (Jean Rychner, ed. [Paris: Honoré Champion, 1966], 5–32), in which the hero is wounded in the thigh, perhaps a euphemism for a genital wound, with other *lais* in which illness plays a role.

164. Chrétien de Troyes, *Perceval, ou Li contes del Graal*, vv. 3480–3513 (Félix Lecoy, ed. [Paris: Honoré Champion, 1972], 1.110–11). It is in fact because of his wound that the king finds hunting on horseback too painful, and takes up fishing, earning him his name.

165. Raimbaut d'Orange, *Chansons* 28 (31): "Qu'aicels don hom es plus gais / Ai perdutz, don ai vergoigna . . ." (Walter Pattison, *The Life and Works of the Troubadour Raimbaut d'Orange* [Minneapolis: University of Minnesota Press, 1952], 164–65).

166. See p. 19.

167. Wolfram von Eschenbach, *Parzival* 9.481–93 (Gottfried Weber, ed. [Darmstadt: Wissenschaftliche Buchgesellschaft, 1967], 404–16).

168. Wolfram von Eschenbach, *Parzival* 13.655–8 (Weber, 553–56).

169. Wolfram von Eschenbach, *Parzival* 13.657: "des wart aldâ gelachet / von Gâwâne sêre" (Weber, 555).

170. See especially Preben Meulengracht Sørensen, *The Unmanly Man: Concepts of Sexual Defamation in Early Northern Society* (Odense: Odense University Press, 1983); see also T. Markey, "Nordic Níthvísur. An Instance of Ritual Inversion?"

Medieval Scandinavia 5 (1972): 7–18.

171. Sturla Þórðarson, *Íslendinga saga* 49 (Gudbrand Vigfusson, ed. [Oxford: Clarendon Press, 1878], 1.255).

172. On this theme, see Joaquín Martínez Pizarro, "On Nið against Bishops," *Medieval Scandinavia* 11 (1982): 149–53.

173. Snorri Sturluson, *Heimskringla* 14.8 (Bjarni Aðalbjarnarson, ed. [Reykjavik: Hið Íslenzka Fornritafélag, 1951], 3.287).

174. Kathryn Ringrose, "Living in the Shadows: Eunuchs and Gender in Byzantium," in G. Herdt, ed., *Third Sex, Third Gender: Beyond Sexual Dimorphism in Culture and History* (New York: Zone Books, 1994), 85–109. The article begins with a discussion of the continuation of ancient Aristotelian and Galenic ideas of sexual difference into the Byzantine period (pp. 86–90), and also discusses the unmanly identity attached to eunuchs, with numerous references to primary sources (pp. 91–96), but much of the article focuses on a twelfth-century defense of eunuchs by Theophylactus of Ohrid (pp. 102–09). Ringrose's article appeared unfortunately too late to incorporate her research more thoroughly into this present article, although compare her remarks (pp. 90–94) with my own comments which follow. On the subject of eunuchs and gender, there is also Guyot (p. 37), who broaches the topic but only briefly and for an earlier period; Rapaport likewise (pp. 26–27) comments on the feminine appearance and behavior of eunuchs.

175. Especially Basil the Great, *Epistula* 115 (PG 32.529–32); see also Jerome, *Commentarius in Evangelium Matthaei* 3.19.12, who says that eunuchs "emolliuntur in feminas . . ." (CCSL 77.168).

176. *Scriptores Historiae Augustae, Severus Alexander* 23.7: ". . . tertius genus hominum . . ." (LCL [D. Magie, ed., 1967], 2.220–21). There is no Latin term which corresponds to our modern definition of gender, but *genus* ("type") is the term from which our English word gender is derived, through Old French *genre/gendre*. Other early comments to this effect, that eunuchs are a third or intermediate sex, can be found in Claudius Mamertinus (*Gratiarum actio Juliano Augusto* 19.4 [PL 18.422]), Claudius Claudianus (*In Eutropium* 1, v. 467; LCL [M. Platnauer, ed., 1976], 1.172); see also comments of Basil and Jerome in n. 175 above.

177. Age of majority: Gaius, *Institutiones* 1.196 (Francis de Zulueta, ed., [Oxford: Clarendon Press, 1946], 1.62); ability to write wills: Paulus, *Sententiae* 3.4A.2 (Ludwig Arndts, ed. *Corpus Iuris Romani Anteiustiniani* [Bonn: Adolf Mark, 1841], 1.92–93); ability to leave estates to posthumous heirs: Justinian, *Digesta* 28.2.6 (DJ 2.820); right to adopt: Gaius, *Institutiones* 1.103 (Zulueta, 1.32), Justinian, *Digesta* 1.7.40 (DJ 1.23), Justinian, *Institutiones* 1.11.9–10 (Peter Birks and Grant McLeod, eds. [Ithaca, NY: Cornell University Press, 1987], 44), Leo, *Novellae Leonis* 26 (Kriegel, 3.772); right to act as legal guardians for minors: Justinian, *Digesta* 27.1.15 (DJ 2.788); right to marry: Leo, *Novellae Leonis* 98 (Kriegel, 3.826–27). See also Gaetano Sciascia, "Eunucos, castratos e 'spadones' no direito romano," in *idem, Varietà giuridiche. Scritti brasiliani di diritto romano e moderno* (Milan: Dott. A. Giuffrè, 1956), 111–18.

178. Leo, *Novellae Leonis* 60: ". . . heteron plasma . . ." (Kriegel, 3.802). *Creatura alia* is the Latin translation given.

179. Leo, *Novellae Leonis* 98 (Kriegel, 3.826–27).

180. Justinian, *Institutiones* 1.11.9–10 (Birks and McLeod, 44).

181. See Claudian, *In Eutropium* 1, vv. 104–9 (LCL [M. Platnauer, ed., 1976], 1.146–47). The very word eunuch of course comes from the Greek words *eun* , "marriage bed," and *echein*, "to guard."

182. See Lactantius, *De mortibus persecutorum* 38 (PL 7.254–56).

183. See Julian, *Misopogon* 352b (LCL [W. Wright, ed., 1969], 2.460–61).

184. Gregory of Tours, *Historia Francorum* 10.15 (PL 71.544–46); see the discussion of this episode by Nancy Partner, "No Sex, No Gender," *Speculum: A Journal of Medieval Studies* 68 (1993): 419–43.

185. Albert the Great, *De animalibus* 8.5.3 (C. Bäumker, ed., *Beiträge zur Geschichte der Philosophie des Mittelalters* [Münster: Aschendorff'scher, 1916], 15.661–63). See also n. 17.

186. See Brundage, pp. 290–92, with many references to canonists: including Huguccio, Pierre de la Palude, William of Pagula, Thomas Aquinas, Bonaventure, Bernardius de Montemirato, Vincentius Hispanus, Petrus de Sampsone. Ignatius Gordon ("Adnotationes quaedam de valore matrimonii virorum qui ex toto secti sunt a tempore Gratiani usque ad Breve 'Cum frequenter,'" *Periodica de re morali, canonici, liturgici* 66 [1977], 171–247), whom Brundage cites, in turn gives an earlier bibliography of the question, and further primary references.

187. Jane Tibbetts Schulenberg, "The Heroics of Virginity: Brides of Christ and Sacrificial Mutilation," in Mary Beth Rose, ed., *Women in the Middle Ages and the Renaissance* (Syracuse, NY: Syracuse University Press, 1986), 29–72. See also Browe, p. 34, who gives examples also of men and women who bit or cut off their tongues.

188. "The presuppositions that we make about sexed bodies . . . are suddenly and significantly upset by those examples that fail to comply with the categories that naturalize and stabilize that field of bodies for us within the terms of cultural conventions. Hence, the strange, the incoherent, that which falls 'outside,' gives us a way of understanding the taken-for-granted world of sexual categorization as a constructed one, indeed, as one that might well be constructed differently" (Judith Butler, *Gender Trouble: Feminism and the Subversion of Identity* [New York: Routledge, 1990], 110).

BIBLIOGRAPHY

Adam, Paul. *Irène et les eunuques*. Vienne: Larousse, 1906.

Bauer, Walter. "Matthäus 19,12 und die alten Christen," in *Neutestamentliche Studien: Georg Heinrici zu seinem 70. Geburtstag (14 Marz 1914) dargebracht von Fachgenossen, Freunden und Schulern*. Leipzig: J.C. Hinrichs, 1914.

Bergmann, Frédéric. *Origine, signification et histoire de la castration, de l'eunuchisme et de la circoncision*. Palermo: L.P. Lauriel, 1883.

Browe, Peter. *Zur Geschichte der Entmannung: eine Religions- und Rechtsgeschichtliche Studie*. Breslau: Müller und Seiffert, 1936.

Bullough, Vern L. *Sexual Variance in Society and History*. Chicago: University of Chicago Press, 1976.

Curry, Walter. "The Pardoner's Secret." *Chaucer and the Medieval Sciences*. New York: Barnes and Noble, 1926.

Gaiffier, Baudouin de. "Palatins et eunuques dans quelques documents hagiographiques." *Analecta Bollandiana* 75 (1957): 17–46.

Gordon, Ignatius. "Adnotationes quaedam de valore matrimonii virorum qui ex toto secti sunt a tempore Gratiani usque ad Breve 'Cum frequenter,'" *Periodica de re morali, canonici, liturgici* 66 (1977): 171–247.

Guilland, Rodolphe. "Études de titulature byzantine: les titres auliques réservés aux eunuques." *Revue des Études byzantines* 13 (1955): 50–84; 14 (1956): 122–57.

———. "Études sur l'histoire administrative de l'Empire byzantin: les titres auliques des eunuques. Le protospathaire." *Byzantion* 25/27 (1955/57): 649–95.

———. "Fonctions et dignités des Eunuques." *Études byzantines* 2 (1944): 185–225; 3 (1945): 179–214.

———. "Les eunuques dans l'Empire byzantin. Étude de titulature et de prosopographie byzantines." *Études byantines* 1 (1943): 196–238.

———. *Recherches sur les institutions byzantines*. 2 vols. Berlin: Akademie-Verlag, 1967.

Guyot, Peter. *Eunuchen als Sklaven und Freigelassene in der griechisch-römischen*

Antike. Stuttgart: Klett-Cotta, 1980.

Hill, Thomas. "Narcissus, Pygmalion, and the castration of Saturn: Two Mythographical Themes in the Roman de la Rose," *Studies in Philology* 71 (1974): 404–26.

Hopkins, Keith. "Eunuchs in Politics in the Later Roman Empire." *Proceedings of the Cambridge Philological Society* 189 (1963): 62–80.

Millant, Richard. *Les eunuques à travers les ages.* Paris: Vigot frères, 1908.

Miller, Robert. "Chaucer's Pardoner, the Scriptural Eunuch, and the Pardoner's Tale." *Speculum* 30 (1955): 180–99.

Rapaport, Ionel. "Les faits de castration rituelle: essai sur les formes pathologiques de la conscience collective." Paris: Université de Paris [Doctoral dissertation], 1945.

Ringrose, Kathryn. "Living in the Shadows: Eunuchs and Gender in Byzantium." In Gilbert Herdt, ed., *Third Sex, Third Gender: Beyond Sexual Dimorphism in Culture and History.* New York: Zone Books, 1994.

Sanders, George. "Les galles et le gallat devant l'opinion chrétienne." In M. de Boer, ed. *Hommages à Maarten Vermaseren.* Leiden: E.J. Brill, 1978.

Schulenberg, Jane Tibbits. "The Heroics of Virginity: Brides of Christ and Sacrificial Mutilation." In Mary Beth Rose, ed., *Women in the Middle Ages and the Renaissance.* Syracuse, NY: Syracuse University Press, 1986.

Sciascia, Gaetano. "Eunucos, castratos e 'spadones' no direito romano." *Varietà giuridiche. Scritti brasiliani di diritto romano e moderno.* Milan: Dott. A. Giuffrè, 1956.

Virdis, Maurizio. *L'immagine della castrazione: un tema ricorrente nella letteratura francese del medioevo.* Cagliari: CUEC, 1983.

Zambaco, Démétrius. *Les eunuques d'aujourd'hui et ceux de jadis.* Paris: Masson, 1911.

III
Cultural Issues

13 A Note on Research into Jewish Sexuality in the Medieval Period

Norman Roth

Sexuality in Jewish thought and practice in the medieval period, as is the case also with Islam, must be separated into "official" and "actual" categories: what was sanctioned and proscribed by law and/or ethical teaching, and what actually was believed and done.

In general, the Scriptures are fairly restrictive with regard to sexual practices, even with regard to one's wife, and certainly with respect to such areas as adulterous relations, homosexuality, and bestiality. Capital punishment was prescribed for some of these offenses, for example, adultery. Sexual intercourse between adult males could also be punished by the death penalty. Masturbation, the "sin of Onan" (Genesis 38: 8–10) was deemed evil but the punishment (death) was at the hands of God. Concubinage was permitted, as was the possession of more than one wife (according to rabbinical dictate, not more than four).

Unfortunately, the attitudes of the rabbis in the talmudic era have often been subject to over-simplified generalizations, as has discussion of actual sexual practices.[1] Though many rabbinical teachings appear to discourage thoughts about sex, even to the point of prohibiting conversation with women or looking at a woman not one's wife, most statements about sexual activities are much less rigid. Those interested in pursuing various sexual topics should consult the index volume to the Babylonian Talmud.[2] Key words which appear helpful are "marriage," "semen," "sex," "intercourse," or "sodomy." Various Hebrew legal sources and codifications also exist, which can prove helpful.

One of the areas most needing exploration is the distinction between (a) ethical statements, (b) legal rulings, and (c) indication of actual practices. The topics most explored in this way are marriage and divorce, but much of that which is known about these topics is only tangential to our theme. Complicating the issue is the determination of chronological limits for the

"medieval period" in Jewish history. Traditional demarcations between ancient and medieval or medieval and modern do not necessarily coincide with developments in Judaism. The final redaction of the "Babylonian Talmud" took place at the end of the fifth century, but this is not regarded as a turning point in Jewish history. There has been a general tendency among scholars of Judaism to begin the medieval period with the end of the geonic era, that is, the period of the sages in Iraq (the heads of the four *yeshivot* or Talmudic academies near Baghdad), who continued the "Babylonian" tradition of commentary and whose legal authority extended over most of the Jewish world. Using such a date literally would mean that the Jewish Middle Ages did not begin until the eleventh century, after the death of the last of the geonim, Hai (Hayye). The author of this article would prefer to consider the ascension of Sa'adyah to the position of *gaon* of Sura in 928. In the first place, he was the first non-"Babylonian" to hold the position, having come from Egypt, emphasizing a growing recognition of the importance of other Jewish communities of the Diaspora. Secondly, he composed a series of works that definitely mark a new emphasis in Jewish literary tradition (grammar, commentary on the Bible, and so on).

Unfortunately there has been little enough research on the geonic period in general (although considerably more on Sa'adyah himself); let alone the issue of sexuality, which as far as I know has never been dealt with. The potential richness of the sources is evident from Sa'adyah's extant responsa (decision on legal questions). In one, we learn of a man who had three wives. More interesting, however, is the controversy between Sa'adyah and the Exilarch David b. Zakai, an important dignitary who later became *gaon* of the Pumbedita *yeshivah*. Khalaf Ibn Sarjado accused Sa'adyah of engaging (passively) in sexual intercourse with boys while in the presence of sacred scriptures. He added that all the youth of Nehardea know where to find him.[3]

Another reason for dating the Jewish Middle Ages with the elevation of Sa'adyah is that the "hegemony" of Jewish civilization had already begun to be transferred to Spain in the tenth century. This was especially true in Al-Andalus, where the Jewish community and its leaders rivaled and soon surpassed Baghdad. Giving impetus to this Jewish "Renaissance" was a reaction to the claim by the Muslims that Arabic was the only language in which poetry could be written This claim was based on the Islamic belief that the "perfection" of Arabic had been revealed in the *Qu'rān*, since it was the language of God. To counter this the Jews of Islamic Spain undertook the revival of Hebrew, a language that had long ago fallen into desuetude. Poets soon emerged who were emulating and soon surpassing Arabic po-

etry in the composition of their secular Hebrew verse. The Jew, Samuel Ibn Naghrīllah (tenth century), who became both prime minister of Granada and commander-in-chief of its army, wrote extensive poems of love in Hebrew about women and boys, both Muslim and Jewish.[4]

Apparently, even before this, elements in the Jewish community were upset over both the fact that some Jewish men were having sexual relations with non-Jews, and that such relationships were not only with women but with boys. To illustrate, a Jewish reader of scripture in the synagogue was dismissed from his position because of such relationships.[5]

All of the Hebrew poets of the "classical" era in Muslim Spain composed such love poetry, including many examples of the *muwashshaḥ* form, in which the final rhymed couplet is in Arabic or a Romance language (or a combination), often of an "erotic" nature. True, the Hebrew language lacked the "scatological" or sexually explicit words that Arabic had, yet the unmistakable nature of the meaning of these poems—as well as the object of the desire—is evident. Some, indeed, come quite close to actual descriptions of sexual activity.

Another form of literature that was also borrowed from the Muslims, but that appears to have become even more popular among Spanish Jews, was the rhymed prose novel, or *maqamah*. Several of these center on erotic themes, and they constitute the first example of a genre devoted entirely to the subject of love.

Before leaving the subject of literature, it should be noted that later Spanish poems by Jewish writers and even more so by *conversos* (Jews who converted to Christianity) and the fifteenth-century collections are replete with sexual insults addressed to a rival, most of which focus on accusations of homosexual behavior.[6]

The influence of Hebrew poets carried over to North Africa where there is at least one example of a "literary" work, the *Hibur yafeh mi-ha-yeshu'ah* by Nissim b. Jacob Ibn Shahin of Qairawan (d. ca. 1065). Some chapters of this work are stories concerning relations with women, derived, however, from midrashic sources.[7]

In addition to the literary sources of the Medieval period, there are legal sources of several kinds: compilation of the *miṣvot*, or commandments contained in the Torah (the most famous of which was by Moses b. Maimon or "Maimonides"); codification of law derived from the *Talmud* and other sources; commentaries on the Bible and, especially, on the *Talmud*; and responsa literature (*she'elot u-teshuvot*), which usually is case law, that is, decisions in reply to specific legal questions. The sheer volume of the extant literature is a daunting challenge to the scholar, but until all the sources of

information are consulted and examined, we will not fully know the story of medieval Jewish sexuality.

Maimonides was recognized by his contemporaries as the foremost legal authority, and he wrote extensively about laws concerning sex and sexual behavior, particularly in his great code *Mishneh Torah*. His commentaries on the *mishnah*, as well as his responsa and various other writings, need to be consulted by anyone exploring the subject of Jewish sexuality. Maimonides was also one of the most famous physicians in his age. His numerous medical works contain some information of interest,[8] but the authenticity of his supposed work on coitus is doubtful. It may well have been the work of a near contemporary Rabbi Moses, also of Cordoba.[9] This, too, requires further investigation, since in his *Regimen of Health* Maimonides makes a very interesting statement regarding the dangers of coitus.[10]

In his philosophical writings, he adhered to the ascetic teachings of the Greek philosophers, particularly those advanced by Aristotle in his *Ethics* and *Politics*. This aspect of Maimonides is important to emphasize, since one of the standard assumptions of many who write about Jewish sexuality is that sexual asceticism was virtually unknown in Jewish teaching.[11] This is not so, at least in the case of Maimonides. His asceticism appears most strongly in his *Guide for the Perplexed*, but to a lesser extent in his other writings where he demonstrated almost total opposition to sexual pleasure.[12] Did these aspects of sexual asceticism have considerable influence on later Jewish writers or were they ignored? This is a subject that also needs to be investigated.

Any discussion of Judaism in the Middle Ages would not be complete without a discussion of the *qabalah*, the esoteric interpretation of Scripture and religious doctrine that appeared in thirteenth-century Provence and Spain (particularly Catalonia). Some attention has been given to sexual imagery and ideas in these teachings, particularly to the sexual imagery in the *Igeret ha-qodesh* ("Holy Letter") erroneously attributed to Moses b. Naḥman (Naḥmanides), one of the early adherents of *qabalah*.[13] Most authorities regard the "letter" as spurious, but it continues to be accepted as genuine by some even today. The work deals entirely with sexual intercourse.

From the pietist Jews of Germany in this same period comes the famous *Sefer ḥasidim* ("Book of the Pious") by Judah *he-ḥasid*, which contains many fascinating stories and admonitions concerning sexual behavior. While generally at least as strict as Maimonides in its message, it includes a story, related without comment, of an older man who was told about a lovely woman who desired him. He was also advised to dye his hair so as not to appear old to her. He replied: "Forfend that I should deceive her, but she shall see that I am old and say what is in her heart if she desires me."[14]

Some strange and contradictory ideas about sex come out of the medieval commentators. For example "Rashi" (Solomon b. Isaac of Troyes), a famous biblical and talmudic commentator of the eleventh century, wrote that it was prohibited to have sexual intercourse in a year of famine.[15] Sa'adyah, whose love of boys is mentioned above, included eight gradations of prohibited sexual relations (animals, males with males, and so forth).[16] Abraham Ibn Ezra, an extreme rationalist, reports that due to the climate, the Egyptian males when they approach forty years of age are unable to have intercourse with a virgin until a youth is brought who briefly engages in intercourse with her. When her introitus has opened sufficiently for penetration, he turns over penetration to the older man.[17] Indicating the willingness of even the most learned commentators to pass on gossip and erroneous information is Ibn Ezra's praise of the morality of the Hindus, apparently unaware of their extensive sexual literature and customs.

Concubinage, sex with slaves (female, certainly, and probably also with boys), continued to exist among Jews long after the Muslim dominance in Spain, and not only in Spain but elsewhere in Europe. Sexual relations and even intermarriage with Christians, though forbidden under severe penalties, both in Jewish and Christian law, were far more common than generally imagined. Rashi (Solomon b. Isaac), mentioned above, wrote that it was "prohibited for a man to say such things as How lovely is this Gentile woman."[18] Despite such statements, however, Jews not only looked but actively engaged in sexual relations with Christians.

Christian men were often attracted to Jewish women, and in medieval Spain at least one ruler had a Jewish mistress. Many famous Christians produced offspring from Jewish women; such offspring usually were baptized and acknowledged by their fathers.[19] While Jews were not permitted to maintain Christian slaves, they did have Muslim ones, and they did not always convert them as Jewish law required. Sexual activity continued well into the late medieval period with such slaves. Several cases of Jewish men engaging in sexual relations with Christian women were found in our sources, and this was not confined to Spain. Neither was pederasty. While we have not noticed any evidence of Lesbianism among medieval Jews, this lack of mention does not mean that it failed to exist. There are only occasional references to masturbation, but in one case a man who claimed he no longer could engage in intercourse sought permission to masturbate his wife. Missing from our sources are also actual incidents of bestiality, as distinct from discussion of such practices in the *Talmud*.

Prostitution was not unknown among Jewish women, and Jewish prostitutes were frequent enough both in Aragon and in some parts of Castile

in medieval Spain to arouse debate as to the desirability of expelling them from the cities. Jewish prostitutes, in fact, played a central role in the anti-Jewish polemic of medieval legends and plays, such as those concerned with the "anti-Christ," who according to Christian tradition was the son of a Jewish whore. There is also an extensive anti-Jewish Christian polemical literature in which the supposed sexual immorality or prowess of the Jews plays a major role. Indeed the decision of the fourth Lateran Council (1215) to require the wearing of distinctive clothing by Jews (which ultimately became the badge of Jews except in Spain) was motivated by the peculiarly worded fear that Christians might "accidentally" engage in sex with Jews.[20]

In sum, the subject of Judaism and sex in the Middle Ages, including superstition and magical customs, remains a field that needs considerable research. The subject has only begun to be explored. Even in my own books, which contain much information on sexuality and other topics, I have only touched the surface.

NOTES

1. See the article "Sex," *Encyclopedia Judaica* (New York: Macmillan, 1972), vol. 14.

2. *The Babylonian Talmud*, English translation edited under the general direction of Isidore Epstein (London: Soncinco Press, 1933). A newer translation is *The Talmud, with English Translation and Commentaries*, edited by A. Ehrman (Jerusalem: El Am, 1965). Both have indices. A translation, incomplete as of this writing, is *The Talmud: The Adin Steinsalz Edition* (New York: Random House, 1989).

3. Norman Roth, "'Deal Gently with the Young Man,'—Love of Boys in Medieval Hebrew Poetry of Spain," p. 23; see there other references to love of men.

4. See, for discussion, Norman Roth, *Jews, Visigoths & Muslims in Medieval Spain* (Leiden: E.J. Brill, 1994), pp. 89. ff.

5. Roth, "Deal Gently," p. 22.

6. Norman Roth, *Conversos, Inquisition and the Expulsion of the Jews from Spain* (Madison: University of Wisconsin Press, 1995).

7. Nissim b. Jacob Ibn Shahin, *Hibur yafeh min-ha-yeshu'ah*, pp. 29 ff., 68 ff., 73 ff. Midrash are rabbinic expositions of the scripture.

8. See Fred Rosner, *Medicine in the Mishneh Torah of Maimonides* (New York: KTAC Pub. House, 1984).

9. There is an extensive literature on this and a brief discussion in English by Fred Rosner, *Maimonides Medical Writings* (Haifa: Maimonides Research Institute, 1984), pp. 156–61. There is also a translation of the work, which in Hebrew is best translated as a "Treatise on Cohabitation," pp. 162–82. There is also a longer version (19 chapters instead of 10) preserved in Arabic and now located in Munich, which most authorities reject as having been written by Maimonides.

10. Maimonides, *Regimen of Health*, p. 29.

11. See the article on sex in the *Encyclopedia Judaica*.

12. Moses ben Maimon, *The Guide of the Perplexed*, and Fred Rosner, *Sex Ethics in the Writings of Maimonides*.

13. Nahmanides [Moses b. Nahman], *Igeret ha qodesh* first ed. (Rome, 1546), and translated into French, *Le secret de la relation entre l'homme et la femme dans la cabale [sic]*. Translated by Charles Mopsik (Lagasse, 1986), and into English by

Seymour J. Cohen as *The Holy Letter: A Study in Sexual Morality* (Northville, NJ: Jason Aronson, 1993).

14. *Sefer hasidim*, ed. Jehuda Wistinetski (Berlin, n.p., 1891), p. 281, no. 1106.

15. Commentary on Genesis, 41:50.

16. As reported by Abraham Ibn 'Ezra, Commentary on Leviticus 18:21.

17. Ibn Ezra on Haggai 2:12. This is part of his biblical commentary, which is not available in translation.

18. *Deuteronomy* 7.3. Some have claimed Rashi was quoting the Talmud, but this quote is original with him.

19. Roth, *Jews, Visigoths, and Muslims*, and *Conversos*.

20. Ibid.

BIBLIOGRAPHY

Sources (only those with translations are included).

Ibn 'Ezra, Moses. *Selected Poems*, trans. Solomon Solis-Cohen (with Hebrew text). 2d ed. Philadelphia: Jewish Publication Society, 1945. Translation often incorrect.

———. *Antologia poética*, trans. Rosa Castillo (with Hebrew text). Madrid: Hiperión, 1993; again has some love poems with accurate translations.

Ibn Shahin, Nissim b. Jacob. *Hibur yafeh min-ha-yeshu'ah*. Jerusalem: Mosad ha Rav Kook, 1969, 29ff., 68ff., 73ff.

———. *Arabic Original of Ibn Shahin's Book of Comfort*, ed. J. Obermann. New Haven, CT: Yale University Press, 1933.

———. *An Elegant Composition Concerning Belief After Adversity*, trans. William M. Brinner. New Haven, CT: Yale University Press, 1977. There are several erroneous statements in the introduction.

Ibn Zabara, Joseph. *The Book of Delight*, trans. Moses Hadas. New York: Columbia University Press, 1932. This is a poor translation.

———. *Llibre d'ensenyaments delectables. Sèfer xaaoxuĩm*, trans. (Catalan) I. Gonzàlez-Llubera. Barcelona: Editorial Alpha, 1931. An excellent translation.

———. *Libro de los entretenimientos*, trans. (Castilian) Marta Forteza-Rey. Madrid: Editora Nacional, 1983. An excellent translation.

al-Ḥarizi, Judah. *The Taḥkemoni*, trans. Victor Reichert. 2 vols. Jerusalem: R.A. Cohen's Press, 1965–73. Adequate translation.

———. *Las assembleas de los sabios*, trans. Carlos del Valle Rodríguez. Murcia, Spain: Universidad de Murcia, 1988. Excellent translation.

Yehudah (Judah) ha-Levy. *Antologia poética*, trans. Rosa Castillo. Madrid: Altalena, 1983. An excellent translation. There is a translation by Nina Salaman, *Selected Poems* (Philadelphia: Jewish Publication Society, 1928), which has some examples of love poetry.

Carmi, T., ed. and trans. *The Penguin Book of Hebrew Verse*. New York: Penguin Books, 1981; has several love poems and, though translations are correct, they are often abridged.

Moses b. Maimon, *Maqālāt fī-tadbīr al-ṣīḥah*, ed. with a German trans. by H. Kroner, *Janus* 27 (1923), 101–16, 286–300; 28 (1924), 61–74, 143–52, 199–217, 408–19, 455–72; 29 (1925), 235–58. An inaccurate edition of the Hebrew translation by Moses Ibn Tibbon was published by S. Munter (Maimonides), *Hanhaget ha-beriut* (Jerusalem, 1957), with an English trans. by H.L. Gordon, *The Preservation of Youth* (New York: Philosophical Library, 1958). An accurate English translation from Judeo-Arabic is A. Bar–Sela et al., *Two Treatises on the Regimen of Health* (Philadelphia: American Philosophical Society, 1964); see p. 29.

(Pseudo Maimonides). "On coitus" (*Fī'l–jima'a*) text with Hebrew and German, trans. Hermann Kroner in (Maimonides), *Sheney mamerey ha-mishgal* (Berlin, 1906); inaccurate English translation, *Maimonides on Sexual Intercourse*, trans. M. Gorlin (New York: Rambash Publications, 1961); another English translation is by Fred Rosner, *Cohabitation*, part 3, in *Maimonides Medical Writings* (Haifa: Maimonides Research Institute, 1984).

(Pseudo Naḥmanides [Moses b. Nahman]). *Igeret ha-qodesh* (1st ed., Rome, 1546), in Moses b. Nahman, *Ḥidushe ha-Ramban . . . Shevu'ot, Nidah*, ed. Charles Chavel (Jerusalem: n.p., 1976), and *Da'at qedushah*, ed. Asher Margaliot (Brooklyn: 1977); French trans. *Lettre sur la sainteté. Le secret de la relation entre l'homme et la femme dans la cabale [sic]*, trans. Charles Mopsik (Lagrasse: Verdige, 1986). See also *The Holy Letter: A Study in Medieval Jewish Sexual Morality Ascribed to Nahmanides*, ed. and trans. Seymour J. Cohen (New York: Ktav, 1976).

Sa'adyah b. Joseph al-Fayyūmī *(Gaon)*. *Book of Beliefs and Opinions*, trans. S. Rosenblatt. New Haven, CT: Yale University Press, 1948, pp. 373ff. (Other statements mentioned in this chapter are in his *She'elot u-teshuvot*, with his *Sefer ha-yerushot*, ed. Joel Müller (Paris: [n.p], 1897, photo reproduction, Jerusalem, 1968).

Secondary Literature

1. GENERAL STUDIES

Assis, Yom-Tov, "Sexual Behavior in Mediaeval Hispano-Jewish Society." In *Essays in Honour of Chimen Abramsky*, ed. Ada Rapoport-Albert and Steven J. Zipperstein (London: P. Halban, 1988), 25–59.

Biale, David. *Eros and the Jews from Biblical Israel to Contemporary America* (New York: Basic Books, 1992).

Edwards, Allen. *Erotica Judaica: A Sexual History of the Jews* (New York: Julian Press, 1967).

Epstein, Louis M. *Marriage Laws in the Bible and the Talmud* (Cambridge, MA: Harvard University Press, 1942).

———. *Sex Laws and Customs in Judaism* (New York: Ktav Publishing House, 1948).

Feldman, David M. *Marital Relations, Birth Control and Abortion*. New York: Schocken Books, 1971.

Goitein, S.D. "The Sexual Mores of the Common People," *Society and the Sexes in Medieval Islam* (Sixth Giorgio Della Vida Biennial Conference), ed. Afaf Lufti al-Sayyid-Marsot. Malibu, CA: Undena Publications, 1979, 43–61.

Orbach, W. "Homosexuality and Jewish Law." *Journal of Family Law* 14 (1975): 353–81.

Plessner, M. (On Sa'adyah's Anatomy of Men [Hebrew]), *Qorot* 1 (1953): 38–45, 99–107.

Roth, Norman. *Jews, Visigoths and Muslims*. Leiden: Brill, 1994.

———. *Conversos, Inquisition and the Expulsion of the Jews from Spain*. Madison: University of Wisconsin Press, 1995. Contains material on homosexual and converso poets. See chapter 6.

2. SEXUAL IDEAS IN MAIMONIDES

Moses b. Maimon, *The Guide of the Perplexed*, trans. Shlomo Pines. Chicago: University of Chicago Press, 1963.

Rosner, Fred. *Maimonides Medical Writings*. Haifa: Maimonides Research Institute, 1984.

————. *Medicine in the Mishneh Torah of Maimonides*. New York: Ktav Publishing, 1984; see index for sexual topics.

————. *Sex Ethics in the Writings of Maimonides*. New York: Bloch Publishing, 1974.

Roth, Norman. *Maimonides. Essays and Texts*. Madison, WI: Hispanic Seminar of Medieval Studies, 1985, 46–47, 51, 116.

3. QABALAH, MAGIC, ETC.

Idel, Moshe. "Métaphores et pratiques sexuelles dans la cabale," in (Pseudo Nahmanides), *Lettre*, cited above.

Scholem, Gershom. *Kabbalah*. New York: Quadrangle Books, 1974, 66, 110, 195.

Trachtenberg, Joshua. *The Devil and the Jews*. New Haven, CT: Yale University Press, 1943, rpt. 1983, especially pp. 34ff.

————. *Jewish Magic and Superstition*. New York: Behrman's Jewish Book House, 1939, and New York: Atheneum, 1975; see index.

4. POETRY AND LITERATURE

Ferrer-Chivite, M. "*Las Coplas del Provincial:* sus conversos y algunos que no lo son." *La Corónica* 10 (1982): 156–85; discusses homosexual references in this anthology.

Gonzalo Maeso, David. *El tema del amor en los poetas hebraicoespañoles medievales*. Granada, Spain: Universidad de Granada, 1971.

Roth, Norman. "The 'Wiles of Women' Motif in Medieval Hebrew Literature of Spain." *Hebrew Annual Review* 2 (1978): 145–65 (deals with some of the *maqamah* literature).

————. "Satire and Debate in Two Famous Medieval Hebrew Poems: Love of Boys vs. Girls, the Pen and Other Themes." *Maghreb Review* 4 (1980): 105–13 (with translation of the poems).

————. "'Deal Gently with the Young Man'—Love of Boys in Medieval Hebrew Poetry of Spain." *Speculum* 57 (1982): 20–51.

————. "My Beloved Is Like a Gazelle: Imagery of the Beloved Boy in Hebrew Religious Poetry." *Hebrew Annual Review* 8 (1984): 143–65; reprinted in Wayne R. Dynes and Stephen Donaldson, eds., *Homosexuality and Religion and Philosophy*. New York: Garland Publishing, 1992.

————. "The Care and Feeding of Gazelles: Medieval Arabic and Hebrew Love Poetry." In Moshé Lazar and Norris R. Lacy, eds., *Poetics of Love in the Middle Ages*. Fairfax, VA: George Mason University Press, 1989, 95–118.

————. "Fawn of My Delights: Boy-Love in Hebrew and Arabic Verse." In Joyce Salisbury, ed., *Sex in the Middle Ages*. New York: Garland Publishing, 1991, 157–72.

Schirmann, J. "The Ephebe in Medieval Hebrew Poetry." *Sefarad* 15 (1955): 55–68.

Stern, David and Mark Jay Mirsky, eds. *Rabbinic Fantasies*. Philadelphia: Jewish Publication Society, 1990; anthology, only chaps. 12 and 13 are relevant, and both contain serious errors of translation.

317

14 A RESEARCH NOTE ON SEXUALITY AND MUSLIM CIVILIZATION

Norman Roth

Islam was strongly influenced from its very origin by Jewish and Christian traditions and laws. Considering this background, it is perhaps remarkable that the *Qur'ān* has very little to say on the subject of sexuality. Statements adopted from the Bible about degrees of permitted marriage are included, but the most important statements concern the crime of "adultery" *(zinā,* literally any extramarital intercourse with women). The punishment for this offense is somewhat contradictory. In one part *(Sūrah* IV) it appears that the punishment, death, is to be left in the hands of Allāh, whereas elsewhere (XXIV), if the requisite three witnesses testify, lashes are to be prescribed for both parties.

There are also frequent hints of the crime of "sodomy," and in one instance (XXVI 160ff.) it is made quite clear that this is detested. No punishment, however, is specified. Ironically, this particular *Sūrah* is called "the Poets," and, as indicated below, poets especially celebrated sexual relations with boys.

In spite of the relatively abundant number of studies on various aspects of sexuality in Islam, no specific study has focused on either theory or practice in early Islam, with the exception of Papo and the brief comments of Coulson.[1] Neither comments on homosexuality at all.

Indeed, much of what has been written so far—one may say nearly all of it—focuses on the readily available literary sources, with some material on medical or "theological" sources. Little enough has been done on the actual practices among Muslims in any society or period in the Middle Ages. Refreshing exceptions to this generalization are the studies of Bosworth, Bullough, and Rosenthal.[2]

An important source that has been almost totally ignored (as it all too often is for other aspects of Muslim history) is the famous *Fihrist* of al-Nadīm, the tenth century bibliographer and reporter of literary traditions

in Islam. This work reveals a remarkable interest in all aspects of sexual activity in the earliest Arabic writings (although little use has been made of the *Fihrist* in this connection. It was, for example, totally unmentioned in any of the papers in the collection *Society and the Sexes in Medieval Islam*).[3] This fact is all the more important because there is an excellent English translation of the work.[4]

One of the early writers mentioned by al-Nadīm was Abū'l- 'Anbas al-Ṣaymarī (d. 888 or before), who was both a judge and a poet and wrote several books on sexual topics including "The Lover and the Beloved," as well as one on "unnatural" sexual intercourse and whores, another on masturbation, possibly one of anecdotes concerning eunuchs, and still another on the "Superiority of the Rectum Over the Mouth."[5] Masturbation was also the subject of a book by Ibn al-Shah al-Ṭāhirī.[6]

Of particular interest are the "evening stories and fables," including a whole series of works about "passionate lovers" in the pre-Islamic and Islamic periods, "loving and fickle girls," stories about slaves and slave girls, etc., of humans in love with *jinn* (demons) and *jinn* in love with humans.[7] It is worth noting that neither manuals of intercourse nor anything dealing with homosexuality is apparently included, although some of the no longer extant stories may have dealt with the latter theme.

Many erroneous ideas about Muslim practices in the medieval period continue to be perpetuated by scholars who ought to know better. For example, the statement is often made that Muslims were prohibited from drinking wine, and therefore any reference to such activity must reflect an audacious "rebellion" against Islām. Nothing could be further from the truth. Wine drinking was *not* prohibited according to most legal schools, and in fact was widely enjoyed. It was in the context of the all-night wine parties *(majālis;* singular *majlis)*, some of which lasted for days, that sexual activity took place. This often involved the dancing girls or boys and/or the boy cup-bearers who poured the wine at such parties. Frequently, it appears, the host would in fact provide sexual entertainment for his guests by presenting them with the object of their desires.

Perhaps the richest and most important source for understanding sexual attitudes and practices in medieval Islamic society is poetry. Pre-Islamic Arabic poetry already contained sections known as the *nasīb,* often erroneously translated as "erotic." In fact, there is nothing erotic about this type of poetry; it was nothing more than a mere convention for describing the abandoned camp of the beloved. There was, however, another early school, the *Ḥijāzi* (ca. 650 C.E.), which was more erotic. The poets of this school wrote in highly stylized form which involved complex and elaborate

meters, and their poems usually began with an expression of yearning for a vanished happiness in love, and ultimately ended up glorifying the poets or their tribe, the real object of the poetry. This type of poetry had considerable effect on the ninth-century poets.

It was claimed in medieval Islam that the pre-Islamic poetry represented a "perfect" style of Arabic, almost on a par with the supposed "perfection" of the *Qur'ān* itself. It was commonplace among Islamic theoreticians (linguists and theologians) that only Arabic was the "perfect" language, and only in that language had poetry ever been written before or could be written in the future (the Muslims knew nothing of Greek poetry, for example). Since most of Muslim civilization developed outside the Arabian peninsula among non-Arabs who had converted to Islām, this concept was challenged, at first in Iran (Persia), where the converts well remembered the ancient Persian literature. By the ninth century C.E., a strong nationalist reaction to all these claims of Arabic superiority had appeared, and as part of this reaction a new school of poets emerged.

This new poetry was characterized by *badī'* ("embellishment," or rhetorical principles) and, more important, *bid'a* ("innovation"), which sought to free Arabic verse from the confining conventions of classical poetry, including the "deserted camp" and camels, both totally meaningless anyway in the sophisticated, essentially metropolitan society of Iran, and later of Irāq.

Poets of the modern school broke with tradition not only in terms of format, but even more important, in reflecting the realities of actual life, wine drinking and love-making, and with the blunt (in fact, obscene) use of everyday language. Such love poems not only concerned sexual relations with women, but also (in the case of Abū Nuwās [d. 810] and others, almost exclusively) with boys. Let there be no mistake, there is none of the modest allusion to romantic reserve associated with most poetry of the European tradition here. Instead, this poetry details in the most explicit description and language the precise sexual activity in which the poet engages.

The popularity of this poetry was immense, and it soon was being imitated also in Muslim Spain (al-Andalus), where, in fact, the overwhelming majority of sexual poetry was written and which has survived. Entire anthologies of such poetry were composed, and not only "professional" poets but secretaries and rulers wrote such verse.

Compared to this poetry as an unquestionably real source of sexual customs, other sources of information are of secondary significance. Nevertheless, these have received a considerable amount of scholarly attention. They include the works of theologians and philosophers such as Ibn Sīnā (Avicenna [980–1037 C.E.] and al-Ghazzālī [1058–1111],[8] numerous medi-

cal writers (including references in the *Canon* of Avicenna, which was translated into Latin in the medieval period). Of particular interest are the many works of the somewhat heterodox philosopher, al-Jāḥiẓ (ca. 776–869). His concept of "passionate love" is at first restricted to women, then tentatively extends to boys, and finally ends up embracing this concept.

Creative literature was relatively underdeveloped in medieval Muslim culture; poetry seems to have played the supreme role. Certainly in contrast to the Hebrew example of the genre, very few *maqāmāt* (rhymed prose novellas) have survived. Those that have generally are of far less interest for sexual topics than their Hebrew counterparts. However, various examples of Persian medieval literature are of importance.

Chronicles and other historical sources are also important, particularly those dealing with Muslim Spain and North Africa. From these can be obtained further insights into such things as prostitution, sexual exploitation of slaves (women and boys), and the attempt of the Almohad rulers in Seville to banish boy prostitutes from the streets.

Though there is a great deal of extant source material relating to heterosexual love, including stories of "famous lovers," poetry, historical sources, as well as love of boys, there is very little available concerning actual homosexuality or Lesbianism. We know that both existed. The famous eleventh-century woman poet of al-Andalus, Wallāda, had not only male lovers but at least one female one.[9] The Andalusian caliph al-Ḥakam II, and several later rulers of the independent *taifa* kingdoms (which dated from 1031 to 1492), were lovers of boys. As in ancient Greece, and among Jews of medieval Spain, and in other societies, Muslim boy-lovers were generally considered heterosexual, usually married men with families.

Among the many works of the important writer al-Jāḥiẓ of Basra (ninth century) was one on "singing slave girls" (prostitutes), while he had three on boy love and "sodomy." It is worthy of comment that the prudish attitudes of many modern scholars led such works to be ignored. C. Pellat, for example, in his biography and anthology of Jāḥiẓ, decided to pass by these works.[10] It was these same attitudes which led to the bowdlerization of many works at the hands of nineteenth-century translators, such as Lane's version of the "Arabian Nights," or Wilson's of Jāmī.[11]

The traditions of love poetry, and the practices that they reflect, continued at least to the fourteenth century, when the famous Ibn Khaldūn (born in North Africa, he also lived in Spain and Egypt) wrote in his *Muqaddimah* ("Introduction" to the history of the Berbers) about homosexuality and also wrote love poetry about boys.[12] Whereas he condemned the former as leading (literally) to the "destruction" of mankind, he has no harsh word for

the love poetry about boys which he quotes, including some written in his own time.

As of this writing only one significant conference has been held on the topic of sexuality in medieval Muslim society, and the papers in that collection overlook most of the important poets.[13] Much research remains to be done; I hope that the future will see increased efforts in this direction and perhaps even joint efforts between scholars of different traditions. The following Bibliography does not claim to be complete, but does provide a listing of most of the important literature.

NOTES

1. M. Papo, "Die sexuelle Ethik in Qoran," 171–292, and Noel J. Coulson, "Regulation of Sexual Behavior Under Islamic Law," *Society and the Sexes*, ed. Afaf Lufti al-Sayyid-Marsot, 63– 64.

2. C.E. Bosworth, *The Medieval Islamic Underworld*; V.L. Bullough, *Sexual Variance in Society and History*, 205–44; and F. Rosenthal, *Muslim Intellectual and Social History*.

3. This was the collection mentioned in note 1, edited by Afaf Lufti al-Sayyid-Marsot.

4. al Nadīm, *The Fihrist of al-Nadīm*, translated by Bayard Dodge.

5. Ibid., I, 332–33.

6. Ibid., 335.

7. Ibid., II, 719–23.

8. al Ghazzālī, *Le Livre du licitè et de l'ilicitè (Book XIV of Ihyā)*.

9. Arjona Castro, *La sexualidad*, 22.

10. Charles Pellat, *The Life and Works of Jāhiz*. Includes translations of selected texts.

11. *The Thousand and One Nights*, trans. E.W. Lane. *Baharistan*, trans. C.E. Wilson.

12. Ibn Khaldūn, *The Muqaddimah*, trans. Franz Rosenthal.

13. See *Society and the Sexes in Medieval Islam*.

BIBLIOGRAPHY

1. General Works

Arjona Castro, A. *La sexualidad en la España musulmana*. Córdoba: Universidad de Córdoba, 1985.

Bosworth, C.E. *The Mediaeval Islamic Underworld*. Leiden: Brill, 1976.

Bousquet, G.H. *La morale de l'Islam et son ethique sexuelle*. Paris: Maisonneuve, 1953; 2nd ed., *L'ethique sexuelle de l'Islam*. Paris: Maisonneuve, 1966.

Bullough, Vern L. *Sexual Variance in Society and History*. Chicago: University of Chicago Press, 1976.

Donaldson, Dwight M. *Studies In Muslim Ethics*. London: Society for the Propagation of Christian Knowledge, 1953.

al-Ghazzālī. *Le livre du licité et de l'ilicité* (Book XIV of *Ihyā*), trans. L. Bercher and G.H. Bousquet. Paris: Maisonneuve, 1981.

———, *Erlaubtes und verbotenes Gut*, trans. Hans Bauer. Halle: H. Niemeyer, 1922.

González Palencia, A. "El amor platónico en la corte de los califas." *Boletín de la real academia de buenas letras y nobles artes de Córdoba* 9 (1929): 77–99.

Ibn Abdun. *Seville musulmane au début du XII siècle*, trans. E. Lévi-Provençal. Paris: Maisonneuve, 1947.

——, *Sevilla a comienzos del siglo XII*, trans. E. Lévi-Provençal and E. García-Gómez. Madrid: Monedoy Creditor, 1948.

Ibn Ḥazm ʿAlī. *Epitre moral (Kitāb al-aḫlaq waʾl-siyar)*, ed. and trans. (French) Nada Tomiche. Beirut: Commissione Internationale pour la Traduction des Chef d'Oeuvre, 1961.

——. *In Pursuit of Virtue: The Moral Theology and Psychology of Ibn Ḥazm*, ed. and trans. Muhammed Abu Laylah. London: Ta Ha, 1990.

——. *Kitāb al-axlaq wa-s-siyar*, critical ed. with notes by Eva Riad. Uppsala: Uppsala Universiteit, 1980.

Ibn Miskawayh. *Traité d'ethique*, trans. (French) M. Arkoun. Damascus: Institute français, 1968.

——. *Refinement of Character*, trans. C. Zurayk. Beirut, n.p., 1968.

Meyerson, M. "Prostitution of Muslim Women in the Kingdom of Valencia." In M. Chiat and K. Reyerson, eds., *The Medieval Mediterranean: Cross Cultural Contacts*. St. Cloud, MN: North Star Press, 1988, 87–96.

al-Nadīm. *The Fihrist of al-Nadīm*, ed. and trans. Bayard Dodge. 2 vols. New York: Columbia University Press, 1970.

Papo, M. "Die sexuelle Ethik in Qoran," *Jahrbuch für jüdische Volkskunde* 2 (1924): 171–291.

Paret, R. *Früharabische Liebesgeschicten (Sprache und Dichtung*, Heft 40). Berne: 1927.

Pellat, C. "Les esclaves chanteuses de Ǧāḥiẓ." *Arabica* 10 (1963): 121–47.

——. *Le milleu basrien et la formation de Ǧāḥiẓ*. Paris: Libraire d'Amerique et d'orient-Maisonneuve, 1953.

——. *The Life and Works of Jāḥiẓ*, trans. D. Hawke. London: Routledge and Kegan Paul, 1969.

Rosenthal, F. "Fiction and Reality: Sources for the Role of Sex in Medieval Muslim Society," and "Reflections on Love in Paradise," chapters in his *Muslim Intellectual and Social History*. Aldershot, Hampshire: Variorum, 1990.

Schimmel, Annemarie. *Mystical Dimensions of Islam*. Chapel Hill: University of North Carolina Press, 1975.

Society and the Sexes in Medieval Islam, ed. Afaf Lufti Al-Sayyid-Marsot. Malibu, CA: Undena Publications, 1979.

von Grunebaum, G.E. "Avicenna's Risālā fiʾl–iq." *Journal of Near Eastern Studies* 11 (1951): 233–38.

2. Studies on Pederasty and Lesbianism

Bosworth, C.E. *The Medieval Muslim Underworld*. Leiden: Brill, 1976.

Nemah, H. "Anadalusian maqāmat." *Journal of Arabic Literature* 5 (1974): 82–92.

Rosenthal, F. *The Herb: Hashish versus Medieval Muslim Society*. Leiden: Brill, 1971.

Roth, N. "The Care and Feeding of Gazelles: Medieval Arabic and Hebrew Love Poetry." In Moshé Lazar and Norris J. Lacy, eds., *Poetics of Love in the Middle Ages*. Fairfax, VA: George Mason University Press, 1989, 96–118.

——. "'Fawn of My Delights': Boy-Love in Arabic and Hebrew Verse." In Joyce Salisbury, ed., *Sex in the Middle Ages*. New York: Garland Publishing, 1991, 157–72.

——. tr. "Hebrew Poetry." In James J. Wilhelm, ed., *Gay and Lesbian Poetry*. New York: Garland Publishing, 1995, 235–60.

Schmitt, Arno and Jeheda Sofar. *Sexuality and Eroticism Among Males in Moslem Societies: Bio-Bibliography*. New York: Haworth Press, 1991.

————, "Arab Terminology for Male-Male Sex Acts and Actors." *Homosexuality, Which Homosexuality?* Amsterdam: Reports of the Congress, 1987; Social Sciences, vol. 1.

al-Tifachi (=al-Tīfashī), Ahmad (15th cent.) *Les delices des coueres,* trans. into French by Rene B. Paris: n.p., 1977, reprinted 1987. Trans. into English as *The Delight of Hearts,* by Winston Leyland. San Francisco: Gay Sunshine Press, 1988.

Wormhoudt, Arthur, tr., "Arabic Poetry." In James J. Wilhelm, ed., *Gay and Lesbian Studies.* New York: Garland Publishing, 1995, 193–234.

3. Medicine and Manuals of Sex

Ibn Kamāl, Fadhil. *The Old Man Young Again,* Trans. "by an English Bohemian." Paris: Carrington, 1898. Extremely rare.

ibn al-Khatīb, Muhammad. *Libro del cuidado de la salud durante les estaciones del año o "Libro de la higiene,"* trans. María de la Concepción Vázquez de Benito. Salamanca: Universidad de Salamanca, 1984.

Ibn Sīnā (Avicenna). *Qanūn,* Book II. 20. *Liber canonis,* trans. Gerard de Cremona. 1522, photo reprint, Hildesheim, Germany, 1964.

————. *Liber canonis medicine.* Brussells: n.p., 1971. See also E.H. Hoops, "Die sexocologischen Kapitel im '*Canon medicinae*' des Avicenna, verglichen mit der Schrift 'De coitu' de Maimonides." *Aesthetische medezin* 16 (1957): 305–08. The work by Maimonides is spurious.

Jacquart, D. and C. Thomasset. *Sexuality and Medicine in the Middle Ages,* trans. Matthew Adamson Princeton, NJ: Princeton University Press, 1988.

Jalāl al-Dīn al-Suyūṭī. *The Book of Exposing (Secrets of Oriental Sexuology [sic]),* trans. "by an English Bohemian." Paris: Carrington, 1900; extremely rare. Unfortunately since al-Suyūṭī was such a prolific author, I am not sure which of his works this represents.

Levey, M. and S. Souryal. "Galen on the Secrets of Women and Men: A Contribution to the History of Arabic Pharmacology." *Janus* 55 (1968): 208–19, an interesting contribution.

al-Shirāzī. 'Abd al-Raḥmān ibn Nasrallah. *The Book of Exposition in the Sciences of Perfect Coition.* London: n.p., 1900, very rare.

4. Literature

Arabian Nights, also known as *Thousand and One Nights: A Plain and Literal Translation of the Arabian Nights Entertainment,* trans. Richard F. Burton. London: Kama Sutra Society, 1885–88, 16 vols. (Best translation, includes Burton's famous essay in vol. 10.) The text was reprinted (with the terminal essay) in *The Book of the Thousand Nights and a Night.* 6 vols. in 3. New York: Heritage Press, 1934. The terminal essay is on 3748–82. *The Thousand and One Nights,* trans. E.W. Lane. London: C. Knight, 1839–41, 3 vols., incomplete. *Tausend und eine Nacht,* trans. Gustav Weil. Stuttgart: Verlag der Classiker, 1889, 3 vols., also expurgated. *Le livre des mille nuits et une nuit,* trans. J.C. Mardrus. Paris: E. Fasquelle, 1900–12, 16 vols.

Eastern Love, trans. E. Powys Mathers. 12 vols. London: J. Rodker, 1927–29; includes some Arabic and Persian.

Hamori, A. *On the Art of Medieval Arabic Literature.* Princeton, NJ: Princeton University Press, 1974.

Jamī, Nūr al-Dīn (15th century). *The Baharistan,* trans. C.B. Abowal and M. Querisky. Ahmedabad: n.p., 1914. Also trans. K.N. Pandet. Calcutta, KLM, 1991. *The Beharistan,* trans. E. Rehatsek. London: Kama Shastra Society, 1887; rare. *Bekharestan,* trans. (Russian) K. Chaikin. Leningrad: n.p., 1935.

al-Nafzawī, Shaykh Aḥmar (15th century). *The Perfumed Garden*, trans. Richard F. Burton. London, Kama Shastra Society, 1886; rare, rep. London, 1963; New York: Castle Books, 1964. *Der dufstende Garten*, trans. H. Conrad. Leipzig: Insel Verlag, 1905. *Liebe im Orient: Der duftende Garten*, trans. F. Leiter and H. Thal. Leipzig: Insel Verlag, 1929. *The Glory of the Perfumed Garden*, including a previously untranslated part. Leiden: Spearman, 1975.

Ritter, H. "Arabische und persische Schriften über die profane und die mystische Liebe." *Der Islam* 21 (1933): 89–100. Not very complete or enlightening.

Saʿdī. *The Gulistan*, trans. E. Rehateck. London: Kama Shastra Society, 1888, rep. London, 1964, 1966.

―――― *Gulistan*, trans. R. Anderson. Pakistan: Institute of Persian Studies, 1985, "with complete analysis of the entire Persian text."

Tuti-Nameh: Das Papageienbuch, trans. George Rosen. Leipzig: Insel Verlag, 1912, reprinted Frankfort A.M.: Insel Verlag, 1957.

5. Poetry Translations

Abū Nuwās. *Diwan*, trans. A. Wormhoudt. Oskaloosa, IA: William Penn College, 1974.

Arberry, A. *Arabic Poetry*. Cambridge: Cambridge University Press, 1965. Not very good.

Ibn Dāwūd, Abū Bakr. *Kitab al-zahra*, ed. A.R. Nykl. Chicago: University of Chicago Press, 1932; no translations but introduction.

Ibn Quzmān. *Todo Ben Quzmān*, ed. and trans. E. García-Gómez. 3 vols., Madrid: Gredos, 1972.

Ibn Sahl, Ibrāhīm. *Diwan*, trans. A. Wormhoudt. Oskaloosa, IA: William Penn College, 1981.

Ibn Saʿīd al Maghribī. *El libro de las banderas de los campeones*, trans. E. García Gómez. Madrid: Instituto de Valencia, 1942; (excerpts) *Moorish Poetry*, trans. A.J. Arberry. Cambridge: Cambridge University Press, 1953; poor translations; (excerpts) *The Banners of the Champions*, trans. J.A. Bellamy and P. Steiner. Madison, WI: Hispanic Seminary of Medieval Studies, 1989.

Ibn Shuhayd. *Diwan*, ed. and trans. James Dickie. Córdoba: Real academia de Córdoba, 1975.

Ibn al-Zaqqāq. *Poesías*, ed. and trans. E. García Gómez. Madrid: Instituto Hispano-Arabe de Cultura, 1952.

Ibn Zaydūn. *The Diwan*, trans. A. Wormhoudt. Oskaloosa, IA: William Penn College, 1973.

―――― *Diwan*, ed. and trans. M. Sobh. Madrid: al-Maʿhad al Isbani al 'Arabi, 1979.

―――― *Poesías*, trans. M.J. Rubiera. Madrid: al-Maʿhad al Isbani al 'Arabi, 1982.

al-Muʿtamid ibn ʿAbbad. *Poesías*, ed. and trans. M.J. Rubiera. Madrid: Instituto Hispano-Arabe de Cultura, 1982.

al-Mutanabbī. *Diwan*, trans. A. Wormhoudt. Oskaloosa, IA: William Penn College, 1971.

Monroe, James. *Hispano-Arabic Poetry*. Berkeley: University of California Press, 1974, with texts.

Nykl, A.R. *Hispano-Arabic Poetry*. Baltimore: J.H. Furst, 1946.

O Tribe that Loves Boys: The Poetry of Abu Nuwas, trans. with a biographical essay by Hakim Bey. Amsterdam: Entimos Press and Abu Nuwas Society, 1993.

Pérès, H. *La poésie andalouse en arabe classique au Xie siècle*. Paris: Maisonneuve, 1953, with texts.

Sayf al-Daula. *Dhikra*, trans. A. Wormhoudt. Oskaloosa, IA: William Penn College, 1975; also includes Abū Firās, *Dhikra*.

Soualah, M. *Ibrahim ibn Sahl, poete musulman d'Espagne*. Algiers: Adolphe Jourdan, 1914–19, excellent study with translations.

Wagner, E. *Abū Nuwās*. Wiesbaden: F. Steiner, 1965, a study with some translations into German.

I have not included any of the Ṣufī poets since most of that poetry is allegorical.

6. Poetry Studies

Blachére, R. "Les principaux themes de la poésie erotique au siècle des Umayyads de Damas." *Annales de l'institute des études orientales* [Algiers] 5 (1939–41): 87–128.

Compton, Linda. *Andalusian Lyrical Poetry and Old Spanish Love Songs*. New York: New York University Press, 1976.

Continente Ferrer, J.M. "Notas sobre la poesía amorosa de Ibn Abd Rabihī." *Al-Andalus* 35 (1970): 335–80.

————. "Aproximación al estudio del tema de amor en la poesía hispano-arabe de los siglos XII y XIII." *Awraq* 1 (1978): 12–28 (essential article; includes some translations).

Cour, A. *Une poete arabe d'Andalousie* (Ibn Zaydūn). Paris: Maisonneuve, 1962.

————. *Poesie d'Ibn Zaydun*. Constantine: Imprimerie M. Boet, 1920.

Cowell, D. "Ibn ʿAbd Rabbihī and his *Ghazal* Verse." *Journal of Arabic Literature* 5 (1974): 72–81.

García-Gómez, E. *Poemas arábigoandaluzas*. Madrid: Editorial Plutarco, 1930.

————. *Poesía arábigoandaluza*. Madrid: Instituto Faruk I de Estudios Islamico, 1951.

————. *Cinco poetas musulmanas*, 2d ed. (Madrid: Esposa-Calpe, 1944.

Giffen, Lois A. *Theory of Profane Love Among the Arabs*. New York: New York University Press, 1976.

von Grunebaum, G.E., ed. *Arabic Poetry: Theory and Development*. Wiesbaden: Harrassowitz, 1973.

Hoenerbach, W. "Notas para una caracterización de Wallāda." *Al-Andalus* 36 (1971): 467–73.

Khairallah, A. *Love, Madness and Poetry: An Interpretation of the Magnun Legend*. Leiden: Brill, 1980.

Lug, S. *Poetic Techniques and Conceptual Elements in Ibn Zaydun's Love Poetry*. Washington, DC: University Press of America, 1982.

Manzalaoui, M. "Tragic Ends of Lovers: Medieval Islam and the Latin West." *Comparative Criticism Yearbook*, ed. E.S. Shaffer. Cambridge: Cambridge University Press, 1979, 37–52.

Monroe, J. "Hispano-Arabic Poetry During the Caliphate of Cordoba," in von Grunebaum, ed., *Arabic Poetry*, 125–54, esp. 142–47. Spanish trans., "La poesia hispanoarabe durante el califato de Córdoba." *Estudios orientales* 6 (1971): 113–51.

Sobh, M. "La poesía amorosa arábigo-andaluza." *Revista del instituto de estudios islámicos en Madrid* 16 (1976): 81–109.

Viguera, Maria. "Aṣluḥu li'l-Maʿali. On the Social Status of Andalusī Women." In S.K. Jayyusi, ed., *The Legacy of Muslim Spain*. Leiden: Brill, 1992, 709–23.

15 EASTERN ORTHODOX CHRISTIANITY

Eve Levin

A very few sexually loaded incidents in the history of medieval Eastern Europe are well known: Procopius's scurrilous portrayal of Empress Theodora's earlier career as a prostitute; the Serbian king Milutin's uncanonical fifth marriage to a five-year-old Byzantine princess. Beyond these anecdotes, scholarship on this topic is sparse. There is no comprehensive monograph concerning traditional Orthodox teachings on sexuality, or on sexual practices and attitudes of nations within the Eastern Christian sphere.[1] Extant studies of canon and civil law pass over legislation concerning sexuality virtually in silence. Older studies of family life frequently intermingled information from modern ethnographical sources with uncritical readings of medieval ecclesiastical texts; their conclusions do not sustain scrutiny. Only a small handful of recent books and articles have begun to explore this terra incognita.

Research on sexuality in Eastern Orthodox nations is still in its early stages, as the brevity of the bibliography attests. There are currently only two monographs on the subject: one on Byzantium in the eleventh to thirteenth century, and one surveying the Slavs in the pre-modern period. These books, as well as the few articles listed here, represent the initial exploration of the topic.

It is not the lack of sources that has limited scholarly research.[2] Prescriptive sources abound: codes of canon and civil law; prelates' commentaries on religious principles and ecclesiastical regulations; penitential questionnaires; liturgies for betrothal, marriage, purification of new mothers, and adoption; saints' lives; didactic tales and sermons. Descriptive sources are also available, although in small and perhaps unrepresentative quantity: records of ecclesiastical court cases; chronicles and histories; travelers' accounts; and even on rare occasion private correspondence. Because these sources are derived so heavily from the pens of ecclesiastical authors or com-

pilers, they shed less light than we might wish on the perspectives of secular society. A substantial body of secular literature survives from Byzantium, and it offers a somewhat different view of sexuality from ecclesiastical sources. Very few similar medieval secular texts from other Eastern European nations survive in contemporary manuscripts, although some were preserved orally into the nineteenth and twentieth centuries.

The Eastern Orthodox world encompassed a diversity of peoples, languages, and cultures exceeding even that in Western Europe. In this chapter, I will not attempt to discuss the Armenian, Syrian, or Coptic offshoots of Eastern Christianity, but rather confine myself to the Greek and Slavic Orthodox traditions. While Greeks and Slavs shared the same religious faith and a great part of the corpus of ecclesiastical writings, their religious traditions differed noticeably. The most obvious manifestation of difference is linguistic: the Byzantines used Greek; the Russians, Bulgarians, and Serbs used Church Slavonic. Few Slavs, even among the clergy, knew Greek; few Greeks, other than those prelates sent to serve in Kiev or Ohrid, had cause to learn Slavic. Furthermore, the Slavs paid little attention to Byzantine philosophical and theological writings and to the Greco-Roman classical heritage preserved in Constantinople. Greek clerics, as a rule, neglected original works composed in Slavic. In addition to the linguistic gulf, there was a huge cultural one. The Byzantine elite inhabited a sophisticated, cosmopolitan, urban milieu quite unlike the rural, culturally callow towns of the Slavic periphery. The Slavs faced the challenge of building new states and inculcating Christianity in a pagan population at a time (tenth to twelfth centuries) when Byzantium had centuries of Christian political and religious experience. Despite the great cultural differences, there were significant points of contact. The Byzantine annexation of Bulgaria in 1018 resulted in the imposition of Greek norms there until the Bulgarian kingdom was reestablished in 1185. The monastic complex at Mount Athos, and in particular the Serbian national monastery, Hilandar, provided a setting for the transfer of ideas and texts. Slavic Orthodox Christians admired Greek spiritual achievements and emulated the artistic styles of their parent civilization. At the same time, they were wary of Byzantine political and religious hegemony, and strove to defend their own locally created traditions.

The structure of the Eastern Orthodox church contributed to the development of divergent national traditions in Christian practice. The patriarch of Constantinople claimed only the loosest authority over the national churches born of Byzantine missionary efforts. Instead each nation received an autocephalous metropolitan or patriarch who was fully empowered to decide any questions of Christian observance or morality. Slavic ecclesiasti-

cal leaders could, and did, seek the patriarch's advice or invoke the moral authority of his opinion; however, the patriarch had little practical control over non-Greek hierarchs. The Eastern Orthodox church did not have an equivalent of the Decretist movement in the West; canon law remained largely uncodified and unindexed, the compilations of the *Nomocanon* and the *syntagma* of Matthew Blastares notwithstanding. Neither did the Eastern church attempt to standardize and centralize the activities of ecclesiastical courts, as the Roman Catholic church did in the later Middle Ages. The patriarch, possessing less power within the church than his counterpart in Rome, also made fewer claims to temporal power vis-à-vis the emperor. The Slavic metropolitans followed in this pattern, usually cooperating with local princes rather than attempting to supplant them. Although acrimonious conflicts between prelates and secular rulers marred the ideal of *symphonia* (harmony), cooperation between church and state was the rule, and in a number of areas, including the regulation of sexual conduct, ecclesiastical and secular jurisdictions overlapped.

THE EASTERN ORTHODOX LEGACY ON SEXUALITY

Sexuality was an important topic of discussion in the early Byzantine church.[3] The depictions of sexuality, the body, and virginity expressed not only early Christian thinkers' understanding of human nature and human behavior, but also their conceptions of the universe, the transformational power of Christ, and the proper ordering of society. Nearly all these religious leaders regarded sexual activity warily and preferred continence even to marriage. However, they disagreed in their understanding of the origin of sexual urges and of the purposes of marriage.

The early Byzantine debates on sexuality grew out of the sometimes radical stances of Christian leaders in the eastern Mediterranean in the second and third centuries. They inherited the problematical pronouncements by St. Paul that depicted sexuality as a dangerous manifestation of the corruptible body standing in opposition to the perfectable spirit. To some early Christians sexuality and its concomitant childbearing represented the continuing cycle of birth and death from which Christ's resurrection promised deliverance. Others saw sexuality as a symptom of humanity's fall from purity and immortality. Manichaeans decried sexual activity and procreation as the perpetuation of the powers of Darkness that captured the true Light of God's creation. To such thinkers, all sex, whether marital or promiscuous, procreative or not, represented human separation from God. Other teachers, such as Clement of Alexandria, were more sanguine about sexuality, seeing it as an appropriate stage of human development that the ma-

ture Christian would eventually leave behind. Procreation, and specifically the perpetuation of the Christian community, was part of God's plan.

These ideas manifested themselves in a variety of systems of sexual behavior. A few groups, known only through scurrilous rumors, seem to have expressed Christian fraternity and love with physical promiscuity. At the other extreme, movements such as the Encratites required complete abstinence from sexual activity as a condition for full admission into the church. Manichaeans demanded of their Elect the strictest asceticism, but for their ordinary followers condoned marriage and even non-marital, non-reproductive sex. Even within the Christian mainstream, persons who observed continence, both men and women, earned particular respect and often leadership positions in the community. Men (and, less often, women) who practiced exceptional asceticism withdrew to desert hermitages to battle against the temptations of the world, including both illicit sex and the homey comfort of marriage. Sexual abstinence could be socially revolutionary. It provided justification for overturning the traditional hierarchies of the household: husbands over wives, parents over children, masters over slaves. Furthermore it blurred the still-forming distinction between clergy and laity, as continent lay people claimed a spiritual excellence unmatched by married clerics.

Other leaders, more in the mainstream, encouraged sexual abstinence within the structures of family and community, and this pattern came to dominate in the Orthodox church. Early churchmen promoted strict codes of sexual behavior, including conspicuous displays of abstinence, as a means of distinguishing the Christian community from pagans and Jews. At the same time, these regulations of marital sex served to defend the institution against the calls by radical Christians for complete abstinence. Clement of Alexandria endorsed sober and moderate marital intercourse in the context of a regulated Christian household and community. Older married couples might take up continence after raising their children; Christian widows became important patrons of the church. Parents might choose to dedicate some—but not all—of their children to God: virgin daughters residing in the households of bishops or bringing spiritual purity to the paternal home; sons becoming celibate priests or monks. Religious communities backed off from individualistic and idiosyncratic asceticism, and developed rigorous rules of conduct, in particular requiring young recruits to yield to the will of their spiritual guides and separating women and men. But in the early Byzantine period, adherents of the "angelic life" did not rail against the life of the laity "in the world," marrying, bearing children, and pursuing secular matters. Celibate monastics, through their prayers and bodily purity, interceded

for the entire community; married lay people provided the human and material resources for the continuity of the church. In this context sexual renunciation reinforced, rather than threatened, the authority of Christian heads of families, the clergy, and ultimately the Christian state. While the Orthodox church had both celibate and non-celibate adherents, it never developed the same sort of strict dichotomy between continent clergy and sexually-active laity that came to characterize the Roman Catholic church. Instead the Eastern Church retained a strong tradition of married priests.

The most influential early Byzantine theologians, Basil of Caesaria, Gregory of Nyssa, and John Chrysostom, inherited the legacy of diverse and often contradictory teachings of their progenitors. Basil, the proponent of organized, socially responsible monasteries, also sought to inculcate among the laity a similar sense of order and ascetic restraint. He formulated detailed rules of conduct for both monks and lay people. Gregory regarded sexuality as an anomaly that was not part of God's original creation. Instead God had granted sexuality to Adam and Eve in order to permit humanity to continue to exist in the face of death. While marriage reflected God's mercy, virginity more closely approximated the purity of the original creation. John's vision of sexuality was much less benign. He agreed with Gregory that sexuality arose only after the Fall; however, to him, it represented not God's gift, but rather human sin. Nearly irresistible sexual urges afflicted fallen humanity, and marriage existed for the purpose of containing them. To avoid debauchery, Christian lay people needed well-structured households, where wives deferred to their husbands and children obeyed their fathers, as a bulwark against the temptations of the sinful world around them. But for all his hostility to sexuality, even John condoned marital sex and the pleasure it gave to spouses.

Later Byzantine writings about sexuality combined the viewpoints of these most prominent Eastern church fathers. They presented sexual desire as something ubiquitous in human beings, at least after the Fall, and combating it was difficult. Monastic writers often characterized concupiscence as the work of demons, who attempted to lead men and women astray into sin. Excessive lust, especially among women, was regarded as a sign of temporary insanity. To some monastic authors sex was a particularly heinous sin that led directly to the death of the soul.

Despite this continuing suspicion of sexuality, Byzantine ecclesiastical and secular authorities regarded marriage as legitimate and even necessary. It provided the means for the continuity of the race and for the channeling of sexual passions. Furthermore, later Byzantine ecclesiastical thinkers looked favorably on sexual pleasure in marriage and the emotional

bonding it brought, although not as an end in itself. Ideal aristocratic marriages were marked by mutual respect, emotional fulfillment, and appreciation of the physical beauty and noble ancestry of one's spouse. By the twelfth century the ideal life for a woman was not perpetual virginity but a respectable and fecund marriage.

Romances of the late Byzantine period promoted the ideal of marital sexual love. Although they were based on ancient or Western European models, the plot lines were adapted to reflect the Byzantine respect for premarital chastity and marital fidelity for both men and women. Even in these fictional relationships, eroticism and romantic love took place within a relationship that culminated in a lifelong, socially recognized marriage. Thus, in late Byzantine society, *eros* (sexual love) could have either a positive or a negative connotation. While some authors, especially within the ranks of the clergy, remained very suspicious of sexuality, a substantial tradition grew up sympathetic to physical love within marriage.

The Orthodox Slavs lost much of the diversity and nuance of the earlier Christian dicta and did not adopt the positive understanding of sexual love found in later Byzantine sources. Slavic churchmen regarded sexuality as a dangerous force of Satanic origin that distracted men and particularly women from righteousness. Virginity became the ideal, even for husbands and wives, because marital sex was tainted with sin. Procreation arose not from sexual intercourse, but in accordance with God's will; the *vitae* of Slavic saints are filled with tales of miraculous conceptions and chaste, but fruitful, marriages. The word *liubov'* (love) was used almost exclusively to mean spiritualized, and therefore non-sexual, devotion; the pejorative noun *blud* ("lust, fornication") and verb *khocheti* ("want") were used to describe sexual emotions. Slavic clerics defended marriage and its concomitant sexual activity most strongly by anathematizing Manichaean heretics, such as the Bogomils, who condemned marriage and procreation. In the absence of an elaborated theoretical defense of marital sex, Slavic churchmen cited scriptural precedent: Jesus' blessing of the marriage at Cana.

The Eastern Orthodox and Roman Catholic churches developed differences in their approaches to sexuality even in late antiquity, before the final collapse of urban, public institutions in the West. The great Catholic theologians of the third and fourth centuries—Ambrose, Jerome, and especially Augustine—elaborated the concepts that became the cornerstone of the Western approach to sexuality. They wrote of the original sin of Adam transmitted through sexual intercourse, the inherent unchastity of sexual pleasure, and the initial and irrevocable distinctions between men and women. Augustine in particular diverged from Eastern Christianity by at-

tributing to Adam and Eve marriage and sexual intercourse, albeit pure and passionless, even in Paradise. Their ideas remained virtually unknown in the Orthodox East. But despite the differences in emphasis in the understandings of sexuality in the Orthodox East and the Catholic West, the expectations for Christian behavior at the functional level retained a great similarity. Augustine believed human sexuality in the current age to be corrupted by disobedient willfulness, and consequently preferred celibacy to marriage, much as his fellow clerics did in the Orthodox East. Although Augustine's concept of the "conjugal debt" whereby spouses owed each other a licit outlet for sexual urges did not gain currency in the East, most married Orthodox Christians expected to yield to their spouses' sexual needs. The philosophical understanding of sexuality in both the Catholic West and the Orthodox East inculcated a sense of anxiety and guilt in sexually active believers, and generated elaborate rules of sexual propriety.

THE REGULATION OF SEXUAL BEHAVIOR

The Orthodox Churches shared the same basic understanding of what constituted licit and illicit sex. However, because of the lack of a centralized ecclesiastical structure and a single, authoritative codification, canon laws differed considerably on details. The large compendia of laws (called *nomokanon* in Greek, and *kormchaia* in Slavic) interspersed the decisions of early church councils with the rulings of local prelates and secular rulers. The more stringent punishments in the code of Basil the Great coexisted in texts with the milder penalizations of John the Penitent. This diversity in the legal tradition allowed confessors and ecclesiastical judges to pick and choose among texts in determining their decisions. They chose to treat male and female offenders alike in the case of most violations, adultery and homosexuality excepted.

Numerous laws concerned the formation and dissolution of marriages. In Byzantine and Slavic societies alike, marriages, especially for the elite, carried political and economic significance because they brought families into alliance and pooled their resources. Because of the secular significance of marriage, Byzantine emperors issued laws regulating the institution, in addition to church canons. Slavic secular law did not address marriage per se, although certain provisions of inheritance law alluded to it. The economic arrangements pertinent to marriage fell under secular law, while the church regulated behavior. Court records from twelfth-century Byzantium (including occupied Bulgaria) indicate that ecclesiastical courts resolved disputes relating to marital property.[4] It is not clear whether the same held true in Russia and Serbia in this period; court records survive only from a much later period.

The Roman tradition of marriage by consent continued in the early Byzantine Empire. However, church marriage developed earlier in Byzantium than in the West. Although the Byzantine secular law code of the eighth century, the Ecloga, recognized common-law marriage, a decree of Emperor Leo VI in the ninth century required the ecclesiastical ceremony for a union to be considered valid.[5] The Slavic churches officially required the church ceremony, but recognized common-law unions. This was particularly true in Russia, where penitential questionnaires from the fifteenth and sixteenth centuries routinely included inquiries concerning whether penitents had married in church. In the Byzantine tradition, it was important that both the young couple and their parents consent to the marriage. Among Slavs parental consent was required for a first marriage, but the agreement of the bride and groom was less necessary. The church upheld their right to refuse an unwanted marriage only obliquely: if a young person committed suicide rather than enter into an unwanted marriage, the parents bore the burden of the sin. Serbian texts baldly condemned a girl who refused her parents' choice of husband. Orthodox betrothal and marriage services of the medieval period did not contain any ritual in which the fiancés stated their consent.

The Byzantine ecclesiastical wedding ceremony contained two parts: a betrothal and the marriage proper. The two were originally separate ceremonies that could be held months or even years apart. But even in the ninth century it was common to combine the betrothal and marriage into a single ceremony. At the betrothal the bride and groom were pledged to each other and exchanged rings. The marriage ceremony, when the bride and groom donned crowns as a sign of honor, united them as husband and wife. An ecclesiastical betrothal was binding; the couple had to seek a formal dissolution if they wished to marry others. Even so, the betrothal did not bestow the right to engage in licit sex. Both in Byzantium and in the Slavic world, families often preferred to conclude secular pre-marital agreements, which were easier to abrogate than ecclesiastical betrothals.

Under the law the legal age of marriage was twelve for girls and fifteen for boys. Surviving sources, although incomplete, suggest that marriages were indeed contracted at young ages, sometimes even in violation of the canonical norms. Although canon law required parental consent for a first marriage, older men and women, usually seeking a second union, did not need anyone's permission to marry. There were restrictions for certain classes, however. Early Byzantine law made no provision for slaves to marry legally, although that changed later. Russian slaves needed their masters' consent to marry, but masters were admonished not to withold consent and also to help

find suitable spouses for their slaves. A Byzantine imperial edict of the twelfth century forbade noble women to marry men of lower rank, but Slavic sources record no similar pronouncements.

Orthodox churchmen granted the legitimacy of a first marriage but frowned on subsequent ones. According to the often-quoted formula of Gregory Nazianzus, "The first marriage is law; the second, dispensation; the third, transgression; the fourth, dishonor: this is a swinish life." Ecclesiastical authors disdainfully referred to such serial monogamy as "polygamy." This disapproval held sway whether a previous union was dissolved by death or by divorce for cause. Persons who sought a second marriage had to accept a period of penance to atone for yielding to fleshly desires. Certain canons restricted access to a third marriage to "young" persons (the age varies) who did not have children from previous unions. Others prohibited third marriages altogether, or did not restrict them at all. Although fourth marriages were condemned, not all texts actually prohibited them, opening the door for their legitimation.

Despite the restrictions, the mortality rates, particularly for childbearing women, guaranteed that there would be many young widows and widowers to seek remarriage. In practice clerics preferred licit marriage to concubinage or illicit fornication, and seem to have authorized remarriages readily. Powerful rulers, such as Milutin of Serbia and Ivan IV (the Terrible) of Muscovy, could find hierarchs, albeit with some searching, to bless uncanonical fifth marriages and more. However, the clerics who blessed remarriage also enforced secular law concerning the disposition of the property of the deceased. The remarried survivor lost all claim to the first spouse's property, which was held in trust for the children of the union or was returned to the deceased's natal family.

Byzantine civil law granted recognition of a sort to concubinage. A woman in a long-term, monogamous relationship with an unmarried man could claim a small share of his estate for herself and her children by him. Although ecclesiastical texts denigrated concubinage as little better than fornication, Byzantine prelates did recognize the institution, and ruled in favor of concubines' claims in court cases. However, they found it difficult to distinguish between informal marriages, concubinal relationships, and fornication.[6] Slavic law did not include the category of concubine at all, perhaps because it recognized the validity of common-law marriage.

Orthodox canon law contained extensive prohibitions of incestuous unions. There is considerable diversity in the exact degrees of relationship that fell under the ban, and both in Byzantium and among the Slavs the prohibitions were gradually extended. Most texts forbade marriage between

blood relatives closer than the sixth or even the eighth degree (second and third cousins). Marriage by in-laws was restricted also: at first, widows and widowers were forbidden to marry their deceased spouses' siblings; later, new rules forbade unions between two sets of siblings or cousins. Persons related by the ties of baptism were forbidden to marry: a godfather could not marry his goddaughter or her mother (in a second marriage). Some churchmen extended the restriction on marriage between spiritual relatives to the same degrees of kinship as for blood. Among Slavs, particularly in Serbia, the witness at a wedding also became a spiritual relative who could then not marry into either spouse's family. The canons against incest did not prevent politically useful marriages among aristocratic or royal relatives, because ecclesiastical authorities rarely protested such unions gratuitously. In Byzantium aristocratic families used incest laws to prevent or dissolve politically damaging alliances, particularly in the eleventh and twelfth centuries.

Orthodox churchmen, citing the precedent of the Gospels, recognized the inviolability of marriage, "except for reason of adultery" (Matthew 19:8). However, codes of canon and civil law both in Byzantium and in Slavic lands considerably extended the grounds for divorce. A husband could divorce his wife if she committed adultery or if she engaged in suspicious conduct, such as leaving the marital home overnight or (in Byzantium) attending a hunt, horserace, or bathhouse. The aggrieved husband could remarry; the offending wife was to be confined to a convent. In surviving cases, however, adulterous women usually did not end up in monasteries. In the reciprocal case of a husband's adultery, the wife did not, officially, have recourse to a divorce. However, when the husband's infidelity was frequent and blatant, and especially when it was accompanied by abuse, the wife was, in fact, awarded a divorce. A wife could seek a divorce if her husband falsely accused her of infidelity, or, under Russian law, if he raped her. Russian law also permitted a wife a divorce if her husband built up massive debts, sold the family into slavery, or drank excessively. Under Byzantine and Slavic law either spouse could seek a divorce for attempted murder or treason by their partner. Certain laws permitted divorce if husbands or wives committed thefts, from each other or elsewhere; others directly forbade separation in these circumstances. Byzantine law permitted the dissolution of a marriage for reasons of non-consummation, barrenness, or impotence. Slavic codes did not adopt this provision, in keeping with the ideal of the non-consummated marriage, but at least in a later period courts found other reasons to end marriages in these circumstances. In Byzantium, a man could break off a betrothal if his fiancée's family could not pay the promised dowry. Both Byzantine and Slavic writers debated the propriety of terminating a marriage because of a spouse's

disappearance, or to allow a spouse to take monastic vows. Surviving records indicate that in fact clerics authorized remarriage in these circumstances. With these broad justifications for divorce, it is possible that unhappy couples could fabricate a cause for legal separation.[7] In practice hierarchs found reasons to dissolve unions marked by persistent and extreme violence; in the absence of ecclesiastical permission, couples separated informally, often with the tacit recognition of the church.

Under the precepts of canon law, much sexual activity, even within marriage, was illicit. Canons prohibited spouses from engaging in intercourse at many times dictated by the wife's hormonal cycle and by the church calendar. Husbands and wives were forbidden sexual contact during her menstrual period and after parturition. To the Slavs the former prohibition was much more binding than the latter. The Slavs also abandonned early Church restrictions on sex during pregnancy and lactation. Spouses were supposed to remain continent on days of particular religious observance: always before and after communion, and sometimes before other rituals as well; always Friday, Saturday, and Sunday, and sometimes Wednesday; always on Easter, and sometimes for the whole of Lent, as well as other periods of fasting. Among Slavs the requirements of marital abstinence increased towards the end of the medieval period to nearly three hundred days out of the year. Because procreation was the primary justification for sexual activity, canons proscribed the use of contraceptives and abortifacients, which Slavic codes equated with infanticide.

Many types of sexual intercourse were prohibited, even between spouses. The only proper sexual contact involved vaginal penetration in the "missionary" position, with the woman supine and the man on top. Anything else could be categorized, rather inexactly, as "unnatural" or "sodomical." However, the degree to which violations were penalized varied considerably. For example, coitus from behind (either vaginal or anal) could be punished by as small a penance as six hundred prostrations or as great a penance as thirty years' exclusion from the church. Canons did not distinguish in their penalties between inappropriate types of intercourse between spouses or between unmarried individuals.

All sexual contact outside marriage was sinful, but the severity of the sin varied with the choice of partner. Here again the laws displayed a great range of penalties for the same offense, but in general extra-marital sex was treated more harshly than simple fornication. Under both canon and Byzantine secular law, a wife's adultery was a more serious offense than a husband's. An erring wife could suffer mutilation, divorce, confinement in a convent, or a long period of exclusion from communion. Indeed, because

canons defined adultery as sex with a married woman, a husband's extra-marital affair technically constituted only simple fornication. However, applications of laws in practice partially corrected this inequity by imposing heavy penances for a husband's "fornication." Most churchmen—and secular authorities as well—tacitly accepted that unmarried men would be apt to engage in sexual relations, and encouraged them to select appropriate partners: prostitutes, slaves, divorcees, or widows. They were less sanguine about young women's premarital sex. The woman suffered the penalties for illicit fornication; the man who deflowered her could be subject to special penalties for rape, even if she consented.

Orthodox canon law acknowledged a specific crime of rape. However, in the case of an underaged girl or a virgin, provisions against forcible rape overlapped with prohibitions on deflowering maidens. In the case of a married woman, the crime of adultery took precedence over the crime of rape in determining the punishment. Under Byzantine civil and canon law, a rapist could be punished with large fines and mutilation; or he could be forced to marry his victim, if she were single and her family agreed. Serbian law included these provisions, and added other options: the family could seek revenge or collect monetary compensation. Russian law, unlike Byzantine, regarded rape primarily as a crime of violence and insult. It omitted any provision for the perpetrator to marry his victim, and instead required that he compensate her for the dishonor she suffered. While the level of compensation varied with the social status of the victim, even slaves and prostitutes were entitled to some small recompense if they could prove that they had been forced.

Early Byzantine laws equated the sins of adultery, bestiality, and homosexuality, but later codes distinguished between them in penalties. Byzantine ecclesiastical and secular codes devoted considerable attention to male homosexual acts, defining them as "against nature," unknown even among animals. They frequently mandated severe penalties: death, castration, imprisonment, or exceptionally long penances. However, there is little evidence of the actual infliction of such penalties in the later Byzantine period. Canons distinguished between anal intercourse, a more serious violation, and intercrural intercourse or mutual masturbation. Some churchmen considered the passive partner to be less culpable. Among Slavs homosexuality attracted much less negative attention. When native Slavic codes mentioned homosexuality at all, they treated it as a sin no more serious—at worst—than adultery. Western European visitors to Russia in the sixteenth century commented derisively on the toleration of homosexual activity. In Slavic lands, unlike Western Europe, homosexuality remained an ecclesiastical offense not

subject to civil sanctions. Homosexual activity by women attracted little attention in canon law and was not heavily penalized.

In a similar way the Slavs mitigated the harsh penalties of Byzantine canon law for another form of "unnatural" sex, bestiality. The penalties under Byzantine law, at their most mild, placed bestiality in the category of adultery or homosexual anal intercourse. Canon law imposed up to fifty-five years of penance, with a reduction to twenty years if the offender was a youth. The penalties in native Slavic codes placed bestiality among simple fornication, uncanonical divorce, and marital sex after mass.

Unlike the Roman Catholic church, the Eastern Orthodox church did not require celibacy of all its clergy. Instead the church developed a two-tiered system of clergy: the celibate monks and nuns (termed in Slavic "black" clergy), and the married parish priests and deacons (the "white" clergy). The path to a higher ecclesiastical career lay through the monastery; "white" clergy, while still married, could hope to advance only to the position of archpriest.

The monastic clergy in theory was completely celibate, but Orthodox monasteries encountered the same problems of discipline as their Western counterparts. The numerous economic and devotional functions of monasteries guaranteed that their inhabitants would interact with lay people. Many men and women entered the monastery as mature adults, some with a true religious vocation and some out of economic or political desperation. Monasteries also played a social service role, providing refuge for the poor and incarcerating certain sexual offenders. Generations of hierarchs complained about illicit contact between the sexes and profane social gatherings in monasteries.

The Eastern church generated a wide range of regulations for the sexual conduct of married clergy and their wives. Priests were charged not only with teaching their parishioners about proper behavior, but also with providing them with a model of a Christian marriage. The Orthodox church's policy on clerical marriage was first established at the Council of Constantinople in 692. Married men were eligible for ordination and could continue to live with their wives. If widowed, priests were forbidden to remarry and continue in their vocation. Men who were bachelors at the time of ordination had to remain celibate. Men who had been remarried or had engaged in non-marital sex were ineligible to become priests. Their wives had to adhere to the same strict standard. Clerical couples were obliged to abstain from sexual intercourse on days when the priest served in the liturgy. Beyond these basic strictures, Orthodox writers debated the details: should a priest divorce his wife on the mere suspicion of misconduct; could a widowed priest con-

tinue to minister to a lay parish; could a widowed priest or a priest's widow legitimately remarry, even renouncing the previous vocation?

The vigorous promotion of continence in ecclesiastical literature and the manifold regulations in canon law and penitential writings present high, virtually unattainable, ideals of sexual conduct. Although the clergy tried, through example, education and penalization, to alter behavior, they did not realistically expect most people to achieve the ideal. Instead they hoped to limit the destructiveness of sexual sin and convince sinners to see the error of their ways. They recognized that not all sexual sins were equally damaging to the individual and to the society.

It is not clear how widely the laity accepted ecclesiastical teachings on sexual behavior. On the one hand, people seem to have violated the ecclesiastical standards of conduct frequently. Adultery, fornication, and even incest often went unpunished, even when discovered. Byzantine secular culture promoted the ideal of sexual and emotional bonding between men and women. On the other hand, the vision of sexuality, in ecclesiastical and secular sources alike, reinforced the idea that sexual desire was potentially dangerous and disruptive to society and that chaste marriage was the only legitimate alternative. The Church, the State, and the family had legitimate rights to control sexual behavior. The primary means of enforcing standards lay in familial discipline and penitential confession, which required the laity to cooperate in the regulation of sexual activity.

These tentative conclusions await further refinement and correction in the light of further research.

NOTES

1. William Basil Zion's *Eros and Transformation: Sexuality and Marriage, An Eastern Orthodox Perspective* (New York: University Press of America, 1992), is currently the closest approximation. Although the author accurately presents considerable material from traditional sources, his purpose is to guide modern Orthodox pastors and believers in their own sexual conduct.

2. Although sources are numerous, publication—in particular of Slavic texts— is spotty. Very few have been translated into English or other modern Western languages. The primary Byzantine texts available in English include the following: S.P. Scott, *The Civil Law* (Cincinnati, Central Trust Company, 1932) [*Corpus Juris Civilis*]; E.H. Freshfield, *A Revised Manual of Eastern Roman Law: The Ecloga* (Cambridge: University Press, 1927); E.H. Freshfield, *A Manual of Eastern Roman Law: The Procheiros Nomos* (Cambridge: University Press, 1928); P. Schaff and H. Wace, *A Select Library of Nicene and Post-Nicene Fathers of the Christian Church* (New York: Christian Literature Company, 1905–1917). Publications of Slavic materials in English include Serge A. Zenkovsky, *Medieval Russia's Epics, Chronicles, and Tales* (New York: Dutton, 1974); Basil Dmytryshyn, *Medieval Russia: A Source Book, 850–1700* (New York: Holt, Rinehart and Winston, 1967); Thomas Butler, *Monumenta Serbocroatica* (Ann Arbor: Michigan Slavic Publications, 1980); Mateja Matejic and Dragan Milivojevic, *An Anthology of Medieval Serbian Literature in English* (Columbus, OH:

Slavica Publishers, 1978); H.W. Dewey and A.M. Kleimola, *Zakon Sudnyj Ljudem (Court Law for the People)*, Michigan Slavic Materials No. 14 (Ann Arbor: University of Michigan, 1978); George Vernadsky, *Medieval Russian Laws* (New York: Columbia University Press, 1969). The best reference volume for editions and studies of the pertinent Byzantine texts is *The Oxford Dictionary of Byzantium* (New York: Oxford University Press, 1991). This volume contains some citations to Slavic materials as well; there is no analogous reference volume for the Orthodox Slavs.

 3. The most complete study is Peter Brown, *The Body and Society* (New York: Columbia University Press, 1988). Much of the following summary is based on his pathbreaking work.

 4. Angeliki E. Laiou, "Contribution a l'étude de l'institution familiale en Epire au XIIIeme siècle," in Laiou, *Mariage, amour, et parenté à Byzance au XIe–XIIIe siècles* (Paris: De Boccard, 1992).

 5. Angeliki E. Laiou, "Consensus Facit Nuptias—Et Non: Pope Nicholas I's *Responsa* to the Bulgarians as a Source for Byzantine Marriage Customs," in Laiou, *Gender, Society and Economic Life in Byzantium* (Brookfield, VT: Variorum, 1992), 194–97.

 6. Laiou, "Contribution a l'étude de l'institution familiale," pp. 296–99.

 7. Laiou, "Contribution a l'étude de l'institution familiale," 303.

BIBLIOGRAPHY

Beck, Hans-Georg. *Byzantinisches Erotikon*. Munich: n.p., 1984.

Brown, Peter. *The Body and Society*. New York: Columbia University Press, 1988.

Dauvillier, Jean and Carlo de Clercq. *Le Mariage en droit canonique oriental*. Paris: Sirey, 1936.

Galatariotou, Catia. "*Eros* and *Thanatos*: A Byzantine Hermit's Conception of Sexuality." *Byzantine and Modern Greek Studies* 13 (1989): 95–137.

Garland, Lynda. "'Be Amorous, But Be Chaste . . .': Sexual Morality in Byzantine Learned and Vernacular Romance." *Byzantine and Modern Greek Studies* 14 (1990): 62–120.

Georgieva, Sashka. "Mnogobrachieto v srednovekovnoto bulgarsko tsarstvo" [Multiple Marriages in the Medieval Bulgarian Empire]. *Istoricheski pregled* 10 (1990): 3–16.

Guilland, R. "Les Noces plurale à Byzance." *Byzantinoslavica* 9 (1947–48): 9–30.

Kazhdan, Alexander. "Byzantine Hagiography and Sex in the Fifth to Twelfth Centuries." *Dumbarton Oaks Papers*, no. 44 (1990): 131–43.

Laiou, Angeliki E. *Gender, Society and Economic Life in Byzantium*. London: Variorum, 1992.

———. *Mariage, amour et parenté a Byzance aux XIe–XIIIe siècles*. Travaux et Memoires du Centre de Recherche d'Histoire et Civilisation de Byzance, no. 7. Paris: De Boccard, 1992.

Levin, Eve. *Sex and Society in the World of the Orthodox Slavs, 900–1700*. Ithaca, NY: Cornell University Press, 1989.

———. "Sexual Vocabulary in Medieval Russia." In *Sexuality and the Body in Russian Culture*, ed. Jane T. Costlow, Stephanie Sandler, and Judith Vowles. Stanford, CA: Stanford University Press, 1993, 41–52.

Meyendorff, John. "Christian Marriage in Byzantium: The Canonical and Liturgical Tradition." *Dumbarton Oaks Papers*, no. 44 (1990): 99–107.

Zion, William Basil. *Eros and Transformation: Sexuality and Marriage, An Eastern Orthodox Perspective*. New York: University Press of America, 1992.

16 SEXUALITY IN MEDIEVAL FRENCH LITERATURE

"SÉPARÉS, ON EST ENSEMBLE"

Laurie A. Finke

> If human beings were not divided into two biological sexes, there would probably be no need for literature. And if literature could truly say what the relations between the sexes are, we would doubtless not need much of it then, either. . . . However, it is not simply a question of literature's ability to say or not to say the truth of sexuality. For from the moment literature begins to try to set things straight on that score, literature itself becomes inextricable from the sexuality it seeks to comprehend. It is not the life of sexuality that literature cannot capture; it is literature that inhabits the very heart of what makes sexuality problematic for us speaking animals. Literature is not only a thwarted investigator but also an incorrigible perpetrator of the problem of sexuality. (Johnson, *The Critical Difference*, 13)

Barbara Johnson provides a convenient starting point for an inquiry into recent scholarship on the relations between literature and sexuality in the French Middle Ages. If literature, like history, science, medicine, psychology, and the law, is always a frustrated investigator of sexuality, it also offers a means to explore the very theories of representation that allow us to talk about sex at all. Literature, Johnson claims, "seduces sexuality away from what we thereby think is literality." Literature does not simply record individuals' sexual experiences or the various prescriptions and proscriptions that attempt to regulate sexual desire. Rather literature problematizes both sexuality and representation, displacing sex into discourse.

I have taken the subtitle of this chapter from a line of Mallarmé's poem, "Le Nénuphar blanc," which seems to me to capture the paradox of literature's investigations of sexuality, especially its preference for textuality over sex: "Séparés, on est ensemble. . ." [Separated, one is together. . .]. Johnson finds this crucial phrase "loaded with numerical ambiguity," which

succinctly evokes the sexual tension that has inhabited French literature since the Middle Ages: literature's representations of sexuality depend for their effectiveness on an endless deferral of consummation. The adjective "séparés" in Mallarmés poem is plural in form yet designates separation, isolation. "On" is singular (in form if not in meaning) and impersonal. Johnson argues that the plural "nous" is expected. While in formal French, "on" is the preferred universal form even in the plural, the impersonal "on," I would argue, still contains the trace of its singularity and so jars when juxtaposed with the plural adjective. "Ensemble" is also a word that, while implying plurality, is grammatically singular. Johnson concludes, "The subject and verb of the first part of the sentence are thus singular and universal in a context of private coupledom" (17). The illusion of sexual communion is countered by the poet's resolute focus on his own inner state. As Johnson suggests in her reading of Mallarmé's poem, French literature, from *Le Roman de la Rose* to *Le Nénuphar blanc*, "overvalues the non-attainment of literal sexual goals" such as consummation. It both titillates and frustrates, whether to promote "higher spiritual values," which the life of the body can only crudely represent, or to indulge the poet's narcissism is a question that fuels current scholarly debates about sexuality in medieval literature.

Literature functions as a part of what Foucault calls an "apparatus of sexuality," a "positive economy of body and pleasure" that serves preferred social ends. While Foucault's sketchy arguments in *A History of Sexuality* (at least in volume 1), which focus primarily on the post-Enlightenment period, can only dimly illuminate the history of sexuality in the Middle Ages, his "interpretive analytics" provide a vocabulary that has allowed medieval scholars to explore the ways in which literature displaces the body into forms of discourse that promote particular interpretations of sexual experience and reinforce social and moral values.[1] While this chapter reviews recent scholarship on sexuality and medieval French literature,[2] it does not claim comprehensiveness; the veritable explosion of interest in this topic in the last decade, primarily the result of interest in literary and feminist theory, makes such comprehensiveness both impossible and, given the purpose of this volume to provide students—both undergraduate and graduate—with a convenient introduction to research on the topic of sexuality, undesirable. Rather, I will outline the development and structure of the field and summarize the most influential problems in current research. For the most part, to avoid unnecessary overlap with other chapters in this volume, I will limit my analyses to literary studies. I will not survey current work being done on sexuality in history, or in the history of science, medicine, or law, philosophy, theology, or religion, except where these fields intersect with literary studies.

My one exception to this rule of thumb will be to recommend some historical introductions to sexual controversies in the Middle Ages to provide a context for literature's deployment of sexuality. A work indispensable to anyone undertaking research on any aspect of medieval sexuality is James A. Brundage's *Law, Sex, and Christian Society in Medieval Europe*. Brundage traces the development of the Church's sex laws from their origins in Judaic, Greek, and Roman legal codes and customs. Focusing on the development of canon law, he examines the legal regulation of sexuality of all kinds in the Middle Ages, including marital sex, adultery, homosexuality, concubinage, prostitution, masturbation, and incest, from 500 to 1500. Not surprisingly, given its range, the book presents a rather daunting challenge to the neophyte simply because of its length, nearly 700 pages. And, while Brundage thoroughly covers church regulation of sexual behavior, other, more secular attitudes, behaviors, and practices that may have conflicted with these proscriptions fall outside the scope of his study. For an introduction to secular marital practice and to the medieval church's and aristocracy's conflicts over the control of marriage in the twelfth century, students should consult Georges Duby's two works on medieval marriage, *The Knight, the Lady, and the Priest: The Making of Modern Marriage in Medieval France*, and *Medieval Marriage: Two Models from Twelfth-Century France*. While historians have subsequently debated and improved Duby's sketches of medieval marriage controversies, his work still remains a useful introduction for students of literature to the historical setting that produced courtly literature.

As the passage from *The Critical Difference* I quoted at the beginning of this chapter is meant to suggest, any assessment of literature's contributions to the medieval history of sexuality requires some consideration of literature's status as a representation of sexuality. Without having to recapitulate the history of literary criticism since Aristotle took up the problem of poetry's imitation of nature, we might usefully distinguish four theoretical perspectives on representation that inform scholarship on medieval French literature and sexuality. Throughout this chapter, I shall call these the reflective, hermeneutic, specular, and dialogic. In the reflective view, literature transparently reflects a prior reality; in the hermeneutic, literature views "in a glass darkly" (to cite the biblical phrase) hidden truths which are inaccessible to a literal reading; in the specular, literature reflexively refers only to itself, its author, or the processes of poetic creation; finally, in the dialogic, literature becomes not merely a passive reflection of medieval life, but an active participant in its construction. I would emphasize that, while my taxonomy will be roughly chronological, implying that criticism of medieval literature has become increasingly sophisticated about the prob-

lem of representation, no one position can be exclusively tied to a particular historical moment in contemporary literary criticism. Though at any given time one position may appear to eclipse the others, all four positions coexist at any time in modern scholarship. Given its relevance to the subject of sexuality, the scholarship on courtly love offers a particularly good example of the ways in which these four positions have been articulated in literary criticism since the nineteenth century.

The most common way of thinking about the relation between literature and life—the way most of us have grown accustomed to thinking about literature—is through a reflection theory of art. From this perspective, which comes closest to an Aristotelian view of imitation, medieval literature simply reflects what life in the Middle Ages was like. Literature is supplementary to the scholarship of the historian. Examples of this view abound in the debates early in this century about courtly love (or *fin' amor*), which attempted to determine whether or not the extra-marital liaisons described in courtly lyrics were commonplace in the courts of twelfth- and thirteenth-century France. The terms of this debate, which effectively continues today, were set by Gaston Paris, who is usually credited with having invented courtly love. He was the first to apply the term "amor courteois" to the code of behavior articulated by the troubadour lyric (and later by Andreas Cappelanus's *De Amore*) and to suggest that these texts more or less reflected actual practices at French courts.[3]

In the 1930s two extremely influential works built on Paris's description of courtly love as an historical phenomenon. C.S. Lewis, in *Allegory of Love*, and Denis de Rougement, in *Love in the Western World*, both espoused the view that courtly love was an actual medieval institution that flourished in the seigneurial courts of Provençe and later at the court of Marie, Countess of Champagne and daughter of Eleanor of Aquitaine. Lewis described courtly love as the idealization of women in the name of romantic passion and argued for a literal cult of love marked by "Humility, Courtesy, Adultery, and the Religion of Love."

> The lover is always abject. Obedience to his lady's slightest wish, however whimsical, and silent acquiescence to her rebukes, however unjust, are the only virtues he dares claim. There is a service of love closely modelled on the service which a feudal vassal owes to his lord. The lover is the lady's "man." . . . The poet normally addresses another man's wife, and the situation is so carelessly accepted that he seldom concerns himself much with her husband: his real enemy is the rival. (*Allegory of Love*, 2–3)

The troubadour lyrics and the treatise known as *De Amore* by Andreas Capellanus, in Lewis's view, described actual sexual relations, secret and adulterous affairs that were a part of court culture, providing an alternative to marriages which were presumed loveless because arranged. Rougement, while rejecting Lewis's romanticized view of what he saw as a narcissistic and destructive desire, shared Lewis's belief that courtly love was a historical institution, one which has shaped a distinctively western belief in the existence of what Anthony Giddens terms "romantic love."[4]

This eroticized view of medieval life was not seriously challenged until the 1960s, when belief in the practice of courtly love was undermined both on theoretical grounds and on the grounds of historical inaccuracy. John F. Benton's 1961 *Speculum* article, "The Court of Champagne as a Literary Center," provides an account of life at the court of Champagne in the 1170s, concluding that the historical evidence does not support the belief that courtly love was ever "practiced" or that the "courts of love" in which aristocratic ladies pronounced judgments on "points of erotic etiquette" (Moi, 13) ever existed. Yet while Benton attacked the myth of courtly love vociferously, he in no way challenged the naive reflectionism on which the myth was based, since, in arguing against the reality of courtly love, he assumed the same transparency of the historical texts he offered as evidence. He assumed that if no explicit discussions of adultery and love exist in non-literary texts then such affairs could not have occurred, because historical texts can reflect unproblematically a prior, independent reality, even if literary texts cannot.

In *A Preface to Chaucer*, D.W. Robertson attacked the prevailing view of courtly love for its too-literal reflectionism; in doing so his work, which attacked reflectionism on theoretical as well as historical grounds, provides an example of the second theory of representation—the hermeneutic. In Robertson's view medieval literature, whether religious or secular, could not simply be taken at face value to mean what it says, especially if at face value it seems to be promoting *cupiditas*. Instead texts about sexual love must invariably be read exegetically as promoting God's love and the Augustinian doctrine of charity. Robertson cites Augustine's injunction in *On Christian Doctrine* that anything in a text that "does not literally pertain to virtuous behavior or the truth of faith" must be "taken to be figurative." The reader must then scrutinize the text "until an interpretation contributing to the reign of charity is produced" (*On Christian Doctrine* III.15.23). The same reading procedure that medieval clerics applied to biblical texts could be expanded to apply to secular texts as well. As Robertson reads Andreas Capellanus's *De Amore*, Books I and II may

seem to promote adulterous love but, because all medieval literature operates under the sign of God's authority, they really mean the opposite of what they say. The irony Andreas intends in Books I and II of *De Amore* is fully revealed and explained in the condemnation of love that occupies Book III which, unlike Books I and II, is read transparently rather than exigetically. Robertson's argument is a version of what Paul Ricour has called a "hermeneutic of suspicion." In its simplest form it can be reduced to two premises: nothing means what it says and everything means the same thing, in this case, the operations of God's love in human activity. Robertson's is a slightly more sophisticated version of reflectionism, in which literature refers to a "hidden reality" accessible only through the hermeneutic operations of exegesis. As with earlier forms of reflectionism, however, the reflected reality, however inaccessible or disguised, is monolithic, static, and single-voiced; the reflection works only in one direction—texts reflect reality, but reality cannot be affected by texts.

It has been common to link Robertsonian analysis with the New Criticism, the other critical paradigm that dominated medieval literary studies in the 1960s and 1970s. Despite their disagreements, both schools of criticism agreed that texts did not transparently refer to medieval life, but required the operations of criticism to reveal the deeper truths the texts disguised. Another, perhaps more contemporary, version of a hermeneutic theory of representation, however, is psychoanalysis.[5] In *The Troubadour Lyric: A Psychocritical Reading*, Rouben Cholakian claims, as Robertson does, that the lyric never means what it says and that meaning of all the lyrics is the same. For Cholakian the lyrics always reveal the profound psychological truths psychoanalysis was designed to uncover. As with the New Critics, for Cholakian those truths are most often found in the figure of the paradox. In *The Troubadour Lyric* he writes, "We must dig deeper in order to uncover the paradox and to identify the crucial leitmotif of contradiction. We must consult the subtext. But conscious or unconscious, overt or covert, the paradox is never absent, and any interpretive reading of the 'courtly' poem must begin there" (182). He dismisses historical or "diachronic" approaches which attempt to explicate troubadour lyrics in terms of their historical "context"; these readings, he argues, substitute similarity for causality and description for explanation. "The psychic subtext of these poems is always their ultimate emerging context" (183). This psychic subtext grounded in Oedipal conflict, like Robertson's *caritas*, is universal and constant, single-voiced and invariant so that the historical ephemera that accompanied the production of the troubadour lyric must necessarily be relegated to a secondary status.

In the 1980s and 1990s scholars' views on the representation of sexuality in courtly literature shifted from the reflective to the reflexive, focusing almost obsessively on that literature's status as discourse or text in what Louis Mackey, in "Eros into Logos: The Rhetoric of Courtly Love," has called a "transformation of eros into logos." In such criticism, "the reality of sex is sublated and sublimated into the discourse of love" (242), illustrating my third perspective on representation, the specular. In this view courtly literature is not about sex or even love; rather, as Peter Allen argues in *The Art of Love*, it is about "the ways and means of amatory fiction, how to turn love into art" (3). For critics such as Allen, works like *De Amore* and *Le Roman de la Rose* are self-reflexive texts whose subject is primarily their own construction and secondarily sex's relation to writing and reading. These texts refer only to themselves, to their status as writing, to the poet's subjectivity, or to other texts in a series of specular relationships. Alexandre Leupin, in *Barbarolexis: Medieval Writing and Sexuality*, characterizes the differences between my first perspective on representation (reflective) and this one (the specular) as the difference between "document" and "monument." In the first view literature illustrates some prior event, usually historical; in the second, literature is granted its own "laws defining the teleology and autonomy that distinguish it from surrounding discourses" (2). This specular approach marks the work of French poststructuralist critics such as Paul Zumthor (*Essai de poétique mediévale*) and Roger Dragonetti (*La vie de la lettre*). Allen's study documents medieval texts' intertextuality, their rewriting of other texts, especially those from antiquity, in this case medieval writers' revision of the Roman poet Ovid. Indeed, the *Roman de la Rose*'s intertextuality with Ovid (in both the Guillaume and Jean de Meun sections) has been a subject of some interest in poststructuralist scholarship.[6]

Julia Kristeva's *Tales of Love* explores the connections between Ovid and his medieval adaptors, between narcissistic self-love and writing, and between sexuality and textuality. Her psychoanalytic and philosophical analyses of courtly love depict it as "a love centered in the self although drawn toward the ideal Other. This is a love that magnifies the individual as a reflection of the unapproachable Other whom I love and who causes me to be" (59). For Kristeva, the narcissist (and the myth of Narcissus) occupies a significant place in the history of Western subjectivity (105). Western discourse on love—especially in the Middle Ages—has been the space in which subjectivity was invented. Love "constitut[ed] the decisive step in the assumption of inner space, the introspective space of the western psyche" (111), so that "the object of Narcissus is psychic space; it is representation itself, fantasy" (116). *Fin' amor* is "essentially an art of Meaning." "The

space of love is the space of writing, . . . and within it any signification, . . . is no more than a fiction" (280). It reflects nothing but itself and refers to nothing but its own genesis in language.

Kristeva's feminist commentators—and to some extent Kristeva herself—have recognized that her psychoanalytic account of the construction of "western subjectivity" is a decidedly masculine affair. The titles and subtitles of the essays in the book—"On Male Sexuality," "Pederastic Eros," "In the Shadow of the Phallus," "A Single Libido—Male"—make abundantly clear the gender of the subjectivity under construction. The supposedly powerful lady worshipped by the courtly lover is revealed as little more than a pretext, a means of shoring up the male poet's ego.[7] She is dissolved into the poet's obsession with his own performance; she slips away "between restrained presence and absence" (287). Howard Bloch's work on medieval misogyny ("Medieval Misogyny" and *Medieval Misogyny and the Invention of Western Romantic Love*) has been accused of much the same practice, of ignoring the material and very real oppression of medieval women in favor of an analysis of texts that turns misogynist topoi such as those condemning women's sexual insatiability or their love of ornamentation into an exploration of the poet's own anxieties about the legitimacy of his craft and medieval fears of textual indeterminacy, of a surplus that exceeds reference and that constitutes the arts.[8]

Feminist criticism has attempted to restore this lost lady as something more substantial than representation's shadow, or the impossibility of signification. To do so, feminist critics have had to return once again to the difficult question of representation and literature's relation to the historical texts of medieval culture in an attempt to work through the theoretical impasse: does the literary representation transparently reflect some other reality or does it only refer specularly to itself? From this rethinking, the fourth perspective on representation—the dialogic—emerges. In this view literature can be neither completely transparent, offering unmediated access to medieval life, nor does it refer only to itself. If texts—both historical and literary—produce a reality of their own, it does not follow that this reality is entirely cut off from its historical moment of production (Moi, 20).

Toril Moi points out that those periods in contemporary literary criticism that saw a revision of our historical understanding of courtly love coincide with periods that "witnessed a crisis of conventional sexual ideology and values" (16). In making this connection, she recognizes that the critic's stance toward the texts she seeks to understand can never be totally impartial, never completely free from her own ideological investments. This is a process Dominick LaCapra (1985) describes as transference, a "repetition-

displacement of the past into the present" (72). The 1930s and 1960s were both decades in which social conflict took the form of conflict over sexual mores; the 1980s and 1990s are surely another such period of crisis. Predictably, as I have shown above, all of these periods saw a renewal of the debates over the sexual politics of courtly love. Recent feminist rereadings of courtly love, of which Moi's essay, "Desire in Language: Andreas Capellanus and the Controversy of Courtly Love," is exemplary, have scrutinized intensely this literature's status as a representation of medieval life. They have also provided us with much more complex and multi-faceted views of the relations between "reality" and its representations.

In another essay in the same volume (David Aers, *Medieval Literature: Criticism, Ideology, and History*), Derek Pearsall cites a passage from P.N. Medvedev's and M.M. Bakhtin's *The Formal Method in Literary Scholarship* to suggest the form that this new view of representation might take:

> The literary structure, like every ideological structure, refracts the generating socioeconomic reality, and does so in its own way. But, at the same time, in its 'content,' literature reflects and refracts the reflections and refractions of other ideological spheres (ethics, epistemology, political doctrines, religion, etc.). That is, in its 'content,' literature reflects the whole of the ideological horizon of which it is itself a part. (126)

The optical images of literature not only reflecting but refracting "socioeconomic reality," as well as reflecting and refracting other texts' reflections and refractions of that reality, imparts some notion of "mobility, activity, and generative force" to all the elements in the relationships among literature, ideology, and history. Literary texts, like any other ideological texts, exist in a complex relation both to other texts and to the social conditions of their creation. They reflect, but also in turn shape, those social conditions in a process that is, finally, dialogic.[9]

In trying to carve out a place for aristocratic women in medieval French literature, feminist critics have understood women's role to be represented in courtly literature in one of two ways. Either it is an expression of a "feminization" of medieval culture which expresses, in Meg Bogin's words, "a deep psychological need left unmet by the unrelenting masculinity of feudal culture" (*The Women Troubadours*, 44–45) or it is, in Jacques Lacan's words, "a fraud," "the only way of coming off elegantly from the absence of sexual relations" in twelfth-century aristocratic culture (Seminar XX, 141). Proponents of the first view, most notably Joan Kelly in her es-

say "Did Women Have a Renaissance?" argue that the power attributed to women in the courtly lyric (and to a lesser extent in the romance) must have some basis in the actual position of aristocratic women in the medieval courts. There is some support for this position in David Herlihy's argument, based on an examination of medieval charters, that there was a slight increase in the use of matronymics in place of patronymics between the tenth and twelfth centuries, which would suggest aristocratic women's increased power and influence within the family (see "Land, Family, and Women in Continental Europe, 701–1200"). William Paden, in *The Voice of the Trobairitz*, also attributes the existence of the trobairitz, female troubadours, to women's greater economic power and freedom within marriage in the south of France (at least prior to the Albigensian Crusade). All of these views, however, have in common a tendency toward a documentary or reflective view of literature's representation in which literature becomes, finally, a means of illustrating something else about medieval life, in this case women's increased social power. Ironically, Kelly, a historian, bases her argument that women had more sexual and political freedom in the Middle Ages than in the Renaissance almost exclusively on the evidence of courtly love literature.

Other feminist commentators, building on the work of Erich Kohler, argue that, far from representing the relations between the sexes, courtly love was an exclusively homosocial bond, a means for men to establish relationships with one another using women as tokens of exchange. Kohler's work on courtly love in the 1960s was not widely cited in English and American analyses of courtly love until the feminist critique of male-authored texts stimulated a renewed interest in the social relations between men that produced courtly love as an ideology. In the wake of Eve Sedgwick's groundbreaking study, *Between Men: English Literature and Male Homosocial Desire*, several critics have argued that romantic love is primarily a form of male competition and bonding in which women function as "floating signifiers" of male value. Within a homosocial system women are defined exclusively in terms of their sexuality, which becomes the reward for competition and the ground for cooperation between men. Roberta Kreuger's 1985 essay, "Love, Honor, and the Exchange of Women in Yvain: Some Remarks on the Female Reader," outlines a "paradigm for the dynamics of sexual exchange" in the spectacle of two knights engaged in combat over a woman, a spectacle that is the stock-in-trade of medieval romances like those of Chrétien de Troyes. Kreuger suggests that, while it would be dishonorable—unchivalric—for a knight to seize a woman who is alone, if a knight "wins" a woman from another knight in battle he may do to her as he wishes

without shame. I have examined this dynamic of woman as prize in Chrétien's *Erec et Enide* in "Towards a Cultural Poetics of the Romance," looking specifically at those rituals designed to reinforce bonds between men (like the hunt) as well as those designed to contain and exploit masculine rivalries (the tournament). Susan Aronstein has examined a similar dynamic at work in the *Gawain Continuation*, in which changes in the political and power relations between men necessitate a redefinition of women's role as sexual pawn.

These feminist readings of the medieval romance were anticipated in essays by Eugene Vance that, while not specifically feminist, did outline at least one version of a system of economic exchange that might illuminate the romance's sexual exchanges. In "Love's Concordance: The Poetics of Desire and the Joy of the Text" and "Chrétien's Yvain and the Ideologies of Exchange," Vance argues that as Champagne, through the efforts of its Count, Henri (Marie's husband), emerged as the commercial center of northern Europe, its prosperity brought with it a new ideology of exchange, based not on the personal and often coercive bonds of feudalism but on the impersonal and shifting contacts of mercantilism founded on "freedom of consent, measure, service, and just prices and wages" ("Chrétien's Yvain," 49). Vance's argument is important primarily because it articulates a theory of representation that goes beyond the reflectionism of the old debates about the "courts of love" in Champagne. Vance is not interested in seeing Chrétien's romances (or the poetry of the trouvère Gace Brulé) as depicting life as it was lived in twelfth-century Champagne. Chrétien's lone knight-errant wandering through marvelous forests in search of honor, fame, and love was, even in the twelfth century, pure fiction. If the new ideology of exchange is represented at all in Chrétien it is at the level of language, not of plot. Vance argues that the many discourses that constitute any given "speech community" "not only develop together, they act upon and interfere with each other." If Chrétien's romances reflect anything, they reflect the conflict between two distinct sets of discourses struggling for hegemony in Champagne: an older discourse of feudalism, order, and hierarchy and a newer economic discourse based on horizontal exchange with money as the medium of exchange. Within Chrétien's nostalgic representation of the feudal *bellatore* lurk the language and ideology of mercantilism and nascent capitalism. The conflict between these two orders is represented through a process of displacement by which women (and their sexuality) take the place of money in the romance's exchanges. In Vance's analysis the poem is not merely reflecting prior events, it is constituting them, refracting the discourses of economics and feudalism and transforming them into the language of romantic love.

This language in turn shapes the discourse of marital love so that the conception of marriage as two individuals' free and consensual exchange of sexual love (*Yvain, Erec et Enide*) existed in literature (and in Church doctrine) long before it did in fact, a striking display of representation's constitutive powers.

Several critics describe what we might call a "discursive displacement" at work in the troubadour lyric, in which sexual conflict becomes the locus for disputing other social, political, and economic conflicts between men. Simon Gaunt argues that women are excluded as subjects from the troubadour lyric (see "Poetry of Exclusion: A Feminist Reading of Some Troubadour Lyrics"). Instead, as he argues in "Marginal Men, Marcabru, and Orthodoxy," these lyrics constituted a lay reaction to the Church's attempts to regulate marriage. The courtly lyric emerged out of the clash between a feudal aristocracy that desired endogamous marriage—or marriage within the kin group—to maintain property intact, family choice of marriage partners, and a husband's right to repudiate his wife, and a church that insisted on exogamy—marriage outside of the kin group—indissoluble marriage, and the free consent of both partners. The ideology of (sometimes adulterous) love in the courtly lyric, in Gaunt's analysis, is a reaction to the church's attempt to regulate marriage, which simultaneously manages to incorporate the church's insistence on the consensual and companionate nature of marital love.

R. Howard Bloch and Laura Kendrick both identify the troubadour lyric as a site of political contestation. In *Etymologies and Genealogies*, Bloch forges connections among poetry, medieval fears about linguistic propriety, and anxieties about the preservation of property through genealogy. The poet, he argues, is a "mixer of words, of meanings, and, by implication, an obscurer of etymologies through the dislocation of linguistic property. Similarly, the adulterer is a mixer of races, of noble fortunes, an obscurer of genealogy through the dislocation of family property. Semantic and genealogical discontinuity go hand in hand" (112). The difficult and opaque style of much troubadour poetry provides a pretext for examining the effects of both kinds of discontinuity.

In *The Game of Love* Kendrick examines the same kind of semantic disruption as a site of a political struggle between the centralizing tendencies of the French and English monarchies and an "acentric" approach to political power characteristic of southern France, in which dynamic and shifting political alliances among extended families or clans were the means of maintaining social order (8). This conflict takes place almost exclusively in the realm of representation: how does the ruler represent his authority to

his subjects? what are the signs of that authority? who or what will represent him in his absence? Writing enabled the centralization that marked twelfth-century government, and Kendrick argues that the troubadours may even have served as informal writing teachers, coaching administrators in the skills of composition and interpretation so necessary to a centralized bureaucracy. The troubadour lyrics, in Kendrick's view, are no longer merely inert reflections of some prior and independent reality but active agents in that reality's creation, especially in the creation of representational strategies for the exercise of political authority.

Kendrick, however, stops short of suggesting why sexuality should be the chosen ground for contesting these political issues. Bloch's focus on genealogy offers at least a partial explanation: the demands of primogeniture and lineage which followed from twelfth-century reorganizations of kinship structures required strict control of women's sexuality. An aristocratic woman's primary function was to guarantee the continuity of her husband's patrimony by producing an heir. To ensure that heir's legitimacy, she must have no other sexual partner than her husband.[10] Bloch's analysis of kinship accounts for the anxiety around the issue of women's sexual desire; it certainly explains the misogynist invectives of a poet like Marcabru. However, the apparent glorification of adultery not only in much troubadour poetry but also in the *De Amore*, romances like Chrétien's *Chevalier de la charette*, Marie de France's lais, and the *Roman de la Rose* (to name only a few examples) would seem counterintuitive unless sexuality was the site not merely of anxiety about women's sexual roles but also of massive contradiction. Elsewhere (*Feminist Theory, Women's Writing*) I have suggested that this is in fact the case. The organization of the twelfth-century aristocratic household required both the control and the display of female sexuality. The system of patronage that bound together groups of unmarried men (Kohler's "marginal men") in the households of their more powerful (and married) overlords required the circulation of some species of "symbolic capital" to reconfigure what were essentially economic transactions as forms of generosity and gift-giving. Women's sexuality was ideally suited for this function, and literary genres like the courtly lyric were ideal vehicles for the covert display of female sexuality and thus for exchanges of symbolic capital. Literary artifacts, because of their metaphoric dimensions—their abilities to transmute, to substitute, to supplement—would not simply reflect life at court, they would reproduce, sustain, and even transform the patronage relationships that constituted life at court.[11] This view provides a more complex account of aristocratic women's position; they are at once empowered and exploited. While the aristocratic woman is still the medium of exchange

between men, her necessary position as patron offers her more power than marriage alone could, a power that was quite obviously used by powerful patrons like Eleanor of Aquitaine and her daughter Marie, countess of Champagne, and which might also account for the emergence within courtly French literature of a tradition (albeit minor) of women writers: the twenty or so *trobairitz*, Marie de France, and even Christine de Pizan in the late Middle Ages.

What becomes increasingly clear from even a brief summary of contemporary scholarship on courtly love is that no single model can account for its variety: the obscenity of a Guillaume IX, the misogynist invective of a Marcabru, the martial displays of a Bertran de Born, the *amor de lohn* of Jaufre Rudel, and the idealizations of Bernard de Ventadorn, for both Guillaume de Lorris and Jean de Meun's version of the *Roman de la Rose*, and for Chrétien's and Marie de France's idealizations of both companionate marriage and adulterous passion. The ways in which this variety challenges earlier notions of courtly love have been a concern of much recent scholarship concerned with the relation of courtly love to other literary and extraliterary genres. These studies go beyond traditional source studies in their engagement with the theoretical concept of intertextuality—the complex interaction among texts, ideologies, traditions, the play of cross-references, echoes, and cultural symbols that constitutes a national literature by binding texts together across space and time.

Kathryn Gravdal's study of rape, *Ravishing Maidens*, is a good example of the application of these theoretical concerns to issues in the history of sexuality. In staking out the terrain of her study, which concerns the relations of literary to legal discourse on the subject of rape, Gravdal is extremely sensitive to the problems of representation articulated above. For her, medieval literature does not merely reflect sexual practices of rape that legal documents record more accurately. In examining both legal theory and practice in the Middle Ages, she questions whether these texts can have any privileged status as a "true" representation of medieval life. Instead, she examines the ways in which legal and literary discourses mutually constitute one another as well as the events they purport to document.[12] For example, she examines the presence of the language of pastourelle[13] in records of rape trials, arguing that these records allude to a literary style that existed prior to either the event or its recording, that appears to offer a linguistic paradigm for sexual violence. This "poetic troping" of rape in which narrative codes for describing rape circulate among several speech genres, some literary (the range of genres Gravdal examines in the study include besides the courtly and the pastorelle, the beast fable and saints' lives), some

(like the law) non-literary, demonstrate the complicity of courtly love with other cultural representations in perpetuating and naturalizing sexual violence against women.

If contemporary writing on courtly literature has become increasingly concerned with the mechanisms by which literature's representation of sexuality participates in cultural constructions of sexual behaviors, scholarship on the old French fabliaux provides a counterpoint that recapitulates many of the same concerns in a slightly different stylistic register. At the same time, the fabliaux's display of the body, its intense scrutiny of the body as a carrier of anxieties about sexuality, provides a convenient means of focusing on recent work on the body in medieval French literature. Criticism of the fabliaux in the reflectionist mode, which dominated late nineteenth and early twentieth-century criticism, saw the genre as an expression of medieval life at its most authentic. The fabliaux (and related genres like the *dits* or beast fables) could provide unmediated access both to the body and to the social body of the French bourgeoisie. Because the collection of (mostly obscene) tales we call collectively the fabliaux contain a much more diverse set of characters than other, more obviously aristocratic medieval genres like the epic, romance, or lyric, and because their "grasping materialism" (the term is Howard Bloch's in *The Scandal of the Fabliaux*) seems closer to our view of human nature than the idealism of courtly literature, it was common until well into this century to assume that these tales offered a privileged glimpse into life as it was truly lived in the thirteenth and fourteenth centuries. In this view, the fabliaux can be read as utterly transparent, reflecting the social reality of the Middle Ages. Their "bodily naturalism" cannot be the result of artifice; therefore they constitute a source of knowledge about the material conditions of medieval life, offering a glimpse into something like a French national character, "l'esprit gaulois."[14]

This simple reflectionism has recently been challenged by theoretical readings that offer both specular and dialogic perspectives on the fabliaux's representations of sexuality and the body. A brief examination of three more or less representative studies by R. Howard Bloch, Alexandre Leupin, and E. Jane Burns should suffice to illustrate the productivity of these approaches. Bloch's *The Scandal of the Fabliaux* provides an example of the specular view of representation. For Bloch, the "scandal of the fabliaux" is not sex, obscenity, or even the display of sexual organs and sexed bodies; rather the obsessive display of the grotesque body provides a "front" for the scandal of representation itself, in particular the inability of language or poetry to represent some stable referent outside of itself. Fabliaux, according to Bloch, more than any other medieval genre, as a group constitute a sustained re-

flection on literary language. They "portray . . . a universe in which language seems to have lost purchase upon the world" (16). Consisting primarily of slippages, tautologies, misunderstandings, substitutions, and complete disjunctions, the fabliaux entirely empty language—and poetic language in particular—of any sense.

The fabliaux's obsessive focus on sexual organs, or on what Mikhail Bakhtin calls the "grotesque body," is not, for Bloch, a sign of "bodily naturalism" but quite the reverse. As he points out, in the fabliaux the body is always fragmented, partial, and distorted; it cannot serve as some extra-textual ground of meaning. Dismemberment, and castration in particular, are common in fabliaux. The detached sexual organ (either penis or vagina) circulates in the tales "as freely as detachable meanings" (61). As the body is reduced to its sexual parts through the medium of language, those detached parts become signs of the detached nature of all signs—of all language—and of language's inability to warrant representation.

In *Barbarolexis: Medieval Writing and Sexuality*, Alexandre Leupin draws on psychoanalysis to examine many of the same issues of representation Bloch articulates. Leupin gathers them together under the term "general reflexivity," by which he means the attempt of certain texts—not only the fabliaux, but also other medieval genres like the rhetorical handbook, saints' lives, and bestiaries—to create a space for the play of the "indescribable alterity of desire, a desire which cannot be reduced to whatever represents it" (4). For Leupin the fabliaux represent not a scandal but an impasse, which is language's inability to represent that desire. Leupin uses psychoanalysis side by side with rhetoric and theology, not as an "applied model" but as a "theoretical prism," because it is, in his words, "The only discipline permitting us to deal critically with the inscription of a specific desire in language, or to understand the contradiction between the unrepresentable and the law that emerges when a writer sets out to write" (5). Castration and bodily dismemberment function as figures for that law in this analysis. Like Bloch, Leupin dismisses the sociological and historical questions of origins and audience that were central to earlier reflectionist critics. His specular account of the fabliaux, he argues, supersedes such concerns. He wants to read these tales not as a "historically mimetic account of our grandfathers' sexual practices" (85), but rather as a "symptom that mythically and repeatedly attempts to fill an incommutable absence" (83). He wants to expose the dream or delerium hidden within their obscenity: the impossible dream that there can be a proper name for the relation between the sexes.

Not all recent scholarship, however, has been content to see the fabliaux merely as commentary on the nature of language and its castra-

tion, its inability to name the sexual relation. Feminist critics, in attempting to understand how representations of gender roles help produce and reproduce the relations between the sexes, have articulated a dialogic approach to the fabliaux's representations of the body (as well as those of other medieval texts). Works like the collection of essays edited by Linda Lomperis and Sarah Stanbury, called *Feminist Approaches to the Body in Medieval Literature*, are concerned with establishing the sociopolitical significance of the body not as some ontological or biological reality that representation passively reflects, or as an insubstantial dream of referentiality but as a production of the social relations of gender. In her essay in that volume Peggy McCracken articulates a model that is drawn upon, either explicitly or implicitly, by most of the contributors to this volume. Beginning with Mary Douglas's anthropological insight that rituals of pollution and taboo involve the human body not simply as an object in the world to be represented but as itself a powerful symbol for society, McCracken argues that rituals designed to reinforce the boundaries of the body—that specify the differences between inside and outside—are a means of policing community boundaries and social margins.[15] Her essay looks specifically at the body of the queen in romance, but, in the same volume, Jane Burns's essay on the fabliaux, "The Prick Which is Not One," begins with much the same premise and, in fact, synthesizes McCracken's anthropological approach with Bloch's and Leupin's arguments about the relationship between the fabliaux's obscenity and anxieties about language's referentiality. She argues that anxieties about female bodies express anxieties about female speech. Extending the arguments in her recent book, *Bodytalk: When Women Speak in Old French Literature*, Burns contends that the fabliaux's obsessive preoccupation with the permeability of female bodies and the accessibility of female sexuality (preoccupations it shares with many other medieval genres including the romance) cannot be separated from a preoccupation with the consequences of female speech. Both sexual and linguistic promiscuity stand as powerful symbols of social chaos in misogynist texts like the fabliaux. But far from reflecting the actual experiences of medieval women, bourgeois or aristocratic, these representations of woman as chaos acted as powerful social controls to silence and contain the threat of femininity. Undoubtedly such representations also managed, with variable success, to keep actual women in line, that is to keep them silenced and access to their sexuality strictly limited. Yet if misogynist texts like the fabliaux could mobilize powerful representations of the female body as a means to dominate and control, Burns argues, these very same textual bodies might also offer possibilities for resistance to that

domination by undercutting the fiction of male control and exposing the fraudulence of the mastery it implies. Such representations might hold out the possibility, however cryptically encoded, of imagining women as knowing and desiring subjects.

Burns's argument brings me full circle to the point with which I began. In the dialogic view of representation I have articulated, literature perpetuates even as it investigates the problem of sexuality, of the relations between the sexes. It does not simply reflect human sexuality; instead it participates in social processes that produce multiple and contradictory forms of sexuality, which include not only prescriptions and proscriptions but resisistance to such restrictions as well. My summary of the major currents in research on sexuality in medieval French literature has focused on the problem of representation in courtly literature and the fabliaux primarily as a convenient device for organizing a large body of diverse scholarship. The two genres highlight in complementary ways several issues that have occupied scholars for the last two decades. They represent high and low registers of literary style, classical and grotesque representations of the human body, aristocratic and bourgeois representations of the social body, idealizations of women and misogynist screeds. By no means do I mean to imply that sexuality has not been the subject of research on other medieval genres or writers; undoutedly there is much I have had to leave out of this survey (the bibliography should refer the interested reader at least to some other relevant studies). But my reading of representation as sexuality's blind spot may point the way to opportunities for future research that will result in more sophisticated and complex models that investigate literature's complicity with other social constructions of sexuality, including those of law, medicine, and religion.

NOTES

1. Michel Foucault, "The Confession of the Flesh," 215–216. See also *History of Sexuality*, vol. 1. One recent critique of Foucault which focuses on his failure to account for the relations between sexuality and romantic love is Anthony Giddens in *The Transformation of Intimacy: Sexuality, Love, and Eroticism in Modern Societies*. This critique is especially significant for medievalists, since any account of sexuality in medieval literature must account for the role romantic love plays in shaping sexual ideologies.

2. Because medieval French literature is a vast field, covering works in dozens of genres, in several dialects, over a period of more than 500 years, and because it is not a literature particularly easy to read and enjoy without some sense of the context out of which it arose, the student new to the field may find useful some general and comprehensive summaries of the field. Jessie Crosland's *Medieval French Literature*, while hardly recent, is still a useful and accessible introduction to the canon of medieval French literature, covering the *chanson de geste*, saints' lives, lyric poetry, romance, fabliaux, *dits*, fables, chronicles, and drama. A useful introduction to the literary criti-

cism in the field during the early part of this century is the chapter on medieval French literature by Charles A. Knudson and Jean Misrahi in John H. Fisher's *The Medieval Literature of Western Europe: A Review of Research, Mainly 1930–1960.*

3. See also Henry Kelly's recent re-reading of Paris's argument in "The Varieties of Love in Medieval Literature According to Gaston Paris." For a summary of the scholarship through the 1970s on the origins and meaning of courtly love see Boase, *The Origin and Meaning of Courtly Love.*

4. In *The Transformation of Intimacy,* Giddens distinguishes sexuality from romantic love. While in sociological practice the two are so inextricably linked as to make their separation nearly impossible, it seems useful to distinguish what Giddens calls "passionate love"—a love directed toward sexual release and whose expression is common to most cultures—from "romantic love," which is characterized by the deferral of sexual release. The latter is a distinctly Western ideology whose origins might be traced to the twelfth-century troubadour lyric.

5. The idea of connecting Robertson's brand of hermeneutics with psychoanalysis was suggested to me by Stanley Fish's essay on the Variorum Milton. See *Is There A Text in This Class?* p. 170.

6. It has also been of interest to scholars who are less self-consciously poststructuralist. Leslie Cahoon, for instance, argues that Jean de Meun borrowed Ovid's imagery of war, architecture, and worship to describe love's disintegration into sexual violence, reification, and pseudo-religion, while Marta Harley describes Guillaume's adaptation of several Ovidian myths as a means of condemning the destructiveness of obsessive passion that has its origins in self-love.

7. This is an argument Cholakian makes as well, see pp. 183–88.

8. See the responses to Bloch's 1987 article in *The Medieval Feminist Newsletter* 7 (1989), 2–16, and Bloch's rebuttal in the introduction to *Medieval Misogyny.*

9. My argument here is indebted not only to Bakhtin, but to Anthony Giddens's structuration theory as well. See *The Constitution of Society,* especially chapter one. I should point out that, although I clearly intend for this last perspective—the dialogic—to reconcile the differing claims of the other three positions, my discussion of the scholarly texts I used to illustrate those positions should not be taken as criticisms of these important works, which have greatly increased our understanding of medieval literature.

10. Jeri Guthrie, in "La femme dans le *Livre des maniers*: surplus economique, surplus erotique," makes a similar argument about aristocratic women's sexual and economic function in the satire of Étienne de Fougères.

11. It should be clear that this argument cannot be limited to literary patronage; rather literary patronage is an element in a larger economy that structured relationships of all kinds—political, military, and economic as well as literary.

12. For another study of the relationships between medieval law and literature that is also sensitive to the issues of representation, see Bloch, *Medieval French Literature and the Law.*

13. The pastourelle is a genre of medieval literature that depicts the seduction or rape of a lower class maiden at the hands of a knight.

14. Bloch offers a fairly concise summary of the fabliaux's reception since the seventeenth century in *The Scandal of the Fabliaux,* pp. 1–21.

15. Both M.M. Bakhtin, in *Rabelais and His World,* and Peter Stallybrass and Allon White, in *The Politics and Poetics of Transgression,* make similar arguments in a different context about early modern texts.

BIBLIOGRAPHY

Allen, Peter. "Ars Amandi, Ars Legendi: Love Poetry and Literary Theory in Ovid, Andreas Capellanus, and Jean de Meun." *Exemplaria* 1 (1984): 181–205.

———. *The Art of Love.* Philadelphia: University of Pennsylvania Press, 1992.

Aronstein, Susan. "Prize or Pawn? Homosocial Order, Marriage, and the Redefinition of Women in the Gawain Continuation." *Romantic Review* 82 (1991): 115–26.

Bakhtin, M.M. *Rabelais and His World*. Trans. Hélène Iswolsky. Bloomington: Indiana University Press, 1984.

———. *Speech Genres and Other Late Essays*. Ed. Michael Holquist and Caryl Emerson. Trans. Vern W. McGee. Austin: University of Texas Press, 1986.

Bakhtin, M.M./Medvedev, P.N. *The Formal Method in Literary Scholarship*. Trans. Albert J. Wehrle. Cambridge, MA: Harvard University Press, 1985.

Benton, John F. "The Court of Champagne as a Literary Center." *Speculum* 36 (1961): 551–91.

Biddick, Kathleen. "Genders, Bodies, Borders: Technologies of the Visible." *Speculum* 68 (1993): 389–418.

Bloch, R. Howard. *Etymologies and Genealogies: A Literary Anthropology of the French Middle Ages*. Chicago: University of Chicago Press, 1983.

———. *Medieval French Literature and the Law*. Berkeley: University of California Press, 1977.

———. "Medieval Misogyny." *Representations* 20 (1987): 1–24.

———. *Medieval Misogyny and the Invention of Western Romantic Love*. Chicago: University of Chicago Press, 1991.

———. *The Scandal of the Fabliaux*. Chicago: University of Chicago Press, 1986.

Boase, Roger. *The Origin and Meaning of Courtly Love: A Critical Study of European Scholarship*. Manchester, Eng.: Manchester University Press, 1977.

Bogin, Meg. *The Women Troubadours*. New York: W.W. Norton, 1980.

Brownlee, Kevin and Sylvia Huot, eds. *Rethinking the Romance of the Rose: Text, Image, Reception*. Philadelphia: University of Pennsylvania Press, 1992.

Brundage, James A. *Law, Sex, and Christian Society in Medieval Europe*. Chicago: University of Chicago Press, 1987.

Burgess, Glyn S., A.D. Deyermond, W.H. Jackson, A.D. Mills, and P.T. Ricketts, eds. *Court and Poet: Selected Proceedings of the Third Congress of International Courtly Literature Society*. Liverpool, Eng.: Cairns, 1981.

Burgess, Glyn S., Robert A. Taylor, Denis Green, and Beryl Rowland, eds. *The Spirit of the Court: Selected Proceedings of the Fourth Congress of the International Courtly Literature Society*. Dover, NH: Brewer, 1985.

Burns, E. Jane. *Bodytalk: When Women Speak in Old French Literature*. Philadelphia: University of Pennsylvania Press, 1993.

———. "Knowing Women: Female Orifices in the Old French Fabliaux." *Exemplaria* 4 (1992): 81–104.

Burrell, Margaret. "The Participation of Chrétien's Heroines in Love's 'Covant.'" *Nottingham French Studies* 30 (1991): 24–33.

Cahoon, Leslie. "Raping the Rose: Jean de Meun's Reading of Ovid's *Amores*." *Classical and Modern Literature: A Quarterly* 6 (1986): 261–85.

Calin, William. "Contre la fin'amor? Contre la femme? Une relecture de textes du Moyen Age." In Keith Busby and Erik Kooper, eds. *Courtly Literature: Culture and Context*. Amsterdam: Benjamins, 1990, 61–82.

Cholakian, Rouben C. *The Troubadour Lyric: A Psychocritical Reading*. Manchester, Eng.: Manchester University Press, 1990.

Crosland, Jessie. *Medieval French Literature*. Westport, CT: Greenwood Press, 1956; rpt. 1976.

Dragonetti, Roger. *La vie de la lettre*. Paris: Edition du Seuil, 1982.

Dronke, Peter. *Women Writers of the Middle Ages: A Critical Study of Texts from Perpetua (203) to Marguerite Porete (1310)*. Cambridge: Cambridge University Press, 1984.

DuBruck, Edelgard E. *New Images of Medieval Women: Essays Toward a Cultural Anthropology*. Lewiston, NY: Edwin Mellen, 1989.

Duby, Georges. *The Knight, the Lady, and the Priest: The Making of Modern Marriage*. Trans. Barbara Bray. New York: Pantheon, 1983.

———. "The Matron and the Mis-Married Woman: Perceptions of Marriage in Northern France circa 1100." In T.H. Aston, P.R. Coss, Christopher Dyer, and Joan Thirsk, eds. *Social Relations and Ideas: Essays in Honor of R.H. Wilton*. Cambridge: Cambridge University Press, 1983, 89–108.

———. *Medieval Marriage: Two Models from Twelfth-Century France*. Baltimore: Johns Hopkins University Press, 1978.

———. "A propos de l'amour que l'on dit courtois." *Bulletin de l'Academie Royale de Langue et de Litterature Francaises* 64 (1986): 278–85.

Edwards, Robert R. and Stephen Spector, eds. *The Olde Daunce: Love, Friendship, Sex, and Marriage in the Medieval World*. Albany, NY: SUNY Press, 1991.

Fichte, Joerg O. "The Treatment of Love and Sex in Selected Specimens of Medieval Visionary Literature." *Geardagum* 9 (1988): 1–21.

Finke, Laurie A. *Feminist Theory, Women's Writing*. Ithaca, NY: Cornell University Press, 1992.

———. "Towards a Cultural Poetics of the Romance." *Genre* 22 (1989): 109–27.

Fish, Stanley. *Is There a Text in This Class? The Authority of Interpretive Communities*. Cambridge, MA: Harvard University Press, 1980.

Fisher, John H. *The Medieval Literature of Western Europe: Review of Research, Mainly 1930–1960*. New York: Modern Language Association, 1966.

Foucault, Michel. "The Confession of the Flesh." In Colin Gordon, ed. *Michel Foucault: Power/Knowledge*. Hemel Hempstead, Eng.: Harvester, 1980: 215–16.

———. *The History of Sexuality, Vol. I: An Introduction*. Trans. Robert Hurley. New York: Pantheon, 1978.

Gaunt, Simon B. "Marginal Men, Marcabru and Orthodoxy: The Early Troubadours and Adultery." *Medium Aevum* 59 (1990): 55–72.

———. *Troubadours and Irony*. New York: Cambridge University Press, 1989.

Giddens, Anthony. *The Constitutions of Society*. Berkeley: University of California Press, 1984.

———. *The Transformation of Intimacy: Sexuality, Love, and Eroticism in Modern Societies*. Stanford, CA: Stanford University Press, 1992.

Glassner, Marc. "Marriage and the Use of Force in Yvain." *Romania* 108 (1987): 484–502.

Gravdal, Kathryn. *Ravishing Maidens: Writing Rape in Medieval French Literature and Law*. Philadelphia: University of Pennsylvania Press, 1991.

Grimbert, Joan-Tasker. "Love, Honor, and Alienation in Thomas's Roman de Tristan." In Keith Busby, ed. *Arthurian Yearbook II*. New York: Garland Publishing, 1992.

Guthrie, Jeri S. "La Femme dans le Livre des maniers: surplus economique, surplus erotique." *Romantic Review* 79 (1988): 253–61.

Hanning, R.W. "Love and Power in the Twelfth Century, with Special Reference to Chrétien de Troyes and Marie de France." In Robert Edwards and Stephen Spector, eds. *The Olde Daunce: Love, Friendship, Sex, and Marriage in the Medieval World*. Albany, NY: SUNY Press, 1991, 87–103.

———. "'I Shal Finde It in a Maner Glose': Versions of Textual Harassment in Medieval Literature." In Laurie A. Finke and Martin B. Shichtman, eds. *Medieval Texts and Contemporary Readers*. Ithaca, NY: Cornell University Press, 1987.

Harley, Marta Powell. "Narcissus, Hermaphroditus, and Attis: Ovidian Lovers at the Fontaine d'Amors in Guillaume de Lorris's *Roman de la Rose*." *PMLA* 101 (1986): 324–37.

Herlihy, David. "Land, Family, and Women in Continental Europe, 701–1200." In Susan Mosher Stuard, ed. *Women in Medieval Society*. Philadelphia: University of Pennsylvania Press, 1976, 13–46.

Huot, Sylvia. "The Daisy and the Laurel: Myths of Desire and Creativity in the Poetry of Jean Froissart." *Yale French Studies* 75 (1991): 240–51.

————. *The Romance of the Rose and Its Medieval Readers: Interpretation, Reception, Manuscript Transmission*. New York: Cambridge University Press, 1993.

Jackson, W.T.H. *The Challenge of the Medieval Text: Studies in Genre and Interpretation*. Joan M. Ferrante and Robert W. Hanning, eds. New York: Columbia University Press, 1985.

Johnson, Barbara. *The Critical Difference: Essays in the Contemporary Rhetoric of Reading*. Baltimore: Johns Hopkins University Press, 1980.

Kay, Sarah. *Subjectivity in Troubadour Poetry*. New York: Cambridge University Press, 1993.

Keller, Hans-Erich. "De l'amour dans le *Roman de Brut*." In Norris J. Lacy and Gloria Torrini-Roblin, eds. *Continuations: Essays on Medieval French Literature and Language in Honor of John L. Grigsby*. Birmingham, AL: Summa Pubs, 1989, 63–81.

Kelly, Allison. "Christine de Pizan and Antoine de la Sale: The Dangers of Love in Theory and Fiction." In Earl Jeffrey Richards, ed. *Reinterpreting Christine de Pizan*. Athens, GA: University of Georgia Press, 1992, 173–86.

Kelly, Henry A. "The Varieties of Love in Medieval Literature according to Gaston Paris." *Romance Philology* 40 (1987): 301–27.

Kelly, Joan. "Did Women Have a Renaissance?" In *Women, History, and Theory: The Essays of Joan Kelly*. Chicago: University of Chicago Press, 1984.

Kendrick, Laura. *The Game of Love: Troubadour Wordplay*. Berkeley: University of California Press, 1988.

Kessel-Brown, Deirdre. "The Emotional Landscape of the Forest in the Mediaeval Love Lament." *Medium Aevum* 59 (1990): 228–47.

Kohler, Erich. "Observations historiques et sociologiques sur la poésie des troubadours." *Cahiers de Civilisation Médiévales* 7 (1964): 27–51.

————. *Trobadorlyrik und hofischer Roman*. Berlin: Rutten and Loening, 1962.

Kreuger, Roberta L. "Love, Honor, and the Exchange of Women in Yvain: Some Remarks on the Female Reader." *Romance Notes* 25 (1985).

Kristeva, Julia. *Tales of Love*. Leon S. Roudiez, trans. New York: Columbia University Press, 1987.

Lacan, Jacques. "Seminar XX: God and the Jouissance of the Woman." In Jacqueline Rose and Juliet Mitchell, eds. *Female Sexuality: Jacques Lacan and the école freudienne*. New York: W.W. Norton, 1981.

LaCapra, Dominick. *History and Criticism*. Ithaca, NY: Cornell University Press, 1985.

Lacy, Norris J. "Gliglois and Love's New Order." *Philological Quarterly* 59 (1980): 249–56.

Lazar, Moshe and Norris J. Lacy. *Poetics of Love in the Middle Ages: Texts and Contexts*. Fairfax, VA: George Mason University Press, 1989.

Leupin, Alexandre. *Barbarolexis: Medieval Writing and Sexuality*. Kate M. Cooper, trans. Cambridge, MA: Harvard University Press, 1989.

Lewis, C.S. *The Allegory of Love*. Oxford: Oxford University Press, 1936.

Lomperis, Linda and Sarah Stanbury. *Feminist Approaches to the Body in Medieval Literature*. Philadelphia: University of Pennsylvania Press, 1993.

Mackey, Louis. "Eros into Logic: The Rhetoric of Courtly Love." In Robert C. Solomon and Kathleen M. Higgins, eds. *The Philosophy of (Erotic) Love*. Lawrence: University of Kansas Press, 1991.

McCash, June Hall. "The Hawk Lover in Marie de France's Yonec." *Medieval Perspectives* 6 (1991): 67–75.

Moi, Toril. "Desire in Language: Andreaus Capellanus and the Controversy of Courtly Love." In David Aers, ed. *Medieval Literature: Criticism, Ideology, and History*. New York: St. Martin's Press, 1986, 11–33.

Nelson, Deborah Hubbard. "Christine de Pizan and Courtly Love." *Fifteenth-Century Studies* 17 (1990): 281–89.

Nichols, Stephen G. "Amorous Imitation: Bakhtin, Augustine, and Le Roman d'Eneas." In Kevin Brownlee and Martina Brownlee, eds. *Romance: Generic Transformation from Chrétien de Troyes to Cervantes.* Hanover, NH: University Press of New England for Dartmouth, 1985, 47–73.

Nightingale, Jeanne A. "Chrétien de Troyes and the Mythographical Tradition: The Couple's Journey in Erec et Enide and Martianus' De Nuptiis." In Valerie Lagorio and Mildred Day, eds. *King Arthur Through the Ages.* Vol. 1. New York: Garland Publishing, 1990, 56–79.

Noble, Peter S. *Love and Marriage in Chrétien de Troyes.* Cardiff: University of Wales Press, 1982.

Novet, Claire. "The Discourse of the 'Whore': An Economy of Sacrifice." *MLN* 105 (1990): 750–73.

Paden, William D. et al. "The Poems of the Trobairitz Na Castelloza." *Romance Philology* 35 (1981): 158–82.

Paden, William D. *The Voice of the Trobairitz: Perspectives on the Women Troubadours.* Philadelphia: University of Pennsylvania Press, 1989.

Paris, Gaston. "Lancelot du Lac 2: Le conte de la charrette." *Romania* 12 (1883).

Pearsall, Derek. "Chaucer's Poetry and its Modern Commentators: The Necessity of History." In David Aers, ed. *Medieval Literature: Criticism, Ideology, and History.* New York: St. Martin's Press, 1986: 123–47.

Picherit, Jean Louis. "Le Motif du tournoi dont le prix est la main d'une riche et noble heritiere." *Romance Quarterly* 36 (1989): 141–52.

Poe, Elizabeth Wilson. "Love in the Afternoon: Courtly Play in the Lai de Lanval." *Neuphilologische-Mitteilungen* 3 (1983): 301–10.

Quilligan, Maureen. *The Allegory of Female Authority: Christine de Pizan's Cité des Dames.* Ithaca, NY: Cornell University Press, 1991.

Robertson, D.W. *A Preface to Chaucer: Studies in Medieval Perspectives.* Princeton, NJ: Princeton University Press, 1962.

Rougement, Denis de. *Love in the Western World.* New York: Harcourt, Brace, 1956.

Sargent-Baur, Barbara Nelson. "Between Fabliau and Romance: Love and Rivalry in Beroul's Tristan." *Romania* 105 (1984): 292–311.

———. "Love in Theory and Practice in the Conte de Graal." In Keith Busby, ed. Arthurian Yearbook II. New York: Garland Publishing, 1992, 179–89.

Sedgwick, Eve Kosofsky. *Between Men: English Literature and Male Homosocial Desire.* New York: Columbia University Press, 1985.

Shapiro, Marianne. "The Provencal Trobairitz and the Limits of Courtly Love." *Signs* 3 (1978): 560–71.

Smith, Nathaniel B. and Joseph T. Snow. *The Expansion and Transformation of Courtly Literature.* Athens, GA: University of Georgia Press, 1980.

Spearing, A.C. "The Medieval Poet as Voyeur." In Robert Edwards and Stephen Spector, eds. *The Olde Daunce: Love, Friendship, Sex, and Marriage in the Medieval World.* Albany, NY: SUNY Press, 1991, 57–86.

Stallybrass, Peter and Allon White. *The Politics and Poetics of Transgression.* Ithaca, NY: Cornell University Press, 1986.

Topsfield, L.T. *Troubadours and Love.* Cambridge: Cambridge University Press, 1975.

Vance, Eugene. "Chrétien's Yvain and the Ideologies of Change and Exchange." *Yale French Studies* 70 (1986): 42–62.

———. "Love's Concordance: The Poetics of Desire and the Joy of the Text." *Diacritics* 5 (1975): 40–52.

White, Sarah M. "Sexual Language and Human Conflict in Old French Fabliaux." *Comparative Studies in Society and History* 24 (1982): 185–210.

Willard, Charity Cannon. "Women and Marriage Around 1400: Three Views." *Fifteenth-Century Studies* 17 (1990): 475–84.

Winn, Collette H. "Gastronomy and Sexuality: 'Table Language' in the Heptameron." *Journal of the Rocky Mountain Medieval and Renaissance Association* 7 (1986): 17–25.

Zeeman, Nicolette. "The Lover-Poet and Love as the Most Pleasing 'Matere' in Medieval French Love Poetry." *Modern Language Review* 83 (1988): 820–42.

———. "The Verse of Courtly Love in the Framing Narrative of the Confessio Amantis." *Medium Aevum* 60 (1991): 222–40.

Zumthor, Paul. *Essai de poétique médiévale*. Paris: Seuil, 1972.

17 OLD NORSE SEXUALITY: MEN, WOMEN, AND BEASTS*

Jenny Jochens

INTRODUCTION

The past contains numerous cases of peoples who have been decimated, even eradicated through warfare, deportation, starvation, and disease, but only rarely can precipitous demographic decline be attributed to insufficient reproduction.[1] The ongoing appearance of new generations is silent but sufficient evidence of heterosexual activity, although, of course, not all sexual acts result in reproduction. This chapter, however, will not focus on the reproductive consequences of sexuality but on its erotic permutations. It will examine sex and sexuality in the Old Norse world from the evidence of the sagas of Icelanders (or family sagas) and the law.[2] Although the subjects are rarely mentioned in the sources and therefore do not allow the broad analysis suggested by Eve Kosofsky Sedgwick's definition of sex and sexuality as "the array of acts, expectations, narratives, pleasures, identity-formations, and knowledges, in both women and men, that tends to cluster most densely around certain genital sensations but is not adequately defined by them,"[3] they do extend beyond those sex acts that result in conception.[4] Since the Norse material was committed to writing beginning in the twelfth century and preserved in copies dating from the thirteenth century or later, mediation by Christian authors and copyists was unavoidable. Nevertheless, the Norse evidence is of particular interest because it contains the only retrievable core of sexual behavior from northern Europe before it was Christianized. This area of human behavior was more influenced by Christian norms than perhaps any other. We shall distinguish between descriptions of actual heterosexual activities engaged in for purposes of reproduction and pleasure, and verbal references to sexual acts between a man and a woman, between two men, and between a man and an animal, most often a horse. The former appear to describe people's behavior, whereas the latter—although undoubt-

* Abbreviations to sources in the text are listed at the beginning of the notes.

edly grounded in experience—are used in verbal accusations between men as they seek to humiliate each other.

Behavior

VIOLENCE

Sources from the Norse world set in the pagan era depict men sexually pursuing women with considerable violence and brutality, thus confirming Freud's suggestion of close linkage in human behavior between aggression and erotic desire. The Icelandic law *Grágás* meted out severe punishment for men who employed rape or other violent means against women, or who gained access to the women's quarters of the house by appearing in female disguise. That this regulation was not superfluous is suggested by numerous references in the sagas to men whose "custom it was to take women who were beautiful or well-to-do and keep them for a while, because the [other] men did not dare stand up against [them]," or who were "very violent in love affairs and law suits."[5] Although this behavior was the particular characteristic of those violent men—most often Swedes or Norwegians—who were identified as berserks, unexceptional Icelandic young men also passed through a violent phase when they were involved with the other sex. Such behavior is suggested by the frequent topos of "the illicit love visit," which occurs more than twenty times in the narrative corpus. The theme depicts an unmarried male who, taking a fancy to a girl, starts to visit her regularly despite the opposition of her family, thereby precipitating a chain of violent actions, often resulting in his own death.

This evidence of male aggression lends credence to the theory of *Raubehe*, marriage by capture, hypothesized by German scholars as a preliminary step in the development of Germanic marriage.[6] During the unsettled conditions of the migrations of the Germanic tribes on the Continent and of the Viking expeditions in the North, men regularly acquired women through capture, retaining some as wives and mistresses. By the mid-thirteenth century, churchmen and kings still found it necessary to prohibit the taking of women in warfare (*herfang*) both in Iceland and Norway.[7]

Since *Raubehe* was clearly dysfunctional in a settled society, it is unlikely that it remained an institution after the marauding ventures subsided; it continued merely as an occasional opportunity. Instead, society channeled male heterosexual energy throughout the Germanic pagan world into marriage in the well-established form of *Kaufehe*.[8] Although this term does not denote a crude purchase of a wife, it nonetheless conveys the underlying notion that Germanic and Norse marriage was a commercial contract ar-

ranged between two men, the groom and the father of the bride, in which the parental families handed over property to the young couple, thus enabling them to conceive and support a new generation. In other words, Germanic/Norse marriage provided a legal framework for the pursuit of heterosexual reproductive activity and thereby facilitated the passing of property from one generation to the next. We may assume that marital sexuality also provided pleasure, which was available from extra-marital outlets as well. The latter remained numerous, although little noticed in the sources during pagan times. Indeed, they became visible in the Christian era particularly because they provoked the displeasure of churchmen.

Love-making

GENERAL TERMS

Like many other cultures, the Old Norse world was relatively mute about love-making, whether exercised for pleasure or reproduction.[9] A dialogue between the Norwegian King Haraldr harðráði and Stúfr, preserved in *Stúfs þáttr*, an epilogue to *Laxdœla saga*, suggests, however, that thoughts about sex were rarely far from people's minds. Puzzled by Stúfr's unusual nickname *kǫttr* (cat), the king inquired whether his father was "the hard (*hvatr*) or the soft (*blauðr*) cat" (5:283). When Stúfr "clasped his hands together, laughed, but did not answer," the king admitted that he had asked a foolish question, since "a person who is soft could not be a father." Used to designate male animals, *hvatr* evokes an erect penis, and *blauð(r)* the female softness.[10]

One obstacle that obscures an analysis of sexual relations is the habitual use of euphemisms, which is illustrated in the topos of the illicit love visit as well. Often resulting in pregnancy, these visits leave no doubt about the man's intentions, as he repeatedly called on a woman against her family's wishes. Almost without exception, however, saga authors claimed that he came "in order to talk with" the girl (*til tals við*). That gestures and caresses were more prominent than words is apparent from a scene in which the lover "placed her [his mistress] on his lap . . . and *talked* with her so all could *see* it"; *Hlf*, 8.4:145). The gestures visible at a distance were clearly not the talking lips, but the caressing arms and hands.

A related obstacle is the use of certain words that denote pleasure in general but at times imply sexual intercourse. One such term is "to amuse oneself" (*at skemmta sér*). Most often referring to activities pleasurable to a couple, it may denote a card game (*Gnl* 3.4:60) or innocent conversation (*Lx* 5.42:127), but also illicit intercourse (*Nj* 12.87:211). Frequently used in connection with "talk" (*tala*), the two expressions—mingled and redo-

lent with double entendres—were employed to good effect in a scene where Bolli blamed Kjartan for neglecting these pleasures in Iceland, as he was talking with Princess Ingibjǫrg in Norway, thereby forgetting Guðrún who was waiting for him at home (*Lx* 5.41:126).[11] A similar term is "to enjoy" or "to derive benefit from" (*njóta*), used in a general way in single- and double-sex relations but frequently referring to sexual intercourse. The magician þórveig thus placed a curse on Kormákr that he would never be able to *njóta* his beloved Steingerðr (*Krm* 8.5:22; 6:223).[12] In this sense such words imply the entire gambit of lovemaking.

More specific are the terms *faðmr* and *faðmlag*. Associated with measurements which use the arm's length, the words suggest sexual embrace. When Hrafn betrayed and killed Gunnlaugr, the man whom his wife Helga loved, he gave as his excuse: "I could not bear the thought that you should enjoy Helga's embrace" (*faðmlagsins Helgu*; *Gnl* 3.12:102).[13] A glimpse of habitual love-making in marriage is conveyed in a story concerning a shipbuilder. Described as "fond of women" (*kvennsamr*), he thought he saw his beautiful wife board the ship on which he was working. Approaching her, "he put her down gently because they were used to this kind of game. He laid with this woman . . . but as they separated, he seemed to understand that she was not his wife but an unclean spirit" (*Bs* 1:605).

Akin to sexuality is nakedness. Given the reticence of the sources, however, it is not surprising that the entire literary corpus yields only two cases of female nakedness, and both inspire horror.[14] The first involves not a living woman but a dead corpse, and the second a woman who wielded her semi-nakedness as a weapon against enemies. Before her death the Christian þórgunna ordered her burial at Skálaholt because she divined its future fame as the episcopal see.[15] When the men who transported her body, "wrapped in an un-stitched linen shroud," were refused hospitality at a farm, they were forced to spend the night "without food," but þórgunna herself appeared in the kitchen, "stark-naked, not a stitch of clothing on her," and started preparing a meal. Her apparition frightened the inhospitable hosts into providing everything needed (*Erb* 4.51:141–44).[16] Since saga people were used to *revenants*, it was þórgunna's nakedness, not her appearance, that was fearsome. This conclusion is confirmed by the other episode, which involved the pregnant Freydís in Vínland. Under attack by Indians, Freydís grabbed the sword of one of her fallen compatriots and ran after the invaders. When they turned around to confront her, "she pulled out her breast from her clothing and slapped it with the sword" (*Erð* 4.11:229, 430).[17] The *skrælingar* fled, replicating the nordic people's reaction to nakedness.[18]

Under the influence of literature translated from French, later saga texts endow love scenes with a romantic atmosphere. Thus one woman remarked upon the sunshine and southerly winds as her lover arrived, and another died of grief when her friend was killed.[19]

FOREPLAY

Beyond these general terms covering the entire cycle of love-making, the sources occasionally permit glimpses of couples taken in intimate action. By arranging sequentially scenes in which men and women made bodily contact, we shall be able to construct a prosopography, as it were, of love-making. When a man is depicted as leading a woman by the hand (*Nj* 12.87:211), we may assume that a relationship already exists.[20] First acquaintance may have occurred at drinking feasts, where women—always in minority—were assigned by lot to men. Each couple shared a horn in *tvímenningr*, invariably leaving some men to drink alone.[21] A young Swedish girl was not too pleased with her assignment to the inexperienced Egill, but she eventually warmed up when he "picked her up and placed her next to himself." Hints of sexuality are conveyed by the description of the woman's looks and behavior. Not surprisingly, "they drank all evening and became *allkát* (very happy"; *Eg* 2.48:120–21).[22]

Egill's gesture, "placing her next to himself," is a formulaic saga expression denoting intimacy and first contact with the body.[23] As a next step, the man would place the woman on his lap (*setja í kné sér*). Hallfreðr exhibited intimacy with his mistress Kolfinna in this way, as did Þórðr with his wife Oddný (*Hlf* 8.4:145; *BHd* 3.12:142). Although a normal step in love-making, these two men employed it with the ulterior motive of annoying the women's future husband and former lover, respectively, who were watching. It is rare to find a woman in this posture, although one saga ascribes it twice to a certain Yngvildr, who used it to betray the man she pretended to seduce (*Svf* 9.18:172–73).[24]

Having placed the woman on his lap, the man proceeded to kiss her (*kyssir hana*), as did both Hallfreðr and Þórðr in the above episodes.[25] In this case Þórðr was tender (*blíðr*) with his wife, but kisses could entail a brusque treatment, as suggested by the verbs *kippir* and *sveigir*, that connote a man violently tugging the woman toward him.[26] Men appeared to take the initiative, but women reciprocated likewise. When a man had smashed his opponent's jaw, he commented that the widow with whom the victim lived would now find him worse for kissing (*Hðr* 3.31:306). It was to be expected, of course, that Queen Gunnhildr—having herself initiated an affair with the visiting Hrútr—should kiss him at his departure (*Nj*

12.6:21). Mutual sexual excitement aroused by kisses and body contact is suggested in the embrace of Helgi and Helga in an episode involving an illicit love visit (*Hb* 8.2:307–08).[27] We recall that Kjartan was infatuated with the Norwegian Princess Ingibjǫrg, but the degree of intimacy was left vague. Taking his leave, Kjartan *hvarf til Ingibjargar* (*Lx* 5.43:131). With a general meaning of "turning toward," *hverfa til* suggests bodily or facial contact. It does not denote an erotic kiss, however, but a kiss exchanged on solemn occasions whether heterosexually or between men, thus making "to embrace" a better rendition. Since Kjartan never saw Ingibjǫrg again, it befits its use here. When Ásdís likewise sent her son Grettir away for the last time, she *hvarf til hans* (*Gr* 7.47:153). With foreboding of the serious events that would befall his son Þórolfr, the old Kveld-Úlfr walked him to his ship and "embraced him." In the next generation Þórolfr's brother Skalla-Grímr took final leave of his son Egill with the same gesture (*Eg* 2.6:15; 58:173).[28] Used under similar circumstances, the word *minnask*, etymologically related to "mouth," more clearly implied kissing, but it was employed primarily among men, as they greeted or took their leave.[29]

Further heterosexual intimacy was signaled when a man placed his head in a woman's lap and her hands framed his face. Ormr assumed this position, although Sigríðr warned him that she was engaged to his brother (*Þhr* 14.5:187–88). This posture could, at times, be devoted to delousing, as, for example, a slave mistress did for her lover.[30] In this case the woman betrayed the man, but his confidence, which allowed him to fall asleep with his head in her lap, suggests that in general a woman's attention to a man's hair was a token of love. The mistress who washed her lover's hair is a frequent topos; wives continued to provide this service to husbands.[31]

A woman could also show her love by making clothes, rendering the shirt a sure token of love. Whereas Steingerðr refused Kormákr's request, Valgerðr made for Ingólfr "all the clothes that demanded the most elaborate work" (*Krm* 8.17:264; *Vtn* 8.38:101). Wives were expected to assume responsibility for their husbands' clothes after marriage, thus turning pleasure into drudgery, as suggested by a conversation between two married women, Ásgerðr and Auðr. Both busy sewing, the former asked the latter to cut a shirt for her husband Þorkell. Apparently tired of the task herself, Ásgerðr assumed that Auðr's previous relationship with her husband would make it an attractive task for her (*Gí* 4.9:30). Another mistress is depicted in the endless task of narrowing the wide sleeves—a characteristic feature of male clothing—to enable her lover to work (*Gr* 7.17:53).[32]

So far, women's active role in love-making has been restricted to the periphery of hair and clothing, thus avoiding skin contact. Only women, however, are seen putting their arms around men's necks. It was mainly a sign of marital affection, but it is not unexpected that the sexually charged Queen Gunnhildr behaved in this way toward her lover Hrútr (Nj 12.6:20).[33] Although the gesture undoubtedly denoted genuine affection, wives frequently used it to elicit favors from husbands. To make her husband agree to keep her foster father, Hallgerðr went to the former and "put her arms around his neck" (lagði hendr upp um háls honum; Nj 12.15:47). Ásgerðr bragged to Auðr that she planned to use the same gesture in bed to obtain her husband's forgiveness after he had overheard the two women admit to earlier affairs (Gí 6.9:31).[34]

INTERCOURSE

Ásgerðr's plan for the night offers a convenient entry into the final act of love-making because the author permits the reader to watch Ásgerðr and her husband in bed together.[35] Despite her earlier boasting to Auðr, Ásgerðr's plan did not work out at first, because Þorkell was so upset by her revelation that he refused to allow her to join him under the covers. Offering him the choice between pretending that nothing had happened and an immediate divorce, Ásgerðr made sure that Þorkell understood that the latter meant financial loss as well as the cessation of their marital relations (hvíluþrǫng [literally, crowding together in bed]). In resignation Þorkell told her to do what she wanted, and Ásgerðr climbed next to him. The author commented that "they had not been lying together long before they settled their problem as if nothing had happened" (Gí 6.9:32–33). Despite this intimate look, the vague expressions—crowded bed, lying together—keep us in the dark on their past and present love-making.

The same saga, fortunately, contains another episode that suggests the process of marital intercourse although it ends in murder. Having decided that he must kill his brother-in-law Þorgrímr—his sister Þórdís's husband—Gísli went to the couple's farm at night. Approaching their bed, he set in motion a remarkable scene that deserves to be quoted in full:

He goes up and feels about and touches her breast; she lay nearest the outside. Then Þórdís said: "Why is your hand so cold, Þorgrímr?" and wakes him. Þorgrímr said: "Do you want me to turn toward you?" She thought he had laid his arm over her. Then Gísli waits a while and warms his hand in his shirt, and they both fall asleep. Now he touches Þorgrímr softly, so that he wakes him up. He thought that

Þórdís had woken him and then turns toward her. Then Gísli pulls the covers off them with one hand and with the other he spears Þorgrímr through with Grásíða [his sword], so that it sticks in the bed.[36]

Scholars have long discussed why Gísli created an erotic situation at this moment, but we are more interested in emphasizing that such a situation has indeed been established. By touching her breast Gísli made Þórdís think that her husband "had laid his arm over her," signaling his desire. In the Eddic poetry this expression (*legja hǫnd yfir*) is a frequent euphemism for love-making.[37] Only half-awake, Þorgrímr undoubtedly did not notice her question about the cold hand but perceived only that she had awakened him. He wanted to make sure of her intentions and asked whether she wished him to "turn toward" her. This expression (*snúask at*) is elsewhere used as preliminary to, or as a metaphor for, sexual intercourse. When the Norwegian King Magnús, for example, joined the reluctant Margrét in bed, "he turned toward her (*snýsk hann til hennar*), spoke tenderly to her, and explained that he was going to do her a great favor if she would only cooperate" (*Msk* 122).[38] Even more explicit is an episode involving King Helgi, who suffered a tattered figure in bed next to him but "turned away from her" (*snýr sér frá henni*). When she was transformed into a beautiful woman during the night, the king "quickly turned toward her (*snýr sér þá skjótt at henni*) with tenderness." Having obtained the miraculous transformation she had hoped for, the woman wanted to leave. Without getting out of bed, Helgi declared he would arrange a "hasty marriage" (*skyndibrullaup*) immediately, and "they spent the night together."[39] The next morning the woman declared that the king had behaved "with desire" and that she was pregnant (*Hrkr*, FSN 1.15:28).[40] During this digression our couple in bed—Þorgrímr and Þórdís—has gone back to sleep. Having warmed his hand, Gísli made a new move, this time awakening Þorgrímr. Assuming that Þórdís again announced her desire, Þorgrímr did not ask about her intentions but simply "turned toward her," ready for action. Instead, he was gored by Gísli's sword.[41]

If this scene has only been suggestive of the emotional and sexual aspects of love-making, a small drama in *Njála*, played out in several episodes, reveals both female initiative and frustration and approaches an almost clinical description of intercourse. We have already touched upon the love affair between Queen Gunnhildr and Hrútr. Engaged to Unnr, Hrútr was forced to postpone their marriage because of pressing business in Norway. Here he encountered the aging Queen Gunnhildr whose sexual appetite is illustrated in several sagas. Providing him with beautiful clothes, Gunnhildr

told him: "'You shall lie with me in the upper chamber (*liggja í lopti hjá mér*) tonight—we two alone'." The saga author continued: "Afterwards they went to bed upstairs and she locked the door from the inside" (*Nj* 12.3:11–15).

After a year in Norway Hrútr became homesick. Taking notice, the queen asked whether he had a woman in Iceland. He denied it, but she did not believe him. When he prepared to take leave, Gunnhildr gave him a bracelet, but she put the curse on him that "you shall not be able to satisfy your desire with the woman you intend in Iceland, but you may have your will with others;" (*þú megir engri munúð fram koma við konu þá, er þú ætlar þér á Íslandi, en fremja skalt þú mega vilja þinn við aðrar konur*; *Nj* 12.6:21). The crucial expression is *munúð* (desire), from *munhugð* (*mun* [love] and *hugr* [mind]), a word stressing the cerebral aspect of desire.[42] Returning home, Hrútr married Unnr, but the queen's curse took effect, as clearly indicated by the statement that "little was happening in their relationship" (*fátt var um með þeim Hrúti um samfarar*), where the last word, *samfǫr* (literally, travelling together) is a euphemism for intercourse (*Nj* 12.6:22). After several years Unnr finally told her father that she wanted a divorce because, as she explained, her husband "is not able to consummate our marriage (*hann má ekki hjúskaparfar eiga við mik*) so I may enjoy him (*njóta hans*), although he is as virile as the best of men in every other respect" (*Nj* 12.7:24).[43] Asked by her father to be more specific, Unnr provided near-clinical details:

As soon as he touches me, his *hǫrund* (skin, here a euphemism for penis) is so enlarged that he cannot have pleasure (*eptirlæti*; literally, lasting sensory impressions) from me, although we both have the greatest desire (*breytni til þess*) that we might reach fulfillment (*at vit mættim njótask*), but it is impossible. And yet, before we draw apart (*vit skilim*), he proves that he is by nature (*í æði sínu*) as normal as other men. (*Nj* 12.7:24)

Provided with this information her father gave her detailed instructions on how to divorce Hrútr.[44] The other part of the queen's prediction was also accomplished. From another narrative we know that Hrútr married two other women with whom he had sixteen sons and ten daughters (*Lx* 5.19:48–49). His mishap with Unnr, however, left a final trace in *Njála* of interest for our inquiry because it provides the most technical term for the male role in sexual intercourse.

After Unnr had left, Hrútr refused to return her dowry to her father and instead challenged him to single combat at the *Alþingi*. Since the father

had pressed the claim with "greed and aggression," sympathy was on Hrútr's side. The case caught the imagination of everyone, including children. On the way back from the meeting Hrútr and his brother stopped overnight with friends. Two boys and a girl were playing on the floor; the boys reenacted the drama several times:

> One of the boys said: "I'll be Mǫrðr [Unnr's father] and divorce you from your wife on the grounds that you couldn't have intercourse with her (*þú hafir ekki sorðit hana*)." The other boy replied: "Then I'll be Hrútr and invalidate your dowry claim if you don't dare fight with me." (*Nj* 12.8:29)

The crucial term is *sorðit*, from *serða*, a verb indicating the male role in intercourse. Its precise translation would be to penetrate, to screw, or to fuck.[45] This is a unique use of the word in the active sense. More common is the passive form (to which we shall return) *sorðinn* (to be used sexually by a man, to be penetrated, or screwed), that describes what happens to the passive male in homosexual relations. In its active form *serða* therefore indicates the male role in sexual intercourse toward the same or opposite sex. That the word originally could be used about heterosexual relations is indicated by our passage from *Njála* and confirmed by the poem *Grettisfœrsla*. Alluded to in the saga named after the protagonist (*Gr* 7.52:168), this poem was erased from a single fifteenth-century manuscript but has been partially restored with ultraviolet technology.[46] Describing Grettir's irrepressible sexuality, it used the active voice of *serða* and the related *streða* in his relations with both sexes as well as with animals.

These voices of the love-makers themselves can be amplified by echoes from outsiders, as they provided suggestive comments about what they thought couples might be doing privately. Although such remarks were often colored by jealousy or hostility, the details are nonetheless useful because the observers also possessed personal experience.

In Queen Gunnhildr we have already encountered an older woman who was enamored of young men or even boys.[47] *Eyrbyggja saga* contains vignettes of two other women, Þórgunna and Katla, who were less successful but no less interested in young men than the powerful queen. The arresting story of the magician Katla, who was desperately in love with the young Gunnlaugr, is of special interest for our purpose.[48] With a son of her own the same age as Gunnlaugr, Katla was no longer young but still "beautiful to behold."[49] Accompanied by Katla's son Oddr, Gunnlaugr made frequent visits to the neighboring farm to learn magical arts from Geirríðr, a

woman of Katla's age. When the young men returned to Katla's farm, she invariably invited Gunnlaugr to spend the night, but he always refused and preferred to go home. One night Geirríðr warned the young men about the journey back, but since they would be traveling together for most of the trip, they were not afraid. When they returned to Katla's farm, it was so late that "Katla was already in bed; she asked Oddr to invite Gunnlaugr to stay but he replied that he had already done so, 'but he [Gunnlaugr] insists on going home.'" Her response, "'Let him go, then, and meet what he has caused,'" prepares the reader for the subsequent disaster. Gunnlaugr never returned home; he was found the next morning outside his house, unconscious and badly wounded.[50] Oddr spread the rumor that Geirríðr "had ridden him," but Katla eventually confessed to the crime herself (Erb 4.15–16, 20:26–30, 54). Discernible throughout the account is Katla's jealousy and sexual frustration, which became palpable in a conversation with Gunnlaugr when she bluntly accused him of going to Geirríðr in order to "caress the old woman's crotch" (Klappa um Kerlingar hárann; Erb 4.15:28).

A similar obscene expression was voiced about the young woman whom we saw attending to Grettir's clothes on board ship. The couple provoked sexual fantasies among the shipmates, who gave vent to their irritation by declaring that Grettir "liked better to stroke the woman's belly" (klappa um kviðinn á konu; Gr 7.17:51]) than to work.[51] The suggestion that the couples were imagined in the missionary position is strengthened in the case of Þjóstólfr, who vented his jealousy by accusing Hallgerðr's husband of having strength only for "romping on Hallgerðr's belly" (brölta á maga Hallgerði; Nj 12.17:49).

The sources are coy about female penetration, the reproductive goal of an erect penis. As a rare exception, a late saga provides graphic illustration in an attempted rape in Norway. Refr, the irate husband, killed the culprit Grani, one of the king's favorites, although his wife assured him that Grani "had in no way damaged his property [her]." Wishing to leave the country, Refr was required to inform the king of his deed. To gain time he employed such flowery language that his message could be understood only after he had made his escape. Pondering Refr's statement that Grani had wanted to "mountain-gorge my wife" (fjallskerða konu mína), the king finally interpreted it to mean that Grani had wanted to "sleep with her (hvíla með henni; literally, rest with her), because that is what it is called when women are penetrated (giljaðar), but the chasms are mountain gorges (en gilin eru fjallskörð;" KrR 14.16–17:152–55). It is difficult to conceive of a more powerful metaphor for penetration than images of canyons.[52]

The comments of outsiders on what they imagined a couple might be doing privately have introduced us to the subject of verbal sexual accusations. We shall deal more fully with this problem when we consider sexual acts between men, but first we must treat heterosexual libel as found in the concept of *mansǫngr* (literally, a song about a woman). Since the publication of Marcel Mauss, *The Gift* (1967) and Claude Lévi-Strauss, *The Elementary Structures of Kinship* (1949; English translation 1969), scholars have realized that "the traffic in women," through which marriages are established in most societies, not only provides a legal framework for heterosexuality and reproduction but also reveals power relations among men.[53] Emphasizing the notion of a bride as a conduit of power between two men, recent gay and lesbian studies have argued that in literature a marital and affective relationship between a man and a woman often is embedded in a triangle consisting of two men and a woman, in which rivalry between the two men and/or erotic attraction is more significant than the relationship between either one and the woman.[54]

The Old Norse concept of *mansǫngr* offers a good illustration of this idea.[55] Although *mansǫngr* eventually came to denote love poetry, its definition in law suggests that the term originally implied erotic libel. On pains of full outlawry (*skóggangr*, the law's highest punishment that placed the person outside society), *Grágás* prohibited the composition and recitation of *mansǫngr* about a woman (*Gg* 1b:184, 2:393). In the two existing manuscripts this paragraph is found in a chapter "On Poetry" (*Um skáldskap*), which the more logical compiler of the so-called *Staðarhólsbók* placed within the large section of "Manslaughter" or "Homicide" (*Gg* 291–407). In order to understand the content of a *mansǫngr* we need to examine its legal context.

The general purpose of the law was to prevent the endless criss-crossing of revenge over generations from the family of the killer to that of the victim. If a victim's family was willing to accept payment and renounce revenge, the case could be finally closed when the killer paid "full *réttr*" (fine)," a payment of forty-eight ounces of silver.

Society considered certain crimes to be so serious, however, that the law condoned the killing of the culprit on the spot. Thus a man was permitted to kill immediately any male who attempted sexual intercourse with any one of six women under his jurisdiction: wife, daughter, mother, sister, foster daughter, or foster mother (*Gg* 2:331; see also 1a:164). Furthermore, he was allowed to kill an accuser who used certain words (to which we shall return) against him, words that implied he had played the passive role in a homosexual act, or, as an alternative, the law ordered the accused to pay

the full fine and suffer outlawry (*Gg* 2:392). Immediately after this paragraph followed the regulation against *mansǫngr*, which, as we saw, also stipulated full outlawry.[56]

This context suggests that originally *mansǫngr* was not a love poem in praise of a woman, a subject the law could afford to ignore, but part of a complex of verbal insults and libels that aroused men's anger and produced violence as revenge was sought. Placed a few sentences after the offensive words that implied passive homosexuality, the social logic and the order of the text suggest that *mansǫngr* also had sexual implications. It must have been an erotic poem that articulated phallic aggression as the poet aimed at insulting the man responsible for the woman by implying his own sexual use of her.

This interpretation is confirmed by the fact that although narratives often refer to the performance of *mansǫngr*, mentioning such poems either generically or by title, they are not inscribed in the texts.[57] The legal prohibition is sufficient to explain this absence, since not only composers, but also subsequent reciters, and, therefore, copyists undoubtedly as well, risked outlawry. Furthermore, several saga contexts confirm the law's suggestion that the content of a *mansǫngr* was erotic libel. The poet's intention was not to praise the woman but to insult the men who controlled her—husband, father, or brother.[58] In some cases the alleged relationship had never materialized and the poems were composed only after the man had been prohibited from seeing the woman, leading to the conclusion that such articulations were prompted not by love but by the poet's own frustration and his intent to hurt the man in control of the woman.[59]

HOMOSEXUALITY AND BESTIALITY
Libel

LAW
The erotic libel implied in the *mansǫngr* envisioned heterosexual acts, although the poem's ultimate destination was not the woman but the man. In contrast to triangles in modern literature, however, the *mansǫngr* contains no hint of an erotic attraction between the two men but is merely indicative of the aggressive pecking order.[60] If the threat of outlawry was sufficient to draw a curtain of silence around these poems, our previous analysis of heterosexual behavior suggests their content.

It might have been expected that the law's double threat of outlawry and fine and/or retaliatory killing against a man who accused another of passive behavior in same-sex activities likewise would have precluded specific information about homosexual libel. Fortunately, this is not the case.

Brief legal statements against male erotic libel can be supplemented with fuller illustrations of such accusations in the narratives. Because of the nature of the evidence, we shall reverse our former sequence in heterosexuality and begin with the erotic libel before we speculate on a possible social grounding in homosexual behavior. We shall examine the legal definition before turning to narrative illustrations of such defamations.

The legal paragraph that preceded the reference to outlawry for *mansǫngr* is the following:

> There are three words—if men's discourse should ever deteriorate that badly—that all carry the penalty of *skóggangr*: if a man calls another man *ragr*, *stroðinn*, or *sorðinn*. These three words are to be prosecuted like other *fullréttisorð* (words for which full payment could be demanded), and, furthermore, the victim has the right to kill in retaliation. (*Gg* 2:392)

The second word *sorðinn* is the same as *sorðit*, from *serða*, which we encountered earlier (*Nj*) for the male role in heterosexual intercourse.[61] Another word with the same meaning, *streða*, was created by metathesis. The past participles of these two words, *sorðinn* and *stroðinn*, were joined by the adjective *ragr* in this paragraph that lists the accusations (*ýki*) that men might direct against each other. *Ragr* had a broad semantic range that included both lack of courage and the general condition of effeminacy, whereas the two other words referred explicitly to the sex act in which one man—designated as having been *stroðinn* or *sorðit*—played the passive role, while the other performed the action of *streða* or *serða*.[62] These three words constitute the Norse *níð* defined as general accusations of effeminacy and/or specific charges of passive homosexual behavior. Whether executed in carved wood—the so-called *treníð* (wood-*níð*) or *níðstǫng* (*níð* pole), visible but silent—or performed in audible words—*tunguníð* (*níð* by the tongue)—such insults resulted in outlawry or even the killing of the offender.[63] In other words, the law did not penalize the two performers of a same-sex act, but an outsider, a third person who accused one of the men of having played the passive role.

Literature

Scattered references to *níð* can be found throughout the literary corpus. Literary as well as legal texts have been ably treated by scholars interested chiefly in the concept's defamatory aspects, and for good reason, because the voices of the participants themselves are not heard. The literary episodes

report neither experience nor observation but merely rumors, accusations, and speculations among outsiders concerning the accused's alleged behavior. Nevertheless, we are more interested in what these vignettes might reveal about same-sex relations among men. By piecing together a composite portrait of one man from several sagas, the rich and powerful Guðmundr Eyjólfsson, we shall be able to obtain an idea of his alleged sexual activities with other men.[64] The libel will also include accusations of bestiality although this was not attributed to Guðmundr himself.

From *Valla-Ljóts saga* we know that Guðmundr inherited the large estate Mǫðruvellir when his father drowned (9.2:237). He was probably quite young, but his many lavish feasts suggest that he was already married. He and his wife Þorlaug eventually produced three sons and a daughter.

In three other sagas Guðmundr was accused of passive homosexual behavior. The fullest account is found in *Ljósvetninga saga*. An initial suggestion emerged during wedding festivities in a conversation between his wife and her friend Geirlaug. Boasting that her marriage was better than Þorlaug's, Geirlaug hinted at rumors about Guðmundr by saying that he was neither "correctly disposed" (*vel hugaðr*) nor "manly" (*snjallr*).[65] Immediately catching the fateful sexual nuances in these words, Þorlaug deemed them "cruelly spoken" (*illa mælt*), and she hoped that her friend was the first to voice these accusations, but Geirlaug claimed that she had heard them from Þorkell hákr (hake) and her own husband, Þórir Helgason. Feigning illness, Þorlaug obliged her husband to leave the party and related the people's "malicious talk" (*fjándmæli*) on the way home. Guðmundr himself employed the same term when he further reported the rumors to a friend (*Ljs*, 10.5(13).18–20).

The rest of the saga is taken up by Guðmundr's vigorous revenge against Þórir Helgason and Þorkell hákr. By assuming the grievances of others against the former, he was able to prosecute a case against him at the *Alþingi*. There Guðmundr's brother Einarr blamed Þórir for having spoken "too openly" about his brother, and Þórir himself admitted not to have been as "careful in words" as other people, suggesting the circulation of a general rumor (10.6(16).38). Omitting circumlocutions, he admitted to Guðmundr that "people say I have accused you of being effeminate" (*ragliga*). He then proposed a duel, and, reverting to the women's language, further argued that this would give Guðmundr a chance to prove whether he was "manly and well disposed" (*maðr snjallr ok vel hugaðr*), or whether it was true, "as many have been saying, that you are not manly" (*eigi snjallr*; 10.6(16).40). The duel was avoided, but Guðmundr was allowed to determine Þórir's punishment himself (*sjálfdœmi*), ordering him to pay the enor-

mous sum of one hundred *aurar* and to submit to the lesser outlawry (*fjǫrbaugsgarðr*) of staying abroad for three years. The saga author added that "the consensus was that Guðmundr had received the greatest share of honor in this case" (10.7(17):43).

In contrast to Þórir Helgason, Þorkell hákr was a poor man. Rather than resorting to legal maneuvers from which no monetary rewards could be gained, Guðmundr decided to kill Þorkell outright. Employing a vagrant as a spy, Guðmundr arrived at Þorkell's house late at night with a party of twenty men. Since the victim lived alone with his wife and small daughter, he was easily overcome, but when Guðmundr himself failed to behave courageously Þorkell heaped on him additional homosexual taunts.

Before we examine the new accusations, a glimpse at the brief *Ǫlkofra þáttr* will also be useful.[66] In this story Guðmundr was likewise accused of passive homosexual behavior, this time by a certain Broddi Bjarnason. The two men were on such unfriendly terms that they did not greet each other when they met at the *Alþingi*, but Broddi nevertheless asked Guðmundr about his return route. When Broddi mentioned the Ljósawater Pass (*Ljósavatnsskarð*) and Guðmundr repeated this location, the established reputation of the latter apparently caused the last syllable of this name, *-skarð* ("mountain-pass" or "cut"), to evoke obscene associations in Broddi's mind. Assuring Guðmundr that he would not be able to prevent him—that is, Broddi—from using this pass on his return trip, he reminded Guðmundr of the trouble "you have had defending the narrow *skarð* (pass) you have between your buttocks" (11.4.94). Such explicit words clearly suggested that Guðmundr had been penetrated.

We can now return to Þorkell's and Guðmundr's last encounter. Awakened in the middle of the night by the arrival of Guðmundr and his party, Þorkell inquired which road they had followed. Guðmundr mentioned the *Hellugnúpsskarð* ("Hellugnúpspass"), and the affix *-skarð* again provoked obscene associations. Þorkell issued a snide remark that the trip's exertion undoubtedly had given Guðmundr a sweaty ass (*hversu rassinn myndi sveitask*). During the ensuing battle Guðmundr fell into a large milk vat, but, although Þorkell by then was so badly wounded that "his intestines were exposed," he still possessed sufficient energy to laugh and to ridicule his enemy: "I imagine that your ass has slaked itself at many streams, but I doubt it has drunk milk before" (10.9(19):52). The focus here remains fixed on Guðmundr's *skarð*, but the images evoke not only penetration but also ejaculation. Receiving milky semen was now added to the alleged penetration, as Guðmundr was accused of the entire female role in intercourse.[67]

On occasion sexual perversity could include rapport with animals. Guðmundr himself was not included in these, but his name surfaced in connection with slander of bestiality directed against Þorkell hákr, his accuser. Before examining this anecdote we need a context of other references to bestiality. The first is found in *Fóstbrœðra saga* in connection with Þormóðr's slaying of five men in Greenland in retaliation for the killing of his foster brother Þorgeirr. Having been told about the events by Þormóðr himself, King Óláfr at first thought the revenge excessive, but Þormóðr justified his action by revealing that the men "had compared me with a mare, saying that I was among men as a mare among stallions." Although this slander does not occur in the narrative, the king accepted the excuse, adding that it was understandable that Þormóðr "did not like their remarks" (*mislíkaði þeira umrœða*; 6.24.259). This episode does not illustrate bestiality in the way it was understood by Christian canonists and theologians, as a man's active genital activity with four-footed beasts. Rather, the mare was simply a metaphor for a man playing the female role among humans.[68] This identity established between females and animals is articulated with particular clarity in the Norwegian law's formulation of the prohibited words for which full compensation was to be paid (*fullréttisorð*):

> Certain expressions are known as *fullréttisorð*. One is if a man says to another that he has given birth to a child; a second, if a man says that the other has been *sannsorðinn* (truthfully penetrated); a third if he compares him with a mare, or call him a bitch, or a prostitute, or compares him with the female of any animal. (*NgL* 1:57; see also 70)

In other words, the comparison between a man and a mare does not denote bestiality in the Christian sense of the word but illustrates the Norse horror of the male playing a female role.

A similar episode in *Ǫlkofra þáttr* however, does not use the mare as metaphor for the male. The story instead implies bestiality as perceived occasionally in the classical world, of the animal taking the active role.[69] Busy distributing sexual insults throughout this little story, Broddi Bjarnason described to a certain Þorkell trefill (fringe) the remarkable sight that the latter had presented when he rode to the *Alþingi*. His skinny mare was attacked from behind by a sleek stallion, but Þorkell did not notice it until the stallion was on his own back. Broddi declared that when Þorkell's horse faltered under him, "it was hard to tell who was being dragged, but everybody could tell that you were stuck there for a long time because the stallion's legs had gotten a grip on your cloak" (11.3.91–92). A similarly passive male role

in connection with a stallion is suggested in a poem by the Icelandic skald Halli about King Haraldr.[70]

Guðmundr's name was not implicated in these accusations of bestiality, but he was included in a story in *Njála* that suggests an active male role in bestiality, although it did not involve the man's genital activity. In the brief interlude between Guðmundr's acts of revenge against Þórir and Þorkell described in *Ljs*, the latter found himself at the *Alþingi* where he became embroiled in negotiations between Njáll's party and Flosi before their final showdown, as described in *Nj*. The Njálssons made six calls at the *Alþingi* to solicit help but received only one clear offer. Whenever they were turned down, Skarpheðinn—although not the leader of the expedition—made snide remarks about the people who had spurned them. Asked for help, Guðmundr did not commit himself at first. As a result Skarpheðinn referred to the "evil talk" (*illmæli*) spoken against Guðmundr by Þorkell hákr and Þórir Helgason which we have already examined (12.119:302–03).

The final call was at the booth of Þorkell hákr himself. When informed that the Njálssons had not obtained promises from Guðmundr, Þorkell immediately understood that they assumed that his own animosity against Guðmundr made him a likely candidate for help. When he refused assistance, he received a volley of insults from Skarpheðinn, who blamed him for having fought against his own father, of rarely having participated in the work of the *Alþingi*, and of being poor. The following constituted the final barrage:

> You would be better occupied with picking out of your own teeth the bits of mare's arse (*razgarnarendann merarinnar*, literally, "the mare's rectum") which you ate before you came here; your shepherd saw you do it and was amazed at such disgusting behavior. (*fúlmennsku*; 12.120.305)

Þorkell's poverty is evident from the killing scene in *Ljs*, but although Icelanders have been known to use every scrap of their animals' protein, this is not a culinary reference, but certainly a sexual insult. No other references to oral sex have surfaced in the sources, but it is difficult to interpret this statement other than as a suggestion that Þorkell had engaged in oral/anal sex with a mare. Since Þorkell was not involved genitally, the damning insult of being *blauðr* (soft) is also present.

It is clear that the audience fully understood the grossness of the intended insult. Guðmundr was delighted when he heard the story. Remembering his own humiliations from Þorkell, he gloated that he himself had

never undergone "such great disgrace" (*jafnmikil sneypa*) as Skarpheðinn now inflicted on his tormentor. Instructing his brother to help the Njálssons immediately, he promised assistance the following year. Approval of Skarpheðinn's strong language also came from Ásgrímr, the leader of the Njálssons' quest for support. Although he blamed Skarpheðinn for having been "rather . . . strong in his words" (*heldr . . . orðhvass*) in most of his responses as they made their visits at the *Alþingi*, he judged that, in the case of Þorkell, "you gave him exactly what he deserved" (12.120.305–06).

Behavior

What conclusions can be drawn concerning social behavior from this evidence of erotic libel? Not surprisingly, we can establish at least that men were perceived to practice same-sex relations. The passive male obviously needed an active partner, but while the former was despised, the latter suffered no opprobrium. No evidence has appeared that the roles could be exchanged, however, and we look in vain for modern gay relations characterized, in the words of David Bergman, as "otherness, genuineness, permanence, and equality."[71] In Guðmundr's case the accusations did not detract from his standing as a leading figure in the community, as witnessed by his vigorous prosecution of his defamators, but the rumors nonetheless persisted. *Sǫrla þáttr*, normally incorporated into *Ljs*, described Guðmundr's splendid estate and his household of more than one hundred people and added:

> It was his [Guðmundr] custom to lodge the sons of distinguished men for long periods of time, and he treated them so splendidly that they had no work to do other than to be always in his company. (10.1(5): 109)[72]

Since this is as close as we can approach Guðmundr's relations with young men, their mutual activities remain hidden. These may have included sexual activities in which Guðmundr could have taken the active role. Since Norse culture did not consider this blameworthy, Guðmundr's many enemies resorted to imagining him in the passive position.

The sagas occasionally suggest that Norse men availed themselves of the sexual services of their female slaves and servants.[73] It is difficult to find comparable indications concerning male slaves, but the statement from the Norwegian *Gulaþingslǫg*, that "every man has the same right to compensation for carnal intercourse (*legorð*) with his male as with his female slaves (*þrælom . . . ambattir*; NgL 1:70), suggests the sexual availability of all slaves. The fact that the male slave in most cases would have assumed the

passive position would further increase the opprobrium attached to this role. Some slaves were married or at least lived in permanent heterosexual unions.[74] Male slaves were undoubtedly less numerous than female and they risked being killed in case they caused trouble.[75] A single reference to the gelding of an Irish slave has surfaced.[76] If this were common practice it would have eliminated the sexual danger presented by slaves for free women but did not preclude their passive role with men.

This meager evidence of homosexual relations in the Norse world does not reflect eroticism and affection but power struggle and domination. This may come as a surprise, because the Germanic world would seem to have provided a perfect setting for a wide spectrum of same-sex relations among men. As the first manifestation of the *Männerbund*, the *comitatus*—which Tacitus identified among the ancient Germans—was also the first social group of non-kin. It is difficult to believe that the bonds of affection between chieftain and warriors, often extending to a willingness to die for the leader, would have excluded homoerotic bonds.[77] Continuing the *comitatus*, the viking band—the nordic version of a *Männerbund*—was on the decline by the time of the saga age, but the old system of male bonding persisted in royal circles, expressed in the court poets' affection for their king or leader. References to love or friendship (*kærleikr*) between and among men are numerous in all saga genres, but they do not include homoerotic connotations.

As an illustration we shall look at the ties of friendship between the Icelandic poet Sigvatr Þórðarson and the Norwegian King Óláfr helgi. Sigvatr left Iceland early in the eleventh century when he heard that Óláfr had arrived in Norway. He became the king's court poet and spent most of his adult life in Óláfr's company, describing in verse the king's battles and other achievements. His poetry bears eloquent witness to an emotional bonding between him and the king of such intensity that his visit to King Knútr of England provoked Óláfr's jealousy, and Óláfr's other courtiers became envious of the relationship between the king and the poet (*Hkr* 27.160:292–93, 206:358). On one occasion Sigvatr even professed his willingness—albeit unreflectingly—to die for Óláfr (27.122:210).

Having obtained leave to go to Rome on a pilgrimage, Sigvatr was not present, however, at the king's last battle at Stiklarstaðir in 1030 and thus missed the final opportunity to demonstrate his love. Receiving news of the king's death abroad, he expressed his profound grief in poetry. In a village somewhere on his return to Norway he overheard a husband bewail the loss of his wife by "beating his breast, tearing his clothes, weeping copiously and saying that he would gladly die." In a stanza treating grief in

general, the poet questioned the price of love when even proud men were forced to shed tears, but he judged that the king's men had suffered a worse loss (*torrek*) than this man who only "loses the woman's embrace" (*missir/ meyjar faðms*; Hkr 28.7:14–15).

No hint can be found, however, of a sexual relationship between the two men, or among the other royal retainers. The king and Sigvatr, in fact, exchanged stories about their sexual exploits with women; the king was married and had at least one mistress, and we know that Sigvatr had "a farm and children" (*bú ok bǫrn*; 28.8:15).[78] These claims to heterosexual activities do not, to be sure, exclude same-sex behavior; indeed, the pronounced defamation of the passive partner reveals extensive knowledge of same-sex activities. As evidence of phallic aggression, some of the alleged cases may have existed only in the accuser's imagination, and others may be classified as male rape. Since the category of *cinaedus*, the willingly penetrated male, has not been found in Norse culture, it is likely that men alternated between active and passive roles.[79] Because only the latter were punishable, any man engaged in same-sex activities could run the risk of exposure. For this reason the problem was largely ignored in the sources and rumors of homosexuality emerge only when sufficient hostility had accumulated. The eruption into erotic libel in Norse society may have served a similar function of social release as did witchcraft accusations in the early Modern period in Denmark.[80]

Eventually, of course, Christianity came to condemn both partners in a homosexual relationship. In the Nordic context this regulation is found only in the Norwegian *Gulaþingslǫg*: "If two men enjoy the pleasures of the flesh and are accused and convicted of it, they shall both suffer permanent outlawry" (NgL 1:20). A recent study suggests that this paragraph was neither a reflection of an earlier Germanic tradition nor a sudden introduction from Continental canon law, but a local response to a power struggle between the Norwegian king and Archbishop Eysteinn in the mid-twelfth century.[81] It is significant that outside this sole paragraph churchmen were unable to codify the well-known Christian prohibition against homosexuality into either the ecclesiastical or the civil laws. In the area of defining sin, however, where churchmen ruled supreme, they fulminated loudly against homosexuality. The crime is mentioned in the Icelandic "Book of Sermons" (*Homilíubók*) from the twelfth century and in Bishop Þorlákr's penitential, probably composed during his episcopacy (1178–93).[82] In both places it was mentioned in the same breath as bestiality.

Churchmen had better success in convincing nordic people that bestiality was a crime. Clearly situated in a Christian context, regulations enjoining the practice were introduced in several Norwegian laws.[83] We no-

tice in passing that in these, as in older and lengthier penitentials, men were perceived as taking an active and genital role with animals.[84] When implementing their marital program, nordic churchmen were still willing to accept native ideas on ready divorce even while they attempted to instill notions of monogamy and fidelity.[85] In a comparable manner, while introducing their sexual program, they may have been willing to overlook ingrained habits of homosexuality as they worked to eradicate bestiality, which was considered with increasing gravity in the course of the thirteenth century.[86] Despite these attempts, however, bestiality undoubtedly persisted in the North, as in most pastoral and rural societies.[87]

To complete this picture of Norse sexuality, we need finally to notice that although Bishop Þorlákr's penitential of 1178 punished love-making between women as harshly as adultery and bestiality and also referred to masturbation (*DI* 1:243), no evidence has surfaced in the narratives of the latter activity nor of women kissing and embracing each other.

CONCLUSION

Based on the legal and literary evidence of erotic libel we can conclude that Norse men engaged not only in heterosexual but also in homosexual and bestial activities. Not limited to marriage, the manifestations of the first group conform to what might be expected from extended general knowledge of these acts. Despite the favorable context of the *Männerbund*, the Germanic/Norse world does not yield evidence of gay couples. Instead men engaged in a wide spectrum of "homosocial" bonding that included both platonic love and friendship, as well as—in the case of Guðmundr—same-sex carnal acts. It is impossible to evaluate the frequency of these latter activities. Although the passive partner was considered with contempt, not he, but his accuser, was singled out for punishment in law. The severity with which this crime was penalized makes it likely that same-sex acts for men otherwise considered heterosexual were more common than revealed in the sources. The legal lack of concern for enforcing the sweeping rule articulated by churchmen against both partners would confirm this assumption. In other words, this study lends support to the theory that although men in the distant past included acts of sodomy among their sexual activities, their culture did not know homosexuality in its modern sense.[88]

ABBREVIATIONS

Ad = *Adonias saga*, LMIR 3.
BHd = *Bjarnar saga Hítdœlakappa*, ÍF 3.
BONIS = *Bibliography of Old Norse-Icelandic Studies*.

Bs = *Biskupa sögur.*

DI = Diplomatarium Islandicum.

Dpl = *Droplaugarsona saga,* ÍF 11.

EA = Editiones Arnamagnæanæ.

Eg = *Egils saga,* ÍF 2.

Erb = *Eyrbyggja saga,* ÍF 4.

Erð = *Eiríks saga rauða,* ÍF 4.

Flm = *Flóamanna saga,* ÍF 14.

FSN = Fornaldar Sögur Norðurlanda.

Ftb = *Fóstbrœðra saga,* ÍF 6.

Gg 1 and 2 = *Grágás* = Finsen 1852 and 1879.

Gí = *Gísla saga,* ÍF 6.

Gnl = *Gunnlaugs saga Ormstungu,* ÍF 3.

Gr = *Grettis saga,* ÍF 7.

Gtr = *Gautreks saga,* FSN 4.

Hðv = *Heiðarvíga saga,* ÍF 3.

Hh = *Þáttr Hrómundar halti,* ÍF 8.

Hkr = *Heimskringla,* ÍF 26–28.

Hlf = *Hallfreðar saga,* ÍF 8.

Hn = *Hœnsa- Þóris saga,* ÍF 3.

HrGt = *Hrólfs saga Gautrekssonar,* FSN 4.

Hrkr = *Hrólf saga kraka,* FSN 1.

Hsf = *Hávarðar saga Ísfirðings,* ÍF 6.

ÍF = *Íslenzk Fornrit.*

JHS = *Journal of the History of Sexuality.*

KLNM = Kulturhistorisk Leksikon for Nordisk Middelalder.

Krm = *Kormáks saga,* ÍF 8.

KrR = *Króka-Refs saga,* ÍF 14.

Ljs = *Ljósvetninga saga,* ÍF 10.

LMIR = Late Medieval Icelandic Romances.

Lnd = *Landnámabók,* ÍF 1.

Lx = *Laxdœla saga,* ÍF 5.

MS = *Mediaeval Scandinavia.*

Msk = *Morkinskinna.*

Nj = *Njála* = *Njála saga,* ÍF 12.

NgL = *Norges gamle Love.*

Qþ = *Qlkofra þáttr,* ÍF 11.

QO = *Qrvar-Odds saga,* RSN 2.

RS = Riddarasögur.

SN = *Saulus saga ok Nikanors,* LMIR 2.

SnH = *Sneglu-Halla þáttr*, ÍF 9.

St = *Sturlunga saga.*

SUGNL = Samfund til udgivelse af gammel nordisk litteratur.

Svf = *Svarfdœla saga*, ÍF 9.

Valla-Ljóts saga, ÍF 9.

Vgl = *Víglundar saga*, ÍF 14.

Vls = *Vǫlsunga saga ok Ragnars saga loðbrókar.*

Vtn = *Vatnsdœla saga*, ÍF 8.

Þhr = *Þórðar saga hreðu*, ÍF 14.

NOTES

I am grateful to my colleague David Bergman for a critical reading of this chapter.

1. An exception is provided by the Norse colony in Greenland. On this problem, see Jochens, 1996.

2. The sagas of Icelanders will be cited from the series Íslenzk fornrit, with abbreviations indicated in the literature list followed by volume, chapter, and page. The Icelandic law, abbreviated *Gg* 1, 2, will be cited from Vilhjálmur Finsen's editions and the Norwegian laws from the collection *Norges gamle Love (NgL)*. Occasional references to sagas outside the genre of the sagas of Icelanders will be explained in the footnotes and literature list.

3. Sedgwick 1990, 29.

4. In the narrative genres translated from or influenced by the Continental literature of chivalric poetry and the *fabliaux* tradition, references to sex and sexuality are more frequent than in the native tradition; see Tómasson 1989.

5. The two quotations are from *Flm* (13.15:259) and *Ljs* (10.1:4). For further illustrations and for the topos of the love visit, see Jochens 1991b.

6. A similar impression is conveyed by the word *brúð(h)laup*, the only Old Norse word for wedding (with similar German cognates). Although its origin is debated, the constitutive elements, *brúðr* (bride) and *(h)laup* (leap or run) most likely suggest violence as the origin of matrimony; see article "Bröllop" in KLNM 2:306–23.

7. *DI* 1:234; *NgL* 1:409; 1:123. The last reference is to King Hákon Hákonarson's Christian Law, of which a translation can be found in Larson 1935, 216.

8. See chapter "Marriage" in Jochens 1995.

9. A different version of this section is found in chapter 3, "Reproduction," in Jochens 1995.

10. For a comparable interpretation of a few crucial stanzas in *Gí*, see Sørensen 1983. On the use in *Krm* of the expression *kaupa um knífa* (exchange knives, or penises) as a sexual metaphor for divorce in a case of impotence, see Jochens 1991b, n. 91. See also Clover 1993.

11. The term *gaman*, with a similar semantic spread, is often used for sexual intercourse in the poetry in the expression *géð ok gaman*. In this sense it is also used at least once in the sagas of Icelanders (*Gr* 7.61:200).

12. For further examples, see the long version of *Gí*, found in Gislason 1849, 98; *Svf* 9.20:186. Used almost exclusively about mistresses, sexual intercourse is also implied in expressions such as "to bed down" (*rekkja*; *Lx* 4.12:24), "go to bed" (*koma í sæng*; *Hlf* 8.9:181), and "lie next to" (*liggja hjá*; *Nj* 12.61:154). The result of illegal sexual activity was sometimes referred to by the verb "to get with child" (*barna*; *Nj* 12.64:160 and *Fnb* 14.40:327).

13. Used in this way about mythical creatures, *faðmlag* and *faðm* are found in *Ftb* 6.3:135 and 6.4:138.

14. On perceptions of the male and female body, see Jochens 1991a.

15. This is the woman who had been in love with a young boy; see n. 48.

16. On the passage, see Lecouteux 1986, 71–72.

17. On this episode, see Baumgartner 1993.

18. A related subject of interest for this inquiry is the problem of gender responsibility for sexual initiative. It is possible to demonstrate a change in perception—undoubtedly promoted by churchmen—from the pagan context of the sagas of Icelanders to the Christian setting of the contemporary sagas that transferred responsibility for sexual activity from men to women, in particular for breaking the sexual code; on this issue, see Jochens 1991b, 376–84.

19. On the first see Þórdís in *Ljs* (10.1(5):110) and on the second Sigríðr in *Hsf* (6.4:307).

20. In another scene a young couple walked down the road holding hands; *St* 1:233.

21. On the connection between drinking and sexual arousal, see Jochens 1993b.

22. She was "well developed" (*vel frumvaxta*) and "walked about and flirted" (*skemmti sér*). A couple would continue to find pleasure in drinking *tvímenningr*, as did Kormákr and Steingerðr in Norway long into their troubled relationship; *Krm* 8.25:295.

23. For examples, see *Hlf* 8.4:145; *Krm* 8.19:272; *Hn* 3.16:42. The formulaic character of the expression is particularly evident in the last case where a young man visited a woman who lived in a tent.

24. Female sexual initiative used for deception is foreign to Old Norse and may be due to Christian influence in this late saga. On women's use of sex for more innocent purposes, see below.

25. Although unable to consummate their relationship, Kormákr continued to kiss Steingerðr; *Krm* 8.24:291–93.

26. The first word is used about Kormakr (*Krm* 8.24:292) and the second about Hallfreðr (*Hlf* 8.4:145).

27. Kisses were not only a sign of erotic love but also of parental affection. Having presented his young and beautiful daughter Hallgerðr to his brother, Hǫskuldr "tilted her chin and kissed her" (*Nj* 12.1:7).

28. In a gesture of general leave taking, Gunnarr *hverfr til allra manna* (*Nj* 12.75:182).

29. For examples, see *Nj* 12.147:421; 149:427; 159:463; *Lx* 5.45:135. The old Hávarðr *minntisk við* his wife before starting out on his revenge (*Hsf* 6.9:321). This was also the way in which Hrútr parted from Queen Gunnhildr after their two-week love tryst; *Nj* 12.3:15.

30. The technical term was to *skoða í hǫfði honum* (literally, to inspect his head); *Lx* 5.24:109.

31. For illustrations, see *Hðr* 3.20:273 (the washing was done by the woman mentioned above who was supposed to mind kissing her lover after his face had been smashed); *Ljs* 10.14(24):77; *Vgl* 14.18:98. The last case involved not only a wash but also a haircut, with the added promise that the hero would not let anyone but his beloved Ketilríðr perform these services, in a vow similar to the one the Norwegian King Haraldr hárfagri gave to Gyða (*Hkr* 26.3–4:96–97).

32. The fullest development of the shirt as a love token is found in ÓO, FSN 2.11–12:238–44.

33. Known to have taken pleasure in Óláfr's company, Sigríðr was accused of having put her arms around his neck, a gesture unsuitable for unmarried people; *Hsf* 6.2:296. A man in Greenland complained that his permanent companion, interested in another man, did not put her arms around him as often as she used to (*Ftb* 6.21:226, n. 1).

34. Likewise, Þuríðr *lagði . . . hendr yfir háls honum* and obtained that her husband did not burn Þórgunna's bed linen as he had promised the dying woman (*Erb* 4.51:143). See also Grimhildr in *Vls* 28:65. However, Yngvildr's similar gesture expressed neither love nor ulterior motives, but gratefulness over having been bought out of slavery (*Svf* 14.27:204).

35. Another wife provided the basic need of warming her cold husband in bed; *Hsf* 6.15:342.

36. Translation (modified) from Sørensen 1986, 249–50, quoting the M text from Gislason 29. The passage is almost identical to the S version used in the ÍF edition (6.16:53–54). The episode has engendered a large literature; for the purpose of the argument developed here, see Andersson 1969.

37. See Andersson 1969, 37–38, for examples.

38. On this passage, see Jochens 1987, esp. 338–39.

39. The expression *hvíldu þau þá nótt* (they rested that night) is another euphemism.

40. Likewise leaving no doubt about the activity, a text specifies that a groom on his wedding night "turned toward the bride intending to destroy her maidenhood" (*SN*, LMIR 2.21:52–53). For female initiative, see Queen Semerana who "turned toward the count" thinking he was her husband, and became pregnant (*Ad*, LMIR 3.7:87; in the same text, see also 3.7:86).

41. An almost identical scene is found in *Dpl* 11.13:170. Divergent views on the relationship between the two episodes exist, but most scholars think that the author of *Gí* borrowed from *Dpl*; see the overview in Andersson 1969, 28–39. The erotic overtones are clearer in *Gí* than in *Dpl*. Echoes of an erotic scene are found also in Þórðr's reaction as he *snerisk a hliðina*, only to be pierced by his former wife's sword (*Lx* 5.35:98).

42. With reference to the apostle Paul, it is used in the *Homiliu-bók* as a term for sexual desire: "his body's desire" (*munoþ síns likama*; Wisén 1872, 117 line 8).

43. *Hjúskaparfar*, from *hjún-skapr* (the creation of a *hjún* [marital couple and/ or household]).

44. In the interval before Unnr's departure "their relationship (*samfarar*) was good," but *samfǫr* here carries a general meaning (*Nj* 12.7:26).

45. See Dronke 1981, 10.

46. Edited and commented on by Halldórsson 1990, 19–50.

47. A generation separated her and Hrútr, and she was even older when "she found pleasure in talking with" (*skemmtan at tala við*) his nephew Óláfr (*Lx* 5.21.52). The double entendre in this expression is increased when the author added that people said she would have enjoyed it whether or not he had been Hrútr's nephew.

48. The other case involved Þórgunna, "a large woman, both tall and broad, and getting stout." In her fifties, she was smitten by a young boy at the age of thirteen or fourteen whom she "loved . . . dearly" (*elskaði . . . mjǫk*; a rare expression). The boy was "both large of size and manly to look at," but her attention "made him keep his distance," a behavior that caused her to become irritable (*skapstygg*; *Erb* 4.50:139). On this episode, see Jochens 1991a.

49. Her competitor Geirríðr grouped her among "witches in beautiful skin" (*flǫgð í fǫgru skinni*; *Erb* 4.16:29).

50. According to another account, he died from his wounds (*Lnd* 1.S79:112).

51. A similar expression is used collectively by a group of men boasting that they proved their manhood better by going against their enemy than by *klappa um maga konum sínum* (*Ftb* 6.17:208). This saga contains a rare reference to a man's fear of wasting his strength by being involved with women; see the description of Þorgrímr as "a man little interested in women" (*lítill kvennamaðr*; *Ftb* 6.3:128).

52. On the language in this saga, see Amory 1988. On the interpretation of geographic features in sexual terms, see Clunies Ross 1973 and 1981. On the almost

pornographic description of intercourse in *Bósa saga*, see Jochens 1991b, 380–81, and S. Tómasson 1989.

53. See Rubin 1975.

54. See Sedgwick 1985, 21–66. The idea was first articulated by Girard 1972.

55. For further analysis of this, see Jochens 1992.

56. Male aggression could be committed with fists as well as with the penis and the tongue. Among the libellous words the identity between bodily and verbal injuries is particularly clear in the term *áljótr*, which is normally translated as "disfigurement" or "visible blemish." A full chapter in *Gg* entitled "On Plots to Disfigure" deals with bodily injuries, warning perpetrators of severe penalties even if the plot did not succeed. In the chapter dealing with poetic insults, however, *áljótr* was used to describe verbal insults: "If a man *says* a blemish . . ." (*Gg* 1b:182).

57. Judged by the saga context, the two (lost) poems composed by Bjǫrn and Þórðr about each other's wives must have been libellous. Named *Eykyndilsvísur* and *Daggeisli*, respectively, they were performed at a "horse *þing*" (*hestaþing*), a forum shunned by women and well-known as an outlet for male aggression (*BHd* 3.16–17:152–56). The only exception for non-inscription is provided by two stanzas in *Eg* that illustrate the previous reference to a *mansǫngr* in the prose (2.56:148–49).

58. For illustrations, see *Hlf*, *Eg*, *BHd*, and *Óþ*. Some of these are analyzed in Jochens 1992.

59. This is the case in *Eg* and *Hlf*.

60. This is also the case in *BHd* where Bjǫrn and Þórðr expressed in poetry their rivalry over Oddý, Þórðr's wife but earlier promised to Bjǫrn and now his mistress (see n. 57). When Bjǫrn produced a carving that showed him as the active and Þórðr as the passive partner in a homosexual act it does not imply erotic attraction, but indicates his further humiliation of Þórðr; see note 63.

61. It was used in a narrative where King Haraldr asked Halli whether he would be willing to let himself be *serðask* to obtain a certain beautiful axe (*SnH* 9.10:294).

62. David Greenberg connects the meaning of "ragamuffin" in *Piers Plowman* with this meaning of *ragr*; Greenberg 1988, 249.

63. The opprobrium associated with the passive role also in sculptural *níð* is suggested by a comment about a carving that showed two men standing behind each other: "It was a bad discovery . . . but it was worse for the one who stood in front"; *Bhd*, 3.17:155). The best modern treatment of *níð* is P.M. Sørensen 1983, but see also the works by B. Almqvist 1965, 1974, T. Markey, E. Noreen, J. Pizarro, and F. Ström. Notice Sørensen's change of mind from the Danish original to the English translation concerning the identity of the active partner in the carving (Sørensen 1980, 69–70; 1983, 56–57).

64. On Guðmundr's appearance in several sagas, see Andersson and Miller 1989, 86–87.

65. The negation of *snjallr* (*úsnjallr*) included a similar semantic range as *ragr* of being effeminate and lacking in courage. Applied to females, however, both words suggested nymphomania.

66. On the accusations in this story, see Sayers 1991.

67. Literary borrowing cannot be excluded. The humiliation of a man showing his backside—in the manner of a presenting female monkey—is demonstrated in both poetry and prose; for examples, see *Gí* 6.15:50, *KrR* 14.5:129–30, and *Fst* 6.23:240. On the last episode, see Kress 1987. It is therefore not surprising that according to law, *klámhǫgg*, the wounding of a man in the buttocks was considered as serious as gelding (*Gg* 1a:148, 2:299). In a saga a woman divorced her husband after he had been wounded in this way, giving him the obscene nickname of *Raza-Bersi* (asshole-Bersi; *Krm* 8.13:254). In a *fornaldarsaga* a woman who took on the ultimate male role of going to war was brought to her senses by a *klámhǫgg* (*HrG* in FSN 4.13:95).

68. This is also the case with Broddi's accusation against Eyjólfr þórðarson in *Qþ*, 11.3:91. On the sexual connotations of the mare, see Almqvist 1991.

69. Expressed in particular by Claudius Aelianus (170–230) in his *On the Characteristics of Animals*; see Salisbury 1991.

70. The text is in *SnH* 9.10.294–95; see Minkov 1988.

71. Bergman 1991, 19.

72. Concerning Guðmundr's feelings for his wife, it deserves notice that he was considering letting her (and a son) perish in a house which he wanted to burn down in order to take revenge on the man who had killed his spy; 10.10(20):57.

73. See Karras 1992 and Jochens 1991b.

74. See the case of Sigríðr in Greenland who lived in an informal union with Loðinn (*fylgja at lagi*; *Ftb* 6.21:225).

75. See the story of the ten Irish slaves (five with male names and five unnamed) who came to Iceland with two of the first settlers. The five men killed one of the settlers and fled "with their women" (*með konur þeira*). When the other settler eventually found them, he killed the men but took the women with him (*Lnd* 1:42–45).

76. A *ragmæli* (accusation of being effeminate) was started about Þorsteinn Siðu-Hallsson, stating that "he was a woman every ninth night and then had intercourse (*viðskipti*) with men," as reported in the saga of his name (11.3:307–08). That rumors of same-sex relations may not have been completely groundless is suggested by the additional information from another narrative that Þorsteinn had gelded an Irish slave named Gilli (*Draumr Þorsteins Siðu-Hallsonar* 11:323–26). The fate of Gilli, the descendent of an Irish king, forms a masculine parallel to Melkorka, a female slave bought at a market in Sweden and brought to Iceland. She gave birth to her master's favorite son, but eventually revealed that she was the daughter of an Irish king (*Lx* 5.12–3:22–28). Gilli's masculine anger provoked him to kill Þorsteinn, a deed that brought about his own death, but Melkorka's protest was limited to pretending to be mute until she was discovered speaking Irish to her son. She married another man and became a respected member of society.

77. For the most recent overview of the literature on the *Männerbund*, see Harris 1992.

78. For the stories about women, see Johnsen and Helgason 1941, 2:686–87.

79. On the Roman *cinaedus*, see Richlin 1993.

80. For the latter, see Johansen 1991.

81. See Gade 1986. The former view is represented by G. Bleibtreu-Ehrenberg 1978 and the latter by J. Boswell 1980.

82. For the former, see Wisén 1872, 137 line 4, and for the latter DI 1:240 and Rafnsson 1983.

83. For text and discussion, see Gade 1986.

84. See Payer 1984, 44–47 and passim.

85. See Jochens 1995, Chapter 2.

86. See Salisbury 1991.

87. See Liliequist 1991.

88. See Sedgwick 1985, Bray 1982, and Goldberg 1992.

Bibliography

Primary Sources

Among narrative texts, the most important for perceptions of native sexuality is the genre known as the sagas of Icelanders or family sagas (*Íslendingasǫgur*) and, to a lesser degree, the kings' sagas (*konungasǫgur*). The standard edition of the former and most of the latter is *Íslenzk fornrit*. The continuation into Christian times of pagan sexual behavior can be stud-

ied from the kings' sagas as well as from the contemporary sagas (*samtíðar-sǫgur*), because some of the narratives in the former group set in Norway overlap chronologically with contemporary sagas that have an Icelandic setting, chief among them *Sturlunga saga*. Imported ideas on sexuality are noticeable in genres committed to writing later, including the heroic sagas (*fornaldarsǫgur*; see FSN) and the chivalric sagas (see RS and LMIR). Most sagas are available in English translations; for specific texts, see Acker 1993 and Fry 1980. Useful surveys of the historiography and recent critical evaluations of the various genres (except the *samtíðarsǫgur* and *fornaldarsǫgur*) are found in Clover and Lindow 1985. The most important legal texts include the Icelandic *Grágás* (see Finsen 1852 and 1879) and the Norwegian collection *Norges gamle Love* (*NgL*). Part of the former is translated in Dennis et al. 1980 and of the latter in Larson 1935. The legislation of churchmen can be found in Diplomatarium Islandicum.

Biskupa sögur. 2 vols. Copenhagen: S.L. Möller, 1858–78.
Dennis, Andrew, Peter Foote, and Richard Perkins, trans. *Laws of Early Iceland: Grágás I.* Winnipeg: University of Manitoba, 1980.
Diplomatarium Islandicum. 15 vols. Copenhagen: S.L. Möller, 1857–.
Finsen, Vilhjálmur, ed. *Grágás: Islændernes Lovbog i Fristatens Tid.* [1852] Rpt. Odense: Universitets forlag, 1974.
———, ed. *Grágás efter det Arnamagnæanske Haandskrift Nr. 334 fol., Staðarhólsbók.* [1879] Rpt. Odense: Universitets forlag, 1974.
Fornaldar Sögur Norðurlanda. Ed. Guðni Jónsson. 4 vols. [1954] Rpt. Reykjavik: Íslendingasagnaútgáfan
Gislason, Konrad. *Tvær Sögur af Gísla Súrssyni.* Nordiske Oldskrifter 8. Copenhagen: S.L. Möller, 1849.
Halldórsson, Ólafur, ed. *Óláfs saga Tryggvasona en mesta.* 2 vols. EA A. Copenhagen: Munksgaard, 1958–61.
———. *Grettisfœrsla.* Reykjavik: Stofnum Arna Magnussonan, 1990.
Íslenzk fornrit. 20 vols. (Still in progress). Reykjavík: Hið Islenzka fornritafélag, 1939–.
Johnsen, Oscar Albert and Jón Helgason. *Den store saga om Olav den Hellige.* 2 vols. Oslo J. Dybwad, 1941.
Larson, Laurence M., trans. *The Earliest Norwegian Laws.* New York: Columbia University Press, 1935.
Late Medieval Icelandic Romances, ed. Agnete Loth. 5 vols. EA B, 20–24. Copenhagen: Munksgaard, 1962–65.
Morkinskinna. Ed. Finnur Jónsson. SUGNL (Samfund til udgivelse af gammel nordisk litteratur) 53 (1928).
Norges gamle Love, eds. R. Keyser and P.A. Munch. 5 vols. Christiania [Oslo]: C. Gröndahl, 1846–95.
Ólafur Halldórsson. See Halldórsson, Ólafur.
Riddarasögur. Ed. Bjarni Vilhjálmsson. 6 vols. Reykjavik: Íslendingasagnaútgáfan Haukadalsútgáfán, 1954.
Sturlunga saga. Eds. Jón Jóhannesson et al. 2 vols. Reykjavik: Starlunguútgafan, 1946.
Vǫlsunga saga ok Ragnars saga loðbrókar. Ed. Magnus Olsen. Samfund til udgivelse af gammel nordisk litteratur 36. Copenhagen: 1906–08.
Wisén, Theodor. *Homiliu-Bók: Isländska Homilier.* Lund: C.W.K. Gleerup, 1872.

Secondary Works

The most sustained interest in nordic sexuality is found in connection with the study of the concept *níð*; see especially the works of Almqvist, Noreen, Ström, and Sörensen. Without being comprehensive, the following list includes works of Norse sexuality not specifically mentioned in the text.

Anonymous. "Spuren von Konträrsexualität bei den alten Skandinaviern." *Jahrbuch für sexuelle Zwischenstufen, mit besonderer Berüchtigung der Homosexualität* 4 (1902): 244–63.

Almqvist, Bo. *Norrön niddiktning: Traditionshistoriska studier i versmagi. 1. Nid mot furstar.* Nordiska texter och undersökningar 21. Stockholm: Almqvist and Wiksell, 1965.

————. *Norrön niddiktning. II 1–2. Nid mot missionärer. Senmedeltida nidtraditioner.* Stockholm: Almqvist and Wiksell, 1974.

————. "The Mare of the People of Midfirth." In Bo Almqvist, *Viking Ale: Studies on Folklore Contacts between the Northern and the Western Worlds*, ed. Éilís Ní Dhuibhne-Almqvist and Séamus Ó Catháin. Aberystwity, Wales: Boetheus Press, 1991, 127–40.

Amory, Frederic. "Pseudoarchaism and fiction in *Króka-Refs saga*." *MS* 12 (1988): 7–23.

Andersson, Theodore M. "Some Ambiguities in *Gísla saga*: A Balance Sheet." *BONIS* (1969): 7–42.

Andersson, Theodore M. and William Ian Miller. *Law and Literature in Medieval Iceland: "Ljósvetninga Saga" and "Valla-Ljóts Saga."* Stanford, CA: Stanford University Press, 1989.

Baumgartner, Walter. "Freydís in Vinland oder Die Vertreibung aus dem Paradies." *Skandinavistik* (1993): 23–35.

Bergman, David. *Gaiety Transfigured: Gay Self-Representation in American Literature.* Madison: University of Wisconsin Press, 1991.

Bleibtreu-Ehrenberg, Gisela. *Tabu: Homosexualität: Die Geschichte eines Vorurteils.* Frankfurt a/Main: S. Fischer, 1978.

Boswell, John Eastburn. *Homosexuality and the Western Christian Tradition: Gay People in Western Christian Europe from the Beginning of the Christian Era to the Fourteenth Century.* Chicago: University of Chicago Press, 1980.

Bray, Alan. *Homosexuality in Renaissance England.* London: Gay Men's Press, 1982.

Brundage, James A. *Law, Sex, and Christian Society in Medieval Europe.* Chicago: University of Chicago Press, 1987.

Clover, Carol J. "Regardless of Sex: Men, Women, and Power in Early Northern Europe." *Speculum* 68 (1993): 363–87.

Clover, Carol J. and John Lindow, eds. *Old Norse-Icelandic Literature: A Critical Guide.* Islandica 40. Ithaca, NY: Cornell University Press, 1985.

Clunies Ross, Margaret. "Hildr's Ring: A Problem in the *Ragnarsdrápa*." *MS* 6 (1973): 75–92.

————. "An Interpretation of the Myth of Þórr's Encounter with Geirrøðr and his Daughters." In *Specvlvm Norroenvm: Norse Studies in Memory of Gabriel Turville-Petre*, eds. Ursula Dronke et al. Odense: Odense University Press, 1981, 370–91.

Dronke, Ursula. *The Role of Sexual Themes in Njáls Saga.* London: Dorothea Coke Memorial Lecture, 1981.

Gade, Kari Ellen. "Homosexuality and Rape of Males in Old Norse Law and Literature." *Scandinavian Studies* 58 (1986): 124–41.

————. "Penile Puns: Personal Names and Phallic Symbols in Skaldic Poetry." In

Essays in Medieval Studies: Proceedings of the Illinois Medieval Association. Urbana: University of Illinois Press, 1989, 57–67.

Girard, René. *Deceit, Desire, and the Novel: Self and Other in Literary Imagination.* Trans. Yvonne Freccero. Baltimore: Johns Hopkins University Press, 1972.

Goldberg, Jonathan. *Sodometries.* Stanford, CA: Stanford University Press, 1992.

Greenberg, David F. *The Construction of Homosexuality.* Chicago: University of Chicago Press, 1988.

Harris, Joseph. "Love and Death in the *Männerbund*: the *Bjarkamál* and the *Battle of Maldon.*" In *Heroic Poetry in the Anglo-Saxon Period: Studies in Honor of Jess B. Bessinger, Jr.*, ed. Helen Damico and John Leyerle. Kalamazoo, MI: Medieval Institute Publications, 1992, 77–114.

Itnire, Cathy Jorgensen. "A Smorgasbord of Sexual Practices." In *Sex in the Middle Ages*, ed. Joyce E. Salisbury. New York: Garland Publishing, 1991, 145–56.

Jochens, Jenny. "The Church and Sexuality in Medieval Iceland." *Journal of Medieval History* 6 (1980): 377–92.

———. "The Politics of Reproduction: Medieval Norwegian Kingship." *American Historical Review* 92 (1987): 327–49.

———. "Before the Male Gaze: The Absence of the Female Body in Old Norse." In *Sex in the Middle Ages*, ed. Joyce E. Salisbury. New York: Garland Publishing, 1991a, 3–29.

———. "The Illicit Love Visit: An Archaeology of Old Norse Sexuality." *JHS* 1 (1991b): 357–92.

———. "From Libel to Lament: Male Manifestations of Love in Old Norse." In *From Sagas to Society*, ed. Gísli Pálsson. Enfield Lock, Middlesex: Hisarlik Press, 1992, 247–64.

———. "Gender and Drinking in the World of the Icelandic Sagas. In *A Special Brew: Essays in Honour of Kristof Glamann*, ed. Thomas Riis. Odense: Odense University Press, 1993a, 155–81.

———. "Med Jákvæði Hennar Sjálfrar: Consent as Signifier in the Old Norse World." In *Consent and Coercion to Sex and Marriage in Ancient and Medieval Societies*, ed. Angeliki E. Laiou. Washington, DC: Dumbarton Oaks Research Library and Collection, 1993b, 271–89.

———. "Vikings Westward to Vínland: Problems of Women and Sexuality." In *Cold Counsel: The Women of Old Norse Literature and Myth*, ed. Karen Swenson and Sarah May Anderson. New York: Garland Publishing, 1996.

———. *Old Norse Images of Women.* Philadelphia: University of Pennsylvania Press, 1996.

———. *Old Women in Old Norse Society,* Ithaca, NY: Cornell University Press, 1995.

Johansen, Jens Christian. *Da Djævelen var ude . . . Trolddom i det 17. århundredes Danmark.* Odense: Odense University Press, 1991.

Karras, Ruth Mazo. "Servitude and Sexuality in Medieval Iceland." In *From Sagas to Society*, ed. Gísli Pálsson. Enfield Lock, Middlesex: Hisarlik Press, 1992, 289–304.

Kress, Helga. "Bróklindi Falgeirs: Fóstbrœðra saga og hláturmenning miðalda." *Skírnir* 161 (1987): 271–86.

Kulturhistorisk Leksikon for Nordisk Middelalder. 22 vols. Copenhagen: Rosenkilde og Bagger, 1957–78.

Lecouteux, Claude. *Fantômes et revenants.* Paris: Imago Diffusion Payot, 1986.

Lévi-Strauss, Claude. *The Elementary Structures of Kinship.* Rev. ed. Trans. James Harle Bell, John Richard von Sturmer, and Rodney Needham. London: Eyre and Spottiswood, 1969.

Liliequist, Jonas. "Peasants against Nature: Crossing the Boundaries between Man and Animal in Seventeenth- and Eighteenth-Century Sweden." *JHS* 1 (1991): 393–423.

Markey, Thomas. "Nordic níðvísur: An Instance of Ritual Inversion." *MS* 5 (1972): 7–18.

Martinez-Pizarro, Joaquîn. "On *Níð* against Bishops." *MS* 11 (1978–79): 149–53.

Mauss, Marcel. *The Gift.* Trans. E.E. Evans-Pritchard. New York: Norton, 1967.

Minkov, Michael. "Sneglu-Halli, 2:11: *Dróttinserðr.*" *Saga-Book of the Viking Society* 22 (1988): 285–86.

Noreen, Erik. "Om niddiktning." In *Studier i fornvästnordisk diktning* 2. Uppsala, 1922.

Payer, Pierre J. *Sex and the Penitentials: The Development of a Sexual Code, 550–1150.* Toronto: University of Toronto Press, 1984.

Rafnsson, Sveinbjörn. "Skriftaboð Þorláks biskups." *Gripla* 5 (1983): 77–114.

Richlin, Amy. "Not Before Homosexuality: The Materiality of the *Cinaedus* and the Roman Law against Love between Men." *JHS* 3 (1993): 523–73.

Rubin, Gayle. "The Traffic in Women." In *Toward an Anthropology of Women,* ed. Rayna R. Reiter. New York: Monthly Review Press, 1985, 157–210.

Salisbury, Joyce E. "Bestiality in the Middle Ages." In *Sex in the Middle Ages: A Book of Essays,* ed. Joyce E. Salisbury. New York: Garland Publishing, 1991, 173–86.

Sayers, William. "Serial Defamation in Two Medieval Tales: Icelandic *Ölkofra þáttr* and Irish *Scéla Mucce Meic Dathó.*" *Oral Tradition* 6 (1991): 35–57.

———. "A Scurrilous Episode in Landnámabók: Tjǫrvi the Mocker." *Maal og Minne* (1993): 127–48.

Scheie, Jon. *Om æreskrænkelser efter norsk ret.* Kristiania [Oslo], 1910.

Sedgwick, Eve Kosofsky. *Between Men: English Literature and Male Homosocial Desire.* New York: Columbia University Press, 1985.

———. *Epistemology of the Closet.* Berkeley: University of California Press, 1990.

Sørensen, Preben Meulengracht. *Norrønt nid.* Odense: Odense Universiteitsforlag, 1980.

———. *The Unmanly Man: Concepts of Sexual Defamation in Early Northern Society.* Trans. Joan Turville-Petre. Odense: Odense University Press, 1983.

———. "Murder in Marital Bed: An Attempt at Understanding a Crucial Scene in *Gísla saga.*" In *Structure and Meaning in Old Norse Literature,* ed. John Lindow et al. Odense: Odense University Press, 1986, 235–63.

Ström, Folke. "Nid och ergi." *Saga och Sed* (1922): 23–47.

———. *Níð, ergi and Old Norse Moral Attitudes.* London: Viking Society for Northern Research, 1974.

Tómasson, Sverrir. "Hugleiðingar um horna bókmenntagrein." *Tímarit máls og menningar* 50 (1989): 211–26.

Vanggaard, Thorkil. *Phallós.* Copenhagen: Gyldendal, 1969, trans. into English by author. New York: International Universities Press, 1972.

18 SEX ROLES AND THE ROLE OF SEX IN MEDIEVAL ENGLISH LITERATURE

David Lampe

"The only true subjects for poetry are sex and death."

W.B. Yeats

My task in this chapter is to sketch out the role of sex and sex roles in one thousand years of English literature. My difficulty, like that body of literature, is double. Old English (or, if you prefer, Anglo-Saxon) seems to show very little interest in sex and Middle English has almost too much. This may be because accidents of history have eliminated many works or because the profoundly traditional and masculine-tribal nature of Old English did not allow for such expression or vision of human experience. Obviously there were sex roles and sexual activity in Anglo-Saxon times, but they are not at the forefront of the meager body of poetry that survives and is all too often completely surrounded by scholars. Nor has it been the task of Anglo-Saxon specialists (till recently, perhaps) to explain or explore the presence of this absence. In *Beowulf*, Wealhtheow is praised as Hrothgar's beautiful and lavishly ornamented queen who serves mead to the whole troop of warriors (ll. 612–41), presents a gift cup to Beowulf (ll. 1162–87), and pleads that Beowulf's special protection be extended to her son, Hrothgar's young heir (ll. 1215–31). She is, as Edward Irving puts it, the "embodiment of ceremonious decorum."[1] Helen Damico has even suggested she is an authority figure by suggesting analogies with Germanic myth and legend.[2]

Hygd, Higlac's queen, is "wis, wel ungen" [wise, virtuous] (l. 1927), and she also performs the ritual presentation of the mead cup (ll. 1980–83) and is the recipient of the necklace Beowulf received from Wealhtheow (ll. 2171–76). Later she offers the throne to Beowulf (ll. 2369–72). Wrenn conjectures that Beowulf later marries her, and it is tempting to read some romance into this behavior though the evidence is extremely slim.[3]

Hrothgar's daughter, Freawaru, also hands out the mead (ll. 2020–23). She herself, we learn, will be used in a treaty-marriage with the Hathobards, a gesture that Beowulf tells us will not succeed (ll. 2023–32). Indeed the implication is that she is a woman who is as effective as a sword (*each seo bryd duge!* [l. 2031]), which parallels line 1660 regarding the power of a sword (*each aet waepen duge*). Both are objects to be used.

Another fascinating, though shadowy figure, is a contrasting woman, Offa's queen, Thrith, who at first in her father's court is shrewish but is then tamed by Offa and becomes a generous gift-giver (ll. 1930–57).[4] She seems to be used as Hermod is, to suggest the dangers of pride and the negative possibilities of royal privilege without an attendant sense of responsibility. But note the idea of *taming*. A woman is cruel and often dangerous in this world until controlled by a man.

Though these examples provide the ceremonial outlines of sex roles, we certainly do not find promiscuous goddesses and servant girls as in *The Odyssey*, of Homeric Greece, nor even in the Scandinavian pantheon of gods and goddesses. The closest we get to a femme fatale is Grendel's mother, that frightening hag who attacks Heorot to revenge the death of her son, Grendel (ll. 1256–99), and whom Beowulf overcomes in a second monster battle in her underwater lair (ll. 1497–1589). Yet, as Irving notes, "She has no name" and since she "has no identifiable mate or spouse, and no . . . history of ancestry," in effect "she has no identity at all . . . other than one dependent on her son."[5] She is, unlike her son, described in animal terms (e.g., 1506, 1599 as a *brimwylf* [sea wolf]), but not as of the lineage of Cain as is Grendel (ll. 102–10). In fact attention is drawn to her betrayal of ordinary battle ethics in keeping with what Irving terms "engrained and unconscious assumptions of male superiority."[6] As the Irish poet John Montague has suggested, the lack of such accounts is a hiatus, a real absence in early English literature that is not found in Celtic literature,[7] or we might add, in early Germanic myths.

The closest we come to the sexual activity of the gods/myths is in *Deor*, where cryptic allusion is made to the rape of Beldhild by Welund:

> Her brother's death meant less to Beldhild
> Than the tears she shed for herself, seeing
> Her belly sprouting and knowing herself
> With child, remembering nothing, never
> Any man's bride but bearing fruit.[8]

Indeed, when we turn to the *Exeter Riddles*, we seem to be dealing with clever though adolescent sexual attitudes based on double entendre and

smirking substitution rather than real or honest depiction of sexuality. There are a number of "obscene" riddles (#12 leather/auto-eroticism; #25 onion/penis; #44 key/penis; #45 dough/penis; #46 Lot's family, incest [Genesis 19: 30–38]; #61 helmet, kirtle/vagina; #62 gimlet, burning arrow, poker, brand/penis; #91 key/penis). Riddles 12 and 61 seem to contain references to masturbation:

> sometimes a slave-girl, raven-haired,
> brought far from Wales, cradles and presses me—
> some stupid, sozzled maidservant, she fills me
> with water on dark nights, warms me
> by the gleaning fire; on my breast
> she places a wanton hand and writhes about,
> then sweeps me against her dark declivity.[9]

> A desperate man stands behind me and develops me
> himself; he carries a cloth.[10]

The few poems that go beyond this veiled naming of parts and address the possibilities of sexual relationships, "The Husband's Message" and "The Wife's Lament," are also found in the *Exeter Book*.[11] Both of these elegaic laments are sufficiently unusual in the sexually sullen context of Anglo-Saxon poetry that they are often placed together even though they are separated in the mss. Whatever their problems of interpretation, clearly both poems present passionate longing for an absent partner. "The Husband's Message" is that of an enforced exile to the wife (or lover) left behind. Having prospered, he invites her to join him in conditions worthy of her and authenticates his request and messenger by final reference to runic inscriptions carved on wood.

> he has a hoard and horses and hall-carousing
> and would have everything within an earl's having
> had he my lady with him; if my lady will come:
> if she will hold to what was sworn and seaked in your youths.[12]

Along with "Dream of the Rood," several of the riddles also use prosopopoeia (the trope by which an inanimate object speaks). Riddle 60, which precedes this poem, has a piece of carved wood speaking, and has been taken by some critics to be part of the riddle. "The Wife's Lament" is a stronger poem and written in a woman's voice:

Some lovers in this world
live dear to each other, lie warm together
at day's beginning; I go by myself
about these earth caves under the oak tree.
Here I must sit the summer day through
here weep out the woes of exile,
the hardships heaped upon me.[13]

Both the experience and the bleak setting of the poem lead her to conclude "Sorrow follows/this too long wait, for one who is estranged" (ll. 52–53).

Obscure as they may be, both of these poems are clearer in context and meaning than the enigmatic "Wulf and Eadwacer," once again an item from the *Exeter Book*, and the "nearest thing to a love-lyric in Old English."[14] The situation seems to be that of a woman carried away from her love and held by another man:

Oh, my Wulf, it was hoping and longing for you
That sickened me, starved for the sight of you,
Bent with despair deeper than hunger.[15]

Though women feature prominently in the hagiographic poetry—Elene, Juliana, and Judith—only the latter poem seems relevant here.[16] And again, any sensual scene is missing. *Judith*, which lacks an indeterminate number of lines from its beginning, does make interesting use of heroic conventions, applying them quite ironically to Holofrenes (eg. *Þearlmud ðeoden gumena* [that stern leader of men, 66a] or *se rica* [that lord, 68a]). It leaves out a number of scenes and figures in the *Vulgate*, yet the beheading scene in Holofrenes's tent is masterfully rendered:

Genam ða þone haeðenan mannan
faeste be feaxe sinum, teah hyne folmum wið hyre weard
bysmerlice, þone bealofullan
listum alede, laðne mannan,
swa heo ðæs unlædan eaðost mihte,
wel gewaldan. Sloh ða wundenlocc
þone feonsceaðan fagum mece
hete þoncolne, þaet heo healfne forcearf
þone þsweoram him, þæt he on swiman læg
druncen ⊁ dolhwund. Næs ða dead þa gyt,
ealles orsawle: sloh ða eornoste

ides ellenróf o þre siðe
þone hæðenan hund, þæt him þæt heafod wand
forð on ða flore. ŋ (ll. 97b–111a)

Taking the sleeping gentile
By the hair she slowly drew him toward her, and with both hands
Watching him with contempt, until that evil
Leader of men lay as she wanted him,
Carefully placed where his God-cursed life
Lay at her mercy. The Judith struck at him,
The hated robber, with his shining sword,
Swung it so well that it cut his neck
Half through, and he opened and closed his eyes,
And lay unconscious, drunken, bleeding.
He was still alive: with a fierce stroke
She struck at the gentile dog again,
And his head leaped from his body, went rolling
Along the floor.[17]

As with heroic epithets elsewhere in the poem, the sex-roles here have been
quite elegantly reversed; victim has become victor, vice has been overcome
by virtue, and Holofrenes is beheaded by his own sword.

One must examine the *Anglo-Saxon Chronicles* to get any clear sense
of what a woman's role may have been. And certainly figures like Hild,
Abbess of Whitby (d. 680); Cuthburt, sister of Ingeled and Ine, who founded
a monastic house at Wimbrone and married Aldfrith, King of Northumbria,
but "parted during their lifetime";[18] and Queen Matilda suggest important
social and religious roles for women.

Since the *Chronicles* are clearly *not* a literary text, it is perhaps ap-
propriate to note the different handlings texts receive in different disci-
plines. Anyone who has team-taught or worked with historians will know
what I mean. As a medievalist I am interested in historical context only as
it helps me to understand the imaginative dimension of the literary text I
am reading. My historian friends, however, are interested in literary texts
only as they reveal history and are often skeptical about fiction and all its
slippery niceties. For example, J.F.C. Harrison, in his history of England,
dismisses my favorite poet as a source on English morals: "we have noth-
ing as definite as statistics of illegitimacy, and Chaucer's references to love,
marriage and lechery in his *Canterbury Tales* tell us little about sexual be-
havior at the peasant level."[19] My preference, of course, is to read those

Chaucerian *fabliaux* rather than parish records. Yet I must commend Harrison's caution, since Chaucerian comedy is both funnier and more subtle than many sober scholars allow for. Perhaps the dangers of over-determining the text are best illustrated by considering the range of response to a twentieth-century author, Philip Roth's *Portnoy's Complaint*—sexual comedy and sharp satire, certainly, but not an immediately reliable social/historical document.[20]

The earliest piece of Middle English Poetry, *The Owl and the Nightingale*, has its two opposed birds debate a range of sexual attitudes and possibilities toward fornication and adultery. Nothing could be further from the tone, manner, and social function of Old English poetry. The birds are, after all, clever debaters who will use any trick or device to make themselves look good at their opponent's expense and to impress their judge, one "Nicholas of Guldeford" who, both agree, is an ideal arbiter.[21]

Middle English "secular" lyrics continue this lightness of touch and tone so that it is often difficult to distinguish the sacred and secular, since both sets of love poems ultimately use the same tropes.

Foweles in the firth	<birds in the woods
The fisses in the flod	<fish in the flood
And I mon waxe wod.	<suffer madness
Mulch sorw I walke with	<much sorrow
For beste of bon and blod	<beast/best[22]

All night by the rose, rose,	
All night by the rose I lay;	
Darf ich nought the rose stele	<I dared not the rose steal
And yet ich bar the flour away.[23]	

The second poem obviously owes much to the "courtly" tradition of the *Roman de la Rose*, in which the beloved and more particularly her sexual parts are described in terms of flowers. At other times Middle English lyrics can be quite explicit about these body parts. Two poems in the famous "Harley Lyrics" collection[24] praise their lady in explicitly sexual terms: "Geynest under gore" [kindest under petticoat]; "Brightest under blis" [brightest under fresh linen]. And Middle English poets could also adopt a female persona. Rossell Hope Robbins gathered together nine "maiden's laments" in his collection of *Secular Lyrics* of the fourteenth and fifteenth centuries, which feature the voice of the abandoned (and often pregnant) girl.[25] Several of these poems compromise the innocence of their speaker with sexual double entendre:

ser Iohn to me Is proferying <generic term for priest
ffor hys plesure ryght well to pay
& In my box he puttes hys offryng—
I haue no powre to say hym nay.

ser Iohn ys taken In my mouse-trappe:
ffayne wold I haue hem bothe nyght and day.
he gropith so nyslye a-bought my lape, <gropes
I hauve no pore to say hym nay. (#26, "Our Sir John," ll. 9–16)

But the most famous double entendre is again from the male perspective:

I Haue a gentil cook <cock, rooster
Crowyt me day; <which crows at day
he doð me rysyn erly, <makes me rise early
my matyins for to say . . . <prayers

his eynyn arn of cristal, <eyes are of crystal
lokyn all in aumbyr; <set all in amber
& euery nyßt he perchith hym <perches
in myn ladyis chaumbyr.[26] (#46 Robbins)

On an entirely different stylistic register, Alison, the Wyf of Bath, avoids doubletalk and delights instead in the naming and discussion of sexual organs:

Telle me also, to what conclusion
Were membres maad of generacion,
And of so parfit wys a wright ywroght?
Trusteth right wel, they were nat maad for nought.
Glose whoso wole, and seye bothe up and down
That they were maked for purgacioun
Of uryne, and oure both thynges smale
Were eek to know a femele from a male,
And for noon oother cause—say ye no?
The experience woot wel it is noght so.
So that the clerkes be nat with me wrothe,
I sey this: that they maked ben for bothe;
That is to seye, for office and for ese
Of engendrure, ther we nat God displese.

Why sholde men elles in hir bookes sette
That man shal yelde to his wyf hire dette?
Now wherewith sholde he make his paiement,
If he ne used his sely instrument? (D. 115–32)

Lest we miss the point, the gloss in *The Riverside Chaucer* reminds us that "sely instrument" should be read as "blessed, innocent tool" that must be used for the marital debt, the "obligation to engage in intercourse" that the Parson discusses. The Wyf later refers to her "*bele chose*" (D. 510) and takes pride in her body and skills; "And trewely, as myne housbondes tolde me,/ I hadde the beste *quoniam* myght be" (D. 608–09). Her Tale is about a "lusty bacheler," a rapist who, to save his life, must learn "What thyng is it that wommen moost desiren." Through a loathly lady he learns that answer:

Wommen desiren to have sovereynetee
As wel over hir housbond as hir love,
And for to been maistre in hym above. (D. 1038–40).

But when the hag claims her reward, ironically for a rapist, he cries "Taak al my good and lat my body go." Yet he must face this fate worse than death and so marries her quietly in the morning "And all day after hidde hym as an owle." In their bridal bed she taunts him

Fareth every knyght thus with his wyf as ye?
Is this the lawe of kyng Arthoures hous?
Is every knyght of his so dangerous? (D. 1088–90)

When he explains that she is both "loothly," "Oold," "And therto comen of so lough a kynde" she counters by lecturing him on "gentillesse," "poverte," and "elde" with all the correct "auctors" and arguments only to present him with a final dilemma:

"Chese now," quod she, "oon of thise thynges tweye;
To han me foul and old til that I deye,
And be to yow a trew, humble wyf,
Or elles ye wol han me yong and fair,
And take youre aventure of the repair
That shal be to youre hous by cause of me,
Or in some oother place, may wel be.
Now chese yourselven, wheither that you liketh." (D. 1219–27)

When he cannot choose, he instead submits to her. After he makes it quite clear that he is giving her "maistrie" (D. 1236–38), she promises that she will be both true and fair. Unlike all five of the Wyf's husbands, we are assured that this couple "lyve unto hir lyves ende In parfit joye." Chaucer was sufficiently proud of his literary creation that he advised a young friend named Bukton, who is about to marry, to consult her:

> The Wyf if Bathe I pray yow that ye rede
> Of this matere that we have on honde.
> God graunte yow your lyf frely to lede
> In fredam, for ful hard is to be bonde.[27]

William Dunbar, "The Tretis of tua mariit Wemen and the Wedo," continues this open "naming of parts" combined with their strategic deployment in the bedroom battle for power. His narrator records the secret conversation of three descendants of the Wyf of Bath. The first wife, a young woman, complains of her aged husband's impotence:

> Quhen kissis me that caryball, than kyndillis all my sorrow;
> As birs of ane brym bair, his berd is als stif
> Bot soft and soupill as the silk is his sary lume;
> He may weill to the syn assent, bot sakles is his deidis.
> (ll. 94–97)
> [When that foul man kisses me, then all my sorrows are kindled
> His beard is as stiff as the bristle of a fierce bear
> But soft and supple as silk is his sorry tool;
> He may well assent to the sin, but blameless is his deed.]

The second continues this lament about her husband who was "hur [whore] maister,"

> He has bene lychour so lang quhill lost is his natur,
> His lume is waxit larbar, and lyis in to swonne:
> Wes never surgeorne wer set na one that snaill tyrit,
> For efter sevin oulkis rest, it will nought rapy anys;
> (ll. 174–77)
> [He had been a lecher so long a while that lost is his nature,
> His tool has become weak, and lies in a swoon
> There was never more futile than for that snail
> For after seven weeks rest, it will not be driven in once;]

The third respondent, the widow, explains how she endured and outlived her husband by ignoring him during their love-making.

> Quhen he ane hail ßear was haynt, and him behufft rage,
> And I wes laith to be loppin with sic a lob avoir
> Alse lang as he was one loft, I lukit one him never,
> Na leit nevir enter in my thoght that he my thing persit,
> Bot ay in mynde ane other man ymagnynit that I haid —
> Or ellis had I never mery bene at that mrythles raid
>
> <div align="right">(ll. 386–92)</div>
>
> [When he a whole year was denied, and he needed to rage,
> And I was loath to be mounted by such clumsy old horse
> As long as he was on top, I looked on him never,
> And let never enter in my thought that he my thing penetrated
> But ever in mind another man I imagined that I had
> Or else had I never been merry at that mirthless raid]

As we have seen Chaucer could name parts, but he also had worked in the "French mode" and translated the *Roman de la Rose*, in which the fastidious lover is shocked when Raison dares to mention *coilles* [testicles]. His early work shows this double possibility. The Dream Vision poems find love their subject—its loss in *BD* with the lamentations of the "Black Knight" who describes a whole pattern of courtship that emboldened him (ll. 1221–97). *PF* dwells on the social nature of love, for '~singular' or "~common profit." The temples of Venus in both *PF* and *KnT* are drawn from Boccaccio's *Tessida* and contain historical and allegorical representations of frustrated love, including "The god Priapus . . . with hys sceptre in hand" (*PF* 253, 6). The Prologue to *LGW* has Chaucer arraigned by Cupid for having betrayed lovers and finally given the penance:

> The moste partye of thy tyme spende
> In makyng of a glorious legende
> Of goode wymmen, maydeness and wyves
> That weren trewe inlovying at hire lyves; (F482–5)

He begins with Cleopatra, "Here may ye sen of women shich a trouthe!"

What Chaucer does in all of these dream visions is to place his narrator, an earlier version of "Geoffrey, the pilgrim," in a range of contexts which that comically bland figure claims not to understand: "I knowe nat Love in deed," he insists in *PF*, "Yit happeth me ful ofte in bokes reede/ Of

his myrakes and his crewel ire" (ll. 8, 10–11). These poems also need to be understood in the French love garden tradition, a genre which allows Chaucer to draw on the classical past from Ovid's *Metamorphosis* or *Heroides* and from a range of medieval poems.[28]

Chaucer's only complete major work, *Troilus and Criseyde,* provides his fullest treatment of love and lovers. Young handomse Troilus, initially scorns love ("O verray fooles! nyce and blynde be ye"), only to become himself the victim of Venus. The lovers are aided by Pandarus, who arranges their meetings and freely gives his advice. Yet circumstances beyond their control force them to part when Criseyde's father arranges her transfer to the Greek camp, where she accepts the attentions of Diomede, leaving Troilus to lament his loss. Yet after his death he can look back from "the eighte spere" and "lough."

Four Fabliaux in *CT* (*MT, RvT, ShT, MerT*) all involve sexual intercourse—or, to use the appropriate medieval classifications from the Parson's Tale, adultery and fornication involving "sondry folk." For an outline, I will borrow Chaucer's own categories from the *GP*:

> Er that I ferther in this tale pace,
> Me thynketh it acordaunt to resoun <according
> To telle yow all the condicioun <condition
> O ech of hem, so as it seemed me,
> And whiche they weren, and of what degree.
> And eek in what array that they were inne. (36–40)

Or as he later puts it "Th' estat, th' array, the nombre, and eek the cause/ Why that assembled was this compaignye" (716–17). By estate, Chaucer means the social grouping: in our instances *students* (Absalom in *MilT* and both John and Alleyn in *RvT*), *clerks* (Daun John in *ShipT* and Nicholas in *MilT*), and *servants* (Damian in *MerT*), to list the male aggressors first. The women are *young wives* (the unforgettable Alisoun in *MilT*, the mercenary wife in *ShipT*, May in *MerT,*) and *old wives* (the hag in *WBT*, and for that matter Dame Alice herself as a young and old woman, the archetypal Eve). Interestingly enough there seem to be no *middle-aged wives* (is this a reflection of Chaucer's categories or the social conditions of marriage that the Wyf of Bath models?). There are *unmarried women* (the miller's daughter in *RvT*—and hence "fornincacioun" rather than "avowtrie" (to use the Parson's terms). Anticipating feminist reaction as did Chaucer when he began his *LGW* with Cleopatra, I have listed only the compliant ladies rather than those who resist. Indeed, the recitation of the list of virtuous

ladies, those who *resist* and remain triumphantly chaste, suggests quite a different social *"condioun."* They are Emile (in *KT*, who wants to remain a maiden but is told by Diana that she must marry and will be given the man who loves her most); Custance in *MLT*, who triumphs over an extraordinary set of trials and attackers; the Old Woman in *SumT* (who I take to be the church), who is falsely accused of cuckolding her husband (Christ) by the shyster she excommunicates; "buxom" Griselda in the *ClT*, the Italian antitype of Lombard May in *MerT*; and the Breton, Dorigen, in *FranT*. Like Sophie in *Melibee* or St. Cecilia in the *SNT*, these are all noble (Emilie, Custance), at least with the exception of Griselda, who like Cecilia is a saint and thus an exception to all rules, *petit bourgeoisie*. And what about the men?

The successful sexual *athletes* are students (from both Cambridge and Oxford), a wily French monk, and perhaps the most athletic of them all, Damian in the pear tree. The failures in courtship are Arcite, the suitor in *KnT*, who is more interested in the battle than the prize; Absalom, the effete parish clerk in *MilT*; Sir Thopas in Chaucer's parody of tail rime romances; a nasty thief-turned-rapist in *MLT* (915–24), whose death occasions an apostrophe against the "foule lust of luxurie"; a young rapist knight in *WBT* who must be taught/"bested" by his wife. Another series of failures are the foolish husbands—a miscellaneous bunch of old and foolish men who even so are more individualized than that stock figure of the fabliaux, the *jaloux*—the gullible carpenter John in *MilT*; the miller in *RvT*; January in *MerT*; Averagus in *FranT*; the nameless merchant husband in *ShipT*; John, that "rich gnof" and carpenter who rents out his house to "hende" Nicholas, fails, the narrator of *MilT* tells us, since "he knew nat Catoun for his wit was rude/That bad man sholde wedden after hire simylitude." That is "Men sholde wedden after hire estaat,/ For youthe and elde is often at debaat" (A 3226–30). Under this wonderfully snobbish (i.e., student) dismissal of the "burel man" who probably could not write his own name, let alone read Cato's *Distichs*, is some sense of the "figuring" of sex in the *Canterbury Tales*. Sex, like everything else in medievial society, is a class-controlled activity (remember the narrator's clear recognition of aristocratic ease and middle class morality when he tells us that Alison was "a pyrmerole, a piggesnuye,/ For any lord to leggen in his bedde,/ Or yet for any good yeman to wedde" (A 3268–70).

But sex is also most successfully practiced by the young: witness poor old foolish January cuckolded by young agile Damian, the proud Miller in *RvT* whose wife and daughter sleep with the Cambridge students and finally beat him up in the finale of that one-bedroom farce. But the situation is further complicated by the passionate and hence "unreliable" nature of women,

what Chaucer elsewhere terms the "sliding courage" of Criseyde. If aristocratic Emilye desires not to marry (cp. St. Cecilia's "chaste marriage" in the *SNT*), she is told that because of her social station she cannot maintain that role, but must marry. Alisoun, May, and Phebus have no such compunctions. Instead they are dominated by their appetites, which must be satisfied. Chaucer's description of old January making love—"The slakke skyn aboute his nekke shaketh/ Whil that he sang" (E 1849–50) makes us sympathize with May. Taking an entirely different tack, the nasty minded Manciple compares an unfaithful wife to a she-wolf; "The lewdeste wolf that she may fynde,/ Or leest of reputacioun, wol she take,/ In tyme whan hir lust to han a make" (H 183–85). This is the inheritance of the misogynistic tradition of antiquity, the officially received tradition regarding women in the Middle Ages. As Aristotle put it, a woman is an infertile man (*De Generatione Animalum* 4, 727b), lacking the ennobling capacity of reason. The Wyf of Bath's clerical husband, Jankyn, was after all reading Alice this misogynistic tradition from his book of wicked wives when she "rente out of his book a leef" (D635—and indeed her whole prologue is a continuation of this "refiguring"). Jankyn's response is to hit her on the side of the head with that book so that she "was somdel deef" (A 446). Alcuin Blamire's recent book on women (both defamed and defended) has drawn materials together that can restore the resonances of this debate for modern readers.[29]

The most vigorous and successful sexual athletes in the Fabliau of *CT*, not surprisingly then, are young men. In *KnT*, *SqT*, or *Tr* they are also the most ridiculous, lacking the practiced art of Pandarus or, perhaps because of their social class, the direct approaches of student seductions in *MilT* and *RvT*. What I am suggesting then, is the truism that "age and youth are often at debate" and also that aristocratic status (which the narrator of the *MilT* sees only as license) can also be a source of restraint (*noblesse oblige*) because of the importance of paternal bloodlines for the inheritance of property and title.

Yet if *fabliaux* alternately enjoys and scorns sex roles and roles of sex, romance also serves to establish the mythos and morality of sex and sex roles in society. Indeed, to do justice to the category of romance would require a separate essay. Not counting the works of Chaucer and Gower, there are 118 works that fall into the genre of Middle English romance.[30] Almost all of them pay some attention to love although, as Lee C. Ramsey reminds us, "Sex occurs in medieval romances because marriage does, but it is understood as a secondary benefit of marriage, or it is symbolic, or it is a source of conflict."[31] A few examples will have to suffice here. For a quick overview the *Manual of Writings in Middle English, 1050–1500*, edited by J. Burke Severs, provides

convenient plot summaries and bibliographic citations.[32] Recently a number of these romances have appeared in *Everyman* editions and more are slated to appear in the *TEAMS Middle English Text Series*.

In the early romance *Floris and Blauncheflour*, the lovers grow up together and then are separated. Floris seeks out his love in a harem where they are reunited:

> To a bedde they ben brought
> That is of palle and of sylke wrought <rich cloth
> And there they sette hem doun,
> And drwogh hemself al a-room.
> There was no man that myght radde <measure
> The joye that they twoo madde. (ll. 823–27)

And there they will be discovered:

> The chamburlayn is foth noom;
> Into chamber he is coom,
> And stondeth byfore hur bedde,
> And fyndeth there, nebbe to nebbe— <body to body
> Nebbe to nebbe and mouth to mouth. (ll. 888–92)

That is the most erotic scene in this romance.

In the Breton lai *Sir Launval*, Queen Guinevere attempts to seduce Launval, who is committed to a secret love by a fairy he has visited. When he rejects the Queen she accuses him of being homosexual:

> Fy on the, thou coward!
> Anhongeth worth thou hye and hard. <may you be hanged
> That thou ever were ybore,
> That thou lyvest hyt ys pyte.
> Thou lovyst no woman, ne no woman the. (ll. 685–89)

The Middle English version of Marie de France's *Le Lai del Fraisne* (*Lay le Freine*) has a jealous woman pronounce the folk tradition that to bear twins, a woman must have slept with two men, only to later herself bear twins:

> "Allas," sche seid, "that this hap come!
> Ich have y-goven min owen dome. <given out
> Forboden bite ich woman

To speke ani other harm opon.
Falsliche another I gan deme; <judge
The selve happe is on me sene." (ll. 89–94)

She gives the midwife her second child to be disposed of: "This child fordo."
Yet the daughter will be raised and only saved from an incestuous marriage
to her twin when her mother recognizes the robe and ring she had sent with
her daughter.

What one might find lacking in any of these poems in terms of sophis-
tication is certainly to be found in the second great poet of the fourteenth cen-
tury, the author of the four poems in Cotton Nero A.x. In SGGK we have the
romance conventions of sexual comedy subtly reversed. Arthur's court, you
will remember, is like him "sumquat chilgered/ His lif liked hym lyßt" (ll. 86–
87) and the power behind the illusion (if not the throne) is feminine—the en-
chantress Morgan la Faye, whose aim is to test the "surquidré" of the "Rounde
Table" (ll. 2457–58). Thus it is quite appropriate that in *Fitt* 3, the lady of
the castle should become the sexual aggressor to test Sir Gawain, the ideal and
chaste knight of Arthur's court who has a reputation for "luf-talkyng" (l. 927)
but must lie passively in bed because of his "trawthe" and even more specifi-
cally because of the oath he has made to the lord of the castle to exchange
winnings. For three days the temptations continue subtly juxtaposed with Sir
Bertilak's hunt for the hind, boar, and fox. It is perhaps useful to remember
that Gawain would be sleeping in the nude, as both medieval convention and
the crude mss. illumination in Cotton Nero A.x suggest, and that each day
he is the prey and acts like the hunted object—the hind, the boar, and the fox.
An additional pattern that is inscribed in the text is that of the three tempta-
tions: the flesh, the world, and the devil. And of course, as a mortal, Gawain
succumbs. But not to sexual desire, rather to the desire to save himself when
he must face the Green Knight in the continuation of the head-chopping con-
test that began the poem. This "pride of life" leads him to accept the "grene
lace" which the Lady of the Castle insists will protect the life of whoever wears
it; "þer is no haþel vnder heuen tohewe hym þat myßt,/ For he myßt not be
slayn for slyßt vpon erþde" [there is no man under heaven that might kill him/
For he might not be slain any way on earth] (ll. 1853–54). When Gawain re-
alizes he has been duped and is marked, though only with a nick in the neck,
in his frustration he blames not himself but all women:

And thurß wyles of wymmen be wonen to be sorße
And so watz Adam in erde with one begyled,
And Salamon with fele sere, and Samson eftsonez—

Dalyda dalt hym hys wyrde—and Dauyth þereafter
Watz blended with Barsade, þat much bale þoled.

<div align="right">(ll. 2415-19).</div>

[And through the wiles of women are we brought to sorrow
For so was Adam at first with one beguiled
And Solomon with many more, and Samson also—
Delilah dealt him his fate—and David thereafter
Was blinded by Bathsheba, that much sadness suffered.]

In writing the libretto for Sir Harrison Birdwhistle's opera *Gawain* (1991),
the English poet David Harsent utilized Jungian psychology to refigure this
outburst. The Green Knight explains his two feints with the axe:

> It cut you for that untruth,
> but didn't kill you;
> it wasn't greed or love that made you lie,
> but fear of death—
> not sin enough to die for.[33]

Gawain strips off the sash and holds it out to the Green Knight.

> Not greed and love?
> I'm guilty of both.
> I wanted fame. I loved myself too much,
> I'm guilty of cowardice, too.
> Take this. I can't be shriven
> while I possess it.[34]

Though the Pearl/Gawain poet shows us the intolerant pride of the prophet
Jonah in *Patience* and (perhaps) the vindication of the antique world in *St.
Erkenwald*, the story of Lot in Sodom in *Purity/Cleanness* presents the "of-
ficial" medieval condemnation of homosexuality, especially in the grotesque
scene in which Lot offers the mob of sodomites his daughters in place of
the handsome young men (angels unaware) who are his guests:

> I schal biteche yow þo two þat arn quoynt
> And laykez wyth hem as yow lyst, and letez my gestes one.

<div align="right">(*Purity* ll. 871-72)</div>

> [I will give you the two girls so gracious and lovely
> Pleasure in them as you lie, but leave my guests alone.][35]

The best known handling of Arthurian materials, of course, is to be found in Sir Thomas Malory's *Morte Darthur*. As his first publisher, William Caxton, put it, Malory "dyd take oute of certeyn bookes of Frensshe" the "noble hystoryes of the sayd Kynge Arthur and of certeyn of his knyghtes" and "reduced it into Englysshe."[36] All the famous sexual dilemmas are to be found therein. Arthur is conceived by use of illusion:

> So after the deth of the duke [her husband] kyng Uther lay with Igrayne, more than thre hours after his deth, and begat on her that nygh[t] Arthur; and or day cam, Merlyn cam to the kyng and bad hym make hym redy, and so he kist the lady Igrayne and departed in all hast. But whan the lady herd telle of the duke her husband, and by al record he was dede or ever kynge Uther came to her, thenne she merveilled who that myghte be that laye with her in lykenes of her lord. So she mourned pryvely and held hir pees. (Bk. l, 5)

The issue here is not so much adultery as the legitimacy and miraculous conception of Arthur. Yet only a few pages later we have unwitting incest which will have tragic consequences:

> she was a passynge fayre lady. Wherefore the kynge [Arthur] caste grete love unto hir and desired to ly by hir. And so they were agreed, and [he] begate uppon hir sir Mordred. And she was syster on the modirs syde Igrayne unto Arthure. . . . "Yes," seyde the olde man . . . ye have done a thynge late that God ys displeased with you, for ye have lyene by youre syster and on hir ye have gotyn a child that shall destroy you and all the knyghtes of youre realme." (Bk. 1, 27, 29)

Although Lancelot realizes the importance of personal morality, "knyghtes that bene adventures sholde nat be advoutrers nor lecherous," he is still irresistibly drawn to Guinivere:

> sir Launcelot went to bedde with the quene and toke no force of hys hurte honde, but toke hys plesaunce and hys lykynge untyll hit was the dawnyng of the day; for wyte you well he slept nat, but wacched. (Bk. XIX, 657)

In rescuing Guinevere, Lancelot kills his friend Gareth. Though Malory will maintain that "for love [at] that tyme was nat as love ys nowadayes" he still shows how issues of loyalty divide Arthur's knights just

as they did in the age in which he lived. The divisive power of love and politics is also apparent in his handling of the Tristan and Isolde legend. Again lovers are brought together, this time by an outside force, a love potion that they mistakenly drink. And again the issue is divided loyalties: king (country, family, duty) vs. love.

Chaucer's friend, the lawyer-poet John Gower, though writing a century earlier, was also aware of the divided loyalties. "Moral Gower," as Chaucer called him in the envoy to *Tr*, has left us three major works—like a good conservative lawyer that he was—one in each of the languages available to him: *Mirroir d'Homme* in French; *Vox Clamantis* in Latin, and *Confessio Amantis* in Middle English (though with a Latin title). This work seems to be designed to present a social/moral fiction with the whole narrative apparatus of priest/advisor/psychoanalyst (Genius) and the tentative suffering love (Amant). Encyclopedic if a bit ponderous in organization, the books survey human behavior via narrative and quite explicitly draw moral conclusions, some of which may be ironic. "The Tale of Florent" (Liber l, 1407–1861) is an analogue to *WBT* as are several other stories (Bk. II—Constance/*MLT*; Bk. III—Pyramus & Thisbee; Dido/*LGW*; Bk. IV—Phyllis/*LGW*; Jephtha's daughter/*PhyT*; Meda/*LGW*; Lucrece/*LGW*). Gower's telling of the Apolonius of Tyre story (Bk. VIII) is the source of Shakespeare's *Pericles*, in which old Gower (who was buried in Southwark Cathedral, the church Shakespeare may also have attended) takes the stage as "Prologue" (a tribute not extended to Chaucer, who is Shakespeare's source for three plays, *MND, T&C, TNK*). Yet the label of "moral Gower" may also cut another way, as the comments of the Man of Law in the Prologue to his tale make clear:

> But certeinly no word ne writieth he
> Of thilke wikke ensample of Canacee, \<that same
> That loved hir owene brother synfully—
> Of swiche cursed stories I sey fy!—
> How that the cursed kyng Antiochus
> Birafte his doghter of hir maydenhede,
> That is so horrible a tale for to rede, . . .
> Of swiche unkynde abhomynacions. (B1 77–84, 88)

Gower's stories (like Chaucer's *LGW*) are drawn primarily from classical sources rather than the contemporary frame of the *CT*. The extensive index to the Macaulay edition of *Confessio Amantis* is an excellent tool in tracking words, themes, character, and ideas in that work.

And finally an Apocalyptic work—*Piers Plowman*—a visionary poem in all its versions A, B, C, and perhaps Z. Here the useful scene is Passus V, in which the tavern vices are seen as recanting only to fall back to old practices. Earlier we have Lady Mede (the "Lady clothed in the sun" and "Whore of Babylon")—the historical allusion is to the lady-in-waiting Alice Perriers, who controlled Edward III in his dotage and stole jewels from his dead body. Langland as a London clerk in minor orders witnessed and commented on these sexual and social desecrations.

Having quickly reviewed the four major writers of the fourteenth century, we cannot ignore the most prolific and prodigious writer of the medieval period, "anonymous," who is, of course, responsible for most of the romances, the range of lyric poems, and for the cycle plays. (The designations we often use—Wakefield Master, York Realist—or even the names that are sometimes attached are little more than convenient scholarly constructs, useful fictions that label rather than explain "authorial function.")

"Pre-Shakespearean drama," as it was once called, or Medieval English drama, the term of choice today, provides few overtly sexual scenes. Richard Moll has discussed the most interesting play from the N-Town (Ludus Coventriae) Cyle, "The Woman Taken in Adultery."[37] Otherwise sexual roles are suggested though not enacted onstage, since as with Elizabethan and Jacobean drama women's parts were played by men. Incest is the subject of "Dux Moraud," an interesting fragment much in the tradition of Gower's *CA* or Shakespeare's *Pericles*. The *Mary Magdalene* play along with *Wisdom* has scenes of sexual temptation. *Mankind* presents a dramatization of the tavern scenes of *Piers Plowman*. These few examples, however sketchy, suggest what dramatists have always known, that sexual roles are as important to theater as the role of sex is to society.

What can we conclude about the role of sex and sex roles in Middle English literature? Especially since I have not considered so many texts and traditions: the Debate poems and Arthurian romances—the list of omissions could be made much longer. First, as historians like J.F.C. Harrison or the example of Philip Roth's *Portnoy* suggest, we must be cautious in generalizing from a literary text alone. And we must be aware of the literary tradition we are drawing on before we use any text as historical evidence. But with that caution in mind, we might conclude that although there were some Jesse Helms figures like the *Man of Law*, generally speaking the depiction of sex and sex roles in literature was for comic purposes. There is communal laughter within the story "And every wight gan laughen at this stryf" (A3849). And the pilgrim's reponse to *MilT* is also jubilant:

When folke hadde laughen at this nyce cas \<silly, foolish
Of Absolon and hende Nicholas
Diverse folk diversely they seyde,
But for the moore part they loghen and pleyde. (A 3855–58)

Though things do get grimmer in *RvT*, reaching their depths in the fragmentary *CkT* with a "wyf" who "swyved for her sustenance" (A 4421–22), the role of sex is socially celebrated. Prudishness was not a trait admired in the medieval world, and in a still rural society where ninety percent of the population (witness *RvT* or *NPT)* lived in one-bedroom houses, sex was not a mystery.

This lack of mystery, this familiarity with sexuality, combined with Continental (French) literary tradition in contrast to the native Anglo-Saxon, allows for a much greater range of literary presentation than in Old English in terms of "Naming of parts" (as with the Wyf of Bath and her descendants), in terms of social comedy (as in *SGGK* and Chaucer), and in terms of social tragedy (Malory's *MA* ct. *Beowulf*). Rape is not merely alluded to (as in *Deor*) but the rapist is even given an education (in *WBT* or *Florent*). Yet there is also a new emphasis. Marriage is necessary for sexual possibilities in the English tradition. Interestingly, the scenes of sexual union in *Floris* and *Blauncheflour* are set in Babylon, not England. When the potentially exotic is brought to English shores, morality seems the rule. Yet the general impression is not one of denial or denigration (except in terms of homosexuality). Although Old English works seem not to consider sexuality, Middle English literary works seem to celebrate and enjoy sexuality and the sex roles of the characters presented. If one wishes to be clever (and unfair) one could conclude, following Yeats, that Old English is the poetry of death and melancholy while Middle English provides the poetry of sex and life.

NOTES

1. Irving, Edward, *Rereading Beowulf*, 74.

2. Helen Damico, *Beowulf's Wealhtheow and the Valkyrie Tradition*.

3. *Beowulf*, ed. C.L. Wrenn.

4. C.L. Wrenn in his edition of *Beowulf* goes out of his way to deny the existence of Thrith on philological grounds. See p. 215 in his edition.

5. Irving, *Rereading Beowulf*, 70.

6. Ibid., 73.

7. John Montague, "Women and Love in Early Irish Poetry," *Acta* (*Celtic Connections*), No. 16 (1989).

8. Burton Raffel, trans., *Poems from the Old English*, ll. 8–12. There is also a brief description of rape in Wulfstan's *Semor Lupi ad Anglos in Homilies of Wulfstan*, ed. Dorothy Bethurum (Oxford: Oxford University Press, 1957), 264.

9. *Riddles from Exeter Book*, ed. and trans. Kevin Crossley-Holland.

10. Ibid.

11. See Helen T. Bennett, "Exile and Semiosis of Gender in Old English Elegies," in *Class and Gender in Early English Literature*, eds. Britton J. Harwood and Gillian R. Overing (Bloomington: Indiana University Press, 1994), 43–58.

12. *Riddles from Exeter Book*, trans. Michael Alexander, ll. 47–50.

13. Ibid., ll. 33–39.

14. C.L. Wrenn, *Beowulf*, 150.

15. Raffel, *Poems from the Old English*, ll. 13–15.

16. See also Jane Chance, *Women as Hero in Old English Literature* (Syracuse, NY: Syracuse University Press, 1986), and Karma Lochrie, "Gender, Sexual Violence, and Politics of War in the Old English *Judith*," in *Class and Gender in Early English Literature*, eds. Harwood and Overing, 1–20.

17. *Judith*, ed. B.J. Timmer, 2d (London: Methuen, 1961); Raffel, *Poems from the Old English*.

18. *The Anglo-Saxon Chronicle*, ed. and trans. G.N. Garmonsway. l. 718 (43).

19. J.F.C. Harrison, *The Common People: A History from the Norman Conquest to the Present* (London: Fontana, 1984, reprinted, 1989), 54.

20. Philip Roth, *Portnoy's Complaint* (New York: Random House, 1969).

21. David Lampe, "Law as Order in *The Owl and the Nightingale*," *High Middle Ages, Acta* 7 (1980): 93–107.

22. Bodleian MS Douce 139, ca. 1270.

23. Bodleian MS 13679 Rawlinson, 14th century.

24. British Museum MS Harley 2253, century.

25. Rossell Hope Robbins, *Secular Lyrics of the 14th and 15th Centuries*, especially nos. 25, 27, 28, 29.

26. BM Sloane 2593, 15th century.

27. "Lenvoy to Bukton," ll. 29–32.

28. For a range of responses to LGW see Robert W. Frank, *Chaucer and LGW* (Cambridge, MA: Harvard University Press, 1972); Lisa J. Kiser, *Telling Classical Tales* (Ithaca, NY: Cornell University Press, 1983); Shelia Delaney, *The Naked Text: Chaucer's LGW* (Berkeley: University of California Press, 1994).

29. Alcuin Blamires, *Woman Defamed and Woman Defended: An Anthology of Medieval Texts* (Oxford: Clarendon Press, 1992).

30. The tally of medieval romances varies according to source and rigidity of categorization. Here I follow *A Manual of Writings in Middle English, 1050–1500*, ed. J. Burke Severs. See also W.R.J. Barron, *English Medieval Romance* (New York: Longman, 1987).

31. Lee C. Ramsey, *Chivalric Romances*, 107.

32. *A Manual of Writings in Middle English, 1050–1500*, ed. J. Burke Severs.

33. David Harsent, *Gawain: A Libretto* (London: Universal Editions, 1991), 71.

34. Ibid.

35. The modern version is by Brian Stone. See bibliography under "Middle English Lyrics."

36. Malory, *Morte DArthur*, xiv–v.

37. Richard Moll, "Sexual Mores and Charivari in The N-Town Plays," *ACTA, Northern Europe* in press.

List of Works Cited

The Anglo-Saxon Chronicle, ed. and trans. G.N. Garmonsway. Everyman. London: Dent, 1972.

Beowulf, ed. C.L. Wrenn. 2d ed. London: Harrap, 1966.

Cleanness, ed. R.J. Menner. New Haven, CT: Yale University Press, 1920.

Damico, Helen. *Beowulf's Wealhtheow and the Valkyrie Tradition*. Madison: University of Wisconsin Press, 1984.

Dunbar, William. *Works*, ed. J. Kinsley. Oxford: Clarendon Press, 1979.

The Earliest English Poems, ed. and trans. Michael Alexander. Berkeley: University of California Press, 1970. Bi-lingual.

Harrison, J.F.C. *The Common People: A History from the Norman Conquest to the Present*. London: Fontana, 1984.

Harsent, David. *Gawain: A Libretto*. London: Universal Editions, 1991.

Harwood, Britton J. and Overing, Gillian R., eds. *Class and Gender in Early English Literature*. Bloomington: Indiana University Press, 1994.

Irving, Edward. *Rereading Beowulf*. Philadelphia: University of Pennsylvania Press, 1988.

Judith, ed. B.J. Timmer. 2d ed. London: Methuen, 1961.

Malory, Sir Thomas. *Works*, ed. Eugene Vinaver. 2d ed. New York: Oxford University Press, 1971.

Middle English Lyrics, ed. Maxwell S. Luria and Richard L. Hoffman. New York: W.W. Norton, 1974.

Middle English Romances, ed. Douglas B. Sands. New York: Holt, Rinehart and Winston, 1966.

Of Love and Chivalry: An Anthology of Middle English Romance, ed. Jennifer Fellows. Everyman. London: Dent, 1993.

Poems from the Old English, trans. Burton Raffel. Lincoln: University of Nebraska Press, 1964.

Ramsey, Lee C. *Chivalric Romances: Popular Literature in Medieval England*. Bloomington: Indiana University Press, 1983.

Riverside Chaucer, ed. Larry Benson et al. Boston: Houghton Mifflin, 1987.

Robbins, R.H. *Secular Lyrics of the 14th and 15th Centuries*. Oxford: Oxford University Press, 1952; 2d ed., 1964.

Sir Gawain and the Green Knight, ed. J.R.R. Tolkien and E.V. Gordon, rev. Norman Davis. Oxford: Oxford University Press, 1966.

Selected Bibliography of Medieval English Literature

Primary Texts: Old English

Beowulf. (3182 lines)

 Beowulf and The Fight at Finnsburg, ed. Friederich Klaeber (1950); C.L. Wrenn (1973), rev. W.F. Bolton.

 Translations: R.K. Gordon (London: R.K. Dent, 1926); C.W. Kennedy (New York: Oxford University Press, 1940); Edwin Morgan (Aldington, England: Hand & Flower Press, 1952); David Wright (Baltimore: Penguin Books, 1957); Burton Raffel (New York: New American Library, 1963); Garmonsway and Simpson (1968); S.A.J. Bradley (1982); Marc Hudson (1990); Frederick Rebsamen (New York: Icon Edition, 1991).

"Deor" (42 lines)

 ASPR, 3; Exeter Book; Kemp Malone (1966) 4th ed.

 Translations: R.K. Gordon (1926); C.W. Kennedy (1960); B. Raffel (1964); S.A.J. Bradley (1982).

"Husband's Message" (53 lines)

 ASPR, Exeter Book, 3

 Translations: R.K. Gordon (1926); C.W. Kennedy (1960); B. Raffel (1964); S.A.J. Bradley (1982).

Judith (349 lines)—OT Apocryphal (Judith 12:10–15:1)

 ASPR, Cotton Vitellius Axv

 Translations: R.K. Gordon (1926); Burton Raffel (1964); S.A.J. Bradley (1982).

Riddles from Exeter Book

 ASPR, 3; Frederick Tupper (1910); A.J. Wyatt (1912); Craig Williamson (1977).

Translations: Paul F. Baum (1963); Kevin Crossley-Holland (1979); Craig
Williamson (1982); Michael Alexander (1982); L.J. Rodriques (1990).
"Wife's Lament" (53 lines)
ASPR, Exeter Book, 3
Trans.: R.K. Gordon (1926); W.C. Kennedy (1960); B. Raffel (1964);
S.A.J. Bradley (1982).
"Wulf and Eadwacer" (19 lines)
ASPR, 3; Exeter Book.
Translations: R.K. Gordon (1926); Burton Raffel (1964); Richard Ryan (1973);
S.A.J. Bradley (1982); Craig Raine (1983).

TRANSLATIONS

Alexander, Michael. *Beowulf*. New York: Penguin, 1973.

Bradley, S.A.J. *Anglo-Saxon Poetry*. Everyman. London: Dent, 1982. Prose with commentary.

Chickering, Howell D. *Beowulf: A Dual Language Edition*. Garden City, NY: Anchor, 1977.

Crossley-Holland, Kevin. *The Anglo Saxon World*. World's Classics. New York: Oxford University Press, 1984.

Donaldson, E.T. *Beowulf*. New York: W.W. Norton, 1975. Prose.

Garmonsway, G.N. and Simpson, Jacqueline. *Beowulf and Its Analogues*. Everyman. London: Dent, 1968. Prose.

Gordon, R.K. *Anglo-Saxon Poetry*. Everyman. London: Dent, 1926. Prose.

Hudson, Marc. *Beowulf*. Hanover, NH: University Press of New England, 1990.

Morgan, Edwin. *Beowulf*. New York: New American Library, 1963.

Raffel, Burton. *Beowulf*. New York: New American Library, 1963.

———. *Old English Poetry*, 2d ed. Lincoln: University of Nebraska Press, 1964.

Rebsamen, Frederick. *Beowulf*. Icon Edition. New York: Harper and Row, 1991.

Wright, David. *Beowulf*. New York: Penguin, 1957.

Secondary Sources

Anderson, George K. *The Literature of the Anglo-Saxons*. Rev. ed., Princeton, NJ: Princeton University Press, 1967.

Bonjour, Adrien. *The Digressions in Beowulf*. Oxford: Basil Blackwell, 1959; reprinted 1970.

Brodeur, Arthur G. *The Art of Beowulf*. Berkeley: University of California Press, 1959.

Godden, Malcolm and Michael Lapidge, eds. *The Cambridge Companion to Old English Literature*. Cambridge: Cambridge University Press, 1991.

Greenfield, Stanley B. *A Critical History of Old English Literature*. New York: New York University Press, 1965.

Irving, Edward B. *A Reading of Beowulf*. New Haven, CT: Yale University Press, 1968.

———. *Rereading Beowulf*. Philadelphia: University of Pennsylvania Press, 1989.

Pearsall, Derek. *Old English and Middle English Poetry*. London: Routledge and Kegan Paul, 1977.

Wilson, Richard M. *The Lost Literature of Medieval England*. London, 1951; 2d ed., revised 1970.

Wrenn, C.L. *A Study of Old English Literature*. New York: W.W. Norton, 1967.

MIDDLE ENGLISH: PRIMARY TEXTS
Geoffrey Chaucer
The Riverside Chaucer, ed. Larry D. Benson et al. Boston: Houghton Mifflin, 1987. The standard scholarly edition with full apparatus, notes.

Translations: Nevil Coghill (1951); Brian Stone (1977); David Wright (1985).
Gawain Poet
> *Cleanness*, ed. R.J. Menner [(1920)]; rpt. Hamden, CT: Archon Books, 1970).
> *Patience*, J.J. Anderson (Manchester, Eng.: Manchester University Press, 1964).
> *Sir Gawain and the Green Knight*, ed. J.R.R. Tolkien and E.V. Gordon (1952);
> rev. Norman Davis (Oxford: Clarendon Press, 1966); R.A. Waldron (London: Edward Arnold, 1970); Theodore Silverstein (Chicago: Chicago University Press, 1971).
> *Works*, ed. A.C. Cawley and J.J. Anderson (New York: Dutton, 1976); Charles Moorman (Jackson: University Press of Mississippi, 1976); Waldron (London: Edward Arnold, 1970).
> Translations: Marie Borroff (New York: W.W. Norton, 1967); John Gardner (Chicago: University of Chicago Press, 1965); J.R.R. Tolkien (Boston: Houghton Mifflin, 1973).

John Gower
> *Confessio Amantis*, ed. G.C. Macaulay. Early English Text Society, henceforth EETS (1901), 2 vols.
> *Confessio Amantis*, ed. Russell Peck (1966), rpt. Toronto: University of Toronto Press, 1980.

William Langland
> *Piers Plowman: A Text*, ed. George Kane and E.T. Donaldson. London: Athlone, 1960. B. Text, 1975.
> *Piers Plowman: C Text*, ed. D. Pearsall. Berkeley: University of California Press, 1979.
> *The Vision of William Concerning Piers Plowman*, ed. W.W. Skeat, 2 vols. Oxford: Oxford University Press, 1986.
> Translations: J.F. Goodridge (1959); E.T. Donaldson (1990).

Middle English Lyrics
> *English Lyrics of the 13th Century*, ed. Carleton Brown. Oxford: Clarendon Press, 1932; rpt. 1965.
> *English Lyrics of the 14th and 15th Century*, ed. R.H. Robbins. Oxford: Clarendon Press, 1952; 2d ed., 1964.
> *Harley Lyrics*, ed. G.L. Brook. Manchester, Eng.: Manchester University Press, 1964.
> *Medieval English Lyrics*, ed. T. Silverstein. York Medieval Texts, London: Arnold, 1971.
> *Middle English Lyrics*, ed. Maxwell C. Luria and Richard L. Hoffman. New York: W.W. Norton, 1974.
> MS Harley 2253 facsimile edition. EETS (1964)
> *Supplement to the Index of Middle English Verse*, ed. R.H. Robbins and J.L. Cutler. Lexington, KY: University of Kentucky Press, 1965.
> *The Index of Middle English Verse*, ed. C. Brown and R.H. Robbins. New York: Columbia University Press, 1943.
> Translations: Loomis and Willard (1948); Brian Stone (1968).

The Owl and the Nightingale
> Ed. E.G. Stanley, *Nelson's Medieval and Renaissance Library*. London: Nelson, 1960.
> Translations: Brian Stone (1971), John Gardner (1971).

Drama
> *N-Town Plays*, ed. Stephen Spector. EETS 1991. For "Women Taken in Adultery," trans. R.T. Davies (1972).
> *The Chester Mystery Cycle*, ed. R.M. Lumiansky and David Mills. EETS. 1974, 1986. Modernized edition, David Mills, 1992.
> *The Late Medieval Religious Plays of Bodleian Mss Digby 133 and Museo 160*, ed. D.C. Baker, J.L. Murphy, and L.B. Hall, Jr. EETS. 1982. For "Magdalene."

The Macro Plays, ed. Mark Eccles. EETS. 1969. For "Mankind" and "Castle of Perseverance."

The Townley Plays, ed. A.W. Pollard. EETS. 1897, rpt. 1978.

The Wakefield Pageants in the Townley Cycle, ed. A.C. Cawley. Manchester, Eng.: Manchester University Press, 1958, rpt. 1971. Trans. Martial Rose. New York: W.W. Norton, 1961.

The York Plays, ed. R. Beadle. London: Arnold, 1982.

York Mystery Plays, ed. R. Beadle and P. King. New York: Oxford University Press, 1984. Twenty-two of the 47 plays in a modern-spelling text.

William Dunbar

Poems, ed. D. Laing. 2 vols. Edinburgh, 1834; ed. John Small, Scots Text Society, 3 vols., Edinburgh, 1884–89; ed. J. Schipper, Vienna, 1894; ed. W. Mackay Mackenzie, London: Faber, 1932, rpt. 1966; ed. James Kinsley, Oxford: Clarendon Press, 1979.

Romance

A Manual of Writings in Middle English, 1050–1500, ed. J. Burke Severs, vol. l, New Haven, CT: Connecticut Academy of Arts and Science, 1967.

Le Bone Florence of Rome, ed. Carol Falvo Heffernan. Old and Middle English Texts. New York: Barnes and Noble, 1976.

Medieval English Romances. 2 vols., ed. A.V.C. Schmidt and N. Jacobs. London: Hodder and Stoughton, 1980.

Middle English Metrical Romances, ed. W.H. French and C.B. Hall. New York: 1930, rpt. 1974.

Of Love and Chivalry: An Anthology of Middle English Romance, ed. Jennifer Fellows. Everyman. London: Dent, 1992.

Six Middle English Romances, ed. Maldwyn Mills. Everyman. London: Dent, 1973.

The Birth of Romance: An Anthology, ed. Judith Weiss. Everyman. London: Dent, 1992. Four Anglo-Norman romances are translated.

The Breton Lays in Middle English, ed. C.T. Rumble. Detroit, MI: Wayne State University Press, 1965. Eight lays.

Yvain and Gawain, ed. Maldwyn Mills. Everyman. London: Dent, 1992.

Translations

Medieval English Verse and Prose, ed. and trans. R.S. Loomis and Rudolph Willard. New York: Appleton-Century Crofts, 1948.

Richard the Lion-Hearted, trans. Bradford B. Broughton. New York: Dutton, 1966.

The Knightly Tales of Sir Gawain, trans. Louis B. Hall. Chicago: Nelson-Hall, 1976.

Sir Thomas Malory

Morte DArthur, ed. Eugene Vinaver. 3 vols. Oxford: Clarendon Press, 1947, revised 1973.

Morte DArthur, ed. Eugene Vinaver. Oxford Standard Authors. London: Oxford University Press, 1954, revised 1977.

Secondary Sources

Alford, John A., ed. *Companion to Piers Plowman*. Berkeley: University of California Press, 1988.

Barratt, Alexandra, ed. *Women's Writing in Middle English*. London: Longman, 1992.

Barron, W.J.R. *English Medieval Romance*. New York: Longman, 1987.

Blamires, Alcuin, ed. *Woman Defamed and Woman Defended*. Oxford: Clarendon Press, 1992.

Beadle, Richard, ed. *The Cambridge Companion to Medieval EnglishTheater*. Cambridge: Cambridge University Press, 1994.

Benson, Larry D. *Art and Tradition in Sir Gawain and the Green Knight.* New Brunswick, NJ: Rutgers University Press, 1965.

———. *Malory's "Morte Darthur."* Cambridge, MA: Harvard University Press, 1976.

Cadden, Joan. *The Meaning of Sex Difference in the Middle Ages: Medicine, Science, and Culture.* Cambridge: Cambridge University Press, 1994.

Chance, Jane. *Women as Hero in Old English Literature.* Syracuse: Syracuse University Press, 1986.

Crane, Susan. *Insular Romance.* Berkeley: University of California Press, 1986.

Davenport, W.A. *The Art of the Gawain Poet.* London: Athlone, 1978.

Edwards, Robert R. and Stephen Spector, eds. *The Olde Daunce: Love, Friendship, Sex and Marriage in the Medieval World.* Albany, NY: SUNY Press, 1991.

Fisher, John Hurt. *John Gower.* New York: New York University Press, 1964.

Hanawalt, Barbara A. *The Ties that Bound: Peasant Families in Medieval England.* New York: Oxford University Press, 1986.

Harrison, J.F.C. *The Common People: A History from the Norman Conquest to the Present.* London: Fontana, 1984.

Herlihy, David. *Medieval Households.* Cambridge, MA: Harvard University Press, 1985.

———. *Opera Muliebria: Women and Work in Medieval Europe.* New York: McGraw-Hill, 1990.

Hine, John. *The Fabliau in English.* London: Longman, 1993.

Hume, Kathryn. *The Owl and the Nightingale: The Poem and Its Critics.* Toronto: University of Toronto Press, 1975.

Kelly, Henry Ansgar. *Love and Marriage in the Age of Chaucer.* Ithaca, NY: Cornell University Press, 1975.

Kennedy, Beverley. *Knighthood in the "Morte Darthur."* Cambridge, Eng.: D.S. Brewer, 1985.

Klassen, Norman. *Chaucer on Love: Knowledge and Sight.* Rochester, NY: Boydell and Brewer, in press.

Meale, Carol M. *Women and Literature in Britain, 1150–1500.* Cambridge: Cambridge University Press, 1993.

Mehl, Dieter. *The Middle English Romances of the 13th and 14th Centuries.* London, 1968.

Olson, Paul A. *The Canterbury Tales and the Good Society.* Princeton, NJ: Princeton University Press, 1986.

Ramsey, Lee C. *Chivalric Romances: Popular Literature in Medieval England.* Bloomington: Indiana University Press, 1983.

Reiss, Edmund. *William Dunbar.* Twayne English Authors Series. New York: Twayne, 1979.

Robertson, D.W. *Preface to Chaucer.* Princeton, NJ: Princeton University Press, 1962.

Ross, Thomas W. *Chaucer's Bawdy.* New York: Dutton, 1972.

Spearing, A.C. *Medieval to Renaissance in English Poetry.* Cambridge: Cambridge University Press, 1985.

———. *The Gawain-Poet: A Critical Study.* Cambridge: Cambridge University Press, 1987.

———. *Readings in Medieval Poetry.* Cambridge: Cambridge University Press, 1987.

———. *The Medieval Poet as Voyeur: Looking and Listening in Medieval Love Narratives.* Cambridge: Cambridge University Press.

Stevens, Martin. *Four Middle English Mystery Cycles; Textual, Contextual, and Critical Interpretations.* Princeton, NJ: Princeton University Press, 1987.

Swanton, Michael. *English Literature Before Chaucer.* New York: Longman, 1987.

Wilson, Edward. *The Gawain Poet.* London: Arnold, 1977.

Witting, Susan. *Stylistic and Narrative Structures in the Middle English Romances.* Austin: University of Texas Press, 1978.

CONTRIBUTORS

James A. Brundage is the Ahmanson-Murphy Distinguished Professor of History and the Courtesy Professor of Law at the University of Kansas, Lawrence.

Vern L. Bullough is State University of New York Distinguished Professor Emeritus, and currently a professor of nursing at the University of Southern California.

Joan Cadden is a now professor of history at University of California, Davis.

Laurie A. Finke is a professor of Women and Gender Studies at Kenyon College, Gambier, Ohio.

Warren Johansson was an independent scholar who devoted his life to the study of homosexuality. He died in 1994 before the final draft of the paper was completed.

Jenny Jochens is now an emeritus professor of history at Towson State University. Her address is 4828 Roland Ave., Baltimore MD 21210.

Ruth Mazo Karras is associate professor of history at Temple University, Philadelphia, Pennsylvania.

Mathew S. Kuefler is an assistant professor of history at San Diego State University, San Diego, California.

David Lampe is now an emeritus professor of English from the State University of New York College at Buffalo.

Eve Levin is associate professor of history at Ohio State University, Columbus.

Margaret McGlynn is assistant professor of history at Wellesley College. Wellesley, Massachusetts.

Richard J. Moll is a lecturer in English literature at Suffolk University, Boston, Massachusetts.

Jacqueline Murray is now a professor of history and director of the Humanities Research Group at the University of Windsor.

Pierre J. Payer is professor of philosophy at Mount Saint Vincent University, Halifax, Nova Scotia, Canada.

William A. Percy is professor of history at the University of Massachusetts, Boston.

John M. Riddle is professor of history at North Carolina State University, Raleigh.

Norman Roth is professor of Hebrew and Semitic Studies at the University of Wisconsin—Madison.

Joyce E. Salisbury is Frankenthal Professor of History at the University of Wisconsin—Green Bay.

INDEX

Abduction, 129, 135
Abelard, Peter, 132–133, 199, 279, 285, 289–290
Abelonians, 34
abortion, xvi, 261–277, 288, 339
abstinence, 57, 66, 107, 127, 130, 141, 331–332, 342
Abū Nuwās, 321
Acta Sanctorum, 228
Acts of Andrew the Apostle, 162
Acts of John, 162
Acts of Paul and Thecla, 162
Acts of Thomas, 162
Adam, 34–35, 86–88, 125–126, 333–334
adultery, 33–34, 42, 45, 131, 138, 198, 204, 309, 319, 335, 338-339, 342, 411, 417, 419; female offense, 338–339; grounds for divorce, 338–339; penalties for, 338–339; presumed, 338; punishment for, 132
adultresses, 86
Advent, 36
Ælfrich, 113
Aelred of Rievaulx, 169, 289
Aeneas, 224
Aers, David, 353
Æthelthryth, St., 109, 113
affection, between women, 196, 206–208, 211
affinity. *See* consanguinity; marriage; sponsorship
Alan of Lille, 170
Albert the Great, 90, 93–94, 96, 266–267, 292
Albertus Magnus. *See* Albert the Great
Albigensian Crusade, 254
Alcuin, 113
Alexander III, Pope, 38–39

Alexis, St., 110, 113–114
Al-Ghazzālī, 321
Al-Hakam II, 322
al-liwat, 64. *See also* alguaagi; alubuati; aluminati
Al-Razi (Rhazes), 271
alguaagi, 64. *See also* al-liwat; alubuati; aluminati
Allen, Peter, 351
alubuati, 64. *See also* alguaagi; al-liwat; aluminati
aluminati, 64. *See also* alguaagi; al-liwat; aluminati
Ambrose, St., 85, 87, 125–126, 133, 164, 227, 334
amenorrhea, 89
American Historical Association, xiv, xv
Ammianus Marcellinus, 281
amonum, 262
Amor de Lohn, 358
amor eros, 65. *See also amor heroes*; *amor heros*
amor heroes, 65
amor heros, 65
Anastasia Patricia, St., 229
anatomy and physiology, sexual, 127–128, 201
Andreas Capellanus, 131, 135, 137, 170
androphilia, 159
Anglo-Saxon Chronicles, 405
animus. *See* soul
anise, 262
Annales, xiii
Anselm, St., 173
Anthony, St., 163
"Anti-Christ," 314
aphrodisiacs, 127, 138–139
Aphrodite, 224, 229. *See also* Venus

Apium graveolens, See celery seeds
Apollinaris (Dorotheus), St., 229
Arabic, 310–311, 321
Arabian Nights, 322
Aretaeus, 82–83
argr, 159, 172
Ariosto, 232
Aristotle, 54–55, 57, 63, 82, 89, 92, 171,
 174–175, 225, 265–266, 268, 312,
 347–348, 413
Arnald of Villanova, 61, 66, 270
Aronstein, Susan, 355
Art of Courtly Love, 131–132, 135–136
Artegall, 232
artemesia, 269–270, 272
Artemis, 269
Arthurian literature, 290
Asarum europaeum. See haselwurtz
asceticism, 36, 312, 332–333
Aspasia, 270
Assyleptos, 264
Assyrians, 264
astrology, 52, 91
Athanasia, St., 229
Athenaeus, 171
Athenagoras, 162
atocium, 264
atokios, 264
Augustine, St., xvi, 34–35. 43, 82, 87–88,
 104–105, 110–111, 126, 164–165,
 173, 195–196, 265, 268, 282, 334–
 35, 349
Augustine, archbishop of Canterbury, St., 136
Augustus Caesar, 265
Ausonius, 290
Autobiography in Service of Ladies, 234
Averroes, 226
Avicenna, 58, 61, 64, 271–272, 321–322

bachelors, 340
badge, Jewish, 314
Bailey, Derrick Sherwin, 155, 157
Bakhtin, M.M., 353, 360
baldness, 286
Baldwin, John, 170
Barbara, St., 235
Bartels, Max, xii
Bartels, Paul, xii
Bartholemew of Exeter, 6
Basil of Caesaria, St. (Basil the Great), 285,
 333, 335
baths, bathhouses, 338
Baudri of Bourgueil, 170
beast fable, 358–359
Beaufort, Margaret, 111

Beccadelli, Antonio, 178
Bede, 109, 113, 283
Beguines, 111, 114, 207
Benedict, St., 164
Benedictines, 261
Benivieni, Girolamo, 178
Benton, John, 349
Beowulf, 401–402
Bernard of Gordon, 52
Bernard of Pavia, 168
Bernardino of Siena, St., 178
Bernart de Ventadorn, 358
Bertran de Born, 358
berserks, 370
bestiality, 43, 200, 309, 313, 340–341, 385–
 387; and law, 389–390
bestiaries, 360
bethrothal, ceremony, 336; repudiation of,
 336, 338
Bible, 280–285, 309–310, 319
Bible moralisée, 208
Bieiris de Romans, 205–206
bigamy, 288
biology, 82, 84, 86, 91, 98
birth control, 59–61
bishops, 329
Black Death, 248
Blasteres, Matthew, 331
Bloch, Howard, 352, 363 n. 8
Bloch, Iwan, xii
blood, 89, 91, 96
body, 330, 333, 359, 361–362; classical,
 362; grotesque, 359–360, 362
Bogin, Meg, 353
Bogomils, 334
Book of the Duchess, 410
Boswell, John, 157–158, 170, 180 n. 13,
 181 n. 19, 182 n. 45, 191–192,
 195, 218; theory on Christian atti-
 tude toward homosexuality before
 thirteenth century, 155; Same-Sex
 Unions, 156, 178–179
Bosworth, 319
Bowers v. Hardwick, 160
Boyle, L.E., 9, 15
Bradamante, 232
Bridget of Sweden, St., 111
Briffault, Robert, xii
Britomart, 232
brothel, 44, 244–248, 250–251, 253–254
Brulé, Gace, 355
Brundage, James A., xvi, 243–244, 347
bugger: origin of word, 158
Bulgaria, 330, 335
Bullough, Vern L., xvi, 155, 249, 319

Burchard, bishop of Worms, 6, 8–9, 168, 215
Burns, Jane, 359, 361–362
Bynum, Caroline, 124, 206
Byzantine Empire, 280, 287, 291, 329–331, 334–338, 340, 342

Cadden, Joan, xvi
Callistus, Pope, 164
Cambrai, 37
canon law, xvi, 33–50, 168–169, 243–244, 335, 338–339, 341, 347; and civil law, 329, 331, 335, 339, 340; collections, 331, 335; enforcement of, 335, 338–412
Canon of Medicine, 64
Cantarella, Eva, 180 n.13
Canterbury Tales. See individual tales under Chaucer, Geoffrey
Canterbury, 267
Cantor, Norman, xi
caper, 270
Cappelanus, Andreas, 348–351, 353, 357
CARA group, xv
caraway, 262
caritas, 350
Carlini, Benedetta, 203–204
Carpocrates, 162
Carrasco, Rafael, 177
Carum carvi. See caraway
castrati, 287
castration, xvi, 125, 133, 137, 140, 201
Catherine of Sweden, 111–112
Cato (Distichs), 412
Catullus, 171
Cecilia, St., 110, 113–114
celery seeds, 262–263, 268
Celestine, Pope, 43
celibacy, 35–37, 41, 130, 133, 141, 333, 335, 341; clerical, 103, 105–107, 109–110; laws penalizing, 104; vows of, 109, 113, 115
Celts, 264
Cervantes, 234
Chapman, John Jay, xiii
Charlemagne, 166–167
chaste marriage: in literature, 114–115; noble, 111–112; obedience within, 112; royal, 109
chastity, 58, 67, 96, 126–127, 129–130, 133, 248, 331–334, 338–339, 341–342
chastity girdle, xii
Chaucer, Geoffrey, 113–114, 138, 290, 410; CIT, 412; KT, 410, 418; MerT,

413; MilT, 412–413; MLT, 412; PF, 410–411; ShipT, 412; SNT, 413; SqT, 413; SumT, 411; Thop, 412; Tr, 411, 413; WBT, 407–409, 412–413
Chester plays, 236–237
Chevalier de la Charette, 357
Childebert, 288
China, 264
chiromancy, 52
Cholakian, Rouben, 350
Chrétien de Troyes, 170, 290, 354–358
Christ, 227. See also Jesus
Christianity. See church, Christian
Christians, 313–314, 319
Christine de Pisan, 358
Christmas, 36
church, Anglican, 34
church, Christian, 33–50, 331
church fathers, 85–88, 92, 96; homophobia of, 161–165
church, Lutheran, 34
church, Orthodox, 34, 329–343
church reform: eleventh-century movement, 199
church, Roman Catholic, 34, 39, 333–335, 341
Cinaedus, 159, 389
circulatory system, 286
circumcision, 284
Claudian, 281, 285
Cleanness. See Purity
Clement of Alexandria, St., 162, 164, 331–332
Clement of Rome, St., 163
clergy, 130; families of, 36–37; marriage of, 36–37, 332–333, 341–342; wives of, 341. See also celibacy; monks; nuns
clothing: as tokens of love, 374, 376–377
codpiece, 133–134
coitus, 55, 58–59, 62, 82, 90, 93, 95, 339
coitus interruptus, 129, 261
complexion, 85, 91–95
conceptus. See embryo
concubinage, ix; clerical, 105; and fornication, 337; legally tolerated, 337
concubines, 37, 309, 313; children of, 337; inheritance by, 337
confession, 3, 42, 45. See also penitentials
confessional literature, 16–17
confessor, 14
conjugal debt, 108–109, 131–132
consanguinity, 38
consent, 104, 108, 336

Consilia, 52
Constantine the African, 52, 55, 58, 268
Constantine I, Emperor, 34
Constantinople, 265. *See also* Byzantine
 Empire; church, Eastern Orthodox
Constantinus Africanus, 127, 138
contraception, xvi, 261–277, 339
contraceptive, 60–61, 67, 253
Corinthians, Book of, 160–161
cotton root, 274
Coulson, Noel J., 319
councils and synods, church, 228, 341, 692;
 Ancyra, 162; Ankara, 106; Bor-
 deaux, 105; Constance, 230; Elvira,
 162; Lateran (First), 36: Lateran
 (Second), 36; Lateran (Third), 9,
 168; Lateran (Fourth), 9, 38, 44;
 Meaux, 6; Nablus, 168; Nicaea,
 284; Paris, 214; Trent, 168
court, canonical, 39, 41–42, 45–47, 109,
 115, 203, 329, 335, 337–339
Court, Champagne, 349, 355
court, French, 202
court, secular, 202–203
court records, 253
court summaries, 52
courtesans, 253. *See also* mistresses
courtly love, 131, 348, 351–354, 356, 358, 361
courts, jurisdiction of, 108
courtship, ix
cross-dressing, xvi, 223–237, 282, 292
Crusades, xiv
cumin, 262
cunnilingus, 43
cupiditas, 349
Curtius, Ernst, 170
Cyprian, St., 162, 227
Cypriot knights, 234

Dalla, Dani lo, 180 n.13
Dall'Orto, Giovanni, 156
Damasus, Pope, 106
Damian, Peter, St., 199
dangers, 66–67
Daniel, the prophet, 281
Daucus carrota. See Queen Anne's lace
De Amore, 348–351, 353, 357
De Gradibus. See "On Degrees"
demons, 320
Deor, 402
desertion of spouse, 338–339
Deuteronomy, Book of, 160, 224
deviant, 200, 248–249, 339–341
*Diagnostic and Statistical Manual of Mental
 Disorders*, 224

Diana, 270
Didache, 33
Digest, 284, 287
dildos, 167, 198–199, 202–203
Dingwall, John, xii
Dioscorides, 267
diseases, 54, 66
disorders, 62
dits, 359, 362 n. 2
diversity, 67
divine intellect, 266
divorce, ix, 33–34, 337–339; grounds for,
 338–339, 341; informal, 341
*Doctrine of the Twelve Apostles. See
 Didache*
Don Quixote, 234
Donatus of Besançon, 196–197
double entendre, 402–403, 406–407
Douglas, Mary, 361
dowry, 42, 335, 338
Dragonetti, Roger, 351
dress, sexual, 133–134
drunkenness, 338
Duby, Georges, 347
Dunbar, William, 409–410
Dynes, Wayne, 156

Ecloga, 336
Edward I of England, 273
Edward II of England, 171, 176, 289
effeminacy, 125, 163; as judged by Hellenes
 and Latins, 158
Eglinton, J.Z., 155
Egypt, 263
Eleanor d'Aquitaine, 348, 358
Eleno/Elena de Desopedes, 231
elephantiasis, 286
Ellenborough Act, 273
Ellis, Havelock, 223
embryo, 264, 267
emmenagogue. *See* menstural stimulator
Encratites, 284, 332
d'Eon de Beaumont, Chevalier, 223
Eonism, 223
Epicurus, 127
epilepsy, 286
Epiphanes, 162
Epistle of Barnabas, 162
Equitius of Valeria, 283
Erec et Enide, 355–356
ergot, 274
Erigena, John Scotus, 281
eros, 334
Eschenbach, Wolfram von, 290
essentialism, 124, 191–194

Eugenia, St., 229
Eulogius of Toledo, 280
eunuchism, xvi, 279–292
eunuchs, 279–292
Euphrosynne, St., 229
Eusebius, 281
Eusebius of Caesarea, 285
Eve, 34, 86–88, 125–126, 333–334
exegesis, 350
Exeter Book, 402–403

fabliaux, 359–62. *See also* Chaucer *for individual tales* (*MilT; RvT; ShipT; MerT*)
Faerie Queen, 232
family, xiii, 332–333, 335
Fasciculus Morum, 243
fear, 82, 84, 86, 96
feminism, 224, 237, 352–356, 361
fennel, 262–263
ferns, 273
fertility, 54, 59–60
Ferula tingitana. See fennel
fetishism, 223
fin' amor , 348, 351
Finke, Laurie, xvii, 355, 357
Firmicus Maternus, 282–283
Fish, Stanley, 363 n. 5
Flavius Josephus, 165
Floris and Blauncheflour, 414, 420
Foeniculum vulgare. See fennel
folk practices, 53
foreplay, 373–375
fornication, 6, 13, 40–42, 45, 109, 138, 411, 414, 420; defined, 339–340; and lesbianism, 197–198; penalties for, 339–342; seriousness of, 339–340
Foucault, Michel, xiv, 16, 124, 346, 362 n. 1
Fougères, Etienne de, 204–205, 209
Frantzen, A., 7
Frauendienst, 234
Frederick II, 280
Freud, Sigmund, 124, 370
friendship, 196, 206, 218

Galen, 54, 58, 84, 127, 200–201, 226, 267
Galli, 282, 287
Garland Publishing, xvi
Gaunt, Simon, 356
Gaveston, Piers, 171, 176, 289
gay (origin of word), 156
gender, ix, xv, xvi, 61, 63; blending, 224; differentiations, 223; roles, 223–237; stereotypes, 223–224

genealogy, 357
genitalia, 124, 136–137, 139–141, 201; mutilation, 201–202, 216
geranium, 262
Gerard of Cremona, 271
Geremek, Bronislaw, 244, 250
Germanic peoples, 264, 312
Gerson, Jean, 41
Giddens, Anthony, 349, 362 nn. 1, 4, 363 n. 9
Giles of Rome, 267
ginger, 262
Gnosticism, 160, 162, 164
God, 55, 87, 96–97, 224–226, 231
godparents, 338. *See also* sponsorship, baptismal
Goldberg, Jeremy, 247–248
Golden Legend, 113
Goodich, Michael, 155
Gospel According to the Egyptians, 162
Gospels, 33
gout, 286
Gower, John, 418
Gratian, 39–41, 108, 168, 170
Gravdal, Kathryn, 358–359
Greek Anthology, 171
Greeks, 264. *See also* Byzantine Empire
Green, Monica, 53
Greenberg, David, 156, 180 n. 7, 181 n. 28
Gregorian reform, 106
Gregory, bishop of Tours, 109, 125, 129–130, 233, 292
Gregory of Nyssa, St., 265, 333
Gregory I, Pope St., 136
Gregory VII, Pope, 37, 167
Gregory IX, Pope, 168–169
Gregory the Great, Pope, 165
Grettisfoersla, 378
Grosseteste, Robert, 6
Guibert of Nogent, 216, 279, 284
Guillaume de Lorris, 351, 358, 363 n. 6
Guillaume IX, 358
Gunnhildr, queen of Norway, 373–378
Guðmundr Eyjólfsson, 383–387
Guy de Roye, 174
Guy of Southwick, 136
gynecology, 51, 53–54
Gynecology, 226

Hadewijch, 97, 207
hagiography, 109–111, 113
Hali Meidenhad, 206
Halloween, 237
Halperin, David, 159
Hamilton, Edith, xiii
Haraldr hardráði, king of Norway, 374

Harley Lyrics, 406–407
Harsent, David, 416
Hartlieb, Johann, 53
haselwurtz, 268–269
health, 57–63, 66–67
heat, 90–92, 94
heat/cool differences, 62–63
Hebrew, 310–311
Heldris de Cornualle, 231
Heloise, 132–133
Henri of Champagne, 355
Henry III, 280
Henry VIII, 39, 158
Hercules, 224
heretics, 203, 331–332, 334. *See also*
 Bogomils; Manichaeans
Herlihy, David, 354
hermaphrodite, 63, 82, 286, 290
hermeneutic of suspicion, 350
hernia, 286
Hesychius, 171
heterosexuality, 206
Hilandar Monastery, 330
Hildefonsus of Toledo, 283
Hildegard of Bingen, 53–54, 93–94, 128,
 199, 207–208, 268–269
Hildegund, St., 229–230
Hincmar, archbishop of Reims, 167, 198
Hippocrates, 267, 272
Hippocratic Oath, 272
Hirschfeld, Magnus, 155, 223
Historia Augusta, 291
History of Magic and Experimental Science,
 52
History of Medieval Sexuality, 251
History of Sexuality, xv, 51–52
homicide, 265, 273
homophobia, 155, 171; roots of in antiq-
 uity, 159–165
homosexual (origin of word), 156
homosexuality, xi, xii, xiii, xvi, 8, 11, 36,
 45, 47, 63, 66, 82, 191–195, 197,
 199–202, 204, 208, 223, 245, 250,
 285–288, 290, 309, 311, 313, 319–
 320, 322, 335, 340, 381–390, 414,
 416; age-asymmetrical, 158; con-
 cepts of (difference between Greco-
 Roman and Judeo-Christian), 158–
 159; condemned by Church in
 Middle Ages, 165–76; criminalized
 by Christian emperors, 160–161; in
 fifteenth-century Florence and
 Venice, 159, 177; gender-discor-
 dant, 159; in medieval literature,
 169–172; penalties for, 340–341

Hostiensis, xiv, 10
Hroswith of Gandersheim, 280
Hrútr, lover of Queen Gunnhildr, 375–378
Hubert, St., 233
Hugh le Despenser, 289
Hugh of Saint-Cher, 173
Hus, John, 230
Husband's Lament, 403

Ibn Al-Shah al-Tahiri, 320
Ibn 'Ezra, 313
Ibn Khaldūn, 322
Ibn Naghrillah, 311
Ibn Sarafyun, 271
Ibn Shahin, 311
Ibn Sīnā, 271–272
illicit love visit, topos of, 370
Imitation of Nature, 347–348
impersonation, 225
impotence, 125, 139–141, 286, 292, 409,
 413; grounds for divorce, 338
incest, 6–7, 40–41, 43, 337–338, 342, 417–
 419. *See also* consanguinity; mar-
 riage, impediments to
India, 262
infanticide, 339
infertility, 56, 60
Ingibjǫrg, princess of Norway, 374
inheritance, 335, 337
Innocent III, Pope, 44
Innocent IV, Pope, 109
intercourse, 52, 55–60, 62–63, 66–67, 82,
 84, 90, 93–94, 96–97, 126–128,
 137, 139–141, 311–313; anal, 166,
 339–340; coital positions in, 339;
 timing of, 339, 341
intermarriage, 313
intertextuality, 358
Iran, 321
Iraq, 310, 321
Irenaeus, St., 164
Irsigler, Franz, 250
Irving, Edward B, 401–402
Isabella of England, 280
Isabella of France, 289
Isaiah the Prophet, 283
Isidore of Seville, 226
Isidore, St., 165
Islam, 280, 288, 309, 319–327
Isolde, 53
Ivan IV, 337
Ivo of Chartres, 168

Jacques de Vitry, 111, 116
al-Jāhiz, 322

Jāmi, 322
Jean de Meun, 351, 358, 363 n. 6
Jean Renard, 170
Jeremiah, the prophet, 281, 283
Jerome, St., 40, 85–87, 105, 110, 125–126,
 133, 164, 168, 226, 264, 281, 283,
 287, 334
Jerusalem, Kingdom of, 288
Jesus, 33, 124–125, 228. *See also* Christ
Jews, 332
Joan of Arc, 228, 230
Joan, Pope, 230. *See also* Anglicus, John
Jochens, Jenny, xvii
Johansson, Warren, xvi, 172
John Chrysostom, St., 105, 163, 195, 214,
 265, 333
John of Gaddesen, 60
John of Gaunt, 236
John the Evangelist, St., 106
John the Penitent, St., 335
John XXI, Pope. *See* Peter of Spain
Johnson, Barbara, 345–347
Joseph, St., 108–109, 114–115, 229–230,
 280
Jovinian, 34
Judah he-hasid, 312
Judaism, xvii, 224, 283–284, 309–317, 319
Judith, 404–405
Julian the Apostate, 282
juniper, 271, 273–274
Justin Martyr, 162, 283
Justinian, Emperor, 161, 281, 286–287,
 291

Karras, Ruth, xvi
Kaufehe. See marriage, by purchase
Kaufringer, Heinrich, 290
Kelly, Joan, 353–354
Kempe, Margery, 111, 115
Kendrick, Laura, 356–357
Kertbeny, Károly Mária, 156
Kibre, Pearl, 52–53
Kiev, 330
Kilwardy, Robert, 267
King David, 281
Kinsey, Alfred, xiii
Knights Templar, 175, 181 n.39
Kohler, Erich, 354, 357
kormchaia, 335
Kottje, R., 4–5, 7
Kowaleski, Maryanne, 247
Krafft-Ebing, Richard von, 223
Kristeva, Julia, 351–352
Krueger, Roberta, 354
Kuefler, Matthew, xvi

La Palud, Pierre de, 169
Lacan, Jacques, 353
LaCapra, Dominick, 352–354
Lactantius, 282
Lady Mede, 419
Lampe, David, xvii
Lane, E.W., 322
Lassotta, Arnold, 250
law, civil, 329, 335, 337, 339, 340–341;
 common, 336–337; Greek, 329,
 335–341; Nordic, 370, 380, 387,
 389; secular, 201; Slavic, 329, 335–
 341
*Law, Sex and Christian Society in Medieval
 Europe*, 347
Laxdoela Saga, 371
Lay le Freine, 414–415
lechery, 12
LeGoff, Jacques, 249
Lent, 36
Leo I, Pope St., 106, 116, 287
Leo VI, 287, 291, 336
Leo IX, Pope, 167, 173
lepers, 95
lepra, 67
leprosy, 67, 286
lesbianism, xvi, 167, 223, 313, 322, 341,
 390; and heresy, 203–204, 216;
 images of, 204, 208–209; as medi-
 cal disorder, 200–201; in
 penetentials, 197–198; punishment
 for, 202–203
lesser evils, 245–246
letters, 207–208, 211
Leupin, Alexandre, 351, 359–361
Lévi-Strauss, Claude, 381
Levin, Eve, xvii
Levitical decrees, 105
Leviticus, Book of, 157, 160, 166, 173
Lewis, C.S., 348–349
Leyerle, John, xv
libel: heterosexual, 380–390; homosexual,
 381–390
Lichtenstein, Ulrich von, 234
literature, Arabic, 311, 320, 322; Greek,
 224; Hebrew, 311; Roman, 224
Livre de Manières, 201
Livres de jostice et de piet, 201
Lombard, Peter, 108
Lomperis, Linda, 361
Lorcin, Marie-Thérèse, 249
Lorsch, 261
love, 65, 86, 94, 97; marital, 334, 342;
 romantic, 334
love-making, 371–379; and hair, 374

lovesickness, 65–66
lust, 83–84, 87–88, 93, 125–126, 132–133, 200, 333–334, 337, 342

Macer, 263, 269–270
Machiavelli, x
Mackey, Louis, 351
Magdalen houses, 253–254
Magdalen, Mary, 249
magic, 52, 268
Magnus, Albert, 52–54, 58–59, 67
Magnus IV, 291
Maid Marian: theatrical character of, 236
Maimonides, 311–312
maleficium, 268
Mallarmé, Stéphane, 345
Malleus Maleficarum, 140
Malory, Thomas (*Morte Darthur*), 417–418, 420
man, 226
Manichaeans, 331–332, 334
Mankind, 419
Mansǫngr, 380–381
maqamah, 311, 322
Marbode of Rennes, 170, 181 n. 30. *See also* Macer
Marcabru, 357–358
Marcionites, 34, 162, 284–285
Mardi Gras, 237
Margarita-Pelagius, St., 228
Margarito, 228
marginal groups, 249
Marie, countess of Champagne, 348, 355, 358
Marie de France, 170, 290, 357–358, 414
Marina (Marinus), St. 229
Marlowe, Christopher, 171
marriage, ix, xii-xiii, xvi, 53, 84, 94, 108–109, 115, 243, 248, 254, 284, 288, 291, 319, 356; absence of spouse, 338– 339; abstinence in, 331–334, 338–339, 341–342; annulment of, 37–39, 139, 338; barren, 38; by capture, 370; at Cana, 334; ceremonies, 329, 336; companionate, 333–334, 342; compared to religious life, 332–335; condemned, 331; consent to, 39–38, 336; consummation of, 37; definition of, 108; ecclesiastical model of, 335, 341; free choice of partner, 336; impediments to, 38–39, 107, 336–338; indissolubility of, 38–39; informal, 336–337; minimum age for, 39, 336–337; origin of, 126; pro-

creation and, 333–334, 337, 339; of prostitutes, 44; by purchase, 370–371; of rapist and victim, 340; as remedy for fornication, 333, 337, 342; sacrament, 108; sex in, 35, 37, 126, 131, 332–335, 339; of slaves, 336 of; spiritual, 35, 37; stability of, 42; tolerated, 333–334
Marriage in the Middle Ages, xv
martyrdom, 110
Mary of Oignies, 111–112, 116
Mary, the Blessed Virgin, 108–109, 114–115
Mary: theatrical character of, 235
masculinity, 82–86, 88, 89, 98, 123–124, 134–135, 139
Massimo, Pacifico, 178
masturbation, 41, 47, 129, 161, 169, 197–198, 200–201; 309, 313, 320, 340, 390, 403; penance in penetentials for, 166
matrons, 195, 197–198, 202, 214
Matthew, Book of, 162
Maurice of Sully, 14
Mauss, Marcel, 381
Mayne, Xavier, 155
McCracken, Peggy, 361
McGlynn, Margaret, xvi
medical views, 51
medicine, xvi, 81, 83, 88, 90, 92, 98, 285–286, 312, 322
Medieval Academy of America, xv
Medieval French Literature and the Law, 363 n. 12
Medieval Misogyny, 352, 363 n. 8
medieval theater, 235–236
medievalist, ix, x, xii, xiii, xv
Medvedev, P.N., 353
melancholy, 65–66
men: dominant perspective, 123–124; dress, 133–134; elderly, 138; fear of women, 140–141; physiology, 127–128; prone to lust, 126–128, 132–133, 141; sexual anxiety, 130, 137, 139–140; sexual virility, 129–130, 133–135, 139
menopause, 37
menses, 63
menstrual stimulator, 264–271
menstruation, 36, 61–63, 67, 88–90, 93, 263
meretrix, 243–244
Merlin, 231–232
Merovingian Society, 125, 129
Middle Ages, xi, xii, xv, xvii, 58, 60–61, 67, 226, 235, 246, 248– 249, 252; attitude toward marriage in, 171;

homosexual literature in, 169–172; homosexual subcultures in, 176–178; past scholarship on homosexuality in, 155–156; religious persecution of homosexuality in, 167–169; roots of homophobia in, 159–161
midwives, 53
Milutin, 329, 337
Mincius Felix, 264
Mishnah, 283–284
misogyny, 204, 352, 357, 361–362
missionary position, 378
mistresses, 253
Moi, Toril, 352–353
Molites, 226
Moll, Richard, xvi
monasticism, 130, 141, 330, 332–333, 341
Money, John, 223–224
monks, 35–36
monogamy, 34
Montague, John, 402
Monte Cassino, 165
Monteiro, Arlindo Camillo, 155
Monter, E. William, 177
Montpellier, 270
Moore, R.I., 250
moral discourse, x
Morris dance, 236
Morte Darthur, 417–418
Mortimer, Roger, 289
Mosaic Law, 160–161
Mount Athos, 330
mulier, 226. See also women
Mulieres Subintroductae, 104–105
Mummer's Parade, 237
Murray, Jacqueline, xvi
Muscovy, 337
Muwashshah, 311
myrrh, 263
mystics, 97–98
mythology, Greek, 224; Roman, 224

al-Nadīm, 319
Nahmanides, 312
nakedness, 372. See also nudity
Narcissus, 351
Narses, 281
Natalia, St., 229
nature, 81–83, 86–92, 97
Nazianzus, Gregory, 337
Neocesaria, 106
Neuss on the Rhine, 229
New Criticism, 350
Níð, 382

Njála. See Njáls Saga
Njáls Saga, 377–378, 386
Noah, wife of: theatrical character of, 235
Nomocanon, 331, 335
Nonus, 228
Noonan, John, 267
North Africa, 311
nudity, 196
nuns, 35–36, 195, 198, 201, 203–204, 206–208, 211, 341; rules for, 195–197, 214
Nuremberg Festivals, 237

obstetrics, 51, 53–54
Ohrid, 330
Óláfr helgi, king of Norway, 388–389
Old English leechbooks, 53
Qlkofra páttr, 384–385
On Christian Doctrine, 349
On Coitus, 62
On Compound Medicines, 270
On Degrees, 268
On Intercourse, 55
On Sterility, 60
On the Diseases of Women, 59
On the Secrets of Women, 52–53, 63, 67
opium poppy, 262
Order of St. Mary Magdalene. See prostitutes, reform of
orgasm, 92, 201
Oribasius, 270
Origen, 160, 162, 285, 289
Orlando Furioso, 232–233
Otis, Leah Lydia, 246
Ovid, 65, 351, 363 n. 6
Owl and Nightingale, 406

Pachomius, St., 163
Pachon of Scetis, 283
Paden, William, 354
pagans, paganism, 34, 330, 332
Paglia, Camille, 182 n. 45
Papaver somniferum. See opium poppy
Papo, 319
Papyrus, Berlin, 263
Paradise, 333–335
Paris, Bishop of, 36
Paris, Gaston, 348, 363 n. 3
Parliament of Fowls (Chaucer), 410
Parlement of the Three Ages, 135
parsley, 262
Pascoe, 274
passion, 86–87, 96
Passion of Saints Perpetua and Felicitas, 164
passivity, 85, 87–88

pastourelle, 358
patronage, 357–358
Paul, St., 33, 104–105, 108, 163, 166, 194–
 195, 331; views on sex, 161
Paulinus of Nola, 104–105
Paulus Aegineta, 286
Payer, Pierre, xvi
Pearsall, Derek, 353
pederasty, x, 310–311, 313, 319, 322;
 mindset of in pagan antiquity, 159
Pelagia, 228. See also Pelagius, Margarito
Pelagius, Margarito, 228–229
Pellat, C., 322
penance, 3, 335–336, 342
penetential canons, 10
Penetential of Theodore, 197
penetentials, 3, 4–8, 20, n. 30. 35–36, 197–
 199, 389–390; treatment of sexual
 behavior in, 165–166
penetration, 378–379, 382
penis, 124, 140, 199, 201; erection, 128,
 134, 136–137; size, 137
penis captivus, 140
Penne, Luca da, 168
pennyroyal, 263, 265
Pentecost, 36
pepper, white, 262
Percy, William, xvi
Perpetua, St., 229
Perry, Mary Elizabeth, 249
pessaries, 272
Peter Damian, St., 167
Peter Lombard, 170
Peter of Spain (Pope John XXI), 61, 66
Peter (Pietro), d'Abano, 64–65
Peter the Chanter, 13, 168, 170, 173
Petroselinum sativum. See parsley
Peucedanum cervaria, 262
phallus, 129, 203, 205, 208
Philip IV, king of France, 176
Philip, the apostle, 283
Philo, 227
Philo Judaeus, 161–162, 165, 175
Phthorion, 264
physicians, 89
physiognomy, 51–52
Pico della Mirandola, Giovanni, 178
Piers Plowman, 419
Pimpinella Anisum, 262
Pincus, Gregory, 261
piperine, 262
Pius IX, Pope, 274
Plato, xiii
Pliny, 226
Pliny the Elder, 271

Ploss, Hermann Heinrich, xii
poetry, 310–311, 320–323
pollution, 93, 95; noctural, 136, 141
Polo, Marco, 280
polygamy, 129, 309
Poor Clares, 111
population decline, 265
Þorlàkr, Bishop, 389–390
Þórðarson (Thórtharson), Sturla, 291
poststructuralism, 351, 362 n. 6
Potiphar, 280
poulaines, 134
pregnancy, 36
priests, 35, 333, 341–342. See also clergy
Prime-Stevenson, Edward Irenaeus, 155
primogeniture, 357
private acts, 52
Problemata, The 63
procopius, 329
procreation, 331–332, 334
prohibitions, 82, 84, 90
promiscuity, 332
prostitutes, 65–66, 236, 243–254, 340; re-
 form of, 45
prostitution, ix, xii, xiii, xvi, 43–44, 135,
 282, 313–314, 320, 322; establish-
 ment of, 245, 253; institutionaliza-
 tion of, 244, 246–248; legalization
 of, 246, 249; licensing of, 246–247;
 marginalization of, 249–251; out-
 lawing of, 244; recriminalization
 of, 246; regulation of, 244, 246,
 249, 251, 253; taxing of, 244; tol-
 eration of, 244, 246–247
Pseudo-Clement, 162
psychoanalysis, 350, 352, 360
puberty, 59
Purity, 416

Qabalah, 312
Queen Anne's lace, 264
Qur'an, 310, 319, 321

Rabanus Maurus, archbishop of Mainz, 197
Radegunde, 233
Ragadie, 65
Raimbaut d'Orange, 290
Ranke, Leopold von, x, xi, xiii
rape, 46, 129, 135–136, 245–246, 248,
 251–252, 288, 357–358, 402, 408,
 420; force as element in, 340; mari-
 tal, 338; penalties for, 340; "statu-
 tory," 340; subsequent marriage of
 perpetrator and victim, 340; vic-
 tims of, 340

Rashi, 313
Raubehe. See marriage, by capture
recipes, 59–61
Reformation, the, 247
regimen of health, 270
Regimen Sanitatis Salernitanum. See regimen of health
Regino of Prün, 6
remarriage, 336–338; and adultery, 338; after divorce, 338
Reovalis, 233
representation, 345, 347, 357–360; dialogic theories of, 347, 352, 359, 361–362, 363 n. 9; hermeneutic theories of, 347, 349–350; reflective theories of, 347–349, 351, 359; specular theories of, 347, 351–352, 359
reproduction, 37–38, 54–56, 58–60, 62–64, 66–67, 85, 91, 369
reserved sins, 12
Rhazes, 61
Rich, Adrienne, 193–194, 204
Ricoeur, Paul, 350
Riddle, John, xvi
riddles (*Exeter Book*), 402–403
Robert le Bougre, 158, 180 n. 6
Robertson, D.W., 349–350
Robinson, James Harvey, xiv
Rock, John, 261
Rocke, Michael J., 156, 177
Roman de la Rose, 281, 346, 351, 357–358, 410
Roman de Silence, Le, 231, 233
Roman Empire, 33
Romans, Book of, 160–161, 163, 194–195
Rosenthal, F., 319
Rossiaud, Jacques, 246, 248
Roth, Norman, xvii
Rougemont, Denis de, 348–349
royal pardons, 52
Rudel, Jaufre, 358
rue, 263, 265, 273
Russia, 330, 335–336, 340. *See also* Muscovy
Ruth, Book of, 214

Sa adyah, 310, 313
saints' lives, 358, 360
Salerno, 271
Salisbury, Joyce, xvi
sanctity, 283
Santa Maria Maggiore, Church of, 282
satyriasis, 286
satyrs, 157, 179–180 n. 2, 180 n. 3
Savanarola, 178

savin. *See* juniper
al-Ṣaymari, 320
Scandal of the Fabliaux, 351–361
Schonau, 230
Schuster, Peter, 245, 249
Secret Gospel of Mark, 161
Sedgwick, Eve Kosofsky, 354, 369
seduction: attempted, 414–415; successful, 407, 412–413
semen, 82–85, 87–91, 94, 96, 127, 136, 141, 286
Seneca, 266
separation: to permit monastic vows, 339
Serapion the Elder. *See* Ibn Sarafyun
Serbia, 329–330, 335–338, 340
Serenus the Gardener, 283
serða. See penetration
Severian, 236
Severus Alexander, Emperor, 291
sex, ix, xiii, xv, xvi, xvii, 54–55, 84–85, 89–90, 97–98, 223–228, 230–232, 237, 243–246, 248, 251–252, anal, 40, 43; arousal, 128, 131–132; astrology, 200; class distinctions, 132, 135–136; and death, 35; and the devil, 39; and evil, 331, 333–335; forbidden periods of, 107, 339, 341; and heresy, 331–332, 334; heterosexual, 36–37; limits on, 35, 39, 43; marital, 37, 39–41; during menstruation, 140; nonmarital, 36; offenses, 42–43; oral, 40, 84; positions in, 40; regulation of, 204; with slaves, 340, 387–388; and spirituality, 204, 206; unnatural, 203, 339; and violence, 129–130, 132–133, 135–136, 146, 370, 381. *See also* adultery; celibacy; fornication; incest; marriage; prostitution; rape; sodomy
Sex in History: A Virgin Field, xiv, xv
sexual activity, 285–288; ambiguity, 63, 65; categorizing, xiv, xv; defect, 331; desires, 55–60, 63–66, 93, 95, 97, 285–287; pleasure, 35, 39, 42, 51, 55–57, 59–60, 64–66, 84–86, 92–93, 333–335; renunciation, 35, 37, 282–284; techniques, 339; variance, xvi
sexuality, female, 81, 84–87, 94–96, 194, 206, 333; initiative in, 373; intercourse in, 371, 375–380; male, 81–82, 84–86, 94–96; social construction of, 191–194
sexually transmitted diseases, 67

Sidonius Apollinaris, 290
Sighvatr Þórðarson, 388–389
silence, 231–232
Simeon Stylites, St., 163
sin, 87, 125–126, 248–249, 252, 254, 333–335, 342
Siricius, Pope, 106
Sir Gawain and the Green Knight, 415–416
Sir Launval, 414
slaves, 313, 320, 322
Slavs, 329–330, 334–341
social control, 15
Sodom, 156, 160, 165, 167, 173
Sodomites, 155–156, 163, 167–170, 172–173, 175, 177–178; origin of medieval interpretation of, 156–158
sodomy, 40–41, 43, 45, 64, 163–169, 172, 179, 182 n. 43, 199–202, 245, 309, 319–320, 322, 339; association with demonic powers, 172–176; origin of medieval notion of, 156–157
Soranus, 127, 226
soul, 87, 91, 97, 265
Spain, 310, 312–314, 321–322
Spenser, Edmund, 232
sperm, 83, 86, 88, 90–91, 93
spermicides, 61
spignel seeds, 262
spiritus. *See* soul
sponsorship, baptismal, 38, 43
spousal exception. *See* rape
Stanbury, Sarah, 361
sterilitas, 264
Stoics, 265
stomach aches, 261
Streða. *See* penetration
structuration, 363 n. 9
Sturluson, Snorri, 291
subcultures, medieval homosexual, 176–178
subjectivity, 351–352
Summa theologias, 200
Summae Confessorum, 9–12
sumptuary legislation, 247
superfluities, 57–59, 62–63, 65–66
symbolic capital, 357
syneisaktism, 103–104
Synod of Angers, 13
syphilis, x, 247

Talmund, 160, 284, 309–311, 313
Tanacetum vulgare. *See* tansy
tansy, 263, 269, 274
Tatian, 162
teleology, 54–57, 59–60, 67
Tentler, T.N., 15

terminology: relative to study of homosexuality in Middle Ages, 156–159
Tertullian, 164, 282, 285
textuality, 345
Thecla, St., 229
Theodora, Empress, 329
Theodora, St., 229
Theodorus Priscianus, 270, 272
Theodosius the Great, emperor, 160–161
theologians, 87–88, 94, 96–98
theories of sexuality, 124, 191–194, 206
Thomas Aquinas, 91, 94–95, 97, 164, 168, 195, 200, 225, 245, 267, 283, 286; commentary on *Nicomachean Ethics*, VII, v, 3–4, 174–175
Thomas of Chobham, 137, 249
Thompson, Stith, 228
Thorndike, Lynn, 52–53
Timothy, Book of, 161
Titus, Book of, 161
Toynbee, Arnold, xiii
traditions: Greek, 51; Islamic, 51; Latin, 52–54, 61
transference, 352–353
transsexuality, 223–224
transvestism, 125, 282, 292
transvestite, 223–224, 229, 237, 251, 253. *See also* transvestism
Tretis of tua mariit Wemen and the Wedo, 409–410
Trexler, Richard, 248
Trobairitz, 354, 358
Trota, 54
Trotula, 52, 54, 270
troubadour lyric, 348–350, 354, 356–357, 362 n. 4
Trumbach, Rudolph, 159

Usener, Herman, 229
uxorcide, 130

vaginismus, 140
Valentinus, 164
Valesians, 285
Vance, Eugene, 355
Varagine, Jacopo da, 173
varicose veins, 286
venereal disease, 253
Venus, 224, 229, 234
vernaculars, 53–54, 252
Victor of Hugh, St., 108
violence, 124, 130, 132, 135–136
vir, 226. *See also* man
virginity, 33, 104, 106–107, 110, 125, 206, 332, 334

virtu, 226
Völsi, 129

Wallāda, 322
Watton, nuns of, 289
wedding, 336
Westermark, Edward, xii
Westphal, Carl, 223
White Ladies. *See* prostitutes, reform of
White, Luise, 248
widowers, 37, 337, 341–342
widows, 37, 104, 197–198, 332, 337, 340, 342
Wife's Lament, 403–404
Wild Woman, the: theatrical character of, 237
William of Conches, 56
William of Saliceto, 64, 201, 272–273
Williams, Craig, 180 n.9
Wilson, C.E., 322
Winchester, bishops of, 245

wine, 320
witchcraft, 140, 203
womb, 91–93, 95
women, xii, 83–89, 93, 95–97, 226, 332–333, 335; inferior to men, 126–127, 130–131, 195, 214 ; in male sexual role, 199–203, 205, 216; as sexually passive, 127, 131, 133; 202–203; as sources of sexual sin, 125–126, 128, 133
women's secrets, 264
Wulf and Eadwacer, 404
Wyf of Bath, 407–409

Yeats, W.B., 401, 420
Yvain, 354–356

Zingiber officinale. See ginger
Zoroastrianism, 160
Zumthor, Paul, 351